ARTIST BEWARE

BY

Michael McCann, Ph.D, C.I.H.

THE LYONS PRESS

Printed in the United States of America

Design by MRP Design

10 9 8 7 6 5 4 3 2 1

Library of Congress Cataloging-in-Publication Data

McCann, Michael, 1943—
 Artist Beware / by Michael McCann.—2nd ed.
 p. cm.
 Previous published: New York : Watson-Guptill, 1979.
 Includes bibliographical references and index.
 ISBN 1-55821-175-6 (cloth) ISBN 1-58574-211-2 (paperback)
 1. Artists—Diseases. 2. Artisans—Diseases. 3. Artists'
 materials—Toxicology. I. Title.
 RC963.6A78M32 1993
 702'.8'9—dc20 92-32295
 CIP

Contents

Preface to Second Edition

I n recent years, many artists have asked me when I was going to write a second edition to *Artist Beware*. Since 1979, much has changed in the area of art hazards, particularly with respect to labeling and the seriousness given the subject by artists, schools, governmental agencies, etc. More has also been learned about the toxic effects of many chemicals in the last decade.

In 1991, the original publisher, Watson-Guptill Publications, declared the book out of print, and released the copyright to me. Lyons and Burford, Publishers, already the publisher of two other books on art hazards, my *Health Hazards Manual for Artists*, and the Center for Safety in the Arts' *Ventilation*, enthusiastically agreed to publish the second edition of *Artist Beware*.

This second edition turned out to be almost a complete rewrite of the first edition. Even the chapters were reorganized. I added extensive sections on labeling and Material Safety Data Sheets; modified the relative toxicity rating system to include an "extremely toxic" category; and added new chapters on physical hazards, new technology in art (neon and laser sculpture, computer art), and commercial art. I also reorganized many of the tables to minimize unnecessary repetition.

I hope that this second edition of *Artist Beware* will prove as successful and useful as the first edition.

Preface to First Edition

The most frequent question I get asked is how did I get interested in the health hazards or art materials. Actually it was the result of two chance occurrences. First, in 1974, I met a friend at a printmaking workshop—the first time I had ever been in one. They were silkscreening at the time, and there was no ventilation. Within half an hour I was experiencing headache, light-headedness, and some eye irritation. After looking at the materials being used—by children as well as adults—I asked my friend whether people working with these materials realized how hazardous they were. The answer was no. That aroused my interest as a science writer.

The second occurrence some months later was my meeting Jackie Skiles, then editor of *Art Workers News*. That meeting resulted in the idea of doing some articles on art hazards for *Art Workers News*, which ended up as a seven-part series that was later compiled and published as the *Health Hazards Manual for Artists*. I also began lecturing on art hazards to art audiences and writing a regular column, "Art Hazards News," in *Art Workers News*.

The more research I did about art and craft materials, the more aware I became of the vast number of toxic chemicals being used by artists as well as the lack of awareness by artists and craftspeople of the hazards and suitable precautions. I soon realized the need for a comprehensive book on the subject. At the suggestion of Andrew Stasik of Pratt Graphics Center, I approached Don Holden, then Editorial Director of Watson-Guptill Publications, with the idea. His enthusiastic response and three more years of work resulted in this book.

This book was primarily written for artists, craftspeople, art teachers, and hobbyists. I hope, however, that it will also prove useful to people who encounter artists professionally and who might need to know about the toxic effects of materials artists are using. In this category I include physicians, school nurses, school safety directors, and other health professionals. I also think that this book can be of use to architects and others responsible for the design and operation of art schools and classrooms.

Although the book emphasizes the individual artist in his or her studio, I would like to stress the importance of this book to art teachers and art students. It is crucial that art students learn the hazards of art materials and how to work safely with these materials, at the same time that they learn the art technique itself. In this way proper and safe work habits can be established and become part of the art technique.

Acknowledgments

Many people contributed their assistance to preparing this second edition of *Artist Beware*, including artists, physicians, industrial hygienists, and others.

A great many artists in individual studios and art teachers in schools and colleges helped directly in updating this book by providing information and reviewing the manuscript. These included: Jacqueline Clipsham (ceramics), Lance Court (metalworking and jewelry), Jim Cook (glassblowing), Melissa Crenshaw (lasers and holography), Stephen Dee Edwards (glassblowing), Coco Gordon (papermaking), June Jasen (enameling), Devora Neumark (printmaking), David Perry (commercial art), Paul Sheridan (photography), Naomi Towner (textiles), Fred Tschida (neon sculpture) and John Underkofler (holography).

Several physicians and industrial hygienists helped in reviewing the toxicology and precautions. These included: Angela Babin (Center for Safety in the Arts), Dr. Howard Kipen (Rutgers University Medical Center), Dr. Richard Norris (National Arts Medicine Center), Dr. Robert Nadig (Beth Israel Medical Center), and Christine Proctor (New York Committee for Occupational Safety and Health).

Several people presently and formerly on staff at the Center for Safety in the Arts reviewed the entire book and I appreciate their dedication. These were Angela Babin, presently director of the Art Hazards Information Center; Karen

Giacalone, associate director; Devora Neumark, former program coordinator and now an art hazards consultant in Montreal; and Christine Proctor, former director of the Information Center.

Many other artists and art teachers have unknowingly assisted over the years in providing me with information on new materials and techniques that have worked their way into this book. This includes all those people who have contacted the Art Hazards Information Center for assistance over the years. I thank them also. In addition, there are all the people who contributed to the first edition of *Artist Beware*, and who were acknowledged in that edition.

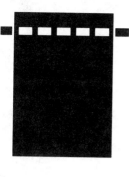

How to Use this Book

This book is divided into two parts, and was written to be used in a particular way. Part One, consisting of Chapters 1 through 11, is a general introduction to the chemical and physical hazards commonly found in art and craft materials and processes, and to suitable precautions. Chapters 1 and 2 describe the history of art hazards and resources to help you. Chapters 3–5 describe the actual hazards of chemicals. Chapters 6–9 discuss setting up a studio, knowing your art materials, ventilation, personal protective equipment, and other precautions. Chapter 10 discusses physical hazards, and Chapter 11 what to do if you actually become ill.

You will need the background material in Part One to understand Part Two, which discusses the hazards of particular art and craft techniques—both the process and the materials used—and the precautions you can take to protect yourself. Having read Part One, you need only read the particular chapters that interest you in Part Two, where each chapter is independent of the others in that section, except for a few cases where I refer you to other chapters to avoid unnecessary repetition. In Part Two, I have broken down the various art or craft techniques described in each chapter into separate operations, with the hazards

1

and precautions for each operation considered separately. Some chapters have tables of chemicals used predominantly in that field.

The toxicity tables in Chapters 4 and 5 and in some of the art technique chapters list the common names, relative toxicity ratings, and specific hazards of the many chemicals. These tables do not list the trade names of the materials for several reasons: first, this could create legal problems; second, there are too many brand-name products in existence; third, the brand-name compositions often change without warning; and fourth, it is often impossible to find out exactly what is in a brand-name product due to trade secrecy.

The best way to use the toxicity tables is to find out what chemicals you are using, and then use the index to look them up in the tables. The number listed in boldface type in the index refers to the page number of the table in which the chemical is listed. You should find the hazardous chemicals listed on the label of the art or craft material. Other ways to find out the contents include writing the manufacturer for Material Safety Data Sheets, and reading the section of this book that deals with the particular art or craft technique in which you are interested.

If you do not know the contents of the material, go directly to the chapter dealing with the particular art or craft technique you are using. There I describe the various chemicals typically used in that technique, along with their hazards and the precautions you can take. Once you find out the contents of the materials, you can use the index to guide you to discussions throughout the book.

PART

1

Chemical
and
Physical
Hazards

Is Your
Art Killing
You?

Vinyl chloride, asbestos, benzene, lead, cigarettes, and now art and craft materials? Every day we find that more and more of the chemicals we eat, drink, breathe, work with, or are exposed to in some other way are hazardous. The twentieth century is the era of chemistry. It is estimated that we are exposed to over 20,000 known toxic chemicals, and of the 500 new chemicals that are introduced into the marketplace every year, most have never been tested for their long-term effects on the human body.

Many artists and craftspeople are surprised to discover that a large number of these same hazardous chemicals are also present in art and craft materials. Most of us have thought of art materials as innocuous, an attitude stemming from the common use of art materials when we were children. Our parents assumed that if something was on the market, it was safe. Thus we were encouraged to express our creativity by really "getting into" our paints and modeling clay and experimenting with them. Only in recent years did we begin to find out that some of the art materials used by children are not as safe as assumed.

The attitude that art materials are safe has carried over into more professional art practices. In fact, many art teachers have perpetuated this attitude by comments such as, "To be a potter, you have to live and breathe clay," and "You will

get used to the smell," and "You have to get close to your materials." As a result, some very dangerous work habits developed, including pointing your paint brush with your lips, eating while you worked, and ignoring the layers of clay and glaze dust covering everything in the studio. Of course, the problem was that most art teachers did not know that art materials could be toxic.

A LOOK BACKWARD

The history of arts and crafts includes terms such as potter's rot, painter's colic, and stonemason's disease, terms that clearly indicate that there was some awareness of hazards in the past. Probably the earliest recognition of the hazards of various arts and crafts was by Bernardini Ramazzini, acknowledged as the father of occupational medicine, in his book *De Morbis Artificum* (*Diseases of Workers*), published in 1713. He described the diseases of many occupational groups, especially craftsmen. The following sections contain quotations from some of his descriptions.

Painters. "I have observed that nearly all the painters who I know, both in this and other cities, are sickly; and if one reads the lives of painters it will be seen that they are by no means long-lived, especially those who were most distinguished.... For their liability to disease there is a more immediate cause, I mean the materials of the colors they handle and smell constantly, such as red lead, cinnabar, white lead, varnish, nut-oil and linseed oil which they use for mixing colors; and the numerous pigments made of various mineral substances."

Stonecutters. "We must not underestimate the maladies that attack stone cutters, sculptors, quarrymen and other such workers... Diemerbroeck gives an interesting account of several stone-cutters who died of asthma; when he dissected their cadavers he found, he says, piles of sand in the lungs, so much of it that in cutting with his knife through the pulmonary vesicles he felt as though he were cutting a body of sand."

Coppersmiths. "In every city, e.g. at Venice, these workers are all congregated in one quarter and are engaged all day in hammering copper to make it ductile so that with it they may manufacture vessels of various kinds. From this quarter there rises such a terrible din that only these workers have shops and homes there; all others flee from that highly disagreeable locality.... To begin with, the ears are injured by that perpetual din, and in fact the whole head, inevitably, so that workers of this class become hard of hearing, and, if they grow old at this work, completely deaf."

Potters. "What city or town is there in which men do not follow the potter's craft, the oldest of all the arts? Now when they need roasted or calcined lead for glazing their pots, they grind the lead in marble vessels, and in order to do this they hang a wooden pole from the roof, fasten a square stone to its end, and then turn it round and round. During this process or again when they use tongs to daub the pots with molten lead before putting them into the furnace, their mouths, nostrils, and the whole body take in the lead poison that has been melted and dissolved in water; hence they are soon attacked by grievous maladies."

A CONTEMPORARY LOOK

In recent times physicians have speculated that some of the illnesses of famous artists might have been the result of poisoning by their materials. For example, Dr. Bertram Carnow has suggested that Van Gogh's insanity might have been caused by lead poisoning and has theorized that the blurring of stars and the halos around lights in Van Gogh's later painting might have been the result of swelling of the optic nerve, a possible effect of lead poisoning. There is documentation of instances of Van Gogh swallowing paint and of his very sloppy painting technique. He was known to use the lead-containing Naples yellow as well as several other highly toxic pigments. Similarly Dr. William Niederland has suggested that Goya's mysterious illness in his middle age might have been lead poisoning and not schizophrenia or syphilis as is commonly suggested. Goya had been known to use large amounts of lead white.

It would be nice to be able to say that these art hazards are in the past. However, the same diseases described by Ramazzini can be found among artists and craftspeople today. Although many artists are aware of certain art-specific hazards—for example, lead in flake white or lead white oil paint, or in pottery glazes—this awareness often does not extend to a consideration of the hazards of other materials. There are also many more materials being used today than in Ramazzini's time

Many of the twentieth-century materials used by artists—such as the plastics, lacquers, solvents, aerosol sprays, and dyes—can be highly toxic, as some modern artists have found out to their sorrow.

In fact, artists are developing many of the same occupational diseases as are found in industry. Of course this should not be entirely surprising, since artists use many industrial chemicals, often in their homes, and without knowledge of the hazards and how to work safely.

Table 1-1 lists the hazards of many of the common art techniques. As you can see, hazards are found in all different types of art media. And we find artists developing occupational diseases in all different types of media. Examples include bladder cancer in painters; lead poisoning in stained-glass artists, potters, and

enamelists; peripheral nerve damage in commercial artists; emphysema in acid etchers; aplastic anemia and leukemia from use of benzene; severe asthma among users of fiber-reactive dyes; cyanide poisoning from electroplating and kidney damage from cadmium silver solders in jewelers; brain damage in silk-screen printers; death of a weaver from anthrax; and metal fume fever in welders.

The only epidemiological study of artists was conducted by the National Cancer Institute in the early 1980s. This study, a proportionate mortality study, consisted of obtaining death certificates on artists and statistically analyzing the causes of deaths of the artists compared to the general population. Lists of deceased artists were obtained from obituaries published in *Who's Who in American Art* between 1940 and 1969. The study of 1,746 white, professional artists found that deaths from arteriosclerotic heart disease and from all cancer sites combined were significantly elevated for painters and, to a lesser degree, for other artists. For male painters, leukemia and cancers of the bladder, kidney, and colorectum were significantly elevated. A case control study of bladder cancer patients, in which the researchers compared the professions of bladder cancer patients to the professions of non-bladder cancer patients, found an overall relative risk estimate of 2.5 for artistic painters, confirming a twofold excess of bladder cancer deaths in the earlier study. The case control study also found that the risk increased with increasing length of employment as an artistic painter.

In other male artists, proportionate mortality ratios for bladder cancer and leukemia were not significantly elevated, but those for colorectal and kidney cancer were. A preliminary report found that among other male artists, colon cancer and prostate cancer were significantly elevated among sculptors.

Early Warning Attempts

The first warning to the arts community that some of these new—and many old—art materials might be toxic came from Robert Mallary, one of the pioneers in the field of art hazards, in an article in *Art News* in 1963. He described how, after working for about 15 years with polyester resins, epoxy resins, other plastics, spray paints, and a variety of solvents, he developed repeated episodes of a flu-like illness. Eventually this was diagnosed by a toxicologist as liver and kidney damage caused by exposure to solvents and plastic resins. In the article, Mallary also described several other cases of illnesses caused by exposure to art materials.

In 1968, Dr. Jerome Siedlicki published an article on hazards in painting and sculpture in the *Journal of the American Medical Association*, which was later published as *The Silent Enemy* by Artists Equity Association in Washington, D.C.

In the mid-1970s, two independent centers for information on art hazards arose, in New York and Chicago. In New York, I had become interested in the problem and began writing a series of articles for *Art Workers News*, a publication of the recently collapsed Foundation for Community of Artists (FCA). At the

same time, I established the Art Hazards Resource Center at FCA to answer artists' inquiries on art hazards. By 1977, the interest in this area was large enough to form a separate organization, the Center for Occupational Hazards (now called the Center for Safety in the Arts), as a national clearinghouse for research and education on art hazards. Monona Rossol and Catherine Jenkins, both chemists and artists, were cofounders.

At the same time, Dr. Bertram Carnow, an occupational health physician, and Gail Barazani, an artist, also began writing about art hazards in Chicago. Gail Barazani formed the organization Hazards in the Arts, which did organizing around this issue in the Chicago area for several years. In Vermont, Dr. Julian Waller and Larry Whitehead wrote articles and did presentations on art hazards in the late 1970's.

Challenging Myths about Artists

In the past, many myths have developed concerning the mental instability, the suffering, and the antisocial behavior of artists. These myths have interfered with the realization that the hazards artists face are real and that some of their unusual behavior may be traced to the fact that the materials they have used over a long period of time might have made them ill or might have produced bizarre psychological effects. For example, almost everyone has heard the phrase "mad as a hatter," or has heard of Lewis Carroll's Mad Hatter in *Alice in Wonderland.* This stereotype has some basis in fact, since hatters used mercuric nitrate to felt hats at the time the book was written, and mercury poisoning does cause severe psychological symptoms.

The myth of the artist as a Sunday painter has also prevented those outside the artistic community from realizing the dangers artists face. For example, when I first started investigating the health hazards of art materials, I had trouble convincing government officials and many doctors that there was a problem. First, they found it hard to believe that artists were working with hazardous materials, and, second, they pictured artists as being exposed to these hazards only occasionally and therefore not being at great risk. It took time to convince them that most artists put in regular hours every day and, in fact, often work very long hours at their art.

WHAT IS THE PROBLEM?

Why are artists getting ill from their art materials? Why don't artists know more about the hazards and how to work safely? This section discusses the major reasons for what is a true public health problem.

9

Too Toxic

Many chemicals found in art materials just shouldn't be there because they are too dangerous to use without prohibitively expensive precautions, or because serious illness or death can easily occur from small exposures or accidents. Cancer-causing chemicals such as asbestos, benzene (formerly found in many paint strippers), chromates and dichromates, and cadmium in some silver solders are one such category of chemicals that should not be in art materials. Since there is no known safe level of exposure to carcinogens, zero exposure is the ideal. That is very difficult and expensive to do.

Many highly toxic chemicals also should not be used in art materials because of the serious nature of their health effects. For example, there have been many cases of hydrogen cyanide poisoning, and even fatalities, from the use of cyanide electroplating solutions and cyanide cleaning solutions. I do not think artists can work safely with cyanide solutions. Other highly toxic chemicals that should not be found in art materials include lead, arsenic, n-hexane (found in rubber cement, for example), and mercury and its compounds.

Why are these chemicals there? There are two reasons. First, in the past there has not been much incentive for art material manufacturers to develop safer products. The passage of the Labeling of Hazardous Art Materials Act of 1988 by the U.S. Congress now gives manufacturers incentives to develop safer products as an alternative to warning users about the risk of cancer, birth defects, brain damage, and the like. The development of lead-free pottery glazes and enamels is a good example of safer products that have become available in recent years.

A second reason is that many artists are using materials that have been developed for industry and not artists. Many of these materials need very expensive ventilation systems and careful training to be used safely. Examples include cyanide gold and silver electroplating solutions, plastic resins (e.g., polyester resin, polyurethane foam resin), and solvent-based silk-screen printing inks. Artists should be very cautious about using such industrial materials unless they are willing to spend the money to do it safely.

Inadequate Labeling

Prior to the 1980s, most art materials were inadequately labeled. The only required labeling was for acute hazards resulting from a singe exposure. However, most artists have repeated exposure to art materials. The lack of proper warnings meant that most artists did not know if they were working with hazardous art materials, or how to work safely with them. The question of proper labeling of art materials is discussed in Chapter 2.

Failure of the Schools and Colleges

Artists should learn about the hazards of art materials and how to work safely with them when they first begin to use them. This should start as early as day care and elementary schools, but becomes most important in secondary schools and colleges. Unfortunately, in the past, most art teachers themselves did not know about the hazards of art materials, and therefore couldn't teach it. In addition, most schools did not have health and safety programs or adequate precautions such as ventilation. This is in the process of changing as groups like the Center for Safety in the Arts offer educational programs on art hazards to teachers and students and provide consultative services to schools and colleges.

Improper Diagnosis

Since artists often don't know about the hazards of their art materials and therefore don't take adequate precautions, they sometimes become ill from exposure to these art materials. Unfortunately, most physicians are not trained in the toxic effects of chemicals. As a result they are often unable to properly diagnose an art-related illness. I have seen, for example, lead poisoning diagnosed as psychosomatic. Instead we have to refer artists with illnesses suspected of being caused by art materials to physicians specializing in occupational medicine. Fortunately, in recent years, several dozen occupational health clinics have organized around the country, and we can refer artists to them.

TABLE 1-1.	Hazards of Art Techniques	
Technique	*Material/Process*	*Hazard*
Airbrush	pigments	lead, cadmium, manganese, cobalt, mercury, etc.
	solvents	mineral spirits, turpentine
Batik	wax	fire, wax fumes
	dying	dyes
Ceramics	clay dust	silica
	glazes	silica, lead, cadmium, other toxic metals
	slip casting	talc, asbestiform materials
	kiln firing	sulfur dioxide, carbon monoxide, fluorides, infrared radiation, etc.

Technique	Material/Process	Hazard
Commercial art	rubber cement	n-hexane, fire
	permanent markers	xylene, propyl alcohol
	spray adhesives	n-hexane, 1,1,1-trichloroethane, fire
	airbrushing	see Airbrush
	typography	see Photography
	photostats, proofs	alkali, propyl alcohol
Computer art	ergonomics	carpel tunnel syndrome, poorly designed workstations
	video display	glare, ELF radiation
Drawing	spray fixatives	n-hexane, other solvents
Electroplating	gold, silver	cyanide salts, hydrogen cyanide
	other metals	acids
Enameling	enamels	lead, cadmium, arsenic,cobalt, etc.
	kiln firing	infrared radiation
Forging	hammering	noise
	hot forge	carbon monoxide
Glassblowing	batch process	lead, silica, arsenic, etc.
	furnaces	heat, infrared radiation
Glassblowing	coloring	metal fumes
	etching	hydrofluoric acid, fluoride salts
	sandblasting	silica
Holography	lasers	nonionizing radiation, electrical
	developing	bromine, pyrogallol, see also Photography
Intaglio	acid etching	hydrochloric and nitric acids, nitrogen dioxide, chlorine gas
	solvents	alcohol, mineral spirits, kerosene
	aquatint	rosin dust, dust explosion
	photoetching	glycol ethers, xylene
Jewelry	silver soldering	cadmium fumes, fluoride fluxes
	pickling baths	acids, sulfur oxides
Lithography	solvents	mineral spirits, isophorone, cyclohexanone, kerosene, methylene chloride, etc.
	acids	nitric, phosphoric,hydrofluoric, hydrochloric, etc.
	talc	asbestiform materials
	photolithography	dichromates
Lost wax casting	investment	cristobalite
	wax burnout	wax fumes, carbon monoxide

Technique	Material/Process	Hazard
Lost wax casting	crucible furnace	carbon monoxide, metal fumes
	metal pouring	metal fumes, infrared radiation, molten metal
	sandblasting	silica
Painting	pigments	lead, cadmium, mercury, cobalt, manganese compounds, etc.
	oil, alkyd	mineral spirits, turpentine
	acrylic	trace amounts ammonia, formaldehyde
Pastels	pigment dusts	lead, cadmium, mercury compounds
Photography	developing bath	hydroquinone, monomethyl-p-aminophenol sulfate, alkalis
	stop bath	acetic acid
	fixing bath	sulfur dioxide
	intensifier	dichromates, hydrochloric acid
	toning	selenium compounds, hydrogen sulfide, uranium nitrate, sulfur dioxide, gold salts
	color processes	formaldehyde, solvents, color developers
Photography	platinum printing	platinum salts, lead, acids, oxalates,
Relief printing	solvents	mineral spirits
Screen printing	pigments	lead, cadium, manganese compounds, etc.
	solvents	mineral spirits, toluene, xylene
	photoemulsions	ammonium dichromate
Sculpture, clay		see Ceramics
Sculpture, laser	lasers	nonionizing radiation, electrical
Sculpture, neon	neon tubes	mercury, electrical
Sculpture, plastics	epoxy resin	amines, diglycidyl ethers
	polyester resin	styrene, methyl methacrylate, methyl ethyl ketone peroxide
	polyurethane resins	isocyanates, organotin compounds, amines, mineral spirits
	acrylic resins	methyl methacrylate, benzoyl peroxide
	plastic fabrication	decomposition products (carbon monoxide, hydrogen chloride, hydrogen cyanide, etc.)
Sculpture, stone	marble	nuisance dust
	soapstone	silica, talc, asbestiform materials

Technique	Material/Process	Hazard
Sculpture, stone	granite, sandstone	silica
	pneumatic tools	vibration, noise
Stained glass	lead came	lead
	soldering	lead, zinc chloride fumes
Weaving	loom	ergonomic problems
	dyeing	dyes, acids, dichromates
Welding	oxyacetylene	carbon monoxide
	arc	ozone, nitrogen dioxide, ultraviolet and infrared radiation, electrical
	metal fumes	copper, zinc, lead, nickel, etc.
Woodworking	machining	wood dust, noise, fire
	glues	formaldehyde, epoxy
	paint strippers	methylene chloride, toluene, methyl alcohol, etc.
	paints, finishes	mineral spirits, toluene, turpentine, ethyl alcohol, etc.
	preservatives	chromated copper arsenate pentachlorophenol, creosote

REFERENCES

Barazani, G. (ed) (1977). *Health Hazards in Art Newsletter I & II*. Chicago: Hazards in Art.

Carnow, B. (1975). *Health Hazards in the Arts and Crafts*. Chicago: Hazards in the Arts.

Mallary, R. (1963). The air of art is poisoned. *Art News* (Oct.), 34–38.

McCann, M. (1975). *Health Hazards Manual for Artists*. 1st ed. New York: Foundation for Community of Artists.

McCann, M. (1974–78). Art Hazards News column. *Art Workers News*.

McCann, M. (ed). (1978 to date). *Art Hazards News*. Center for Occupational Hazards.

Miller, A.B., Blair, A., and McCann, M. (1985). Mortality patterns among professional artists: A preliminary report. *J. Environ. Path. Toxicol. Oncol.* 6, 303–13.

Miller, A.B., Silverman, D.T., Hoover, R.N., and Blair, A. (1986). Cancer risk among artistic painters. *Am. J. Ind. Med.* 9, 281–87.

Ramazzini, B. (1713). *De Morbis Artificum (Diseases of Workers)*. 2d ed. Translated by W.C. Wright (1940). Chicago: University of Chicago Press.

Siedlicki, J. (1968). Occupational health hazards of painters and sculptors. *J. Amer. Med. Assoc.* 204, 1176.

Siedlicki, J. (1975). *The Silent Enemy*. 2d ed. Washington, DC: Artists Equity Association.

Waller, J., and Whitehead, L. (1977–79). Health issues column. *Craft Horizons*.

2

Who Protects Artists?

Having seen that artists can become ill from exposure to hazardous art materials, you should be asking yourself, "How do I get help and more information?" Of course this book is one source of information. But it isn't enough. How do you know whether a particular brand of art material is dangerous? Who do you turn to for help? This chapter tries to answer these questions.

The Labeling Issue

The first thing you see on an art material is usually a label. Any warnings on the label should be your first alert as to whether the material is hazardous or not. At least this is true if the art material is properly labeled, as required under the Labeling of Hazardous Art Materials Act of 1988. This law applies only to the United States. I discuss Canadian laws later.

The campaign to obtain adequate warning labels on art materials started in the late 1970s, as an adjunct to education about art hazards. At that time, the only warnings required on art materials (and other consumer products) were for acute

hazards, that is, from a single exposure. The Federal Hazardous Substances Act, the law regulating consumer products, only required acute toxicity tests for single-dose ingestion, inhalation, skin absorption, and eye contact. If less than half the animals died within two weeks at a dose rate of 5 grams per kilogram of body weight, then the material could be labeled "nontoxic." Under this law, asbestos could have been labeled nontoxic because it wouldn't kill you in two weeks!

The problem was, and is, that artists and even hobbyists have to be concerned about the health effects of repeated exposures to art materials, not just a single exposure. This concern about the chronic effects of art materials led to congressional hearings in 1980 and an attempt to pass a law requiring the chronic hazards to be listed on the label of art materials.

Voluntary Labeling Standard

Faced with the possibility of mandatory federal legislation, manufacturers responded in the early 1980s by developing a voluntary labeling standard under the auspices of the American Society for Testing and Materials (ASTM) Subcommittee D-01.57 on Artist Paints and Related Materials. A coalition of manufacturers of art materials, representatives of artists' organizations, and health experts (including this author) worked to develop this standard, which was published as ASTM D-4236, *Standard Practice for Labeling Art Materials for Chronic Health Hazards*.

To be in compliance with this voluntary standard, a manufacturer of an art material would have to submit the formulation to a toxicologist who would evaluate the chronic hazards of the product based on current knowledge. If a chronic hazard is found, then the label would have to contain the following:

- The signal word WARNING, if only a chronic hazard exists.
- A list of the possible chronic hazards.
- The names of chronically hazardous components.
- Safe handling instructions.
- List of sensitizing components (i.e., chemicals that can cause allergic reactions).
- Sources for further information.

Of course, if there is an acute hazard, then the label must also carry the acute hazard warnings mandated by the Federal Hazardous Substances Act. If acute hazard labeling requires the signal word DANGER, then this would be the only signal word.

The main industry organization adopting ASTM D-4236 was the Arts and Crafts Materials Institute (ACMI), a trade association of art material manufacturers that had been active in the labeling of children's art materials since 1939. Art materials that were labeled in conformance with ASTM D-4236 carried an HL (Health Label) seal. According to the ACMI, "Products bearing the HL Health Label (Cautions Required) Seal of the Art and Craft Materials Institute, Inc., are certified to be properly labeled in a program of toxicological evaluation by a medical expert. This program is reviewed by the Institute's Toxicological Review Board. These products are certified by the Institute to be labeled in accordance with the voluntary chronic hazard labeling standard ASTM D-4236." The toxicologist for the ACMI does not actually test art materials, but instead uses his or her expertise and the current available literature to evaluate the product.

ASTM D-4236 was only a voluntary standard. Although the manufacturers of most painting and drawing materials complied with this standard, most of the manufacturers of the more dangerous art materials, for example, solvent-based silk-screen printing inks, did not.

State Mandatory Laws

The problem with ASTM D-4236 is that it was a voluntary, not a mandatory, labeling standard. Many people, including this author, believed that in areas of health, it should not be up to a manufacturer to decide whether or not to put on a warning label on a hazardous product. However, in the political climate of Washington in the early 1980s, there was no chance of passing a mandatory chronic hazards labeling law. As a result, the focus shifted to the state legislatures.

At this time, the Nader Public Interest Research Group (PIRG) movement got involved. PIRGs in a number of different states, with the assistance of the Center for Safety in the Arts, researched the hazards of art materials used in elementary and secondary schools—and found that children in many states were being exposed to hazardous art materials. The various state PIRGs worked with legislators in several states to pass laws requiring chronic hazard labeling of art materials and the banning of toxic art materials from elementary schools. In 1984, California became the first state to pass such a law. During the mid-1980s, Oregon, Tennessee, Illinois, Florida, Virginia, and Connecticut followed suit.

Labeling of Hazardous Art Materials Act of 1988

Art material manufacturers soon became concerned about the problems of variations in labeling laws from state to state. In addition, manufacturers participat-

ing in the voluntary labeling program were concerned about losing sales to manufacturers that did not place a warning label on essentially identical art materials. As a result the art materials industry supported the move for federal legislation and, on November 18, 1988, Congress passed the Labeling of Hazardous Art Materials Act.

The lobbying for this law was led by the U.S. Public Interest Research Group (USPIRG), the national lobbying office for state PIRGs. Other organizations that supported this bill included the American Association of Pediatrics, American Association of School Administrators, American Public Health Association, Artists Equity, Center for Safety in the Arts, National Education Association, National Parents and Teachers Association, and a coalition of art material manufacturers, dealers, health professionals, and artists.

The Labeling of Hazardous Art Materials Act amends the Federal Hazardous Substances Act to require chronic hazard labeling of art materials. In essence, the new law adopts the voluntary standard ASTM D-4236. The labeling requirements of the bill became effective on November 18, 1990. Art materials whose labeling conforms to the law are required to carry the statement "Conforms to ASTM D-4236" or a similar statement.

The Labeling of Hazardous Art Materials Act requires art and craft manufacturers to determine whether their products have the potential to cause chronic illness and to place labels on those products that do. However, rather than leaving the criteria for chronic hazards up to individual manufacturers, the law requires that the Consumer Product Safety Commission (CPSC) develop guidelines for chronic hazards. These guidelines include criteria for (1) determining chronic health effects in adults and children, (2) determining which chemicals in art materials can cause chronic adverse health effects such as cancer and reproductive effects, (3) determining how much is absorbed into the body (the bioavailability), and (4) determining acceptable daily intake levels for chronically hazardous substances in art materials.

The law also requires that all chronically hazardous art materials carry a statement that such materials are inappropriate for children and allows the CPSC to obtain a court injunction against schools that purchase chronically hazardous art materials for use by children in grade six and below. The Labeling of Hazardous Art Materials Act also preempted existing state laws on art material labeling.

Industrial Products

Many artists use products that were originally developed for industry. Examples include screen printing inks and other screen printing products, plastics resins, and ceramics materials. Sometimes these products are labeled "For Industrial Use Only." Do these come under the jurisdiction of the Labeling of Hazardous Art Materials Act? It depends on how the product is marketed. If it is sold in art

supply stores or other locations where consumers can walk in and purchase it, if the manufacturer advertises it as suitable for making art, or sells it to schools, then it does have to be labeled in accordance with the Labeling of Hazardous Art Materials Act.

If it does not meet these requirements, then the product does not have to be labeled as an art material. As discussed below in the section on Material Safety Data Sheets, if the product is hazardous, it would still have to be labeled with its identity and hazard information under the Hazard Communication Standard of the Occupational Safety and Health Administration (OSHA).

Canadian Labeling Laws

As in the United States, there are two types of labeling regulations: one for products used in the workplace, and one for consumer products. Products used, handled, or stored in workplaces—which includes schools and, in some provinces (Alberta, New Brunswick, Newfoundland, Quebec, and Saskatchewan), self-employed artists—come under the jurisdiction of the Workplace Hazardous Materials Information System (WHMIS). This is Canada's Right-To-Know regulation. This regulation requires the labeling of hazardous products, Material Safety Data Sheets (MSDSs), and education of employees about WHMIS and hazardous materials.

A product is regulated under WHMIS as a Controlled Product (Part II of the federal Hazardous Product Act) if it falls into one or more of the following classes: compressed gas, flammable and combustible materials, oxidizing materials, poisonous and infectious materials, corrosive materials, or dangerously reactive materials. The labels of Controlled Products must contain the product identifier, supplier identifier, a statement about the availability of MSDSs, risk phrases, precautionary measures, Canadian hazard symbol(s), and first-aid measures.

Hazardous products packaged for consumer use are regulated under Part I (Prohibited and Restricted Products) of the federal Hazardous Products Act, administered by the Department of Consumer and Corporate Affairs. Many art materials come under this category. A Prohibited Product cannot be imported, sold, or used in Canada. A Restricted Product can be imported, sold, or used under specified conditions that can include a warning label and hazard symbol. Note, however, that WHMIS hazard symbols differ from consumer product hazard symbols.

MATERIAL SAFETY DATA SHEETS

As I said, the label should be your first alert about the hazards of art materials. However, label warnings are not sufficient. Enough information to fully describe

the hazards and tell you just how to protect yourself will not fit on the label. Other sources of information are needed to accomplish this.

Such sources of information should include placing warnings in product catalogues, putting precautionary steps in product use bulletins, publishing separate informational booklets on safety, and Material Safety Data Sheets. The best example of a separate booklet on safety is AMACO's *Ceramics: Art Material Safety in the Classroom and Studio,* first published in 1987. More of these types of educational materials are needed.

Material Safety Data Sheets (MSDSs) have become the main source of further information. A major problem is that MSDSs were originally intended for use by health and safety professionals, first in the shipbuilding industry, and then in general industry. As such they tended to be very technical. In addition, the quality of most MSDSs left much to be desired, especially in the area of chronic hazards. This was often because they were written by product managers and others without health and safety expertise. However, often it was also because of a reluctance to scare people off with adequate warnings.

OSHA's Hazard Communication Standard

During the late 1970s and early 1980s, the Right-To-Know movement among health and safety activists and unions pressured the Occupational Safety and Health Administration (OSHA) to adopt regulations giving workers the right to know about the chemicals they were working with and how to work safely with them. In 1983, OSHA finally adopted a Hazard Communication Standard, which required employers in the chemical manufacturing and using industries to evaluate the hazards of their products, prepare warning labels and Material Safety Data Sheets on hazardous products, and provide training to their employees on the hazards and safe use of chemicals in the workplace. The MSDSs have to be sent to employers and distributors the first time the product is purchased and whenever the MSDS is revised (for example, due to new information). There was also a very rigid definition of trade secrets in this standard that would have allowed employers to state that the ingredients in their products were trade secrets, without having to prove it.

The labor movement challenged the narrow scope of the standard and the definition of trade secrets. The U.S. Supreme Court ruled that OSHA had to extend the Hazard Communication Standard to all employers covered by OSHA, and that OSHA couldn't use a definition of trade secrets that violated state laws. As a result, in 1987 OSHA extended the scope of the Hazard Communication Standard to all employers covered by OSHA.

However, as artists, you still might not have the legal right to receive an MSDS from the manufacturer. Self-employed people—including artists—do not

come under OSHA's jurisdiction, which covers only private employers. If you are a public employee —for example, a public school art teacher—you are also not protected by OSHA unless your state has adopted a state OSHA plan. In that instance, and this is true for about half the states, you would come under the state OSHA jurisdiction, and the OSHA Hazard Communication Standard would protect you.

What do you do if you are not protected by OSHA? Then you don't have a legal right to obtain MSDSs on the art materials you use, but most reputable manufacturers will send you one anyway. In general, write to manufacturers rather than distributors, since you have a better chance of getting MSDSs from manufacturers.

Information on the contents of MSDSs is found in Chapter 6.

Canadian WHMIS Regulations

As mentioned earlier, the Canadian Workplace Hazardous Materials Information System (WHMIS) regulations required warning labels on hazardous products used in the workplace, provision of Material Safety Data Sheets, and training of employees in WHMIS regulations and hazardous materials.

Canadian WHMIS regulations on MSDSs are more stringent than OSHA's. However, many of the same difficulties self-employed American artists have in obtaining MSDSs apply to Canadian artists (or hobbyists). One exception is those provinces where self-employed individuals come under WHMIS. In those provinces, artists have the legal right to obtain MSDSs from manufacturers or distributors, and should contact the provincial Ministry of Labor if they have problems.

GOVERNMENT RESOURCES

This section discusses the various governmental agencies that can assist artists.

Consumer Product Safety Commission (CPSC)

The U.S. Consumer Product Safety Commission has the responsibility for administering the Federal Hazardous Substances Act, the Labeling of Hazardous Art Materials Act of 1988, and several other laws relating to the safety of consumer products. It does not regulate how a product is used, but it can ban products with "an unreasonable risk of injury," or require precautionary labeling. Unfortunate-

ly, the CPSC has often been reluctant to act and relies more on voluntary compliance, even though history has frequently shown this to be ineffective. It predominantly acts upon complaints from consumers, but is often slow to respond.

Environmental Protection Agency (EPA)

The Environmental Protection Agency, broadly speaking, is concerned with protecting people and the environment from toxic substances entering the water and air we breathe. The EPA administers a wide variety of laws dealing with waste disposal, air and water pollution, pesticides, toxic substances, community right to know, and so on. Much of the enforcement of these laws is delegated to the states.

National Institute for Occupational Safety and Health (NIOSH)

The National Institute for Occupational Safety and Health was set up by Congress to do research on occupational safety and health and to provide technical assistance to, and recommend standards to, the Occupational Safety and Health Administration. At the request of three employees or the employer, NIOSH will come into a workplace and carry out a Health Hazard Evaluation, which includes measurements of employee exposure and medical evaluations if needed. In addition, the employer can request a Technical Assistance Inspection, a more limited version of the Health Hazard Evaluation. NIOSH has provided assistance to a number of art schools and even some individual artists under these programs.

NIOSH also answers technical inquiries from employers and employees and has a wide variety of literature available. NIOSH also tests and certifies respirators.

1-800-35-NIOSH
(M–F 8 AM–4:30 PM EST)

NIOSH
1600 Clifton Road NE
Atlanta, GA 30333
(404) 639-3061

Appalachian Laboratory for Occupational Safety & Health
944 Chestnut Ridge Road
Morgantown, WV 26505-2888
(304) 291-4126

Robert A. Taft Laboratories
4676 Columbia Parkway

Cincinnati, OH 45226
(513) 533-8236

Public Health Service
DHHS Region I Office
John F. Kennedy Federal Building
Government Center, Room 1401
Boston, MA 02203
(617) 565-1439

DHHS Region IV Office
101 Marietta Tower, Suite 1106
Atlanta, GA 30323
(404) 331-2396

DHHS Region VIII Office
1185 Federal Building
1961 Stout Street
Denver, CO 80294
(303) 844-6166

New Jersey Right-to-Know Program

The New Jersey Department of Health's Right-to-Know Program has prepared Hazardous Substance Fact Sheets on over 900 individual chemicals. In contrast to Material Safety Data Sheets, these six-page fact sheets are written for lay readers and are easy to understand. Most of these fact sheets can be downloaded from the Center for Safety in the Arts' computer bulletin board system.

Right-to-Know Program
New Jersey Department of Health
CN 368
Trenton, NJ 08625
(609) 984-2202

Occupational Safety and Health Administration (OSHA)

The Occupational Safety and Health Administration enforces the Occupational Safety and Health Act of 1970. OSHA issues health and safety standards, carries out inspections, and can fine employers that are in violation of health and safety standards.

As mentioned earlier, OSHA covers only private employers. In those states

with approved state plans, public employees are also covered. Self-employed artists and students do not come under OSHA's jurisdiction.

OSHA can inspect any workplace without advance notice. In addition, employees can file a complaint about unsafe working conditions and request that their identity be kept confidential. However, I would caution art teachers or other art workers against filing an OSHA complaint in many situations. OSHA's standards for chemicals are based on industrial exposures, and levels that are allowed in industry are often unacceptable to most people. In addition, OSHA standards are not intended to protect children, pregnant women, or people with health problems. OSHA can come in and give a clean bill of health to an employer if it finds that concentrations of chemicals in the air are below OSHA standards, even though people are getting ill.

OSHA
200 Constitution Avenue, NW
Washington, DC 20210
(202) 523-8151

Region I: Connecticut, Maine, Massachusetts, New Hampshire,
 Rhode Island, Vermont
US DOL—OSHA
133 Portland Street, 1st Floor
Boston, MA 02114
(617) 565-7164

Region II: New Jersey, New York, Puerto Rico
US DOL—OSHA
201 Varick Street, Room 670
New York, NY 10014
(212) 337-2378

Region III: Delaware, District of Columbia, Maryland, Virginia,
 Pennsylvania, West Virginia
US DOL—OSHA
Gateway Building, Suite 2100
3535 Market Street
Philadelphia, PA 19104
(215) 596-1201

Region IV: Alabama, Florida, Georgia, Kentucky, Mississippi,
 North Carolina, South Carolina, Tennessee
US DOL—OSHA
1375 Peachtree Street, NE, Suite 587
Atlanta, GA 30367
(404) 347-3573

Region V: Indiana, Illinois, Michigan, Minnesota, Ohio, Wisconsin
US DOL—OSHA
230 S. Dearborn Street, Room 3244
Chicago, IL 60604
(312) 353-2220

Region VI: Arkansas, Louisiana, New Mexico, Oklahoma, Texas
US DOL—OSHA
525 Griffin Street, Room 602
Dallas, TX 75202
(214) 767-4731

Region VII: Iowa, Kansas, Missouri, Nebraska
US DOL—OSHA
911 Walnut Street, Room 406
Kansas City, MO 64106
(816) 426-5861

Region VIII: Colorado, Montana, North Dakota, Utah, Wyoming
US DOL—OSHA
Federal Building, Room 1576
1961 Stout Street
Denver, CO 80294
(303) 844-3061

Region IX: American Samoa, Arizona, California, Guam,
Hawaii, Nevada, Trust Territory of the Pacific Islands
US DOL—OSHA
71 Stevenson Street, Room 415
San Francisco, CA 94105
(415) 744-6670

Region X: Alaska, Idaho, Oregon, Washington
US DOL—OSHA
1111 3rd Avenue, Suite 715
Seattle, WA 98101-3212
(206) 553-5930

State Departments of Labor and Health

Each state has a Health Department and a Labor Department. The state Health Departments are often sources of information and assistance, and you do not have to be an employee to use their services.

The state Labor Departments administer state OSHA plans in those states with approved plans. In addition, most state Labor Departments are also funded

25

by OSHA to operate voluntary compliance programs. Under this free program, which is not part of OSHA enforcement, an employer can request an inspection of its premises. As long as the employer is working with the voluntary compliance program, OSHA will not make an inspection. In addition, in some states, the voluntary compliance program provides assistance to individual artists.

NONGOVERNMENTAL RESOURCES

American Lung Association

The various state and local chapters of the American Lung Association are a source of information and referrals related to lung problems. They have helped fund many educational programs on art hazards, have a variety of publications, and a short sound/slide tape on art hazards that is suitable for secondary school students.

American Lung Association
1740 Broadway
New York, NY 10036
(212) 315-8700

Arts and Crafts Materials Institute (ACMI)

The ACMI evaluates the safety of children's and adult's art materials for manufacturers participating in the program. It publish a list of art materials with the CP (Certified Product) or AP (Approved Product) seal for children's materials and the HL seal (for adult art materials). See the discussion of the voluntary labeling standard in this chapter, and also Chapter 25, Children and Art Materials.

Arts and Crafts Materials Institute
715 Boylston Street
Boston, MA 02116
(617) 266-6800

Center for Safety in the Arts (CSA)

The Center for Safety in the Arts is an international clearinghouse for research and education on hazards in the arts. CSA offers a variety of programs for artists, schools, colleges, and museums. These include:

- *Art Hazards Information Center.* CSA answer over 50 letters and telephone calls a day on art hazards and distributes over 100 publications.
- *Art Hazards News.* An eight-page newsletter appearing four times a year, plus a 24-page Resource Issue.
- *Educational Programs.* Half- and full-day lectures and workshops; a five-day, 25-hour course given every year in June in New York; and three-day courses given locally upon request.
- *Consultative Programs.* On-site industrial hygiene inspections with a written report, or planning consultations for new or renovated arts facilities.
- *Occupational Safety and Health Bulletin Board System (OSHBBS).* A computer bulletin board system that has many health and safety resources available for downloading, and an electronic message service.
- *Library.* CSA's library has the most extensive collection of information on art hazards in the country.

Center for Safety in the Arts
5 Beekman Street, Suite 1030
New York, NY 10038
(212) 227-6220
(212) 385-2034 (OSHBBS)

COSH Groups

COSH groups (Committees for Occupational Safety and Health) are coalitions of health professionals and unions that provide education, lobbying, and assistance on occupational health and safety issues. There are over two dozen of these groups around the country. Contact the Center for Safety in the Arts (above) for an updated list.

National Fire Protection Association (NFPA)

The NFPA is the major national source of information and codes on fire safety. Many of its codes have been adopted by fire departments. The NFPA has a wide variety of publications, videotapes, and motion pictures.

National Fire Protection Association
1 Batterymarch Park
P.O. Box 9101
Quincy, MA 02269
(800) 344-3555

National Safety Council

The National Safety Council publishes a magazine and distrubutes a wide variety of publications and audiovisual materials on safety in the home and workplace.

National Safety Council
444 North Michigan Avenue
Chicago, IL 60611
(312) 527-4800

Occupational Health Clinics

There are over 70 occupational health clinics in the United States and Canada that specialize in occupational health problems. These clinics will see artists with occupational health problems. The formation of these clinics during the 1980s has provided artists with a source of medical expertise on the toxic effects of art materials. Contact CSA (above) for an updated list.

Regional Poison Control Centers

There are hundreds of Poison Control Centers around the United States and Canada that are operated by hospitals. Poison Control Centers can provide assistance in acute poisoning cases, especially those involving ingestion of substances. However, their expertise varies widely. There are fewer than 50 Regional Poison Control Centers that are accredited by the American Association of Poison Control Centers. I recommend calling a Regional Poison Control Center in an emergency rather than a local one. Contact CSA (above) for an updated list.

▆▆▆▆ CANADIAN RESOURCES

Canadian Center for Occupational Health and Safety (CCOHS)

The Canadian Center for Occupational Health and Safety answers occupational health and safety inquiries, has a wide range of literature available, conducts research, and operates CCINFOLINE, an on-line compendium of health and safety computer databases. These are also available as CD-ROM discs. CCOHS is one of the most widely respected health and safety organizations. It is funded by the Canadian government.

Canadian Center for Occupational Health and Safety
250 Main Street East
Hamilton, Ontario, Canada
(418) 643-6084

Consumer and Corporate Affairs (CCA)

Consumer and Corporate Affairs is a federal agency with responsibility for the labeling of consumer and industrial products and for administering WHMIS.

Product Safety Branch
Consumer and Corporate Affairs Canada
16th Floor, Zone 5
Place du Portage I
Hull, Quebec, Canada K1A 0C9
(819) 997-1194

Health and Welfare Canada

The Consumer Products Section of the National Department of Health and Welfare has been a source of information on art hazards for several years. In 1981, it established an Ad Hoc Committee on the Health Hazards in Arts and Craft Materials, consisting of representatives from Canadian arts and crafts organizations, plus this author, to provide guidance to the government. The department produced 10 posters and several booklets and data sheets on art hazards (see the Bibliography).

Consumer Product Section
Room 233
Environmental Health Centre
Health and Welfare Canada
Ottawa, Ontario, Canada K1A 0L2
(613) 957-1881

Ontario Crafts Council

The Ontario Crafts Council has an art hazards library and has several slide/sound shows and videotapes on art hazards.

Ontario Crafts Council
346 Dundas Street West
Toronto, Ontario, Canada M5T 1G5
(416) 977-3551

Provincial Ministries of Labor

In Canada, occupational health and safety comes under the jurisdiction of the provinces, usually through the Ministries of Labor. They operate in a similar manner to OSHA in the United States. As discussed earlier, self-employed artists come under WHMIS and the occupational safety and health laws in some provinces.

3

How Art Materials Can Hurt You

Art materials may be hazardous to your health. In this chapter, I discuss the extent of the risk, how art material can enter the body, and the types of body injury they can cause.

HOW GREAT IS THE RISK?

Today our bodies are being flooded with chemicals in the air we breathe, the water we drink, the food we eat, the chemical materials we are exposed to at work or in hobbies, and the medicines we take, many of which can harm us. Considering each aspect of our lives separately does not give a true picture of the risk to our bodies. Factors such as exposures to single chemicals in different environments, exposure to many different chemicals, and individual susceptibility all combine to affect the degree of risk to which we are exposed.

Degree of Exposure

Your risk is determined to a large extent by the way in which you work with your materials. This includes the amount of material you are exposed to, the duration of

31

the exposure, and the frequency of the exposure—all factors related to what toxicologists call the dose. For example, if you use a cup of paint remover to remove paint from some wood, your risk is lower than if you use a gallon. If you use it only once a week for 15 minutes, your risk is less than if you use it every day.

The duration of exposure is important for other reasons. Government safety standards, for example, are set for an eight-hour work day. This is based on the concept that the body can detoxify and eliminate many materials if it has a sufficient rest period between exposures in which to recover. If you work longer than eight hours at a time, this recovery time is reduced, and you cannot tolerate as much exposure as you could for an eight-hour period.

This is important to artists for several reasons. Many artists work long hours for weeks or months on end when preparing for a show, or when they are simply caught up in their work. In this situation, they might be at greater risk than an industrial worker who does a similar job eight hours a day the entire year round. This could also apply to art teachers who work at the school all day, and then do their own art work. Since most artists have home studios, they can often be exposing themselves, as well as other family members, to toxic dusts and other materials 24 hours a day, instead of just while they are working.

Multiple Sources of a Chemical

In judging your exposure to a given chemical, it is important to include all possible sources, environmental as well as from your art processes.

For example, consider carbon monoxide. We can be exposed to carbon monoxide from a variety of sources in our everyday life, including auto exhaust fumes, improperly vented space and water heaters, and cigarette smoke. Carbon monoxide is also the waste product of many art processes, including gas-fired kilns, oxyacetylene welding, carbon arcs, foundry processes, and glassblowing. In addition, the solvent methylene chloride is metabolized to carbon monoxide in the body.

Within the body, carbon monoxide attaches to the hemoglobin in the blood, forming carboxyhemoglobin—which prevents oxygen from getting to body tissues where it is needed for cell survival, particularly affecting the brain and heart. The amount of damage caused by the carbon monoxide depends upon the total amount attached to the hemoglobin. Exposure to carboxyhemoglobin levels of from 10 to 30% can cause headaches, dizziness, and abnormal heart rhythms. Heavy smokers, for example, can have carboxyhemoglobin levels as high as 10%. Thus if you smoke and also work with methylene chloride, or are exposed to carbon monoxide from a kiln, you have a greater risk of damage than from any one source of exposure. Carbon monoxide exposures are additive and cumulative, although the levels in the body decline within hours after removal from exposure.

32

Toxicity

Another crucial factor determining the risk of using a given art material is its toxicity. The toxicity of something is its ability to cause damage to the body. The higher the toxicity, the less material needed to cause injury. It takes much less cyanide to kill you than, for example, aspirin. Similarly, since ethyl alcohol is much less toxic than toluene (found in many lacquer thinners), it takes much less inhalation of toluene vapors than alcohol vapors to make you ill. The question of which art materials are toxic and to what degree is considered in greater detail in Chapters 4 and 5.

Total Body Burden

Most chemicals do not accumulate in the body, but are eliminated either directly or after being metabolized in the liver. While they are present in the body, however, they can cause damage, and it is this damage that accumulates with repeated exposure.

Some metals—for example, lead, mercury, cadmium, manganese, and arsenic—do accumulate because the body can eliminate only a certain amount of these metals each day. If you absorb more than the body can excrete, then that metal begins to be stored in the body. The total amount of metal accumulated in the body is called the total body burden of that metal.

Multiple Exposures

One complicating factor is that we are being simultaneously exposed to many different chemicals, each of which can have its own effect on the body. If two or more of these chemicals can damage the same organ, we have to worry about multiple insults to the same body organ.

One type of effect is called an additive effect, where the total damage to an organ is the sum of the separate damages caused by individual chemical exposures. For example, oil painters using turpentine as a thinner are constantly exposed to the turpentine, and often even wash up with it. Turpentine is a skin irritant, and repeated exposures can cause dermatitis. However, if the painter also uses paint thinner, which can also cause dermatitis, the total severity of the dermatitis would be the sum of the separate irritations caused by each solvent.

An even more serious problem is that of synergistic effects of two chemicals. A synergistic effect is one in which the combined effect of two chemicals is many times more damaging than either one alone. A well-known example is that of alcohol and barbiturates. Separately, each can have a serious effect in large doses; combined, even in small doses, they can be fatal. Small amounts of

alcoholic beverages can cause similar synergistic effects with many solvents, especially the chlorinated hydrocarbons such as carbon tetrachloride and trichloroethylene.

Another example of a synergistic effect is smoking and exposure to asbestos. Smokers have about 10 times the chance of getting lung cancer as nonsmokers. Nonsmoking asbestos workers have about a fivefold excess risk of lung cancer. The risk of getting lung cancer in people who both smoke and work with asbestos, however, is 50 to 90 times greater than in people who do neither.

High-Risk Groups

Two people, exposed to the same chemical under the same conditions, will quite possibly react differently; one might get ill, while the other would not. The reason for this is that they have different personal susceptibilities. A high-risk group is generally defined as a group of people who, because of biological or other factors, tend to be more susceptible.

Children

Children and adolescents are at higher risk from exposure to chemicals than are adults for a number of reasons. From a physiological perspective, they are still growing and have a more rapid metabolism than adults. As a result they absorb toxic materials into their bodies more readily. In addition, a given amount of chemical is more concentrated in a small child's body than that of a larger adult, and therefore can cause more damage.

From a psychological point of view, children under age 12 are at higher risk because they cannot be relied on to understand the hazards of chemicals and carry out precautions on a consistent basis.

For these reasons, children under 12 should not be exposed to toxic chemicals. All these factors combine to make children susceptible to small amounts of toxic materials that would not harm an adult. The problem of children and art materials is discussed in detail in Chapter 25.

The fetus is also at particularly high risk, and exposure of pregnant women to even small amounts of many materials can damage the fetus. This is discussed in more detail later in the chapter.

Disabled Individuals

Many permanently or temporarily disabled people are also artists. In addition, art programs in hospitals, other health care institutions, and schools reach many disabled children and adults. Unfortunately, exposure to art materials or process-

es, or placement in situations that exceed an individual's physical limitations, may sometimes place a disabled individual at higher risk for further illness or injury. Some examples of such potentially high-risk situations are:

- People with hearing impairments in noisy environments, such as woodshops.

- People with epilepsy exposed to organic solvents such as turpentine, lacquer thinners, and paint thinners—all of which affect the nervous system and may lower the threshold for seizures.

- Retarded individuals with difficulty in reading and following directions, and difficulty in understanding warning labels.

- Emotionally disturbed individuals who have a tendency to "sniff" hazardous solvents.

- Orthopedically or neurologically impaired individuals experiencing difficulty in operating hazardous machinery.

- Someone with hepatitis exposed to organic solvents which affect the liver.

- Asthmatics exposed to dusts, molds, spray mists, sulfur dioxide, etc.

- People with heart arrhythmias exposed to solvents such as methylene chloride, 1,1,1-trichloroethane, freons, and toluene, which can induce arrhythmias.

- People taking some medications who are exposed to solvents.

It is important to recognize that not all disabled individuals are at higher risk, and individual medical evaluations are needed to determine any degree of extra risk. Informed people should not necessarily be excluded from activities against their will just on the basis of extra risk, especially since simple precautions can often minimize any special risk.

Those on Medication

I have seen many instances of artists becoming ill when taking medications that affect the central nervous system and simultaneously being exposed to low levels of solvents that did not affect other people in the area. This can be due to either an additive or a synergistic interaction between the medication and solvent. This type of problem is well known in relation to drinking alcoholic beverages while taking many medications, which physicians will warn you against. Since most solvents also affect the central nervous system, you should not be exposed to solvents while taking many medications. This might mean extra precautions to ensure that solvents are not being absorbed into the body. Table 3-1 is a list of common medications that may interact with solvent exposures.

| TABLE 3-1. | Medications Affecting the Central Nervous System |

Antianxiety drugs. See Sedatives	Muscle relaxants, skeletal
Antiarrhythmics (heart)	- benzodiazepines
-quinidine	- baclofen
-lidocaine	- dantrolene
	- orphenadrine
Anticonvulsants	- carisoprodol
- hydantoins	- chlorzoxazone
- succinimides	- cyclobenzaprine
- carbamazepine	- methocarbamol
Antidepressants	Narcotics
- tricyclic	- codeine
- monamine oxidase inhibitors	- meperidine
Antihistamines	- methadone
	- morphine
Antineoplastic agents	- propoxyphene
- procarbazine	Pain medications. See Narcotics
Antipsychotics	Sedatives
- phenothiazines	- barbiturates
- thioxanthines	- benzodiazepines
- butyrophenones	- chloral derivatives
	- clomethiazole
Cough suppressants	- ethyl alcohol
- codeine	- meprobromate
- diphenylhydramine	Tranquilizers. See Sedatives, Antipsy-
- dextromethorphan	chotics
Hypnotics. See Sedatives	

Generic names are used rather than brand names because of the large number of different brand names for a particular medication. When several members of a class of medications cause central nervous system effects, the generic class name is used instead of listing individual medications. This list is not complete, and anyone taking medication should check with his or her physician concerning possible interactions with art materials.

Some medications interact adversely with ethyl alcohol in ways not related to central nervous system depression. These medications include many drugs for hypertension as well as anticoagulants, beta-blockers, and antibiotics. These medications might also interact with other alcohols such as isopropyl and methyl alcohols. If you are taking medications, you should ask your physician about possible interactions with solvents or other art materials.

Other High-Risk Groups

Many other groups can be at higher risk for a variety of reasons. These high-risk groups include smokers, heavy drinkers, and the elderly, the latter because they may have many medical problems, their body's defenses may be wearing down, and they may be taking a variety of medications. In addition, many people may have a high individual susceptibility to chemicals for hereditary reasons, or because they might be under physical or emotional stress at a particular time. This might require their taking extra precautions.

HOW DOES EXPOSURE OCCUR?

There are three ways in which toxic substances can contact and enter the body: skin contact, inhalation, and ingestion.

Skin Contact

Our skin consists of two layers, the outer epidermis and the inner dermis (see Figure 3-1). The epidermis provides the skin with a defensive barrier, a surface layer that is resistant to water, dust, germs, and many chemicals. Hair follicles, sweat glands, and blood vessels in the epidermis help regulate body temperature, and nerve cells give warning of danger. The inner layer of the skin, the dermis, consists of fat and connective tissue whose main function is that of insulation.

Despite its protective barriers, our skin is not impervious. Sharp edges and abrasive substances can puncture the skin. Fungal and other infections, burns, and many chemicals—including alkalis, solvents, acids, and bleaches—can attack and destroy the protective barriers of the skin. Besides causing damage to the skin itself (which is discussed later in the chapter), this enables toxic chemicals to enter the body through open sores, cuts, and abrasions. If these chemicals get into the bloodstream, they can travel to other parts of the body.

In addition to this, many solvents—such as turpentine, benzene, phenol, methyl alcohol, xylene, toluene, glycol ethers, and the chlorinated hydrocar-

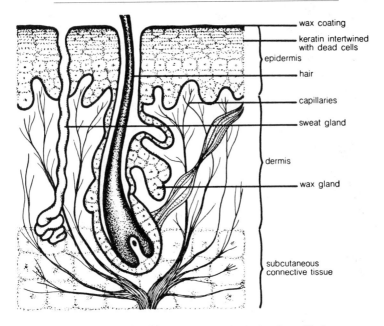

Figure 3-1. Diagram of the skin. *Illustration by Carlene Joyce Meeker*

bons—may reach the skin as liquid or vapor and penetrate the skin directly without any sores, cuts, or abrasions.

Inhalation

The most common way in which chemicals and germs enter our bodies is through the respiratory system. Figure 3-2 shows the lung system and the pathway air travels through as it is inhaled. In this way, solvent vapors, aerosol sprays, gases, dusts, metal fumes, and germs can cause damage to the respiratory system itself or can be absorbed from the lungs into the bloodstream, where they can affect other parts of the body.

In order to protect against this type of damage, our bodies have various defenses, starting with the nose, which contains large hairs and mucous membranes to trap large particles, in addition to special receptor cells that give us our sense of smell and warn us if we are exposed to irritating chemicals. However, with continued exposure, these receptor cells can become overloaded and no longer respond to the chemical. This is called olfactory fatigue, and is one reason why we cannot rely on our sense of smell to determine when we are being overexposed to many chemicals. Other reasons are that our noses cannot detect many chemicals at concentrations at which they are hazardous, and many pleasant-smelling chemicals are also dangerous.

Figure 3-2. Diagram of the respiratory system.

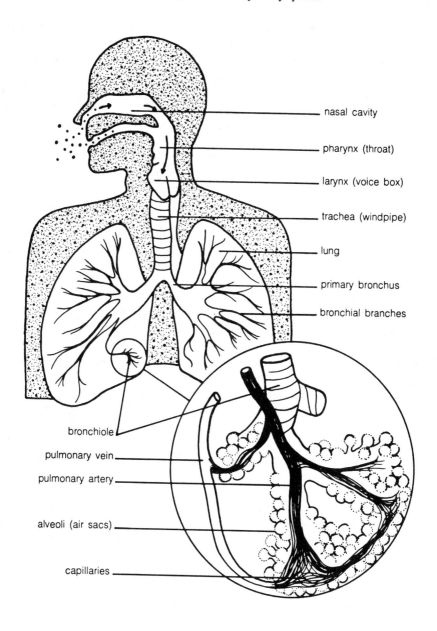

nasal cavity

pharynx (throat)

larynx (voice box)

trachea (windpipe)

lung

primary bronchus

bronchial branches

bronchiole

pulmonary vein

pulmonary artery

alveoli (air sacs)

capillaries

Illustration by Carlene Joyce Meeker

The respiratory system's second line of defense consists of the mucous linings of the trachea and bronchial tubes, which trap dust and send it back to the throat where it can be spit out. Coughing is also a defense mechanism that helps get rid of the mucus and contaminants.

The small muscles surrounding the bronchioles function as a defense against irritating chemicals that get into the lungs. These muscles can spasm and close off the bronchioles when stimulated by irritating gases and vapors. This is the choking feeling experienced by some people when they are suddenly exposed to large amounts of irritating gases such as ammonia and sulfur dioxide.

Of course, all these defenses can be overwhelmed by massive exposures. One particular problem is that the respiratory system's defenses are not very effective against solvent vapors, irritating gases, and other nondust chemicals. These often either damage the lungs (as will be seen later in the chapter) or enter the bloodstream. Smoking while working can be very dangerous, since cigarette smoke contains large amounts of small dust particles as well as a large variety of toxic gases, and other chemicals can be carried into the lungs on the surface of these particles.

Ingestion

Poisoning is usually associated with ingestion. However, although deliberately swallowing the toxic material is still the most common way in which poisoning occurs in children, adults are more commonly poisoned by less direct means. A classic example of accidental ingestion of poisonous materials occurs through the habit of pointing a paint brush with the lips. For example, a study of silk kimono painters in Japan found they had a high rate of bladder cancer. They painted with dyes that are now known to cause bladder cancer, and had a habit of pointing their brushes with their lips.

There are other examples. Eating and drinking in the studio while working can allow vapors and dusts to dissolve in drinks or collect on sandwiches, and paint from paint-covered hands can easily be carried to the mouth. Smoking can also allow chemicals on the hand to get on the cigarette, and thus into the mouth. Failure to clean your hands properly after work, or using kitchen utensils in your work, can transmit poisonous chemicals to your mouth. Swallowing of mucus-containing dusts that were ejected from the lungs by ciliary action is still another way to take poisons into the stomach.

Corrosive chemicals that are ingested can have harmful effects on the mouth, throat, esophagus, and stomach. Inducing vomiting after swallowing corrosive chemicals is not recommended because of the risk of further damage to the esophagus and throat. Other ingested toxic chemicals can be absorbed into the bloodstream through the stomach and intestines. This is sometimes not as dangerous as inhalation, since the lungs have a much larger surface area through which to absorb materials than the gastrointestinal system. Materials that are ab-

sorbed through the gastrointestinal system have a better chance of causing harm to the liver, since the blood from the stomach and intestines reaches the liver before reaching other body organs.

EFFECTS ON THE BODY

Chemicals can have a variety of damaging effects on the body.

Acute versus Chronic Effects

Acute illnesses result from single exposures to toxic chemicals through ingestion (a child swallowing paint thinner), inhalation (metal fume fever, a severe flu-like disease resulting from inhaling zinc metal fumes), or skin contact (acid burns resulting from spills). The effects of acute exposures are usually immediate.

Chronic illnesses resulting from prolonged and repeated exposure to toxic chemicals, often in small amounts, may take years to appear. Illnesses of this type are much more insidious; the hazard may not be apparent because of the long period of time between exposure and the onset of the resulting disease. For example, silicosis, a crippling disease involving severe scarring of the lungs caused by exposure to silica—which is found in clays, flint, sandstone, and lost wax investment plaster—normally takes at least 10 years to develop. Other chronic diseases encountered by artists are chronic lead and mercury poisoning, liver damage from exposure to chlorinated hydrocarbons used as plastics solvents and degreasers, and emphysema from repeated exposure to nitric acid etching gases.

Local versus Systemic Effects

Local effects are injuries that occur at the initial site of contact with the chemical. Corrosive chemicals cause tissue destruction; for example, concentrated acids spilled on the skin can cause serious skin burns. Irritating chemicals cause inflammation, for example, reddening of the skin from exposure to dilute acids and alkalis. Local effects can also occur in the lungs and gastrointestinal system.

Systemic effects are injuries that occur in parts of the body remote from the area of contact. The chemical is usually transported to the organ through the blood. For example, most solvents can cause central nervous system depression, although the initial contact is usually through the lungs or skin. In addition, many chemicals can damage more than one organ of the body at the same time. Chlorinated hydrocarbons, for example, can affect the central nervous system, the liver, and the kidneys.

Allergies

Certain chemicals—called sensitizers—can cause allergic reactions in people who are susceptible. Examples of strong sensitizers are chromate and dichromate salts, epoxy resins and hardeners, many tropical woods, formaldehyde, nickel compounds, turpentine, photographic developers, isocyanates, and fiber-reactive dyes. A large number of other chemicals are weaker sensitizers, causing allergies in small numbers of people who are particularly susceptible.

Allergic reactions do not develop when a person is first exposed to a sensitizer. The sensitization process takes at least 7 to 10 days after first exposure. In many instances, exposure may continue for many years before an allergy develops. However, once a person is sensitized, the body may react to even small amounts of the sensitizer. This sensitivity may continue for years or even permanently, even if there is not ongoing exposure to the sensitizer.

Once you have become sensitized to a chemical and start reacting to trace amounts, you usually have to stop exposure to the sensitizer and find a substitute. This is in contrast to irritants, where lowering exposure will usually solve the problem.

Cancer

Cancer is a chronic disease that deserves special mention. Different types of cancer may be caused by exposure to particular chemicals or physical agents: skin cancer from ultraviolet light or lamp black; lung cancer from inhalation of arsenic oxide, lead chromate or zinc chromate, cigarette smoke, nickel compounds, uranium oxide, and asbestos; bladder cancer from inhalation or ingestion of benzidine-type direct dyes; leukemia from exposure to benzene (benzol); and liver cancer from inhalation of vinyl chloride and other chlorinated hydrocarbons.

Normally the latent period for most cancers, the time it takes the cancer to develop following first exposure, is from 20 to 40 years. The risk of developing cancer from exposure to a chemical increases with the length of exposure (although there are many cases in which cancer has developed after only months of exposure) and with the level of exposure. Present evidence suggests that there is no safe level of exposure to a cancer-causing chemical (carcinogen). The only way to be safe is to avoid all exposure to carcinogens.

In this book three terms will be used: known human carcinogen, probable human carcinogen, and possible human carcinogen. The term *known human carcinogen* is used for chemicals that have been shown, through studies on human beings, to cause cancer. The term *probable human carcinogen* is used for chemicals with limited evidence of carcinogenicity in humans or that have been shown to cause cancer in animals. *Possible human carcinogens* have limited evidence of carcinogenicity in animals. Mostly only known and probable human carcinogens are listed in this book.

Since almost all chemicals that cause cancer in humans also cause cancer in animals, there is no reason to believe that the reverse is not also true. By using animal studies as a guide, we do not have to wait 30 or 40 years to prove that a chemical also causes cancer in humans.

Mutations

Chemicals that can alter deoxyribonucleic acid (DNA), the genetic material of the cell, are called mutagens. If the mutagen affects normal body cells, the result is a somatic mutation. Many mutagens are also carcinogens. If the mutagen affects the sperm or egg cells, then the result is a germ cell mutation. Germ cell mutations may be passed along to the progeny of the affected parent and can cause miscarriages or other developmental effects. See the section, Reproductive System.

Chemicals that are known or probable mutagens include benzene, chromium, ethylene dichloride, formaldehyde, hydrogen peroxide, hydroquinone, phenol, selenium oxide, sodium arsenite, styrene, thiourea, and trichloroethylene. Of course, one of the best known mutagens is ionizing radiation.

Multiple Chemical Sensitivities

In some individuals, for unknown reasons, a large acute exposure or chronic exposure to a chemical is associated with subsequent severe reactions to that chemical at very low doses. Often, the person then becomes hypersensitive to low concentrations of a wide variety of other chemicals, including solvents, perfumes, hair sprays, auto exhaust, and other common materials. The symptoms can be general, including headaches, nausea, fatigue, and memory problems, and can affect many body systems, including the nervous system, lungs, and immune system. This is not a classical allergic reaction, and we do not know the actual cause of these symptoms. In the past, they were often diagnosed as psychosomatic. Today, however, multiple chemical sensitivity has become more generally recognized as a real medical problem with symptoms related to chemical exposures, even if we do not yet know how it is caused. At present, identifying and avoiding exposures to materials causing the symptoms appears to be the only treatment.

SKIN

As mentioned earlier, many things can damage the skin's protective barrier. Flying chips from stone carving can break the skin; abrasive substances such as sandpaper can wear the skin away; hot liquids, sparks, and molten metals can burn the skin; and ultraviolet light can cause severe sunburn.

But in addition to these physical effects, fungi, molds, and bacteria can cause infections, particularly if the skin is already broken. Chemicals can also attack the skin's barriers and cause skin irritation, skin allergies, and skin cancer. The likelihood of chemicals causing skin diseases is increased by preexisting problems such as cuts, infections, acne, and eczema.

Direct Skin Irritation

Many chemicals, in sufficient amounts, always damage the skin. These chemicals are called primary skin irritants. The type of damage that occurs, called contact dermatitis (skin inflammation), includes reddening of the skin, blistering, itching, thickening of the skin, and flaking. Strong primary irritants will penetrate the protective barriers and damage the underlying skin after only a brief contact. Examples include strong acids, alkalis, fiberglass, iodine, phenol, potassium permanganate, zinc chloride, potassium sulfide, and some organic solvents.

Weaker primary irritants cause dermatitis after prolonged and repeated exposures. Preexisting skin problems increase the risk of damage. Examples of weak primary irritants include most organic solvents, mild or diluted acids and alkalis, many metals (antimony compounds, barium carbonate, chromium compounds, selenium compounds, and silver nitrate), formaldehyde, amines, and some tropical woods.

With primary skin irritants, the dermatitis usually disappears when the exposure is ended. If exposure is repeated, the dermatitis will return. If exposure is lengthy, the dermatitis may become permanent.

Skin Allergies

In contrast to primary irritants, which, with sufficient exposure, cause dermatitis in everyone, sensitizers cause skin allergies or allergic contact dermatitis only in people who are susceptible. (See the section on Allergies.) A common example of a skin allergy is poison ivy itch. Approximately 70% of the population is susceptible. The chemical urushiol in poison ivy causes the allergy, and it is also found in Japanese lacquer.

Other strong skin sensitizers include chromate and dichromate salts, epoxy resins and hardeners, many tropical woods, formaldehyde, nickel compounds, turpentine, and photographic developers.

As discussed earlier, a major problem with allergic reactions is that, once sensitized, you can react to small amounts of the sensitizer. One artist who developed an allergy to formaldehyde discovered that she became sensitive even to the tiny amounts found in acrylic paints and synthetic fibers. These and many other art materials contain trace amounts of formaldehyde as a preservative.

For a skin irritation to be diagnosed as allergic contact dermatitis, there must have been exposure to a possible sensitizer at least 7 to 10 days prior to the appearance of symptoms, and often much longer. Also, the location of the inflammation usually has to have been directly exposed to the chemical, and there must be a positive patch test.

A patch test consists of placing a known amount of the chemical on a patch, applying it to the skin for 48 hours, and checking for a positive reaction after 48 and 72 hours. Patch tests should be done by doctors, since there is the danger of creating a sensitization where none previously existed.

Skin Cancer

A variety of agents found in artists' materials have been proven to cause skin cancer. These include arsenic pigments, petroleum oils, coal tar and its derivatives (e.g., lamp black), and ultraviolet light. Skin cancer, which usually takes 20 to 30 years to develop, is curable if caught early. In general, skin cancers, except melanoma, are not considered as dangerous as other types of cancer. Melanoma may be caused by exposure to ultraviolet light.

Other Skin Diseases

Some chemicals can cause deep, slow-healing skin ulcers. Examples are the dichromate salts and calcium oxide (unslaked lime). Some dyes, heavy metals, chlorinated hydrocarbons, tars, and sunlight can cause changes in skin pigmentation.

Oils, waxes, tars, and chlorinated hydrocarbons can block the hair follicles, oil glands, and sweat pores. Bacterial infection of blocked hair follicles, for example, can easily occur and is called folliculitis. These diseases are easily prevented by washing often with soap and water.

EYES

Our eyes are very delicate organs, and are therefore very susceptible to damage. They do have several defenses to prevent injury. The eyelids and eyelashes prevent large particles from getting into the eye, the inner surfaces and corners of the eyelids contain mucous membranes to lubricate the eye, and the tear ducts produce fluid to wash the surface of the eye and remove contaminants.

Damage to the eyes is very common and can be quite serious. Flying chips from stone carving and grinding can cause physical damage; welding and electric arc sparks and radiation (e.g., ultraviolet and infrared radiation, lasers) can cause harm to eye tissues. Chemicals can also have very serious effects. Splashing of liq-

uids and exposure to dusts, aerosol sprays, and gases can all damage the eyes. In fact, most primary skin irritants will also damage the eyes. Examples of the types of damage that can occur are inflammation of the mucous membranes (conjunctivitis or pink eye), irritation of the cornea, opacity of the lens (cataracts), and inflammation of tear ducts. Common chemicals that can cause specific eye damage include acids, alkalis, ammonia, epoxy hardeners, cyanoacrylate "instant" glues, irritating gases, mercury compounds, naphthalene, photographic developers, organic peroxide plastics resin hardeners, silver nitrate, and solvents. Methyl ethyl ketone peroxide, for example, may cause blindness if splashed in the eye.

Protection against eye damage involves wearing approved safety goggles. The type of goggles that must be worn depends upon the nature of the chemicals or processes being used. Goggles are discussed in more detail in Chapter 9.

RESPIRATORY SYSTEM

The respiratory system is one of the main ways in which airborne chemicals enter the body. If they get into the bloodstream, they can travel to other parts of the body. However, many chemicals cause direct damage to the respiratory system itself.

Acute Respiratory Diseases

Many gases are so irritating to tissues that a single exposure to even small amounts can cause injury. Examples include nitrogen dioxide (from arc welding, carbon arcs, etching), chlorine gas (from preparing Dutch mordant), hydrogen chloride (from heating polyvinyl chloride), ozone, sulfur dioxide, formaldehyde, and ammonia. Other less irritating chemicals that can cause acute respiratory problems include liquid vapors—such as acetic acid, toluene, acetone, turpentine, and other solvents—and caustic dusts—such as lime, potassium dichromate, and soda ash.

The part of the respiratory system injured depends on how soluble these materials are in water. Highly soluble chemicals such as sulfur dioxide, ammonia, hydrogen chloride, formaldehyde, acetic acid, and the caustic dusts primarily affect the upper respiratory system because they quickly dissolve as they pass down the upper reaches of the throat and large bronchi. They cause immediate symptoms such as pain, hoarseness, sore throat, reddening, and coughing. Exposure to large amounts of these chemicals can also affect the deeper parts of the lungs.

Poorly soluble gases such as nitrogen dioxide and phosgene primarily affect the lower respiratory system, including the air sacs, because the gases have a chance to reach the deeper parts of the lungs before dissolving in the lung linings. These gases are more hazardous than the soluble ones mentioned above because

symptoms often take hours to appear and there is no immediate awareness that exposure to dangerous levels of a substance has occurred. Sufficient exposure can cause chemical pneumonia, also called pulmonary edema (fluid in the lungs).

Some gases, such as chlorine (from making Dutch mordant) and hydrogen sulfide (rotten egg gas), affect both the upper and lower respiratory systems, even in small amounts.

These gases and vapors dissolve in the lungs to injure the lung tissues in much the same way that burns can damage the skin. Just as skin burns often fill with fluid, so can the lungs, resulting in a chemical pneumonia. If this occurs over a sufficient part of the lungs, death can occur. Another possible complication is bacterial pneumonia, since fluid in the lungs provides an ideal growth medium for bacteria.

Another type of acute respiratory disease is an allergic reaction to a chemical. If the upper respiratory system is affected, hay-fever-type symptoms result; if the lower respiratory system is affected, asthma occurs. Chemicals that frequently cause these types of allergies include many woods, fiber-reactive dyes, formaldehyde, turpentine, and isocyanates used in polyurethane resins. People with a history of hay fever or asthma are particularly susceptible.

Another form of allergy—hypersensitivity pneumonia—can be caused by redwood dust, some maple dusts, bone, ivory and shell dusts, stored sugar cane fibers (bagassosis), moldy cork dust (suberosis), many feathers, sawdust (joiner's disease), contaminated air-conditioning systems (air-conditioner fever), and moldy hay or grain (farmer's lung). This is thought to result from an allergy to certain bacteria or molds present in these materials. Lung scarring may result from prolonged exposure.

Metal fume fever, mentioned earlier, is caused by exposure to freshly formed metal fumes (especially zinc and copper, but also other metals) from welding and metal casting. Symptoms appear a few hours after exposure and include chills, nausea, headaches, fever, weakness, dryness of mouth, and other symptoms similar to the flu. These symptoms disappear after 24 to 36 hours, and recovery is complete.

Chronic Respiratory Diseases

Repeated exposures to small amounts of lung irritants can cause chronic bronchitis. Medically this is defined as a recurrent cough with phlegm on most days for at least three consecutive months for at least two successive years. When exposed to an irritating substance, the lungs react by producing mucus to dissolve the substance so it can be carried away by the cilia. The mucus and irritant are removed by coughing. When this irritation takes place day after day, the mucus-producing cells become adjusted to producing excess amounts of mucus, and produce it even when the irritation does not occur. Coughing then occurs even

on days when you are not exposed to the irritant, since you have to get rid of this constant extra mucus. In addition, the bronchial tubes tend to remain constricted.

This extra mucus becomes a breeding ground for bacteria and viruses, and a person with chronic bronchitis becomes very susceptible to respiratory infections. The narrowing of the air tubes leads to increased difficulty in breathing. These repeated infections and narrowing of the bronchial tubes can also lead to emphysema, a chronic disease in which the fragile air sacs burst to produce dead air space in which absorption of oxygen does not occur. One of the first symptoms of emphysema is breathlessness when exercising or otherwise exerting oneself. Other symptoms are the absence of phlegm and a dry cough. In advanced emphysema, breathlessness occurs even when resting, due to lack of sufficient oxygen.

The combined effects of smoking and exposure to irritants at work can be even more harmful. Death can occur in advanced cases of either chronic bronchitis or emphysema (or both) from fatal infections, from failure of the respiratory system to provide enough oxygen for the body to survive, or from heart failure due to the added strain on the heart.

Inhalation of cotton, flax, and hemp dusts can cause a disease called byssinosis or brown lung. It is similar to chronic bronchitis, and symptoms include chest tightness, shortness of breath, and increased sputum flow, resulting in a decrease in lung capacity. In the early reversible stages, the symptoms occur only when inhalation of the dust takes place after being away from the dust for a few days. After 10 to 20 years, the symptoms occur whenever the person is exposed, and eventually they are present all the time. During these stages the disease is not reversible, and advanced cases of brown lung are often fatal.

Another class of chronic lung disease are the pneumoconioses, a group of diseases in which the lung tissue reacts to the accumulation of dust in the lungs. Many dusts, such as iron oxide, barium sulfate, and aluminum dust, may cause mild tissue reactions in the lungs but do not appear to cause any ill effects.

However, years of exposure to dusts such as asbestos, silica (quartz, many stones, clay), coal, talc, and soapstone (both talc and soapstone often contain asbestos and silica) can cause a serious form of pneumoconiosis called pulmonary fibrosis (lung scarring), with the resulting diseases known by names such as asbestosis, silicosis, talcosis, and black lung. These dusts cause the walls of the air sacs to form scar tissue, which prevents the passage of oxygen to the bloodstream. In addition, the lungs become rigid instead of elastic, creating breathing difficulties. Since both these effects result in oxygen starvation, pulmonary fibrosis is often fatal.

A final lung disease with which we should be concerned is lung cancer. A wide variety of art materials are known or probable human lung carcinogens, including chromate pigments such as chrome yellow and zinc yellow, dichromates, asbestos and asbestos-containing materials such as serpentine, many talcs and soapstones, silica, arsenic and nickel compounds, and uranium oxide. Of course, I also have to mention the well-known connection between smoking and lung

cancer. In addition, the possibility of synergistic effects between cigarette smoke and chemicals, as described earlier in this chapter for asbestos and smoking, also has to be taken into account.

CIRCULATORY SYSTEM

The cardiovascular or circulatory system—consisting of the heart, blood vessels, and blood—serves the crucial function of transporting oxygen from the lungs to the rest of the body, and carbon dioxide in the opposite direction. In addition, the circulatory system is the body's major transport system for nutrients, hormones, white blood cells, and platelets.

Heart

The heart, like other body tissues, can be injured by chemicals and by certain types of physical stress. Soluble barium compounds, cobalt compounds, and nicotine are examples of the former; heat, noise, and vibration are examples of the latter. Some chemicals can cause heart arrhythmias at high concentrations, including methylene chloride, 1,1,1-trichloroethane, and other halogenated hydrocarbons, freons, and toluene.

The heart can also be damaged by conditions that force it to work harder, such as having to pump blood through the narrowed blood vessels of the lung that result when the lungs have been scarred. People with lung damage are thus often very susceptible to heart damage. Similarly, people who are overweight or are diabetic have extra stress placed on the heart.

The heart itself, being very active, needs a large and continual supply of blood. This is provided by the coronary arteries and capillaries. If the heart needs more oxygen than the coronary blood vessels can deliver, a heart attack or heart muscle damage results.

Blood and Blood Vessels

The blood vessels themselves can be damaged by lack of oxygen. Nicotine, ethyl alcohol, and noise can all cause narrowing of blood vessels by forcing contraction of the muscles controlling these vessels. This obviously decreases the amount of oxygen available to the blood vessels, as well as to the rest of the body.

One of the most crucial components of the blood is the red blood cell; it carries hemoglobin, which transports oxygen to the rest of the body. Several chemicals can interfere with the ability of hemoglobin to pick up and transport oxygen. One we have already mentioned is carbon monoxide, which attaches itself to the

hemoglobin in such a way that it cannot be used for oxygen transport. This carbon monoxide-hemoglobin combination is a cherry red color, and people with very severe carbon monoxide poisoning have faces and nails that are pink or cherry red.

Carbon monoxide is a colorless, odorless gas that is produced whenever there is incomplete combustion, such as in smoking, gas-fired kilns and furnaces, metal casting, oxyacetylene welding, carbon arcs, and auto exhaust. Another source of carbon monoxide is decomposition of the solvent methylene chloride in the body. In 1976, a furniture refinisher using a methylene chloride paint stripper had three heart attacks, the third being fatal. They were caused by the carbon monoxide formed from the decomposition of the methylene chloride.

Some chemicals, for example, photographic developers, hydroxylamine (used in color photography), some dyes, and nitrites (e.g., cobalt yellow), can interfere with the ability of hemoglobin to transport oxygen. This is called methemoglobinemia, and results in cyanosis, in which the lips, fingernails, and face turn blue.

Other chemicals, such as lead, benzene, and naphthalene, can disrupt the red blood cell membrane, resulting in hemolytic anemia. The severity of the anemia depends on the amount of exposure and the chemical causing it. Further damage can result from the released hemoglobin molecules blocking the kidney tubules.

Blood damage also occurs if a substance prevents the formation of new red blood cells, white blood cells, and platelets by damaging the bone marrow where these cells are formed. Lead, entering the body, can cause anemia by preventing the formation of red blood cells. Ethylene glycol ethers (commonly called cellosolves), a class of solvents found in some water-based materials, can also cause anemia by affecting the bone marrow.

Benzene (benzol) is even more insidious. Repeated exposure to benzene can destroy the bone marrow, causing aplastic anemia. In this disease, there are severe deficiencies in red blood cells, white blood cells, and platelets. The lack of white blood cells—an essential part of the body's defenses—leads to repeated serious infections. The lack of the blood-clotting platelets can lead to serious hemorrhaging. Aplastic anemia is often fatal.

Repeated exposure to even very small amounts of benzene can also cause leukemia, a form of blood cancer that is often fatal, although it may be controlled for some time with drugs and radiation. For these reasons, I recommend against the use of any materials containing benzene. Until the late 1970s, benzene was found in many paint and varnish removers.

LIVER AND URINARY SYSTEM

Chemicals can also harm the liver, the kidneys, and the bladder, which are the organs of detoxification and excretion.

Liver

The liver is the body's chemical factory. It is involved in almost every step of protein, fat, and carbohydrate metabolism. From our point of view, the liver has another extremely important function—it detoxifies foreign chemicals by either altering them or destroying them. As with other defenses of the body, the capacity of the liver to detoxify chemicals can be exceeded, and liver damage can result. Furthermore, when the liver is damaged, it can no longer carry on its normal functions (including detoxification of harmful chemicals produced by the body itself). This can result in injury to the rest of the body. Sometimes the metabolized chemicals are more dangerous than the original chemical.

Hepatitis, or inflammation of the liver, is commonly thought of as a viral disease, but it can also be caused by toxic chemicals. It will usually heal without lasting damage once the exposure is ended, except in severe cases. Then scarring (cirrhosis) of the liver can result. Examples of chemicals that may cause liver damage are ethyl alcohol, the chlorinated hydrocarbons, styrene, toluene, xylene, phenol, nitrobenzene, dimethylformamide, and arsenic.

One common symptom of advanced liver damage is jaundice, a yellowish or greenish tinge to the skin. Other symptoms are vague and include tenderness and swelling of the liver, nausea, loss of appetite, and fatigue. Early and reversible liver damage, before symptoms develop, can be detected by an elevation of liver enzyme levels in the blood.

Kidneys

Our kidneys filter unwanted chemicals and metabolites out of the bloodstream, regulate the volume and composition of our body fluids, and maintain the acid-base balance in our blood. All these unwanted materials make up our urine.

Acute kidney damage can result from loss of blood supply to the kidneys from carbon monoxide poisoning, heat stress that diverts blood to the skin, and accidents that involve large losses of blood. Large exposures to oxalic acid, turpentine, carbon disulfide, lead compounds, ethylene glycol, and mercury can also cause acute kidney damage.

Chronic kidney disease can result from long-term exposure to many metals (arsenic, cadmium, chromates and dichromates, lead, lithium, mercury, selenium, and uranium compounds), solvents (carbon disulfide, chlorinated hydrocarbons, styrene, toluene, and xylene), and oxalic acid and its salts.

Kidney damage can usually be detected by the presence of small proteins in the urine.

Bladder

Long-term inhalation of certain dyes, particularly those direct dyes derived from the known powerful carcinogen benzidine, can cause bladder cancer. It has been

shown that such dyes can be broken down to yield benzidine. Dyes based on dimethyl benzidine and dimethoxy benzidine are probable human carcinogens.

Studies conducted in the former Soviet Union have indicated that dye workers get chronic cystitis, and have suggested that this is a precancerous state. In addition many amines, particularly those involved in dyes, can cause hemorrhagic cystitis (i.e., blood in the urine). Blood in the urine is a serious indication of damage to the kidneys or bladder.

NERVOUS SYSTEM

Everything we do, such as thinking, breathing, eating, walking, talking, is controlled by our nervous system. And, as with the other organ systems in our body, our nervous system is susceptible to damage from chemicals, trauma, and other types of physical agents.

Basically the nervous system can be divided into two parts: the central nervous system, consisting of the brain and spinal cord, and the peripheral nervous system, consisting of the cranial nerves, spinal nerves, and the autonomic nervous system. One of the major differences between the central and peripheral nervous systems is that damage to the nerves of the central nervous system is irreversible, whereas damage to the peripheral nerves can sometimes be reversed. For example, if the spinal cord is severed, there is no way to recover the functions that are lost. But damage to nerves of the hands and feet can often reverse itself in time.

Some chemicals, such as lead, mercury, manganese, organophosphate plasticizers and pesticides, and carbon disulfide, may affect both the central and peripheral nervous systems, altering or destroying nerve function. Other chemicals can affect the central nervous system directly or indirectly. Hydrogen sulfide (rotten egg gas), carbon disulfide, and hydrogen cyanide (produced in the decomposition of some plastics) can directly poison the brain by affecting enzymes that use oxygen. On the other hand, brain damage can occur indirectly due to oxygen starvation caused by a gas such as carbon monoxide, which interferes with oxygen supply. Or gases such as acetylene and carbon dioxide can cause asphyxiation if they are present in amounts large enough to decrease the percentage of oxygen in the air.

One of the most common types of central nervous system disorder is acute solvent intoxication or narcosis. Most solvents, particularly the chlorinated hydrocarbons and aromatic hydrocarbons (e.g., toluene, xylene), cause depression of the central nervous system. Symptoms from overexposure include a feeling of being "high," fatigue, dizziness, lack of coordination, mental confusion, sleepiness, and nausea. Very high levels of exposure can result in coma, and sometimes death. Even slight intoxication can be a hazard if you are working with machinery where loss of coordination or reflexes could result in an accident.

If the exposure is not great enough to cause immediate serious illness, the symptoms disappear after removal from exposure. However, evidence has accumulated over the last decade that chronic solvent exposure can cause irreversible brain damage. Symptoms include memory loss, mood changes, emotional swings, decrease in intelligence, loss of hand-eye coordination, and other psychoneurological effects. This is also called mild chronic toxic encephalopathy. A more severe form can occur from solvent "sniffing." Long-term exposure to high levels of chlorinated hydrocarbons, aromatic hydrocarbons, and mineral spirits has been implicated in many of these studies.

Another type of chronic neurological problem is peripheral neuropathy, or damage to the nerves of the extremities. This can be caused by carbon disulfide, trichloroethylene, carbon tetrachloride, thallium, arsenic, lead, n-hexane, mercury, and methyl n-butyl ketone.

The solvent n-hexane is of particular concern since it is found in most rubber cements, rubber cement thinners, many contact cements, spray adhesives, spray fixatives and lacquer thinners. It can cause numbness and weakness of the hands, arms, legs, and feet, and in severe cases paralysis. Sometimes damage to the nerves of the eyes also occurs. These symptoms usually go away in two to three years. However, sometimes permanent central nervous system damage, such as fatigue, weakness, memory problems, and spasticity, can occur. I have seen quite a few cases of peripheral neuropathy in commercial artists using large amounts of spray adhesives, rubber cement, and rubber cement thinner.

REPRODUCTIVE SYSTEM

Unfortunately, not enough is known about the effects of chemicals on the reproductive system. Due to the inconclusiveness of most human studies, we have to rely on animal studies. We do know from animal studies and a few human epidemiological studies that many chemicals can affect the reproductive systems of both men and women and can affect their offspring.

Scientists divide possible reproductive effects into two general categories: reproductive toxicants, and developmental toxicants.

Reproductive Toxicants

A reproductive toxicant is one that interferes with the reproductive or sexual functioning of a person from puberty through adulthood. Toxic effects can include interference with sexual functioning (e.g., loss of or decreased sex drive), impotence, lowered fertility, and difficulty in conceiving. Women can develop menstrual disorders, and men can develop problems with the testes and prostate.

High lead levels, for example, can cause menstrual disorders in women and loss of sex drive, atrophy of testes, and possible sperm alterations in men. It is also thought to decrease fertility. Benzene, xylene, toluene, and styrene are suspected of causing menstrual disorders in women. Other probable reproductive toxicants include boron, cadmium, carbon disulfide, many glycol ethers, manganese, and mercury.

Developmental Toxicants

Developmental toxicants are agents that cause an adverse effect in the offspring from conception to puberty. There are four main types of developmental effects: (1) death of the embryo or fetus leading to a miscarriage; (2) structural abnormality leading to birth defects; (3) altered growth, for example low birth weight; and (4) functional deficiency, for example, mental retardation.

In small amounts, chemicals that are embryotoxic or fetotoxic can affect the growth of the fetus, resulting in lower birth weight (e.g., carbon monoxide, cigarette smoking), or effects on infant learning or brain function (e.g., lead). Some can cause permanent malformations or birth defects (e.g., the drug thalidomide, toluene). Chemicals that can cause birth defects are also called teratogens. In large amounts, embryotoxic or fetotoxic chemicals can also cause spontaneous abortions or miscarriages, and may also affect the pregnant woman.

Chemicals that are thought to be developmental toxicants include certain metals (arsenic, cadmium, lead, lithium, phenylmercuric compounds), organic solvents (ethyl alcohol, toluene, carbon disulfide, many glycol ethers, and probably many other solvents), carbon monoxide (cigarette smoking causes underweight babies), anesthetic gases, and aspirin. In addition, it is believed that some cancer-causing chemicals may cause cancer in the children of women exposed to the carcinogens during pregnancy.

Time of Exposure

From the point of view of the reproductive process itself, the effects of chemicals on reproduction can be divided into three main time periods: effects prior to pregnancy, effects during pregnancy, and effects on the newborn infant.

Prior to Pregnancy

As discussed above, both men and women are at risk of harm to the reproductive system from reproductive toxicants. Some developmental toxicants, however, can also affect future offspring from exposures prior to pregnancy.

Some human epidemiological studies have shown that wives of some chemical workers had more stillbirths and miscarriages than other women. There is also growing evidence from animal studies that the offspring of animals exposed

to certain chemicals prior to pregnancy have higher rates of birth defects, fetal death, low birth weight, and learning and behavioral abnormalities.

The main reason for this is damage to germ cells, the male sperm in particular. This damage is more likely to occur in men because they are constantly producing new sperm; women have all their eggs from birth. In particular, the three months prior to pregnancy are of greatest concern, since it takes that long for sperm to form and mature. Mutagens might cause damage in this way.

During Pregnancy

As discussed earlier, developmental toxicants can cause a variety of harmful effects. These developmental toxicants are especially problematic during the first trimester, when organ development occurs, since their interference with cells that are in the process of developing into organ systems can have serious structural effects. Later in pregnancy, developmental toxicants tend to result in behavioral and other functional problems.

Many developmental toxicants can also affect the woman during pregnancy, especially at high concentrations. In addition, the pregnant woman may be at somewhat higher risk from other exposures due to the fact that, during pregnancy, a woman's metabolism is very different from her metabolism in the nonpregnant state. In particular, the respiratory system and circulatory system are affected, and chemicals such as solvents, dyes, metals, toxic dusts, and gases affecting these systems may create an extra hazard. In addition, physical and other forms of stress may cause problems.

After Pregnancy

Finally, many chemicals can injure infants and young children. A breast-fed infant can be poisoned if the mother has been exposed to toxic chemicals (for example, methylene chloride has been shown to be present in a mother's milk up to 17 hours after exposure). And children can be exposed to toxic substances if they are present in the work area, or if toxic dusts are carried home on clothes and shoes. In one example, an 18-month-old girl developed lead poisoning from playing in the kitchen while her parents were doing stained glass there.

Protection

The above discussion suggests that the times of greatest risk are the three months prior to pregnancy for men and during pregnancy, especially the first trimester, for women. Since we do not know what is a safe level of exposure at these times, the solution is to avoid or minimize the absorption of toxic chemicals into the body during these time periods. This advice is similar to the advice physicians give about medications during pregnancy.

This does not necessarily mean avoiding art materials during these periods. If you can work with art materials without absorbing them into the body, then there is no problem. Avoiding skin contact and ingestion of toxic materials is relatively easy through simple hygiene precautions. Inhalation of toxic, airborne materials is often harder to avoid. This is especially of concern with toxic solvent vapors, metal dusts, and gases. With careful cleanup and personal hygiene, however, activities such as water-based painting and printmaking, using oil pastels (not dusty pastels), weaving (except using powdered dyes), black-and-white photography (but no mixing of powdered developers, intensifying, or toning), and stone sculpture are just a few examples of art processes that would not involve risk to the fetus (although they might involve risks to the pregnant woman).

In the case of pregnant women exposed to these materials at work, the solution might involve paid furloughs or job transfers without loss of pay or seniority, as is the practice in several European countries. The basic problem with this approach is that often a woman does not know that she is pregnant for several weeks, and it is the first 12 weeks of pregnancy that are the most risky to the fetus. This makes it crucial for a woman to find out if she is pregnant as soon as possible, or to modify exposure when she is trying to become pregnant.

Overall, the solution to these problems is to identify chemicals that are particularly dangerous and not to use them, and to minimize exposure to all chemicals so that you are protected from any substance that might be discovered to affect the reproductive system or affect the growth of the fetus.

REFERENCES

Gilman, A. G., Goodman, L., Rall, T., and Murad, F. (eds). (1985). *Goodman and Gilman's The Pharmacological Basis of Therapeutics*. 7th ed. New York: Macmillan Publishing Co.

Gosselin, R., Smith, R., and Hodge, H. (1987). *Clinical Toxicology of Commercial Products*. 6th ed. Baltimore: Williams and Wilkins.

Hamilton, A., and Hardy, H. L. (1973). *Industrial Toxicology*. 3d ed. Acton, MA: Publishing Sciences Group, Inc.

Klaasen, C. D., Ambdur, M. O., and Doull, J. (eds). (1986). *Casarett and Doull's Toxicology*. 3d ed. New York: Macmillan Publishing Co.

National Institute for Occupational Safety and Health. (1977). *Occupational Diseases: A Guide to Their Recognition*, rev. ed. Washington, DC: U.S. Government Printing Office.

New Jersey Right-to-Know Program. (1989). *Right to Know Hazardous Substance List*. Trenton: NJ Department of Health.

Patty, F. (ed). (1982). *Industrial Hygiene and Toxicology*. Vol. II. 3 parts. 3d ed. New York: Interscience Publishers.

U.S. Congress, Office of Technology Assessment. (1985). *Reproductive Health Hazards in the Workplace*. OTA-BA-266. Washington, DC: U.S. Government Printing Office.

4

Which Art Materials Can Hurt You: Gases and Liquids

Having seen the types of bodily injury that can result from exposure to toxic art materials, let us now see which materials are toxic and to what extent. This and the next chapter contain an overview of broad categories of materials that can harm you: solvents, aerosol sprays, gases, acids and alkalis in this chapter; mineral dusts, metals and their compounds, pigments, and dyes in Chapter 5. More detailed discussions of the hazards of these materials and the precautions you can take to protect yourself are also discussed in later chapters in Part One and in the chapters in Part Two that deal with specific art and craft techniques.

The following discussion of toxicity rating systems, and of the rating system I use in this book, will help you understand the hazards of materials discussed throughout this book.

TOXICITY RATINGS

As discussed in Chapter 3, the toxicity of art materials is one of many factors affecting how hazardous they may be to use. To evaluate the hazard of a particular

material, you must have some idea of its toxicity so you can decide what precautions you must take to work safely with it.

There are several types of toxicity rating systems in common use, depending on route of entry and the type of injury studied. You will probably encounter most of the ones I describe if you obtain Material Safety Data Sheets on your art materials.

Lethal and Toxic Dose Ratings

One of the standard tests used by toxicologists in evaluating acute toxicity is measuring the LD(50) or LC(50). The LD(50) of a chemical is the dose (in milligrams per kilogram of body weight) that kills 50% of a group of test animals, usually rats, within two weeks. This dose can be administered orally, by injection, or through skin contact. The LC(50) is the concentration of the chemical in air that kills 50% of the animals in a study.

A chemical is considered highly toxic if its LD(50) is 50 milligrams or less per kilogram of body weight. For a 150-pound man, this amounts to 3.4 grams, or about $\frac{1}{8}$ ounce; for a 50-pound child, this is about 1 gram. Under Federal Hazardous Substances Act regulations, a chemical is acutely nontoxic if its LD(50) is over 5 grams per kilogram (4 ounces for a 50-pound child). A chemical is highly toxic by inhalation if its LC(50) is 200 parts or less of vapor or gas per million parts of air (ppm), or 2 milligrams or less of particles per liter of air.

Since we are not really interested in what dose kills 50% of the people, toxicologists sometimes also report the following exposure effects in humans or animals: LDL(0), the lowest lethal dose in humans or animals; TDL(0), the lowest toxic dose by any route except inhalation; and TCL(0), the lowest toxic concentration in air.

Probable Oral Lethal Dose Ratings

One of the classic references on toxicology is *Clinical Toxicology of Commercial Products* by Gosselin and associates, which lists numerical toxicity ratings for thousands of chemicals. These ratings indicate the probable oral lethal dose for adult humans. These ratings do not indicate the lowest lethal dose, but the mean lethal dose. In addition, people could experience toxic effects at about one tenth the probable lethal dose. The following is their rating system:

Toxicity Rating or Class	Probable Oral Lethal Dose	
	Dose	70 kg (150 pound) Person
6 Super toxic	Less than 5 mg/kg	A taste (less than 7 drops)
5 Extremely toxic	5–50 mg/kg	Between 7 drops and 1 teaspoon
4 Very toxic	50–500 mg/kg	Between 1 teaspoon and 1 ounce
3 Moderately toxic	0.5–5.0 gm/kg	Between 1 ounce and 1 pint (or 1 pound)
2 Slightly toxic	5–15 gm/kg	Between 1 pint and 1 quart
1 Practically nontoxic	More than 15 gm/kg	More than 1 quart (2.2 pounds)

For lighter or heavier people, including children, the dose is typically (but not always) proportionately smaller or greater. I use these ratings in my relative toxicity rating for ingestion.

Exposure Limits

ACGIH Threshold Limit Values. For inhalation, a common toxicity indicator is the time-weighted average (TWA) Threshold Limit Value (TLV) developed by the American Conference of Governmental Industrial Hygienists (ACGIH) for use in industry. The TLV of a substance is the average concentration in air to which *most* people can be repeatedly exposed 8 hours a day, 40 hours a week, without adverse effect. There are TLVs for over 600 chemicals, and they are sporadically updated and added to.

Besides the 8-hour, time-weighted average TLV, there is the Short-Term Exposure Limit (STEL), which is the 15-minute average exposure that should not be exceeded at any time during the workday, and the Threshold Limit Value-Ceiling (TLV-C), which is the concentration that should not be exceeded even momentarily.

However, I want to include some caveats about TLVs. First, TLVs are developed for industry, where workers on the whole tend to be healthier than the general population. And the definition of the TLV states that it is intended to protect only *most* workers, not everyone. TLVs should not be used for a general population, which can include children, pregnant women, people with various illnesses and disabilities that could put them at higher risk, and other high-risk groups.

Second, there is considerable controversy over the strong role industry has played in the development of TLVs. Many health professionals believe that the TLVs for many chemicals are set way too high, in order to protect industry from too strict standards. In fact, you can find many examples in the medical literature of people becoming ill from exposures below the TLV of a particular chemical.

Third, to use a TLV you must be able to measure the concentration of a substance in air. This is difficult for artists, since it requires special equipment and training. For art schools, however, TLVs can be important, since under some circumstances colleges may choose to do air sampling for certain chemicals. I would recommend keeping concentrations of chemicals below one tenth of the TLVs in order to provide a minimal safety factor.

Fourth, a TLV applies only to inhalation. Relying on the TLV does not take into account possible skin absorption and inadvertent ingestion.

Fifth, the normal TLV is based on an 8-hour time-weighted average exposure and does not take into account high peak exposures. Only a few chemicals have Short Term Exposure Limits.

NIOSH Recommended Exposure Limits.
The National Institute for Occupational Safety and Health (NIOSH) has the responsibility for advising OSHA on health standards. NIOSH established Recommended Exposure Limits (RELs) for a number of chemicals which are usually 10-hour time-weighted average exposures over a 40-hour week. These are often lower than either the TLVs or PELs.

OSHA Permissible Exposure Limits.
The Occupational Safety and Health Administration (OSHA) has established Permissible Exposure Limits (PELs) for over 400 chemicals. The original PELs were mostly based on the 1968 TLVs. However, in 1989, OSHA updated most of its PELs to agree with the 1988 TLVs or with NIOSH RELs, but an appeals court threw these charges out in 1992 on the basis that OSHA didn't prove the new PELs were stringent enough. OSHA's PELs are legally enforceable, and as this book goes to press, OSHA is still enforcing the revised PELs and has not decided yet whether to appeal the court ruling. TLVs, by contrast, are only advisory. The PEL's can also be STELS or C values.

Note that since TLVs and PELs do not adequately protect artists, you should be cautious about calling OSHA into a workplace because you think it is unsafe. If the concentration of the chemical is not above the PEL, then OSHA will not issue a violation—even though the workplace may in fact be making you ill. In this case, the employer would be able to say that OSHA gave it a clean bill of health.

Exposure Limits Reported in this Book.
I have reported the TLVs of many substances in this and the next chapter since you will come across their use of Material Safety Data Sheets and in the scientific literature. The TLVs reported are in the 1991/92 ACGIH TLV booklet. When the OSHA PEL or NIOSH REL is lower, I report them instead of the ACGIH TLV. Due to the court decision rejecting the recent updating of PELs, I do not report them (unless otherwise noted), but do report the TLVs or RELs from which they were derived.

TOXICITY RATING SYSTEM USED IN THIS BOOK

The relative toxicity ratings used in this book are based on similar rating systems used by toxicologists as well as on my own judgment of the relevant literature and of the nature of artists' exposure to the materials. Note that these relative toxicity ratings are to be applied only to adults, not to children. Children should use only materials that are not significantly toxic. These ratings also do not apply to high-risk groups such as pregnant women or people with chronic heart disease, lung disease, or asthma.

In the first edition of *Artist Beware*, I used a relative toxicity rating system with four categories: highly toxic, moderately toxic, slightly toxic, and not significantly toxic. I also gave separate ratings for skin contact, inhalation and ingestion. I used this system because it was simple and therefore the most useful to artists and craftspeople.

I modified the system for this edition by including a new category: extremely toxic. I did this because the highly toxic category did not differentiate between chemicals that could be used safely if very careful precautions were taken and chemicals that should never be used because of the chance of fatality or major life-threatening illness from small exposures.

Since the method by which a chemical enters the body can affect whether it can cause illness, I give separate ratings for skin contact, inhalation, and ingestion. For example, clay is not significantly toxic by skin contact or ingestion, but is highly toxic by inhalation. The ratings for ingestion primarily reflect the risk for acute ingestion, since, except for young children, chronic ingestion should not be a problem. The ingestion ratings are based on the ratings in *Clinical Toxicology of Commercial Products*, which I discussed earlier.

Extremely Toxic

Acute Effects. Fatality from low level of exposure, e.g., inhalation of hydrogen cyanide.

An extremely toxic ingestion rating corresponds to super toxic (6) and extremely toxic (5) ratings of *Clinical Toxicology of Commercial Products.*

Chronic Effects. Major, possibly life-threatening, permanent injury from low-level exposure, e.g., kidney or liver damage from skin absorption or inhalation of carbon tetrachloride.

Allergies. Life-threatening allergic reactions at a very low concentration, e.g., severe asthma from inhalation of methylene bisphenyl isocyanate (MDI) found in polyurethane foam and castings resins.

Cancer. Known human carcinogen (see page 42 for definitions), e.g., asbestos, cadmium fumes from cadmium silver solders.

Comments. Do not use extremely toxic materials. The risk of severe injury or fatality from low-level exposures—for example, accidental spills—is too great. Similarly, since there is no known safe level of exposure to known cancer-causing chemicals, I recommend against their use.

Highly Toxic

Acute Effects. Major permanent or major temporary damage, or fatality, from normal exposure levels, e.g., severe burns from skin contact with concentrated acids or alkalis.

A highly toxic ingestion rating corresponds to the very toxic (4) rating of *Clinical Toxicology of Commercial Products.*

Chronic Effects. Major permanent or major temporary injury can result from repeated, long-term exposures to normal amounts of the material, e.g., peripheral neuropathy from chronic inhalation of n-hexane from rubber cement, silicosis from years of inhalation of clay dusts containing crystalline silica.

Allergies. A high frequency of severe and possibly life-threatening allergies from exposure to normal amounts, e.g., asthma from inhalation of fiber-reactive dyes.

Cancer. Probable human carcinogen, e.g., methylene chloride, cadmium sulfide.

Reproductive Hazards. Known human developmental toxicant, e.g., ethylene glycol monomethyl ether.

Comments. Avoid highly toxic chemicals, if possible. If they must be used, use very careful precautions such as local exhaust ventilation and other precautions (see Chapters 6-9).

Moderately Toxic

Acute Effects. Minor temporary or permanent damage from a single exposure to normal amounts of the materials, e.g., burns from skin contact with sodium carbonate (soda ash) or zinc chloride soldering flux, metal fume fever from inhalation of zinc or copper fumes.

Major permanent or temporary injury, or fatality, from a very high exposure to the material, e.g., heart arrhythmias and possible cardiac arrest from inhalation of large amounts of 1,1,1-trichloroethane (methyl chloroform).

A moderately toxic ingestion rating corresponds to the moderately toxic (3) rating of *Clinical Toxicology of Commercial Products.*

Chronic Effects. Minor temporary or permanent damage from repeated normal exposure to the material, e.g., dermatitis from repeated skin contact with most organic solvents, mild lung impairment from chronic inhalation of acid soldering fluxes.

Allergies. Allergic reaction in a large percentage of people, e.g., allergic skin reactions from turpentine, epoxy resins, nickel compounds.

Reproductive Hazards. Probable human developmental toxicant, e.g. cadmium.

Slightly Toxic

Acute Effects. Readily reversible, minor injury from a single exposure to normal amounts of the material, e.g., mild respiratory irritation or intoxication from solvent inhalation.

More serious injury from large overdoses of the material, e.g., metal fume fever from inhalation of iron oxide fumes.

A slightly toxic ingestion rating corresponds to the slightly toxic (2) rating of *Clinical Toxicology of Commercial Products.*

Chronic Effects. Readily reversible, minor injury from repeated exposure to normal amounts of the material, e.g., minor skin irritation from repeated skin contact with solvents.

Allergies. Allergic reactions in small numbers of people, e.g., skin allergies from potassium alum (a dye mordant) and gum acacia (gum arabic), asthma from repeated inhalation of rosin dust.

Not Significantly Toxic

A material is not significantly toxic if it causes some toxic effects only under highly unusual conditions, or by exposure to massive amounts of the material, such as ingestion of clay or iron oxides or inhalation of titanium oxide pigment, barium sulfate, or tin oxide.

A not significantly toxic ingestion rating corresponds to the practically non-toxic (1) rating of *Clinical Toxicology of Commercial Products.*

GASES

With the exception of oxygen, acetylene, and propane used in welding and brazing, and propellant gases used in aerosol cans, gases are not commonly found as art materials. However, toxic gases are side products of many art processes, such as nitric acid etching, welding, kiln firing, decomposition of plastics from heating and sanding, and the use of furnaces. The three categories of gases that concern us are asphyxiating gases, irritating gases, and nonirritating poisonous gases.

In general, gases are potential hazards by inhalation and, in some instances, by skin absorption.

Asphyxiating Gases

Asphyxiating gases—not usually a problem with most art processes—are most likely to occur in situations such as welding in a confined space, for example, a basement or ship's hold where there can be a buildup of the gas as it displaces oxygen. Although these gases have no toxic effects themselves, gases such as acetylene (used in welding), nitrogen (especially when the oxygen in the air is used up), propane, and carbon dioxide can be hazardous, since they lower the percentage of oxygen in the air and can lead to asphyxiation.

Irritating Gases

Irritating gases include hydrogen selenide (from adding acid to selenium compounds), hydrogen fluoride (from glass etching), chlorine (from mixing Dutch mordant), phosgene (from decomposition of chlorinated hydrocarbons with heat or ultraviolet light), ozone (from arc welding and carbon arcs), nitrogen dioxide (from nitric acid etching), ammonia, sulfur dioxide, fluorine, hydrogen sulfide, and formaldehyde.

Hazards

1. Irritating gases primarily affect the eyes (particularly ammonia) and the respiratory system. Most are highly toxic.
2. Acute exposure, particularly to phosgene, chlorine gas, hydrogen fluoride, nitrogen dioxide, ozone, and hydrogen selenide, can cause sore throat,

bronchospasms, shortness of breath, and, at higher concentrations, chemical pneumonia.

3. Chronic exposure to smaller amounts of irritating gases can cause chronic bronchitis and emphysema and lead to a greater susceptibility to infections.

4. Phosgene (a decomposition product from exposing chlorinated hydrocarbons to heat or ultraviolet radiation, or from the burning of some plastics) is extremely toxic by inhalation, and can be fatal.

5. Many asthmatics are very sensitive to sulfur dioxide, given off in kiln firings and from photographic fixing baths.

6. Formaldehyde gas, besides being a skin, eye, and respiratory irritant, is a strong sensitizer and probable human carcinogen.

7. See Table 4-1 for exposure limits of irritating gases.

Precautions

1. The best precaution against the dangers of irritating gases is local exhaust ventilation such as fume hoods. General ventilation is not recommended, except for very low concentrations.

2. If ventilation is not adequate, use a NIOSH-approved respirator with an appropriate cartridge. Respirators are discussed in Chapter 9.

Poisonous Gases

Nonirritating poisonous gases are gases that affect parts of the body other than the lungs. The major examples are carbon monoxide (from methylene chloride and from incomplete combustion of fuels in furnaces, gas-fired kilns, or space heaters) and hydrogen cyanide (produced by adding acid to cyanide solutions, from decomposition of several plastics, and from cyanide solutions in photography and electroplating). Hydrogen sulfide is an irritating poisonous gas given off when metal sulfides react with acid (e.g., sulfide photographic toners and metal patinas).

Hazards

1. Carbon monoxide is highly toxic by inhalation. It combines with the hemoglobin in the blood, preventing the blood from carrying oxygen to body tissues. Symptoms of exposure include severe frontal headache, nausea, dizziness, vomiting, and, at high concentrations, coma and death. It

can also cause heart attacks. Cherry red lips and fingernails are signs of acute carbon monoxide poisoning.

2. Hydrogen cyanide is extremely toxic by all routes of absorption, and it can be absorbed through the skin. Inhalation is frequently fatal within minutes by chemical asphyxiation. It can also be formed in the stomach by ingestion of cyanide salts and subsequent reaction with stomach acid.

3. Hydrogen sulfide is highly toxic by inhalation and ingestion. It can cause chemical pneumonia and fatalities from chemical asphyxiation and can also be formed by ingestion of metal sulfides and subsequent reaction with stomach acid.

4. See Table 4-1 for the exposure limits of poisonous gases.

TABLE 4-1.	Exposure Limits for Irritating and Poisonous Gases	
Gas	*TLV (TWA) in ppm*	*Other*
Ammonia	25	STEL 35 ppm
Carbon monoxide	25**	C 200 ppm***
Chlorine	0.5	STEL 1 ppm
Fluorine	0.1 (NIOSH REL)*	
Formaldehyde	C 0.3**	NIOSH REL 0.016 ppm; C 0.1 ppm
Hydrogen chloride	C 5	
Hydrogen cyanide	ST 4.7 (NIOSH REL)*	absorbed through skin
Hydrogen fluoride	C 3	
Hydrogen selenide	0.05	
Hydrogen sulfide	C 10 (NIOSH REL)*	
Nitrogen dioxide	ST 1 (NIOSH REL)*	
Ozone	C 0.1 (NIOSH REL)*	
Phosgene	0.1	NIOSH C 0.2 ppm
Sulfur dioxide	2	STEL 5 ppm

C, TLV-ceiling

*OSHA Permissible Exposure Limits or NIOSH Recommended Exposure Limits are listed when they are lower than ACGIH Threshold Limit Values (TLVs). See page 59 for definitions.

**Proposed 1991/92.

***Proposed by OSHA and rejected in court.

Precautions

1. Make sure any process producing carbon monoxide is properly vented to the outside.

2. Do not use cyanide solutions.

3. Sulfide toners and patinas should be used only with local exhaust ventilation. See Chapter 7. If the ventilation is not adequate, wear a NIOSH-approved respirator with acid gas cartridge.

LIQUIDS

The liquids most commonly used by artists are either based on water—for example, acid and alkaline solutions—or based on organic liquids—for example, organic solvents and oils. Potential hazards from liquids include skin contact—and sometimes skin absorption, inhalation of vapors from the evaporated liquid, and ingestion.

Acids

Acids are used for many purposes in art processes, including cleaning, etching, and adjusting the acidity of an art material or solution.

Most acids are liquids or solutions of gases in liquids, although a few, such as tannic acid and sodium bisulfate, are solids. Acids, usually bought in concentrated solutions and then diluted to the desired concentration, are used in photographic solutions, as etches in printmaking, as disinfectants, for metal cleaning and pickling, for etching glass, as soldering and brazing fluxes, and in dyeing.

Common acids used in art include acetic, boric, chromic, hydrochloric, hydrofluoric, nitric, oxalic, sulfuric, and tannic acids.

Hazards

1. Most concentrated acids are highly corrosive by skin and eye contact and by ingestion. They can cause severe stomach damage and may be fatal. The concentration of the acid is more important than the amount, with 1 ounce being possibly fatal. Smaller amounts, even a few milliliters (less than a teaspoon) can be fatal if aspirated into the lungs.

2. Diluted acids are less hazardous. Repeated or prolonged skin contact can cause irritant dermatitis.

3. The hazards of particular acids are discussed in Table 4-2.

Precautions

1. Wear natural or neoprene rubber gloves and goggles when handling concentrated and dilute acids.

2. When diluting concentrated acids, always add the acid to the water, never the reverse. If you add water to concentrated acids, the heat of reaction will cause hot concentrated acid to splatter.

3. Use acids with adequate ventilation. Local exhaust ventilation is needed for nitric acid etching or acid pickling baths. Hoods and ducts should be corrosion resistant.

4. Do not work with concentrated hydrofluoric acid. Instead use moderately toxic bifluoride pastes. These still produce small amounts of hydrofluoric acid in solution, but they do not have the severe hazards of concentrated hydrofluoric acid, nor the risk of dangerous spills.

5. Emergency showers and eyewash fountains should be located in areas where concentrated acids are used. In cases of spills on the skin, wash with lots of water; in case of eye contact, rinse for at least 15 minutes and call a doctor.

6. In case of ingestion of concentrated acids, do not induce vomiting. Take one or two glasses of water and call a doctor. See Chapter 11.

Alkalis

Most alkalis are solids that are dissolved in water. One major exception is ammonium hydroxide, which is ammonia gas dissolved in water. Alkalis are used in cleaning solutions, paint removers, dye baths, ceramic glazes, and photographic developing baths. Examples of common alkalis used in art are ammonium hydroxide, calcium hydroxide (slaked lime), calcium oxide (lime), lithium oxide, potassium hydroxide (caustic potash), potassium carbonate (potash), potassium oxide, sodium carbonate (soda ash), sodium hydroxide (caustic soda), sodium oxide, sodium silicate, and trisodium phosphate.

Hazards

1. Most alkalis are highly corrosive to the skin and eyes.

2. Ingestion of small amounts of concentrated alkaline solutions can cause severe pain and damage to the mouth, esophagus, and stomach and can be fatal. As with acids, the concentration is more important than the amount. Granular alkalis tend to damage the mouth.

3. Inhalation of alkali dusts can cause chemical pneumonia. Some inhalation of alkaline solutions may occur during accidental ingestion.

4. Dilute alkaline solutions are more corrosive to the skin and eyes than dilute acid solutions.

5. See Table 4-3 for hazards of particular alkalis.

Precautions

1. Wear rubber gloves and goggles when handling alkaline powders and solutions.

2. In cases of spills, wash with lots of water; in case of eye contact, rinse with water for at least 15 minutes and call a doctor.

3. Do not induce vomiting if ingested. Take one to two glasses of water and call a doctor.

Solvents

Solvents are liquids that can dissolve other materials. Many are highly volatile, meaning that large amounts can evaporate into the air in short periods of time. One of the best examples of a solvent is water. However, many of the chemicals used in art materials are not soluble in water, and organic solvents must be used instead. In art, these organic solvents are used to dissolve oils, resins, waxes, plastics, varnishes, and paints; thin oil paints, lacquers, inks, varnishes, and resins; and clean brushes, rollers, tools, metal, silk screens, and even—despite the hazards—hands. Complex mixtures of solvents are often found in trade name products—for example, in lacquer thinners and paint and varnish removers.

Hazards

1. Most organic solvents are hazardous if swallowed or if their vapors are inhaled in sufficient quantities, and most solvents can cause dermatitis after sufficient skin contact. In addition, many solvents (e.g., toluene, xylene, turpentine, methyl alcohol, chlorinated hydrocarbons) can be absorbed through the skin.

2. Acute inhalation of almost any solvent can cause some degree of eye, nose, and throat irritation as well as narcosis or central nervous system depression that involves intoxication, with symptoms of dizziness, feelings of being "high," headaches, loss of coordination, mental confusion, and possibly even coma and death in the case of very high levels of exposure.

3. Research in the late 1970s and early 1980s showed that chronic inhalation of many solvents may cause irreversible brain damage. Symptoms can include memory loss, emotional instability, irrational anger, poor hand-eye coordination, confusion, and lowered intelligence. These studies usually involved exposure to many different solvents, with the chlorinated hydrocarbons, mineral spirits, and toluene being the most frequently mentioned.

4. Many solvents can affect other body organs. Examples include hexane and the peripheral nervous system, methylene chloride and the heart, benzene and bone marrow, turpentine and the kidneys, perchloroethylene and the liver, and glycol ethers and the reproductive system.

5. Extremely toxic solvents include benzene, carbon tetrachloride, and gasoline.

6. Highly toxic solvents include most of the aromatic and chlorinated hydrocarbons (such as toluene, xylene, styrene, methylene chloride, ethylene dichloride, perchloroethylene), as well as solvents such as methyl butyl ketone and n-hexane.

7. Most solvents can be classified as moderately toxic, including most ketones, esters, alcohols, and petroleum distillates. Acetone, isopropyl alcohol, and ethyl alcohol are slightly toxic.

8. Some solvents can be detected by odor at safe concentrations. The odor of most solvents, however, is not a reliable indication of the degree of hazard, since it cannot be detected until the concentration of the solvent in the air is above the danger level. Examples are methyl alcohol and most chlorinated hydrocarbons. Many pleasant-smelling solvents are highly toxic, such as chloroform and toluene; conversely, many solvents with unpleasant odors are much less toxic, such as acetone and most acetates.

9. With the exception of the chlorinated hydrocarbons, most organic solvents are either flammable or combustible. The flammability of a solvent is determined by its flash point, which is the lowest temperature at which a solvent gives off enough vapors to form an ignitable mixture with air. If a source of ignition is present, fire can result. In addition, most solvents can be explosive if the concentration in the air is high enough (the lower explosion limit). However, this concentration is usually many times higher than the concentration needed to cause illness. The fire and explosive properties of solvents are discussed in greater detail in Chapter 8.

10. See Table 4-4 for more information on the hazards of organic solvents.

Precautions

1. Do not use extremely toxic solvents. Whenever possible, replace highly toxic solvents with less toxic solvents. To determine the safest solvents, see Table 4-4.

2. Wear appropriate gloves and goggles when handling solvents. Make sure that the type of glove you choose will protect against the particular solvent being used. Glove and goggle selection is discussed in Chapter 9.

3. Use adequate ventilation with solvents. Highly toxic solvents require local exhaust ventilation or organic vapor respirators for all but small amounts. Chapter 7 gives specific guidelines on how to ventilate your work space properly for safety.

4. Do not smoke or allow open flames when using solvents, and use proper storage and disposal procedures. Chapter 8 discusses safe storage and disposal procedures for hazardous solvents.

AEROSOL SPRAYS

Aerosol sprays, or mists as they are more accurately called, are composed of materials suspended or dissolved in a liquid that is then ejected through a small nozzle under pressure to yield very fine liquid droplets in the air. In art, aerosol sprays are used in spray painting, retouching of photographs, fixing of drawings, application of glazes and enamels, and adhesive coating. These sprays can be produced by spray guns and air brushes powered by air compressors, by aerosol spray cans powered by propellant gases under pressure, and by mouth-powered spray atomizers.

Aerosol Spray Cans

Aerosol spray cans contain organic solvents to dissolve or suspend the substance being sprayed, such as a fixative, adhesive, or lacquer. Solvents used include hexane, petroleum distillates, toluene, chlorinated hydrocarbons, and ketones. Vinyl chloride was a common propellant until it was banned in 1973 after it was discovered to cause liver cancer. Propellants used today include propane, butane, and carbon dioxide. Freons have also been banned as propellants because of their harmful effect on the upper atmosphere's ozone layer.

Hazards. The U.S. Consumer Product Safety Commission reports that there are over 5,000 injuries annually from the use of aerosol spray cans that require

emergency-room treatment. In the late 1970s, a NIOSH study showed that hair-dressers in beauty salons have a much higher rate of chronic lung diseases than the general population.

1. One hazard from aerosol spray results from the solvent mist droplets, which are fine enough to enter the lungs easily by inhalation. This is more hazardous than simply breathing in solvent vapors, since the spray mists are liquid droplets that contain much more solvent; therefore, much higher concentrations of solvents can be achieved in the lungs.

2. Although the solvent usually evaporates quickly to vapor form, it leaves behind the very fine aerosol particles of pigment, resin, or whatever else the solvent was the vehicle for. These very fine particles can remain in the air where they can be inhaled for several hours, even though no odor is detectable. The hazard depends on the particular material.

3. Other hazards associated with aerosol spray cans include explosions if the can is punctured, and freezing, blistering, and inflammation of the skin as well as eye injuries from spraying too close.

Precautions

1. Whenever possible, avoid spraying by using other techniques such as brushing or dipping.

2. Spray in a spray booth or use a spray respirator with an exhaust fan (see Chapters 7 and 9 for details on both these precautionary measures). For occasional use, use spray cans outside.

3. Be careful in directing spray can mists to avoid accidents.

Air Brushes, Spray Guns, and Atomizers

These instruments can use either organic solvents or water to suspend the substance being sprayed. Mouth atomizers do not produce as fine a spray as do the other methods.

Hazards

1. If the spray vehicle contains organic solvents, the hazards are similar to those discussed for aerosol spray cans.

2. Mouth atomizers create the additional hazard of ingestion or entry into the lungs by backup of the liquid into the mouth.

3. Compressors can present noise hazards.

4. High-pressure airless spray guns have caused severe injuries by the accidental injection of paint into fingers and hands. According to the Consumer Product Safety Commission, this has resulted in several amputations of fingers and chronic disabling scarring of the hands.

Precautions

1. See the precautions listed for aerosol spray cans.

2. Use water-based materials rather than organic solvent-based materials whenever possible.

3. Do not use mouth atomizers. For some purposes, squeeze bulb-type atomizers or plunger-type spray bottles might work.

TABLE 4-2. HAZARDS OF ACIDS

The acids are listed in order of increasing toxicity. ACGIH Threshold Limit Values (TLVs) are listed, except when the NIOSH Recommended Exposure Limits (RELs) or OSHA Permissible Exposure Limits (PELs) are lower. Unless otherwise indicated, TLVs are 8-hour time-weighted averages.

General Hazards

Most concentrated acids are highly corrosive by skin and eye contact and by ingestion. Ingestion can cause severe stomach damage and may be fatal. Diluted acids are less hazardous; repeated or prolonged skin contact can cause irritant dermatitis.

Tannic Acid (tannin)

Relative Toxicity Rating

Skin contact: slight
Inhalation: slight
Ingestion: moderate

Specific Hazards

Powder. Possible human carcinogen; slight irritant. Ingestion of large doses can cause vomiting, gastritis, pain, diarrhea, constipation, and possible liver and kidney damage. Use with care.

Ferric Chloride (iron perchloride)

Relative Toxicity Rating

Skin contact: slight
Inhalation: not significant
Ingestion: moderate

Specific Hazards

Powder. Forms small amount of hydrochloric acid in solution. Ingestion of large amounts by children could cause iron poisoning. A substitute for Dutch mordant in copper etching.

Sodium Bisulfate (sodium hydrogen sulfate, Sparex)

Relative Toxicity Rating

Skin contact: moderate
Inhalation: high
Ingestion: high

Specific Hazards

Powder. Produces strongly acidic solutions. Heating produces sulfur oxide gases, which are highly irritating by inhalation. Recommended as a substitute for sulfuric acid pickling baths.

Ammonium Bifluoride (ammonium hydrogen fluoride)

Relative Toxicity Rating TLV: 2.5 mg/m^3, as fluoride

Skin contact: moderate
Inhalation: slight
Ingestion: high

Specific Hazards

Usually available in paste form. Produces hydrofluoric acid in solution. Skin contact can cause delayed burns. Recommended as a replacement for concentrated hydrofluoric acid.

Boric Acid

Relative Toxicity Rating

Skin contact: slight
Inhalation: moderate
Ingestion: moderate to high

Specific Hazards

Powder. Absorption through burned skin, ingestion, or inhalation can cause nausea, abdominal pain, diarrhea, violent vomiting, and skin rash. Chronic poisoning may cause loss of appetite, gastroenteritis, liver and kidney damage, skin rash.

Oxalic Acid

Relative Toxicity Rating TLV: 1 mg/m^3

Skin contact: high
Inhalation: moderate
Ingestion: high

Specific Hazards

Powder. Corrosive to skin, eyes, respiratory system, and gastrointestinal system. Ingestion can also cause severe gastroenteritis and kidney damage. Sufficient skin contact can cause gangrene of extremities.

Phosphoric Acid

Relative Toxicity Rating TLV: 1 mg/m^3

Skin contact: high
Inhalation: high
Ingestion: high

Specific Hazards

See general hazards.

Hydrochloric Acid (muriatic acid)

Relative Toxicity Rating TLV-C: 7.5 mg/m^3

Skin contact: high
Inhalation: moderate
Ingestion: high

Specific Hazards

See general hazards.

Acetic Acid, Glacial

Relative Toxicity Rating TLV: 25 mg/m^3

Skin contact: high
Inhalation: high
Ingestion: high

Specific Hazards

Concentrated (glacial) acetic acid is corrosive to skin, eyes, mucous membranes, and stomach and can cause severe burns. Ingestion may be fatal. Diluted solutions (e.g., vinegar) are slightly irritating. Acetic acid vapors are eye and respiratory irritants, and chronic exposure could cause chronic bronchitis. Glacial acetic acid is combustible (flash point 103°F or 39°C).

Sulfuric Acid (oleum)

Relative Toxicity Rating TLV: 1 mg/m^3

Skin contact: high
Inhalation: high
Ingestion: high

Specific Hazards

See general hazards. Heating can release large amounts of highly toxic sulfur oxides. Chronic inhalation may cause chronic bronchitis. Replace with sodium bisulfate (Sparex) when possible.

Nitric Acid

Relative Toxicity Rating TLV: 5.2 mg/m^3

Skin contact: high
Inhalation: high
Ingestion: high

Specific Hazards

See general hazards. Metal etching and cleaning gives off nitrogen dioxide, which can cause chemical pneumonia in a large, acute exposure and emphysema from smaller, chronic exposures. It also gives off flammable hydrogen gas in small amounts.

Phenol (carbolic acid)

Relative Toxicity Rating TLV: 19 mg/m^3 (skin)

Skin contact: high
Inhalation: moderate
Ingestion: high

Specific Hazards

Major spills of liquid on skin can be fatal by rapid skin absorption. Skin absorption is more hazardous than inhalation due to its low volatility. Acute exposure can cause nervous system depression and liver, kidney, and spleen damage. Repeated exposure affects central nervous system, digestive system, liver, and kidneys. Skin contact causes severe burns. Avoid if possible.

Hydrofluoric Acid

Relative Toxicity Rating TLV-C: 2.6 mg/m^3 (as fluoride)

Skin contact: high
Inhalation: high
Ingestion: high

Specific Hazards

See general hazards. Highly corrosive by all routes of entry. May be absorbed through skin. Can cause ulceration and delayed severe, deep skin burns without immediate pain. There is a potential for systemic poisoning. An antidote and medical treatment are necessary. Vapors are highly corrosive and may cause chemical pneumonia. Chronic exposure can cause bone and teeth problems (osteofluorosis) and possibly kidney damage. Do not use. Replace with bifluoride paste.

Chromic Acid

Relative Toxicity Rating NIOSH REL: 0.001 mg/m^3; TLV: 0.05 mg/m^3 (as chromium)

Skin contact: extreme
Inhalation: extreme
Ingestion: high

Specific Hazards

Powder. Known human carcinogen. For acute reactions of solutions, see general hazards. Chronic exposure may cause lung cancer, skin and nasal ulcers, and allergic reactions. Do not use.

TABLE 4-3. HAZARDS OF ALKALIS

General Hazards

Most alkalis are highly corrosive to the skin and eyes. Ingestion of small amounts of concentrated alkaline solutions can cause severe pain and damage to the mouth and esophagus and can be fatal. Inhalation of alkali dusts can cause chemical pneumonia. Some inhalation of alkaline solutions may occur during accidental ingestion. Dilute alkaline solutions are more corrosive to the skin and eyes than dilute acid solutions.

	TLV (TWA) in mg/m^3
Calcium oxide (unslaked lime, quicklime, burnt lime)	2
Lithium oxide	—
Potassium carbonate (potash)	—
Potassium hydroxide (caustic potash)	C2
Potassium oxide	—
Sodium carbonate (soda ash)	—
Sodium hydroxide (caustic soda, lye)	C2
Sodium metasilicate	—
Sodium oxide	—
Trisodium phosphate	—

Ammonium Hydroxide (ammonia water)

Relative Toxicity Rating TLV: 25 ppm

Skin contact: high
Inhalation: high
Ingestion: moderate to high

Specific Hazards

Household ammonia is 5 to 10% ammonia; 27 to 30% concentrations are also available. Skin contact can cause first- and second-degree burns. The eyes and respiratory system are very sensitive to ammonia. High concentrations can cause chemical pneumonia. For ingestion, see general hazards. Mixing ammonia with alkalis causes release of ammonia gas; mixing with chlorine bleaches causes formation of a poison gas.

Calcium Hydroxide (slaked lime)

Relative Toxicity Rating TLV: 5 mg/m^3

Skin contact: moderate
Inhalation: not significant
Ingestion: moderate

Specific Hazards

Not as corrosive as other alkalis because of its low solubility. See general hazards.

Sodium Silicate (sodium orthosilicate)

Relative Toxicity Rating

Skin contact: moderate
Inhalation: moderate
Ingestion: moderate

Specific Hazards

In general, a skin, eye, and respiratory irritant, rather than corrosive.

TABLE 4-4. HAZARDS OF SOLVENTS

The solvents listed in each category are in order of increasing toxicity. ACGIH Threshold Limit Values (TLVs) are listed, except when the NIOSH Recommended Exposure Limits (RELs) or OSHA Permissible Exposure Limits (PELs) are lower. Unless otherwise indicated, TLVs are 8-hour time-weighted averages.

ALCOHOLS

Uses

Paint and varnish remover; lacquer, plastic, dye, shellac solvent.

General Hazards

Eye, nose, and throat irritation; mild narcotic properties.

Ethyl Alcohol (ethanol, grain alcohol, denatured alcohol)

Flash Point	Relative Toxicity Rating
55°F (13°C)	Skin contact: slight
	Inhalation: slight
TLV: 1,000 ppm	Ingestion: moderate

Specific Hazards

Acute ingestion causes intoxication. Chronic ingestion of large amounts can cause liver damage. Denatured alcohol contains methyl alcohol or other chemicals to make it poisonous.

Isopropyl Alcohol (rubbing alcohol)

Flash Point	Relative Toxicity Rating
53°F (11°C)	Skin contact: slight
	Inhalation: slight
TLV: 400 ppm	Ingestion: moderate

Specific Hazards

See general hazards. Good odor warning properties.

Benzyl Alcohol

Flash Point	Relative Toxicity Rating
200°F (93°C)	Skin contact: moderate
	Inhalation: slight
TLV: none established	Ingestion: moderate

Specific Hazards

The pure alcohol is irritating and corrosive to the skin, eyes, and respiratory system. Ingestion of large amounts causes vomiting, diarrhea, and central nervous system depression. Inhalation causes narcosis, but is unlikely due to low volatility unless heated. Reproductive toxin.

Methyl Alcohol (methanol, wood alcohol, methylated spirits)

Flash Point	Relative Toxicity Rating
52°F (11°C)	Skin contact: moderate
	Inhalation: moderate
TLV: 200 ppm	Ingestion: moderate

Specific Hazards

Skin absorption and inhalation causes narcosis, nervous system damage (especially to vision), and possible liver and kidney damage. Ingestion may cause severe metabolic derangement (acidosis), blindness, and death. Both acute and chronic effects are serious.

Isoamyl Alcohol (amyl alcohol, fusel oil)

Flash Point	Relative Toxicity Rating
109°F (43°C)	Skin contact: moderate
	Inhalation: moderate
TLV: 100 ppm	Ingestion: moderate

Specific Hazards

Severe skin and eye irritation. May be absorbed through the skin and may cause nervous system and digestive system damage. Acute ingestion and inhalation may be fatal.

Butyl Alcohols (n-butyl, isobutyl, t-butyl, sec-butyl alcohols)

Flash Point	Relative Toxicity Rating
52–84°F (11–29°C)	Skin contact: moderate
	Inhalation: moderate to high
TLV: 50–100 ppm	Ingestion: moderate

Specific Hazards

n-butyl alcohol may be absorbed through skin. Can cause eye, nose, and throat irritation and narcosis.

ALIPHATIC HYDROCARBONS

Uses

Paint and lacquer thinner, rubber solvent, metal degreasing, cleaning fluid, general solvent.

General Hazards

Primary skin irritant; eye, nose, throat, and lung irritant, and narcotic. Moderately toxic by ingestion, with fatal dose probably 4–6 ounces. However, even much smaller amounts can be fatal due to chemical pneumonia if aspiration into the lungs occurs. This is common, especially with children, during ingestion or if vomiting is induced. Chronic inhalation is implicated in brain damage. Boiling point range and flash point are often more important in determining hazard than name.

Heptane

Flash Point	Boiling Point	Relative Toxicity Rating
25°F (-4°C)	208°F (98°C)	Skin contact: slight
		Inhalation: moderate
TLV: 400 ppm (NIOSH REL 85 ppm)		Ingestion: moderate

Specific Hazards

Least toxic aliphatic hydrocarbon. Good odor warning. Possible substitute for n-hexane.

Petroleum Distillates (petroleum spirits, petroleum benzin, petroleum ether, naphtha, benzine, lactol spirits)

Flash Point	Boiling Point	Relative Toxicity Rating
-70° to -50°F	86–140°F	Skin contact: moderate
(-57° to -46°C)	(30–60°C)	Inhalation: moderate
TLV: none established		Ingestion: moderate

Specific Hazards

See general hazards. If it contains n-hexane (boiling point 156°F), it may cause nerve damage. Ingestion not likely to result in chemical pneumonia due to volatility. Extremely flammable.

VM&P Naphtha (benzine, ligroin, high-boiling petroleum ether)

Flash Point	Boiling Point	Relative Toxicity Rating
20–55°F	205–320°F	Skin contact: moderate
(-7 to 13°C)	(95–160°C)	Inhalation: moderate
TLV: 300 ppm		Ingestion: moderate

Specific Hazards

See general hazards. Flammable.

Mineral Spirits (paint thinner, white spirits, substitute turpentine, turpenoid, odorless paint thinner, Stoddard solvent)

Flash Point	Boiling Point	Relative Toxicity Rating
86–105°F	302–392°F	Skin contact: moderate
(30–40°C)	(150–200°C)	Inhalation: moderate
TLV: 100 ppm		Ingestion: moderate

Specific Hazards

See general hazards. Mineral spirits often have about 15% aromatic hydrocarbons as contaminants; odorless paint thinner and turpenoids have the aromatics removed and are less toxic. Stoddard solvent flash points are a minimum of 100°F (380°C) and can be much higher.

Kerosene (#1 fuel oil)

Flash Point	Boiling Point	Relative Toxicity Rating
100–165°F	347–617°F	Skin contact: moderate
(38–74°C)	(175–325°C)	Inhalation: moderate
TLV: none established		Ingestion: moderate

Specific Hazards

See general hazards. Kerosene is more irritating to skin, eyes, and respiratory system than mineral spirits.

n-Hexane

Flash Point	Boiling Point	Relative Toxicity Rating
-7°F (-22°C)	156°F (69°C)	Skin contact: slight
		Inhalation: high
TLV: 50 ppm		Ingestion: moderate

Specific Hazards

Most toxic aliphatic hydrocarbon. Chronic inhalation can cause peripheral neuropathy (numbness and weakness in hands, arms, legs, feet) and possible central nervous system damage. Ingestion not likely to result in chemical pneumonia due to volatility. Extremely flammable. Avoid if possible.

Gasoline (petrol)

Flash Point	Boiling Point	Relative Toxicity Rating
-50°F (-46°C)	100–400°F	Skin contact: extreme
	(38–205°C)	Inhalation: extreme
TLV: 300 ppm		Ingestion: moderate

Specific Hazards

Unleaded gasoline contains the known human carcinogen benzene and the probable human carcinogen ethylene dibromide. Leaded gasoline contains tetraethyl lead, which can be absorbed through the skin. Extremely flammable. See also general hazards. Do not use.

AROMATIC HYDROCARBONS

Uses

Paint and varnish remover; lacquer, ink, and plastics solvent.

General Hazards

Strong narcotic properties; skin irritation and absorption. More toxic than aliphatic hydrocarbons by ingestion. Aspiration into lungs (e.g., by inducing vomiting after ingestion) may cause chemical pneumonia. Good odor-warning properties. Chronic inhalation has been implicated in brain damage and menstrual irregularities in women.

Xylene (xylol, aromatic naphtha)

Flash Point

Relative Toxicity Rating

81°F (27°C)

Skin contact: moderate
Inhalation: high

TLV: 100 ppm

Ingestion: high

Specific Hazards

Similar to, but possibly more toxic than, toluene.

Toluene (toluol, aromatic naphtha)

Flash Point

Relative Toxicity Rating

40°F (4°C)

Skin contact: moderate
Inhalation: high

TLV: 50 ppm (proposed 1991)

Ingestion: high

Specific Hazards

Causes skin defatting. May be absorbed through skin. Can cause irritation of nose and throat, narcosis, and possible chronic liver and kidney damage. Inhalation of large amounts may cause heart sensitization and death (glue sniffer's syndrome, dementia). May cause menstrual disorders and other reproductive problems. May cause brain birth defects at high concentrations.

Styrene (vinylbenzene)

Flash Point

Relative Toxicity Rating

88°F (31°C)

Skin contact: moderate
Inhalation: high

TLV: 50 ppm

Ingestion: moderate

Specific Hazards

Probable human carcinogen and mutagen. Absorbed through skin. Causes severe skin drying and cracking. Inhalation causes narcosis; irritation to eyes, nose, and throat; nervous system damage; and possible chronic liver and blood damage.

Benzene (benzol)

Flash Point

Relative Toxicity Rating

12°F (-11°C)

Skin contact: high
Inhalation: extreme

TLV: 0.1 ppm (proposed 1991–92)

Ingestion: high

Specific Hazards

Known human carcinogen. Cumulative poison by all methods of entry. May harm bone marrow, causing aplastic anemia. May cause myeloid leukemia, Hodgkin's disease, and lymphomas in humans. Mutagen. Extremely flammable. Do not use.

CHLORINATED HYDROCARBONS

Uses

Degreasing metal, cleaning fluid, plastic, and wax solvent.

General Hazards

Strong narcotic; liver and kidney damage; dermatitis; adverse effects with alcoholic beverages before or after exposure; poor odor warning. May cause chronic brain damage. Avoid whenever possible. Most chlorinated hydrocarbons are probable or possible human carcinogens. Most produce phosgene gas in the presence of heat, flames, lit cigarettes or ultraviolet radiation.

1,1,1-Trichloroethane (methyl chloroform, chlorothene)

Flash Point	Relative Toxicity Rating
Not applicable	Skin contact: slight
	Inhalation: moderate
TLV: 350 ppm (NIOSH C 350 ppm)	Ingestion: moderate

Specific Hazards

Causes skin and eye irritation, mild narcosis. May cause heart arrhythmias and death at high concentrations (e.g., enclosed spaces, "sniffing"). Chronic exposure to large amounts may cause some liver damage.

o-Dichlorobenzene (ortho-dichlorobenzene)

Flash Point	Relative Toxicity Rating
165°F (74°C)	Skin contact: moderate
	Inhalation: high
TLV-C: 50 ppm	Ingestion: high

Specific Hazards

Skin and eye irritant. Causes narcosis and possible chronic liver and kidney damage. Vapors very irritating to nose.

Methylene Chloride *(methylene dichloride, dichloromethane)*

Flash Point Relative Toxicity Rating

Not applicable Skin contact: moderate
 Inhalation: high
PEL: 25 ppm (proposed 1991) Ingestion: moderate

Specific Hazards

Probable human carcinogen. Highly volatile. Acute exposure can cause severe lung irritation and narcosis. Breaks down in the body to form carbon monoxide and has caused fatal heart attacks; also causes heart arrhythmias. Causes dermatitis. Avoid if possible.

Trichloroethylene *(ethylene trichloride, trichloroethene, triclene)*

Flash Point Relative Toxicity Rating

90°F (32°C) Skin contact: high
 Inhalation: high
TLV: 50 ppm (NIOSH REL 25 ppm) Ingestion: moderate

Specific Hazards

Probable human carcinogen, mutagen, and developmental toxicant. Absorbed through skin. May cause dermatitis, nerve damage, liver and kidney damage. High concentrations can cause heart arrhythmias. Avoid if possible.

Perchloroethylene *(tetrachloroethylene)*

Flash Point Relative Toxicity Rating

Not applicable Skin contact: high
 Inhalation: high
TLV: 50 ppm (1989 PEL: 25 ppm) Ingestion: moderate

Specific Hazards

Probable human carcinogen. Causes dermatitis, and can be absorbed through skin; causes eye irritation. Inhalation can cause narcosis, liver and kidney damage, possible behavioral effects, and flushed face and neck (especially with alcohol). Avoid if possible.

Chloroform

Flash Point Relative Toxicity Rating

Not applicable Skin contact: high
 Inhalation: high
NIOSH ST: 2 ppm Ingestion: moderate

Specific Hazards

Probable human carcinogen. Toxicity similar to, but somewhat less than that of carbon tetrachloride, except it is a more powerful narcotic. Do not use.

Ethylene Dichloride (1,2-dichloroethane)

Flash Point	Relative Toxicity Rating
56°F (13°C)	Skin contact: high
	Inhalation: high
NIOSH REL: 1 ppm	Ingestion: high

Specific Hazards

Probable human carcinogen and mutagen. May be absorbed through skin. Acute exposure causes severe narcosis and respiratory irritation. Chronic exposure will cause kidney and liver damage. Avoid if possible.

Carbon Tetrachloride (carbon tet)

Flash Point	Relative Toxicity Rating
Not applicable	Skin contact: extreme
	Inhalation: extreme
NIOSH ST: 2 ppm	Ingestion: high

Specific Hazards

Probable human carcinogen. Absorbed through skin; causes severe liver and kidney damage even in small amounts, especially in combination with drinking alcohol. Larger exposures are frequently fatal. Do not use.

Tetrachloroethane (acetylene tetrachloride)

Flash Point	Relative Toxicity Rating
Not applicable	Skin contact: extreme
	Inhalation: extreme
TLV: 1 ppm	Ingestion: high to extreme

Specific Hazards

Probable human carcinogen. Absorbed through skin; causes severe liver, kidney, gastrointestinal, nervous system, and blood damage; often fatal. Do not use.

ESTERS

Uses

Lacquer and plastic solvent.

General Hazards

Skin, eye, nose, and throat irritant; some narcotic effects; good odor-warning properties.

Ethyl Acetate

Flash Point

24°F (-5°C)

TLV: 400 ppm

Relative Toxicity Rating

Skin contact: slight
Inhalation: moderate
Ingestion: moderate

Specific Hazards

Least toxic acetate. See general hazards.

Butyl Acetate (n-butyl acetate)

Flash Point

72°F (22°C)

TLV: 150 ppm

Relative Toxicity Rating

Skin contact: slight
Inhalation: moderate
Ingestion: moderate

Specific Hazards

See general hazards.

Amyl Acetates (n-amyl acetate, isoamyl acetate—banana oil, sec-amyl acetate)

Flash Point

77–89°F (25–32°C)

TLV: 100-125 ppm

Relative Toxicity Rating

Skin contact: moderate
Inhalation: moderate
Ingestion: moderate

Specific Hazards

Most toxic of the acetates (see general hazards).

GLYCOLS, GLYCOL ETHERS, AND DERIVATIVES

Uses

Solvent for resins, lacquers, inks, paints, varnishes, and dyes.

General Hazards

Can cause poisoning by skin absorption, ingestion, and sometimes inhalation; eye irritant. Causes narcosis, kidney damage, and sometimes anemia. Several glycol ethers can cause testicular atrophy, sterility, miscarriages, and birth defects. Odor-warning properties are unreliable.

Propylene Glycol (1,2-propanediol)

Flash Point

210°F (99°C)

TLV: none established

Relative Toxicity Rating

Skin contact: slight
Inhalation: slight
Ingestion: slight

Specific Hazards

Slight skin and eye irritation. Least toxic glycol.

Triethylene Glycol (triglycol)

Flash Point

350°F (177°C)

TLV: none established

Relative Toxicity Rating

Skin contact: slight
Inhalation: slight
Ingestion: slight

Specific Hazards

Slight skin and eye irritation. Slightly toxic by ingestion.

Ethylene Glycol (glycol, 1,2-ethanediol)

Flash Point

241°F (116°C)

TLV-C: 50 ppm (for mist)

Relative Toxicity Rating

Skin contact: moderate
Inhalation: slight
Ingestion: moderate

Specific Hazards

Ingestion is the most serious problem: 3 ounces (100 ml) can be fatal in adults, affecting kidneys and central nervous system. Chronic ingestion affects kidneys and possibly liver. Low volatility unless heated. Probable developmental toxicant.

Diethylene Glycol

Flash Point

255°F (124°C)

TLV: 50 ppm (American Industrial Hygiene Association)

Relative Toxicity Rating

Skin contact: moderate
Inhalation: slight
Ingestion: moderate

Specific Hazards

Similar to ethylene glycol. Lethal oral dose for adults about 70 ml.

88

Ethoxydiglycol (diethylene glycol ethyl ether, 2-(2-ethoxyethyl)ethanol, carbitol)

Flash Point

201°F (94°C)

TLV: none established

Relative Toxicity Rating

Skin contact: slight
Inhalation: slight
Ingestion: moderate

Specific Hazards

Probable human developmental toxicant. Causes eye irritation and mild skin irritation. May be absorbed through skin. Similar to ethylene glycol. Causes low birth weight in animals. Not appreciably volatile unless heated.

Butyl Cellosolve (ethylene glycol monobutyl ether, 2-butoxy ether)

Flash Point

143°F (62°C)

TLV: 25 ppm (NIOSH REL 5 ppm)

Relative Toxicity Rating

Skin contact: high
Inhalation: high
Ingestion: high

Specific Hazards

Skin absorption more serious than inhalation. Causes anemia, liver and kidney damage, and behavioral problems. Not quite as toxic as methyl cellosolve. Studies have not shown reproductive problems. Avoid if possible.

Cellosolve (ethylene glycol monoethyl ether, 2-ethoxy ethanol)

Flash Point

110°F (43°C)

TLV: 5 ppm

Relative Toxicity Rating

Skin contact: high
Inhalation: high
Ingestion: moderate

Specific Hazards

Known human developmental toxicant. Slight skin and eye irritation. Skin absorption especially, inhalation, or ingestion can cause severe reproductive effects (testicular atrophy and lowered sperm counts in men, birth defects and miscarriages in female animals), kidney damage, anemia, and behavioral changes. Inhalation can cause narcosis and pulmonary edema. Do not use.

Cellosolve Acetate (ethylene glycol monoethyl ether acetate, 2-ethoxyethyl acetate)

Flash Point

124°F (51°C)

TLV: 5 ppm

Relative Toxicity Rating

Skin contact: high
Inhalation: high
Ingestion: moderate

Specific Hazards

More irritating than cellosolve. Otherwise similar. Do not use.

Methyl Cellosolve (ethylene glycol monomethyl ether, 2-methoxy ethanol)

Flash Point	Relative Toxicity Rating
102°F (39°C)	Skin contact: high
	Inhalation: high
TLV: 5 ppm	Ingestion: moderate

Specific Hazards

Similar to but more toxic than Cellosolve. Do not use.

Methyl Cellosolve Acetate (ethylene glycol monomethyl ether acetate)

Flash Point	Relative Toxicity Rating
120°F (49°C)	Skin contact: high
	Inhalation: high
TLV: 5 ppm	Ingestion: moderate

Specific Hazards

More irritating than methyl cellosolve. Other health effects similar. Do not use.

KETONES

Uses

Paint and varnish remover, lacquer and plastic solvent.

General Hazards

Skin, eye, nose, and throat irritation; narcosis in large amounts; good odor-warning properties; ingestion causes vomiting, nausea, abdominal pain.

Acetone

Flash Point	Relative Toxicity Rating
0°F (-18°C)	Skin contact: slight
	Inhalation: slight
TLV: 750 ppm	Ingestion: moderate
(NIOSH REL 250 ppm)	

Specific Hazards

Least toxic ketone. Vapors can cause narcosis at high levels. Extremely flammable. See general hazards.

Methyl Ethyl Ketone (MEK, 2-butanone)

Flash Point

16°F (-9°C)

TLV: 200 ppm

Relative Toxicity Rating

Skin contact: moderate
Inhalation: moderate
Ingestion: moderate

Specific Hazards

Synergistic with n-hexane and methyl butyl ketone, causing peripheral neuropathy sooner and at lower concentrations than n-hexane and MBK alone. Dermatitis common on repeated exposures. See general hazards.

Methyl Isobutyl Ketone (MIBK, hexone)

Flash Point

64°F (18°C)

TLV: 50 ppm

Relative Toxicity Rating

Skin contact: moderate
Inhalation: high
Ingestion: moderate

Specific Hazards

Absorbed through skin. Very objectionable odor. May also be synergistic with n-hexane and methyl butyl ketone. See general hazards.

Cyclohexanone

Flash Point

146°F (63°C)

TLV: 25 ppm

Relative Toxicity Rating

Skin contact: moderate
Inhalation: high
Ingestion: slight

Specific Hazards

Absorbed through skin. May cause skin, eye, nose, and throat irritation and some narcosis at high levels. Chronic exposure may cause liver and kidney damage.

Isophorone (3,5,5-trimethyl-2-cyclohexene-1-one)

Flash Point

184°F (84°C)

NIOSH REL: 4 ppm

Relative Toxicity Rating

Skin contact: moderate
Inhalation: high
Ingestion: unknown

Specific Hazards

Causes severe narcosis and eye, nose, and throat irritation. Also may cause chemical pneumonia and chronic kidney damage. Avoid if possible.

Methyl Butyl Ketone (MBK, 2-hexanone)

Flash Point	Relative Toxicity Rating
77°F (25°C)	Skin contact: high
	Inhalation: extreme
TLV: 5 ppm (NIOSH REL 1 ppm)	Ingestion: moderate

Specific Hazards

May be absorbed through the skin. Chronic absorption by all routes of entry may cause neuropathy (loss of sensation, weakness, loss of coordination, and sometimes paralysis of arms and legs) and possible central nervous system damage. Do not use.

MISCELLANEOUS SOLVENTS

Freon 113 (trichlorofluoroethane)

Flash Point	Relative Toxicity Rating
Not applicable	Skin contact: slight
	Inhalation: slight
TLV: 1000 ppm	Ingestion: not applicable

Specific Hazards

Gas used as aerosol propellant. May cause narcosis and heart arrhythmias at high concentrations. Slight respiratory irritation. Emits phosgene gas when exposed to heat, flame, lit cigarettes.

Lithotine (dipentene, d-limonene, citrus solvent)

Flash Point	Relative Toxicity Rating
118°F (48°C)	Skin contact: moderate
	Inhalation: moderate
TLV: none established	Ingestion: slight to moderate

Specific Hazards

Possible carcinogen. D-limonene and citrus solvents are often sold as nontoxic solvents and have low oral toxicity. They are skin and eye irritants. Beware attractive citrus odor of d-limonene or citrus solvents around children. Solvent-soaked rags are a spontaneous combustion hazard.

Cyclohexane

Flash Point	Relative Toxicity Rating
0°F (-18°C)	Skin contact: moderate
	Inhalation: moderate
TLV: 300 ppm	Ingestion: moderate

Specific Hazards

Skin, eye, nose, and throat irritant. Acute exposure may cause some narcosis.

Turpentine (gum turpentine, gum spirits, spirits of turpentine, wood turpentine, steam-distilled turpentine)

Flash Point

Relative Toxicity Rating

95°F (35°C)

Skin contact: moderate
Inhalation: moderate
TLV: 100 ppm

Ingestion: moderate

Specific Hazards

Absorbed through skin. Causes skin irritation and allergies, sometimes after years of exposure. Vapors are irritating to eyes, nose, and throat. Wood and steam-distilled turpentine are more irritating than gum turpentine. Chronic exposure can cause kidney damage. Ingestion of one-half ounce can be fatal to children. Accidental aspiration into lungs during ingestion is common and can cause fatal chemical pneumonia; also occurs if vomiting is induced after ingestion. Odorless paint thinner or turpenoid are recommended substitutes. Solvent-soaked rags are a spontaneous combustion hazard.

Morpholine

Flash Point

Relative Toxicity Rating

98°F (37°C)

Skin contact: moderate
Inhalation: high
TLV: 20 ppm

Ingestion: high

Specific Hazards

Absorbed through skin. Strongly alkaline. Causes eye, nose, and throat irritation. Possible chronic liver and kidney damage.

Cutting oils

Flash Point

Relative Toxicity Rating

Not applicable

Skin contact: moderate/high
Inhalation: moderate/high
TLV: none established

Ingestion: slight

Specific Hazards

Some types are known human carcinogens. May cause dermatitis, especially acne-like reactions. May cause skin cancer and other forms of cancer due to presence of nitrosamines in many varieties. Inhalation of dense mists may cause lipoid pneumonia.

Tetrahydrofuran (THF)

Flash Point

6°F (-14°C)

TLV: 200 ppm

Relative Toxicity Rating

Skin contact: moderate
Inhalation: moderate
Ingestion: high

Specific Hazards

Eye, nose, throat irritant; narcosis. Extremely flammable. Forms explosive peroxides in contact with air. Do not use.

Ethyl Ether (ether, diethyl ether)

Flash Point

-49°F (-45°C)

TLV: 400 ppm

Relative Toxicity Rating

Skin contact: slight
Inhalation: moderate
Ingestion: moderate

Specific Hazards

Powerful narcotic agent and anesthetic. Extremely flammable. Forms explosive peroxides in contact with air. Do not use.

Dioxane

Flash Point

55°F (13°C)

TLV: 25 ppm
 (NIOSH REL 1 ppm C)

Relative Toxicity Rating

Skin contact: high
Inhalation: high
Ingestion: moderate

Specific Hazards

Probable human carcinogen. Absorbed through skin; eye, nose, and throat irritant. Acute exposure may cause narcosis and liver and kidney damage. Some fatalities from chronic kidney damage. Causes cancer in animals. Forms explosive peroxides in contact with air. Avoid if possible.

Dimethyl Formamide (DMF)

Flash Point

136°F (58°C)

TLV: 10 ppm (skin)

Relative Toxicity Rating

Skin contact: high
Inhalation: high
Ingestion: moderate

Specific Hazards

Probable human carcinogen. May cause testicular cancer in humans. Absorbed through skin. Can cause narcosis, severe liver damage, kidney damage, high blood pressure, dermatitis. Avoid if possible.

Carbon Disulfide (carbon bisulfide)

Flash Point

-22°F (-30°C)

NIOSH REL: 1 ppm

Relative Toxicity Rating

Skin contact: extreme
Inhalation: extreme
Ingestion: moderate to high

Specific Hazards

Can be absorbed through skin. Acute exposure may cause very strong narcosis, nerve damage, psychosis, and frequently death. Chronic exposure causes central and peripheral nervous system damage and affects blood, liver, heart, and kidneys. Chronic exposure may also be fatal. Also affects reproductive system. Poor odor warning. Do not use.

REFERENCES

American Conference of Governmental Industrial Hygienists. (1986). *Documentation of the Threshold Limit Values for Substances in Workroom Air*. 5th ed. Cincinnati: ACGIH.

American Conference of Governmental Industrial Hygienists. (1990). *Threshold Limit Values for Chemical Substances and Physical Agents in the Workroom Environment*. Cincinnati: ACGIH.

Gosselin, R., Smith, R., and Hodge, H. (1987). *Clinical Toxicology of Commercial Products*. 6th ed. Baltimore: Williams and Wilkins.

Hawley, G. (ed.). (1987). *The Condensed Chemical Dictionary*. 11th ed. New York: Van Nostrand Reinhold.

Industrial Hygiene Subcommittee, Alliance of American Insurers. (1986). *Handbook of Organic Industrial Solvents*. 6th ed. Chicago: Alliance of American Insurers.

International Labor Office. (1983) *Encyclopedia of Occupational Safety and Health*. 2 vols. 3d ed. Geneva, Switzerland: ILO.

Lewis, R. (1991). *Carcinogenically Active Chemicals: A Reference Guide*. New York: Van Nostrand Reinhold.

National Institute of Occupational Safety and Health. *Criteria for Recommended Standards: Occupational Exposure to [various chemicals].*

New Jersey Hazardous Substance Fact Sheets on [various chemicals]. Trenton: New Jersey State Department of Health.

Patty, F. (ed). (1982). *Industrial Hygiene and Toxicology.* Vol II, 3 parts. 3rd ed. New York: Interscience Publishers.

Stellman, J., and Daum, S. (1973). *Work Is Dangerous to Your Health.* New York: Vintage.

5

Which Art Materials Can Hurt You: Dusts and Fumes

Dusts are light, solid particles that are produced by the use of art materials such as stone, glazes, dyes, pigments, wood, asbestos, silica, metals, and metallic compounds. Although some dusts (or solids) can cause irritant or allergic dermatitis, or can be poisonous if ingested, the most common hazards of dusts are due to inhalation. Inhalation of dusts primarily affects the lungs, although many can be absorbed into the body and affect other organs as well.

Particle size is an important factor in determining the effects of dusts. Large dust particles (greater than 5 microns, about 1/5000 of an inch) are likely to be trapped by the defenses of the upper respiratory system and either spit out or swallowed. In the latter case, poisoning can occur if the dust is toxic by ingestion (e.g., lead and other metals).

Dusts with a diameter less than 5 microns can penetrate to the air sacs of the lungs, where they can cause the most serious damage. With high dust concentrations that can overload the respiratory system defenses, however, even large dust particles may cause damage to the lung airways, even if they do not penetrate to the air sacs. The amount of dust inhaled, the nature of the dust, smoking habits, and respiratory infections are all factors determining the seriousness of the hazards.

▰▰▰ MINERAL DUSTS

Mineral dusts are a by-product of stone carving and ceramics and are used by artists and craftspeople as plastics resin fillers and abrasives. Of special concern are minerals that contain silica, asbestos, and man-made mineral fibers (MMMFs) such as fiberglass, mineral wood, and ceramic fibers. Other minerals used by artists include carbon pigments such as those found in paints and inks; carborundum (silicon carbide) abrasives used in sculpture, stone carving, and polishing; coal, limestone, and marble for carving; and graphite as a mold release. Metal-containing minerals are discussed later in the chapter.

The major categories of lung diseases caused by mineral dusts are the pneumoconioses ("dusty lung" diseases) and cancer, as well as bronchitis.

The pneumoconioses are a group of diseases in which the dust causes lung tissues to react. In some cases the lung reaction is minor and no serious inflammation or scarring occurs. (Examples of nonmineral dusts causing this type of benign pneumoconiosis are iron oxide, tin oxide, and barium sulfate.)

Fibrogenic dusts, however, cause a much more serious form of pneumoconiosis that involves lung scarring. The classic examples of this are silicosis, asbestosis, and black lung. In addition, asbestos and asbestos-containing dusts can cause lung cancer and mesothelioma (cancer of the lining of the chest and abdomen). There is also growing concern about the possible carcinogenicity of man-made mineral fibers.

The hazards of silica, silicates, asbestos, and man-made mineral fibers are discussed in the following pages. Table 5-1 lists the hazards of particular minerals of interest to artists.

Silica

Silica (silicon dioxide) is one of nature's most common minerals and is used in many art processes. It comes in both crystalline and noncrystalline or amorphous forms, each with several varieties.

The most common form of crystalline silica is quartz. Agate, amethyst, chalcedony, chert, flint, onyx, and silica flour are all quartz. Other minerals containing large amounts of quartz include sandstone, granite, clays, feldspars, and slate. Other forms of crystalline silica are cristobalite and tridymite. They are produced by the conversion of quartz by geological heat processes or by kiln firings. Fused silica, a synthetic silica, was at one time thought to be amorphous, but studies show that it has very small crystals.

A natural amorphous silica is uncalcined diatomaceous earth (calcined diatomaceous earth is cristobalite). Synthetic amorphous silicas are fumed silica (cab-o-sil), and precipitated silica (silica gel, silicic acid).

Hazards

1. Crystalline silica is highly toxic by inhalation, causing silicosis, a chronic illness that occurs in two forms: an acute or rapidly developing silicosis

98

and a slower developing, progressive form. The rapidly developing silicosis occurs when workers (sandblasters, tunnel workers, abrasive soap powder manufacturers) are exposed to massive amounts of silica dust over a short period of time. Symptoms are an abrupt onset of violent coughing, severe shortness of breath, and weight loss about eight to eighteen months after exposure. This form does not show the normal x-ray pattern of slowly developing silicosis and is usually fatal within months to a few years.

Except under unusual conditions, artists and craftspeople need worry about only the slowly developing form of silicosis. After about 10 to 20 years, chest x-rays begin to show circular nodules in the lungs due to the formation of scar tissue, before symptoms develop. The first symptoms are a dry cough and increasing shortness of breath. Changes also show up in lung function tests. After a certain point the disease becomes progressive, even with the elimination of further exposure to silica dust. Emphysema, smoking, aging, and increased susceptibility to lung infections are other complicating factors. The tridymite and cristobalite forms are more toxic than the quartz form. Fused silica may also cause silicosis, but it takes larger exposures and is less serious.

2. The crystalline silicas are probable human carcinogens, according to animal studies. In addition, human epidemiological studies suggest that people with silicosis have a higher risk of lung cancer.

3. Amorphous silica is only slightly toxic by inhalation, possibly causing milder forms of pneumoconiosis at high levels of exposure.

4. The American Conference of Governmental Industrial Hygienists (ACGIH) Threshold Limit Values (TLVs) for the various forms of silica are as follows:

Form	Type	TLV (mg/m^3)
Crystalline	quartz	0.1 respirable dust*
	cristobalite	0.05 respirable dust
	tridymite	0.05 respirable dust
	tripoli	0.1 of contained respirable quartz
Amorphous	diatomaceous earth (uncalcined)	10 total dust (1989 PEL: 6)
	precipitated silica	10 total dust (1989 PEL: 6)
	fumed silica	2 respirable dust
	fused silica	0.1 respirable dust

*Respirable dust is dust that is smaller than 5 microns and is therefore inhaled deep into the lungs.

†Occupational Safety and Health Administration (OSHA) Permissible Exposure Limits (PELs) that are under court challenge.

5. For minerals containing quartz silica, the OSHA PEL for total dust is:

$$\frac{30 \text{ mg/m}^3}{2(\% \text{ SiO}^2 + 2)}$$

Precautions. Use good housekeeping measures, proper ventilation, and respiratory protection, if necessary. (See Chapters 6-9 for discussion of safe studio practices, proper ventilation, and protective equipment.)

Silicates

Silicates such as soapstone, talc, vermiculite, and clay usually contain silica bound to metals and water. Large amounts of free silica may also be found in some silicate minerals. (Asbestos, a silicate mineral, is considered separately.)

Hazards. Silicates by themselves do not cause silicosis, although if free silica is present in large amounts this can occur. In some cases, exposure to large amounts of silicates can cause diffuse or mild scarring of the lungs. Silicates are slightly toxic by inhalation.

Precautions. Use good housekeeping measures to keep dust levels down and, if possible, try to use procedures which that keep the dust wet or moist so that it cannot be inhaled. If the silicate mineral contains large amounts of free silica, see precautions in the preceding discussion of silica.

Asbestos

Asbestos is a magnesium silicate mineral that is made up of long microscopic fibers. These fibers are heat resistant, fireproof, and resistant to most chemicals—properties for which there are a multitude of uses. Since asbestos can also be made into thread and cloth, it can be used to make such articles as heat-resistant and fireproof clothing, blankets, insulation, shields, and gloves. Sprayed asbestos cement has been commonly used in many buildings. Asbestos has been used in the past in a wide variety of drywall taping and spackling compounds. As a result, asbestos is found in many homes and buildings.

Asbestos is also used in art materials as a plastics filler, in mold making for jewelry, as sheeting and blocks for insulation and fireproofing, and, in the past, as a basis for artificial pâpier-machés. In addition, asbestos or asbestos-like materials can be a contaminant in materials such as talc, French chalk, soapstone, greenstone, and serpentine.

Hazards. Asbestos is extremely toxic by inhalation due to possible asbestosis, and is a known human carcinogen by inhalation. The effect of ingestion of asbestos is unknown.

1. Steady exposure to asbestos dust over a period of years can cause asbestosis, which first appears at least 10 to 20 years after the initial exposure. As with silicosis, this is a fibrosis involving lung scarring. Again, chest x-rays can detect asbestosis before symptoms occur. Symptoms can include clubbing of fingers, shortness of breath, and sometimes chest pain. There is no early bronchitis. Later changes involve diffuse x-ray changes (unlike the nodules found in silicosis), reduced lung functions, and thickening of the pleura (the lining of the lung). Investigation of lung tissue shows the presence of asbestos bodies consisting of large numbers of asbestos fibers. (Small numbers of asbestos bodies have been found in the lungs of most city people tested, the result of ambient environmental exposure to asbestos.) Infections are a frequent complication, and even slight infections are often fatal. Cigarette smoking increases both the severity and the risk of getting asbestosis.

2. Lung cancer is also caused by asbestos exposure. This occurs to an even much greater extent among asbestos workers who also smoke cigarettes. Asbestos workers who smoke have 50 to 90 times the risk of getting lung cancer as people who neither smoke nor work with asbestos.

3. Mesothelioma, a cancer of the membrane lining of the chest (the pleura) or the abdomen (the peritoneum) used to be very rare. As a result of the increasing use of asbestos, it is becoming much more common. Relatively low or few exposures to asbestos can, in some cases, cause mesothelioma. This form of cancer is not affected by cigarette smoking.

4. Other forms of cancer that have been associated with asbestos exposure include intestinal cancer, stomach cancer, and rectal cancer.

5. The OSHA PEL for asbestos fibers is 0.2 fibers per cubic centimeter for particles longer than 5 microns. The National Institute for Occupational Safety and Health (NIOSH) Recommended Exposure Limit (REL) is 0.1 fibers per cubic centimeter.

Precautions. Do not use asbestos or asbestos-containing materials.

Man-Made Mineral Fibers

Man-made mineral fibers (MMMFs) include fiberglass (glass wool and textile wool), rock or slag wool (mineral wool), and refractory ceramic fibers. These

find wide uses in sound and heat insulation. Refractory ceramic fibers, in particular, are used in art for ceramic kiln and foundry furnace insulation.

Hazards

1. Fiberglass is moderately irritating to the skin and respiratory system. In 1987, the International Agency for Research on Cancer (IARC) found that there was inadequate evidence to conclude that fiberglass is carcinogenic in humans. A specialty type of small-diameter fiberglass is a cancer suspect, since it can cause mesothelioma in animals. Artists, however, would not be exposed to this type of fiberglass. OSHA, however, requires a cancer warning on the label and a Material Safety Data Sheet for fiberglass.

2. Mineral wool, produced by spinning or blowing molten slag or rock, was found to cause an excess of lung cancer in workers manufacturing the mineral wool. The IARC classified mineral wool as possibly carcinogenic.

3. Based on animal studies, the IARC has classified refractory ceramic fibers as possible carcinogens. Refractory ceramic fibers are also partially converted to cristobalite, one of the more toxic forms of silica, above 1,800°F (982°C).

Precautions

1. Wear gloves and other skin protection when handling fiberglass. If you are sanding it or otherwise producing airborne fibers, wear a NIOSH-approved toxic dust respirator.

2. If possible, avoid exposure to the dusts of mineral wool and refractory ceramic fibers. If you must cut it, wear a NIOSH-approved toxic dust respirator.

3. If possible, enclose refractory ceramic fibers used as kiln insulation so that the fibers cannot be released into the air.

METALS AND THEIR COMPOUNDS

Metals are elements that conduct electricity and can be shaped, welded, cast, and cut into many different forms. The properties of particular metals can be varied by mixing in other metals to form alloys. Metals and their alloys are used in art for metal casting, jewelry making, welding, brazing, soldering, and forging.

Metals can also react with other elements or combinations of elements to form metallic compounds: oxides, sulfides, chlorides, carbonates, nitrates, and other salts. In these metallic compounds, the metal is positively charged (called a cation), and the elements the metal combines with are negatively charged (called anions). These anions can affect the solubility and toxicity of metallic compounds.

These metallic compounds, particularly the oxides, are used as pigments for paints and inks and as colorants for ceramics, enameling, glass blowing, stained glass, and plastics. Metallic compounds are also used as dye mordants, photographic chemicals, and glazes.

Dusts of Metals and Their Compounds

Metallic dusts may be produced by grinding, cutting, and polishing metals or their alloys. Metallic compounds such as inorganic pigments, ceramic glazes, glassblowing chemicals, and dye mordants can be purchased in powder form.

Hazards

1. The dusts of many metals and their compounds can be hazardous if inhaled or ingested. The degree of the hazard depends to a great extent on the solubility of the metal or metallic compound in body fluids. Highly soluble toxic compounds are more dangerous because they can dissolve easily in the body and may immediately affect many internal organs. Ingested insoluble metals and their compounds are mostly excreted. Inhaled, insoluble metals and their compounds can accumulate in the lungs. With some materials—for example, cobalt and its compounds—chronic lung problems might result. Over long periods of time, small amounts of insoluble metal dusts in the lungs may dissolve and accumulate in the body to cause chronic diseases. Some metal compounds—including chromates and dichromates, arsenic, nickel, cadmium, and uranium—are known or probable human carcinogens.

2. Some metals and their compounds can cause skin irritation and allergies. Examples are compounds of chromium, nickel, cobalt, antimony, arsenic, and selenium.

3. Table 5-2 lists the hazards of metals and their compounds.

4. Table 5-3 lists the hazards of various types of anions that combine with metals.

5. The hazards of inorganic pigments are discussed in Chapter 12.

Precautions. Precautions for handling dusts of metals and their compounds include local exhaust ventilation for dust-producing processes, proper housekeeping procedures to reduce dust levels, attention to personal hygiene, and sometimes respiratory protection. These precautions are discussed in following chapters.

Metal Fumes

When metals and their alloys are heated above their melting points, some of the molten metal begins to vaporize. The amount of metal vapor produced depends on how close the temperature is to the boiling point of the metal. These metal vapors react easily with the oxygen in the air to form metal oxide fumes, which are very fine solid particles. Metal fumes are produced in soldering, welding, metal casting, jewelry making, kiln firing, and glassblowing. Metallic salts, when heated, can also produce metal oxide fumes.

Hazards

1. When many freshly produced metal fumes are inhaled, they can cause an acute disease called metal fume fever. This disease is also known by a variety of other names, including foundry shakes or ague, zinc shakes, brass chills, and Monday morning fever. Symptoms are flu-like and include headaches, dizziness, fever, chills, and muscular pains, etc. which can last 24–36 hours. Metal fume fever can be caused by a variety of metals, especially copper, zinc and their alloys (e.g., brass, bronze, galvanized metals), as well as by metals such as nickel, iron, manganese, and magnesium.

2. The fumes of some metals are even more hazardous. Inhalation of cadmium fumes, for example, can cause chemical pneumonia, and there have been deaths from inhaling the fumes of cadmium-containing metals, for example low-melting silver solders. Cadmium fumes can also cause lung cancer. Other toxic metals include lead, manganese, nickel, mercury, and antimony.

3. See Table 5-2 for more information on the hazards of particular metals and their fumes.

Precautions

1. Avoid overheating metals; this will reduce the amount of fumes produced.

2. Ventilate all metal-melting processes such as soldering, welding, and metal casting directly to the outside. If this is not sufficient, use respiratory protection. See succeeding chapters for more information on precautions.

DYES AND ORGANIC PIGMENTS

Dyes and organic pigments are organic molecules containing chemical groupings that absorb certain wavelengths of light or color but not others. Although both dyes and pigments are used to color materials, dyes actually bind or become attached to the material being colored (such as dying paper or cloth), but pigments must be held in place by a binder (pigment in oil paint must be attached to a binder before it will adhere to a surface).

Dyes

Dyes can be either natural or synthetic, although today most dyes used are synthetic. The terms *aniline dyes* or *coal tar dyes* are often used interchangeably with the term *synthetic dyes*. This is because the first synthetic dyes were made from aniline, a chemical that was produced from coal tar. Today, most dyes are made from petrochemicals and are synthetic.

Dyes are classified into categories depending on how the dye is applied. Dye classes used by artists include acid dyes, azoic dyes, basic dyes, direct dyes, disperse dyes, fiber-reactive dyes, mordant dyes, and vat dyes. Union or all-purpose dyes commonly sold in supermarkets are mixtures of several classes of dyes so that they can dye any type of fabric.

Hazards. Unfortunately, most dyes, including natural dyes, have not been adequately investigated as to potential hazards, particularly regarding their cancer-causing properties. The hazards of dyes are discussed in detail in Chapter 21. Use all dyes with caution, since their long-term hazards are unknown.

Organic Pigments

Some traditional pigments such as rose madder are based on animal or plant materials. In the twentieth century, however, as with dyes, a large number of synthetic organic pigments—so-called because they are manufactured in a chemical laboratory—have come into use. One problem with both the natural and synthetic organic pigments is that in most cases adequate research has not been done to determine long-term effects on the body.

Hazards. As with dyes, the hazards of most organic pigments have not been adequately investigated. There is concern about the possible cancer-causing properties of many of these materials as well as concern about the presence of toxic impurities. Table 12-1 in Chapter 12 lists the known hazards of some of these organic pigments.

Precautions. Handle organic pigments with caution, since their long-term effects are not well-studied.

BIOLOGICAL DUSTS

Biological dusts that concern us are of two basic types: molds, bacteria, and fungi, which may contaminate art materials, such as clays, yarns, woods, and water-based paints; and dusts created by grinding, carving, or otherwise processing biological materials such as plant fibers, animal fibers, wood, bones, antlers, horn, and shells.

Hazards

1. Molds present in many materials can cause respiratory and skin allergies and, in some cases, hypersensitivity pneumonia. Examples of the latter include joiner's disease caused by moldy sawdust, weaver's cough from moldy yarn or cotton, and sequoisis from redwood sawdust.

2. Anthrax spores (which can't be seen) from yarns, wool, hair, bone, or antlers imported from countries in which anthrax is present in animals may cause anthrax in humans. There are two types of anthrax: a frequently fatal inhalation form (wool-sorters' disease), and a skin form. In 1976, a California weaver died from the inhalation form of anthrax.

3. Wood dusts can cause a variety of illnesses, including skin irritation, respiratory irritation, allergies such as asthma, hypersensitivity pneumonia, and some systemic poisoning. This is particularly true of tropical woods. In addition, hardwood dust can cause nasal and nasal sinus cancer. This cancer has a latent period (time since first exposure) of 40 to 45 years. The hazards of woods are discussed in detail in Chapter 17.

4. Plant fibers; bone, antler, and horn dusts; and shell dusts may cause respiratory irritation and allergies and are usually slightly toxic by inhalation.

5. Cotton, flax, and hemp dusts are highly toxic by inhalation. Chronic exposure can cause brown lung or byssinosis, particularly in people exposed to raw cotton. This disease resembles chronic bronchitis and emphysema in its later, irreversible stages. Artists are not likely to have a high enough exposure to cause brown lung.

6. Ivory and mother-of-pearl dusts are moderately toxic by inhalation. Ivory dust causes an increased susceptibility to pneumonia; mother-of-pearl

dust can cause a pneumonia-like disease and, especially in young people, ossification and inflammation of the tissue covering the bones.

Precautions

1. Use good housekeeping, local exhaust ventilation for grinding, and techniques for keeping dusts damp or wet to minimize dust levels in the air.
2. Decontaminate materials that could be contaminated with anthrax spores—preferably before purchase.
3. Refer to Chapters 6-9 for more detailed precautions.

TABLE 5-1.	Hazards of Minerals

Uses

Ceramics, glassblowing, stone carving, abrasives, plastics fillers, etc.

General Hazards

Mostly an inhalation hazard. Major concerns are silica and asbestos-containing minerals.
 ACGIH Threshold Limit Values (TLVs) are listed, except when the NIOSH Recommended Exposure Limits (RELs) or OSHA Permissible Exposure Limits (PELs) are lower. Unless otherwise indicated, TLVs are 8-hour time-weighted averages. The TLVs are listed in mg/m^3, in terms of total dust, unless otherwise indicated. TLVs marked with an asterisk (*) do not apply if there is more than 1% quartz. Instead, use the formula for minerals containing silica (see page 100).

African Wonderstone (pyrophyllite, aluminum, silica)

Specific Hazards

Unknown, except for silica (see Silica).

Agate (see Silica)

Alabaster (calcium sulfate)

Relative Toxicity Rating TLV: 10 mg/m^3*

Skin contact: slight
Inhalation: slight
Ingestion: slight

Specific Hazards

May cause eye and some respiratory irritation. Ingestion may cause obstruction due to hardening in stomach.

Albany Slip (see Clays)

Amber (fossil resin)

Specific Hazards

No significant hazards

Amethyst (quartz, silica; see Silica)

Asbestine (see Talc)

Asbestos

Relative Toxicity Rating PEL: 0.2 fibers/cc (OSHA), 0.1 fibers/cc (NIOSH)

Skin contact: slight
Inhalation: extreme
Ingestion: unknown

Specific Hazards

Known human carcinogen. Skin contact may cause asbestos corns. Chronic inhalation may cause asbestosis (a form of lung fibrosis), lung cancer, mesothelioma, and stomach and intestinal cancer. Ingestion of asbestos is also suspect as a cause of cancer. (See also the text of this chapter). Do not use.

Azurite (malachite, basic copper carbonate; see Copper Compounds in Table 5-2)

Ball Clay (see Clays)

Bentonite (see Clays)

Bone Ash (calcium phosphate)

Relative Toxicity Rating

Skin contact: slight
Inhalation: slight
Ingestion: slight

Specific Hazards

Skin contact, inhalation, or ingestion may cause irritation of skin, eyes, nose, throat, or gastric system.

Calcite (chalk, calcium carbonate) TLV: 10 mg/m^3 *

No significant hazards.

Carbon Black (carbon)

Relative Toxicity Rating TLV: 3.5 mg/m^3

Skin contact: slight
Inhalation: slight
Ingestion: not significant

Specific Hazards

Possible human carcinogen. Large overexposure may cause cough with phlegm; chronic inhalation of large amounts may cause some lung scarring. May be contaminated with polycyclic aromatic hydrocarbons (known human carcinogens), but they appear to be tightly bound to the carbon.

Carborundum (silicon carbide)

Relative Toxicity Rating TLV: 10 mg/m^3*

Skin contact: not significant
Inhalation: slight
Ingestion: not significant

Specific Hazards

Heavy, chronic exposure may cause pneumoconiosis.

Cerium Oxide (ceric oxide)

Relative Toxicity Rating

Skin contact: slight
Inhalation: moderate
Ingestion: moderate

Specific Hazards

Dust particles may cause corneal damage. Chronic inhalation may cause some lung scarring.

Cerrusite (lead carbonate; see Lead compounds in Table 5-2)

Chalcedony (agate; see Silica)

China Clay (see Clays)

Chromite (iron chromate; see Chromium (VI) Compounds in Table 5-2))

Clays (hydrated aluminum silicates, usually containing large amounts of free silica)

Relative Toxicity Rating

Skin contact: slight
Inhalation: high
Ingestion: not significant

Specific Hazards

Skin contact with wet clay may cause skin drying and irritation. Chronic inhalation can cause silicosis, a disease involving severe lung scarring. See also Silica.

Coal

Relative Toxicity Rating TLV: 2 mg/m^3 respirable dust (<5% silica)

Skin contact: not significant
Inhalation: high
Ingestion: not significant

Specific Hazards

Chronic inhalation of soft coal (bituminous) may cause black lung, a disease with symptoms similar to chronic bronchitis and emphysema.

Colemanite (hydrated calcium borate; see Boron Compounds in Table 5-2)

Cornish Stone (feldspar containing some sodium aluminum fluoride and silica; see Cryolite)

Corundum (aluminum oxide)

Relative Toxicity Rating TLV: 10 mg/m^3 (as aluminum)*

Skin contact: not significant
Inhalation: moderate
Ingestion: not significant

Specific Hazards

Chronic inhalation of large amounts may cause some lung scarring and emphysema; cause is not certain.

Crocus Martis (iron sulfate; see Iron Compounds in Table 5-2)

Cryolite (sodium aluminum fluoride)

Relative Toxicity Rating

Skin contact: moderate
Inhalation: high
Ingestion: slight

Specific Hazards

Acute inhalation of dusts may cause lung irritation; acute ingestion may cause gastric, intestinal, circulatory, and nervous system problems and skin rashes. Chronic inhalation may cause loss of weight and appetite, anemia, dental and bone defects, and silicosis if silica content is significant. Gives off highly toxic fluorine gas during kiln firing.

Cullet (powdered glass)

Relative Toxicity Rating

Skin contact: slight
Inhalation: slight
Ingestion: moderate

Specific Hazards

Powdered glass is an irritant to skin, eyes, nose, throat, and gastrointestinal system.

Diabase (complex mineral that may contain silica; see Silica)

Diamond Dust (carbon)

No significant hazards.

Dolomite (calcium magnesium carbonate)

No significant hazards, although dolomite food supplement pills have been found contaminated with lead and arsenic.

Erionite (crystalline, fibrous zeolite)

Relative Toxicity Rating

Skin contact: slight
Inhalation: extreme
Ingestion: unknown

Specific Hazards

Known human carcinogen. Chronic inhalation may cause mesothelioma.

Feldspars (combination of silica, alumina, alkali oxides, and other metal compounds)

Relative Toxicity Rating

Skin contact: slight
Inhalation: high
Ingestion: no significant hazards

Specific Hazards

Chronic inhalation may cause silicosis due to the presence of substantial amounts of free silica. May contain irritating sodium oxide (soda spars), potassium oxide (potash spars), and calcium oxide (lime spars) in insoluble form. See also Silica.

Fire Clays (see Clays)

Flint (silica; see Silica)

Fluorspar (calcium fluoride)

Relative Toxicity Rating

Skin contact: moderate
Inhalation: high
Ingestion: moderate

Specific Hazards

Skin irritant. Acute inhalation may cause lung irritation; acute ingestion may cause gastric, intestinal, circulatory, and nervous system problems. Chronic inhalation or ingestion may cause loss of weight and appetite, anemia, and bone and teeth defects. Gives off fluorine during kiln firing.

Galena (lead sulfide; see Lead Compounds in Table 5-2)

Garnet (silica; see Silica)

Granite (silica; see Silica)

Greenstone (possible silica and asbestos contamination; see Asbestos and Silica)

Grog (see Clays)

Gypsum (hydrated calcium sulfate) TLV: 10 mg/m^3 *

No significant hazards

Hematite (iron oxides)

No significant hazards.

Jade

No significant hazards.

Jaspar (high silica; see Silica)

Kaolin (see also Clays)

Relative Toxicity Rating TLV: 2 mg/m^3 (respirable dust)

Skin contact: not significant
Inhalation: slight
Ingestion: not significant

Specific Hazards

Inhalation of large quantities of kaolin may cause kaolinosis, a mild form of pneumoconiosis. If the kaolin contains more than 1% silica, see Silica.

Lapis Lazuli (contains sodium sulfide; may also contain silica)

Relative Toxicity Rating

Skin contact: slight
Inhalation: moderate
Ingestion: high

Specific Hazards

Causes skin and respiratory irritation. Ingestion may cause gastrointestinal irritation and possibly hydrogen sulfide poisoning if stomach acidity is high enough to decompose the sodium sulfide. See Silica and Sulfides in Table 5-3.

Lepidolite (free alkali and silica)

Relative Toxicity Rating

Skin contact: moderate
Inhalation: high
Ingestion: moderate

Specific Hazards

Skin contact may cause burns. Inhalation and ingestion may cause respiratory and gastrointestinal irritation. Chronic inhalation may cause silicosis.

Limestone (calcium carbonate) TLV: 10 mg/m^3 *

No significant hazards.

Litharge (lead monoxide; see Lead Compounds in Table 5-2)

Malachite (basic copper carbonate; see Copper Compounds in Table 5-2)

Marble (calcium carbonate) TLV: 10 mg/m^3*

No significant hazards.

Nepheline Syenite (see Feldspars)

Onyx (high silica; see Silica)

Opal (contains amorphous silica) TLV: 10 mg/m^3

Relative Toxicity Rating

Skin contact: not significant
Inhalation: moderate
Ingestion: not significant

Specific Hazards

Chronic inhalation of large amounts may cause some lung scarring.

Petalite (see Feldspars)

Plant Ash (free alkali)

Relative Toxicity Rating

Skin contact: moderate
Inhalation: moderate
Ingestion: high

Specific Hazards

Skin contact, inhalation, or ingestion can cause irritation and burns due to the presence of alkali.

Porphyry (may contain high silica; see Silica)

Pumice (some free silica; see Silica)

Putty (tin oxide, stannous oxide)

Relative Toxicity Rating TLV: 2 mg/m^3

Skin contact: not significant
Inhalation: slight
Ingestion: not significant

Specific Hazards

Inhalation of large amounts over several years may cause stannosis, a benign pneumoconiosis without any ill effects. It shows on lung x-rays.

Pyrolusite (manganese dioxide; see Manganese Compounds in Table 5-2)

Realgar (arsenic trisulfide; see Arsenic compounds in Table 5-2)

Rouge (iron oxides; may contain silica) PEL (total dust): $10mg/m^3$
 PEL (respirable dust): $5mg/m^3$

No significant hazards, unless the rouge contains silica. See also Silica.

Rutile (titanium oxide; see Titanium Compounds in Table 5-2)

Sandstone (free silica; see Silica)

Serpentine (may contain asbestos; see Asbestos)

Silica

Relative Toxicity Rating TLV (quartz): $0.1 \ mg/m^3$ respirable dust

Skin contact: not significant
Inhalation: high
Ingestion: not significant

Specific Hazards

Chronic inhalation may cause silicosis. See also the text of this chapter.

Silicon Carbide (see Carborundum) PEL (total dust): $10 \ mg/m^3$,
 PEL (respirable dust): $5mg/m^3$

Slate (high silica; see Silica)

Soapstone (see Talc) TLV (total dust): $6 \ mg/m^3$*
 TLV (respirable dust): $3 \ mg/m^3$

Steatite (see Talc)

Talc (hydrated magnesium silicate, asbestine, French chalk, steatite)

Relative Toxicity Rating TLV: $2 \ mg/m^3$ respirable dust (no asbestos)*

Skin contact: not significant
Inhalation: high
Ingestion: possibly high

115

Specific Hazards

Chronic inhalation of talc may cause lung scarring, silicosis if silica is present, or asbestosis, lung cancer, and mesothelioma if asbestos or asbestos-like minerals are present.

Tin Oxide (see Putty)

Travertine (Calcium carbonate)

No significant hazards

Tripoli (amorphous silica with some crystalline silica)

Relative Toxicity Rating TLV: 0.1 mg/m^3 respirable quartz

Skin contact: not significant
Inhalation: slight to high
Ingestion: not significant

Specific Hazards

Chronic inhalation of large amounts may cause some lung scarring. If much crystalline silica is present, silicosis may result.

Turquoise (copper and aluminum phosphate mineral; may contain some silica)

Relative Toxicity Rating

Skin contact: slight
Inhalation: moderate
Ingestion: moderate

Specific Hazards

May cause skin allergies and irritation of skin, eyes, nose, and throat, and possibly ulceration and perforation of nasal septum and congestion. Acute ingestion may cause gastrointestinal irritation and vomiting; chronic ingestion may cause anemia.

Vermiculite (often contains asbestos)

Relative Toxicity Rating

Skin contact: not significant
Inhalation: possibly extreme
Ingestion: possibly high

Specific Hazards

Chronic inhalation may cause asbestosis, lung cancer, and mesothelioma if asbestos is present. Ingestion is suspected in stomach and intestinal cancer.

Whiting (calcium carbonate) TLV: 10 mg/m^3*

No significant hazards

Witherite (barium carbonate; see Barium compounds in Table 5-2)

Wollastonite (calcium silicate)

Relative Toxicity Rating TLV: 10 mg/m^3*

Skin contact: slight
Inhalation: slight
Ingestion: slight

Specific Hazards

May cause some skin, eye, and respiratory irritation.

Zirconia (zirconium oxide; see Zirconium Compounds in Table 5-2)

TABLE 5-2. **Hazards of Metals and Their Compounds**

Uses

Metal casting, jewelry making, welding, brazing, soldering, and forging; pigments for paints and inks; colorants for ceramics, enameling, glassblowing, stained glass, and plastics; dye mordants, photographic chemicals, and glazes.

General Hazards

Inhalation of the fumes of many metals can cause metal fume fever or chronic poisoning. The dusts of many metals or their compounds may be hazardous by inhalation and ingestion. Some metals can cause skin irritation and allergic reactions.

 ACGIH Threshold Limit Values (TLVs) are listed, except when the NIOSH Recommended Exposure Limits (RELs) or OSHA Permissible Exposure Limits (PELs) are lower. Unless otherwise indicated, TLVs are 8-hour time-weighted averages. The TLVs are listed in mg/m^3, expressed in terms of the metal. TLVs marked with an asterisk (*) do not apply if there is more than 1% quartz.

ALUMINUM COMPOUNDS PEL (soluble salts): 2mg/m^3

Aluminum Oxide (aluminum hydrate, alumina)

Relative Toxicity Rating TLV: dust 10 mg/m^3, (welding fumes 5 mg/m^3)

Skin contact: not significant
Inhalation: moderate
Ingestion: not significant

Specific Hazards

Chronic inhalation of large amounts of aluminum oxide dust or fumes may cause some lung scarring and emphysema; cause is not certain.

ANTIMONY COMPOUNDS

Relative Toxicity Rating TLV: 0.5 mg/m^3

Skin contact: moderate
Inhalation: high
Ingestion: moderate

General Hazards

May be absorbed through skin. Similar to arsenic poisoning. Skin contact may cause severe lesions, including ulcers. Acute inhalation of fumes or dusts, or ingestion, may cause metallic taste, vomiting, diarrhea, severe irritation of mouth and nose, slow, shallow breathing, irregular heartbeat, and pulmonary congestion. Chronic exposure may cause loss of appetite and weight, nausea, headache, sleeplessness, and later liver and kidney damage. Probable cause of birth defects and miscarriages. May vaporize during kiln or glass furnace firing. Reaction with acid causes formation of poisonous stibine gas. Pentavalent compounds are less toxic than trivalent compounds. Avoid if possible.

Antimony Oxide (antimony trioxide)

Specific Hazards

Probable human carcinogen. See also general hazards. Avoid if possible.

Antimony Sulfide (antimony trisulfide)

Specific Hazards

See general hazards. Ingestion may also cause formation of hydrogen sulfide gas by reacting with stomach acid.

Lead Antimoniate (Naples yellow)

Relative Toxicity Rating PEL: 0.05 mg/m^3 (as lead)

Skin contact: moderate
Inhalation: high
Ingestion: unknown

Specific Hazards

See general hazards. Less toxic than trivalent compounds.

ARSENIC COMPOUNDS

Relative Toxicity Rating PEL: 0.01 mg/m³, NIOSH: C 0.002 mg/m³

Skin contact: high
Inhalation: extreme
Ingestion: extreme

General Hazards

Known human carcinogen, and probable mutagen and developmental toxicant. Skin contact can cause skin irritation and allergies, skin thickening and loss of skin pigmentation, ulceration, and skin cancer. Inhalation can cause respiratory irritation and skin, lung, and liver cancer. Inhalation or ingestion may cause digestive disturbances, hair loss, liver damage, peripheral nervous system damage, and kidney and blood damage. Acute ingestion may be fatal. Reaction with acid forms poisonous arsine gas. Do not use.

Arsenic Trisulfide (Realgar)

Specific Hazards

See general hazards. Ingestion may also cause formation of hydrogen sulfide gas by reacting with stomach acid. See Sulfides in Table 5-3.

Arsenic Oxide (arsenic trioxide)

Specific Hazards

See general hazards.

Chromated Copper Arsenate (CCA)

Specific Hazards

See general hazards. See also Chromium (VI) Compounds.

Copper Acetoarsenite (Paris Green, C.I. Pigment Green 21)

Specific Hazards

See general hazards.

BARIUM COMPOUNDS

Relative Toxicity Rating TLV (soluble compounds): 0.5 mg/m³

Skin contact: slight
Inhalation: high
Ingestion: extreme

General Hazards

Soluble barium compounds may cause skin, eye, nose, and throat irritation. Inhalation or ingestion of soluble salts may cause barium poisoning with symptoms of severe heart muscle contractions, intestinal spasms, and severe muscle pains. Chronic poisoning most likely by inhalation.

Barium Carbonate (witherite, C.I. Pigment White 10)

Specific Hazards

See general hazards.

Barium chromate: see Chromium (VI) Compounds

Barium oxide

Specific Hazards

See general hazards.

Barium Sulfate

Relative Toxicity Rating TLV: 10 mg/m^3*

Skin contact: not significant
Inhalation: not significant
Ingestion: not significant

Specific Hazards

Barium sulfate is almost completely insoluble and does not cause barium poisoning unless contaminated with soluble barium compounds. Chronic inhalation of barium sulfate can cause a benign pneumoconiosis, which has no ill effects but can show on x-rays.

BERYLLIUM COMPOUNDS

Relative Toxicity Rating TLV: 0.002 mg/m^3,
 NIOSH REL: 0.0005 mg/m^3

Skin contact: moderate
Inhalation: extreme
Ingestion: slight

General Hazards

Probable human carcinogen. Skin contact may cause chronic skin ulcers if salts get into cuts or abrasions. Acute inhalation, or chronic inhalation of small amounts, causes berylliosis, a severe, allergic (hypersensitivity) pneumonia-like disease that is frequently fatal and can result in permanent lung damage for those who recover. Chronic beryllio-

120

sis may take from 1 to 20 years to develop and severely affects lungs, liver, heart, and kidneys. Chronic berylliosis is often confused with sarcoidosis. Inhalation may cause bronchogenic cancer. Do not use.

Beryllium Metal
Specific Hazards

See general hazards.

Beryllium Oxide (beryl, beryllia)
Specific Hazards

See general hazards.

BORON COMPOUNDS

Relative Toxicity Rating TLV: varies

Skin contact: slight
Inhalation: moderate
Ingestion: moderate to high

General Hazards

Powder. Absorption through burned skin, ingestion, or inhalation can cause nausea, abdominal pain, diarrhea, violent vomiting, and skin rash. Chronic poisoning may cause loss of appetite, gastroenteritis, liver and kidney damage, testicular damage, and skin rash.

Borax (sodium tetraborate, sodium pyroborate) TLV: 1–5 mg/m³
Specific Hazards

Solutions of borax are alkaline. See also general hazards. Moderately toxic by ingestion.

Boric Acid
Specific Hazards

Solutions are acidic. See general hazards.

Boron oxide (boric oxide, boron trioxide) TLV: 10 mg/m³
Specific Hazards

See general hazards.

Colemanite (hydrated calcium borate)
Specific Hazards

See general hazards.

CADMIUM COMPOUNDS

Relative Toxicity Rating

TLV: 0.01 mg/m^3 (total dust)
0.002 mg/m^3 respirable dust (proposed 1991–92)

Skin contact: not significant
Inhalation: extreme
Ingestion: extreme

General Hazards

Known or probable human carcinogens and developmental toxicant. Chronic inhalation or ingestion may cause chronic lung damage, kidney damage, anemia, loss of smell, and bone, teeth, and liver damage. Chronic cadmium exposure is associated with prostate cancer and lung cancer. May cause chromosomal damage, testicular atrophy, and other damage to male reproductive system. Acute ingestion may cause illness resembling food poisoning

Cadmium Metal

Specific Hazards

Known human carcinogen. Acute exposure to cadmium fumes may cause severe lung irritation and possibly fatal chemical pneumonia. Early symptoms resemble metal fume fever. See also general hazards. Do not use.

Cadmium Oxide

Specific Hazards

Known human carcinogen. May vaporize during firing. See also general hazards.

Cadmium Selenide

Specific Hazards

Probable human carcinogen. See Cadmium sulfide and Selenium Compounds.

Cadmium Sulfide (cadmium yellow, C.L Pigment Yellow 37)

Relative Toxicity Rating

Skin contact: not significant
Inhalation: high
Ingestion: slight

Specific Hazards

Probable human carcinogen. Causes cancer in animals. Cadmium sulfide itself is insoluble, but is often contaminated with soluble cadmium compounds. Not an acute ingestion hazard, but may be a chronic hazard. See general hazards. Hot or concentrated acids can cause formation of hydrogen sulfide gas.

CALCIUM COMPOUNDS

TLV: Varies

General Hazards

The calcium ion itself is not toxic except for generalized gastric irritation. The type of anion determines the toxicity (see Table 5-3).

Calcium Carbonate (whiting, calcite)

TLV: 10 mg/m³*

No significant hazards.

Calcium Fluoride (fluorspar)

Relative Toxicity Rating

TLV: 2.5 mg/m³ (as fluoride)

Skin contact: moderate
Inhalation: high
Ingestion: moderate

Specific Hazards

Skin irritant. Acute inhalation may cause lung irritation; acute ingestion may cause gastric, intestinal, circulatory, and nervous system problems. Chronic inhalation or ingestion may cause loss of weight and appetite, anemia, and bone and teeth defects. Gives off fluorine during kiln firing.

CHROMIUM (VI) COMPOUNDS

Relative Toxicity Rating

TLV: 0.05 mg/m³,
NIOSH: 0.001 mg/m³ (10-hour REL)

Skin contact: high
Inhalation: extreme
Ingestion: high to extreme

General Hazards

Known or probable human carcinogens and mutagens. Hexavalent chromium compounds are corrosive by skin contact; may cause irritation, ulceration, and allergies. Chronic inhalation may cause lung cancer, respiratory irritation, allergies, and perforated nasal septum. Ingestion may cause violent gastroenteritis, circulatory collapse, and kidney damage. Do not use.

Ammonium Dichromate (ammonium bichromate)

Specific Hazards

Cancer hazards unknown. See general hazards. Strong oxidizer; can cause fire in contact with reducing agents, solvents, and other organic materials.

Barium Chromate (barium yellow)

Specific Hazards

See general hazards.

Calcium chromate

Specific Hazards

See general hazards.

Chromite (iron chromite)

Specific Hazards

Known human carcinogen during ore processing.

Chromium Metal

Specific Hazards TLV: 0.5 mg/m^3

Known human carcinogen. Metal fumes contain hexavalent chromium and may cause lung cancer. See general hazards.

Lead Chromate (chrome yellow)

Specific Hazards

See general hazards and also Lead Compounds.

Potassium Dichromate (potassium bichromate)

Specific Hazards

Probable human carcinogen. See general hazards. Strong oxidizer; can cause fire in contact with reducing agents, solvents, and other organic materials.

Sodium Dichromate (sodium bichromate)

Specific Hazards

Possible human carcinogen. See general hazards. Strong oxidizer; can cause fire in contact with reducing agents, solvents, and other organic materials.

Strontium chromate

Specific Hazards

See general hazards.

Zinc Chromate (zinc yellow)

Specific Hazards

See general hazards.

CHROMIUM (III) COMPOUNDS

TLV: 0.5 mg/m^3

Chromium Oxide [(chrome oxide, chromic oxide, chromium (III) oxide, chrome green, C.I. Pigment Green 17)]

Relative Toxicity Rating

Skin contact: slight
Inhalation: slight
Ingestion: slight

Specific Hazards

Possible human carcinogen. May cause occasional skin and respiratory irritation and allergies. Causes cancer in animals.

COBALT COMPOUNDS

Relative Toxicity Rating

TLV: 0.05 mg/m^3

Skin contact: slight
Inhalation: high
Ingestion: high

General Hazards

Probable human carcinogen from animal studies. Repeated skin contact may cause allergies, especially at elbows, neck, and ankles. Chronic inhalation may cause asthma, heart problems, and possible pulmonary fibrosis. Ingestion may cause acute illness with vomiting, diarrhea, and sensation of hotness.

Cobalt Carbonate

Specific Hazards

See general hazards.

Cobalt Oxides (cobaltous oxide, cobaltic oxide)

Relative Toxicity Rating

Skin contact: slight
Inhalation: moderate
Ingestion: moderate

Specific Hazards

Cobalt oxides are less soluble than cobalt carbonate, and therefore less toxic. See general hazards.

COPPER COMPOUNDS

Relative Toxicity Rating TLV (dusts and mists): 1 mg/m^3

Skin contact: slight
Inhalation: moderate
Ingestion: high

General Hazards

May cause skin allergies and irritation to skin, eyes, nose, and throat, and possibly ulceration and perforation of nasal septum and congestion. Acute ingestion causes gastrointestinal irritation and vomiting. If vomiting does not occur, more serious poisoning can result.

Copper Carbonate (malachite)

Specific Hazards

See general hazards.

Copper Chloride (cuprous chloride, cupric chloride)

Specific Hazards

See general hazards. Cuprous chloride is about twice as toxic as cupric chloride.

Copper metal PEL (fumes): 0.1 mg/m^3

Specific Hazards

Fresh copper fumes from welding or melting of copper or alloys can cause metal fume fever.

Copper Nitrate

Specific Hazards

See general hazards.

Copper Oxide, Black (cupric oxide)

Specific Hazards

Likely to be moderately toxic by ingestion. See also general hazards.

Copper Oxide, Red (cuprous oxide, cuprite)

Specific Hazards

Moderately toxic by ingestion. See also general hazards.

Copper Sulfate (cupric sulfate)

Specific Hazards

See general hazards.

GOLD COMPOUNDS

Relative Toxicity Rating

Skin contact: moderate
Inhalation: moderate
Ingestion: moderate

General Hazards

Gold salts can cause severe allergies by inhalation. Chronic inhalation and ingestion may cause anemia, and liver, kidney, and nervous system damage.

Gold Chloride

Specific Hazards: See general hazards.

Gold Metal

Specific Hazards

No significant hazards from the metal or its fumes.

IRON COMPOUNDS

Relative Toxicity Rating TLV (soluble salts): 1 mg/m^3

Skin contact: slight
Inhalation: slight
Ingestion: moderate

General Hazards

Soluble iron salts are slightly irritating to skin, eyes, nose, and throat, and can cause poisoning if ingested in large amounts (especially by children).

Chromite (ferric chromate)

Relative Toxicity Rating

Skin contact: moderate
Inhalation: high
Ingestion: high

Specific Hazards

Skin contact may cause skin irritation, allergies, or ulcers. Acute ingestion may cause chromium poisoning (gastroenteritis, vertigo, muscle cramps, kidney damage). Chronic inhalation may cause lung cancer, perforation of nasal septum, and respiratory allergies and irritation.

Ferric Ammonium Citrate

Specific Hazards

See general hazards.

Iron metal TLV (fumes): 5 mg/m^3

Specific Hazards

Acute inhalation of large amounts of fresh iron fumes may cause metal fume fever. Chronic inhalation may cause siderosis (iron pigmentation of lungs) but does not have any known ill effects; shows on x-rays.

Iron Oxide, Black (ferrous oxide)

No significant hazards.

Iron Oxide, Red (ferric oxide)

No significant hazards.

Iron Perchloride (ferric chloride, iron perchloride)

Specific Hazards

Powder. Forms small amount of hydrochloric acid in solution. Skin and eye irritant in solution. Ingestion of large amounts by children could cause iron poisoning. Substitute for Dutch mordant in copper etching. Heating to decomposition releases highly toxic hydrogen chloride gas, which can cause severe lung irritation and pulmonary edema.

Iron Sulfate (ferrous sulfate, crocus martis)

Specific Hazards

See general hazards.

Potassium Ferricyanide (Farmer's reducer)

Specific Hazards

See general hazards. When heated strongly, treated with acid, or exposed to ultraviolet radiation, potassium ferricyanide decomposes to poisonous hydrogen cyanide gas.

LEAD COMPOUNDS

Relative Toxicity Rating PEL (inorganic lead): 0.05 mg/m^3

Skin contact: not significant
Inhalation: high
Ingestion: high

General Hazards

Known human mutagen and developmental toxicant. Both acute and chronic ingestion or inhalation can cause inorganic lead poisoning. Inhalation is more of a problem than ingestion. Lead affects the gastrointestinal system (lead colic), red blood cells (anemia), brain (cognitive defects, encephalopathy), and neuromuscular system (weakening of wrists, fingers, ankles, toes). Other common effects include weakness, headaches, irritability, malaise, pain in joints and muscles, liver and kidney damage, and possible miscarriages and brain damage in offspring.

Lead Bisilicate (used in lead frits)

Specific Hazards

See general hazards.

Lead Carbonate (white lead)

Specific Hazards

More soluble than other lead compounds used in art. See General Hazards.

Lead Chromate (chrome yellow)

Relative Toxicity Rating TLV: 0.05 mg/m^3 (as lead); 0.012 mg/m^3 (as chromium),
 NIOSH REL: 0.001 mg/m^3 (as chromium (VI))

Skin contact: high
Inhalation: extreme
Ingestion: high

Specific Hazards

Known human carcinogen. See general hazards. See also Chromium (VI) Compounds. Do not use.

129

Lead Frits (lead silicates)

Specific Hazards

See general hazards.

Lead metal

Specific Hazards

See general hazards.

Lead Monosilicate (used in lead frits)

Specific Hazards

See general hazards

Lead Monoxide (litharge)

Specific Hazards

See general hazards

Lead Sulfide (galena)

Specific Hazards

See general hazards. Ingestion may cause hydrogen sulfide poisoning due to reaction with stomach acid.

Lead Tetroxide (red lead)

Specific Hazards

See general hazards

LITHIUM COMPOUNDS

Relative Toxicity Rating

Skin contact: moderate
Inhalation: moderate
Ingestion: moderate

General Hazards

Dusts are eye, nose, and throat irritants, and can cause kidney damage. Ingestion can cause drowsiness, weakness, nausea, anorexia, tremors, blurring of vision, coma, and death.

Lithium Carbonate

Specific Hazards

Known human developmental toxicant. Aqueous solutions of lithium carbonate are corrosive to skin (see Table 4-3). Lithium carbonate is used in the treatment of manic depression. See general hazards.

MAGNESIUM COMPOUNDS

Relative Toxicity Rating

Skin contact: not significant
Inhalation: not significant
Ingestion: moderate

General Hazards

Ingestion may cause purging.

Magnesium Carbonate (magnesite)

TLV: 10 mg/m^3

Specific Hazards

See general hazards.

Magnesium Metal

TLV (fumes): 10 mg/m^3

Specific Hazards

Magnesium fumes may cause metal fume fever

Magnesium Oxide (magnesia)

Specific Hazards

See general hazards.

MANGANESE COMPOUNDS

Relative Toxicity Rating

PEL: C 5 mg/m^3
NIOSH REL: 1 mg/m^3

Skin contact: not significant
Inhalation: high
Ingestion: moderate

General Hazards

Manganese salts are poorly absorbed in the lungs and gastrointestinal system. Chronic inhalation may cause manganism, a serious nervous system disease resembling Parkinson's disease. Early symptoms include apathy, loss of appetite, weakness, spasms, headaches, and irritability. May cause impotence, sterility, and loss of sex drive.

Manganese Carbonate

Specific Hazards

See general hazards.

Manganese Dioxide (manganese oxide, pyrolusite)

Specific Hazards

See general hazards.

Manganese Metal TLV (fumes): 1 mg/m³

Specific Hazards

Acute inhalation of manganese fumes may cause chemical pneumonia.
See general hazards.

Potassium Permanganate

Relative Toxicity Rating

Skin contact: high
Inhalation: high
Ingestion: high

Specific Hazards

Oxidizing agent. Mildly irritating in dilute solutions, but highly corrosive in
concentrated solutions. If it is ingested, death may occur from edema of the
tissues lining the larynx.

MERCURY COMPOUNDS

Relative Toxicity Rating TLV (inorganic): 0.05 mg/m³ (skin)

Skin contact: moderate
Inhalation: high
Ingestion: extreme

General Hazards

Probable developmental toxicant. Skin irritant. Skin absorption, ingestion, or inhalation
may cause acute or chronic mercury poisoning, primarily affecting the nervous system
but also the gastrointestinal system and kidneys. Acute poisoning is accompanied by
metallic taste, salivation, swelling of gums, vomiting, and bloody diarrhea. Chronic poi-
soning also severely affects the nervous system, causing muscular tremors, irritability,

and psychic changes (e.g., depression, loss of memory, frequent anger). Possible menstrual effects in women and sperm damage in male animals.

Mercuric Chloride (bichloride of mercury)

Specific Hazards

Most toxic mercury compound. Corrosive to skin and gastrointestinal system. Ingestion of 0.5 grams can be fatal. See general hazards.

Mercuric Iodide

Specific Hazards

See general hazards.

Mercuric Sulfide (cinnabar, vermilion)

Specific Hazards

Can cause skin allergies. See general hazards. Forms hydrogen sulfide in combination with stomach acid.

Mercury Metal

Relative Toxicity Rating

Skin contact: moderate
Inhalation: high
Ingestion: slight

Specific Hazards

May be absorbed through skin. Very volatile; inhalation is the most serious route of exposure. Large, acute exposures (e.g., from heating mercury) can cause chemical pneumonia. Not appreciably absorbed by ingestion. See general hazards.

Phenyl Mercuric Acetate

Specific Hazards

Probable developmental toxicant. Absorbed by skin contact, inhalation, and ingestion. Skin irritant. See general hazards.

MOLYBDENUM COMPOUNDS

TLV (soluble): 5 mg/m^3,
TLV (insoluble): 10 mg/m^3

General Hazards

Slight irritants. Not well studied. See particular compounds.

Molybdate Orange (mixture of lead molybdate, lead sulfate, and lead chromate)

Relative Toxicity Rating

TLV: 0.05 mg/m^3 as lead; 0.012 mg/m^3 as chromium; NIOSH REL: 0.001 mg/m^3 as chromium (VI)

Skin contact: high
Inhalation: extreme
Ingestion: high

Specific Hazards

Toxicity determined by lead and chromate. Known human carcinogen. See Lead Compounds and Chromium (VI) Compounds. Do not use.

Molybdenum Sulfide (molybdenum disulfide, molybdenite)

Relative Toxicity Rating

Skin contact: slight
Inhalation: moderate
Ingestion: slight

Specific Hazards

Molybdenum sulfide dust is slightly irritating by skin contact. Insoluble in water and dilute acids. Molybdenum fumes and sulfur dioxide gas from firing are more toxic by inhalation, causing respiratory irritation.

NICKEL COMPOUNDS

Relative Toxicity Rating

TLV: 0.05 mg/m^3 (proposed 1991–92); NIOSH REL: 0.015 mg/m^3

Skin Contact: moderate
Inhalation: high to extreme
Ingestion: high

General Hazards

Known or probable human carcinogens. Nickel compounds can cause skin allergies (nickel itch) with severe rashes and itching and skin and eye irritation. Chronic inhalation of nickel compounds may cause lung cancer or nasal cancer. Inhalation may also cause irritation of upper respiratory tract. Ingestion usually causes vomiting due to irritating action.

Nickel Carbonate

Specific Hazards

See general hazards.

Nickel Metal

Specific Hazards

Fresh nickel fumes can cause metal fume fever. Oxyacetylene welding with nickel alloys may cause the formation of extremely toxic nickel carbonyl gas, which can cause chemical pneumonia. See general hazards.

Nickel Oxide

Specific Hazards

See general hazards.

PALLADIUM COMPOUNDS

Relative Toxicity Rating

Skin contact: slight
Inhalation: slight
Ingestion: moderate

General Hazards

May cause some skin irritation. Hazards mostly unknown.

Palladium Chloride

Specific Hazards

See general hazards.

PLATINUM COMPOUNDS

Relative Toxicity Rating

Skin contact: moderate
Inhalation: high
Ingestion: unknown

TLV (soluble salts): 0.002 mg/m^3;
TLV (metal): 1 mg/m^3

General Hazards

Skin contact can cause severe skin allergies. Inhalation can cause nasal allergies (similar to hay fever) and platinosis, a severe form of asthma. Some lung scarring and emphysema may also occur. People with red or light hair and fine-textured skin appear most susceptible.

Platinum Chloride (platinum tetrachloride)

Specific Hazards

See general hazards.

Potassium Chloroplatinite

Specific Hazards

See general hazards.

POTASSIUM COMPOUNDS

General Hazards

The toxicity of potassium compounds is usually determined by the type of anion (see Table 5-3). Acute oral toxicity is rare because large doses induce vomiting and it is normally quickly excreted. Potassium can affect the heart and blood pressure.

SELENIUM COMPOUNDS

Relative Toxicity Rating TLV: 0.2 mg/m^3

Skin contact: moderate
Inhalation: high
Ingestion: high to extreme

General Hazards

Mutagen. Can cause severe eye irritation, skin burns, and allergies; may also be absorbed through the skin. Acute inhalation may cause respiratory irritation, chemical pneumonia, and bronchitis. Acute toxicity of soluble compounds very high. Chronic inhalation or ingestion may cause garlic odor, nervousness, nausea, vomiting, nervous disorders, hair loss, liver and kidney damage. Similar to arsenic poisoning. Treatment of selenium compounds with acid can cause the formation of the extremely toxic gas hydrogen selenide.

Cadmium Selenide TLV (total dust): 0.01 mg/m^3 (as cadmium);
 TLV (respirable dust): 0.002 mg/m^3 (as cadmium),
Relative Toxicity Rating (proposed 1991–92)

Skin contact: not significant
Inhalation: high
Ingestion: slight?

Specific Hazards

Probable human carcinogen. See Cadmium sulfide.

Selenium Dioxide

Specific Hazards

See General Hazards.

Selenium Metal

Specific Hazards

Selenium metal is not significantly toxic, but inhalation of fresh fumes can cause intense irritation of nose, eyes, and throat, followed by possible bronchial spasms, bronchitis, and chemical pneumonia. See general hazards.

Sodium Selenate

Specific Hazards

Extremely toxic by ingestion. See general hazards.

SILVER COMPOUNDS

Relative Toxicity Rating TLV (soluble compounds): 0.01 mg/m^3

Skin contact: slight
Inhalation: slight
Ingestion: slight

General Hazards

Silver particles that become imbedded in the skin can cause a permanent tattoo; particles in the eyes can cause a permanent blue-black stain. Chronic inhalation of silver dust or fumes can cause argyria—a permanent bluish-black discoloration of eyes, nails, inner nose, mouth, throat, skin, and internal organs— which is very disfiguring but does not have any known ill effects. It may also cause clouding of the cornea and decreased night vision. High repeated exposure may cause kidney damage.

Silver Chloride

Specific Hazards

See general hazards.

Silver Metal PEL: 0.01 mg/m^3

Specific Hazards

See general hazards.

Silver nitrate

Relative Toxicity Rating

Skin contact: moderate
Inhalation: high
Ingestion: high

Specific Hazards

Silver nitrate is corrosive to skin, eyes, and mucous membranes. May cause blindness. Ingestion may cause severe gastroenteritis, shock, vertigo, coma, and convulsions.

Silver Solder (see Cadmium)

SODIUM COMPOUNDS

General Hazards

The toxicity of sodium compounds is usually determined by the anion (see Table 5-3).

STRONTIUM COMPOUNDS

Relative Toxicity Rating

Skin contact: not significant
Inhalation: slight
Ingestion: slight to moderate

General Hazards

Ingestion may cause vomiting and diarrhea.

Strontium Carbonate

Specific Hazards

See general hazards.

Strontium Chromate TLV: 0.005 mg/m^3 (as chromium);
 NIOSH REL: 0.001 mg/m^3 (as chromium (VI))

Specific Hazards

Probable human carcinogen. See Chromium (VI) Compounds.

TIN COMPOUNDS

Relative Toxicity Rating TLV: 2 mg/m^3

Skin contact: slight
Inhalation: slight
Ingestion: variable

General Hazards

Toxicity depends on solubility. Acute ingestion of soluble compounds causes nausea, vomiting, and diarrhea without other effects.

Tin Chloride (stannous chloride)

Relative Toxicity Rating

Skin contact: slight
Inhalation: moderate
Ingestion: moderate

Specific Hazards

Tin chloride is irritating to the skin, eyes, mucous membranes, and gastrointestinal system.

Tin Metal TLV: 2 mg/m^3

Specific Hazards

Inhalation of large amounts of tin fumes over several years may cause stannosis, a benign pneumoconiosis without any ill effects. It shows on lung x-rays.

Tin Oxide (putty, stannous oxide)

Specific Hazards

No significant hazards. Inhalation of large amounts may cause stannosis (see Tin Metal).

TITANIUM COMPOUNDS

General Hazards

See specific compound.

Titanium Metal

Relative Toxicity Rating

Skin contact: not significant
Inhalation: not significant
Ingestion: not significant

Specific Hazards

Titanium metal is combustible, requiring a Class D fire extinguisher. Dust and filings are particular fire hazards.

Titanium Oxide (rutile, titanium dioxide) TLV: 10 mg/m^3*

Specific Hazards

No significant hazards. Inhalation of large amounts over several years may cause a benign pneumoconiosis without any ill effects. It shows on lung x-rays.

Titanium Tetrachloride

Relative Toxicity Rating

Skin contact: moderate
Inhalation: high
Ingestion: moderate

Specific Hazards

Corrosive to skin, eyes, respiratory system, and gastrointestinal system due to formation of hydrochloric acid. Inhalation of fumes or spray may cause chemical pneumonia.

URANIUM COMPOUNDS TLV (insoluble compounds): 0.2 mg/m^3;
PEL (soluble compounds): 0.05 mg/m^3

General Hazards

All uranium compounds are radioactive, with the risk of lung cancer after inhalation. See specific compound.

Uranium Nitrate (uranyl nitrate)

Relative Toxicity Rating

Skin contact: slight
Inhalation: high
Ingestion: moderate

Specific Hazards

Soluble uranium compounds are poorly absorbed but can cause severe kidney damage and kidney failure. Do not use.

Uranium Oxides

Relative Toxicity Rating

Skin contact: slight
Inhalation: extreme
Ingestion: slight

Specific Hazards

Chronic exposure to insoluble uranium compounds occurs mostly by inhalation and may cause emphysema, lung cancer, and blood and nervous system damage. This is primarily due to the radioactivity. "Depleted" uranium has the U-235 removed, but is still radioactive.

VANADIUM COMPOUNDS

Relative Toxicity Rating

Skin contact: moderate
Inhalation: high
Ingestion: extreme

General Hazards

Skin contact causes skin and eye irritation. Inhalation causes both acute and chronic problems, including irritation, chemical pneumonia, asthma, shortness of breath, and bronchitis. Inhalation and ingestion may also turn the tongue green, cause anemia, blindness, and intestinal, kidney, and nervous system damage.

Vanadium Oxide (vanadium pentoxide and/or vanadium trioxide)

Specific Hazards

TLV: 0.05 mg/m^3 respirable dust (as V_2O_5)

See general hazards.

Vanadium Tetrachloride

Specific Hazards

Corrosive to skin, eyes, and respiratory and gastrointestinal systems due to formation of hydrochloric acid. See also general hazards.

ZINC COMPOUNDS

General Hazards

See specific compound.

141

Zinc Chloride

Relative Toxicity Rating TLV (fumes): 1 mg/m^3

Skin contact: moderate
Inhalation: high
Ingestion: high

Specific Hazards

Irritating to skin, eyes, respiratory system, and gastrointestinal system, since it produces hydrochloric acid in contact with water.

Zinc Chromate (zinc yellow)

Relative Toxicity Rating TLV: 0.01 mg/m^3 (as chromium);
 NIOSH REL: 0.001 mg/m^3 (as chromium (VI))

Skin: moderate
Inhalation: extreme
Ingestion: high

Specific Hazards

Known human carcinogen. See Chromium (VI) Compounds. Do not use.

Zinc Metal

Relative Toxicity Rating TLV (fumes): 5 mg/m^3

Skin contact: not significant
Inhalation: moderate
Ingestion: unknown

Specific Hazards

Acute exposure to fresh zinc fumes frequently causes metal fume fever.

Zinc Naphthenate

Relative Toxicity Rating

Skin contact: slight
Inhalation: slight
Ingestion: slight

Specific Hazards

Slight irritant.

Zinc Oxide (Chinese white, zinc white)

Relative Toxicity Rating TLV (dust): 10 mg/m^3*

Skin contact: not significant
Inhalation: slight
Ingestion: moderate

Specific Hazards

Inhalation of dust may cause slight irritation of respiratory system. Ingestion may cause effects similar to those of ingesting copper.

Zinc Sulfide

Relative Toxicity Rating

Skin contact: not significant
Inhalation: moderate
Ingestion: extreme

Specific Hazards

Ingestion of zinc sulfide may cause formation of highly toxic hydrogen sulfide gas if stomach acidity is high.

ZIRCONIUM COMPOUNDS

Relative Toxicity Rating TLV: 5 mg/m^3

Skin contact: slight
Inhalation: moderate
Ingestion: slight to moderate

General Hazards

Zirconium compounds cause nodules under the skin from contact with abraded skin, and in the lungs from inhalation. These are thought to be allergy reactions.

Zirconium Oxide (zirconia, zirconium dioxide)

Specific Hazards

See general hazards.

Zirconium Silicate (zircon)

Specific Hazards

See general hazards.

TABLE 5-3. Hazards of Common Anions

General Hazards

The anion component of metallic compounds can affect the solubility and the toxicity of the particular metal. Some anions (e.g., cyanide) can be the major determinant of toxicity.

Bisulfites
Specific Hazards

Usually moderately toxic by ingestion. Heating, acids, or even old solutions can release highly irritating sulfur dioxide gas.

Bromides
Specific Hazards

Usually moderately toxic by ingestion. Causes vomiting. Main effects are skin rashes, sensory disturbances, drowsiness, irritability, confusion, malaise, hallucinations, and coma.

Carbonates
Specific Hazards

The metal determines the toxicity of carbonates. Heating carbonates or treating with acid causes the release of carbon dioxide.

Chlorides
Specific Hazards

Chlorides are usually more soluble than other anions. The metal usually determines the toxicity. Metallic compounds with three or more chlorine atoms (e.g., titanium tetrachloride) are irritants because they release hydrochloric acid in solution or in contact with mucous membranes. Heating chlorides usually releases hydrochloric acid or chlorine.

Chromates [see Chromium (VI) in Table 5-2]

Cyanides TLV: 5 mg/m^3 (as cyanide) (skin)
Specific Hazards

Soluble cyanide salts are extremely toxic by inhalation and ingestion. Chronic skin contact may cause skin rashes; some may also be absorbed through the skin. Acute ingestion is frequently fatal, even in small amounts, causing chemical asphyxia. Acute inhalation may also cause chemical asphyxia. Chronic inhalation of small amounts may cause nasal and respiratory irritation, including nasal ulceration, and systemic effects with symptoms of loss of appetite, headaches, nausea, weakness, and dizziness. Heating

or adding acid to cyanide causes the formation of extremely toxic hydrogen cyanide gas which can be rapidly fatal by inhalation. Ferricyanides and ferrocyanides are only moderately toxic by ingestion, unless heated or treated with acid or ultraviolet radiation.

Fluorides TLV: 2.5 mg/m^3 (as fluoride)

Specific Hazards

Usually highly toxic by ingestion. Highly irritating. May also have long-term effects on bone and teeth (osteofluorosis).

Hydroxides

Specific Hazards

Soluble hydroxides are highly corrosive; less soluble ones are less hazardous. Concentration is most important factor. See Table 4-3.

Nitrates

Specific Hazards

Usually very soluble. The metal usually determines the toxicity. Nitrates may be converted by intestinal bacteria into nitrites if ingested and not quickly absorbed. Nitrates are strong oxidizing agents, and some may burn or explode if heated. They can emit toxic nitrogen oxides when heated to high temperatures. See also Nitrites.

Nitrites

Specific Hazards

Soluble nitrites may cause vomiting, nausea, and cyanosis (methemoglobinemia) in large amounts. Sodium and potassium nitrites, for example, are extremely toxic by acute ingestion. Do not use.

Oxides

Specific Hazards

The metal determines the toxicity.

Phosphates

Specific Hazards

The metal usually determines the toxicity. Heating some phosphates to high temperatures can cause release of corrosive phosphorus oxides.

Silicates

Specific Hazards

Usually slightly toxic by ingestion due to low solubility. See also Silicates in the text of this chapter.

Sulfates

Specific Hazards

The metal determines the toxicity. Heating to high temperatures can cause formation of highly irritating sulfur oxide gases.

Sulfides

Specific Hazards

Most are insoluble. Skin irritants. Most are extremely toxic by ingestion, since they can react with stomach acid to produce poisonous hydrogen sulfide gas. Heating can cause formation of highly irritating sulfur oxide gases.

Sulfites

Specific Hazards

See Bisulfites.

REFERENCES

American Conference of Governmental Industrial Hygienists. (1986). *Documentation of the Threshold Limit Values for Substances in Workroom Air*. 5th ed. Cincinnati: ACGIH.

American Conference of Governmental Industrial Hygienists. (1990). *Threshold Limit Values for Chemical Substances and Physical Agents in the Workroom Environment*. Cincinnati: ACGIH.

Gosselin, R., Smith, R., and Hodge, H. (1987). *Clinical Toxicology of Commercial Products*. 6th ed. Baltimore: Williams and Wilkins.

Hawley, G. (ed). (1987). *The Condensed Chemical Dictionary*. 11th ed. New York: Van Nostrand Reinhold.

International Labor Organization. (1983). *Encyclopedia of Occupational Safety and Health*. 2 vols. 3d ed. Geneva, Switzerland: ILO.

Lewis, R. (1991). *Carcinogenically Active Chemicals: A Reference Guide.* New York: Van Nostrand Reinhold.

National Institute of Occupational Safety and Health. *Criteria for Recommended Standards: Occupational Exposure to [various chemicals]*. Cincinnati: NIOSH.

New Jersey Hazardous Substance Fact Sheets on [various chemicals]. Trenton: New Jersey State Department of Health.

Patty, F. (ed). 1982. *Industrial Hygiene and Toxicology* vol II. 3 parts, 3d ed. New York: Interscience Publishers. (1982)

Safety In
The Studio

ow that you are aware of the hazards involved in working with art materials, it is important to understand the precautions that can be taken in your studio to minimize these hazards. Although the discussion in this chapter is primarily aimed at artists or craftspeople with their own studios, it also applies to art schools, art workshops, and other similar settings in which art materials are used.

SOME GENERAL CONCEPTS

To handle art materials safely, you have to be aware of certain basic ideas.

1. *Art materials are chemicals.* The fact that you are working with potentially hazardous chemicals should be a major factor in determining your work habits.

2. *You should inquire about the hazards of art materials and how to work safely with them when you first learn about a particular art technique.* That way,

working safely with these materials becomes an integral part of your work routine. Safe working habits, however, can be developed at any time.

3. *You should consider ways in which you may be exposed to hazardous art materials.* One of the aims of safe working practices is to prevent absorption of hazardous materials into the body, whether by skin contact, inhalation, or ingestion. You should examine each material you use and how you use it to determine if your work habits might contaminate your body. Check manufacturers' warnings and instructions. Many precautions then become common sense.

4. *Safety takes longer.* Precautions such as putting on gloves before cleanup, cleaning up spills immediately, not eating in the studio, and washing your hands carefully after work take time. It is often tempting to skip a precaution in order to save time. Don't. This is how many accidents and overexposure to chemicals occur. Making these precautions a normal part of your work routine is the only way to be safe. An extra 20 minutes a day now may save you years later.

SETTING UP YOUR STUDIO

It is easier to set up a safe studio from the beginning than to modify an already existing studio; however, for those of you who already have a studio, do not be discouraged, since the basic principles are the same.

Problems of Home Studios

The first important question to consider in setting up a studio is proper location. Most artists and craftspeople have studios at home. This is hazardous because: (1) you may be exposing yourself to hazardous materials 24 hours a day, and (2) you may be exposing other members of your family. Some art media—for example, painting, drawing, and collage—can be carried on at home with simple precautions. However, in general, it is advisable not to work at home, if at all possible. For those of you who must, I recommend special care in setting up your studio as well as in following the precautions that are discussed in this and subsequent chapters.

Another consideration for professional artists with home studios is insurance. In standard home-owner (or rental) policies, you certify that you don't have any unusual hazards. Also, this type of policy does not allow you to carry on a business in your home, that is, produce art for sale. Insurance companies have refused to pay artists for damage caused by a fire that was caused by their art activ-

ities when they had only a standard home-owner policy. One solution is to obtain a special rider on your policy to cover your art activities.

The concept of several artists forming a cooperative to obtain and set up a safe studio is one possible alternative for those who cannot afford a separate studio. This is common in printmaking, for example, because of the cost of printing presses. There is no reason that cooperative working arrangements among artists should not be motivated by the desire for safer working conditions, such as adequate ventilation systems.

Factors in Studio Location

There are other factors that should be taken into account concerning choice of studio location. Listed below are some of the factors to consider that apply to all art techniques. Obviously, some art techniques have additional safety requirements.

1. You must have a source of running water readily accessible so you can wash up after work, clean up spills, and provide first aid when hazardous materials get on your skin or in your eyes.

2. The electrical supply into your studio must be adequate for any electrical equipment you will use.

3. You must be able to ventilate your studio if you are working with materials that can be inhaled. For this reason, basement studios are often a handicap, since many basements do not have readily accessible windows. I consider the question of proper ventilation in the next chapter.

4. You have to consider air pollution laws if you are producing toxic gases or vapors that may enter other tenants' apartments or lofts. Many air pollution codes require that you vent hazardous gases and vapors above the roof of the building or remove them from the air. In any case, upper floors are an advantage.

5. You need adequate lighting to work properly and to prevent eye strain.

6. You may need to use gas space heaters, but you should be aware that a fire hazard exists if you are working with flammable solvents. Many municipalities have laws regulating the amount of flammable and combustible solvents you can store, as well as special laws concerning welding. This is discussed in more detail in Chapter 8. Improperly vented space heaters (or furnaces) can produce dangerous amounts of carbon monoxide.

7. You should have at least two exits in your studio in case of fire.

Essential Emergency
Protective Equipment

There are some essential types of emergency safety equipment and information concerning their use that should be available in every studio.

1. *Fire extinguishers.* Every studio that stores and uses flammable and combustible materials should have fire extinguishers in each area. Fires are classified as class A, B, C, or D, depending on the type of combustible material causing the fire, You should buy a fire extinguisher suited to the type of materials in use in your studio and the particular class of fire you might have. Using the wrong type of fire extinguisher for a fire can be dangerous, as it can result in further spreading of the fire. Table 6-1 lists the various fire extinguishers recommended for different classes of fires, as recommended by the National Fire Protection Association. The fire extinguisher you buy should be readily available in the studio and easy to use, and everyone in the studio should know how to use it. Fire extinguishers should also be checked regularly to ensure that they are working properly.

2. *Sprinkler systems.* Studios should have automatic sprinkler systems if possible, particularly if a lot of combustible materials are present.

3. *Smoke detectors.* Smoke detectors can be particularly important if your studio is in your home. Studies have shown that smoke detectors save lives because of the early warning capability.

4. *First-aid kit.* A good first-aid kit should be readily available. The suggested contents of a good first-aid kit are discussed in Chapter 11.

5. *A telephone.* Your studio should have a telephone for emergencies. A list of emergency telephone numbers should be readily accessible and should include your local fire department, hospital, doctor, ambulance service, regional poison control center, and police.

KNOWING YOUR ART MATERIALS

In order to determine what precautions you have to take with your art materials, you have to know what art materials you have in your studio, what's in these art materials, and their hazards. As discussed in Chapter 2, labels and Material Safety Data Sheets (MSDSs) are important sources of information on your art materials.

Table 6.1 Types of Fire Extinguishers

Class of fire	Type of fire	Water solution	Carbon dioxide	Dry chemical	Dry powder
A	Fires caused by ordinary combustibles such as wood, paper, textiles	Recommended	Use for small fires only. Follow up with water	Use only multi-purpose dry chemical	Not recommended
B	Fires caused by flammable liquids and gases, including oil, paint, grease, and solvents	Use foam type only. Do not use with water-immiscible solvents such as acetone and alcohol	Recommended	Recommended	Not recommended
C	Electrical fires	Not recommended	Recommended	Recommended	Not recommended
D	Fires caused by combustible metals such as magnesium, powdered aluminum, titanium, and zinc	Not recommended	Not recommended	Not recommended	Recomended type of dry powder fire extinguisher depends upon the type of metal powder burning.

Based on recommendations of the National Fire Protection Association.

151

Inventory

One of the first things you should do is to assemble an inventory of the art materials in your studio. This is especially important for schools, where there can be art materials that are years old. This inventory is helpful in deciding what materials should be disposed of and in determining what materials for which you don't have Material Safety Data Sheets.The inventory should list the name of the art material, the amount on hand, any special hazards (e.g., flammable, oxidizer, toxic), and, if there are several rooms, where they are stored.

Labels

Figure 6-1 is a typical health hazard label for a common type of rubber cement. This label gives you a fair amount of information about this product. The full label would also contain information on the fire hazards of the rubber cement.

Figure 6.1 Sample Health Hazard Label

WARNING

MAY PRODUCE DAMAGE TO CENTRAL AND PERIPHERAL NERVOUS SYSTEM BY SKIN CONTACT OR BY INHALING

CONTAINS n-HEXANE (CAS 110-54-3)

Avoid inhaling vapors or skin contact.
Use only in well-ventilated area.
When using do not eat, drink, or smoke.

If swallowed, do NOT induce vomiting.
CALL PHYSICIAN IMMEDIATELY.

For further health information,
contact your local poison center.

1. Signal Word. The signal word tells you the extent of the hazard. **DANGER** is the most serious, followed by **WARNING** and **CAUTION**, respectively. **DANGER** is used for products that are highly toxic, corrosive, or extremely flammable. **WARNING** or **CAUTION** is used for substances that are less hazardous. **WARNING** is also used for products that have only chronic hazards. Some manufacturers also place symbols on the label to indicate the degree and type of danger. This is mandatory in Canada.

152

For further discussion of toxicity ratings, see Chapter 4; for discussion of flammability ratings, see Chapter 8.

2. List of Potential Hazards. This section lists the known significant acute and chronic hazards under reasonably foreseeable uses of the product. The hazards should be listed in order of descending severity and should specify the type of hazard.

3. Name of Hazardous Component(s). This contains a list of the common or usual names of hazardous ingredients and known hazardous decomposition products, with acutely hazardous ingredients listed first. If there is no common name, then chemical names should be used. This should include known sensitizers present in sufficient amounts to cause allergic reactions in sensitized individuals..

4. Safe Handling Instructions. This section should include appropriate precautionary statements concerning fire safety, work practices, ventilation, and personal protection.

5. First Aid. This section includes recommendations for emergency first aid.

6. Sources of Further Information. This can include referrals to a local poison center, 24-hour emergency number, availability of MSDSs, and other information.

Material Safety Data Sheets

If you have MSDSs on your art material, the next step is to try to understand them. As I mentioned in Chapter 2, MSDSs were first developed for health and safety professionals, and only later became a safety data sheet for users. At the time of writing this second edition (1991), the Occupational Safety and Health Administration (OSHA) and other governmental agencies were beginning to question the comprehensibility of safety information provided to workers. But for now, we are stuck with the present MSDSs.

Figure 6-2 is the typical format of an MSDS. Manufacturers are not required to use this format as long as all the information specified is present. So let's go through the various sections of an MSDS, as required by the OSHA Hazard Communication Standard.

The MSDS must be in English. Blank spaces are not allowed on an MSDS. If a particular section is not applicable or no information is available, then the section must specify that.

Identity. The identity of the product should be the same name as found on the product label.

153

Figure 6-2. Typical format for a Material Safety Data Sheet.

Material Safety Data Sheet
May be used to comply with
OSHA's Hazard Communication Standard,
29 CFR 1910.1200. Standard must be
consulted for specific requirements.

U.S. Department of Labor
Occupational Safety and Health Administration
(Non-Mandatory Form)
Form Approved
OMB No. 1218-0072

IDENTITY (As Used on Label and List)

Note: Blank spaces are not permitted. If any item is not applicable, or no information is available, the space must be marked to indicate that.

Section I

Manufacturer's Name	Emergency Telephone Number
Address (Number, Street, City, State, and ZIP Code)	Telephone Number for Information
	Date Prepared
	Signature of Preparer (optional)

Section II — Hazardous Ingredients/Identity Information

Hazardous Components (Specific Chemical Identity; Common Name(s))	OSHA PEL	ACGIH TLV	Other Limits Recommended	% (optional)

Section III — Physical/Chemical Characteristics

Boiling Point	Specific Gravity (H_2O = 1)
Vapor Pressure (mm Hg.)	Melting Point
Vapor Density (AIR = 1)	Evaporation Rate (Butyl Acetate = 1)
Solubility in Water	
Appearance and Odor	

Section IV — Fire and Explosion Hazard Data

Flash Point (Method Used)	Flammable Limits	LEL	UEL
Extinguishing Media			
Special Fire Fighting Procedures			
Unusual Fire and Explosion Hazards			

produce locally)

OSHA 174, Sept. 1985

Figure 6-2 *(continued)*

Section V — Reactivity Data

Stability	Unstable		Conditions to Avoid
	Stable		

Incompatibility *(Materials to Avoid)*

Hazardous Decomposition or Byproducts

Hazardous Polymerization	May Occur		Conditions to Avoid
	Will Not Occur		

Section VI — Health Hazard Data

Route(s) of Entry:	Inhalation?	Skin?	Ingestion?

Health Hazards *(Acute and Chronic)*

Carcinogenicity:	NTP?	IARC Monographs?	OSHA Regulated?

Signs and Symptoms of Exposure

Medical Conditions
Generally Aggravated by Exposure

Emergency and First Aid Procedures

Section VII — Precautions for Safe Handling and Use

Steps to Be Taken in Case Material Is Released or Spilled

Waste Disposal Method

Precautions to Be Taken in Handling and Storing

Other Precautions

Section VIII — Control Measures

Respiratory Protection *(Specify Type)*

Ventilation	Local Exhaust		Special	
	Mechanical *(General)*		Other	

Protective Gloves	Eye Protection

Other Protective Clothing or Equipment

Work/Hygienic Practices

Section I. The MSDS must have the name, address, and telephone number of the chemical manufacturer, importer, employer, or other responsible party preparing the MSDS who can give further information on the product hazards and emergency procedures. It must also give the date of preparation of the most recent version. Usually the telephone number is listed under Emergency Telephone Number. In my experience, however, in some cases you cannot reach anyone at this emergency number after hours or at lunchtime.

Section II—Hazardous Ingredients/Identity Information. This
section must have information on hazardous ingredients. This must include the chemical and common names of hazardous ingredients. For mixtures that have been tested as a whole, only the ingredients found to be hazardous must be listed. If the mixture has not been tested, all toxic ingredients at a concentration greater than 1% and all carcinogenic ingredients at concentrations over 0.1% must be listed. Materials are considered hazardous if they are listed in OSHA's Z list (29 CFR 1910, Subpart Z, Toxic and Hazardous Substances); if the American Conference of Governmental Industrial Hygienists (ACGIH) has assigned a Threshold Limit Value (TLV) to the material; or if it has been found to be toxic, carcinogenic, irritating, sensitizing, or damaging to certain body organs. See Chapter 4 for more information on what is considered toxic or carcinogenic.

Unfortunately, the MSDS does not have to list the percentage concentration of each ingredient. This was common on old MSDSs, but many companies stopped doing this when the OSHA Hazard Communication Standard did not require it. Many companies, however, do list ranges of concentrations of ingredients.

This section must also have the OSHA Permissible Exposure Limit (PEL), the ACGIH TLV, or any other exposure limit used by the manufacturer. For information on exposure limits, see Chapter 4.

Many manufacturers list only general categories of chemicals in their MSDSs, for example, listing ketones instead of methyl ethyl ketone. This is actually illegal unless they claim that it is a trade secret. According to OSHA, if the manufacturer claims and is able to document that an ingredient is a trade secret, it must state that fact on the MSDS. Unfortunately, challenging a trade secret exemption is very difficult. Another problem is that some manufacturers list only hazardous chemicals found in OSHA's Z list. This table is only one source of information manufacturers must use in determining the hazard of a product.

Section III—Physical/Chemical Characteristics. This section should
include information on boiling point, vapor pressure, vapor density, solubility in water, specific gravity, percent volatile, evaporation rate, and appearance and odor. Sometimes the pH is included for aqueous solutions.

Some of this information can be helpful in determining how much will

evaporate and how fast. This is especially useful for products containing organic solvents. The percent volatile, for example, can tell you how much can evaporate. The evaporation rate will give you an idea of how long it will take to evaporate. Unfortunately, different manufacturers use different standards, but, in general, low numbers mean it takes longer to evaporate. The boiling point can also give you an idea of how fast the product will evaporate. Boiling points below 212°F (100°C) mean that the product evaporates quicker than water.

For aqueous solutions the pH, if present, is useful. Usually it is included only for products that are very acidic or very basic, and are therefore corrosive.

Section IV—Fire and Explosion Hazard Data.

This section has information on the flammability of the product, on types of fire extinguishers needed, and on other special precautions. These data are important when planning for emergencies.

This section can be especially important for solvent-containing materials. If the flash point is under 100°F, the product is flammable and might catch fire if a source of ignition is present at or below the flash point. See Chapter 8 for more information on flammability of liquids. The flammable limits are the lower and upper concentrations of the gas or vapor in air between which the gas or vapor can burn or explode if enclosed.

Section V—Reactivity Data.

This section is very important if you might heat the product, mix it with other chemicals, or expose it to ultraviolet radiation. It tells you about the product's compatibility with other chemicals and special conditions to avoid. The stability of the product indicates whether the product can decompose and what conditions can do this. For example, potassium ferricyanide (Farmer's reducer) can decompose to release hydrogen cyanide gas if heated or exposed to ultraviolet radiation.

The incompatibility section tells you what chemicals can react with the product. For example, chlorine bleach is incompatible with ammonia, since they react to produce a poison gas. This section is very important in determining what materials you should not store near this product.

The hazardous decomposition section tells you what hazardous chemicals can be produced when the product is heated or burned. For example, when you heat or burn plexiglas, you can produce the irritant methyl methacrylate.

The hazardous polymerization section tells you whether the product can polymerize, and what conditions can cause this.

Section VI—Health Hazard Data.

This section should tell you the routes (skin contact, inhalation, ingestion) by which the product can affect you, the symptoms of overexposure, acute and chronic health effects, emergency first-aid measures, and carcinogenicity.

157

If the product or chemicals in the product have been found to be a carcinogen or probable carcinogen by the International Agency for Research on Cancer (IARC) or OSHA, or is listed in the National Toxicology Program's *Annual Report on Carcinogens*, then the MSDS must state so.

The MSDS should also list medical conditions that could be aggravated by exposure to the product.

The health section is usually one of the worst sections in MSDSs. I recommend that you try to find out more about the hazards of the chemicals listed in Section II by checking Chapters 3, 4, and 5 of this book, and the references listed in those chapters.

Section VII—Precautions for Safe Handling and Use.
This section covers such topics as spill control, waste disposal, storage and handling precautions, and other special precautions such as personal protective equipment needed for spills. Unfortunately, the section on waste disposal often just tells you to dispose of the material according to local, state, and federal regulations. Precautions are discussed in detail later in this chapter and in subsequent chapters.

Section VIII—Control Measures.
This section should give you a lot of information about respirators, ventilation, and other personal protective equipment, but it often doesn't.

The respirator recommendations should state what type of cartridge should be used. The ventilation section should tell you whether general mechanical ventilation (dilution ventilation) is sufficient, or if local exhaust ventilation is recommended, and if so, what type. This section should also list other recommended personal protective equipment such as gloves, goggles, and protective clothing. Unfortunately, most MSDSs do not tell you what type of gloves to use.

For more information on ventilation, see Chapter 7; for information on personal protective equipment, see Chapter 9. For more detailed information on Material Safety Data Sheets, see the references at the end of this chapter.

Canadian MSDSs

The overall format of an MSDS that meets the Workplace Hazardous Materials Information System (WHMIS) regulations is similar to that of MSDSs required by OSHA in the United States. However, WHMIS requirements are more stringent. I will describe some of the most important differences.

To comply with Canadian regulations, the MSDS must have the name and telephone number of the person, group, or department preparing the MSDS, along with the date of preparation. Also, MSDSs over three years old are not valid.

The section on ingredients must include the chemical identity and concen-

tration of controlled products, of any other ingredient that the manufacturer has reason to believe is hazardous, and of ingredients of unknown toxicity. It must also include the CAS number (Chemical Abstract Services registration number), the UN number (number assigned by the United Nations to hazardous materials being transported), and/or an NA number assigned by Transport Canada and the U.S. Department of Transportation (if no UN number has been assigned).

Toxicological information must include the LD(50) (the single dose by ingestion that kills 50% of the test animals) and the LC(50) (the concentration in air that kills 50% of the test animals inhaling it). Other toxicological information required, in addition to standard toxic and carcinogenic effects, includes information on sensitization potential, reproductive effects, teratogenic effects (birth defects), mutagenic (genetic) effects, and synergism (ability to enhance the effects of, or be enhanced by, other chemicals).

CHOOSING YOUR ART MATERIALS

Use the Least Toxic Materials

One of the first rules of safety is to use the least toxic materials possible. In doing this, you decrease the risk from constant exposure to the materials, and also from possible accidents. Part Two of this book gives extensive lists of materials used in various art processes. By comparing the toxicity ratings of these materials, you can determine the least toxic materials that can be used.

One of the most important areas in which substitution of safer art materials is possible is in the use of solvents and solvent mixtures. Table 4-4 in Chapter 4 lists solvents and their relative toxicity—the least toxic being denatured alcohol, isopropyl alcohol, acetone, and odorless mineral spirits; and the most toxic being the aromatic and chlorinated hydrocarbons. Therefore, any time that an aromatic hydrocarbon such as toluene (found in most lacquer thinners) or a chlorinated hydrocarbon such as perchloroethylene (found in many degreasing solvents) can be replaced with solvents such as acetone or odorless mineral spirits, you are working more safely.

In some cases, selecting an alternative solvent may involve the substitution of one hazard for another. For example, acetone is less toxic but more flammable than most other solvents. Therefore, in replacing a more toxic solvent with acetone, you may be increasing the risk of fire.

Of course the rule of choosing the least hazardous material in terms of toxicity also applies to flammability. If you have a choice between mineral spirits and benzine (VM&P naphtha), you should choose the mineral spirits, since it is less flammable.

The question of safer alternatives applies not only to solvents, but also to other types of art materials such as dyes, pigments, glazes, solders, and so on. Some common safer substitutes are lead-free pottery glazes, enamels, and solders; cadmium-free silver solders; silicon carbide or alumina abrasive blasting agents instead of sand; and fluoride-free fluxes, to give a few examples. Note that in many cases, the substitutes are also toxic, but to a lesser degree. However, in these cases I believe that they can be used with proper precautions if safer alternatives are not available.

Use Water-Based Materials

Water-based materials are usually safer than solvent-based ones because you do not have to be concerned about inhaling solvent vapors. Examples are replacing solvent-based screen printing inks with water-based inks, and using water colors or acrylics instead of oil paints. You have to get Material Safety Data Sheets even on water-based materials because some water-based materials contain a certain percentage of solvents to dissolve the resins. However, this is still usually safer than a material that contains only solvents.

Avoid Powders

Buying materials in liquid form instead of powder form means that you do not have to worry about inhaling the powder. Examples include purchasing wet clay instead of dry clay and liquid dyes instead of powdered dyes.

Choose the Safest Process

There are a variety of process changes that can be used to minimize hazards. These include brushing on paints instead of spraying them, doing wet grinding instead of dry grinding, and using the lowest practical temperature when heating waxes and plastics to minimize decomposition.

Avoid Cancer-Causing Chemicals

In the preceding chapters I have stated that certain materials, for example, benzene (previously found in many paint and varnish removers), asbestos, and most chlorinated solvents should not be used because they are known or probable human carcinogens. Since there is no known safe limit of exposure to cancer-causing materials, and since artists cannot completely eliminate exposure to materials even with respirators, I do not believe that you can work safely with any material that is known to cause cancer.

Using Substitutes

Many artists try a substitute for a few weeks and then give up, saying that the substitute does not work. This is usually due to the fact that the artist has tried to use the new material in the same way as the original material. The problem is that substitutes, especially when substituting water-based materials for solvent-based ones, have their own properties and take time to learn how to use. For example, you would never try to use acrylics or water colors in the same painting technique as oil paints.

New Materials

In this book I try to provide information on the hazards of art materials whenever the information is available, and if I know that a particular chemical is being used. However, artists often experiment with new materials and found materials, or use old materials in new and possibly dangerous ways. In these cases you should always specifically ask the manufacturer for information in writing on the hazards of the material and what precautions to take. In some instances, the way in which you are using it might not be covered in the Material Safety Data Sheet.

▮▮▮ NEED FOR RESEARCH

Finding less toxic substitutes for many of the art materials presently being used is one area in which much work needs to be done. Art students interested in the properties of art materials could do research in this area, possibly even for dissertations. A more important source of research, of course, should be the art material manufacturers, which should be developing the safest art materials possible. This area of developing safer substitutes is one of the more crucial research needs.

▮▮▮ REFERENCES

Accrocco, J. O. (1988). *The MSDS Pocket Dictionary* (rev.). Schenectady, NY: Genium Publishing Company.

Callaghan, Dumschat, and Whiting. (1989). *The Material Safety Data Sheet: A Basic Guide for Users*. Hamilton, Ontario: Canadian Centre for Occupational Health and Safety, CCOHS No. P87-16E. (This publication is also available in French.)

National Fire Protection Association. (1988). *NFPA 10. Portable Fire Extinguishers*. Boston: NFPA.

Ventilation Of Your Studio

Ventilation, which can be defined as the use of airflow to control the environment, has three basic purposes: (1) to control heat and humidity for comfort; (2) to prevent fire and explosions; and (3) to remove toxic vapors, gases, dusts, and fumes. The first reason is the most familiar, for example, using air conditioners to cool rooms on hot days. However, for artists and craftspeople, the second and third reasons for ventilation can be critical to their health.

Many solvents and their mixtures contain the warning "Use with adequate ventilation" on their labels. The question is, what is "adequate ventilation"? To many people, this simply means opening a window or door. Except when working with very small amounts of solvents, however, this is not adequate ventilation, since you have no control over the direction or the amount of the airflow. The wind might blow the contaminants in your face. Nor is an air conditioner adequate ventilation. Air conditioners recirculate the air, including whatever is contaminating the air. Even on vent, most of the air is recirculated.

Many people also think that working outdoors is sufficient protection. With highly toxic materials, this is not sufficient if there is no wind or if the wind happens to change direction and blow the toxic vapors or gases back in your face. This can also happen if you depend only on an open window.

In the discussion that follows, I discuss what constitutes adequate ventilation in different situations.

There are two basic types of ventilation: general or dilution ventilation, and local exhaust ventilation. General ventilation operates on the principle of diluting the concentration of toxic materials in the air you breathe by mixing in uncontaminated air, and then exhausting the air. Local exhaust ventilation, on the other hand, works on the principle of capturing the toxic materials at their source before they have a chance to contaminate the air in the room that you breathe.

Obviously, local exhaust ventilation is preferred in cases in which the contaminants are highly toxic, or in which large amounts of toxic materials are being produced. Examples are the use of aerosol sprays, washing of printing screens, etching with nitric acid, resin casting and molding, drying of screen prints, and kiln firing. Dusts and fumes from processes such as welding, mixing dry clay, and grinding operations are also usually best controlled by local exhaust ventilation. In addition, since local exhaust ventilation requires the exhaust of less air than dilution ventilation, it is a cheaper method in situations in which you have to heat or cool the incoming makeup air to make it comfortable.

DILUTION VENTILATION

A dilution ventilation system can consist of a supply of clean air, air heaters or coolers to make the air comfortable, blowers, and exhaust fans. In some cases, ducting may be necessary to transport the clean air to where it is needed. The minimum needed is a supply of clean air and an exhaust fan.

The sources just listed do not include air conditioning. Although air conditioning is useful in providing comfort, it can be hazardous in art studios and workshops, since these systems will recirculate any toxic vapors or gases in the air. In addition, when the ventilation system is tied into the rest of the building, as in central air-conditioning systems, other people may needlessly be exposed to toxic substances. The use of filters and other types of air cleaners to remove toxic contaminants from recirculating air-conditioning systems is not advisable because of the constant need for ensuring that the air cleaner is working properly. Studios using toxic substances should have their own ventilation systems, and they should not be the recirculating type.

In using a general ventilation system to dilute toxic solvent vapors, the important question is how much air is required to dilute the vapors to a safer level. The ventilation rate depends on the toxicity of the material, the amount of material being evaporated, the time period over which this occurs, and the degree to which the contaminated and uncontaminated air mixes. If these factors are known, the required ventilation rate can be calculated (see the book *Ventilation* in the references for this chapter).

For example, if a pint of mineral spirits is used and evaporates over a four-hour period, then the amount of dilution ventilation needed would be about 1,400 cubic feet per minute (using a safety factor of 10). If you increased the amount evaporated, the amount of dilution ventilation needed would be correspondingly increased. If the solvent evaporates over a longer period of time, then the amount of dilution ventilation needed would decrease, since the solvent concentration would be less at any given time. Other solvents have different dilution exhaust rates.

The following are some simple rules to observe for dilution ventilation:

1. Do not use dilution ventilation with highly toxic materials or with large volumes of toxic materials. The amount of makeup air needed for large amounts of gases or vapors, or highly toxic ones, is very large. Dilution ventilation should also not be used with dusts, since you will be stirring up the dust.

2. Make sure that enough clean or makeup air is entering the studio to replace or make up for the air being exhausted. Otherwise your ventilation system will not be working as designed. A simple way to check this is to open the door to your studio. If the door opens outward and is difficult to open, or if it opens inward and opens too easily, then you are not providing sufficient makeup air.

3. When large quantities of makeup air are required, a fan should be used as a blower to supply the air to prevent a negative air pressure in the studio.

4. Make sure that the air intake and exhaust are sufficiently far apart so that the contaminated air leaving the studio does not reenter through the air intake.

5. The ventilation system should be designed so that the fresh air passes through your breathing zones before being contaminated and exhausted (see Figure 7-1). For this reason, overhead exhaust fans are usually not recommended.

6. Make sure that the clean makeup air reaches all parts of the studio and that there are no uncomfortable drafts.

7. If necessary, cool or heat the makeup air to a comfortable temperature.

8. Check the components of the ventilation system regularly to see that they are working properly.

9. Make sure that the exhaust fan has sufficient capacity to meet the required ventilation rate (see the section on fans in this chapter). Note that just opening a window will not provide ventilation, since the direction of airflow will depend on the wind direction.

Figure 7-1. Good and Bad Dilution Ventilation

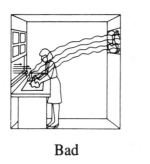 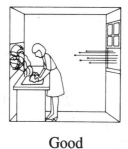

Bad Good

Illustration by Sedonia Champlain

10. A simple way to test the effectiveness of your dilution ventilation is to use a child's soap bubble kit. The movement of the soap bubbles will show you the air patterns in the room. If the bubbles just fall, then your system is not effective.

LOCAL EXHAUST VENTILATION

Local exhaust ventilation is usually preferred over dilution ventilation. Not only does it involve the movement of less air (requiring a smaller fan and less heating or cooling), but, more importantly, it prevents any exposure to the toxic materials. Furthermore, local exhaust systems can be used to control dust, which is impossible to achieve with dilution ventilation.

The components of a local exhaust system are shown in Figure 7-2, and consist of a hood, ducting, and exhaust fan. Ideally, it should also have an air-cleaning device in front of the exhaust fan to remove the contaminants so that the environment is not polluted. The reason for using exhaust rather than blowing to capture the contaminants can also be seen from Figure 7-2. The blowing effect extends for a considerable distance, but is limited to a narrow volume of space. Exhausting, on the other hand, pulls the air from all directions. However, as you can see, the velocity of the air entering the hood drops off very rapidly as you get further from the exhaust hood opening. For this reason, local exhaust hoods should be located as close to the source of contamination as possible.

In certain types of processes, the Occupational Safety and Health Act of 1970 requires local exhaust ventilation (for those workplaces covered by OSHA). These include abrasive blasting, grinding, polishing and buffing, spray finishing and painting, welding, open surface tanks of solvents and other toxic liquids, cut-

Booth type Hood

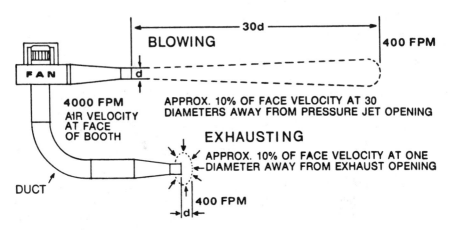

Figure 7-2. Diagram of local exhaust system.
Committee on Industrial Ventilation. (1992). Industrial Ventilation: A Manual of Recommended Practice, 21st ed. Cincinnati: Ameri-can Conference of Governmental Industrial Hygienists.

ting, and brazing. Also, local exhaust ventilation is required with flammable and combustible liquids in storage rooms and enclosures. If OSHA applies to you, you should check its regulations for these processes. Of course individual artists should also use local exhaust ventilation in these instances. The following are simple rules for local exhaust ventilation:

1. Enclose the process as much as possible. The more the process is enclosed, the lower the chance of contaminating the studio and the less airflow required.

2. Make sure that the airflow at the source of the contamination is great enough to capture the contaminant so that it does not escape into the studio. The velocity required is called the capture velocity. Dusts require a much higher capture velocity than do vapors and gases.

3. Make sure that the flow of contaminated air is away from your face so that you do not inhale airborne toxic materials.

4. Make sure that the exhausted air cannot reenter the studio.

5. Make sure that you supply enough makeup air to replace the air exhausted.

6. Regularly check the local exhaust system to make sure it is working. Use soap bubbles as a test. The bubbles should be steadily drawn into the exhaust hood.

Local Exhaust Hoods

Basically there are three types of local exhaust hoods: enclosures, receiving hoods, and exterior hoods.

Enclosures. Complete enclosures are not common in art processes because of the artist's need to work with the materials. One example of a complete enclosure would be a venting system attached directly to a gas-fired kiln. More common types of modified enclosure hoods found in art processes are laboratory fume hoods and spray booths in which the process is carried on inside the hood, but the hood is partially open on one side. See the spray booth, for example, in Figure 7-3.

Receiving Hoods. With receiving hoods, the exhaust hood receives a stream of contaminated air and then exhausts it. The source of the gases, vapors, or dusts is not inside the hood. Receiving hoods take advantage of the natural patterns of airflow induced by the art process. For example, receiving hoods are often attached to grinding wheels, sanders, and woodworking machines so that the hood is located in the pathway of the dust as it is thrown off by the machine (see the dust-collecting hood in Figure 7-3).

Another type of receiving hood is a canopy hood (see Figure 7-3). A common example is an overhead stove hood that captures the rising steam and grease from cooking. Canopy hoods are useful for venting kilns because the hot fumes and air rise. The major problem with canopy hoods is that your head can be in the pathway of the contaminated air if you lean over the process. Therefore they are not recommended in situations in which you are working over the contaminant source. In addition, canopy hoods require a lot of exhaust air and are not very effective at a distance from the source of the contaminants.

Exterior Hoods. Exterior hoods are similar to receiving hoods except that exterior hoods do not depend on a natural flow of contaminated air into the hood. Instead, the contaminants have to be pulled into the hood by the exhaust air alone. The exhaust air has to have an adequate capture velocity. The slot hood and plain opening hood in Figure 7-3 are examples of exterior hoods. Slot hoods, for example, are often used for soldering operations, solvent cleaning operations, and screen printing. Plain opening hoods with flexible ducts are often used for welding. Another example of an exterior hood is an exhaust hose hooked up to an electric drill or similar hand tool (see Figure 7-4).

With exterior hoods, the limiting factor in efficiency is how far the source of contamination is from the hood inlet. For most effective use, try to place the exhaust hood as close as possible. Another way to improve the efficiency is to put flanges or side shields on the hood inlet to control the flow of air so that all the air entering the inlet comes from the contamination source.

Figure 7-3. Hoods for local exhaust ventilation systems *Illustration by Sedonia Champlain*

Local Exhaust Ventilation for Art and Craft Processes

CANOPY HOOD

Process: ceramic kiln, metal foundry, forging.
Form: vapor, gas, fume, steam.
Not ready made.*

Advantages
Captures upward-moving contaminants.
Good for heat-producing operations.
Handles surges of hot air.
Easy to construct.
Designed in various sizes.
Disadvantages
Exposes worker to contaminants if he works under hood.
 Often used improperly.
Should not be used for dust.

SLOT HOOD

Process; silkscreening, acid etching, bench welding, soldering.
Form: vapor, gas, fume.
Not ready made.*

Advantages
Has universal applications.
Does not interfere with most processes.
Can cover a long work area: four-foot maximum selections are used side by side.
Good for processes performed on a work bench.
Disadvantages
Work must be kept in close proximity of slot opening.
Work-table depth has a 36" maximum.
Can be difficult and costly to construct.

SPRAY BOOTH
and other enclosed hoods

Process: spraying laquer, paint, ceramic glazes, flammable materials, highly toxic materials.
Form: vapor, gas, fume, dust.
Ready made.*

Advantages
Completely encloses contaminant.
Safest hood for flammables and highly toxic materials.
Conserves materials.
Reduces housekeeping.
Designed in various sizes.
Disadvantages
Cost of operation high.
Requires more space than other hoods.
Requires constant cleaning.

PLAIN-OPENING HOOD

Process: welding, soldering, art conservation.
Form: vapor, gas fume.
Ready made.*

Advantages
Can be used in areas where conventional hood will not fit.
Can be connected to flexible ducting for repositioning to fit work and for several alternating locations.
Easy and inexpensive to construct.
Disadvantages
Must be in a range of four to six inches from opening for effective capture.

DUST-COLLECTING HOOD

Process: grinding, woodworking, polishing.
Form: dust.
Sometimes ready made.*

Advantages
Reduces housekeeping.
Reduces fire hazards.
Disadvantages
Ready-made hoods often ineffective.
Requires constant cleaning.

* Ready-made hoods are available in set sizes and are complete with all equipment from manufacturer and dealers. Others must be fabricated by a sheet-metal shop.

168

Figure 7-4. Local exhaust of an electric drill. *Illustration by Carlene Joyce Meeker*

In cases in which a local exhaust system is too expensive or impractical for an individual artist, a modified local exhaust can often be obtained by use of a window exhaust fan and screens or walls to control the direction of the airflow. Note that the fan should be at or slightly above table level, since solvent vapors do not normally fall (except in still-air situations). The work table should be placed right against the window to have the art process as close as possible to the window fan. This is shown clearly in the example of good ventilation in Figure 7-1.

This type of system in combination with a respirator might be used in cases such as paint spraying or polyester resin casting, in which the respirator will protect you while working and the exhaust fan will remove the vapors so that your respirator can be removed after work. Of course this should be a last resort, not a first choice.

EXHAUST DUCTS

Ducts in local exhaust systems transport the contaminated air from the hood to the point of discharge. In the case of dust contaminants, the air velocity in the duct must be high enough to prevent the dust from settling in the ducts (at least 3,500 feet per minute).

If the ducts are just transporting solvent vapors, fumes, or gases, then the duct velocity is a compromise between the various costs of duct size, fan size, motor size, and power consumption. For example, larger ducts—which are more

169

expensive—permit lower transport velocities and therefore smaller fans. Often duct velocities between 1,200 and 2,500 feet per minute are used.

Normally in local exhaust ducts, circular ducts are used rather than the rectangular ducts common in air-conditioning. Ducts should be made of fire-resistant materials. If the material being exhausted is corrosive, the ducts should be corrosion resistant. Ducts should have as few bends as possible and should not have sharp changes of direction, since these can cause a loss of air velocity, which would have to be overcome by a more powerful fan. Industrial ventilation manufacturers can supply the ducting needed. Details on designing hood and duct systems can be found in the references for this chapter.

FANS

Fan selection is one of the most important parts of ventilation system design. There are two basic types of fans: axial flow fans and centrifugal fans (see Figure 7-5). In axial flow fans, the direction of airflow is parallel to the axis of rotation of the fan. The standard propeller fan is one of the most common examples. This type of fan is normally used for dilution ventilation of solvent vapors and gases and sometimes for spray booths if there are only a few feet of ducting. Axial fans are not effective in exhausting air against resistance (e.g., from filters, long stretches of ducts, hoods).

With centrifugal fans (e.g., squirrel cage fans), on the other hand, the airflow is perpendicular to the fan axis of rotation. Centrifugal fans—especially the radial blade type—are commonly used for dusts, for example, from grinding, mixing clay, and sanding.

Choosing a Fan

In choosing a fan, the following factors should be considered:

1. *Required airflow.* The size and type of fan you choose will depend to a great extent on the ventilation rate needed. For example, propeller fans are used for removing large volumes of air at low velocity, whereas centrifugal fans are used when less air movement is needed, but at a higher velocity (e.g., for dusts).

2. *The nature of the contaminant.* As discussed above, the contaminant determines whether you will choose an axial flow or centrifugal fan. In general, centrifugal fans are used for dusts.

Axial Flow Fans

Centrifigul Fans

MOUNTING RING

PROPELLER FAN

BACKWARD CURVED BLADES

TUBE-AXIAL FAN

STRAIGHT OR RADIAL BLADES

GUIDE VANE

VANE-AXIAL FAN

FORWARD CURVED BLADES

Figure 7-5. Basic fan types.
This material is reproduced with permission from American National Standard Fundamentals Governing the Design and Operation of Local Exhaust Systems, ANSI Z9.2 1989, copyright 1989 by the American National Standards Institute. Copies of this standard may be purchased from the American National Standards Insitute at 11 West 42nd Street, New York, N.Y. 10036.

3. *Flammability and explosive hazards.* If the contaminant is flammable or explosive, special types of fans will be needed (see the next section).

4. *Noise level.* The higher the speed of the fan blade tip, the noisier the fan. This can be an important factor limiting the speed of the fan. With propeller fans, you can often cut the noise level and achieve the same airflow rate by using a larger fan blade with a slower fan speed. Some fans can be equipped with silencers. In addition, vibration is often a major source of noise. This can be prevented by mounting the fan on rubber shock absorbers.

FIRE AND EXPLOSION HAZARDS

If flammable solvents evaporate in an enclosed space—for example, in a solvent storage room—there is a chance of an explosion if the concentration of solvent vapors builds up to the lower explosive limit for that solvent and there is a source of ignition present. In such cases, exhaust ventilation is needed to ensure that the lower explosive limit is not reached.

Reaching the lower explosive limits of a solvent is not a problem if you are properly ventilating your studio to protect yourself against the health hazards of the solvent. The reason for this is that the concentrations of solvents that are unhealthy are much lower than the lower explosive limits; therefore, ventilating for health reasons will automatically keep the vapor concentration in the studio below the lower explosive limit.

Local exhaust systems that are exhausting flammable solvents or gases require special consideration. If the fan motor is in the path of the solvent vapors (i.e., inside the duct), then an explosion-proof fan motor is necessary because the solvent vapors inside the duct might build up to the lower explosive limit, and a spark from the motor could set off an explosion. If the fan motor is outside the path of the vapors and a belt-driven fan is used, then the blades should be non-sparking (e.g., aluminum) and the belt should be enclosed. All fan parts should be electrically grounded and conform to standards of the National Board of Fire Underwriters and the National Fire Protection Association (NFPA).

Explosion-proof fans might also be necessary in dilution ventilation systems when there is a risk of spilling large amounts of flammable solvents, or when solvent-containing materials are sprayed outside a spray booth.

HELP WITH YOUR VENTILATION SYSTEM

This chapter has described the principles of ventilation for exhausting toxic, airborne chemicals. But how do you actually go about the actual design and installation of a ventilation system?

If all you need is a window exhaust fan, then it is fairly simple. You can calculate the capacity of the exhaust fan in cubic feet per minute if you know how much solvent you are evaporating, as discussed earlier. The book *Ventilation* tells you how to do this for many solvents. Similarly, spray booths and movable exhaust hoods for welding can be purchased directly. If you are not sure what type of system you need, you should consult an industrial hygienist or contact the Center for Safety in the Arts.

However, often you need experts to design your exhaust system, build it, and install it. For this, you need a registered professional engineer with expertise in industrial ventilation. Most heating, ventilating, and air-conditioning engineers do not have this expertise, although with the help of the books in the chapter references, they should be able to do the job. Ask whoever you get to design the system for references from similar types of jobs and check them.

The actual manufacture and installation are often done by sheet metal workers. Make sure that any electrical work is done by licensed electricians. The installation and testing of the ventilation system should be supervised by the engineer.

REFERENCES

American National Standards Institute. (1971). *Fundamentals Governing the Design and Operation of Local Exhaust Systems.* ANSI Z9.2-1971. New York: ANSI.

Clark, N., Cutter, T., and McGrane, J. (1984). *Ventilation.* New York: Lyons & Burford, Publishers.

Committee on Industrial Ventilation. (1992). *Industrial Ventilation: A Manual of Practice.* 21st ed. East Lansing, MI: American Conference of Governmental Industrial Hygienists. (Updated regularly).

8

Using Flammable and Toxic Art Materials Safely

The storage of your art materials, their handling, cleanup of spills, disposal of waste art materials, and other precautions depend on the flammability and toxicity of the art materials.

▒▒▒ FIRE AND EXPLOSION

In my inspections of many artist's studios, school art rooms, and college art departments, I have often found fire hazards to be the greatest immediate problem, especially because of poor solvent storage. Fire is not only a risk to artists working with flammable or combustible materials, but also to other people in the area who might get caught in the fire and to property. In this chapter, I discuss fire and explosion hazards, flammable and combustible liquids, combustible solids, spontaneous combustion, oxidizing agents, and compressed gases. Electrical fire hazards are discussed in Chapter 10.

The Fire Triangle

For a fire to start, three conditions must be met at the same time. There must be (1) something to burn—a fuel; (2) a source of oxygen—air or some other oxidizer; and (3) a source of ignition, such as a flame, sparks, static electricity, hot metal surfaces, or heated electric elements.

Flammable and Combustible Liquids

Most municipalities have their own fire regulations relating to the storage and use of flammable and combustible liquids. In addition, places in which people are employed are covered by the regulations of the Occupational Safety and Health Act of 1970. The National Fire Protection Association (NFPA) and the standards of the American National Standards Institute (ANSI) are the basis for these regulations in most cases. Unfortunately, there are no uniform fire-prevention standards for artists' studios. This is particularly a problem in commercial lofts used both as studios and for living.

Flammable versus Combustible. According to NFPA definitions, a liquid is defined as *flammable* if its flash point is under 100°F (38°C), and *combustible* if its flash point is at or above 100°F (38°C). The flash point of a liquid is the lowest temperature at which the liquid gives off enough vapors to form an ignitable mixture with air at the surface of the liquid. Most common solvents used by artists are flammable, as defined above.

As shown in Table 8-1, flammable liquids are divided into Classes IA, IB, and IC, depending on their flash points and boiling points. Class IA and IB liquids have flash points below normal room temperature, and therefore can cause flash fires under normal conditions. Class IC liquids, with flash points above room temperature, are a fire hazard on hot days or if near a source of heat.

Combustible liquids are divided into Class II liquids with flash points between 100° and 140°F (38° and 60°C), and Class III liquids with flash points above 140°F (60°C). Class III liquids are subdivided into Classes IIIA and IIIB. (Note that if you heat a liquid to within 30°F degrees (17°C) of its flash point, you should treat it as a liquid of the next lower class.)

The above definitions of flammability and combustibility are used by the Occupational Safety and Health Administration (OSHA) and most municipalities. However, consumer products bought in hardware stores and art supply stores—including paint removers, aerosol sprays, and thinners—come under the jurisdiction of the Federal Hazardous Substances Act (FHSA), which has slightly different definitions of flammability and combustibility.

Under the FHSA, a consumer product must be labeled as *extremely flammable* if its flash point is below 20°F (-7°C), as *flammable* if its flash point is

175

TABLE 8-1. Flammability and Combustibility of Liquids

Class	Flammable Liquids
IA Flash point: below 73°F (23°C) Boiling point: below 100°F (38°C)	Ethyl ether "Extremely Flammable" aerosol sprays
IB Flash point: below 73°F (23°C) Boiling point: over 100°F (38°C)	Acetone Benzene (benzol) Benzine (VM&P naphtha) Butyl acetate Cyclohexane Dioxane Ethyl acetate Ethyl alcohol Ethylene dichloride Gasoline Hexane Isopropyl alcohol Methyl acetate Methyl alcohol Methyl ethyl ketone Toluene (toluol)
IC Flash point: 73–100°F (23–38°C) Boiling point: over 100°F (38°C)	Amyl acetate Amyl alcohol Butyl alcohol Methyl butyl ketone Methyl isobutyl ketone n-Propyl alcohol Styrene Trichloroethylene Turpentine Xylene (xylol)

Class	Combustible Liquids
II Flash point: 100°–140°F (38–60°C)	Cellosolve acetate Cyclohexanone Dimethyl formamide Ethyl silicate Isoamyl alcohol Kerosene Methyl cellosolve Mineral spirits
IIIA Flash point: 140–200°F (60–93°C)	Butyl cellosolve
IIIB Flash point: over 200°F (93°C)	Cellosolve Diethylene glycol Ethylene glycol Hexylene glycol

between 20° and 80°F (-7°and 27°C), and as *combustible* if its flash point is between 80° and 150°F (27° and 66°C). Examples of extremely flammable liquids are acetone, hexane, benzene (benzol), gasoline, and ethyl ether. Further, aerosol sprays that are labeled extremely flammable under the FHSA are considered by NFPA to fall within Class IA.

The basic difference between the two definitions lies with liquids with flash points between 80° and 100°F (27° and 38°C). Liquids in this category are defined as flammable Class IC liquids by the NFPA, but are defined as combustible by the FHSA. The most common liquids in this in-between category are turpentine, xylene (xylol), styrene (in polyester resins), and some components of lacquer thinners. This difference in the two definitions can become important on hot days, when the temperature in your studio might reach the flash point of these liquids. In this case they should be considered as flammable. Class IIIA liquids are not combustible according to the FHSA.

Storage of Flammable and Combustible Liquids. Table 8-2 lists the NFPA recommendations for maximum container size and type for the various classes of flammable and combustible liquids, and the maximum recommended storage quantities outside an approved storage cabinet (see Figure 8-1). Note that in any teaching situation, the maximum container size for Class I and II liquids is one gallon (although two-gallon safety cans are allowed). The safety cans should meet NFPA and OSHA standards.

As mentioned earlier, however, you should check your local fire department for special regulations. For example, in New York City, you need a fire permit to store or use more than 5 gallons of Class I and II liquids combined, more than 10 gallons of Class IIIA liquids, or more than 20 gallons of paints. Approved storage cabinets may be used to store up to 60 gallons of Class I and II liquids combined.

Precautions. Here are some simple rules that can help prevent fires caused by flammable and combustible liquids.

1. Purchase in as small a quantity as possible. Although larger containers might be cheaper on a per volume basis, having large quantities of flammable or combustible liquids around is a serious fire hazard.

2. Do not smoke or permit smoking in any studio containing flammable or combustible liquids. Flammable vapors can travel considerable distances, resulting in fire hazards in other parts of the studio.

3. Keep all other sources of ignition away from flammable liquids. This includes flames, sparks, static electricity, hot metal surfaces, and electric elements.

4. When pouring flammable liquids from large metal drums into metal containers, connect the two metal containers together with wire to bond

177

Table 8.2 Storage of Flammable and Combustible Liquids

Type of Container	Maximum Container Size				
	Flammable			Combustible	
	Class IA	Class IB	Class IC	Class II	Class IIIA
Glass or approved plastic	1 pt	1 qt	1 gal	1 gal	1 gal
Metal	1 gal	5 gal*	5 gal*	5 gal*	5 gal
Safety cans	2 gal	5 gal**	5 gal**	5 gal**	5 gal
Metal drums (approved by Dept. of Transport)	5 gal*	5 gal*	5 gal*	60 gal*	60 gal

Type of building	Maximum storage quantities				
Less than three dwellings in building	Maximum of 25 gal of Class I and II combined				60 gal
More than three dwellings in building	Maximum of 10 gal of Class I and II combined				60 gal
Educational facility	Maximum of 10 gal of Class I and II combined or maximum of 25 gal in safety cans				60 gal

This table is based on recommendations of the National Fire Protection Association.
*In teaching situations, the maximum container size is 1 gallon.
**In teaching situations, the maximum container size is 2 gallons.

Figure 8-1.

Oily waste can

Flammable storage cabinet with safety cans

Safety disposal can

Plunger cans

Courtesy of Lab Safety Supply, Inc., Janesville, WI

179

them. This prevents the buildup of static electricity, which can ignite the flammable liquids. The metal drum should also be grounded with a ground wire leading to a ground such as a tap or radiator.

5. Store flammable and combustible solvents in safety cans in the studio. For dispensing small amounts of solvents, store the solvents in spring-loaded dispensers (see Figure 8-1).

6. Make sure all electrical equipment is in good repair and adequately grounded. In areas in which large amounts of flammable liquids are used, all wiring and equipment should meet standards of the NFPA's Electrical Code. (See also Chapter 10.)

7. Fans in local exhaust ventilation systems should have nonsparking or nonferrous blades, and the motor and controls should be outside the path of the vapors or be explosion proof.

8. Do not use gas-fired space heaters unless the heater is approved for use in the presence of flammable materials.

9. Waste flammable or combustible liquids should be stored in approved solvent disposal cans, while awaiting proper disposal (see Figure 8-1). See the waste management section later in this chapter.

10. Solvent-soaked rags and paper should be stored in self-closing oily waste cans or other closed metal containers. These should be emptied daily. See the waste management section for disposal methods.

11. Do not store flammable or combustible liquids near escape routes from studios.

12. Keep a dry chemical or carbon dioxide fire extinguisher on hand for emergency use.

13. Clean up spills of flammable liquids immediately. See the detailed discussion of spill control later in this chapter.

Flammable and Combustible Solids

Many solids are combustible and can create fire or explosive hazards if proper precautions are not taken to prevent sparks, static electricity, or other sources of ignition. The greatest hazard (equivalent to extremely flammable liquids) results from those solids that can form an explosive mixture with air. Examples include finely divided dusts of combustible solids such as carbon; metal powders such as aluminum, zinc, magnesium, and iron; wood dust, rosin dusts, and plastic dusts. This type of explosion hazard is commonly associated with grain elevator explosions, but can occur in studios. In one instance, a rosin aquatint box exploded due to a spark from the movement of the steel handle against the steel bushing.

A lesser but still important flammability hazard (equivalent to flammable liquids) is due to coarse dusts that may burn rapidly but do not form explosive mixtures with air. These include solid fibers and shredded materials such as cotton and hemp, which can create flash fires in the presence of an ignition source.

Precautions

1. Keep sources of sparks, flames, lit cigarettes, and other sources of ignition away from combustible solids.

2. Carefully wet mop or vacuum explosive dusts and other combustible solids and store them in approved self-closing, noncombustible waste cans. Only use vacuum cleaners approved for combustible dusts.

Spontaneous Combustion

Oil-soaked rags are a potential fire hazard if not stored properly. Materials such as linseed oil, tung oil, and other organic oils, as well as turpentine and limonene, slowly oxidize in air and release heat. If the heat cannot dissipate, it builds up and can reach the self-ignition temperature of the rag. This is particularly a hazard when oily rags are placed in piles where the heat cannot dissipate.

Precautions

1. Keep oil-soaked rags in approved oily waste cans that allow air to circulate around the can to dissipate heat. Do not put plastic liners in these containers since that will prevent the heat from dissipating. Empty daily. See the waste management section for disposal information.

2. Alternatives are to hang the oily rags separately, or place them in a pail of water.

Oxidizing Agents

Oxidizing agents, or oxidizers, can react with organic solvents, combustible materials (e.g., wood dust, paper, cloth), and other organic materials to cause fires or explosions. Examples of strong oxidizing agents are:

- chlorates (e.g., potassium chlorate)
- chromium (VI) compounds (e.g., dichromates, chromates)

- hydrogen peroxide, concentrated
- nitrates (e.g., ammonium nitrate)
- nitric acid, concentrated
- periodates (e.g., potassium periodate)
- persulfates (e.g., potassium persulfate)
- potassium permanganate

Precautions

1. Store oxidizing agents away from solvents, combustible materials, and other organic compounds.
2. Do not grind oxidizers into a fine powder.
3. Do not mix oxidizers with solvents or other organic materials. Keep away from paper, wood dust, cloth, and the like.

Oxygen and Flammable Gases

Flammable gases are treated the same as extremely flammable liquids. In this category are acetylene and liquefied petroleum gases used in silver soldering and welding processes. I include compressed oxygen cylinders in this category, since, although oxygen itself is not flammable, it supports combustion and can make combustible materials burn much more readily. This was shown with tragic results several years ago when two astronauts died in a fire that was caused primarily by the high percentage of oxygen in the atmosphere of their space capsule. Note that many cities, including New York City, require fire permits to do oxyacetylene welding. The precautions here and below for handling oxygen and acetylene cylinders, and the general precautions for welding, are adapted from the Canadian Centre for Occupational Health and Safety's Safety Infograms on Gas Welding and Cutting. Detailed precautions are also found in ANSI Z49.1-1973, "Safety in Welding and Cutting." You should also refer to manufacturers' operating manuals for regulators and other equipment.

Precautions

1. Make sure that all compressed gas cylinders you purchase have Department of Transportation (DOT) approvals.
2. Always call oxygen by its name, oxygen; do not refer to it as air. Call fuel gases, such as acetylene, by their proper names; do not call them gases.

3. Store oxygen cylinders at least 20 feet (6 meters) from fuel cylinders or other flammable materials such as paints, solvents, or oil; or separate them by a 5-foot (1.5 meter) high wall with a fire-resistance rating of at least a half-hour. Do not store them near high-traffic areas. Ventilate indoor storage areas.

4. Keep cylinders away from all sources of sparks, electric arcs, open flames, direct sunlight, and other sources of heat.

5. Identify cylinder storage areas, and post No Smoking signs.

6. Secure all cylinders upright with chains or other fasteners.

7. Separate full and empty cylinders. Empty cylinders should be marked empty (or MT); their valves should be closed and protection caps attached.

8. Ensure that grease or oil cannot come in contact with the cylinders, especially near the nozzle or valve, in order to protect against fire. Do not handle with oily or greasy hands.

9. Keep cylinders in carts designed for them. Transport these cylinders upright in carts. When transporting, remove regulators and attach valve protection caps.

10. Do not drag or slide cylinders. Roll them on their bottom edge.

11. If an acetylene cylinder has been on its side, set it upright for at least one hour before use.

12. Open cylinder valves slightly, and then close immediately, to blow out any trapped dust.

13. Never use oxygen or fuel cylinders without attaching to oxygen and fuel gas regulators. Make sure that the proper regulators are attached to the cylinders. Oxygen cylinders have right turning valves and connections; fuel cylinders have left turning valves and connections. Tighten nuts with the right size wrench, not pliers or pipe wrenches. Ensure that all connections are tight. Check the accuracy of regulator pressure gauges annually.

14. Check hoses for damage before attaching. Connect one end of the green (or black) hose to the oxygen regulator, and the other to the oxygen inlet on the torch. Connect the red hose to the fuel cylinder and the fuel inlet on the torch. Tighten hose nuts with fingers before using a wrench.

15. Before opening cylinder valves, drain the regulator of gas by fully releasing the pressure-adjusting screw and opening the downstream line to the air.

16. Stand to one side away from the regulator face when opening cylinder valves. Open cylinder valves slowly, using approved keys or handwheels.

Do not force. Oxygen cylinders should be opened fully, but acetylene cylinder valves should be turned only 1 1/2 times. Leave key wrenches attached to the cylinder so they can be closed quickly. Never use acetylene at pressures in excess of 15 psi. The use of higher pressures is prohibited by all insurance authorities and by law in many localities.

17. Check the regulators for pressure "creep." If the regulator shows a gradual pressure increase with the torch valves closed, replace the regulator immediately. Never try to repair defective cylinder valves or regulators.

18. When closing down, shut cylinder valves and open torch valves before loosening the pressure-adjusting screw.

19. Never attempt to transfer oxygen or fuel gases from one cylinder to another, refill a cylinder, or mix any other gas or gases in a cylinder.

20. Test for gas leaks at cylinder valves, regulators, hoses, and torch connections every time you set up equipment. Use soapy water (nonfat soap) or an approved leak test solution. If the leak is at the valve stem, close the cylinder valve. If it is at the cylinder valve, attach a regulator as a temporary measure.

21. Should a leak occur in a fuel gas cylinder, take the cylinder out in the open air and post a sign to keep fires or other sources of ignition at least 20 feet (6 meters) away from the leaking cylinder. Open the cylinder valve slightly to allow gas to escape slowly. Notify the manufacturer at once.

22. When using oxygen and acetylene supplied through distribution piping systems, the instructor must give the trainee specific directions on setting up, taking down, and safety precautions applicable to this equipment.

TOXIC MATERIALS

As discussed in earlier chapters, many art materials are toxic by skin contact, inhalation, or ingestion. The precautions in the next sections tell you how to work safely with various types of toxic materials.

Storage

General Precautions

1. Purchase in as small a quantity as possible. Although larger containers might be cheaper on a per volume basis, having large quantities of toxic

and flammable materials around is more of a hazard, and disposal of left-over amounts is a problem.

2. Obtain Material Safety Data Sheets (MSDSs) on all art materials that have warnings on their label.

3. Label all containers clearly as to their contents and special hazards.

4. Store hazardous materials in nonbreakable containers when possible. Use metal or plastic containers, not glass. Do not use food or beverage containers that might tempt children.

5. Do not store large containers on high shelves where they might be in danger of falling and breaking. Ideally, art materials should not be stored above eye level. If space limitations require you to store materials on high shelves, put a lip on the shelf or use some other means to prevent your art materials from falling.

6. Do not store chemicals that may react with one another in the same area (e.g., acids and ammonia). The reactivity section of Material Safety Data Sheets should tell you what materials to keep away from your art materials.

7. If an art material in powder form comes in a paper bag or sack, store the opened bag in a metal or plastic container with a lid. You can also empty the paper bag into the container.

Handling

General Precautions

1. Keep all containers closed, even when working, to prevent escape of vapors, dusts, and the like into the air.

2. Do not eat, drink, smoke, chew gum, or apply makeup in the studio because of the danger of contaminating the food, cigarettes, or liquids. This can result in ingestion of toxic materials. Furthermore, smoking can multiply the harmful effects of many toxic materials on the lungs and, in some cases, can even convert materials into more hazardous forms. For example, methylene chloride, used as a plastics and paint solvent, can be converted into the poisonous gas phosgene by lit cigarettes.

3. Wear separate clothing in the studio and remove it after work. Wash it frequently and separately from other clothing. This prevents you from transporting toxic materials home or into living areas.

4. In cases of spills or accidental contact with irritating or corrosive chemicals, wash the affected area with lots of water. In case of eye contact, rinse your eyes for at least 15 to 20 minutes and call a doctor. Eyewash foun-

tains should be available. If you are working with concentrated acids or alkalis, you should have access to an emergency shower. See Chapter 11 for more details on first aid.

5. Wash hands carefully with soap and water after work, before eating, and during work breaks. Never use solvents to clean your hands; if soap and water are not sufficient, use baby oil, a vegetable oil, or a waterless hand cleanser and then soap and water. Make sure that the hand cleanser is not abrasive or alkaline and does not contain solvents.

Special Precautions for Liquids

1. Wear gloves or protective barrier creams to protect your hands against dermatitis from solvents, acids, and alkalis. See Chapter 9 for more details on gloves and barrier creams.

2. Wipe up small spills immediately with paper towels and place these in an approved, covered oily waste can to prevent evaporation of volatile liquids into the air. Cleaning up larger spills is discussed later in this chapter.

3. If the liquid is stored in a large container (e.g. five-gallon drum), use a hand pump to dispense the liquid. Do not pour by tipping the drum because of the danger of spilling. If the liquid is flammable, see special precautions to prevent fires earlier in this chapter.

4. Wear hooded safety goggles when pouring liquids that can splash and cause eye damage (see Chapter 9).

Special Precautions for Powders

1. Transfer powders that create dusts with spoons, scoops, or similar implements. Do not dump powders, since this creates a lot of dust in the air.

2. To prevent inhalation, handle dusts in wet form whenever possible. Make up large batches rather than several small batches to keep exposure to dusts to a minimum.

3. Mix small amounts of powders into liquid form inside a glove box to prevent inhalation of dust. A glove box is made by covering an ordinary cardboard box with a glass or plexiglas top, or clear plastic film, and then cutting two holes in the sides for your gloved hands (see Figure 8-2). The powder is made into a paste or concentrated solution inside this glove box. After mixing and allowing any dust to settle, the liquid solution or paste can be removed and diluted as desired. The glove box can be wiped clean.

Figure 8-2. Enclosure for mixing powders

Illustration by Sedonia Champlain

4. Wear an approved dust respirator when transferring and handling toxic dusts unless you are working in a glove box or with local exhaust ventilation (see Chapter 7).

5. Dust in the air from processes such as stone carving, cutting plastics, and grinding and sanding can be kept to a minimum if you work wet or spray the work area with water. Note that you cannot do this if there are electrical hazards unless you install a ground fault circuit interrupter, and even then the water should not touch the electrical machinery or outlets.

6. Clean up powder spills immediately with wet paper towels or water.

Special Precautions for Toxic Gases. Many art processes produce toxic gases (e.g., nitric acid etching, welding, photography, kiln firing, cutting plastics). Adequate ventilation and, as a second choice, respiratory protection are the only ways to protect against these hazards. See Chapters 7 and 9.

Housekeeping and Spill Control

Routine cleaning up after work and keeping your work area clear of toxic materials is essential to prevent needless exposure. This is even more crucial to those who have a home studio and might accidentally contaminate the living areas. Most housekeeping precautions are very simple; however, to be effective they must be followed regularly. Routine housekeeping is particularly important for dusts.

Small spills can usually be cleaned up easily with little problem. Large spills of volatile and flammable liquids can present major hazards due to the evaporation of the liquid. The liquid vapors can present serious health hazards due to in-

halation. High concentrations of flammable vapors are, however, also a fire and explosion hazard if the vapor concentration reaches the lower explosive limit and a source of ignition is present.

Precautions for Dusts

1. Wet mop dusty surfaces and floors. A detergent in the water will help prevent leaving a fine film of dust. Do not sweep or brush, since this just stirs up the dust and contaminates the air. I do not recommend sweeping compounds for floors, since large amounts are needed and it is difficult to use them under shelves and around equipment.

2. For vacuuming wood dust, for example, use only industrial vacuum cleaners. Household vacuum cleaners are not adequate. Industrial vacuum cleaners with wet pickup can also be used. For highly toxic dusts such as silica-containing clay dust, use a vacuum cleaner with a special high efficiency HEPA filter to trap the very fine dust that will go through normal industrial vacuum cleaners.

3. If you have a cement floor, seal it so it will not trap dust.

4. If you have a floor drain, you can hose down the floor. However, do not hose down large amounts of plaster or clay unless you have a trap to capture the dusts; otherwise you can clog up the drainpipes.

Precautions for Volatile Liquid Spills

1. Spills of volatile liquids can be a serious inhalation health hazard. If the liquid is also flammable, there is the danger of a fire or explosion if the lower explosive limit is reached by evaporation of the liquid and a source of ignition is present.

2. Large spills of volatile liquids (more than one quart) are serious health hazards and often fire hazards. Such spills require cleanup with self-contained breathing apparatus (SCBA) and needs to be done by experienced personnel (e.g., fire department Hazardous Materials—HazMat—teams). For large spills, follow these procedures:

 - Turn off all open flames if the spill is flammable.
 - Open windows and turn on fans if the spill is not flammable.
 - Notify the fire department or emergency services.
 - Evacuate the area. For very large spills, the building might have to be evacuated.

- Shut off power to the room at a circuit breaker or fuse box outside the room if the spill is flammable. (Turning off lights or motor switches can cause sparks.)

3. For small spills (less than a quart), do the following:

- Turn off flames if the spill is flammable.

- Open windows and turn on fans if the spill is not flammable.

- Evacuate the immediate area of nonessential personnel.

- Wear air-purifying respirators. Only minimal spills do not need respiratory protection. Other personal protective equipment that may be needed include impermeable gloves, goggles, boots, and protective clothing.

- Wipe up the liquid with special spill-control materials available from a safety-supply company, which will absorb the liquid and not allow it to evaporate. Clay dust or kitty litter will also work. Paper towels should *not* be used for more than tiny amounts of volatile liquids because the paper will aid evaporation.

- The contaminated spill-control materials should be placed in a self-closing oily waste can for later disposal (using sparkproof tools for flammable liquid spills).

Precautions for Nonvolatile Liquids

1. If the liquid spilled is hazardous by skin contact, but not volatile (e.g., many acids and alkalis), protective equipment should be worn, including protective clothing, gloves, goggles, and rubber boots.

2. Acids and alkalis can be diluted with water, neutralized, and then mopped up. See the next section on disposal for neutralization procedures. Universal spill-control materials can also be used.

3. If the spill involves two or more incompatible liquids (e.g., acids and cyanide solutions), treat it as a toxic, volatile spill. For cyanide spills, evacuate the whole building.

4. Spills of nonhazardous, water-based liquids (e.g., latex paints, dye solutions) can be cleaned up with paper towels for small spills, or mops and pails for larger spills.

Precautions for Oxidizing Agents

1. Materials such as concentrated hydrogen peroxide, concentrated nitric acid, chromates, and dichromates are strong oxidizing agents that can react explosively with solvents and other combustible materials.

2. Do not touch spills of oxidizers. Keep combustible materials such as wood, paper, and mops away from the spill. Use noncombustible tools for cleanup.

3. See MSDSs for the materials for detailed spill cleanup procedures.

Waste Management

Artists can produce waste materials that need proper disposal. Nonhazardous waste can be placed in the trash for disposal in ordinary landfills. But which art materials are classified as hazardous waste, and how do you dispose of it?

In the United States, the Environmental Protection Agency (EPA) regulates the disposal of hazardous waste under the Resources and Conservation Recovery Act (RCRA). This law and other environmental laws are administered by the individual states. In Canada, the provinces pass the environmental laws. Canadian regulations are usually similar to the U.S. laws.

Legally, everyone—companies, schools, colleges, and even individual artists—has to properly dispose of hazardous waste. If you produce more than 100 kilograms or 220 pounds per month of hazardous waste (or more than 1 kilogram or 2.2 pounds of acutely hazardous waste), then you also have to prove that you disposed of the hazardous waste properly through the EPA's waste manifest system.

Types of Hazardous Waste. There are several categories of chemicals used by artists that come under the heading of hazardous waste. These include:

1. *Hazardous waste chemicals.* Toxic chemicals such as solvents, formaldehyde, lead compounds, mercury, chromates, and so on.

2. *Ignitable waste:*

 - Liquids with a flash point less than 142°F (61°C) (e.g., most solvents)
 - Solids capable of causing fire through friction, absorption of moisture, or spontaneous combustion (e.g., oil-soaked rags)
 - Ignitable compressed gases (e.g., propane, acetylene)
 - Oxidizing substances (e.g., potassium chlorate, concentrated nitric acid, dichromates)

3. *Corrosive waste.* Wastes with a pH less than 2 or greater than 12 (e.g.,acids, alkalis)

4. *Reactive waste:*

 - Normally unstable compounds that can undergo violent change without detonating (e.g., methyl ethyl ketone peroxide)

190

- Compounds that react violently with water (e.g., phosphorus)
- Compounds that form potentially explosive mixtures with water
- Cyanide or sulfide wastes, which can generate dangerous amounts of toxic gases at pHs between 2 and 12.5 (e.g., cyanide electroplating solutions)

5. *Acute hazardous waste.* This is hazardous waste that is very dangerous even in small amounts. You have to follow EPA regulations if you generate more than 1 kilogram (2.2 pounds) of these materials in a month. Examples include arsenic compounds, hydrogen cyanide and cyanide salts, many pesticides, and vanadium pentoxide.

6. *Leachable toxic waste.* These are waste materials that can leach into water more than specified levels of the following metals: arsenic, barium, cadmium, chromium, lead, mercury, selenium, and silver. In addition, leachable levels of other chemicals are regulated, including benzene, cresols, p-dichlorobenzene, methyl ethyl ketone, pentachlorophenol, perchloroethylene, trichloroethylene, and several pesticides.

Other classes of hazardous waste, not normally encountered by artists, include radioactive materials and pathological waste.

Methods of Waste Disposal.

There is a variety of methods of disposing of waste materials, including recycling, treatment, pouring it down the drain, evaporation, ordinary landfills, and taking it to a hazardous waste disposal company. Some of these options do not apply to most hazardous waste.

Recycling. Many waste art materials can be reused or used by someone else. For example, mineral spirits used for cleaning oil painting brushes can be allowed to settle and then strained through fine cheesecloth to remove the solids. The filtered solvent can then be reused. Leftover art materials can be donated to an art center or secondary school. Note that hazardous materials should never be donated to elementary schools, and highly toxic materials like lead glazes should not be recycled.

Sewage system. Besides RCRA, the Clean Water Act and other laws restrict what can be dumped into the sewer system. The concentrations of copper and zinc ions, for example, although not classified as hazardous waste by RCRA, are controlled by sewer codes.

Nontoxic liquids (e.g., neutralized acids and alkalis) and small amounts of some hazardous, water-based solutions (e.g., dye solutions, photographic solutions) can be poured down the drain with lots of water if the sewage system has a waste-water treatment plant with a bacterial treatment stage that can detoxify small amounts of chemicals. Septic tank systems are more sensitive, since you don't want to kill off the septic tank bacteria. Solvents should never be poured down the sink.

Evaporation. Small amounts of solvents or solvent-containing materials (less than a pint) can be evaporated if no better alternative is available. Of course, this evaporation should take place outside, or inside a local exhaust hood where no one will be exposed to the solvent vapors.

Landfill. Nonhazardous, solid waste materials can be placed in the regular trash for carting to a normal landfill. Some toxic materials can also be placed in the trash, including clay, metals, and paint residues. Glazed pottery can also be placed in the trash if it does not leach toxic metals.

Treatment. Neutralization of acids and alkalis and recovery of silver from photographic fixer solutions are two examples of chemical treatment of hazardous waste that artists can do to make it nonhazardous.

Hazardous waste disposal companies. Hazardous materials that can't be properly disposed of in other ways should be taken to a licensed hazardous waste disposal company or picked up by a licensed hazardous waste transporter. Often this can be expensive. If you are considering transporting the hazardous waste yourself, you should be aware that many fire departments restrict the transportation of flammable liquids by car, and RCRA also regulates the transport of hazardous waste.

An alternative is the growing number of household hazardous waste collection programs, often organized by counties or municipalities, that have sprung up in recent years. These are intended to collect hazardous waste from homes. Some of these programs will accept an artist's hazardous waste if the artist has his or her studio at home. Many will accept waste art materials from hobbyists, but not from professional artists. Artists' organizations should lobby these programs to make sure that they will take artists' hazardous waste, and to expand the programs to include artists' studios outside the home. Write the Center for Safety in the Arts for an updated list of hazardous waste contacts in each state.

Table 8-3 lists specific waste disposal recommendations for many common art materials and their wastes.

TABLE 8-3. Recommendations for Disposal of Art Materials

Acids	
dilute solutions	Neutralize to pH 7 by slowly adding baking soda (sodium bicarbonate) until bubbling stops. Check the pH with pH paper. Pour down the sink with lots of water.
concentrated solutions	Small amounts (less than a cup) can be diluted by slowly pouring into 10 parts of water to one of acid, and then neutralized as above. Gloves, goggles, and protective apron should be worn. Always add the acid to the water. For larger amounts, recycle or hazardous waste collection.

Aerosol spray cans	Make sure they are completely empty by spraying, and then place in garbage.
Alkalis	
dilute solutions	Neutralize to pH 7 by slowly adding citric acid or white vinegar using pH paper to indicate when neutral; then flush down drain with lots of water.
concentrated solutions	Small amounts (less than a cup) can be diluted by pouring into 10 parts of water to one of alkali, and then neutralized as above. Always add the alkali to the water and wear gloves, goggles, and protective apron. For larger amounts, recycle or use hazardous waste collection.
solid alkalis	Recycle or use hazardous waste collection.
Ceramics	
clay, minerals	Recycle or place in garbage.
glaze chemicals	Recycle or use hazardous waste collection.
liquid glazes	Recycle if possible. If the glazes contain toxic, leachable metals, use hazardous waste collection; otherwise, place in garbage.
Dyes	
powders	Recycle or place in garbage.
solutions	Pour down drain with lots of water. If the dye bath is acidic or alkaline, neutralize as above.
Glues and cements	
water-based	Allow to dry, and place in garbage.
solvent-based	Allow to evaporate in safe place, and place in garbage.
Metals and compounds	
metals, alloys	Recycle or place in garbage.
compounds	Recycle or use hazardous waste collection for toxic metals; garbage for others.
Paints, varnishes, stains	
water-based	Recycle or allow to dry and then place in garbage; for toxic pigments, use hazardous waste collection.
solvent-based	Recycle. Less than 1 pint: allow to evaporate in safe place, then place in garbage; for toxic pigments, use hazardous waste collection. More than 1 pint: hazardous waste collection.
Pesticides	Hazardous waste collection. Containers, once completely empty, should be triple-rinsed and placed in garbage; rinse water can be used as pesticide.

Photochemicals concentrates	Recycle or use hazardous waste collection.
solutions	Pour down sink, one at a time, with lots of water, if local regulations permit. (See Chapter 15.)
Plastics resins	Recycle or use hazardous waste collection for large amounts. Smaller amounts can be reacted to form solid plastic.
Solvents	
liquid only	Less than 1 pint: evaporate in safe place. More than 1 pint: recycle or use hazardous waste collection. Chlorinated solvents (or mixtures containing them) should be collected separately from other solvents.
solid-containing	Let settle, filter, and recycle.

REFERENCES

American National Standards Institute. (1973). *Safety in Welding and Cutting.* ANSI Z49.1-1973. New York: ANSI.

Babin, A., and McCann, M. (1992). *Waste Management and Disposal for Artists and Schools.* New York: Center for Safety in the Arts.

Canadian Centre for Occupational Health and Safety. (1988). Infograms on Welding. 17 pp. Hamilton, Ontario, Canada: CCOHS.

Environmental Protection Agency. *40 CFR 260 to 267. Hazardous Waste Management Regulations.* Washington, DC: Government Printing Office.

McCann, M. (1992). *Emergency Response for Spills and Leaks.* New York: Center for Safety in the Arts.

National Fire Protection Association. (1987). *NFPA #30. Flammable and Combustible Liquids Code.* Boston: NFPA.

National Fire Protection Association. (1986). *NFPA #45. Fire Protection for Laboratories Using Chemicals.* Boston: NFPA.

National Fire Protection Association. (1974). *NFPA #58. Storage and Handling of Liquefied Petroleum Gases.* Boston: NFPA.

National Institute for Occupational Safety and Health. (1973). *The Industrial Environment: Its Evaluation and Control.* Washington, DC: Government Printing Office.

National Safety Council. (1981). *Accident Prevention Manual for Industrial Operations.* 8th ed. Chicago: NSC.

9

Personal Protective Equipment

Personal protective equipment includes respirators, gloves, face shields, goggles, ear plugs and muffs, and protective clothing and equipment.

WHEN TO USE PERSONAL PROTECTIVE EQUIPMENT

Personal protective equipment should be your last resort because it can be uncomfortable for long periods, it can restrict your mobility, and it does not protect other people in the same environment. In addition, personal protective equipment does not remove the contaminants from your immediate environment. Before deciding to use personal protective equipment, you should try other methods of control, such as substitution of less toxic materials or less hazardous techniques, ventilation, and housekeeping. In fact, this concept is part of the Occupational Safety and Health Act.

If you do decide to use personal protective equipment, then you should be careful to use equipment that meets proper standards. In most cases, these stan-

dards are set by the American National Standards Institute (ANSI) and are used by the Occupational Safety and Health Administration (OSHA). (In Canada, safety equipment is approved by the Canadian Standards Association, CSA.) Approved equipment might cost a little more, but you can be more certain that it will protect you adequately.

RESPIRATORY PROTECTION

Respirators are personal protective devices worn over the mouth and nose, and sometimes the entire face, to protect the wearer against the inhalation of toxic airborne materials. OSHA standards state that respirators are to be used only when appropriate engineering controls are not feasible, while engineering controls are being installed, or in emergencies. OSHA has specific regulations regarding respirator use in workplaces, including a written respirator program.

Types of Respirators

Respirators are of two basic types: air-supplying and air-purifying. Air-supplying respirators provide a source of uncontaminated air for the wearer to breathe. The air can come from a self-contained breathing apparatus (SCBA), compressed air tanks, or a compressor. Air-supplying respirators are expensive and are needed only in cases of oxygen deficiency, or with materials that are immediately dangerous to life or health. Examples of these conditions include welding with cadmium or other highly toxic metals, spraying polyurethane foam resins, sandblasting, and processes that produce asbestos dust. In general, I advise artists not to work with any of these processes because of the extreme hazards involved.

Air-purifying respirators, on the other hand, remove the toxic materials from the air you breathe. They consist of two basic parts: the face piece, and the cartridge and/or filters. The cartridges (or canisters for full-face types) contain chemicals to remove the contaminating gases or vapors. Particulate matter— dust, metal fumes, and mists—are removed by filters that entrap the particles. In some disposable dust respirators, the mask itself is a filter. Also, most respirators can combine a cartridge with a filter to protect against both vapors or gases and particulates.

Air-purifying respirators come in various forms, including full-face masks, half-face masks (covering the nose, mouth, and chin), and quarter-face masks (covering just the mouth and nose). Examples of several different types of respirators are shown in Figure 9-1.

Air-purifying respirators have several advantages. They are inexpensive, easy to maintain, not too large, and restrict the wearer's movements the least.

Figure 9-1.

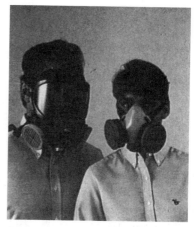

Disposable toxic dust respirator Half face respirator and full face respirator

Courtesy of Lab Safety Supply, Inc., Janesville, WI

Full-face respirators have the additional advantage of protecting against eye irritants and, because of the larger canister sizes, protecting against larger concentrations of toxic contaminants.

The disadvantages of air-purifying respirators are discomfort, difficulty in fitting, need to replace filters and cartridges frequently, and, with half- and quarter-face models, lack of eye protection. In addition, air-purifying respirators do not stop all chemicals from passing though. The standard half-face respirator, for example, is assigned a protection factor of 10. This means that one tenth of the airborne material may pass through the cartridge.

Choosing a Respirator

Choosing the appropriate respirator for your needs is crucial. In many cases, people have used a respirator that is not suited to the contaminants to which they were exposed. This is particularly true of cheap dust masks bought in hardware stores. The most important rule to follow—and, for employers, it is the law—is to buy respirators approved by the National Institute for Occupational Safety and Health (NIOSH) for the particular contaminants to which you are exposed. Different cartridges and filters or combinations of the two are available for protection against particular substances (see Table 9-1 for the best one to choose).

197

TABLE 9-1. Selection of Respirator Cartridges and/or Filters

Substance or Process	Cartridge	Filter
Acids (except nitric acid)	AG	—
Aerosol spray cans	OV	DM
Air brush		
water-based	—	DM
solvent-based	OV	DM
cadmium, chromium (VI) pigments		HEPA
Ammonia	A	—
Asbestos (low levels only)	—	HEPA*
Chlorine gas	AG	—
Dusts (clay, glazes, etc.).	—	DM†
Dye powders	—	DM
Enamel powders	—	DM
Fiberglass dust	—	DM
Formaldehyde	OV	—
Hydrofluoric acid	AG	—
Hydrogen chloride gas	AG	—
Lacquers	OV	—
Metal fumes (casting, welding)	—	DMF†
Metal powders	—	DM†
Paint strippers (solvent type)	OV	—
Pastel dusts	—	DM†
Pigment powders	—	DM†
Plastic resins and glues	OV	—
Plastics sanding, grinding	—	DM
polyvinyl chloride	AG	DM
polyurethane	OV	DM
formaldehyde plastics	OV	DM
Soldering	—	DMF
with acid, fluoride, zinc		
chloride fluxes	AG	DMF
Solvents	OV	—
Spraying		
water-based	—	DM
solvent-based	OV	DM
polyurethane foam resins	SCBA	—
Sulfur dioxide	AG	—
Welding (metal fumes only)	—	DMF†

*Supplied-air recommended for high levels of asbestos dust.
†For arsenic, beryllium, cadmium, chromium (VI), nickel, platinum, and soluble silver compounds, use HEPA or supplied-air respirators.

A ammonia

AG acid gas

DM toxic dusts and mists with a TLV not less than 0.05 mg/m^3

DMF dusts, mists, and fumes with a TLV not less than 0.05 mg/m^3

HEPA high-efficiency filter for contaminants with a TLV less than 0.05 mg/m^3

OV organic vapor

SCBA self-contained breathing apparatus

198

Air-purifying respirators should not be used in situations involving exposure to substances that are immediately dangerous to life or health (including possible long-term effects such as cancer) and exposure to gases or vapors that have poor odor-warning properties. Examples of the latter are carbon monoxide from gas-fired kilns, nitric acid etching gases, and solvents such as methyl alcohol. These gases or vapors with poor odor-warning properties give no warning as to when the cartridge or canister is used up and you are being exposed to hazardous concentrations of these substances. Local exhaust ventilation or supplied-air respirators are recommended in these cases.

Full-face respirators should be used instead of half- or quarter-face respirators when the contaminant is an eye irritant (e.g., ammonia), or when the concentration of the contaminant is high (between 10 and 50 times the TLV). At higher concentrations, supplied-air respirators are necessary. If you think you are being exposed to very high concentrations of toxic contaminants, you should seek professional help. The Center for Safety in the Arts can provide you with assistance. See also the resources in Chapter 2.

Having decided what type of respirator and cartridge and/or filter you need, you have to decide what brand of respirator to buy. The names of safety equipment suppliers that sell NIOSH-approved respirators and other personal protective equipment are listed in the Appendix at the end of this chapter. Many of these companies have local offices in major cities. In addition, most large cities have companies that specialize in distributing personal protective equipment of all types (try the Yellow Pages under Safety Equipment).

Fit Testing

The crucial factors in deciding which company's respirator or brand of respirator to buy are how well and how comfortably the respirator fits.

The correctness of fit is crucial since, if air leaks in, so can toxic contaminants. Since people have different face sizes and shapes, it is not surprising that one model of respirator does not fit everyone. In the past, women in particular had difficulty finding respirators that fit, since most respirators were designed for men's faces. Today, most companies have respirators in different sizes, so you should be able to find one that fits.

There are some simple tests that can be used to find out if a respirator fits properly. The first, a negative pressure test, consists of closing off the inlets of the cartridges or filters by covering them with the palms of your hands (or by putting on the seal), inhaling gently until the mask collapses slightly, and holding your breath for 15 to 20 seconds. If the fit is not adequate, air will leak in and the mask will resume its normal shape (or if there is a very bad fit, it will not collapse in the first place).

The second is a positive pressure test. This consists of blocking the exhala-

tion valve with your finger and gently breathing out, causing the mask to expand. If air leaks past the edge of the mask (particularly near the eyes), the mask will collapse to normal.

If the respirator fails either of these tests, try adjusting the straps and face piece. Note that in any fitting test, the straps of the respirator should not be too tight, since this can cause discomfort when wearing the respirator for any length of time. If this still does not work, try another respirator of the same model or another model.

More sophisticated qualitative fit tests involve testing with substances to see if you can detect the odor. One such fit test is done with isoamyl acetate vapor (banana oil) using organic vapor cartridges. Of course, you must be able to detect the presence of the solvent at low concentrations for this test to work.

The following is a protocol for qualitative fit testing with isoamyl acetate:

1. Check first with a small concentration of isoamyl acetate to make sure you can detect the odor of banana oil. If you cannot detect the odor of banana oil, repeat the steps below with irritant smoke tubes and dust and mist filters. Be sure to close your eyes when doing this test.

2. Put on the respirator and adjust the straps to get a comfortable fit.

3. Carry out a negative pressure test to see if the fit is approximate.

4. Carry out a positive pressure test if possible.

5. If you do not pass either the negative or positive pressure test, go to step 9.

6. Wear the respirator for a while in a clean atmosphere to get used to it.

7. Saturate a sponge or piece of fabric with isoamyl acetate and then move it around the face-piece seal. An improved version of this test involves using a hood (e.g., the plastic lining of a 55-gallon drum on a wire frame) and placing the saturated fabric or sponge inside the hood.

 It is important to keep individuals to be tested isolated from the isoamyl acetate-contaminated environment, since olfactory fatigue can reduce the ability to detect the isoamyl acetate odor over time.

8. Perform the following exercises for two minutes: (a) normal breathing, (b) deep breathing (five breaths), (c) moving head up and down, (d) moving head from side to side, (e) talking, and (f) normal breathing. If you can detect the odor of the banana oil, then the respirator fails the test.

9. If your respirator fails either the positive or negative pressure test, or the isoamyl acetate test, then you should first readjust the position of the face piece and adjust the straps to get a comfortable yet secure fit. Then retry the fit test. If you still cannot get a fit, try another model or size.

This test can also be used to determine if your organic vapor cartridge is used up and as a regular checkup to determine if your respirator has been damaged and no longer gives a good fit.

You should carefully read the label on the package of the respirator you purchase and any accompanying instructions, since they might have particular instructions about the fitting and care of the particular brand of respirator.

Beards, sideburns, stubble, and sometimes even moustaches make it difficult or impossible to get a good respirator fit. The facial hair lying between the skin and the respirator edge will prevent a proper seal, which means that air and contaminants can leak in. Similarly, broken noses, facial scarring, or other problems that could interfere with a proper fit could prevent a person from safely wearing a respirator.

Medical factors may also preclude wearing respirators. These include heart and lung problems (since the breathing resistance of respirators do put some strain on the heart), asthma, and claustrophobia. If there is any question, you should obtain a medical examination to determine whether you can wear a respirator safely.

If the respirator is not comfortable, there may be a tendency not to wear it when you should. For this reason, comfort is important. Other factors affecting comfort are the degree of difficulty in breathing through the respirator, interference with wearing eyeglasses, restriction of vision due to bulkiness, and restriction of head movements.

Use and Maintenance of Respirators

The filters and cartridges of air-purifying respirators have to be replaced regularly. Since the lifetime of chemical cartridges depends on the concentration of the gas or vapor and the period of exposure, there is no accurate way to tell how long a cartridge will last, since different people will be working under different conditions. The only indication that the cartridge is used up is the smell of gas or vapor coming through the respirator. This is why it is so important not to use chemical cartridge respirators to protect against vapors or gases with inadequate odor-warning properties. As mentioned above, the isoamyl acetate vapor test can be used to determine if the cartridge is still good. A rule of thumb is that you should change cartridges 10 days after opening a new cartridge, after 8 hours of use, or if you can detect odor breakthrough.

It is easier to tell when a filter is clogged because it becomes difficult to breathe through it. An extra supply of filters should always be on hand, since they can clog up very quickly in dusty atmospheres. Also, instead of using a respirator with a disposable filter, in many instances you can use disposable dust respirators that are approved for many different situations.

Respirators should be worn by only one person who is responsible for its up-keep. If the respirator is used only occasionally, then weekly or even monthly cleaning are all that is necessary. If more than one person uses the respirator, it should be cleaned and disinfected. Otherwise, the following cleaning procedure may be followed:

1. Remove filters, cartridges, canisters, etc.

2. Wash face piece and any tubing with warm water (between 120° and 140°F (49° to 60°C)) and a detergent. Use a handbrush to remove dirt.

3. Rinse completely in warm water.

4. Air dry in a clean place. Do not heat.

5. Clean any other parts as recommended by the manufacturer.

6. Inspect parts for defects and reassemble the respirator. Look for excessive dirt, cracking, tearing, inflexibility, or broken parts in cartridge holders, straps, cartridges, etc. In many cases the broken or defective parts can be replaced, but be sure they are the approved parts for that respirator. Never improvise or use parts from other models even if they seem to fit.

7. Place in a sealable plastic bag or other container for storage. Do not hang on the wall or store with chemicals that might contaminate the insides of the respirator.

To disinfect the respirator, use a solution of two tablespoons of household chlorine bleach per gallon of water. Immerse the respirator in this solution for eight minutes after washing and then rinse thoroughly. If the rinsing is not complete, then you run the risk of getting dermatitis.

FACE AND EYE PROTECTION

There are three basic categories of hazards against which the eyes and face must be protected: (1) flying particles; (2) splashes or dusts of acids, alkalis, solvents, or other irritants; and (3) harmful radiation. The type of eye and face protection needed depends on the type of the hazard and its severity. OSHA specifies that all goggles and face protection must meet the standards set by the American National Standards Institute (ANSI). Table 9-2 is a selection chart for the appropriate type of protection excerpted from ANSI Z87.1-1989, "Practice for Occupational and Educational Eye and Face Protection." All equipment meeting these standards must state so on the box, and the actual goggle will have a Z87 stamped on it somewhere.

Flying Particles

The face and eye equipment designed to protect against the flying particles produced in grinding, chipping, and machining are of four basic types: (1) spectacles with or without side shields, (2) flexible-fitting goggles, (3) cushion-fitting goggles with rigid frame, and (4) chipping goggles. In general, spectacles without side shields are not recommended, except for visitors. Face shields by themselves are also not recommended. Face shields protect the face only; they do not adequately protect the eyes. If you are wearing a face shield, you should wear goggles under it.

People who wear eyeglasses can either have a special prescription built into their goggles or can wear flexible or cushioned goggles over their eyeglasses. Regular eyeglasses or contact lenses are not considered adequate protection against flying particles because they do not meet ANSI impact-resistant standards.

Chemical Splashes and Dusts

If the protection needed is only against eye irritation, or from dusts and noncorrosive chemicals, then hooded goggles are sufficient. If the chemical splash risk is from concentrated acids or alkalis in which face and neck protection is also needed, then approved face shields should be used with goggles underneath. If nonventilated goggles are used for protection against irritating vapors, then a nonfogging material should be used. For severe exposure from irritating vapors, full-face respirators are preferred. ANSI-approved chemical splash goggles also protect against light impact.

Contact lenses are a special problem. Dusts may get under the lens and cause corneal scratching, and soft contact lenses may absorb hazardous gases and vapors. In addition, in case of splashes in the eyes, it takes time to remove the lenses to rinse out the eyes. The general recommendation has been to wear eyeglasses with flexible goggles in studios where chemicals may splash in the eyes. An alternative for people who can't or won't wear eyeglasses is to wear tight-fitting, sealed (nonventilated) goggles.

Radiation

Ultraviolet, infrared, and visible glare radiation require goggles with appropriate degrees of shading to protect against the intensity of the radiation. Processes in which this type of protection is needed include welding, brazing, furnace operations (including kilns), molten metals, and carbon arcs, for example. A general rule of thumb is to use the darkest shade you can, while still having visibility.

Table 9-2

		ASSESSMENT SEE NOTE (1)	PROTECTOR TYPE	PROTECTORS	LIMITATIONS	NOT RECOMMENDED
SELECTION CHART				**PROTECTORS**		
I M P A C T	Chipping, grinding, machining, masonry work, riveting, and sanding.	Flying fragments, objects, large chips, particles, sand, dirt, etc.	B,C,D, E,F,G, H,I,J, K,L,N	Spectacles, goggles faceshields SEE NOTES (1) (3) (5) (6) (10) For severe exposure add N	Protective devices do not provide unlimited protection. SEE NOTE (7)	Protectors that do not provide protection from side exposure. SEE NOTE (10) Filter or tinted lenses that restrict light transmittance, unless it is determined that a glare hazard exists. Refer to OPTICAL RADIATION.
H E A T	Furnace operations, pouring, casting, hot dipping, gas cutting, and welding.	Hot sparks	B,C,D, E,F,G, H,I,J, K,L,*N	Faceshields, goggles, spectacles *For severe exposure add N SEE NOTE (2) (3)	Spectacles, cup and cover type goggles do not provide unlimited facial protection. SEE NOTE (2)	Protectors that do not provide protection from side exposure.
		Splash from molten metals	*N	*Faceshields worn over goggles H,K SEE NOTE (2) (3)		
		High temperature exposure	N	Screen faceshields, Reflective faceshields. SEE NOTE (2) (3)	SEE NOTE (3)	
C H E M I C A L	Acid and chemicals handling, degreasing, plating	Splash	G,H,K *N	Goggles, eyecup and cover types. *For severe exposure, add N	Ventilation should be adequate but well protected from splash entry	Spectacles, welding helmets, handshields
		Irritating mists	G	Special purpose goggles	SEE NOTE (3)	
D U S T	Woodworking, buffing, general dusty conditions.	Nuisance dust	G,H,K	Goggles, eyecup and cover types	Atmospheric conditions and the restricted ventilation of the protector can cause lenses to fog. Frequent cleaning may be required.	
O P T I C A L R A D I A T I O N				**TYPICAL FILTER LENS PRO- SHADE TECTORS**		
	WELDING:			SEE NOTE (9)		
	Electric Arc		O,P,Q	10-14 Welding Helmets or Welding Shields	Protection from optical radiation is directly related to filter lens density. SEE NOTE (4). Select the darkest shade that allows adequate task performance.	Protectors that do not provide protection from optical radiation. SEE NOTE (4)
	WELDING:			SEE NOTE (9)		
	Gas		J,K,L, M,N,O, P,Q	4-8 Welding Goggles or Welding Faceshield		
	CUTTING			3-6		
	TORCH BRAZING			3-4	SEE NOTE (3)	
	TORCH SOLDERING		B,C,D, E,F,N	1.5-3 Spectacles or Welding Faceshield		
	GLARE		A,B	Spectacle SEE NOTE (9) (10)	Shaded or Special Purpose lenses, as suitable. SEE NOTE (8)	

16

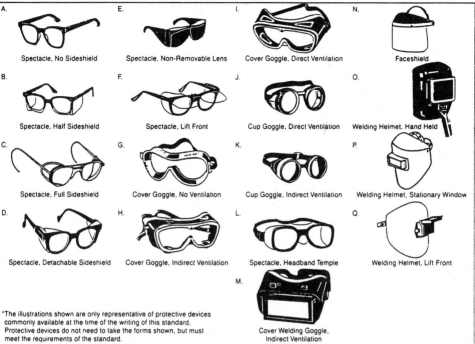

A. Spectacle, No Sideshield

B. Spectacle, Half Sideshield

C. Spectacle, Full Sideshield

D. Spectacle, Detachable Sideshield

E. Spectacle, Non-Removable Lens

F. Spectacle, Lift Front

G. Cover Goggle, No Ventilation

H. Cover Goggle, Indirect Ventilation

I. Cover Goggle, Direct Ventilation

J. Cup Goggle, Direct Ventilation

K. Cup Goggle, Indirect Ventilation

L. Spectacle, Headband Temple

M. Cover Welding Goggle, Indirect Ventilation

N. Faceshield

O. Welding Helmet, Hand Held

P. Welding Helmet, Stationary Window

Q. Welding Helmet, Lift Front

*The illustrations shown are only representative of protective devices commonly available at the time of the writing of this standard. Protective devices do not need to take the forms shown, but must meet the requirements of the standard.

NOTES:
(1) Care shall be taken to recognize the possibility of multiple and simultaneous exposure to a variety of hazards. Adequate protection against the highest level of each of the hazards must be provided.
(2) Operations involving heat may also involve optical radiation. Protection from both hazards shall be provided.
(3) Faceshields shall only be worn over primary eye protection.
(4) Filter lenses shall meet the requirements for shade designations in Table 1.
(5) Persons whose vision requires the use of prescription (Rx) lenses shall wear either protective devices fitted with prescription (Rx) lenses or protective devices designed to be worn over regular prescription (Rx) eyewear.

(6) Wearers of contact lenses shall also be required to wear appropriate covering eye and face protection devices in a hazardous environment. It should be recognized that dusty and/or chemical environments may represent an additional hazard to contact lens wearers.
(7) Caution should be exercised in the use of metal frame protective devices in electrical hazard areas.
(8) Refer to Section 6.5, Special Purpose Lenses.
(9) Welding helmets or handshields shall be used only over primary eye protection.
(10) Non-sideshield spectacles are available for frontal protection only.

Table 9-2. This material is reproduced with permission from American National Standard Practice for Occupational and Educational Eye and Face Protection, ANSI Z87.1 1989, copyright 1989 by the American National Standards Institute. Copies of this standard may be purchased from the American National Standards Institute at 11 West 42nd Street, New York, N.Y. 10036

For protection against infrared radiation (soldering, glassblowing, molten metal, looking into hot kilns), use welding goggles with shade numbers between 1.7 and 2.5, or the new polycarbonate goggles developed for infrared radiation. For protection against ultraviolet radiation, see Table 9-2. Hand-held shields can be used in some cases (e.g., for looking into kilns).

If the operation involves intense ultraviolet radiation that could damage the skin, or possible splashing of molten metals and sparks (e.g., arc welding), then a combination of face shields and appropriate goggles or welding helmets is recommended.

For laser radiation, there are special laser goggles, depending on the type and intensity of the laser radiation.

Besides being resistant to radiation, all face shields and hand-held shields should also be impact resistant.

HAND PROTECTION

There is a wide variety of equipment available to protect your skin against dermatitis from solvents and other chemicals, as well as against radiation, abrasion, heat, and cuts. This includes gloves and barrier creams.

Gloves

Gloves are one of the most important ways of preventing skin problems, since the skin of the hands and fingers is the area most exposed to hazards. Gloves are available that can protect you against most skin hazards. These include chrome-tanned leather gloves for protection against heat, sparks, molten metal, chipping, and cuts; cotton or fabric work gloves for protection against dirt, abrasion, cold, and slivers; metal mesh gloves to protect against knives and similar tools (but not power tools); and plastic and rubber gloves to protect against corrosive and toxic liquids. Note that I do not recommend asbestos gloves (or other asbestos clothing) because they can release cancer-causing asbestos fibers into the air, even when new.

One problem with gloves is that there is no one type of glove that will protect against all chemicals. Therefore you have to choose a type of glove for the particular chemicals with which you are working. Table 9-3 is a glove selection chart to use as a guide. You should also check with glove manufacturers if there is any question. Most glove manufacturers have glove charts for their gloves.

Other factors to consider when choosing gloves include the degree of dexterity required, their grip, whether lined or unlined, disposable or nondisposable, and the length of the glove. With respect to the last point, gloves are available that extend up to elbow length. These are particularly useful when you might be dipping your hands into deep containers of liquids.

The life of a glove in use depends on several factors, including length of contact with the chemicals, temperature, concentration of the liquid, and physical wear and tear. For example, your gloves will last longer if you are just using them to protect your hands against solvent-soaked rags than if you are using them to dip your hands into pure solvent for long periods of time. The life of your gloves (and your hands) can be prolonged by washing them with soap and warm water before removing, and allowing them to air dry before using them again. Irritation and sweating can be prevented by dusting the insides of the gloves with corn starch or an asbestos-free talc (e.g., baby powder), or by using lined gloves. Note that some people are allergic to latex rubber gloves.

The gloves available in hardware stores or art supply stores are usually latex rubber, neoprene, or polyvinyl chloride (vinyl gloves). As seen in Table 9-3, the latex and vinyl gloves do not provide good protection against many solvents. Other types of gloves can be purchased from safety equipment companies and scientific supply houses. Some of these are listed in the Appendix at the end of the chapter.

Protective Creams and Waterless Hand Cleansers

Protective barrier creams, the so-called invisible gloves, are creams that are applied before work to prevent chemicals from coming into contact with your skin. They should be used only when gloves are not practical, since they do not provide as much protection as gloves.

The protective creams come in two basic types: water-soluble types, for protection against organic solvents, cutting oils, paints, lacquers, and varnishes; and water-resistant types for use with water-containing materials such as dye baths, acrylics, and mild acids.

Note that protective creams should be washed off with soap and water and reapplied frequently; they do not protect against highly corrosive substances.

There is a large number of waterless hand cleansers on the market that are meant to remove paint and inks and other materials from the hands, but many of these products are just as hazardous as solvents, since they contain kerosene or other hazardous solvents, alkalis, or harsh abrasives. Obtain waterless hand cleansers from safety equipment suppliers. As an alternative, baby oil or even vegetable oils will usually work to remove paint, grease, and grime.

In using waterless hand cleansers, remember that they are not a substitute for soap and water. You should wash your hands with soap and water after using these products. In addition, mild lanolin-containing skin creams used after washing can help keep your skin from becoming dry.

The Appendix to this chapter lists companies that manufacture and sell protective barrier creams and waterless hand cleansers.

HEAD AND FOOT PROTECTION

Head Protection

Some art processes might require head protection for safety. For example, if you have long hair and are working around machinery in which your hair might get trapped, you should wear a hair net or hair-restraining cap. You should also do this when working around chemicals into which your hair could fall. You should wear protective headgear when welding or working with other processes that might create flying sparks or splatters of molten metal. Hard hats can be used

Table 9-3. Choosing the Right Glove

This table shows the relative resistance ratings of various glove materials to some industrial solutions. **NOTE:** The purpose of gloves is to eliminate or reduce skin exposure to chemical substances. NEVER IMMERSE the hands, even with gloves rated E (excellent).

KEY TO CHARTS: E = excellent; G = good; F = fair; P = poor (Ratings are subject to variation, depending on formulation, thickness, and whether the material is supported by fabric).

The listings were taken from various glove manufacturers and NIOSH, and are ONLY A GENERAL GUIDE. When selecting gloves for any application, contact the manufacturer, giving as much detailed information as possible, according to the following:

1. Ability of glove to resist penetration of the chemical, thus ensuring the protection of the wearer
2. Chemical composition of the solution
3. Degree of concentration
4. Abrasive effects of materials being handled
5. Temperature conditions
6. Time cycle of use
7. Specify in purchase order what materials are to be handled
8. Cost

Chemical Resistance Chart

Glove Material	mineral acids / Hydrochloric (38%)	organic acids / Acetic	caustics / Sodium Hydroxide (50%)	alcohols / Methanol	aromatic solvents / Toluene	petroleum solvents / Naphtha	ketonic solvents / Methyl Ethyl Ketone	chlorinated solvents / Perchlorethylene
Natural Rubber	G	E	E	E	NR	F	E	NR
Neoprene	E	E	E	E	F	E	G	P
Polyvinyl Chloride	G	G	G	G	P	F	NR	NR
Polyvinyl Alcohol	P	NR	NR	F	E	E	F	E
NBR	E	G	E	G	G	E	F	G

Miscellaneous

Glove Material	Lacquer Thinner	Benzene	Formaldehyde	Ethyl Acetate	Vegetable Oils	Animal Fats	Turpentine	Phenol
Natural Rubber	F	NR	E	F	F	P	F	F
Neoprene	G	P	E	G	G	E	G	E
Polyvinyl Chloride	F	P	E	P	F	G	G	G
Polyvinyl Alcohol	E	E	P	P	E	E	E	F
NBR	G	G	E	G	E	E	E	G

Physical Performance Chart*

Coating	Abrasion Resistance	Cut Resistance	Puncture Resistance	Heat Resistance	Flexibility	Ozone Resistance	Tear Resistance	Relative Cost
Natural Rubber	E	E	E	F	E	P	E	Medium
Neoprene	E	E	G	G	G	E	G	Medium
Chlorinated Polyethylene (CPE)	E	G	G	G	G	E	G	Low
Butyl Rubber	F	G	G	E	G	E	G	High
Polyvinyl Chloride	G	P	G	P	F	E	G	Low
Polyvinyl Alcohol	F	F	F	G	P	E	G	Very High
Polyethylene	F	F	P	F	G	F	F	Low
Nitrile Rubber	E	E	E	G	E	F	G	Medium
Nitrile Rubber/Polyvinyl Chloride (Nitrile PVC)	G	G	G	F	G	E	G	Medium
Polyurethane	E	G	G	G	E	G	G	High
Styrene-butadiene Rubber (SBR)	E	G	F	G	G	F	F	Low
Viton	G	G	G	G	G	E	G	Very High

*Grip/slip is related to glove surface and is enhanced when the glove surface is rough.
Dexterity/tactility is related to glove thickness and decreases as the glove thickness increases.

not only to protect your head against falling objects but against flying particles and electric shock. Hard hats or safety hats should meet the requirement of ANSI Z89.1 "Safety Requirements for Industrial Head Protection." See the Appendix to this chapter for a list of manufacturers and distributors.

Foot Protection

Safety shoes may be needed to protect against electric shock, sparks, or molten metal from welding, heavy stones that might fall in sculpture or lithography, and slippery floors, as well as to prevent static electricity when working with large amounts of flammable solvents. These shoes come in a variety of styles for both men and women, such as safety toe, insulated, nonsparking, wooden sole, and rubber. Men's safety shoes must meet the standards of ANSI Z41.1 "Men's Safety Toe Footwear." There are no standards for women's safety shoes as yet. These various types of safety shoes are available from the safety equipment companies listed in the Appendix to this chapter.

HEARING PROTECTORS

Noise and hearing loss are described in the next chapter. There are three types of hearing protectors to protect against excessive noise: ear plugs, ear muffs, and the rarer helmets. However, these all have the same disadvantages of possibly reducing the use of your ears as a warning device and of being uncomfortable.

Ear Plugs

Ear plugs, properly fitted and used, can reduce noise levels by 25 to 30 dB at the more hazardous higher frequencies. This allows their use at noise levels of 115 to 120 dB. They can be made of a variety of materials, including pliable rubber, plastics, or wax. One of the most effective types of ear plugs today are moldable foam types. These are compressed to fit into the ear, and then expand to fit the ear canal. Custom-molded ear plugs made of silicone are also available. These are custom fitted and should not be used by others. In addition, these custom-molded ear plugs must be fitted by trained personnel. Cotton or other homemade ear plugs are not recommended. They do not reduce the sound levels sufficiently, and may cause infections.

Ear Muffs

Ear muff-type protectors can reduce noise levels by 10 to 15 dB more than ear plugs, allowing them to be used against noise levels in the range of 130 to 135 dB.

These are easier to fit and come in a variety of styles, depending on how they are attached. In cases in which the noise level is very high and engineering controls have no effect, you can wear a combination of ear plugs and ear muffs to get greater noise reduction.

Whatever type of ear protector you choose, you should first make sure that the ear plug or muff will sufficiently reduce the noise level. If in doubt, sound level measurements should be made. In addition, you should have regular audiograms to test your hearing.

OTHER PROTECTIVE CLOTHING AND EQUIPMENT

Just as it is important to protect your hands and fingers against many types of hazards, it is also important to protect other parts of your body. For example, when welding, your arms, legs, and the front of your body need protection against radiation and flying sparks. When pouring concentrated acids to make up etching solutions or pickling baths, you need protection against accidental splashes by the corrosive acids. When glassblowing you need protection against infrared radiation.

There are special types of clothing to protect you against all of these. Clothing to protect particular parts of the body or the entire body includes leggings, sleeves, hair coverings, aprons, overalls, knee pads, shoe coverings, and complete body suits. Again, as with gloves, these are available in a variety of materials for different purposes: leather to protect against heat, sparks, and molten metal; wool to protect against ultraviolet and infrared radiation; leather and metal mesh to protect against cuts and impact; impervious plastics and synthetic nonwoven clothing to protect against chemicals; and many others. In some cases—for example, complete body suits—the clothing is disposable.

As mentioned in previous chapters, you should wear separate clothing for work, even if it is not special protective clothing, and change it immediately after work so as not to contaminate living areas and the home. Protective and work clothing should also be washed separately from other clothing so as not to contaminate your regular clothing.

REFERENCES

A.M. Best Company. *Best's Safety Directory.* 2 vols. Oldwick: A. M. Best (Updated regularly.)

American National Standards Institute. (1989). *Practice for Occupational and Educational Eye and Face Protection.* ANSI Z87.1-1989. New York: ANSI.

American National Standards Institute. (1980). *Practices for Respiratory Protection.* ANSI Z88.2-1980. New York: ANSI.

American National Standards Institute. (1972). *Safety Requirement for Industrial Head Protection.* ANSI Z89.1-1969. New York: ANSI.

American National Standards Institute. (1972). *Men's Safety-Toe Footwear.* ANSI Z41.1-1967 (R1972). New York: ANSI.

National Institute of Occupational Safety and Health. (1976). *A Guide to Industrial Respiratory Protection.* DHEW (NIOSH) #76-189. Washington, DC: Government Printing Office.

National Institute of Occupational Safety and Health. (1988). *NIOSH Certified Equipment List as of October 1, 1987.* DHEW (NIOSH) #88-107. Washington, DC: Government Printing Office.

National Safety Council. (1981). *Accident Prevention Manual for Industrial Operations.* 6th ed. Chicago: NSC.

Occupational Safety and Health Administration. (1988) *Occupational Safety and Health Standards for General Industry—Respiratory Protection.* 29 CFR 1910.134.

Plog, B. (ed.) (1988). *Fundamentals of Industrial Hygiene.* 3d ed. Chicago: National Safety Council.

APPENDIX: SOURCES OF PERSONAL PROTECTIVE EQUIPMENT

American All Safe Co., Inc., 1245 Niagara St., Buffalo, NY 14213

American Optical Corp., Safety Products Div., 100 Canal St., Putnam, CT 06260

American Safety Equipment Corp., Industrial Division, 3535 De La Cruz Blvd., Santa Clara, CA 95050

Cesco Safety Products, Parmalee Industries Inc., P.O. Box 1237, Kansas City, MO 64141

Eastco Industrial Safety Corp., 130 W. 10th St., Huntington Station, NY 11746

General Scientific Equipment Co., Limekiln Pike & William Ave., Philadelphia, PA 19150

Glendale Optical Co., 130 Crossways Park Dr., Woodbury, NY 11797

Mine Safety Appliances Co., 400 Penn Center Blvd., Pittsburgh, PA 15235

Pulmosan Safety Equipment Corp., 30-48 Linden Pl., Flushing, NY 11354

Safeline Products, P.O. Box 550, Putnam, CT 06260

Safety Supply Canada, 90 West Beaver Creek Rd., Richmond Hills, Ontario, L4B 1E7 (distributors in major cities)

Sellstrom Manufacturing Co., 59 E. Buren St., Chicago, IL 60605

3M Company, Occupational Health & Safety Division, 3M Center, St. Paul, MN 55101 (distributors in major cities)

United States Safety Service, P.O. Box 1237, Kansas City, MO 64141

Welsh Manufacturing Co., 9 Magnolia St., Providence, RI 02909

Willson Products Div., ESB, Inc., Box 622, Reading, PA 19603

10

Physical Hazards

A rtists can also face a number of physical hazards, in addition to the chemical hazards associated with art materials. These physical hazards can include electromagnetic radiation, noise, ergonomic hazards, machine safety, electrical safety, and heat stress.

ELECTROMAGNETIC RADIATION

Electromagnetic radiation includes x-rays, ultraviolet radiation, visible light, infrared radiation, radio waves, and microwaves, as shown in Figure 10-1.

Electromagnetic radiation can be characterized by frequency (or wavelength) and by intensity. The higher the frequency, the more energy is contained in the radiation, and the shorter the wavelength. High-energy radiation, for example, x-rays and shorter wavelength ultraviolet radiation, is called ionizing radiation because it can strip electrons off atoms and cause serious tissue destruction.

Lower-energy radiation (to the left of ionizing radiation in Figure 10-1) is called nonionizing radiation. Its health effects are not as severe, although differ-

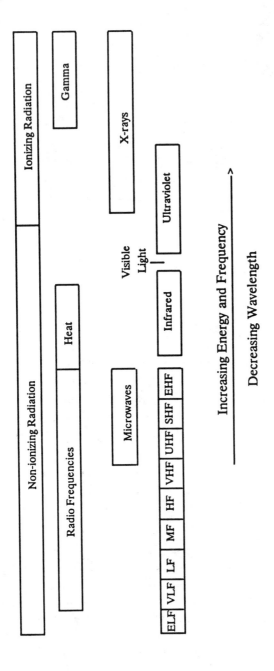

Figure 10-1. The Electromagnetic Spectrum.

ent types of nonionizing radiation can cause particular types of problems. I discuss only nonionizing radiation because, in general, artists are not exposed to the ionizing type.

The other characteristic of electromagnetic radiation is its intensity, or the amount of radiation emitted. The greater the intensity, the greater the hazard. For example, carbon arc lamps are more dangerous than other lamps because they emit much greater amounts of ultraviolet radiation.

Ultraviolet Radiation

Ultraviolet (UV) radiation is emitted by the sun, although only small amounts reach the earth's surface. Even this small amount, however, causes sunburn and skin cancer. Ultraviolet radiation is also given off by a number of art processes, especially carbon arcs and arc welding. Xenon lamps and oxyacetylene welding also emit lesser amounts of UV radiation. Short wavelength ultraviolet radiation is ionizing.

Hazards

1. Short-term or acute exposures to ultraviolet radiation can cause sunburn and conjunctivitis (pink eye), which has been described as a feeling like sand in the eyes. According to recent research, UV radiation can also cause cataracts.

2. Chronic exposure to ultraviolet radiation may cause skin cancer, both the normal type and the more deadly melanoma.

3. Intense UV radiation, for example, from arc welding and carbon arcs, reacts with oxygen and nitrogen in the air to produce ozone and nitrogen dioxide gases, which can cause chemical pneumonia and emphysema from acute exposure and chronic lung problems from long-term exposure. In addition, carbon arcs can emit copper fumes and rare earth metal fumes.

4. Ultraviolet radiation can also react with some chemicals. For example, most chlorinated hydrocarbons form poisonous phosgene gas when exposed to UV light, and ferricyanide compounds (used as reducers in photography and in blueprinting) decompose to hydrogen cyanide gas in the presence of UV radiation.

Precautions

1. Proper eye and skin protection should be worn when ultraviolet radiation is present. In the past, the American National Standards Institute (ANSI)

recommended particular shade numbers of goggles and face shields for different types of welding processes. Its most recent recommendations are to wear the darkest shade number consistent with being able to see your work (ANSI Z87.1-1989, " *American National Standard Practice for Educational and Occupational Eye and Face Protection*"; see Table 9-2).

For arc welding, face shields should be worn. If other welders are also present and protective shields not available, UV goggles should be worn under the face shield so that you do not get exposed to UV radiation from other people doing arc welding when you lift your face shield to check your work. The sum of the shade numbers for the face shield and goggles should be the same as the shade number for the welding shield used alone.

2. Walls and other possible reflecting surfaces should be coated with a UV-absorbing paint (e.g., zinc oxide) to minimize risk from reflected UV radiation. Fire-resistant, UV-absorbing screens should be used to prevent the UV radiation from exposing other people in the area.

3. Check the reactivity section of Material Safety Data Sheets of your art materials to determine if they are sensitive to UV radiation. If so, keep them away from exposure to UV radiation.

4. Avoid carbon arcs, since you do not need that intense a source of UV radiation for photo printmaking or blueprinting. Instead use other light sources such as photofloods.

Visible Light

Visible light, although crucial to us, is only a small part of the electromagnetic spectrum sandwiched between the ultraviolet region and the infrared region.

Lasers are sometimes used as a form of light sculpture and in making holograms. In contrast to normal visible light, which consists of many different wavelengths, lasers emit light of just one wavelength or a narrow range of wavelengths, which can be very intense.

Hazards

1. Excluding lasers, visible light is not as hazardous as other forms of electromagnetic radiation. However, glare and insufficient lighting can cause headaches and eye strain and can contribute to accidents and increase mistakes.

2. Glare is caused by direct viewing of light sources and by reflections off shiny surfaces.

3. The stroboscopic effect that may occur with fluorescent lighting may induce seizures in some epileptic individuals.

4. Laser beams can cause eye damage, skin damage, and present other hazards depending on the class of laser. Laser sculpture and holography are discussed in Chapter 23.

Precautions

1. Glare can be avoided by shielding light sources, decreasing excessive lighting levels, putting blinds or curtains on windows, and mounting lights so that they illuminate the work rather than shining into your eyes. Light-colored matte finishes on walls are recommended to avoid glare.

2. Avoid shadows by having light come from several directions rather than just one. This is best obtained by a combination of lighting directly on the work area (task lighting) and diffuse background lighting from sources such as fluorescent lighting, multiple lighting sources, and reflections off walls, ceilings, and even floors. The light-colored matte wall finishes mentioned above can provide this type of diffuse reflection.

3. Full-spectrum fluorescent lighting is preferred over yellow or cool white types. Fluorescent bulbs should never be left bare but should always have diffusers.

4. Older people usually need higher lighting levels than younger people.

5. Lighting systems need to be cleaned, and burned-out fixtures quickly replaced. Flickering fluorescent lights in particular should be immediately fixed. Humming fluorescent lights might need their ballasts changed. Old fluorescent lights (prior to 1978) might have PCB-containing ballasts, which should be replaced and disposed of as hazardous waste.

6. Precautions for lasers include using the lowest power lasers possible, engineering controls to control the direction and spread of the laser beam, wearing of appropriate laser goggles, and ensuring that bystanders are not exposed to hazardous laser levels. See Chapter 23 for more information.

Infrared Radiation

Infrared radiation is emitted by heated objects. The hotter the object, the more intense the infrared radiation. Welding, glassblowing, foundry, and kilns (both enameling and pottery) can emit hazardous amounts of infrared radiation. Infrared radiation is absorbed by water.

217

Hazards

1. Intense amounts of infrared radiation can cause skin burns. I know of one college art student who had severe burns of the neck, face, and upper chest from participating in a foundry pour. She was wearing only a low-cut leotard top and goggles.

2. Years of exposure to infrared radiation can cause cataracts. In glassblowing this was common enough to be called "glassblower's cataracts." I have also seen cases of cataracts in potters and enamelists from looking into the hot kiln without infrared protection.

Precautions

1. All skin surfaces should be covered when exposed to large amounts of infrared radiation. Where sparks can fly, or molten metal can splash, the protective clothing must not be flammable or susceptible to melting.

2. Infrared goggles should be worn for glassblowing, looking into kilns, or other situations in which metals or other materials are heated to high temperatures. Goggles with a shade number between 1.8 and 3 can be used. Didymium lenses are not sufficient for glassblowing. They remove the intense yellow light from molten glass, but do not remove sufficient amounts of infrared radiation.

Extremely Low-Frequency Radiation

Any electrical equipment produces extremely low-frequency (ELF) radiation in the range of 60 cycles per second. High-tension wires and other high-voltage equipment produces high intensities of this ELF radiation, but even ordinary electrical equipment such as electrical blankets, electric clocks, computers, and photocopiers also produce this radiation, but at lower intensities.

Hazards

1. In recent years, there have been a number of studies of children living near high-tension lines and linemen possibly implicating ELF radiation in leukemia and other types of cancer, including rare breast cancers in men. Other types of health effects found in animal studies include immune system problems and chromosomal changes. ELF radiation should be classified as a possible human carcinogen.

2. For several years, there has been controversy over whether video display terminals used with computers cause a higher incidence of birth defects

and miscarriages. Clusters of these have occurred in several workplaces, but it is not certain whether these have been sheer chance or a real effect. Human studies have not been conclusive either way. Animal studies, however, suggest that ELF radiation can cause certain types of reproductive problems.

Precautions

1. Given the uncertain state of knowledge concerning ELF radiation, I recommend taking steps to minimize exposure to ELF radiation whenever possible. Below are some possible ways to do this.

2. The intensity of electromagnetic radiation, including ELF, falls off sharply with increasing distance from the source (double the distance and the intensity decreases fourfold). Therefore, set up electrical equipment as far away from you as possible.

3. The absorbed dose increases with increasing length of exposure. Therefore, try to minimize the amount of time spent next to electrical equipment such as photocopiers, laser printers, and arc welders.

NOISE

Noise, basically, is unwanted sound. Like electromagnetic radiation, noise can be characterized by its frequency (pitch) and its intensity (loudness). Frequency is measured in cycles per second or Hertz (Hz). We can normally hear sounds in the range of 16 to 20,000 Hz. The speech range is 250 to 3,000 Hz.

Sound intensity is measured in decibels (dB), on a logarithmic scale. In this scale, 90 dB is 10 times more intense than 80 dB, and 110 dB is 10 times more intense than 100 dB. The sound intensity doubles for every increase of 3 dB, showing that small increases in decibel levels can involve large increases in sound intensity. Table 10-1 shows the decibel levels of common sounds.

In art processes, noise can be caused by vibration, forging, exhaust fans, woodworking and other machinery, pneumatic tools, and so on. In particular, worn or improperly maintained equipment tends to create more noise. In general, if you have to raise your voice to speak to someone one to two feet away, then the noise level is too high, especially if it is a steady noise. In that case, you might need to make sound level measurements in order to determine the extent of the problem.

Hazards

1. Acute exposure to high intensity, continuous noise affects the sensory cells in the cochlea of the inner ear, causing a temporary hearing loss.

This is also called a temporary threshold shift, indicating that the threshold for hearing sounds of a particular frequency has been increased. Symptoms include ringing in the ears (tinnitus) and fuzziness of sound. Normal hearing will recover within 14 hours following the noise exposure.

2. If the noise exposure is chronic, then gradually the hearing will not completely recover after a day's exposure, leaving a permanent noise-induced hearing loss. At first, this permanent hearing loss occurs at 4,000 Hz. At this stage, people complain of difficulty in hearing higher-pitched women's and children's voices and in hearing on the telephone. With increasing exposure, the hearing loss gets worse at 4,000 Hz and begins spreading down to the main speech frequencies. This noise-induced hearing loss is in addition to the normal hearing loss experienced by people as they get older (called presbycusis).

3. Impact noise, such as that from a gunshot or a forging hammer, can damage the eardrums or bones in the middle ear, to cause a mechanical hearing loss as opposed to the sensory hearing loss caused by continuous noise.

4. Noise can also cause a wide range of physiological problems, including increased heart rate, blood pressure, breathing rate, muscular contractions, and perspiration. Psychological effects can include nervousness, tension, anger, and irritability.

5. The Occupational Safety and Health Administration (OSHA) noise standard sets the Permissible Exposure Limit for noise at 90 dB as an 8-hour, time-weighted average. For every 5 dB increase in noise, the time allowed is cut in half, with a 115 dB maximum for 15 minutes. The standard provides for regular hearing tests, hearing protection, and other measures at 85 dB.

Precautions

1. Try to eliminate the sound. Mounting fans and machinery on vibration isolators (similar to shock absorbers) can dampen the vibrations causing the noise. Installing a sleeve between the fan and duct can decrease noise.

2. Good maintenance also decreases noise, since worn bearings and other parts generate noise.

3. New equipment is usually quieter than old equipment. When purchasing machinery, find out how much noise it produces.

4. Isolating the noise-producing equipment in separate rooms can avoid exposing other people. Sometimes enclosing a particular piece of noisy equipment with soundproofing materials can help.

5. Like electromagnetic radiation, noise levels decrease sharply with increasing distance. Therefore, placing noisy equipment at a distance from other people can help decrease noise exposure.

6. If the above measures do not decrease the noise level sufficiently, then it might be necessary to wear ear plugs or ear muffs. See Chapter 9 for information on hearing protectors.

7. Anyone exposed to high noise levels on a regular basis should have regular audiometric examinations to determine the extent of any hearing loss.

Table 10-1. Approximate Sound Levels of Common Noise Sources

Source	Sound Level (dB)
Jet engine	160
Loud amplified music	118
Planer	115
Portable grinder	110
Circular saw	105
Sander, foundry	95
Classroom teaching voice at 3 feet	75
Normal speaking voice at 3 feet	70
Air conditioner	60
Quiet office	50
Urban home	40
Suburban home	30
Whisper	20
Rustling leaves	10
Threshold of hearing	0

ERGONOMICS

Ergonomics is a field of safety that tries to adapt jobs to the human being. This can include teaching proper lifting techniques, design of chairs, design of tools and so on. Improper ergonomics can lead to a variety of illnesses and injuries, including back strain, carpal tunnel syndrome, tendinitis, and circulatory system problems.

Lifting

Lifting of heavy equipment or materials such as lithographic and sculpture stones, etc. often occurs in art and is a common cause of back injuries.

Precautions

1. Whenever possible, use mechanical devices such as adjustable height carts to move heavy objects.

2. Never lift weights that are too heavy. For men aged 20 to 35, the maximum should be 55 pounds; for women, 33 pounds. The maximum weight for older and younger people is less.

3. The lifting method most generally recommended is to flex your knees, keep your back straight, and, with the weight close to your body, lift so that you don't twist your spine. Hold your stomach in as this will give your back extra support.

Repetitive Trauma Disorders

A variety of "overuse" disorders can be caused by how you work and by the tools you use.

Hazards

1. Repetitive motions, such as using a paintbrush or chisel, typing at computer keyboards, or weaving for hours on end, can cause problems such as tendinitis in hands, arms, wrists, and fingers. Sudden increases in how long you work, or suddenly switching to new tools or materials, can strain muscles and tendons not used to it. This results in inflammation of the muscles or tendons, with symptoms of pain, warmth, swelling, and difficulty in moving the afflicted part. This can also be exacerbated by tight grips on tools such as pencils, brushes, and chisels.

2. Prolonged bending of the wrists to angles near 90 degrees can lead to carpel tunnel syndrome. Working on a potter's wheel, painting or drawing in awkward positions, and using a chisel are some situations that have caused carpel tunnel syndrome in artists. This is a nerve entrapment disease in which the bent wrist puts pressure on the median nerve, which runs through a narrow space in the wrist surrounded by wrist bones and ligaments (the carpel tunnel). Symptoms include pain, numbness, and/or pins and needles in the thumb and first three fingers. This can have serious long-term effects and often requires surgical intervention.

3. Pneumatic and vibrating equipment such as chain saws can also create problems due to vibration. Raynaud's phenomenon, which is also called "white fingers" or "dead fingers," affects the circulation of the fingers,

causing them to turn white from lack of blood and to lose sensation. Vibration can cause this, particularly when you are also exposed to cold, for example, from the air blast of pneumatic tools. This condition, which is a lot more common than is normally realized, is initially temporary, but can spread to the whole hand and cause permanent damage.

Precautions

1. Take rest breaks to stretch your muscles every 45 minutes or so. When possible, try a variety of tasks to relieve the strain on particular muscles.

2. Use tools that are comfortable. Built-up handles on tools are better than thin handles that lead you to grip the tool more strongly. Cushioned handles also help prevent problems from developing. Tools with right-angled handles can prevent you from having your wrists in a bent position. Tools designed for left-handed people are also becoming increasingly available.

3. When working with pneumatic tools, keep your hands warm and make sure you take work breaks in a warm place. Try to direct the air blast from the tools away from your hands.

4. If you have any of the symptoms described, you should see a physician with experience with these types of disorders.

5. According to specialists, a general treatment program for tendinitis includes: (a) applying gentle heat for 5 to 10 minutes (except in the case of acute inflammation); (b) massaging and stretching sore muscles to the point of moderate discomfort for 60 seconds; (c) relaxing the muscles, shaking them out, and repeating step b; (d) massaging with ice for 5 to 10 minutes, to the point of numbness; and (e) using over-the-counter anti-inflammatory medications.

6. Use of a wrist support or splint can help maintain the wrists in normal positions to help prevent carpel tunnel syndrome from developing further. In advanced cases, surgery might be necessary. Proper diagnosis, however, is crucial, since it is often misdiagnosed.

▧ MACHINE AND TOOL SAFETY

Hazards

1. Improper use of machines and tools can result in a variety of injuries ranging from minor cuts to major accidents involving loss of limbs or even fatalities. Personal factors such as fatigue, carelessness, or emotional

states of mind can increase the risk of accidents. Solvent overexposure can also be a factor in accidents, since inhalation of solvent vapors can cause fatigue and loss of judgment, reflexes, and coordination.

2. Major causes of accidents include removing machine guards, using the wrong type of machine for a particular operation, and inadvertently using malfunctioning equipment. According to OSHA, all malfunctioning machinery should be locked out and tagged.

3. A 1980 survey by the U.S. Consumer Product Safety Commission found that a quarter million people received medical attention for injuries from home workshop power tools. Of these, two thirds were associated with power saws, both portable and stationary, and almost one third were associated with drills, grinders, buffers, and polishers. The majority of injuries were hand and finger or eye injuries. Another survey by *Fine Woodworking* found that the table saw caused a majority (44%) of all serious injuries, with the jointer and radial-arm saw second and third, respectively, in causes of injury.

Precautions for Hand Tools

1. All hand tools must be maintained in good condition and replaced if damaged. Cutting tools should be kept sharp. Broken, split, or chipped tools are dangerous and should be replaced.

2. Tools should be used only for the specific job that they are intended for.

3. Always use the tool so that you cut away from your body and do not place your hand in front of the tool.

4. Approved safety goggles should be worn while using hand tools.

5. Tools should be stored safely and neatly.

Precautions for Powered Hand Tools

1. Power tools should be used only for the specific job that they are intended for. Tools should be in good condition. All guards, shields, and attachments should be in place and functioning. Operators should be trained in their importance and use.

2. All electric cords must be in good condition, and inspected and maintained. (See also the section on electrical safety below.)

3 Special precautions must be taken if the work is damp or contains flammables or combustibles.

4. Safety goggles and dust respirators should be used when necessary. Work clothing should fit properly, preventing the danger of loose clothing catching in moving tool parts.

5. Hand-held electrical power tools must have a quick-release (dead-man) control that shuts off power when the control switch is released.

6. The frame of electrical tools must be grounded and double-insulated, and thus labeled.

7. Pneumatic tools must be securely fastened to the hose, with a tool retainer added that restrains the attachment.

Precautions for Machinery

1. Everyone using machinery should be properly trained in the safe use of the machinery.

2. Everyone should wear safety goggles or a face shield plus safety goggles if the machine produces dust or particles. Eyeglasses are not sufficient protection.

3. Dust masks should used when necessary. For more information, see Chapter 9.

4. Hearing protection may be necessary, since noise levels from machinery can be very high. A good rule of thumb is that hearing protection is necessary when there is difficulty hearing someone one to two feet away.

5. Loose clothing, work gloves, neckties, and dangling jewelry should not be worn around machinery, in order to avoid getting caught in the machinery.

6. All safety devices and guards for machines should be in position and adjusted if necessary. All equipment should be properly grounded.

7. Operating switches should be easily accessible to the user without having to move from the operating position.

8. The work area should be kept clean, swept, and well-lit. Floors should be free of all debris, slippery materials, or water.

9. Never leave any machine that is running unattended. Turn off the power and wait until the machine isn't moving before leaving the work area.

10. Certain machines have specific safety considerations. For further information on woodworking machines and discussion of hazards and precautions of specific machines, see the data sheets prepared by the Canadian Centre for Occupational Health and Safety (CCOHS).

ELECTRICAL SAFETY

Artists use a wide variety of electrical equipment in making art, varying from ordinary machinery to high-voltage arc welders.

Standard Electrical Equipment

This section discusses working with standard 110 volt/220 volt electrical equipment.

Hazards

1. Defective electrical wiring and equipment or accidental contact with live electrical components can cause electrical shock. This can result in burns, unconsciousness from paralysis of the respiratory center, and/or heart fibrillation. In 1980, a graduate art student was electrocuted when he put his hand in the unguarded electrical coils of a plastics vacuum-forming machine.

2. Faulty electrical equipment is one of the major causes of fires.

Precautions

1. Avoid extension cords, cube taps, and multiple jacks. If needed, more outlets should be installed.

2. Circuit breakers and fuse boxes must be either recognizable or labeled. Outlets, switches, and junction boxes must be covered. All electrical boxes should be secured to the wall.

3. The circuit breaker panel or fuse box should be easily accessible. Each switch should be labeled as to its function.

4. Ground fault circuit interrupters, which shut off the electrical current in the case of electrical shorts, should be installed whenever electrical outlets or equipment are located within six feet of the risk of water splashing.

5. Do not insert three-pronged plugs into two-pronged outlets unless you connect the ground on the three-pronged plug to a ground on the outlet.

6. Electrical motor frames must be grounded. If there is any chance of operation in a wet or damp location, electrical contact with metal, voltage greater than 150 volts, or operation in a hazardous location, then all exposed metal parts must be grounded, even if noncurrent carrying. Likewise, noncurrent metal parts of appliances and hand-held motor-

operated tools must be grounded and labeled. Use only grounded plugs in wet areas.

7. Flexible cords should be inspected, maintained, and replaced if there are any signs of damage, fraying, or deterioration. Cords should never be used as a substitute for fixed wiring. There should not be pull on joints or terminal screws of cords.

8. Do not run flexible cords through holes in windows, doors, ceilings, floors, or walls. Cords may not be attached to building surfaces.

9. Splices and repairs on flexible cord must be done by welding, brazing or soldering, or splicing devices. Do not tape wires. Both splices and free ends of conductors must be insulated.

10. 220-volt and 110-volt wiring should be separate and identifiable. Don't use compatible plugs.

11. Don't let sawdust or other debris build up around motors, since the debris may ignite if the motor overheats.

12. Never handle electrical equipment while hands, feet, or body are damp, or while standing on wet floors.

13. Learn rescue procedures for helping victims of possible electrocution. See Chapter 11.

High-Voltage Equipment

High-voltage equipment is used in art with lasers, neon sculpture, arc welders and so on.

Precautions

1. Avoid wearing rings and other metallic objects.

2. Whenever possible, use only one hand to work on electrical circuits or control devices.

3. Consider all floors as conductive and leading to ground, unless covered with insulating rubber mats.

4. All high-voltage equipment should be labeled and properly shielded.

5. Use only high-voltage connectors and wiring that meets National Electrical Code standards.

6. All electrical terminals, cables, and exposed electrical contacts should be enclosed by grounded metal enclosures that are locked or have safety interlocks.

7. High-voltage capacitors should be checked to ensure that they are discharged, shorted, and grounded before working around them.

8. Have proper equipment such as insulated rubber gloves, rubber-soled shoes, safety goggles, insulated screwdrivers, grounding cables, and metering devices.

HEAT STRESS

Glassblowing studios, foundries, and kiln rooms are some examples of situations in art where large amounts of heat can be produced. The resulting high temperatures can produce a variety of heat stress diseases.

Hazards

1. People who are not acclimatized to high heat can be at risk. Normal healthy adults can take several days to acclimatize to hot environments. However, this acclimatization can be increasingly lost as more time is spent away from the heat. People with heart, kidney, and other chronic diseases, older people, and overweight people are particularly susceptible to heat stress diseases.

2. Heat syncope, or fainting while standing erect and immobile in heat, occurs when most of the blood rushes to the skin and lower parts of the body in an effort to dissipate the heat, thus depriving the brain of sufficient blood and oxygen. Recovery is prompt and complete upon removal to a cooler area. One way to prevent this is by intermittent activity to circulate the blood.

3. Heat stroke is a serious medical emergency and results from a failure in the body's heat regulatory system and a subsequent sharp rise in internal body temperature. Symptoms include hot, dry skin; rising body temperature; mental confusion; delirium; loss of consciousness; and possible fatal coma if the temperature rise is not halted. This is more common in the elderly, in overweight people, in people with chronic heart problems, and in cases of heavy exertion when unacclimatized. Recent alcohol intake and dehydration can also adversely contribute to heat stroke.

4. Salt and/or water depletion can result in heat shock. Symptoms include fatigue, nausea, dizziness, clammy skin, irritability, and possible muscular cramps.

5. Heat fatigue, a vague, emotional reaction to a hot environment, is characterized by symptoms of discomfort, lassitude, and tiredness. This can result in loss of efficiency and a tendency toward accidents.

6. Heat rash (prickly heat) occurs when skin is continuously wet due to clogged sweat pores.

Precautions

1. Allowing time for acclimatization is essential if you are going to work on a project for an extended period of time. The period of acclimatization itself can take about five to seven days. You should not suddenly jump into a full day of high heat exposure, but increase your work load gradually over several days.

2. Rest breaks should be integrated into the workday. Work-rest cycles allow the body an opportunity to get rid of excess heat, slow down the production of internal heat, and provide greater blood flow to the skin. Short but frequent rest cycles are the best for those working in hot environments. Ideally, the work load should be distributed evenly over the course of the day.

3. In very hot situations, there should be cool rest areas available. Although it is not known conclusively what the ideal temperature of the rest area should be, a rest area temperature of 76°F appears to be comfortable, but not chilly, to those working in a hot environment.

4. Noncarbonated beverages and water should be readily available for replenishment of fluid and salt. People often don't replace the large volumes of liquid they sweat daily, so one shouldn't rely on thirst to signal fluid intake. Persons working in a hot environment should drink five to seven ounces of fluids every 15 or 20 minutes. In particularly hot environments, liquids with salt or other special additives (e.g., Gatorade or other similar brands) should be available. The use of salt tablets is not recommended. The drinking of salted beverages, of course, should be controlled for individuals with medical conditions requiring a low-sodium diet.

5. Certain types of protective clothing may alleviate heat stress for individuals for whom clothing doesn't interfere with work.

6. See the Heat Stress section in Chapter 11 for first-aid information.

REFERENCES

American National Standards Institute. (1989). *Practice for Occupational and Educational Eye and Face Protection.* ANSI Z87.1-1989. New York: ANSI.

Canadian Centre for Occupational Health and Safety. (1988). *Infograms on Hand Tools.* 16 pp. Hamilton, Ontario, Canada: CCOHS.

Canadian Centre for Occupational Health and Safety. (1988). *Infograms on Powered Hand Tools*. 11 pp. Hamilton, Ontario, Canada: CCOHS.

Canadian Centre for Occupational Health and Safety. (1988). *Infograms on Woodworking Machines*. 10 pp. Hamilton, Ontario, Canada: CCOHS.

National Fire Protection Association. (1987). *NFPA 70. National Electrical Code.* Boston: NFPA.

National Institute for Occupational Safety and Health. (1986). *Working in Hot Environments.* DHHS (NIOSH) Publication #86-112. Cincinnati: NIOSH.

National Safety Council. (1981). *Accident Prevention Manual for Industrial Operations.* 6th ed. Chicago: NSC.

Occupational Safety and Health Administration. (1988). *Occupational Safety and Health Standards for General Industry—Occupational Noise Exposure.* 29 CFR 1910.95.

Pinsky, M. (1987). *The VDT Book—A Computer User's Guide to Health and Safety.* New York: New York Committee for Occupational Safety and Health.

Stellman, J., and Henifin, M. S. (1983). *Office Work Can Be Dangerous to Your Health.* New York: Pantheon Books.

In Case
of Illness
or Injury

Having discussed the hazards of different art materials, how they affect the body, and what you can do to protect yourself, we now consider the question of what to do if you do get sick or injured as a result of using art materials.

RECOGNIZING THE PROBLEM

One of the greatest problems is to recognize when an illness is the result of exposure to hazardous art materials. Symptoms are usually nonspecific and can often be mistaken for other types of illnesses, for example, the flu or fatigue. If symptoms appear only while working and disappear when you stop working (although the time it takes for symptoms to disappear is variable), then you should suspect that the illness is caused by some material you are using. A common example of this type of acute illness is headache, dizziness, and nausea resulting from overexposure to solvents. Another example is dermatitis resulting from skin exposure to acids, alkalis, and other primary skin irritants.

More difficult to recognize are chronic illnesses resulting from repeated exposures to chemicals over a long period of time. In many cases, these get diagnosed only after the disease has developed to an advanced stage—for example, silicosis from exposure to silica in ceramics and stone carving. Many metals and solvents can also have long-term effects, particularly on the liver, kidneys, and nervous system.

If you have frequent symptoms such as headache, dizziness, blurred vision, fatigue, vomiting, nausea, loss of appetite, chronic cough, skin discoloration, depression, shortness of breath, wheezing, or fever, you should be suspicious. Of course, you must remember that these symptoms can also be due to illnesses resulting from bacteria, viruses, and other causes.

In many cases, mild behavioral changes occur before permanent damage to the body ensues, particularly with solvent exposure. These changes can include slowed reaction times, dulled senses, reduced ability to perform fine motions, and irritability. Although this type of warning signal is accepted as an indication of toxic effects in much of Scandinavia and Eastern Europe, it has not gained wide acceptance in the United States. However, I believe that you can use these symptoms as early warning signals.

If you are a member of a high-risk group, for example, asthmatic, susceptible to allergies, a heavy drinker or smoker, elderly, or a child, or if you have chronic heart, lung, or kidney disease, you should be particularly alert to symptoms that indicate that you are being poisoned. For example, an asthmatic can be particularly sensitive to dusts or other chemicals that might irritate the lungs or cause allergies.

What to Tell Your Physician

If you are having persistent symptoms of the type just described, then there is a chance that your materials are poisoning you. When you visit your physician, be sure to tell exactly what materials you are using, how they are used, and the chemical names whenever possible. Remember that if you do not tell your physician what materials you are working with, there is no way he or she can consider their possible involvement when making a diagnosis.

You may find that your physician does not know the possible toxic effects of the materials with which you work. Unfortunately, in this country, most physicians do not get training in the toxic effects of chemicals during medical school, and only a few physicians get any training in this subject at any time in their careers. This is especially true of general practitioners. Dermatologists and some other specialists are more likely to have this knowledge.

If your physician does not know the possible toxic effects of the chemicals with which you work, you should not hesitate to ask for a consultation with a

specialist who is knowledgeable about occupational health problems. After all, it is your life, and you should make sure that you get the best possible medical treatment.

One source of information about the toxic effects of chemicals are Regional Poison Control Centers in major cities across the country. They also have access to the composition and toxic effects of brand-name products. Another source of information is the Art Hazards Information Center of the Center for Safety in the Arts, which can refer you to occupational health clinics that have physicians specializing in occupational medicine.

Medical Tests

There are three main purposes for medical tests: (1) to obtain baseline information on your health, (2) for ongoing medical surveillance, and (3) for diagnosing an illness.

Baseline Medical Information. It is common to have a preemployment medical examination in order to determine the state of your health. This can be useful to determine whether a given job might put you at high risk for some reason. It can also give you a baseline for comparison in later years. For example, if your baseline audiogram indicates no hearing loss, and you subsequently develop hearing loss from excess noise at work, the baseline audiogram can be used to prove that work was the cause.

Medical Surveillance. Many artists ask me whether they should have blood or urine tests for the solvents, metals, or other chemicals they are using. There are a wide variety of tests that can be used to detect chemicals in the body, such as the Breathalyzer test for alcohol. However, the Breathalyzer test is not helpful after several hours, because the alcohol doesn't accumulate in the body. For that reason, tests for solvents, for example, are not useful under most circumstances, since they only detect that day's exposure.

Many metals—for example, lead, cadmium, mercury, and manganese—can accumulate in the body. However, except for lead and cadmium, there is not a good correlation between the metal concentration in the blood and damage to body organs. Therefore, usually only blood tests for lead and cadmium are recommended on a routine basis. Urine tests can be useful for mercury if the sample is collected appropriately.

Hair tests for metals are not considered reliable, since test results can vary widely depending on what part of the head the hair is taken from and on other factors such as hair length and laboratory procedures.

233

Ongoing medical surveillance relies on tests that detect organ damage. Some of the best examples of this are chest x-rays and lung function tests, which can measure how well your lungs are operating; liver and kidney tests to detect damage to those organs; and audiograms to test hearing.

In many cases, these tests can be used to detect changes in your health before they become serious. For example, if you are a potter, biannual lung function tests can establish a baseline of your lungs' normal function and enable your physician to diagnose early changes in lung function that might indicate an early stage of silicosis. Similarly, regular blood tests for lead can alert you to potential lead poisoning.

It should be emphasized at this point that these tests are not a substitute for adequate housekeeping and other protective measures.

Diagnosis. The same tests that are used for ongoing medical surveillance can be used to diagnose an art-related illness. If symptoms are present, the physician will probably include a battery of other tests to eliminate various causes.

▰▰▰ FIRST-AID

In an emergency—an accident, inhalation or ingestion of large amounts of a highly toxic chemical, skin or eye contact with corrosive chemical, or electric shock—knowing some simple first aid can prevent serious damage or death.

First-Aid Kit

Every artist's studio, art center, or art school should have a first-aid kit for emergencies, and everyone working there should be familiar with it. For workplaces under the jurisdiction of the Occupational Safety and Health Administration (OSHA), a first-aid kit approved by a consulting physician is mandatory. The size and number of first-aid kits that should be available depend on the number of people they are supposed to service.

The simple first-aid kits sold for home use in drugstores are usually not adequate for artists' studios because of the greater number of hazards found there. Table 11-1 contains a list of suggested contents for a first-aid kit for an individual artist in a studio. Many of the safety equipment companies listed in the Appendix at the end of Chapter 9 also sell first-aid kits.

Basic Rules of First Aid

The most important things to remember about first aid is that the first-aid measures taken must be simple and quick, and that they are only a stopgap until emergency medical services arrive or you can get the injured person to a physician.

TABLE 11-1. Suggested First-Aid Kit Contents

1/2 pint	mixed activated charcoal solution for ingestions
1/2 pint	ipecac syrup to induce vomiting in children (upon advice of physician)
1 tube	burn ointment
6	8-oz paper cups (sealed)
16	plastic adhesive bandages with Telfa pads, 1" × 33/8"
6	plastic adhesive bandages with Telfa pads, 2¼" × 3½"
10	3" × 3" sterile gauze compresses
4	2" bandage compresses with Telfa pad and 48" tails
1	4" bandage compress with Telfa pad and 84" tail
1	40" triangular bandage
4	eye units (sterile eye pads and adhesive strips)
1 pair	scissors
1 pair	tweezers
1 roll	1" adhesive tape
1	mouth-to-mouth resuscitator (optional)
1 liter	sterile saline solution (for rinsing eyes)
1 pint	chlorine bleach or isopropyl alcohol (for disinfecting)

The basic rule of first-aid assumes that you are not working alone, so that there is always someone around to help you in case of accident (or so you can help someone else). If you are working by yourself, make sure that someone knows you are there and checks on you so that, in case of accident, you can get help. This is one reason why it is important to have a telephone in your studio.

The following discussion is adapted in part from the *American Red Cross Standard First Aid Workbook.* I highly recommend that you attend a Red Cross first-aid course if you are interested in further knowledge in this area. Much of this material assumes that you have some knowledge in first aid. Do not try to help someone if you do not know what to do.

Survey the Situation. Is it safe for you? Fire, chemical spills, high concentrations of toxic gases or vapors, and other immediate dangers might make you a victim if you are not careful. If there is emergency equipment—and you know how to use it—then you can try to reach the victim. Otherwise, do not risk yourself, but immediately call 911 or emergency medical services (EMS).

Remove the victim from hazardous areas containing chemical spills or high concentrations of toxic gases, vapors, or fumes, if you can do so safely. In general, avoid moving victims until you determine their condition and whether it is safe to do so. Do not move a person with possible broken bones or possible head or internal injuries unless the victim is threatened by fire or fumes. Then, improvise a splint support to prevent aggravating the fracture.

Do a Primary Survey of the Victim. The purpose of this survey is to determine possible life-threatening situations and administer urgent first aid.

1. *Determine whether the person is unconscious.* Tap the victim on the shoulder and ask if he or she is OK. If the person is unconscious, call for help and check the ABCs—an open Airway, Breathing, and Circulation (pulse and severe bleeding).

 If the person is conscious, identify yourself and ask his or her consent to give first aid. Then check the ABCs.

2. *Open the airway.* The victim should be carefully rolled onto his or her back, if he or she is not already there. Open the victim's airway using the head-tilt/chin-lift method: Place your hand nearest the victim's head on the victim's forehead. Place two fingers of your other hand under the bony part of the victim's lower jaw near the chin. Tilt his or her head back and lift the jaw. Avoid closing the victim's mouth or pushing on soft parts under the chin.

3. *Check for breathing.* Maintain an open airway and place your ear over the victim's mouth and nose. Look at the victim's chest, listen, and feel for breathing for three to five seconds.

4. *Check the pulse.* This determines if the heart is beating. Maintain the head-tilt with one hand on the victim's forehead. Locate the Adam's apple with the middle and index fingers of your other hand and slide your fingers down into the groove of the neck on the side closer to you. Feel for the carotid pulse for 5 to 10 seconds.

5. *Check for severe bleeding.* Look the victim's body over carefully and quickly to see whether he or she is bleeding severely. Spurting blood indicates arterial bleeding and must be stopped quickly.

6. Complete the primary survey before commencing urgent first aid. Then treat life-threatening situations before giving first aid for less serious problems.

Emergency Medical Services System. If any of the ABCs are negative, shout for help. If someone else is present, that person should phone the emergency medical services (EMS). If no one responds to your call for help after one minute of urgent first aid, phone the EMS yourself.

Call the EMS (911 in many areas) in cases of unconsciousness; breathing difficulties; persistent chest or abdominal pain or pressure; no pulse; severe bleeding; vomiting or passing blood; seizures; injuries to head, neck, or back; and possible broken bones. In cases of poisoning, call your regional Poison Control Center.

When calling EMS, state the location of the accident, type of accident, your telephone number, and the number of people injured. Never hang up first, to ensure that all necessary information has been relayed.

First-Aid Actions. This section briefly considers the types of first-aid actions in certain situations. First, attend to life-threatening situations, then check for secondary or less serious problems. The actual first-aid measures are discussed on the pages mentioned.

1. If there is no breathing, begin rescue breathing. See page 240.
2. If no pulse is detected during rescue breathing (or when initially checking the ABCs), begin CPR. See page 242.
3. If there is severe bleeding, control the bleeding and monitor the ABCs. See page 242.
4. For shock, see page 244.
5. In cases of acute chemical poisoning, see page 237.
6. For thermal burns, see page 237.
7. For electrical shock, see page 245.
8. For heat stress, see page 246.
9. Never give liquids (or anything else by mouth) to an unconscious person, to persons with abdominal or lower chest injuries, or to persons having convulsions.

ACUTE CHEMICAL POISONING

In all cases of acute exposure to hazardous chemicals, speed of treatment is necessary to prevent further injury or death.

Chemical Burns

In cases of splashes or spills on the skin or in the eyes, take the following steps immediately:

1. Immediately flush affected areas with large amounts of running water. Remove all contaminated clothing and jewelry. If the material splashed is only slightly water soluble, then wash skin with soap and water.

237

2. In the case of splashes of liquids or solids into the eyes, rinse the eyes for at least 15 to 20 minutes with cool water. If pain or disruption of vision persists, continue to flush until seen by a physician.

3. In the case of chemical burns from acids or alkalis, do not use salves or ointments, since they may actually increase absorption of the chemicals. Chemical burns may be covered with a wet lint or gauze dressing for protection until medical treatment is possible.

4. Contact a physician in all cases of splashes in the eye, and for all but minor skin contaminations.

Emergency Eyewashes and Showers. In emergencies in which extensive areas of the body or the eyes are exposed to corrosive chemicals, it is important to rinse the affected areas with lots of water immediately. The best way to accomplish this is with deluge or emergency showers, which can quickly deliver large quantities of water, and with eyewash fountains (see Figure 11-1). In fact, these emergency systems are required by OSHA in places of employment where chemical splashes can occur. Only American National Standards Institute (ANSI)-approved eyewashes and emergency showers should be installed.

Emergency showers are needed wherever concentrated acids, alkalis, and other caustic chemicals are being used. Eyewash fountains are essential wherev-

Figure 11-1. Eyewash fountain

Combination emergency shower/
eyewash fountain

er there is any risk of irritating chemicals—such as acids, alkalis, solvents, and other irritants—splashing into the eyes.

Portable eyewash bottles are not recommended, since they can easily become contaminated and can cause eye infections. Also, they do not hold enough water to adequately rinse your eyes and are awkward if both eyes need rinsing. If standard bowl-type eyewashes are not practical, eyewashes can be purchased that fit onto standard or gooseneck faucets. ANSI-approved self-contained eyewashes are also available where there is not a plumbed source of water.

Deluge showers and eyewashes should be conveniently placed near where chemicals are used, since immediate treatment is needed to prevent damage to the skin or eyes. They should be within 25 feet and readily visible, since seconds can make a difference in terms of damage.

The operation of these eyewashes and deluge showers should be very simple and should not require temperature adjustment of water or other complicated controls. The water temperature should not be above 112°F (45°C) and not freezing, although cold water is preferable to hot water. The devices should be checked regularly to ensure proper functioning.

Chemical Inhalation

If a person is overcome by inhalation of solvent vapors, gases, or other materials, take the following steps:

1. Remove the person from the source of the gas, vapors, or fumes. If necessary, wear appropriate respiratory equipment and protective clothing. If appropriate protective equipment is not available and is needed, do not risk yourself but immediately call for assistance.

2. Check the ABCs. If the injured person has stopped breathing or has no pulse, remove him or her from the source of the exposure and immediately start rescue breathing or CPR.

3. Call EMS and make sure the injured person gets plenty of fresh air.

4. Treat the victim for shock. (See the section on shock.)

Chemical Ingestion

If anyone accidentally swallows potentially toxic materials, take the following steps:

1. First phone the nearest Regional Poison Control Center and describe what was swallowed and how much. You should assume that if any chemical gets in the mouth, some of it has been swallowed.

2. The normal emergency treatment for ingestion of poisons is to induce vomiting. This should be done upon a physician's instructions, since there are exceptions (see (4) below). Vomiting can be induced as follows:

 a. Give the person one to two glasses of water.

 b. Have the person stick his or her finger in the back of the throat and tickle it (or do it for the person).

 c. Give one tablespoon of ipecac syrup (less for small infants). It usually takes about 20 minutes to work.

 d. Repeat the second step.

 e. If vomiting does not occur within 30 minutes, repeat steps a–d once.

3. After vomiting has occurred, give the adult victim 60 grams of premixed charcoal solution (or several teaspoons of activated charcoal in one to two glasses of water if premixed solution is not available) or give the victim one to two glasses of water.

4. Do not induce vomiting for the following chemicals: strong acids or alkalis, turpentine, petroleum distillates (gasoline, naphtha, benzine, kerosene), odorless paint thinner, mineral spirits, or cyanide, or if the person is having convulsions.

5. For acids, alkalis, petroleum distillates, and other chemicals in which vomiting should not be induced, give one to two glasses of milk or water. Cyanide ingestion (or inhalation) requires special treatment.

6. After this emergency treatment, get the patient to a treatment center as soon as possible.

RESCUE BREATHING

If breathing stops for any reason—inhalation of toxic gases, ingestion of poisons, electric shock, suffocation, and so on—start rescue breathing (also called artificial respiration) immediately. Seconds can be crucial. Call EMS as soon as possible.

The mouth-to-mouth method of rescue breathing is almost universally accepted as the best method and should be used whenever possible. The mouth-to-nose method can also be used.

Figure 11-2 is reprinted with permission from the *American Red Cross Standard First Aid Workbook*. This is not intended to make you an expert in rescue breathing. I recommend that people obtain first-aid training from the American Red Cross and use this as a reminder.

In case of vomiting, turn the victim quickly on his or her side, wipe out the mouth, and then reposition. Do not give liquids to someone who is unconscious.

American Red Cross First Aid:
When an Adult Stops Breathing

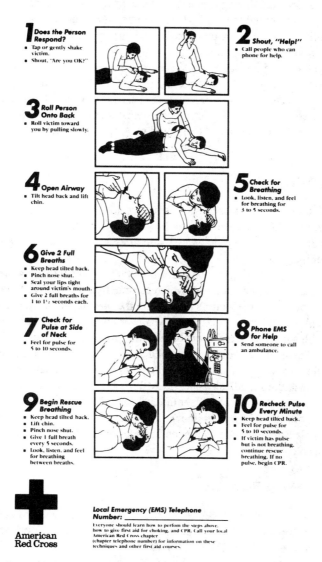

1 Does the Person Respond?
- Tap or gently shake victim.
- Shout, "Are you OK?"

2 Shout, "Help!"
- Call people who can phone for help.

3 Roll Person Onto Back
- Roll victim toward you by pulling slowly.

4 Open Airway
- Tilt head back and lift chin.

5 Check for Breathing
- Look, listen, and feel for breathing for 3 to 5 seconds.

6 Give 2 Full Breaths
- Keep head tilted back.
- Pinch nose shut.
- Seal your lips tight around victim's mouth.
- Give 2 full breaths for 1 to 1½ seconds each.

7 Check for Pulse at Side of Neck
- Feel for pulse for 5 to 10 seconds.

8 Phone EMS for Help
- Send someone to call an ambulance.

9 Begin Rescue Breathing
- Keep head tilted back.
- Lift chin.
- Pinch nose shut.
- Give 1 full breath every 5 seconds.
- Look, listen, and feel for breathing between breaths.

10 Recheck Pulse Every Minute
- Keep head tilted back.
- Feel for pulse for 5 to 10 seconds.
- If victim has pulse but is not breathing, continue rescue breathing. If no pulse, begin CPR.

American Red Cross

Local Emergency (EMS) Telephone Number:
Everyone should learn how to perform the steps above, how to give first aid for choking, and CPR. Call your local American Red Cross chapter (chapter telephone number) for information on these techniques and other first aid courses.

Figure 11-2. *Courtesy of the American Red Cross*

Plastic mouth-to-mouth resuscitators are available that prevent the tongue from blocking the air passages and alleviate people's concerns about catching infections.

CPR

If no pulse is detected during rescue breathing, or in case of heart attacks or cardiac arrest, it is essential that CPR (cardiopulmonary resuscitation) begin immediately. Without oxygen being pumped to the brain by the heart, brain cells begin to die within four to six minutes.

CPR is the standard way to try to restart the heart. CPR is a combination of chest compressions and rescue breathing. Figure 11-3 is reprinted with permission from the *American Red Cross Standard First Aid Workbook*. This is not intended to make you an expert in CPR. I recommend that people obtain first-aid training from the American Red Cross and use this as a reminder.

BLEEDING

Arterial bleeding involves bright-red, spurting blood. Venous bleeding is dark red or maroon and flows steadily from the wound. Capillary bleeding is slow. Arterial bleeding and bleeding that won't stop after first-aid measures are taken is life-threatening.

To reduce the risk of transmission of infection when controlling bleeding always folow "universal precautions" which assume that the victim's blood may be infected. Do not touch the victim's blood directly. Use the victim's hand, plastic or disposable gloves, a layer of plastic, or whatever else is handy. Wash your hands carefully with soap and water immediately after giving first aid, even if you wore protection. Excess blood should be mopped up with heavy compresses and placed in a sealable plastic bag. If saturated or dripping, these materials should be disposed of as hazardous medical waste. If EMS has been called, or in a school environment, cleanup and disposal should be handled by trained personnel in accordance with the OSHA Bloodborne Pathogens Standard. Contaminated surfaces and tools can be disinfected by chlorine bleach, diluted 1:10 with water, or by isopropyl alcohol.

Severe External Bleeding

1. Stop severe external bleeding before giving other urgent first aid. Apply a large compress, with direct pressure on the wound, and elevate the injured part above heart level if bone breaks are not suspected. If bleeding stops, apply a pressure bandage. If blood soaks through, add more compresses.

American Red Cross First Aid:
CPR for an Adult

1 Does the Person Respond?
- Tap or gently shake victim.
- Shout, "Are you OK?"

2 Shout, "Help!"
- Call people who can phone for help.

3 Roll Person Onto Back
- Roll victim toward you by pulling slowly.

4 Open Airway and Check for Breathing
- Tilt head back and lift chin.
- Look, listen, and feel for breathing for 3 to 5 seconds.

5 Give 2 Full Breaths
- Keep head tilted back.
- Pinch nose shut.
- Seal your lips tight around victim's mouth.
- Give 2 full breaths for 1 to 1½ seconds each.

6 Check for Pulse at Side of Neck
- Feel for pulse for 5 to 10 seconds.

7 Phone EMS for Help
- Send someone to call an ambulance.

8 Find Hand Position
- Locate notch at lower end of breastbone.
- Place heel of other hand on breastbone, next to fingers.
- Remove hand from notch and put it on top of other hand.
- Keep fingers off chest.

9 Give 15 Compressions
- Position shoulders over hands.
- Compress breastbone 1½ to 2 inches.
- Do 15 compressions in approximately 10 seconds.

10 Give 2 Full Breaths
- Tilt head back and lift chin.
- Pinch nose shut.
- Seal your lips tight around victim's mouth.
- Give 2 full breaths for 1 to 1½ seconds each.

11 Repeat Compression/Breathing Cycles
- Do 4 cycles of 15 compressions and 2 breaths.
- Recheck pulse after 1 minute. If no pulse, give 2 full breaths and continue CPR.

Local Emergency (EMS) Telephone Number:
Everyone should learn how to perform the steps above and how to give first aid for breathing and choking emergencies. Call your local American Red Cross chapter (chapter telephone number) for information on these techniques and other first aid courses.

American Red Cross

Figure 11-3. *Courtesy of the American Red Cross*

243

2. If bleeding continues, press on an arterial pressure point. See Figure 11-4.

3. Continue to monitor the ABCs and care for shock, if present.

4. In cases of portions of skin or fingers being torn away (e.g., an accident with machinery), control the bleeding with direct pressure as above. Wrap the missing part in sterile gauze or clean cloth, place it in a plastic bag, and place it on ice to keep it cool.

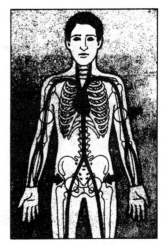

Figure 11-4.

Courtesy of the American Red Cross

Severe Internal Bleeding

1. In chest and abdominal injuries, where internal bleeding may be present, cover the wound with a sterile, airproof dressing (or several layers of gauze and a piece of tarpaulin) to prevent lung collapse. Do not attempt to replace protruding viscera.

2. Monitor the ABCs and get help.

Minor Bleeding

1. If the cut is slight and bleeding is not excessive, remove all foreign material (glass, dirt, etc.) projecting from the wound (but do not gouge for embedded material). Remove the foreign material by washing carefully with soap and water. Apply an antiseptic to all parts of the cut and to approximately one-half inch of skin around the cut. Iodine is not recommended.

2. For bruises, apply ice or a cold pack to help reduce pain and swelling. Put a cloth between skin and the ice or ice pack.

SHOCK

Shock occurs to some extent in all injuries. It varies with the individual and can cause death. Some easily recognized symptoms are paleness, cold and moist skin with perspiration on the forehead and palms of the hand, nausea, shallow breathing, and trembling. The following are first-aid recommendations for shock:

1. Place the victim in a reclining position with the head lower than the body, except in cases of severe head bleeding, fractured skull, sunstroke, or convulsions, in which case the head should be elevated. Elevate the legs if there are no broken bones.

2. Help the victim maintain normal body temperature. Keep from chilling by placing blankets underneath and around the body. In hot environments, try to cool him or her by providing shade (if in sun) and loosening clothing.

3. If the victim vomits, place the victim on his or her side to avoid blocking the airway with fluids.

4. Monitor the ABCs.

5. Do not give the victim anything to drink or eat.

6. Call EMS immediately.

THERMAL BURNS

Burns can vary widely in severity. First-degree burns are classified as superficial, involving only the outer layer of the epidermis. They are characterized by reddening, tenderness, and pain, but no blistering.

Second-degree burns can involve both the epidermis and the underlying dermis, but are not critical enough to prevent complete healing. Blistering is usually present, and infections are a danger.

Third-degree burns involve much more extensive destruction of the skin tissue, possibly involving tissues beneath the skin. Charring or coagulation of the skin is often present. If an extensive area is damaged by second- or third-degree burns, there is danger of shock and even death.

Take the following steps in case of burns caused by fire or hot objects:

1. In case of fire, smother flames by rolling the person in a fire blanket. If this is not available, a heavy coat may also work. If clothing adheres to the burned skin, do not attempt to remove it, but cut the clothing carefully around the burned area.

2. If the burn is slight, immerse the burned part in cold water and ice to relieve pain and limit burn damage. Continue until the edges of the burn are cool; apply a dry, sterile dressing; and bandage securely but not tightly. You may use antibiotic burn ointments on mild burns.

3. Severe burns should not be treated with anything but cool water (not iced water). After the burn edge is cool, cut or carefully remove clothing from the burn area. Do not remove cloth if it sticks. Do not use ointments. Cover with a dry sterile dressing. A physician can dress the burn after determining its degree and extent. **Caution:** Do not open blisters. Watch for shock.

245

ELECTRICAL SHOCK

In case of severe electrical shock, take the following steps:

1. Shut off the electrical current at the fuse or circuit breaker. If this is not possible, carefully remove the electrical contact from the victim, using an insulator. Use heavy rubber gloves, or place your hand inside a glass or plastic container to push the victim or current source aside. A dry stick or dry towel will not suffice. For high voltages, use only insulating rubber gloves.

2. Start rescue breathing immediately if the victim is not breathing.

3. Continue artificial respiration for at least four hours or until a physician certifies death, even though there is no sign of regaining consciousness. Early rigidity or stiffening are not reasons to stop in cases of electrical shock.

4. Keep the victim warm using blankets and hot-water bottles against the body.

HEAT STRESS

In case of reactions to hot environments, you should do the following:

1. Move yourself or any other person displaying a reaction to a hot environment into a cooler environment.

2. In cases of fainting as a result of standing immobile in the heat, and if no other symptoms exist, treat for shock.

3. If the person is experiencing heat stroke—characterized by rapidly rising body temperature, hot dry skin, mental confusion, and possible loss of consciousness—immerse him or her in cold water (or give a sponge bath) and massage. This is a medical emergency and requires hospital treatment.

4. If the person is experiencing heat shock caused by salt and/or water depletion—characterized by symptoms of fatigue, nausea, dizziness, clammy skin, and cramps—replace the lost body fluids with salted water (one teaspoon per gallon).

5. Heat rash can be helped with mild, drying skin lotions and cooled sleeping quarters to allow the skin to dry better.

6. Call a physician in all cases of heat stress.

REFERENCES

American National Standards Institute. (1990). *Emergency Eyewash and Shower Equipment* New York: ANSI.

American Red Cross. (1991). *American Red Cross Standard First Aid Workbook.* 2d ed. Washington, DC: American National Red Cross.

Gosselin, R., Smith, R., and Hodge, H. (1987). *Clinical Toxicology of Commercial Products.* 6th ed. Baltimore: Williams and Wilkins.

Schwartz, G. K., et al. (1986). *Principles and Practice of Emergency Medicine.* Philadelphia: W.B. Saunders Co.

Art
and
Craft
Techniques

12

Painting
and
Drawing

I n the first chapter of this book, I quoted from Bernardini Ramazzini's 1713 book, *Diseases of Workers*. He attributed the general sickliness of the painters of his time to the colors and materials they handled and smelled constantly such as red lead, cinnabar, white lead, nut oil, varnish, and linseed oil. Unfortunately, Ramazzini's statement about the hazards of the materials painters use is still true today, since a wide variety of toxic pigments, solvents, preservatives, aerosol sprays, and other substances are used in painting.

Paints consist of pigments mixed with a vehicle such as water or linseed oil, and a binder. In addition, various additives such as driers, preservatives, and pigment extenders can be present. If you mix up your own paints, you may also be exposed to concentrated amounts of these additives. Paints commonly used by artists include oil paint, acrylic paint, watercolor, gouache, casein, encaustic, fresco, pastels, and tempera.

PIGMENTS

Pigments are used as colorants in painting. Most artists buy ready-to-use tube paints, and thus are not exposed to the powdered pigment. Artists who mix their

own paints from the powder are at higher risk because of the chance of inhaling the pigment powder.

Inorganic Pigments. Over the centuries, many different pigments have been used in painting and printmaking. Many of the early pigments were inorganic, usually of mineral origin. These included ceruse (white lead), cinnabar (mercuric sulfide), and the earth colors. Many of the ancient, inorganic pigments—including highly toxic pigments such as verdigris (copper acetate), King's yellow (arsenic trisulfide), and iodine scarlet (mercuric iodide)—are no longer used. However, many ancient pigments are still in use, including flake white (lead carbonate) and vermilion (mercuric sulfide). In addition, other toxic, inorganic pigments, such as the cadmium and chrome pigments, have come into use in the last few centuries.

Organic Pigments. Although most traditional pigments used for painting are minerals or metallic compounds such as the earth colors (from iron oxides), some traditional pigments such as rose madder are based on animal or plant materials. In the twentieth century, however, a large number of synthetic organic pigments—so-called because they are manufactured in a chemical laboratory— have come into use. One problem with both the "natural" and synthetic organic pigments is that, in most cases, adequate research has not been done to determine long-term effects on the body.

As a result, today, the painter's palette is a mixture of both inorganic and organic pigments. One problem, however, is finding out the chemical composition of the pigments you are using. Not all manufacturers use the same name for the same pigment. Those manufacturers listing the chemical composition and Color Index name of their pigments (such as Pigment White 4 for zinc white) are the most reliable.

Hazards

1. The major pigment hazard in painting is from accidental ingestion of the pigment. This can occur as a result of getting paint on hands, and from there to the mouth (e.g., eating while working, smoking while working, or pointing your paintbrush with your lips). With the exception of lead and arsenic pigments, acute poisoning from ingestion is not likely. The concern is with chronic exposure through poor working habits.

 Examples of chronically toxic pigments include compounds of cadmium, cobalt, lead, manganese and mercury. Some pigments—for example, chrome yellow, zinc yellow, strontium yellow, and cadmium pigments— are known or probable human carcinogens and may cause lung cancer.

Unfortunately, there is inadequate information about the long-term hazards of most of the organic pigments. Table 12-1 lists the hazards of particular pigments.

2. Inhalation can be a potential hazard if you grind your own pigments, mix pigments for encaustic, or spray paint containing toxic pigments.

3. Some pigments can cause skin irritation and allergies. These include the chromate-containing pigments such as chrome yellow and zinc yellow, and cobalt pigments.

4. Some cases of poisoning have occurred by getting the pigments (or paint) in cuts or sores.

Precautions

1. Preferably buy paints that list the Color Index Names on the labels so you can be sure what pigments are present. You should also obtain Material Safety Data Sheets on your paints.

2. Avoid mixing powdered pigments, if possible. If you work with more than minimal amounts of powdered pigments, either use a glove box (see Chapter 8), or wear a National Institute for Occupational Safety and Health (NIOSH)-approved toxic dust respirator.

3. Do not eat, drink, or smoke in the studio. Wash your hands carefully after work, including under the fingernails. Clean up all spilled pigment powders with a wet paper towel.

4. Do not point your paintbrush with your lips.

WATER-BASED PAINTS

Water-based paints include acrylic, watercolor, gouache, casein, and tempera. Water is used for thinning and cleanup. They do not involve the use of organic solvents. Spray painting is discussed in a later section.

General Hazards

1. See the pigments section above for the hazards of pigments in water-based (or any other) paint.

2. Water-based paints may contain trace amounts of formaldehyde or other preservatives. This is not enough to cause someone to develop irritant

dermatitis or to become sensitized, but a painter already sensitized to formaldehyde from another source could develop allergic skin reactions to acrylic or other paints containing formaldehyde.

General Precautions

1. Do not eat, drink, or smoke in the studio. Wash your hands carefully after work, including under the fingernails.
2. If you are sensitized to formaldehyde, you will probably have to switch to a formaldehyde-free painting medium.
3. If you mix your own paints from dry pigments, see the section on pigments for precautions to avoid inhaling the pigment powder.
4. If you add preservatives to your paint, use the least toxic preservatives possible. See the section on preservatives later in this chapter.

Acrylic Paints

There are two varieties of acrylic paints: water emulsion and solvent based. Water-emulsion acrylics are made by suspending the pigment in an acrylic emulsion consisting of acrylic polymer, water, trace amounts of formaldehyde (as a preservative), and small amounts of ammonia. Polymer medium is an acrylic emulsion with a pigment extender such as calcium carbonate added. Solvent-based acrylics are discussed under nonwater-based paints.

Hazards

1. See general hazards above.
2. Acrylic paint and emulsions contain a small amount of ammonia. This may cause eye, nose, and throat irritation in a few sensitive painters, especially if large amounts of the gel or polymer medium are used.

Precautions

1. See general precautions above.
2. If you experience irritation from the small amounts of ammonia in acrylic paints or polymer emulsion, install a window exhaust fan. If you mix large amounts of your own paints using dry pigments and acrylic emulsion, you definitely need a window exhaust fan to remove ammonia gas.

Watercolors and Gouache

These paints are fairly similar, consisting basically of a gum (gum arabic or gum tragacanth), water, preservatives, and pigments. They may also contain glycerin, syrup, and other nontoxic ingredients. Gouache contains precipitated chalk (calcium carbonate) to make it opaque.

Hazards

1. See general hazards above.
2. Gum arabic and gum tragacanth are slightly toxic by skin contact, causing skin allergies in a few people. Gum arabic is moderately toxic by inhalation (e.g., if sprayed), causing asthma.

Precautions. See general precautions above.

Casein Paints

Casein paints may contain larger amounts of ammonia to dissolve the casein, a milk protein. Artists making their own casein paints may add ammonia solution.

Hazards

1. See general hazards.
2. Ammonia is a strong skin, eye, and respiratory irritant.

Precautions

1. See general precautions.
2. An exhaust fan is essential if you mix casein paints using ammonium hydroxide. Wear gloves, goggles, and a protective apron during this process. An eyewash fountain should be readily available.

Tempera

Tempera is sold as powdered pigments or paints suspended in a variety of mediums using water as a vehicle, with various binders including egg, egg/oil, gum casein, and wax. Poster paints consist of dry pigments and inert fillers such as calcium carbonate in a medium consisting of gum as a binder, water as a vehicle,

and preservatives. Casein tempera is a mixture of casein solution with oil. Egg tempera uses egg yolk or egg/oil.

In egg/oil tempera, the use of tetrachloroethane has been suggested as a solvent for making a special copal varnish for some pigments. Preservatives that have been suggested for egg tempera include phenol (carbolic acid) and sodium orthophenylphenate. Pine oil has also been suggested as a preservative for egg/oil tempera, if preservation is needed for only a short period of time.

Hazards

1. See the pigment section for the hazards of powdered pigments. Usually only small amounts of pigments are used at a time, thus minimizing the risk.

2. Tetrachloroethane is highly toxic by inhalation and skin absorption. It is more toxic than carbon tetrachloride, causing severe liver damage.

3. See hazards of preservatives later in this chapter.

Precautions

1. Use careful personal hygiene when painting. Do not eat, drink, or smoke in the studio. Wash your hands carefully after work.

2. Do not use tetrachloroethane.

Fresco Paints

Fresco paints are made by grinding the pigment into pure water or water with limewater added.

Hazards

1. See general hazards.

2. Limewater (calcium hydroxide) is moderately toxic by skin and eye contact, and by ingestion. Powdered lime is highly corrosive by inhalation and eye contact.

Precautions

1. See general precautions.

2. Wear gloves and goggles when handling limewater and lime. An eyewash fountain should be available.

Latex Paints

Commercial latex paints usually contain about 5% ethylene glycol, propylene glycol, or similar glycols to help dissolve the resin. In addition, they may contain mercury preservatives. Indoor latex paints made after 1991 do not contain mercury preservatives.

Hazards

1. See general hazards.
2. Although hazardous by ingestion, ethylene glycol and other glycols are present in such small quantities that ingestion is not a serious hazard. If the latex contains glycol ethers such as ethylene glycol monoethyl ether, there could be a hazard by skin absorption.
3. Do not use paints containing mercury preservatives.

▪ NONWATER-BASED PAINTS

Nonwater-based paints can contain a variety of vehicles, including solvents, linseed oil, egg, or liquid wax. Spray painting is discussed in a later section.

Oil Paints

Oil paints use linseed oil as a vehicle, although sometimes small amounts of solvents can be present. Turpentine and mineral spirits are used for thinning, in painting mediums, in varnishes, and for cleanup.

Hazards

1. Pigment poisoning can occur if paint gets into cuts or sores, or if paint is accidentally ingested by pointing the brush with your lips, eating or smoking while painting, or failing to wash your hands thoroughly after work. This may result in chronic poisoning.
2. Turpentine and mineral spirits (paint thinner) are moderately toxic by all routes of entry. They are both irritants and narcotics (dizziness, headaches, nausea, etc.). Turpentine, however, is absorbed through the skin and can cause allergic reactions and kidney damage. Wood or steam-distilled turpentine is more toxic than gum turpentine.

3. Turpentine washes are very hazardous, since a large amount of solvent is placed on the canvas and evaporated in a short period of time. This can result in serious overexposure by inhalation of the turpentine vapors.

Precautions

1. Use careful personal hygiene when painting. Do not eat, drink, or smoke in the studio. Do not point brushes with your lips, and wash your hands carefully after work.

2. Whenever possible, replace turpentine with the less toxic and less flammable turpenoid or odorless paint mineral spirits (mineral spirits with the more toxic aromatic hydrocarbons removed).

3. If possible, set up your easel close to a window containing a window exhaust fan at work level, which pulls the solvent vapors away from your face. The size of fan needed depends on the amount of solvent evaporating in a given period of time. For example, if you evaporate one-half cup of mineral spirits over a four-hour period, you would need a fan exhausting 350 cubic feet per minute (cfm). The fan should be running as long as the solvent is evaporating (not the entire time the linseed oil paint film is oxidatively drying).

4. A turpentine wash using one pint of turpentine over one hour would require a fan exhausting about 4,000 cfm. For this reason I would recommend not doing turpentine washes unless you are wearing a respirator with organic vapor cartridges and have ventilation. Acrylic underpainting is a safer alternative.

5. Wear neoprene gloves when cleaning brushes with solvents.

6. Used cleanup solvent can be reclaimed by allowing the paint particles to settle and then pouring the clear solvent through a cloth filter.

7. Small amounts of waste solvent can be disposed of by evaporation in a safe location. Do not pour solvents down the sink. Dispose of solvent-soaked rags or waste in an approved self-closing waste disposal can.

8. Oil paint can be removed from hands with baby oil or vegetable oil, and then soap and water. A safe waterless hand cleanser can also be used. Never use solvents to clean your hands.

9. During pregnancy, switch to a water-based painting medium to avoid solvent inhalation.

Alkyd and Other Solvent-Based Paints

Alkyd paints and solvent-based acrylic paints use solvents as a vehicle and plastic polymers as a binder. In addition, many commercial paints used by artists can

be solvent based. Artists' solvent-based paints and commercial alkyd paints usually contain turpentine or mineral spirits. Some commercial paints (e.g., sign paints, car paints) may contain toluene, xylene, or other toxic solvents.

Hazards

1. See the pigments section for the hazards of pigments. Note that car paints, sign paints, and other exterior paints often contain lead chromate, a known human carcinogen.

2. Solvent-based paints are more hazardous than oil paints because they contain large amounts of solvents as a vehicle instead of linseed oil. Therefore, there is a lot more solvent exposure when the solvent evaporates.

3. Paints containing toluene and xylene are much more toxic than those containing mineral spirits. In addition, toluene and xylene are flammable. (See the solvents section of Chapter 4.)

Precautions

1. See the precautions for oil paints.

2. A more powerful exhaust fan is needed with solvent-based paints because of the larger amounts of solvents used. This would particularly be a problem when painting on a large scale.

3. If ventilation is not adequate, you should wear a NIOSH-approved respirator with organic vapor cartridges.

4. If the paint contains flammable solvents, eliminate all sources of ignition such as flames, lit cigarettes, hot plates with exposed elements, and the like.

Encaustic

Encaustic paints are made by suspending small amounts of pigments in melted wax along with other media such as Venice turpentine, balsams, and drying oils. Ready-made encaustic paints are also available.

Hazards

1. See the pigment section for the hazards of powdered pigments. Usually only small amounts of pigments are used at a time, thus minimizing the risk.

259

2. Heating wax for encaustic can create a fire hazard from wax vapors and respiratory irritation from decomposition of the wax, if overheated.

3. See the section on varnishes, lacquers, and mediums for information on their hazards.

Precautions

1. Use careful personal hygiene when painting. Do not eat, drink, or smoke in the studio. Wash your hands carefully after work.

2. Always cover containers of dry pigments.

3. Melt wax in a double boiler on a hot plate that does not have an exposed element, or use an electric frying pan. Do not use a flame. Use the lowest temperature feasible on the double boiler and heated palette to minimize vaporization and decomposition of the wax.

4. If solvents are used, see precautions in the sections on oil paints and varnishes, lacquers, and mediums.

Epoxy Paints

Epoxy paints are popular for painting murals. The pigments are dispersed in the epoxy resin, and this resin-pigment mixture is then combined with the hardener to make the final epoxy paint. This must be painted onto the surface before the epoxy has had a chance to harden.

Hazards

1. See the pigments section for the hazards of pigments.

2. The epoxy hardeners are moderately toxic by skin contact and inhalation, causing large numbers of skin and respiratory allergies. (See the section on plastics in Chapter 16 for more complete details.)

3. The solvents in epoxy systems can include aromatic hydrocarbons such as toluene, which are highly toxic by inhalation, causing irritation, narcosis, and possible liver damage.

Precautions

1. Use careful personal hygiene when painting. Do not eat, drink, or smoke in the studio. Wash your hands carefully after work.

2. Wear gloves when handling epoxy paints and have very good general ventilation.

3. Use an organic vapor respirator when working indoors with large amounts of epoxy paints, if ventilation is not adequate.

4. See also precautions under oil paints.

VARNISHES, LACQUERS, AND MEDIUMS

Varnishes, lacquers, and mediums are solutions of natural or synthetic resins dissolved in volatile solvents. Many of these resins—for example, damar, mastic, copal, and acrylic—are dissolved in mineral spirits or turpentine. Shellac is dissolved in methyl alcohol or ethyl alcohol, and pyroxylin (cellulose resin) lacquers are dissolved in complex solvent mixtures containing, for example, acetone, toluene, acetates, alcohols, and petroleum distillates. The lacquer thinners also contain a variety of solvents. There are also a wide variety of other natural resins sometimes used by painters, including natural Oriental lacquers (e.g., Japanese lacquer), balsa resins, and Venice turpentine.

A variety of solvents is used to remove paints and varnishes. Most of these contain methylene chloride, although toluene and methyl alcohol are also found.

Hazards

1. Turpentine and mineral spirits (paint thinner) are moderately toxic by skin contact, inhalation, and ingestion. They are irritants and narcotics. Turpentine is absorbed through the skin and can also cause kidney damage and allergies.

2. Methyl alcohol is moderately toxic by skin contact, inhalation, and ingestion. Methyl alcohol affects the nervous system (particularly the eyes), liver, and kidneys. Ethyl alcohol is slightly toxic by skin contact and inhalation, and moderately toxic by chronic ingestion.

3. The most toxic component of lacquer thinners is usually toluene (toluol) or xylene (xylol). These are highly toxic by inhalation and moderately toxic by skin contact. They are absorbed through the skin. Since they constitute a large portion of lacquer thinners, these thinners should be considered highly toxic by inhalation. Extremely flammable lacquer thinners probably contain n-hexane, which is highly toxic and can cause peripheral nerve damage.

4. Methylene chloride is moderately toxic by skin contact and ingestion, and highly toxic by eye contact and inhalation. It is a probable human carcinogen and is a powerful narcotic. It decomposes in the body to form carbon monoxide, and can cause heart arrhythmias, possibly resulting in fatal heart attacks.

5. Most of the solvents discussed are flammable.

6. Most of the various resins themselves (gum acacia, gum tragacanth, rosin, copal, and damar) are slightly toxic and may cause allergies in a few people. Japanese lacquer can cause severe skin irritation and allergies, since it contains the same chemical, urushiol, that causes allergic reactions to poison ivy. Venice turpentine has hazards similar to those of turpentine.

Precautions

1. Wear gloves when handling varnishes, lacquers, and their thinners.

2. When using varnishes, lacquers, lacquer thinners, and paint and varnish removers, have good general ventilation. For large amounts of lacquer thinner or paint and varnish removers, you need local exhaust ventilation or should wear a NIOSH-approved organic vapor respirator.

3. People with arrhythmia problems should not use methylene chloride-containing paint and varnish removers.

4. Take precautions against fire. Store more than one quart of flammable solvents in approved safety containers. Do not smoke or have open flames or sparks in the studio. Place solvent-soaked rags and newspapers in approved, self-closing waste disposal cans that are emptied each day.

5. Never use solvents to clean your hands. Wear gloves or a protective barrier cream when working. After work, wash your hands with baby oil or vegetable oil, and then soap and water.

6. See Table 4-4 in Chapter 4 for the hazards and precautions of solvents.

PRESERVATIVES

Preservatives are used in many water-based paints and other art materials to prevent the growth of molds or bacteria while the art material is on the store's shelf. In many instances, there is not sufficient preservative to prevent growth of microorganisms after the container has been opened for an extended period. In addition, some artists add preservatives to paints they make themselves.

Hazards

1. The amount of preservatives in most art materials is usually not sufficient to harm individuals from skin contact or inhalation. With children, however, ingestion of art materials with toxic preservatives could be a hazard.

2. Use of pure preservatives to add to art materials can be a hazard to the artist, depending on the preservative. See Table 12-2 for information on the hazards of particular preservatives.

Precautions

1. With children, use only art materials approved for children, containing preservatives that have been approved for children. See Chapter 25 on children and art materials.

2. If you add your own preservatives, use the least toxic preservatives that will work.

3. Use suitable precautions such as gloves, ventilation, and personal protective equipment when working with pure preservatives.

▮▮▮▮ SPRAY PAINTING

Many painters use spray guns, airbrushes, or spray paints in aerosol cans for painting. The paints being sprayed may be either water based or solvent based. In addition, there is widespread use of aerosol spray fixatives and spray varnishes, all of which contain organic solvents and propellants such as butane or carbon dioxide.

Hazards

1. Spray painting and the use of aerosol spray cans is highly hazardous by inhalation. Spray guns, airbrushes, and aerosol spray cans all produce a very fine particulate mist that is easily inhaled and can remain suspended in the air for up to two hours, long after the solvent vapors have dissipated. The hazards from the spray mist include toxic pigments, solvents, and propellants. Symptoms experienced by spray painters have included headaches, nausea, fatigue, and flu-like symptoms. Chronic poisoning from toxic pigments is also possible.

2. High-pressure spray guns have caused serious accidents due to accidental injection of the high-pressure spray into fingers. In several cases this has resulted in injuries that have required amputation of fingers.

3. Spraying of solvent-containing paints or aerosol spray cans containing flammable propellants is a serious fire hazard.

Precautions

1. If possible, spray or airbrush in a spray booth exhausted to the outside. (One company that makes spray booths for graphic arts is Paasche.) Otherwise wear a NIOSH-approved toxic dust and mist respirator for water-based sprays, and an approved paint spray respirator with organic vapor cartridges and dust and mist (or spray) prefilters for solvent-based sprays. There should also be an exhaust fan in the studio to remove the excess spray so you can take off your respirator safely.

2. Do not spray with pigments that are known human carcinogens (e.g., lead chromate and zinc chromate).

3. When spraying flammable materials, there should be no sources of ignition—cigarettes, open flames, sparks, electric motors—within 20 feet of the spraying area. The spray booth should be sparkproof.

4. When using high-pressure spray guns, be careful to avoid getting your fingers in the way.

DRY DRAWING MEDIA

Dry drawing materials include dust-producing charcoal, graphite, pencils, chalk, pastels, waxy crayons, and oil pastels.

Pastels

Pastel sticks and pencils are made by binding pigments with resins and compressed calcium carbonate. Other additives may be present. Some pastels are dustier than others.

Hazards

1. Pastels can contain many toxic pigments, including chrome yellow (lead chromate), cadmium pigments, and manganese pigments. In general, pastels are poorly labeled as to the identity of the pigments used. Many art material manufacturers are trying to eliminate toxic pigments from pastels.

2. Inhalation of pastel dusts is the major hazard, as noticed by many pastel artists who have complained of blowing their noses in many colors after working with pastels. Blowing off excess pastel dust greatly increases the amount of dust inhalation.

3. Some asthmatics may be sensitive to pastel dusts (and other dusts). This is, however, usually a nonspecific reaction to dusts, not a toxic reaction.

4. Inhalation of the spray mists from spray fixatives is also a hazard. Spray fixatives may contain n-hexane, a highly toxic solvent causing peripheral nerve damage, and other toxic solvents.

Precautions

1. Do not use pastels containing lead chromate or other extremely or highly toxic pigments. Obtain Material Safety Data Sheets on your pastels.

2. Do not blow off excess pastel dust. Tap the drawing to allow the excess pigment to fall, and then clean up by wet mopping.

3. One way to tell if you are inhaling the pastel dust is to tie a white handkerchief over your mouth and nose while working, and then see if it becomes colored. If so, you can wear a NIOSH-approved toxic dust respirator.

4. Do not hand rub the drawing; instead use paper stomps or chamois cloths.

5. Clean up pastel dust on floors and surfaces by wet mopping.

6. If you are having problems with inhalation of pastel dusts, switch to a less dusty pastel or to some other medium such as oil pastels.

7. Occasional fixing of drawings can be done outside. Otherwise, use spray fixatives in a sparkproof spray booth exhausted to the outside, or wear a NIOSH-approved paint spray respirator with organic vapor cartridges and dust and mist (or spray) prefilters. In the latter case, there should also be an exhaust fan in the studio to remove the excess spray so you can take off your respirator safely.

Pencils, Graphite, Charcoal, and Chalks

Pencils have been made with graphite and/or clay for the last several centuries, rather than the lead that gave them the name lead pencils. The amount of clay binder determines the softness of the pencil. In the past, the paint on the outside of ordinary yellow pencils contained lead chromate, but this was eliminated about 20 years ago. Colored pencils have small amounts of pigments added to clay and resin binders. The amount of dust produced by pencils is normally minimal. Graphite is also used in compressed sticks and bars, and as a powder.

Charcoal sticks and bars are usually made by dry heating of willow or vine, often with various resins as binders. Colored chalks are usually made from calcium carbonate with added pigments. These drawings are usually fixed with spray fixatives.

Water-based and solvent-based drawing gums are often used as resists.

Hazards

1. Graphite has no significant hazards, although inhalation of large amounts of the dust over a period of years may cause a benign pneumoconiosis. Graphite dust is fairly heavy and falls to the ground easily.

2. Charcoal has no significant hazards by any route of entry, although inhalation of any dust should be kept to a minimum. Blowing off excess charcoal dust is the major cause of inhalation of charcoal dust.

3. Colored chalks are normally considered to have no significant hazards. "Dustless" chalks have binders added to minimize the amount and particle size of dust created.

4. Solvent-based drawing gums (e.g., rubber cement) are hazardous by skin contact and inhalation. See the section on varnishes, lacquers, and mediums.

5. Inhalation of the mist of spray fixatives is hazardous, as discussed under pastels.

Precautions

1. See precautions listed under pastels.

2. Use water-based drawing gums rather than solvent-based types.

Oil Pastels, Oil Sticks, and Crayons

Oil pastels are basically pastels with small amounts of added oils and waxes to eliminate dusting. Oil sticks have pigments, linseed oil, and wax. Crayons are made of pigments, fillers, and wax. Conte crayons and pencils use high-quality pigments with clay and wax. Water-soluble, artist-quality crayons are also available. Sometimes, small amounts of solvents, such as turpentine or mineral spirits, are used with oil pastels and oil sticks.

Hazards

1. Industrial crayons may have toxic pigments such as lead chromate. Children's varieties should have only nontoxic pigments and pigment exten-

ders. The major hazard is by ingestion, although chromate pigments are also skin irritants and sensitizers.

2. Oil pastels and oil sticks may also have toxic pigments and would be a possible ingestion hazard.

3. Small amounts of solvents are likely to be a minor skin or inhalation hazard.

Precautions

1. Avoid crayons, oil pastels, or oil sticks containing lead chromate or other extremely toxic pigments.

2. Use a window exhaust fan if you use solvents. See also the section on varnishes, lacquers, and mediums.

LIQUID DRAWING MEDIA

Liquid drawing media include drawing inks and felt-tip markers. They can be either water based or solvent based.

Pen and Ink

Water-based drawing inks contain carbon black or other pigments or dyes, and preservatives. Permanent drawing inks have pigments, shellac, and borax in water or solvent. Solvent-based drawing inks often contain toluene or other aromatic hydrocarbons as the vehicle.

Hazards

1. Water-based drawing inks are not normally considered hazardous, although little is known about the hazards of the dyes used in some of these inks (especially those intended for airbrushing). Sometimes, artists airbrushing these inks report respiratory irritation.

2. Solvent-based drawing inks containing toluene are highly toxic by inhalation and may be absorbed through the skin.

Precautions

1. Obtain Material Safety Data Sheets on solvent-based drawing inks.

2. Do not airbrush solvent-based drawing inks. For other precautions while airbrushing, see the section on paint spraying.

Felt-Tip Markers

Felt-tip markers can be either water based or solvent based. Solvent-based permanent markers traditionally used xylene as the vehicle; in recent years, felt-tip markers containing propyl alcohol, ethyl alcohol, and methyl isobutyl ketone have been developed. Most markers contain dyes, although there are some marker pens containing pigments.

Hazards

1. Water-based felt-tip markers are not normally considered hazardous, although not much information is available on the dyes used.

2. Xylene-containing permanent markers may cause dizziness, headaches, nausea, and other narcotic symptoms if several of these are used together without adequate ventilation.

3. Permanent markers based on ethyl alcohol and propyl alcohol are less toxic. The solvent vapors would mostly cause minor eye and respiratory irritation.

4. The vapors from felt-tip markers based on methyl isobutyl ketone are strongly irritating and objectionable to most people.

Precautions

1. If possible, use water-based markers or markers containing alcohols.

2. Use a window exhaust fan when using large numbers of permanent markers, or when using them for extended periods of time.

TABLE 12-1. Hazards of Pigments

General Hazards

Powdered pigments are predominantly a hazard by inhalation, and liquid paints by accidental ingestion. Spraying pigments can also be an inhalation hazard.

This list is not complete, but does include most common pigments used by artists. Note that pigment names are variable and the pigment name should be checked. The pigments are listed in alphabetical order for each color.

268

BLACK PIGMENTS

Antimony Black (antimony sulfide)

Color Index No. 77050

Specific Hazards

Moderately toxic by skin contact, highly toxic by inhalation, extremely toxic by inges-tion. Reaction with stomach acid may cause formation of hydrogen sulfide. See Antimo-ny Compounds in Table 5-2 and Sulfides in Table 5-3.

Black Spinels (complex natural or synthetic oxides)

Chromium iron nickel black
Copper chromite black, Pigment Black 28
Iron cobalt black, Pigment Black 29
Iron cobalt chromite black, Pigment Black 27
Manganese ferrite black, Pigment Black 26

Specific Hazards

No significant hazards by ingestion. Otherwise not well studied.

Bone Black (charred animal bone)

Animal black, ivory black, Frankfurt black, Pigment Black 9.
No significant hazards.

Carbon Black (carbon)

Channel black, lamp black, Pigment Black 6 and 7

Specific Hazards

Slightly toxic by skin contact and inhalation. See also page 105.

Charcoal Black (carbon and mineral)

Birch black, mineral black, vegetable black, vine black, willow black, Pigment Black 8
No significant hazards.

Graphite

Black lead, plumbago, stove black, Pigment Black 10

Specific Hazards

No significant hazards unless co⸱ ᴸaminated with silica.

Logwood (logwood extract)

Natural black 3

Specific Hazards

Ingestion may cause poisoning.

Manganese Black (manganese dioxide)

Pigment Black 14

Specific Hazards

Highly toxic by inhalation; moderately toxic by ingestion. See Manganese Compounds in Table 5-2.

Mars Black (iron oxides)

Black iron oxide, magnetic oxide, Pigment Black 11
No significant hazards.

BLUE PIGMENTS

Antwerp Blue (Prussian blue, aluminum oxide)

Pigment Blue 27

Specific Hazards

See Prussian blue.

Azurite (copper mineral)

Mountain blue, Pigment Blue 30

Specific Hazards

Highly toxic by ingestion, moderately toxic by inhalation. See Copper Compounds in Table 5-2.

Calcium-Strontium Sulfide (calcium sulfide, strontium sulfide)

Pigment White 8, 9; fluorescent blue.

Specific Hazards

Highly toxic by ingestion due to formation of hydrogen sulfide in stomach. Also may cause skin irritation. See Sulfides in Table 5-3.

Cerulean Blue (cobaltous stannate)

Pigment Blue 35

Specific Hazards

Moderately toxic by inhalation and ingestion; slightly toxic by skin contact. See Cobalt Compounds and Tin Compounds in Table 5-2.

Cobalt Blue (cobaltous aluminate)

Thenard's blue, Pigment Blue 28

Specific Hazards

Moderately toxic by inhalation and ingestion; slightly toxic by skin contact. See Cobalt Compounds in Table 5-2.

Egyptian Blue (copper calcium silicate)

Pigment Blue 31

Specific Hazards

Moderately toxic by ingestion, inhalation. See Copper Compounds in Table 5-2.

Indanthrene Blues (complex, insoluble anthraquinone vat dyes)

Pigment Blues 21, 22, 60, 64, 65

Specific Hazards

Acute toxicity varies, but generally slight. Long-term studies under way.

Manganese Blue (barium manganate, barium sulfate)

Pigment Blue 33

Specific Hazards

Possibly highly toxic by inhalation, ingestion. See Barium Compounds and Manganese Compounds in Table 5-2.

Peacock Blue (barium lake or precipitate of organic dye)

Brilliant blue, erioglaucine blue, Pigment Blue 24

Specific Hazards

Slightly toxic by ingestion. Chronic hazards unknown.

Peacock Blue R (organic pigment)

Pigment Blue 3

Specific Hazards

Unknown.

Phthalocyanine Blue (copper phthalocyanine)

Cyan blue, monastral blue, thalo blue, winsor blue, Pigment Blue 15

271

Specific Hazards

No significant hazards. Was contaminated by PCBs prior to 1982.

Prussian Blue (ferric ferrocyanide)

Berlin blue, Chinese blue, iron blue, milori blue, Paris blue, steel blue, Pigment Blue 27

Specific Hazards

Moderately toxic by ingestion; if heated or treated with acid or ultraviolet radiation, will emit extremely toxic hydrogen cyanide gas.

Smalt (potassium cobaltous silicate of variable composition)

Pigment Blue 32

Specific Hazards

Moderately toxic by inhalation and ingestion; slightly toxic by skin contact. See Cobalt Compounds in Table 5-2.

Ultramarine Blue (complex silicate of sodium and aluminum with sulfur)

Pigment Blue 29
No significant hazards.

Victoria Blue (organic pigment)

Pigment Blue 10

Specific Hazards

Unknown.

Victoria Blue B (organic pigment)

Pigment Blue 2

Specific Hazards

Unknown.

Victoria Pure Blue B (organic pigment)

Pigment Blue 2

Specific Hazards

Not significant by ingestion; otherwise unknown.

BROWN PIGMENTS

BON Browns (azo pigment)

Pigment Brown 5

Specific Hazards

Unknown.

Burnt Sienna (iron oxides)

Raw sienna, Pigment Brown 6

No significant hazards.

Burnt Umber (iron oxides, possibly manganese silicates or dioxide)

Mars brown, raw brown, Pigment Brown 7

Specific Hazards

Possibly highly toxic by inhalation, moderately toxic by ingestion if contaminated with manganese compounds. See Manganese Compounds in Table 5-2.

Manganite (manganese hydroxide and oxides)

Manganese brown, Pigment Brown 8

Specific Hazards

Highly toxic by inhalation, moderately toxic by ingestion. See Manganese Compounds in Table 5-2.

Sepia (cuttlefish ink or mixture of burnt sienna and lamp black)

Natural Brown 9

No significant hazards.

Van Dyke Brown (treated Cassel earth with 80-90% organic materials and iron, alumina, and silica)

Pigment Brown 9

No significant hazards.

GREEN PIGMENTS

Brilliant Green (organic pigment)

Pigment Green 1

Specific Hazards

Slightly toxic by ingestion. Long-term hazards unknown.

Chrome green (lead chromate, ferric ferrocyanide)

Milori green, Prussian green, Pigment Green 15

Specific Hazards

Known human carcinogen. Extremely toxic by inhalation; highly toxic by skin contact, ingestion. See Chromium (VI) Compounds and Lead Compounds in Table 5-2. Do not use.

Chromium Oxide Green (chromic oxide)

Chrome oxide green, olive green, permanent green, Pigment Green 17

Specific Hazards

Possible human carcinogen. Slightly toxic. See Chromium (III) Compounds in Table 5-2.

Cobalt Green (calcined cobalt, zinc and aluminum oxides)

Pigment Green 19

Specific Hazards

Moderately toxic by inhalation and ingestion; slightly toxic by skin contact. See Cobalt Compounds and Zinc Compounds in Table 5-2.

Emerald Green (copper acetoarsenite)

Paris green, Veronese green, Pigment Green 21

Specific Hazards

Known human carcinogen. Extremely toxic by inhalation, ingestion; highly toxic by skin contact. Not used any more. See Arsenic Compounds in Table 5-2. Sometimes this name is used for less toxic pigments.

Green Earth (hydrated iron, magnesium, aluminum and potassium silicates)

Pigment Green 23
No significant hazards.

Hooker's Green (mixture of organic pigments)

Specific Hazards

See specific pigments in mixture.

Phthalocyanine Green (polychlorinated copper phthalocyanine)

Cyan green, monstral green, thalo green, Pigment Green 7

Specific Hazards

No significant hazards. Was often contaminated by PCBs prior to 1982.

Pigment Green (nitroso green)

Pigment Green 8

Specific Hazards

No significant acute toxicity. Chronic hazards not well studied.

Prussian Green (chlorinated and brominated copper phthalocyanine; may also be other pigments)

Pigment Green 36

Specific Hazards

Unknown.

Scheele's Green (cupric acetoarsenite; originally copper arsenite)

Paris green, Pigment Green 22

Specific Hazards

Known human carcinogen. Extremely toxic by inhalation, ingestion; highly toxic by skin contact. Not used any more. See Arsenic Compounds in Table 5-2.

Ultramarine Green (complex silicate of aluminum and sodium with sulfur)

Pigment Green 24
No significant hazards.

Verdigris (copper dibasic acetate)

Pigment Green 20

Specific Hazards

Moderately toxic by inhalation; highly toxic by ingestion. See Copper Compounds in Table 5-2.

Viridian (hydrated chromic oxide)

Emerald oxide of chromium, Emeraude green, Pigment Green 18

Specific Hazards

Possible human carcinogen. Slightly toxic. See Chromium (III) Compounds in Table 5-2.

ORANGE PIGMENTS

Ananthranone Orange

Pigment Red 168

Specific Hazards

No significant acute toxicity. Long-term hazards unknown.

Benzidine Orange (insoluble azo pigment)

Diarylide, Pigment Orange 13

Specific Hazards

No significant acute toxicity.

Cadmium Barium Orange (cadmium sulfide, cadmium selenide, barium sulfate)

Cadmium lithopone orange, Pigment Orange 20:1

Specific Hazards

Probable human carcinogen. Highly toxic by inhalation, slightly toxic by ingestion. See Cadmium Compounds and Selenium Compounds in Table 5-2.

Cadmium Orange (cadmium sulfide, cadmium selenide)

Pigment Orange 20

Specific Hazards

Probable human carcinogen. Highly toxic by inhalation, slightly toxic by ingestion. See Cadmium Compounds and Selenium Compounds in Table 5-2.

Chrome Orange (basic lead chromate)

Pigment Orange 21

Specific Hazards

Known human carcinogen. Extremely toxic by inhalation; highly toxic by skin contact, ingestion. See Chromium (VI) Compounds and Lead Compounds in Table 5-2. Do not use.

Hansa Oranges (insoluble azo pigments)

Dinitroaniline orange, orthonitroaniline orange, Pigment Orange 1, 2, 5

Specific Hazards

Slightly toxic by ingestion. Mutagenic in bacteria.

Mars Orange (iron oxides)

Pigment Red 101
No significant hazards.

Mercadmium colors (cadmium sulfide, mercuric sulfide complexes)

Pigment Orange 23

Specific Hazards

Probable human carcinogen. Extremely toxic by ingestion, highly toxic by inhalation, slightly toxic by skin contact. Can cause skin allergies. Forms hydrogen sulfide in combination with stomach acid. See Cadmium Compounds and Mercury Compounds in Table 5-2.

Molybdate Orange (lead chromate, lead molybdate, lead sulfate)

Pigment Red 104

Specific Hazards

Known human carcinogen. Extremely toxic by inhalation; highly toxic by skin contact, ingestion. See Chromium (VI) Compounds and Lead Compounds in Table 5-2. Do not use.

Persian Orange (barium lake of an azo dye)

Pigment Orange 17, 17:1

Specific Hazards

No significant acute toxicity. Long-term hazards unknown.

RED PIGMENTS

Acid Red (barium lake of azo dye or insoluble azo pigment)

Acid scarlet, pigment scarlet, scarlet red, Pigment Red 60

Specific Hazards

Unknown.

Alizarin Crimson (lakes of 1,2-dihydroxyanthraquinone or insoluble anthraquinone pigment)

Alizarin, crimson madder, rose madder, madder lake, Pigment Red 83

Specific Hazards

Slightly toxic by skin contact; may cause some allergies. No significant acute toxicity.

Aniline Red (chlorinated para-nitroaniline pigment)

Permanent red, Pigment Red 4

Specific Hazards

No significant acute toxicity.

Anthraquinone Red (anthraquinone pigment)

Pigment Red 177

Specific Hazards

No significant acute toxicity. Long-term hazards unknown.

Arylide Reds (azo pigments)

Pigment Red 2, 5, 7, 9, 14, 17, 22, 23, 63, 112, 146, 148, 170

Specific Hazards

No significant acute toxicity for those tested (all but Pigment Red 7, 63, 148). Long-term hazards unknown.

BON Reds and Maroons (calcium, barium, and manganese salts of beta-hydroxynaphthoic acid dyes)

Segnale reds; Pigment Red 48, 48:1, 48:2, 48:3, 48:4, 52:1

Specific Hazards

No significant acute toxicity. Long-term hazards unknown.

Cadmium Barium Red (cadmium sulfide, cadmium selenide, barium sulfate)

Cadmium lithopone red, Pigment Red 108

Specific Hazards

Probable human carcinogen. Possible chronic hazard by ingestion, inhalation. Can cause skin allergies. See Cadmium Compounds and Mercury Compounds in Table 5-2.

Cadmium Red (cadmium sulfide, cadmium selenide)

Cadmium scarlet, Pigment Red 108

Specific Hazards

Probable human carcinogen. Highly toxic by inhalation, slightly toxic by ingestion. See Cadmium Compounds and Selenium Compounds in Table 5-2.

Cadmium Vermilion Red (cadmium sulfide, mercuric sulfide)

Cadmium mercury red, Pigment Red 113

Specific Hazards

Probable human carcinogen. No significant acute toxicity. Highly toxic by inhalation, slightly toxic by skin contact. Can cause skin allergies. See Cadmium Compounds and Mercury Compounds in Table 5-2.

Disazo Red (azo pigment)

Pigment Red 144

Specific Hazards

No significant acute toxicity. Long-term hazards unknown.

English Red (iron oxides)

Indian red, light red, Mars red, red iron oxide, terra rosa, Tuscan red, Pigment Red 101
No significant hazards.

Hansa red (See Toluidine Red)

Lithol Reds (sodium, barium, and calcium salts of soluble azo pigment)

Red lake R; Pigment Red 49, 49:1, 49:2

Specific Hazards

Its presence in lipstick has caused allergies. Some grades are contaminated with soluble barium compounds. May be contaminated with known human carcinogen (beta-naphthylamine). See Barium Compounds in Table 5-2.

Lithol Rubines (calcium salt of soluble azo dye)

Pigment Red 57, 57:1, 57:2

Specific Hazards

No significant acute toxicity. Long-term hazards unknown.

Para Red (insoluble azo pigment)

Pigment Red 1

Specific Hazards

Mostly unknown. Ingestion has caused cyanosis due to methemoglobinemia. Causes bacterial mutations.

Perylene Pigments (organic pigments)

Perylene maroon, Pigment Red 179
Perylene red, Pigment Red 149
Perylene scarlet, Pigment Red 190
Perylene vermilion, Pigment Red 123

Specific Hazards

No significant acute toxicity. Long-term hazards unknown.

Pyrazolone Reds and Maroons (azo pigments)

Pigment Red 38, 41

Specific Hazards

No significant acute toxicity. Long-term hazards unknown.

Quinacridone Pigments (organic pigments)

Quinacridone maroon, Pigment Red 206
Quinacridone maroon B, Pigment Violet 42
Quinacridone magenta, Pigment Red 202
Quinacridone red, Pigment Red 122 (also Pigment Violet 19)

Specific Hazards

Mostly unknown.

Red Lake C (insoluble metal salts of azo dyes)

Pigment Red 53:1, 53:2

Specific Hazards

No significant acute toxicity. Some grades have high soluble barium content. See Barium Compounds in Table 5-2.

Red Lead (lead tetroxide)

Pigment Red 105

Specific Hazards

Highly toxic by inhalation and ingestion. See Lead Compounds in Table 5-2.

Rhodamine (phosphorus, tungsten, and molybdenum salt of dye)

Day-Glo red, fluorescent red, Pigment Red 81, Pigment Violet 1

Specific Hazards

No significant acute toxicity.

Toluidine Red (insoluble azo pigments)

Hansa red, Pigment Red 3

Specific Hazards

Mostly unknown. In the past, ingestion has caused cyanosis due to methemoglobinemia due to contamination.

Ultramarine Red (complex silicate of sodium and aluminum with sulfur)

Pigment Violet 15

No significant hazards.

Venetian Red (iron oxide, silica, alumina, lime, and magnesia)

Persian gulf oxide, red chalk, Spanish oxide, Pigment Red 102

Specific Hazards

No significant acute toxicity. Long-term hazards unknown.

Vermilion (mercuric sulfide)

Chinese vermilion, cinnabar, English vermilion, Pigment Red 106

Specific Hazards

Extremely toxic by ingestion, highly toxic by inhalation, slightly toxic by skin contact. Can cause skin allergies. Forms hydrogen sulfide in combination with stomach acid. See Mercury Compounds in Table 5-2 and Sulfides in Table 5-3. Note: Most vermilion today is a mixture of less toxic organic pigments.

VIOLET PIGMENTS

Cobalt Violet (cobalt phosphate)

Pigment Violet 14

Specific Hazards

Highly toxic by ingestion, inhalation. See Cobalt Compounds in Table 5-2.

Cobalt Violet (cobalt arsenite)

Violet phosphates, Pigment Violet 14

Specific Hazards

Known human carcinogen. Extremely toxic by inhalation, ingestion; highly toxic by skin contact. See Arsenic Compounds in Table 5-2. Not a common pigment. Do not use.

Manganese Violet (manganese ammonium pyrophosphate)

Fast violet, Nurnberg violet, permanent mauve, permanent violet, Pigment Violet 16

Specific Hazards

Highly toxic by inhalation; moderately toxic by ingestion. See Manganese Compounds in Table 5-2.

Mars Violet (iron oxides)

Pigment Red 101

No significant hazards.

Quinacridone Violet (organic pigment)

Quinacridone red, Pigment Violet 19 (also Pigment Red 122)

Specific Hazards

No significant acute toxicity. Long-term hazards unknown.

Rhodamine (phosphorus, tungsten, and molybdenum salt of dye)

Day-Glo red, fluorescent red, Pigment Red 81, Pigment Violet 1

Specific Hazards

No significant acute toxicity. May cause light sensitivity.

Thioindigoid Maroon (indigo derivative)

Pigment Violet 38

Specific Hazards

Unknown.

Ultramarine Violet (complex silicate of sodium and aluminum with sulfur)

Pigment Violet 15

No significant hazards.

WHITE PIGMENTS

Aluminum Hydrate (aluminum oxide)
Pigment White 24
No significant hazards.

Antimony White (antimony trioxide)
Antimony oxide, Pigment White 11.

Specific Hazards

Probable human carcinogen. Moderately toxic by skin contact and ingestion; highly toxic by inhalation. See Antimony Compounds in Table 5-2.

Barium White (barium sulfate)
Barytes; blanc fixe; Pigment White 21, 22

Specific Hazards

No significant hazards, unless contaminated with soluble barium compounds. See Barium Sulfate in Table 5-2.

Chalk (calcium carbonate)
Whiting, Pigment White 18
No significant hazards.

Gloss White (aluminum hydroxide, barium sulfate)
Pigment White 23
No significant hazards.

Leaded Zinc Oxide (zinc oxide, lead sulfate)
Pigment White 4

Specific Hazards

Highly toxic by inhalation, ingestion. See Lead Compounds in Table 5-2.

Lithopone (barium sulfate, zinc sulfide)
Pigment White 5

Specific Hazards

Extremely toxic by ingestion; moderately toxic by inhalation. Zinc sulfide might react with stomach acid to produce hydrogen sulfide. See Sulfides in Table 5-3.

Magnesite (magnesium carbonate)

Light magnesium oxide, Pigment White 18

Specific Hazards

Moderately toxic by ingestion. See Magnesium Compounds in Table 5-2.

Mica

Pumice, Pigment White 20

Specific Hazards

No significant acute toxicity.

Mixed White (basic lead carbonate, zinc oxide)

Specific Hazards

Highly toxic by inhalation, ingestion. See Lead Compounds in Table 5-2.

Silica (quartz)

Pigment White 27

Specific Hazards

No significant acute toxicity. Chronic inhalation may cause silicosis.
See Silica in Table 5-1.

Talc (hydrated magnesium silicate)

Pigment White 26

Specific Hazards

No significant acute toxicity. Highly toxic by chronic inhalation. May be contaminated
with asbestos or silica. See Talc in Table 5-1.

Titanium White (titanium dioxide)

Titanium oxide, Pigment White 6

Specific Hazards

No significant hazards. Inhalation of large amounts over several years may cause a be-
nign pneumoconiosis without ill effects. Shows on x-rays.

White Lead (basic lead carbonate, sometimes with small amounts of extenders)

Cremnitz white, flake white, foundation white, silver white, Pigment White 1

Specific Hazards

Highly toxic by inhalation, ingestion. See Lead Compounds in Table 5-2.

White Lead (basic lead sulfate, sometimes with a small amount of zinc oxide)
Basic sulfate white lead, Pigment White 2

Specific Hazards

Highly toxic by inhalation, ingestion. See Lead Compounds in Table 5-2.

Witherite (barium carbonate)
Pigment White 10

Specific Hazards

Highly toxic by inhalation; extremely toxic by ingestion. see Barium Compounds in Table 5-2.

Zinc Sulfide
Pigment White 7

Specific Hazards

Extremely toxic by ingestion; moderately toxic by inhalation. Zinc sulfide might react with stomach acid to produce hydrogen sulfide. See Sulfides in Table 5-3.

Zinc White (zinc oxide)
Chinese white, permanent white, Pigment White 4

Specific Hazards

Moderately toxic by ingestion, slightly toxic by inhalation. See Zinc Compounds in Table 5-2. (Pigment White 4 may also contain lead; see leaded zinc oxide above.)

YELLOW PIGMENTS

Anthrapyrimidine Yellow (organic pigment)
Pigment Yellow 108

Specific Hazards

No significant acute hazards; chronic hazards not well studied.

Barium Yellow (barium chromate)

Lemon yellow, Pigment Yellow 31

Specific Hazards

Known human carcinogen. Extremely toxic by inhalation, highly toxic by skin contact and ingestion. See Chromium (VI) Compounds in Table 5-2.

Benzidine Yellows (insoluble azo pigments)

Diarylide; Pigment Yellow 12, 13, 14, 17, 20, 55, 83

Specific Hazards

No significant acute hazards; chronic hazards not well studied. Prior to 1982, could be contaminated with PCBs.

Cadmium Yellow (cadmium sulfide)

Aurora, cadmium primrose yellow; Pigment Yellow 35, 37

Specific Hazards

Probable human carcinogen. Possible chronic hazard by ingestion, inhalation. See Cadmium Compounds in Table 5-2.

Cadmium Barium Yellow (cadmium sulfide, cadmium selenide, barium sulfate, zinc sulfide)

Cadmium lithpone yellow, Pigment Yellow 35

Specific Hazards

Probable human carcinogen. Possible chronic hazard by ingestion, inhalation. See Cadmium Compounds and Selenium Compounds in Table 5-2.

Chrome Yellow (lead chromate, sometimes with lead sulfate)

Chrome lemon, lemon chrome yellow, primrose, primrose yellow, yellow chrome orange, Pigment Yellow 34

Specific Hazards

Known human carcinogen. Extremely toxic by inhalation; highly toxic by skin contact, ingestion. See Chromium (VI) Compounds and Lead Compounds in Table 5-2.
Do not use.

Cobalt Yellow (potassium cobaltinitrite)

Aureolin, Pigment Yellow 40

Specific Hazards

Highly toxic by inhalation, ingestion. Ingestion has caused cyanosis due to methemoglobinemia. See Nitrites in Table 5-3 and Cobalt Compounds in Table 5-2.

Hansa Yellow (insoluble azo pigments)

Pigment Yellow 1-6, 10, 60, 65, 73-75; Pigment Orange 1

Specific Hazards

No significant acute hazards; chronic hazards not well studied.

King's Yellow (arsenic trisulfide, sometimes lead chromate)

Orpiment, realgar, Pigment Yellow 39

Specific Hazards

Known human carcinogen. Extremely toxic by inhalation, ingestion; highly toxic by skin contact. See Arsenic Compounds in Table 5-2. Not used today.

Mars Yellow (iron oxides)

Ochre; raw sienna; sienna; yellow ochre; yellow iron oxide; Pigment Yellow 42, 43
No significant hazards.

Naples Yellow (lead antimonate, sometimes with zinc and bismuth oxides)

Antimony yellow, Pigment Yellow 41

Specific Hazards

Moderately toxic by skin contact, highly toxic by inhalation and unknown by ingestion. See Lead Compounds and Antimony Compounds in Table 5-2. Note: Most Naples yellow pigments today are a mixture of less toxic organic pigments.

Strontium Yellow (strontium chromate)

Lemon yellow, Pigment Yellow 32

Specific Hazards

Known human carcinogen. Extremely toxic by inhalation, highly toxic by skin contact and ingestion. See Chromium (VI) Compounds in Table 5-2.

Toluidine Yellow (insoluble azo pigment)

Pigment Yellow 1, 3

Specific Hazards

Mostly unknown. Ingestion has caused cyanosis due to methemoglobinemia.

Zinc Yellow (zinc chromate)

Pigment Yellow 36

Specific Hazards

Known human carcinogen. Extremely toxic by inhalation; highly toxic by skin contact, ingestion. See Chromium (VI) Compounds in Table 5-2. Do not use.

METALLIC PIGMENTS

Aluminum Powder (aluminum)

Pigment Metal 1
No significant hazards.

Bronze Powder (80-90% copper, 1% zinc, iron)

Copper bronze powder, Pigment Metal 2

Specific Hazards

See Gold bronze powders.

Copper Alloy (copper, zinc, aluminum, tin)

Pigment Metal 2

Specific Hazards

See Gold bronze powders.

Gold Bronze Powders (68-92% copper, 6-31% zinc, 0.25-10% aluminum)

Green gold bronze, pale gold bronze, rich gold bronze, Pigment Green 10

Specific Hazards

Moderately toxic by ingestion, especially if corroded by exposure to moisture. See Copper Compounds in Table 5-2.

Metallic Gold

Pigment Metal 3
No significant hazards.

Metallic Lead

Pigment Metal 4

Specific Hazards

Highly toxic by ingestion, inhalation. See Lead Compounds in Table 5-2.

Metallic Silver

Specific Hazards

Silver particles that become embedded in the skin can cause localized argyria, a bluish-black discoloration that does not have any known ill effects.

TABLE 12-2. Hazards of Preservatives

General Hazards

Many preservatives are highly toxic, especially by ingestion or inhalation. The major hazard is acute illness, not chronic illness, for most artists.

General Precautions

Use the least toxic preservative possible. Wear gloves and a respirator where necessary. Buy preservatives in liquid form rather than the easily inhaled powder form, whenever possible.

Beta-Naphthol (2-naphthol)

Relative Toxicity Rating

Skin contact: moderate
Inhalation: moderate
Ingestion: high

Specific Hazards

Skin irritant. Ingestion causes abdominal pain, nausea, vomiting, and sometimes convulsions. May damage liver and kidneys and cause hemolytic anemia. Similar to but less toxic than phenol.

Bleach (household chlorine bleach, 5% sodium hypochlorite)

Relative Toxicity Rating

Skin contact: moderate
Inhalation: moderate
Ingestion: moderate

Specific Hazards

A skin irritant, particularly from repeated contact. Releases highly toxic chlorine gas in acid, or when heated. Forms poisonous gas when mixed with ammonia.

Boric Acid

Relative Toxicity Rating

Skin contact: slight
Inhalation: moderate
Ingestion: moderate to high

Specific Hazards

Powder. Absorption through burned skin, ingestion, or inhalation can cause nausea, abdominal pain, diarrhea, violent vomiting, and skin rash. Chronic poisoning may cause loss of appetite, gastroenteritis, liver and kidney damage, and skin rash.

Borax (sodium tetraborate)

Specific Hazards

See Boric acid.

Chromated Copper Arsenate (CCA)

Relative Toxicity Rating

Skin contact: high
Inhalation: extreme
Ingestion: extreme

Specific Hazards

Known human carcinogen. Skin contact can cause skin irritation and allergies, skin thickening, loss of skin pigmentation, ulceration, and skin cancer. Inhalation can cause respiratory irritation and skin, lung and liver cancer. Inhalation or ingestion may cause digestive disturbances, liver damage, peripheral nervous system damage, and kidney and blood damage. Acute ingestion may be fatal. Do not use.

Ethyl Parabens (ethyl para-hydroxybenzoate)

Specific Hazards

No significant hazards, except occasional allergic reactions.

Formalin (30–37% formaldehyde, 0–15% methyl alcohol)

Relative Toxicity Rating

Skin contact: moderate
Inhalation: extreme
Ingestion: moderate to high

Specific Hazards

Probable human carcinogen. Strong irritant to skin, eyes, nose, and respiratory system. Causes allergic reactions by skin contact and inhalation, including asthma. Pure formaldehyde is highly toxic by ingestion. See also Methyl Alcohol in Table 4-4. Do not use.

Magnesium Silicofluoride (magnesium fluosilicate)

Relative Toxicity Rating

Skin contact: moderate
Inhalation: moderate
Ingestion: high

Specific Hazards

Acute poisoning usually results from ingestion. Skin, eye, and respiratory irritant, including possible skin ulceration. Similar to but less toxic than sodium fluoride.

Mercuric Chloride

Relative Toxicity Rating

Skin contact: moderate
Inhalation: high
Ingestion: extreme

Specific Hazards

Most toxic mercury compound. Corrosive to skin. Skin absorption, ingestion, or inhalation may cause acute or chronic mercury poisoning, primarily affecting the nervous system but also the gastrointestinal system and kidneys. Acute poisoning is accompanied by metallic taste, salivation, swelling of gums, vomiting, and bloody diarrhea. Ingestion of 0.5 grams can be fatal. Chronic poisoning also severely affects the nervous system, causing muscular tremors, irritability, and psychic changes (e.g., depression, loss of memory, frequent anger).

Methyl parabens (methyl para-hydroxybenzoate)

Specific Hazards

No significant hazards, except occasional allergic reactions.

Oil of Cloves (eugenol)

Relative Toxicity Rating

Skin contact: slight
Inhalation: not significant
Ingestion: moderate

Specific Hazards

Mild irritant and local anesthetic. Ingestion may cause gastroenteritis and vomiting.

Pentachlorophenol

Relative Toxicity Rating

Skin contact: high
Inhalation: high
Ingestion: high

Specific Hazards

Probable human carcinogen. Skin contact may cause chloracne, an acne-like dermatitis. Absorbed through skin. Ingestion affects respiratory system, central nervous system. Chronic exposure can cause liver and kidney damage. More toxic than phenol. Do not use. It and its salt (sodium pentachlorophenate) are banned for sale.

Phenol (carbolic acid)

Relative Toxicity Rating

Skin contact: high
Inhalation: high
Ingestion: high

Specific Hazards

Pure phenol can be absorbed through the skin or stomach and cause death. Very corrosive to skin. Damages the central nervous system, kidneys, liver. Do not use.

Phenyl Mercuric Acetate

Relative Toxicity Rating

Skin contact: moderate
Inhalation: high
Ingestion: high

Specific Hazards

Less corrosive, less toxic, and less quickly absorbed than mercuric chloride. Symptoms are similar to mercuric chloride poisoning.

Phenyl Mercuric Chloride (See Phenyl Mercuric Acetate)

Propyl Parabens (propyl para-hydroxybenzoate)

Specific Hazards

No significant hazards, except occasional allergic reactions.

Sodium Benzoate

Relative Toxicity Rating

Skin contact: not significant
Inhalation: not significant
Ingestion: moderate

Specific Hazards

Ingestion may cause nausea and vomiting.

Sodium Fluoride

Relative Toxicity Rating

Skin contact: moderate
Inhalation: high
Ingestion: high

Specific Hazards

A skin and respiratory irritant and general cell poison. Ingestion of 1 gram (less than 1 teaspoon) can be fatal. Symptoms of poisoning include salty or soapy taste, nausea, vomiting, diarrhea, and abdominal pain followed by muscular weakness, tremors, central nervous system depression, and shock. Do not use.

Sodium Ortho-Phenyl Phenate

Relative Toxicity Rating

Skin contact: moderate
Inhalation: high
Ingestion: moderate

Specific Hazards

Probable human carcinogen. Skin irritant in more than 0.5% aqueous solution. Dust may irritate eyes, nose, and throat.

Sodium 2,4,5-Trichlorophenate

Relative Toxicity Rating

Skin contact: moderate
Inhalation: high
Ingestion: moderate

Specific Hazards

Probable human carcinogen. Skin and eye irritant. Chronic effects unknown. Contains trace amounts of chemicals that may cause cancer and birth defects. Do not use.

Thymol

Relative Toxicity Rating

Skin contact: slight
Inhalation: moderate
Ingestion: high

Specific Hazards

Mild skin irritant. Ingestion causes gastric pain, nausea, vomiting, and occasionally convulsions and coma.

Zinc Chloride

Relative Toxicity Rating

Skin contact: moderate
Inhalation: high
Ingestion: high

Specific Hazards

Irritating to skin, eyes, respiratory system, and gastrointestinal system, since it produces hydrochloric acid in contact with water. Can cause skin ulcers. Ingestion of a few grams (approx. 1-2 teaspoons) has been fatal. Symptoms include violent vomiting and purging.

Zinc Naphthenate

Relative Toxicity Rating

Skin contact: slight
Inhalation: slight
Ingestion: slight

Specific Hazards

Low-toxicity wood preservative.

REFERENCES

Gosselin, R., Smith, R., and Hodge, H. (1987). *Clinical Toxicology of Commercial Products.* 6th ed. Baltimore: Williams and Wilkins.

Mayer, R. (1991). *The Artist's Handbook of Materials and Techniques.* 5th ed. New York: Viking Penguin Press.

Spandorfer, M., Curtiss, D., and Snyder, J. (1992). *Making Art Safely.* New York: Van Nostrand Reinhold.

Printmaking

There are four basic printmaking techniques: lithography, intaglio, relief, and screen printing. Although each of these techniques has its separate hazards, which are discussed later in the chapter, the hazards of the inks and the printing processes in lithography, intaglio, and relief printmaking are similar and are treated collectively. Photoprintmaking is discussed under the main technique.

PRINTMAKING INKS

Inks consist of three basic components: the pigments, the vehicle, and the modifiers, which give the desired physical properties to the ink. I discuss the hazards of the ink components separately, since some printmakers make or modify their own inks.

Pigments

There are two types of pigments: inorganic pigments, and synthetic organic pigments. In general, the hazards of the inorganic pigments have been fairly well re-

searched. However, very little research has been done on the hazards of the synthetic organic pigments.

Hazards

1. The major pigment hazard in printmaking is from accidental ingestion of the pigment. This can occur as a result of getting the paint on your hands and from there to the mouth (e.g., eating or smoking while working). With the exception of lead pigments, acute poisoning from ingestion is not likely. The concern is with chronic exposure through poor working habits.

 Examples of chronically toxic pigments include compounds of cadmium, cobalt, manganese, and mercury. Some pigments—for example, chrome yellow, zinc yellow, and strontium yellow, and cadmium pigments—are known or probable human carcinogens and may cause lung cancer. Unfortunately, there is inadequate information about the long-term hazards of most of the organic pigments. Table 12-1 discusses the hazards of particular pigments. Since not all manufacturers use the same names for pigments, the table lists their color index names, which are the recognized names.

2. Inhalation can be a potential hazard if you mix your own inks from the powdered pigment.

3. Some pigments can cause skin irritation and allergies. These include the chromate-containing pigments, such as chrome yellow and zinc yellow, and cobalt pigments.

4. Some cases of poisoning have occurred by getting the pigments (or ink) in cuts or sores.

Precautions

1. You should obtain Material Safety Data Sheets on your printmaking inks.

2. Use ready-made inks whenever possible to avoid the hazard of inhaling the pigment powders. In particular, never mix your own chrome yellow, zinc yellow, chrome green, molybdate orange, or any other pigments that are known human carcinogens. If possible, do not mix highly toxic pigments such as lead white or the cadmium colors.

3. If you do handle pigments in dry form, use a glove box (see Chapter 8) or wear a NIOSH-approved toxic dust respirator.

4. Wash work surfaces carefully after use, so pigment dust does not accumulate.

5. Do not eat, drink, or smoke in the studio, and wash hands carefully after work, including under the fingernails.

Vehicles

For oil-based lithography, intaglio, and relief inks, the vehicles are linseed oil derivatives (raw linseed oil, linseed oil varnishes, and burnt plate oil). Some commercial lithographic inks may also contain small amounts of mineral spirits. Water is used in some screen printing inks and some relief inks. These may contain small amounts of solvents or preservatives. Solvent-based inks are found only in screen printing and are discussed separately under screen printing.

Hazards

1. Oil vehicles are flammable when heated, and rags soaked in these oils may ignite by spontaneous combustion.
2. Oil vehicles are slightly hazardous from chronic skin contact, possibly causing skin allergies in a few people.

Precautions

1. Do not use an open flame to heat linseed oil, linseed oil varnishes, or burnt plate oil. Take normal fire prevention measures by not smoking or using open flames in the work area.
2. Place oil-soaked rags in self-closing disposal cans and remove them from the studio each day. An alternative is to place the oil-soaked rags in a pail of water.

Modifiers

There are several types of modifiers that can be used in printmaking to give the ink the properties you desire: (1) ink reducers to thin the ink; (2) tack reducers to reduce the stickiness of the ink; (3) stiffeners to give more body to the ink; and (4) antiskinning agents to retard drying of the ink.

Hazards

1. Benzine used with magnesium carbonate as a tack reducer is moderately toxic by skin contact, inhalation, and ingestion. Benzine is also flammable. Vaseline, cup grease, and Crisco are not significantly hazardous.

2. Magnesium carbonate used as a stiffener is not significantly toxic.

3. Aluminum stearate, also used as a stiffener, is a skin, eye, and respiratory irritant. Inhalation of large amounts may cause chemical pneumonia. In powder form, aluminum stearate is explosive.

4. Eugenol or oil of cloves, used as an antiskinning agent, is moderately toxic by ingestion and slightly irritating by skin contact.

5. Aerosol-type antiskinning agents are highly toxic by inhalation of the spray.

6. Lead and manganese driers are highly toxic by inhalation or ingestion. Cobalt linoleate is slightly toxic by skin contact and moderately toxic by inhalation or ingestion.

Precautions

1. Do not use lead or manganese driers; instead use cobalt linoleate, which is less toxic.

2. Take precautions against possible fire hazards when using flammable linseed oil varnishes or benzine.

PRINTING

Although the techniques of lithography, intaglio, and relief printmaking vary considerably, they all involve inking the plates, setting up and operating the printing press, and cleanup. The main hazards occur during the inking and cleaning steps.

Inking and Printing

This process is done with various types of rollers or by hand. Basically the same process is involved whether black or colored inks are used.

Hazards

1. In handling prepared inks, there are no hazards due to inhalation of the pigment unless old ink is allowed to dry on surfaces, where it can eventually form a powder.

2. The major hazards with these inks are due to skin contact and accidental ingestion. This can be a problem with hand-wiping techniques. Using

bare hands increases the possibility of getting the ink in cuts and sores, and of transferring ink from hands to mouth.

3. Using the old, solid inking rollers may cause back problems due to their weight.

4. Presses use high pressure, and there is the risk of accidents if fingers, long hair, loose sleeves, or necklaces get caught in the mechanism.

Precautions

1. Use water-based relief printing inks whenever possible to avoid use of solvents for cleanup.

2. Avoid spreading ink on plates or wiping plates with your bare hands whenever possible. Wear gloves and ink the plates using tarlatan (starched cheesecloth or crinoline) that has been destarched, cardboard squares, or soft pieces of plastic.

3. For processes in which you must hand wipe, apply a barrier cream beforehand.

4. The inking table should be at a comfortable height to reduce back strain when using heavy inking rollers. See also the section on lifting in Chapter 10.

5. Do not eat, drink, or smoke in your work area. Wash hands carefully and often with soap and water. Do not wait until the ink dries on your hands. Baby oil or vegetable oil, and then soap and water, will remove inks from the skin.

6. All presses should have safety guards to prevent hands or fingers getting trapped. Bind up long hair, and do not wear loose sleeves or necklaces.

Cleanup

Cleanup in printmaking includes cleaning ink off inking slabs, press beds, rollers, and blankets. It also involves cleaning your plates. For most cleaning steps, the following solvents are commonly used: kerosene, benzine (not to be confused with benzene), mineral spirits, odorless paint thinner, turpentine, lithotine, denatured alcohol, and acetone. Special cleaning jobs—for example, cleaning photoetching and photolithographic plates—may require other solvents or solvent mixtures.

Hazards

1. Many solvents used in cleanup are flammable, although to different degrees. Kerosene and mineral spirits are combustible.

2. Kerosene, mineral spirits, benzine, lithotine, and turpentine are moderately toxic by repeated skin contact, inhalation, and ingestion. Turpentine also can cause kidney damage and allergies. Acetone is only slightly toxic.

3. Many brand-name solvent mixtures and lacquer thinners are highly toxic by inhalation, including many of the mixtures sold for cleaning plates, rollers, and blankets. This particularly includes solvent mixtures containing chlorinated hydrocarbons (e.g., trichloroethylene) and aromatic hydrocarbons (e.g., toluene, xylene). Any products containing benzene (benzol) should not be used, although benzene is rarely found today. See Table 4-4 in Chapter 4 for more information on the hazards of solvents.

4. The use of solvent-soaked sawdust to clean etching plates and the storage of solvent-soaked rags in piles or enclosed spaces are hazardous because of the danger of spontaneous combustion. In addition, open containers of solvent-soaked sawdust is an inhalation hazard due to solvent evaporation.

5. Talc or French chalk, sometimes used to clean residues off rollers and used inside gloves, is highly toxic by inhalation. Some talcs contain asbestos-like minerals, which can cause lung cancer and other forms of cancer. Repeated inhalation of talc itself may cause lung scarring.

Precautions

1. Buy solvents by chemical name or generic name whenever possible so you can look up their hazards. If you must use a brand-name product, request a Material Safety Data Sheet from the manufacturer to find its composition, and then look up the hazards in this book. One way to avoid having to use more hazardous solvents is to clean rollers and the press bed immediately after work before the ink has a chance to dry.

2. Minimize solvent use by cleaning excess ink off inking slabs with safety-edged razor blades before cleaning residue with solvents.

3. Use the least toxic solvents available. Do not use benzene (benzol) under any conditions. Alternatives in order of preference are acetone, denatured alcohol, odorless mineral spirits, mineral spirits, lithotine, benzine, toluene, and xylene. Note that the latter two solvents are highly toxic by inhalation, and acetone is extremely flammable.

4. Store flammable and combustible solvents in approved safety cans. Use spring-loaded dispensing cans to dispense small amounts of solvents for cleanup (see Figure 8-1). Dispose of solvent-soaked rags in self-closing waste disposal cans that are emptied each day. Do not allow smoking or open flames in the work area. Make sure all containers are kept closed.

5. Wear appropriate gloves to avoid skin contact when cleaning up. Do not

wash your hands with solvents, since this is a potential cause of dermatitis; use baby oil or vegetable oil, and then soap and water. A safe waterless hand cleanser can also be used. Wash hands frequently to prevent ink from drying on them.

6. Cleaning plates and rollers—processes requiring large amounts of solvents—should be done in a laboratory hood or in front of a slot exhaust hood. Working on a benchtop immediately in front of a window containing an exhaust fan at work level will also provide adequate ventilation.

7. Cleaning of inking slabs and press beds uses much smaller amounts of solvents. Dilution ventilation (e.g., a window exhaust fan) is sufficient. Using half a cup of mineral spirits in cleanup over a four-hour period would need at least 350 cfm of exhaust.

8. If ventilation is not adequate, wear a NIOSH-approved respirator with organic vapor cartridges.

9. Store solvent-soaked rags in self-closing oily waste cans that are emptied every day. Do not use solvent-soaked sawdust for cleaning plates. Instead use solvents that are stored in safety cans for disposal or reclaiming.

10. Replace talcs and French chalk of unknown composition with corn starch in gloves, and with asbestos-free talcs such as Johnson's Baby Powder for other purposes.

LITHOGRAPHY

Lithography can be done on either stones or thin zinc or aluminum metal plates. In both cases, the purpose of the various chemicals used to prepare the plates or stone is to make the image areas ink receptive and to make the nonimage areas water receptive—and therefore ink repellent.

Drawing Materials

Before drawing on stone, the stone surface has to be ground smooth and the previous lithographic image has to be removed. This is done with carborundum abrasive while the stone is wet and does not involve any hazards. Metal plates are usually bought already grained. They can be either coated or uncoated (see photolithography discussion later in this section). If the grained plates have been sitting and become dirty or have any surface blemishes created by oxidation, the plate must be counteretched before drawing.

Drawing materials for both stone and metal plates contain materials with

high grease and fatty acid content. Lithographic crayons and pencils contain waxes, soaps, and lamp black. Lithographic tusches are similar to the crayons, but they can be mixed with water or a solvent such as turpentine, lithotine, benzine, or alcohol. Some lithographers airbrush liquid drawing materials, or use spray enamel paints.

Hazards

1. Lamp black may cause skin cancer due to contamination by cancer-causing chemicals and is rated as moderately toxic by skin contact.

2. Solvents used in tusches are rated as moderately toxic by inhalation, except for alcohol, which is only slightly toxic.

3. Airbrushing or use of spray paints for drawing is more hazardous due to the risk of inhaling the spray mist.

Precautions

1. Avoid skin contact with lamp black and solvents as much as possible, and wash hands thoroughly after work.

2. With the amounts of solvents used in drawing materials, dilution ventilation (e.g., a window exhaust fan) is usually sufficient protection.

3. Airbrushing or use of spray paints should be done in a spray booth, or while wearing a NIOSH-approved respirator with organic vapor cartridges and toxic dust and mist filters.

Stone Processing

The basic steps in processing the image on stone consist of etching, dusting with rosin and talc, washing out the image with lithotine or another solvent, rolling up with liquid asphaltum and then ink, and making corrections. With stones, much of this work takes place right on the press.

Hazards

1. Stone etches consist of solutions of gum arabic and acids. Preparation of gum etches from concentrated acids can cause severe skin burns and eye damage from splashes (see the acid section in Chapter 4 and Table 4-2). The final gum etch is only weakly acidic and is not significantly hazardous.

2. Hydrofluoric acid is used by some lithographers. Hydrofluoric acid is highly toxic by all routes of entry. It can cause severe, deep skin burns that require medical attention. There are no immediate pain warnings from contact with hydrofluoric acid.

3. Rosin dust may cause respiratory allergies, for example, asthma. Talc or French chalk often contain asbestos, which may cause lung cancer and other forms of cancer.

4. Washout of the image is usually done with lithotine, a moderately toxic solvent.

5. Liquid asphaltum, used in roll-up and as a blockout, contains pitch in an oil or turpentine base. It may cause skin irritation.

6. Counteretches used for correcting the image consist of either diluted acetic acid or saturated alum solution. Some counteretches contain dichromate salts. Concentrated acetic acid is highly corrosive to the skin, eyes, and respiratory system. Dichromates are probable human carcinogens, can cause skin ulcers and allergic reactions, and are strong oxidizers. Alum may cause skin allergies in some people.

7. Fountain solutions may also contain dichromates or phenol.

Precautions

1. Preferably use prepared etches to avoid working with concentrated acids, rather than preparing your own etch.

2. Do not use hydrofluoric acid.

3. Wear gloves, goggles, and a protective apron when handling all concentrated acids to avoid skin and eye contact. When diluting concentrated acids, always add the acid slowly to the water, never the reverse.

4. An emergency shower and eyewash fountain should be readily available when working with concentrated acids. In cases of spills on the skin, wash with lots of water; in case of eye contact, rinse for at least 15 minutes and call a doctor.

5. In case of ingestion of concentrated acids, do not induce vomiting. Take one to two glasses of water and call a doctor.

6. Neutralize used acid solutions by adding sodium bicarbonate (baking soda) until neutral (when bubbling stops). Pour down the sink with lots of water.

7. Replace talcs or French chalks of unknown composition with an asbestos-free talc, such as baby powder, which can be bought in bulk.

8. Use normal precautions when handling solvents to avoid skin contact and inhalation.

9. Avoid counteretches or fountain solutions containing dichromates or phenol. Water and a bit of gum arabic can be used as a fountain solution.

10. Wash hands carefully to remove ink and asphaltum.

Stone Cleaning

Antitint solutions of gum arabic and phosphoric acid are used to remove excess ink during printing. The *Tamarind Book of Lithography* suggests using mixtures of phenol/gasoline or phenol/water/caustic soda to remove the image from stones and chemically clean them.

Hazards

1. Concentrated phosphoric acid is highly corrosive to skin and eyes (see the previous section, and Table 4-2).

2. Phenol (carbolic acid) is highly toxic by both skin absorption and ingestion. Inhalation is not as serious a hazard due to its high boiling point. Contact with full-strength phenol for even several minutes can be fatal. Even dilute solutions can cause severe skin burns.

3. Caustic soda (sodium hydroxide) is highly corrosive to the skin, eyes, and gastrointestinal system.

4. The final gum arabic/phosphoric acid mixture is only slightly hazardous by skin contact.

Precautions

1. Do not use phenol for cleaning stones.

2. Wear gloves, goggles, and protective apron when handling full-strength phosphoric acid and caustic soda to prevent skin and eye damage.

Metal Plate Processing

Most of the steps in processing zinc and aluminum plates are the same as for stone, except that metal plates often require a preliminary counteretch before drawing on the plate. Metal plate images also have to be fortified with plate

bases, usually vinyl lacquers, for long print runs. In most cases, the actual chemicals used in the processing steps are different from those used with stone.

Hazards

1. Many acids are used in counteretches and etches for metal plates, including acetic acid, nitric acid, hydrochloric acid, phosphoric acid, and tannic acid. Except for tannic acid, these acids are strong skin and eye irritants when concentrated. The final etches and counteretches are also acidic enough to cause mild skin and eye irritation. (See the discussion above under Stone Processing.)

2. Many etches and fountain solutions contain ammonium or potassium dichromates, or potassium chrome alum. The dichromates are probable human carcinogens. They are also moderately toxic by skin contact, causing severe rashes, irritation, and skin ulcers. They are highly toxic by inhalation, possibly causing irritation, allergies, and perforation of the nasal septum.

3. Phenol, used in some zinc plate etches, is highly toxic and may be fatal through skin absorption. Even dilute solutions can cause severe skin burns.

4. Vinyl lacquers used as plate bases contain highly toxic aromatic hydrocarbons and ketones (isophorone and cyclohexanone). Methyl ethyl ketone is often used as a thinner. The major hazard is by inhalation, although these solvents also cause dermatitis. Aromatic hydrocarbons may also be absorbed through the skin.

5. Corrections of the image are commonly done with moderately toxic solvents such as benzine, petroleum naphtha (lactol spirits), gasoline, and kerosene. Brand-name mixtures, which often contain more toxic solvents, are also used. They are all highly flammable, especially gasoline. Gasoline may also contain highly toxic lead compounds, which can be absorbed through the skin.

6. The *Tamarind Book of Lithography* recommends the use of saturated caustic potash for correcting zinc plates and concentrated sulfuric or saturated oxalic acid for correcting aluminum plates. All of these chemicals are highly corrosive to the skin and eyes.

Precautions

1. Do not use phenol or dichromate solutions if possible. Avoid concentrated acids if possible. Do not use gasoline.

2. Wear gloves, goggles, and protective apron when handling or mixing solutions of concentrated acids. (See the discussion of acids in the Stone Processing section above.)

3. When using vinyl lacquer plate bases, work in a laboratory hood, or in front of a slot exhaust hood or window exhaust fan at work level. If this is not possible, wear a NIOSH-approved organic vapor respirator. Use acetone instead of lacquer thinners.

4. Use dilution ventilation (e.g., window exhaust fan) when using moderately toxic solvents such as benzine and lithotine.

5. Place solvent-soaked rags in oily waste cans that are emptied daily.

Photolithography

Photographic images can be transferred to stones or metal plates that are coated with a light-sensitive emulsion. You can coat the stone or metal plate yourself, or use presensitized metal plates. For stone, the light-sensitive emulsions consist of a mixture of powdered albumin, ammonium dichromate, water, and ammonia; commercial emulsions are usually based on diazo compounds. The developing solutions for these brand-name mixtures often contain highly toxic solvents.

For metal plates, diazo-sensitizing solutions, developers with highly toxic solvents, plate conditioners containing strong alkalis, and other brand-name mixtures are used.

Exposure of the coated plate or stone is often done with carbon arcs. Other light sources include quartz mercury lamps and metal halide lamps.

Hazards

1. The ammonium dichromate used for coating stone is a probable human carcinogen, is moderately toxic by skin contact, and may cause allergies, irritation, and external ulcers; it is highly flammable and a strong oxidizer.

2. Ammonia is a skin irritant and highly toxic by inhalation. Ammonia is highly corrosive to the eyes. It has good odor-warning properties.

3. Diazo photosensitive emulsions are eye irritants.

4. Many of the solvents used in photolithographic developing solutions are highly toxic by both inhalation and skin absorption.

5. Plate conditioners contain alkalis that are highly corrosive to the skin and eyes.

6. Carbon arc fumes are highly toxic. The carbon electrodes consist of a central core of rare earth metals, carbon, tar, and pitch surrounded by a cop-

per coating. When lit, carbon arcs emit nitrogen oxides, carbon monoxide, ozone, copper and rare earth fumes, and intense ultraviolet radiation. Hazardous amounts of the fumes can be inhaled without noticeable discomfort. Acute exposure can cause chemical pneumonia, and chronic exposure can cause emphysema. The ultraviolet radiation can cause skin cancer and eye damage.

Precautions

1. Avoid ammonium dichromate and use presensitized plates if possible. If you use ammonium dichromate solutions, wear gloves and goggles. Store them away from heat, solvents, and other organic materials.

2. Use ammonia solutions or solvent-containing photolithographic solutions inside a laboratory hood, or in front of a slot exhaust hood. Wear gloves, goggles, and, if ventilation is inadequate, a NIOSH-approved respirator with organic vapor cartridges for solvents and an ammonia cartridge for ammonia.

3. Wear gloves, goggles, and protective apron when handing alkaline solutions.

4. Do not use carbon arcs unless they are equipped with local exhaust ventilation exhausted to the outside. Quartz mercury or metal halide lamps are safer.

5. Paint walls in the darkroom with a zinc oxide paint that will absorb ultraviolet radiation. When the carbon arc is on, wear welding goggles with as dark a shade number as enables you to see.

INTAGLIO: Acid Etching

Intaglio involves the printing of areas that have been cut away or etched from the plate. Besides acid etching, intaglio processes include engraving, drypoint, and mezzotint (see below).

Acid etching involves application of various resists to the plate sections not to be etched, etching the plate with acids, and the actual printing.

Etching Grounds and Stop-outs

Etching grounds basically consist of beeswax, asphaltum, and rosin mixed with various amounts of solvents. Hard ground is prepared by cooking these ingredi-

ents together. Xylene is sometimes added to speed up the process, and some ben-
zine is added to give the desired consistency.

Liquid soft ground consists of hard ground, axle grease, and vaseline or
mineral oil, plus mineral spirits or benzine to give the desired consistency. Com-
mercial soft grounds today often contain large quantities of benzine. Other
grounds sometimes used include sugar lift ground, consisting of corn syrup,
India ink, soap, and gum arabic; and white ground, consisting of titanium diox-
ide, soap, linseed oil, and water. Large amounts of liquid grounds can be used to
coat plates.

Stop-outs consist of rosin and denatured alcohol, or asphaltum, which is sol-
uble in mineral spirits.

Hazards

1. The xylene used in making hard ground is highly toxic by inhalation. It is
 absorbed through the skin and is flammable. Since it is not essential to the
 preparation of the ground, it should not be used.

2. Benzine and mineral spirits used in the preparation of hard grounds, soft
 grounds, and asphaltum stop-outs can cause dermatitis and eye and mu-
 cous membrane irritation. They are classified as moderately toxic. Ben-
 zine is also flammable. The use of large quantities of soft grounds makes
 solvent inhalation a particular hazard.

3. Ethyl or denatured alcohol is slightly toxic. Brand-name stop-outs may
 contain more hazardous solvents.

4. Rosin dust is slightly toxic by inhalation, possibly causing respiratory al-
 lergies.

5. Asphaltum is slightly toxic by skin contact, possibly causing skin irrita-
 tion. Polycyclic aromatic hydrocarbon (PAH) contaminants found in as-
 phaltum may vaporize if the asphaltum is heated over 200°F (93°C)
 during heating of grounds. These PAHs are probable human carcinogens.

Precautions

1. Store all flammable solvents in approved safety cans.

2. Use local exhaust ventilation (e.g., slot hood, or working at a table in front
 of a window with an exhaust fan at work level) when using large amounts
 of soft grounds or other solvents.

3. Wash hands carefully after work, and do not eat, drink, or smoke in the
 studio.

4. Use the lowest feasible temperature on hot plates used for smoking grounds to prevent vaporization of PAHs. Provide local exhaust ventilation.

Aquatints

Aquatinting is a way of creating tonal areas in a print. The basic aquatint grounds are rosin powder of varying degrees of fineness, powdered asphaltum, and spray enamel paints. Rosin dust can be shaken onto the plate by enclosing it in cheesecloth, or by placing the plate inside a rosin box and agitating the rosin dust (or asphaltum).

Hazards

1. Rosin dust can cause respiratory allergies. This is particularly a problem in aquatinting because of the fineness of the dust and the process by which it is shaken onto the plate.
2. Rosin and asphaltum dusts are explosive. This is a hazard in mechanically driven rosin boxes and in hand-driven ones using iron handles, which can create sparks.
3. Spray paints are highly toxic by inhalation because of the toxicity of the pigments and of the solvents.

Precautions

1. Wear a NIOSH-approved toxic dust respirator when dusting rosin onto plates by hand.
2. If you use a mechanized rosin box, be sure that it is sparkproof. If it is a manual one, make sure all components are nonsparking.
3. Clean up all rosin dust carefully by wet mopping.
4. Use spray paints in a spray hood or outdoors. An alternative is to use a NIOSH-approved respirator with organic vapor cartridges and spray prefilters.

Etching Process

Different acids are used to etch different metal plates. Zinc plates are etched with nitric acid of various strengths. Copper plates are etched with nitric acid, Dutch mordant (a mixture of potassium chlorate, water, and hydrochloric acid), or iron

perchloride (ferric chloride). Other less common etches include mixtures of potassium dichromate, sulfuric and hydrochloric acids for aluminum, and nitric acid for steel plates.

Hazards

1. Concentrated nitric and hydrochloric acids are highly corrosive by skin and eye contact, and by ingestion. They can cause severe stomach damage, and may be fatal. See Table 4-2. The diluted acids are less hazardous. Repeated or prolonged skin contact can cause irritant dermatitis.

2. Potassium chlorate, used in making Dutch mordant, and concentrated nitric acid are strong oxidizing agents and can react with solvents and other organic materials (such as rosin) to cause fires. Potassium chlorate is also a skin and respiratory irritant and is highly toxic by ingestion.

3. Mixing hydrochloric acid and potassium chlorate to make Dutch mordant produces highly toxic chlorine gas.

4. Nitric acid etching gives off hydrogen gas and nitrogen dioxide. Hydrogen is flammable, but is not normally a problem. Acute inhalation of large amounts of nitrogen dioxide can cause chemical pneumonia, but this is a problem only with large plates or acid solutions more concentrated than usual. Chronic inhalation of nitrogen dioxide has caused emphysema in several printmakers. Note that nitrogen dioxide has poor odor-warning properties.

5. Ferric chloride is a skin irritant.

6. Acid etching can cause the edges of plates to become extremely sharp and jagged, possibly resulting in cuts.

Precautions

1. If possible, use ferric chloride rather than the more hazardous Dutch mordant.

2. Store concentrated nitric acid and potassium chlorate separately from other chemicals.

3. Wear gloves, goggles, and protective apron when handling all concentrated acids to avoid skin and eye contact. When diluting concentrated acids, always add the acid slowly to the water, never the reverse.

4. Preparation of acid baths and etching should be done with local exhaust ventilation, or immediately in front of a window exhaust fan. Note that the acid gases will corrode ordinary galvanized ducts and fans. Epoxy-coated ducting or stainless steel should be used.

5. If the acid bath overheats during the etching process, remove the plate (with gloves) and cool with cold water. If excess nitrogen dioxide is emitted (you can see a brown gas), add sodium bicarbonate to neutralize the acid. Do not expose yourself.

6. An emergency shower and eyewash fountain should be readily available when working with concentrated acids. In cases of spills on the skin, wash with lots of water; in case of eye contact, rinse for at least 15 minutes and call a doctor.

7. In case of ingestion of concentrated acids, do not induce vomiting. Take one to two glasses of water and call a doctor.

8. Protect the edges and back of the plate with stop-out varnish to protect against etching.

9. Used acid solutions can be neutralized by adding sodium bicarbonate (baking soda) until pH 7 is attained and bubbling stops. However, used acid etching solutions also contain large concentrations of zinc or copper ion, which can exceed sewer code limits on these metals. Further adjusting of the pH to 8.5 causes the precipitation of zinc and copper hydroxide, which could be filtered after settling (e.g., through a coffee filter).

10. Cover acid baths when not in use.

Photoetching

The most widely used photoresist system is KPR. The photoresist dye contains xylene, ethylene glycol monoethyl ether acetate (2-ethoxyethyl acetate or cellosolve acetate), and benzaldehyde. The developer contains xylene and ethylene glycol monomethyl ether acetate (2-methoxyethyl acetate or methyl cellosolve acetate). An alternative to coating plates yourself with the photoresist is to use presensitized plates. The developer also contains solvents, but is less toxic. Exposure of the plate is done with ultraviolet sources such as carbon arcs, mercury lamps, or metal halide lamps.

Hazards

1. The methyl and ethyl ether acetates of ethylene glycol are highly toxic by skin absorption and inhalation, and moderately toxic by ingestion. They can cause severe reproductive effects (birth defects and miscarriages in women, testicular atrophy and lowered sperm counts in men), kidney damage, anemia, and behavioral changes. Inhalation can cause narcosis and pulmonary edema.

2. Butyl cellosolve is highly toxic. It does not cause the reproductive effects, but otherwise is similar to methyl cellosolve.

3. Xylene is moderately toxic by skin absorption and highly toxic by inhalation and ingestion. It is a strong narcotic.

4. See the discussion under photolithography for the hazards of carbon arcs.

Precautions

1. Use presensitized plates if possible.

2. Use photoresist solutions with local exhaust ventilation, or wear an organic vapor respirator. Wear butyl rubber gloves when handling KPR solutions.

3. Do not use carbon arcs unless you have local exhaust ventilation. When using carbon arcs, wear welding goggles of the darkest shade possible. Paint the darkroom walls with zinc oxide paint to prevent reflection of ultraviolet radiation.

INTAGLIO: Drypoint, Engraving, and Mezzotint

Drypoint uses a diamond- or carbide-tipped needle to incise lines in a metal plate, leaving behind a rough furrow called a burr. Engraving uses a sharp tool called a burin, which removes wiry bits of metal, leaving a clean groove. Engraving can be done on either metal or plastic plates. Mezzotint uses tools to abrade the plate, leaving small pits. Flexible shaft tools are also used.

For large editions on copper plates, steel facing is sometimes done to make a longer-lasting plate. Steel facing involves first descaling the copper plate with vinegar and salt, and then electroplating in an ammonium chloride solution with an iron cathode.

Hazards

1. One hazard of these techniques is the risk of cutting your hand through improper use of tools, or cutting yourself on small scraps of metal.

2. Long-term use of these tools can cause carpel tunnel syndrome, which can cause numbness and pain in the first three fingers. It can be crippling in severe cases (see Chapter 10).

3. Flexible shaft tools can create fine metal dust, which can be irritating to the respiratory system.

4. The major hazards in steel facing are electrical shock from the electroplating equipment.

5. See the printmaking inks and printing sections earlier in this chapter for the hazards and precautions of these parts of the process.

Precautions

1. Clamp the plate to the table to prevent it from slipping.

2. Hold tools properly and cut away from your body. Never place your hands in front of the tool.

3. Store tools carefully in canvas or cloth holders. Needles and other sharp-pointed tools can be stored with the points embedded in corks. Keep tools sharp so they cut easily and do not slip out of your hands.

4. Carpel tunnel syndrome can be minimized or avoided by using tools with wide handles, avoiding tight grips, and taking rest periods with hand-flexing exercises. The height of the work table can also influence the degree of wrist flexing needed.

5. Wear a NIOSH-approved toxic dust respirator when using flexible shaft tools.

6. If steel facing is desired, I recommend sending the plate out to have it done. See the electroplating section in Chapter 18 for precautions with electroplating.

RELIEF PRINTING

Relief printing involves the cutting away of plate areas that are not to be printed. The main relief printmaking techniques are woodcuts, wood engravings, and linocuts. Relief inks can be either water based or oil based.

Woodcuts and Wood Engraving

Woodcuts are made by cutting out areas of a smooth plank of hardwood with knives, gouges, and tools such as metal engraving tools to incise lines in blocks of wood (e.g., boxwood and red maple).

Hazards

1. Some of the woods used—for example, boxwoods and some beeches— are moderately toxic skin irritants or can cause skin allergies. The dusts from many of these woods are moderately toxic if inhaled (see Chapter 17 for more information).

2. Careless handling of sharp hand tools can cause cuts and other wounds in the skin.

3. Use of wood-carving and cutting tools can cause carpel tunnel syndrome, as discussed above and in Chapter 10.

Precautions

1. See the beginning of the chapter for precautions in printing and cleanup.

2. Vacuum or mop up all wood dust to diminish inhalation of it. If you develop respiratory allergies to a particular type of wood, you will have to try another variety.

3. Protect your hands against irritating or allergenic woods by wearing protective creams.

4. Always cut in a direction away from you, with your free hand on the side or behind the hand with the tool.

5. Carpel tunnel syndrome can be minimized or avoided by using tools with wide handles, avoiding tight grips, and taking rest periods with hand-flexing exercises. Switching to linoleum cutting can also help, since the linoleum is softer to work.

Linocuts

Linocuts can be done with tools that are lighter than the tools used with wood, although the same cutting techniques can be employed. As a result, they are popular with children. In addition, linoleum can be etched with caustic soda. Asphaltum, varnish, or heated paraffin wax can be used as etching resists.

Hazards

1. The tools used for cutting linoleum are less likely to slip and cause cuts than those used with wood. Thus it is a better technique for children to use.

2. Caustic soda is highly corrosive and can cause very serious skin and eye burns.

3. Solvents in stop-outs and varnishes are moderately toxic. In addition, heated wax and solvents are flammable. Asphaltum may cause skin irritation.

Precautions

1. See the beginning of the chapter for precautions in printing and cleanup.

2. Obey simple precautions for handling sharp tools, such as cutting in a direction away from you and never placing your free hand in front of the hand with the cutting tool. Heating the linoleum with an electric pad makes cutting easier. Use low heat only.

3. Wear gloves and goggles when preparing and handling caustic soda solutions. Do not allow children to use this chemical.

4. Do not allow smoking or open flames near resists. Wash hands carefully after work.

SCREEN PRINTING

Screen printing with solvent-based inks is one of the more hazardous art techniques due to high solvent exposures. I have seen dermatitis, narcosis (dizziness, headaches, nausea), eye irritation, chronic nosebleeds, liver damage, adverse reproductive effects (e.g., miscarriages), and brain damage—all resulting from screen printing.

Screen printing is a stencil technique in which the ink is forced through areas of a fabric screen that has a design blocking out part of it. This ink then reproduces the negative of that design on paper or other matrices. Screen printing differs from other printmaking techniques in the wide variety of types of printing inks available and in the types of materials on which you can print. There are two basic types of screen printing inks: water based and solvent based. The types of solvents in the inks can vary depending on what type of material the ink is printed onto. Screen printing inks are usually ready-made.

Stencils

Screens can be prepared by a large number of different stencil techniques, including blockout and resist stencils, paper stencils, film stencils, and photosten-

cils. Of these, paper stencils are the least hazardous, since solvents are not used in their preparation.

The type of stencil used depends on the type of ink. Stencils for water-based inks need to be insoluble in water at room temperature so that the stencil does not dissolve in the ink. Similarly, stencils for solvent-based inks must be insoluble in the ink solvents.

Resists and Blockouts

There are a large number of different blockout materials or combinations of resist and blockouts that can be used to prepare screen stencils. Common blockout materials include water-soluble glues, lacquers, and shellacs. Less common materials are polyurethane varnishes and caustic resist enamels. Resist/blockout combinations include tusche/water-soluble glues, lacquer resists/glue blockout, liquid wax/shellac or enamel, and rubber latex resist (liquid frisket) and glue, shellac, or lacquer blockout.

Hazards

1. Water-soluble glues, liquid wax, and liquid frisket are the least hazardous materials, since they do not contain toxic solvents or require solvents for reclaiming screens. They may cause some eye irritation if splashed in the eyes.

2. Shellac may contain ethyl alcohol or methyl alcohol. It can be thinned and removed with ethyl alcohol (denatured alcohol). Ethyl alcohol is only slightly toxic by skin contact or inhalation. Methyl alcohol is moderately toxic by inhalation, skin contact, skin absorption, and ingestion.

3. Lacquers, lacquer thinners, polyurethane varnishes, and caustic enamels often contain large amounts of aromatic hydrocarbons such as toluene or xylene. These solvents are highly toxic by inhalation and moderately toxic by skin absorption.

4. Tusche often contains small amounts of mineral spirits or turpentine; these solvents are used to thin tusche, and kerosene is used to remove it from the screen. Mineral spirits, kerosene, and turpentine are moderately toxic by inhalation and skin contact. Turpentine may also cause skin and respiratory allergies and kidney damage.

5. All the solvents mentioned are flammable except for kerosene and mineral spirits, which are combustible.

Precautions

1. Wear protective gloves and goggles when pouring, thinning, or washing out blockouts or resists. Do not use solvents to wash hands; use soap and water.

2. Have adequate general ventilation when preparing stencils with solvent-based materials. If the highly toxic lacquers and their thinners are used, work with local exhaust ventilation or immediately in front of a window exhaust fan. If the ventilation is not adequate, wear a NIOSH-approved respirator with organic vapor cartridges.

3. Keep all solvent containers closed, and dispose of solvent-soaked rags in a self-closing oily waste can that is emptied each day.

4. Obey normal fire prevention rules. These include storing solvents in approved safety cans, use of self-closing waste disposal cans, and no smoking or open flames near work areas.

5. See Table 4-4 in Chapter 4 for the hazards and precautions of solvents.

Film Stencils

Lacquer film stencils are adhered to the screen with adhering fluid for lacquer-type emulsion films, and with a mixture of isopropyl alcohol and water for water-soluble emulsion films. Water-emulsion films are removed with water, and lacquer-type emulsions with film removers.

Stencils for water-based inks can also be prepared by adhering self-adhesive materials such as contact paper or photomount paper to the underside of the screen. Water-soluble stencils can also be used in combination with screen fillers followed by removal of the water-soluble stencil.

Hazards

1. Adhering fluids for lacquer-type emulsions usually contain acetates, ketones, and alcohols and are moderately toxic by inhalation. They are also slight to moderate skin irritants. Film removers often contain aromatic hydrocarbons and are highly toxic by inhalation. The aromatic hydrocarbons can be absorbed through the skin.

2. Isopropyl alcohol is slightly toxic by inhalation. It presents no significant hazard by skin contact, but is an eye irritant.

3. Isopropyl alcohol, adhering fluids, and film removers are all flammable.

Precautions

1. Adhering fluids and isopropyl alcohol require normal general ventilation (e.g. window exhaust fan). They both have good odor-warning properties.

2. Some artists also use the adhering fluids to remove the film. This is less hazardous than using film remover, even though it may take a little longer.

3. Obey normal fire prevention rules for flammable solvents.

Photo Stencils

There are two types of photo-stencil techniques in screen printing: direct emulsion techniques and indirect techniques. The direct emulsion techniques involve coating the screen with a liquid photoemulsion (dichromate or diazo types) or adhering presensitized films to the screen. The screens are then exposed and developed. Indirect techniques involve adhering sensitized, gelatinized transfer films to the screen after exposure.

Exposure of the emulsions is done with an intense light source such as a no. 2 photoflood reflector bulb, sunlamp, and, in some cases, carbon arc.

Hazards

1. Ammonium dichromate sensitizers are moderately toxic by skin contact, causing skin ulcers and allergies. Inhalation of the powder can cause severe respiratory irritation, ulceration of the nasal septum, and respiratory allergies. It is a probable human carcinogen. Ammonium dichromate is also flammable and an oxidizer.

2. Diazo sensitizing solutions are eye irritants by direct contact.

3. Carbon arcs are highly hazardous, giving off metal fumes, nitrogen oxides, and ozone, all of which are severe lung irritants. In addition, the ultraviolet light produced is harmful to the eyes (see the photolithography section).

Precautions

1. Wear gloves and goggles when mixing and using photo-stencil solutions and when cleaning the screen.

2. Diazo photoemulsions are the safest to use. Presensitized emulsions are a good choice for making photostencils, since it is not necessary to handle the more hazardous ammonium dichromate.

3. Do not use carbon arcs. Instead use a photoflood or sunlamp.

Screen Printing Inks

The same pigments used in other types of printmaking and in painting are used in screen printing. The vehicle for most screen printing inks can be water or solvents. Water-based inks are available for both paper and textiles. Mineral spirits, and sometimes toluene, are used in the standard alkyd resin poster inks and oil-based textile emulsion inks. In addition, there are specialty inks, such as vinyl inks, high-solids plastisol inks, and polymerizing inks (e.g., epoxy, UV-curing).

Modifiers of screen printing inks include transparent base to add body and to increase the transparency of the ink, extender base as a filler to make the ink stretch further, toners to intensify the color of the ink, retarders to slow drying of the ink on the screen, and solvents or varnishes to thin the ink. Common corn starch is sometimes used as a thickener; calcium carbonate is used less frequently. For solvent-based inks, the transparent bases and extenders usually contain the same solvent as the ink. Retarders and other modifiers can often contain other solvents.

Hazards

1. Standard poster inks can contain up to 50% mineral spirits, and sometimes toluene. Mineral spirits are moderately toxic by skin contact, inhalation, and ingestion. Toluene is highly toxic by inhalation. Acute exposure can cause narcosis and respiratory irritation. Chronic exposure to the large amounts of solvents can cause a variety of chronic effects, including brain damage.

2. Vinyl inks, used to print on polyvinyl chloride, can contain isophorone and other highly toxic ketones. Acute exposure can cause narcosis at very low levels and respiratory irritation, including possible chemical pneumonia. Repeated exposure can cause kidney damage.

3. Epoxy inks can cause skin and respiratory irritation and allergies.

4. High-solids plastisol inks have much lower concentrations of mineral spirits and are therefore less hazardous than standard poster inks.

5. Retarders and reducers are solvent mixtures. Many are proprietary or trade mixtures whose actual composition is not known. From the data available, they are mostly aromatic hydrocarbons and are classified as highly toxic by inhalation and moderately toxic by skin absorption.

6. Solvents such as turpentine, benzine, naphtha, and kerosene are also used as modifiers. These solvents are classified as moderately toxic by inhalation, skin contact, and ingestion.

7. Some water-based inks contain small amounts of solvents. Propylene glycol and ethylene glycol would not be considered hazardous in the amounts present. Glycol ethers, such as ethylene glycol ethyl ether, if present, would be more hazardous due to their adverse reproductive effects and possible anemia.

8. See Table 4-4 for the hazards of particular solvents.

Precautions

1. Obtain Material Safety Data Sheets on all inks and modifiers used, including water-based systems. Whenever possible, buy solvents by chemical name rather than buying trade-name solvent mixtures, which are often more hazardous.

2. Use water-based screen printing inks if possible. Note that using water-based inks can result in considerable savings since large amounts of toxic and expensive solvents are not needed for cleanup. See the chapter references for books on printing with water-based inks.

3. If using mineral spirits and other solvents, you need excellent local exhaust ventilation. Note that printing and drying processes are more hazardous because of the much larger volumes of solvent being evaporated. This is discussed in the next section.

4. Obey normal fire prevention rules. These include storing solvents in approved safety cans, using self-closing waste disposal cans that are emptied each day, and banning smoking or open flames in the work area.

Printing and Drying

During printing with solvent-based inks, you are directly exposed to the vapors from the ink. When printing large editions, which takes some hours, this can involve considerable inhalation of solvent. The print is then hung up or placed in a rack for drying. For poster inks, this takes about 15 to 20 minutes as the solvent evaporates into the air. Screen printing on textiles usually requires a curing step, which usually consists of heating or ironing the textile. Water-based textile inks may also require heat curing.

Hazards

1. Printing is a highly hazardous process because of the high toxicity of many of the solvents and the large amount of solvents evaporating from

the inks. This is compounded by the fact that you are so close to the evaporating solvents.

2. The drying of the prints creates similar hazards, since large volumes of solvent can be evaporated into the air in a short period of time.

3. Postprint curing of fabrics by heating may release gases or fumes that are slightly irritating to the respiratory system.

Precautions

1. Screen printing with solvent-based inks requires a slot exhaust hood to pull the solvent vapors away from your face. If your ventilation is not adequate, wearing a NIOSH-approved respirator with organic vapor cartridges is essential.

2. Dry large numbers of prints in a specially ventilated area, or place the drying rack directly in front of an explosion-proof window exhaust fan. Enclosing the sides and top of the drying rack will increase the effectiveness of the exhaust system.

3. No special ventilation is needed for water-based inks, unless toxic solvents are also in these inks.

4. Use dilution ventilation for postprint curing of fabrics if any fumes are emitted.

Cleanup

Cleaning the ink from the screens can be done with water for water-based inks and solvents for solvent-based inks. Mineral spirits, kerosene, or turpentine can be used for poster inks and other inks using mineral spirits as thinner. Other inks might require lacquer thinners. Many companies recommend brand-name washups for this process, many of which contain aromatic hydrocarbons. These are not needed for poster inks under normal conditions. Cleaning the ink is often done with solvent-soaked newspapers followed by soft rags to remove the ink completely.

Reclaiming the screen is done with a variety of materials, including hot water, detergent solutions, bleaches, and solvents.

Hazards

1. Cleanup is probably the most hazardous step in screen printing with solvent-based inks, because of the widespread use of highly toxic commer-

cial washups and the practice of tossing solvent-soaked rags in an open wastepaper basket. This can result in evaporation of large amounts of highly toxic vapors into the studio in a short period of time. In addition, these solvents are moderate skin irritants and fire hazards. Mineral spirits, kerosene, and turpentine are moderately toxic by skin contact and inhalation.

2. Screen reclaiming solutions include strongly alkaline solutions, enzymes that can cause skin allergies and asthma in some people, and bleach, which is moderately toxic by skin contact and highly toxic by inhalation if sprayed.

Precautions

1. Clean the ink off the screen before it has a chance to dry. Even water-based inks are harder to remove once dried.

2. Use acetone, odorless mineral spirits, or lithotine in preference to commercial washups, which are highly toxic. For nonposter inks, more toxic solvents might be required. For poster inks, a mixture of about 10 to 15% xylene and 85 to 90% mineral spirits can work when pure mineral spirits are ineffective (especially when the ink has dried).

3. Screen cleaning with solvents must be done with local exhaust ventilation or a combination of dilution ventilation plus a NIOSH-approved respirator with organic vapor cartridges.

4. Wear gloves and goggles during cleanup to avoid skin and eye contact with the solvents or detergent solutions.

5. Place ink and solvent-soaked rags and newspapers in an OSHA-approved oily waste can with a self-closing top to prevent evaporation of the solvents and reduce the fire hazard. Dispose of these materials at the end of every day. Do not store overnight.

6. Follow normal precautions against fire around solvents, such as no smoking or other open flames, using safety cans, and storing large amounts of solvent-containing materials in flammable storage cabinets.

OTHER PRINTING PROCESSES

Collagraphs

Collage involves gluing materials such as paper, fabric, pieces of metal, and sand onto a rigid support to make a plate, and making prints from this plate. The col-

lagraph can be printed by either relief or intaglio processes. The print produced is called a collagraph. A wide variety of glues is used in the making of collages or collagraph plates.

Hazards

1. Glues based on organic solvents or plastics resins (e.g., epoxies, cyano-acrylate instant glues) are hazardous by skin contact and inhalation. Rubber cement contains n-hexane, a solvent that can cause peripheral nerve damage.

2. Collagraph plates are often coated with acrylic medium or modeling paste, and sanded. The sanding process can create dusts that are slightly irritating to the respiratory system.

3. Spraying the back and edges of plates with fixatives to make them water-proof is hazardous due to possible inhalation of the aerosol spray fixative.

Precautions

1. See the beginning of the chapter for precautions in printing and cleanup.

2. Avoid the more toxic glues whenever possible. If you must use them, wear gloves and have adequate ventilation to prevent inhalation of the solvent vapors. Use the safer water-based glues rather than solvent-based glues whenever possible.

3. Wear a NIOSH-approved dust mask when sanding plates, or do the sanding with local exhaust ventilation.

4. Instead of spraying plates with fixatives for waterproofing, brush on a protective coating or dip the plate in an appropriate solution. Use acrylic medium or shellac. Spraying can be done outside, in a spray booth, or while wearing a NIOSH-approved respirator with organic vapor cartridges and dust and mist filters.

Plastic Prints

Plastic prints involve making prints from a wide variety of plastic materials and resins. The plate can be made by drilling, machining, cutting, or sanding of finished plastics (e.g., Plexiglas) or by casting a plate from epoxy or other plastics resins. It can involve intaglio or relief techniques.

Hazards and Precautions

1. See the plastics section of Chapter 16 for information on the hazards and precautions involved in working with plastics.

2. See the parent techniques for information on the hazards and suitable precautions for printing.

Monoprints

Monoprints involve normal intaglio, lithographic, or other printmaking techniques, but only one print is made.

Hazards and Precautions. See the parent techniques for information on the hazards and suitable precautions.

REFERENCES

Johnson, L. M., and Stinnett, H. (1991). *Water-Based Inks: A Screenprinting Manual for Studio and Classroom.* 2d ed. Philadelphia: Philadelphia Colleges of the Arts Printing Workshop.

Moses, C., Purdham, J., Bohay, D., and Hoslin, R. (1978). *Health and Safety in Printmaking.* Edmonton, Alberta, Canada: Occupational Hygiene Branch, Alberta Labor.

Spandorfer, M., Curtiss, D., and Snyder, J. (1992). *Making Art Safely.* New York: Van Nostrand Reinhold.

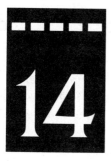

Ceramics

 eramics involves working with clay to form a clay object, firing it in a kiln, then possibly applying a glaze and firing it again.

WORKING WITH CLAY

Most potters either manipulate wet clay by such methods as hand building or using a potter's wheel, or they do slip casting, which involves making a clay slurry and then casting it in a mold.

Clays are minerals composed of hydrated aluminum silicates, often containing high percentages of crystalline free silica as an impurity. There can be wide variations in the amount of free silica in a particular clay body, depending on its source. Other materials, such as grog (ground firebrick), sand, talc, vermiculite, perlite, and small amounts of minerals such as barium and metal oxides are often added to modify the properties of the clay. Clays are also contaminated with organic matter and sulfur compounds.

Mixing Dry Clay

Clay is mixed by pouring bags of dry clay and water into a clay mixer. This process can generate very high concentrations of silica dust. In making clay slip, large amounts of talc are added. Ceramic talcs are often contaminated with large amounts of fibrous asbestos or asbestos-like materials, especially talcs from New York State. Pfizer has some fiber-free talcs.

Hazards

1. Inhalation of large amounts of free silica during the mixing of powdered clay is highly hazardous, possibly causing silicosis, or "potter's rot," after years of exposure. Silicosis, which usually takes at least 10 years to develop, can cause shortness of breath, dry cough, emphysema, and high susceptibility to lung infections such as tuberculosis. Skin contact and ingestion pose no significant hazards. (See the discussion of silicosis in Chapter 5.)

2. Inhalation of large amounts of China clay powder is moderately hazardous, causing kaolinosis, a disease in which the lungs become mechanically clogged by the clay. China clay may also cause silicosis if it contains much free silica.

3. Asbestos is extremely toxic by inhalation and possibly by ingestion. Asbestos inhalation may cause asbestosis, lung cancer, mesothelioma, stomach cancer, and intestinal cancer.

4. Sand, perlite, grog, and vermiculite contain free silica and are, therefore, highly toxic by inhalation. Vermiculite is also frequently contaminated with asbestos.

5. Adding extra water or clay to a clay mixer while the clay mixer is in operation has caused many accidents, including amputations of arms.

6. Lifting heavy bags of clay or glaze materials can cause back problems.

Precautions

1. Preferably buy premixed clay to avoid exposure to large quantities of clay dust.

2. Clay storage and mixing should take place in a separate room. Bags of clay (and other pottery materials) should be stacked on palettes off the floor to enable easier cleanup.

3. All clay mixers should be equipped with local exhaust ventilation to remove fine silica dust particles from the air. Since many local exhaust sys-

tems used with clay mixers are not totally effective, it may be necessary to also wear a National Institute of Occupational Safety and Health (NIOSH)-approved toxic dust respirator.

4. Wet mop dust on the floor, or hose the floor down if your studio is equipped with a suitable drainage system and clay trap. The floor should be coated with a sealant or a material such as linoleum so that it is easier to clean up the dust. Special vacuum cleaners with high-efficiency (HEPA) filters are necessary when vacuuming, since the fine silica dust will pass through regular industrial vacuum cleaners.

5. While working, wear special clothes, preferably made out of a closely woven material that does not entrap dust. The clothes should not have pockets or other obstructions that can catch dust that you can breathe in later. Coveralls are one suggested type of clothing. Change out of these clothes before leaving the studio. Wash these clothes weekly, separately from other laundry.

6. Do not use asbestos or asbestos-contaminated talcs.

7. Clay mixers should be equipped with proper machine guards so that they cannot be opened to add more clay or water while the mixer blades are turning.

8. See Chapter 10 for information on proper lifting methods.

Handling Wet Clay

After mixing the clay, a variety of processes occurs in which the wet clay is handled, including wedging, souring or aging, and shaping and drying until the pot or sculpture is ready for firing. Some of these have specific hazards.

Hazards

1. Respiratory problems, such as hypersensitivity pneumonia and asthma, can result from molds that grow when clay is soured or aged in a damp place, or when clay slips stand for months. Respiratory problems can also result from inhalation of powders that develop when aged clay dries. The molds, which can contribute to the workability of the clay, can also cause skin problems, particularly if there is a preexisting dermatitis.

2. Working on a potter's wheel for extended periods of time can result in carpel tunnel syndrome, since the wrists are bent back in an unnatural position. Symptoms include pain, numbness, and/or pins and needles in the thumb and first three fingers. This can have serious long-term effects. In

addition, back problems can occur from extended periods of bending over the potter's wheel.

3. Handling cold wet clay, such as when throwing clay, can cause abrasion and drying of the hands, particularly the fingertips. This is a result of the mechanical friction or rubbing of the clay particles on the hands, the oil-absorbing ability of clay, and the harmful effects from prolonged exposure to cold water.

4. The use of a kickwheel for throwing clay is a mechanical hazard, since the moving parts can cause cuts and abrasions, particularly with children.

5. Small pieces of wet clay that collect on the floor and bench can dry and become pulverized, producing an inhalation hazard due to the presence of free silica.

6. Reconditioning clay or grog by pulverizing it can create very high concentrations of hazardous silica dust.

7. Finishing green ware by sanding it when dry can result in the inhalation of free silica.

Precautions

1. Avoid contact of clay with broken skin by wearing gloves if necessary. Prevent drying of skin by applying a skin cream after work to replace lost oils.

2. To prevent carpel tunnel syndrome, try to keep your wrists in an unflexed position as much as possible. Take frequent work breaks instead of working extended periods of time. Exercise and massage can also help.

3. Avoid or alleviate back problems from throwing by using a standup potter's wheel (Cranbrook-style treadle wheel), or raise your electric wheel to a comfortable height by placing it on a secure base.

4. Be careful of moving parts on kickwheels, and do not allow young children to use kick-style potter's wheels.

5. Clean up spilled clay before it has a chance to dry out and get crushed underfoot. Wet mop daily.

6. Do not recondition dry clay by pulverizing it or breaking it up by hand. Instead, cut the clay while still wet into moderate-sized pieces (1"–1¼"), allow to dry out, and then soak in a barrel of water. Putting a chicken-wire screen over the barrel ensures that clay pieces are small enough.

7. Finish green ware while still wet or damp with a fine sponge instead of sanding when dry. If this is not possible, wear a NIOSH-approved toxic dust respirator when sanding. Do not sand green ware containing fibrous talc.

GLAZES

Glazes consist of silica, a flux to lower the melting point of the silica, and colorants. Fluxes include lead, barium, lithium, calcium, and sodium, and constitute a high percentage of the glaze. Colorants consist of metal oxides and usually constitute less than 5% of the glaze by weight.

Leaded versus Leadless Glazes

Until the turn of the century, soluble raw lead compounds such as red lead, white lead, galena, and litharge—all of which are highly poisonous—were the common lead compounds used in low-fire glazes. (Lead is not used in high-fire glazes because lead vaporizes at high-fire temperatures.) In 1897, 432 cases of lead poisoning were reported among potters in England. The simultaneous introduction of lead frits and careful housekeeping measures drastically lowered the number of lead-poisoning cases.

Frits are made by melting minerals and metal compounds together to produce a glass-like material, which is sintered and ground into a powder. Lead frits are commonly assumed to be insoluble and nontoxic. However, this is not true. Leaching tests using acids have shown that many frits are as soluble as raw lead compounds. In fact, many cases of lead poisoning have developed from inhalation or ingestion of prepared glazes containing lead frits.

The availability of high-fire porcelain and stoneware techniques to studio potters in the post-World War II years allowed potters to eliminate lead and its problems.

Leadless glazes based on alkali earth or alkaline earth fluxes can be used for low-fire conditions instead of lead. In addition, leadless glazes can be based on boric oxide as the glass former, instead of silica. Alkali earth fluxes include sodium, potassium, and lithium oxides; alkaline earth fluxes include calcium, magnesium, barium, and strontium oxides. Minerals containing these fluxes include certain feldspars, nepheline syenite, petalite, bone and plant ashes, whiting, and dolomite.

Hazards

1. All lead compounds are highly toxic by inhalation or ingestion. The Occupational Safety and Health Administration (OSHA) regulates lead frits the same as other lead compounds. Lead can cause anemia, peripheral nervous system damage, brain damage, kidney damage, intestinal problems, chromosomal damage, birth defects, and miscarriages. See Chapter 5 for more information on the hazards of lead compounds.

2. Lead-glazed pottery used for eating or drinking can result in lead poisoning if the pottery is not fired properly, or if the composition of the lead glaze is not properly adjusted. For example, copper used with lead frits upsets the stability of the lead glazes and can result in a much higher solubility of the lead in the final fired ware. This is true even if a copper-containing glaze comes in touch with the lead glaze. The hazard increases if the pottery vessel contains acidic substances such as tomato juice, citric juices, sodas, tea, or coffee.

3. "Lead-safe" on the label of a glaze does not mean that the glaze does not contain lead. It means that the finished ware, if fired properly, will not release lead into food or drink. The glaze itself is still hazardous to handle and fire. In addition, it is very difficult for craft potters to adequately control firing conditions to ensure proper firing. See also the discussion of copper above.

4. Barium and lithium fluxes are also highly toxic by inhalation, but less so than lead. See Chapter 5 for more information on the hazards of these materials.

Precautions

1. Use lead-free glazes instead of lead glazes in pottery. In many countries, including Britain, it is illegal to use lead glazes in schools. If a glaze does not say lead-free or leadless on the label, you should assume it contains lead until proven otherwise.

2. If you must use lead glazes, do not make ware that can be used for eating or drinking vessels. Drilling a hole in the pot can ensure that it is not used improperly. All pottery made with lead glazes should state so.

Ceramic Colorants

A variety of metal oxides or other metal compounds is added to glazes to produce particular colors when fired. Since they are added in small amounts (usually not more than 5% of the total glaze weight), they are not usually as great a hazard as many of the other glaze ingredients present in much larger quantities.

Hazards

1. Compounds of the following metals are known or probable human carcinogens: arsenic, beryllium, cadmium, chromium (VI), nickel, and uranium.

330

2. Compounds of the following metals are highly toxic by inhalation: antimony, barium, cobalt, lead, lithium, manganese, and vanadium.

3. Antimony compounds, arsenic compounds, chromium compounds, vanadium compounds, and nickel compounds are moderately toxic by skin contact.

4. Table 5-2 in Chapter 5 lists the hazards of specific metal compounds.

Precautions. Do not use known human carcinogens and avoid probable human carcinogens, if possible, since there is no known safe level of inhalation of these materials.

Preparing Glazes

Glaze mixing involves the weighing out and mixing of the glaze components with water. Since these glaze materials are finely ground, the glaze-mixing process can involve high dust exposures.

Hazards

1. Large amounts of free silica may be found in many of the clays, plant ash, flint, quartz feldspars, and talcs used in glazes. Inhalation of the dusts from these materials over extended periods can cause silicosis. See Table 5-1 for the hazards of specific minerals.

2. As discussed above, many of the other materials used in glazes are also toxic by inhalation, skin contact, or ingestion.

3. Dust created by the weighing-out process can become an inhalation hazard.

4. Besides the metals discussed in the previous section, skin irritants used in glazes include soda ash, potassium carbonate, alkaline feldspars, and fluorspar.

Precautions

1. Use a plain-opening exhaust hood with flexible ducting, or wear a NIOSH-approved toxic dust respirator when weighing and mixing glaze powders. Once in wet form, the glaze is not an inhalation hazard. Clean up all spills and carry out normal housekeeping precautions to avoid inhalation or ingestion of toxic dusts.

2. Wear gloves when handling glaze materials, as skin irritations can occur whether the glaze materials are in a wet or dry form. Barrier creams do not work, since they may cause the glaze to creep during firing.

3. Wet mop any spilled glaze materials.

Applying the Glaze

Glazes can be applied by dipping, brushing, pouring, or spraying. Commercial prepared glazes usually contain frits, stabilizers, colorants, preservatives, and water. Some underglazes and overglazes use mineral spirits as the vehicle instead of water.

Luster glazes are glazes that give a metallic finish when fired in a reduction atmosphere. Luster glazes may contain mercury, arsenic, highly toxic solvents such as aromatic and chlorinated hydrocarbons, and oils such as lavender oil. The metals used are usually metal resinates of gold, platinum, silver, and copper.

Hazards

1. Spraying is one of the greatest hazards in applying glazes because of the danger of inhaling the glaze mist.

2. The major hazards in dipping, pouring, and brushing are skin contact with materials that are skin irritants and accidental ingestion of glaze materials through careless personal hygiene habits.

3. Solvent-based glazes are also a hazard due to flammability and inhalation of the solvent vapors from the drying glazes.

Precautions

1. Spraying of glazes should be done only in a spray booth exhausted to the outside. If the glaze is solvent based, the spray booth must be explosion proof. A second, although not as good, alternative is to wear a NIOSH-approved respirator with toxic dust and mist filters (plus organic vapor cartridges if solvents are present) and have a window exhaust fan. This is not suggested if there are other people working in the area.

2. Good dilution ventilation or local exhaust ventilation should be available when applying solvent-containing glazes.

3. Follow simple hygiene rules: Do not eat or drink in the studio area, do not smoke while working, wear gloves, wash hands carefully after work, and wear special work clothes (e.g., coveralls).

4. Leftover glazes and glaze scrapings from the spray booth can be combined and accumulated as scrap glazes. These can be homogenized, tested, and used as a glaze. If needed, they can be adjusted with fluxes and colorants.

KILN FIRING

Two basic types of kilns are used today: electric kilns and fuel-fired kilns. Electric kilns use electrical resistance (in heating coils) to heat the pottery to the desired firing temperature. Fuel-fired kilns are heated by burning a variety of materials, including gas (natural or propane), oil, wood, coke, and charcoal. All these fuels produce carbon monoxide and other combustion gases. To remove these gases, fuel-fired kilns are usually vented at the top through a chimney.

Firing temperatures in both electric and fuel-fired kilns can vary from as low as 1,382°F (750°C) for raku and bisque wares, to as high as 2,372°F (1,300°C) for stoneware, and 2,642°F (1,450°C) for certain porcelains.

During the early stages of bisque firing, the organic matter in clay is oxidized to carbon monoxide and other combustion gases. Sulfur, found in many clays and sulfur-containing materials, breaks down slightly later to produce highly irritating sulfur oxides. Nitrates and nitrogen-containing organic matter in clays also break down to release nitrogen oxides.

Glaze firings can also release toxic gases and fumes. Carbonates, chlorides, and fluorides break down to release carbon dioxide, chlorine, and fluorine gases. Glaze minerals that can release these gases include galena, cornish stone, crude feldspars, low-grade fire clays, fluorspar, gypsum, lepidolite, and cryolite.

At stoneware-firing temperatures and above, certain metals, including lead, antimony, cadmium, selenium, and the precious metals, are vaporized. These metal fumes can escape from the kiln or settle on the kiln insides or any ware in the kiln. At these temperatures, nitrogen oxides and ozone can be produced from oxygen and nitrogen in the air.

Hazards

1. Chlorine, fluorine, sulfur dioxide, nitrogen dioxide, and ozone—all of which can be produced during kiln firings—are all highly toxic by inhalation. Large acute exposures to these gases are unlikely, except in the case of sulfur dioxide. There have been instances of dense clouds of choking white gases coming off during bisque firings with high sulfur clays. Inhalation of large amounts of these gases could cause severe acute or chronic lung problems. Regular inhalation of these gases at low levels

333

could cause chronic bronchitis and emphysema, since they are all lung irritants. Fluorine can also cause bone and teeth problems.

2. Many metal fumes generated at high temperatures are highly toxic by inhalation. This is a particular problem with lead, since it vaporizes at a relatively low temperature.

3. Carbon monoxide produced by fuel-fired kilns and from combustion of organic matter in clays is highly toxic by inhalation, causing oxygen starvation. One symptom of carbon monoxide poisoning is a strong frontal headache that is not relieved by aspirin.

4. Many potters add all sorts of materials during kiln firings to get special effects. Depending on the material, this can result in the generation of many types of toxic, volatile materials that are emitted by the kiln. This may also damage electric kiln elements, shortening their useful life.

5. Hot kilns produce large amounts of heat, and direct contact with the kiln can cause severe thermal burns. Hot kilns also produce infrared radiation, which can be an eye hazard, possibly causing cataracts from years of looking inside hot kilns.

Precautions

1. All kilns must be vented directly to the outside. Kiln ventilation is discussed in the next sections.

2. Kilns should be kept in a separate room to avoid excess heat problems in the working areas.

3. Wear approved infrared goggles or hand-held welding shields to protect your eyes when looking inside the kiln. A shade number of between 1.7 and 3.0 should be adequate, but check for spots in front of your eyes after looking away to be sure.

4. Do not use lead compounds at stoneware temperatures, since the lead will vaporize and is not needed.

Electric Kilns

Electric kilns are commonly found in schools, art centers, and many potter's studios. Electric kilns contain heating elements that heat the kiln when electric current is passed through the coils. The kiln temperature continues to rise until the kiln is shut off.

Hazards

1. The hazards of toxic gases produced by kiln firings were discussed in the previous section.

2. The heat produced by even small electric kilns can cause fires if combustible materials or flammable liquids are located nearby. This can include wooden floors. Measurements done at the Edward Orton Jr. Ceramic Foundation found kiln surface temperatures of 595°F (313°C) and above, and temperatures of 156°F (69°C) and above 12 inches from the peephole of a small hobby kiln when the internal kiln temperature was 2,370°F (1,300°C).

3. Failure of the kiln to shut off causes the temperature to continue to rise until the heating elements melt, possibly causing a fire. There have been many fires caused by electric kilns not shutting down at the proper time.

Precautions

1. All electric kilns should be provided with local exhaust ventilation. This is usually done with canopy hoods. For top-loading kilns, where the canopy hood has to be high enough to allow opening of the kiln top, enclosing the kiln with fireproof curtains will ensure effective capture of kiln gases. Note that the curtains should not extend all the way to the bottom to allow entry of makeup air.

2. Ready-made, commercial canopy hoods that can be raised or lowered must be tested in actual use to ensure that they are effective.

3. For octagonal kilns, the Orton Foundation developed a direct exhaust system, which attaches to the bottom of the kiln and exhausts the air inside the kiln through holes in the top and bottom of the kiln. This works with only relatively new kilns that have a tight seal.

4. If the kiln is in a separate room where no one works, then electric kilns can be vented with a window exhaust fan near the kiln.

5. Do not store lumber, paper, solvents, or other combustible or flammable materials in kiln areas. Electric kilns should be at least a foot off the floor to allow air circulation, and at least two feet from any wall. If the floor is wooden, protect it with fire brick or other fireproof materials (not asbestos).

6. All electric kilns should meet local fire and electrical codes and should be installed by a licensed electrician.

7. Electric kilns should have two automatic shutoffs. The primary shutoff should be a cone-operated shut-off or a pyrometer. Since these are not completely reliable, a timer backup should also be installed. Even then, always check to ensure that the kiln has shut off.

Fuel-Fired Kilns

The most common types of fuel-fired kilns are propane gas or natural gas kilns. These can be located either indoors or outdoors. Gas kilns generate large amounts of carbon monoxide, especially when a reduction firing is done. Gas kilns usually have a stack or chimney to remove these gases.

Hazards

1. Gas kilns generate large amounts of heat, with kiln room temperatures often exceeding 100°F (38°C).

2. Carbon monoxide is a very serious hazard with gas kilns. Many gas kilns have small canopy hoods over the exhaust on top of the kiln. These hoods are too small and often do not capture all the carbon monoxide generated, especially during reduction firings, when there is a deliberate deficiency of oxygen. Even gas kilns equipped with chimneys often do not capture all the carbon monoxide.

3. Natural gas and propane are fire and explosion hazards, making leaks hazardous. Note that propane, being heavier than air, can collect at floor level and not disperse.

4. Kiln chimneys are often not high enough, allowing kiln gases to enter nearby buildings.

5. Additional exhaust systems in the gas kiln area must be planned carefully. If there is not sufficient makeup air, exhaust fans in the kiln area can actually pull air containing carbon monoxide from the kiln into the room. Weather conditions can also sometimes prevent an efficient kiln draft.

Precautions

1. A carbon monoxide alarm should be located in the area where indoor gas kilns are located.

2. Gas lines should be installed by qualified personnel. The gas lines should be equipped with regulators that automatically shut off the kiln if the airflow stops or if a negative pressure develops in the kiln area. See also the oxygen and flammable gases section in Chapter 8.

336

3. If gas leaks are suspected (e.g., by smell), shut off the gas at the source and shut off power to the kiln room at the circuit breaker. Call the gas company. Test for leaks with nonfat, soapy water or use approved leak-detecting solutions. You should be able to identify the odor of natural gas or propane (or find out if you can't detect the odor).

4. Indoor gas kilns, in particular, should have canopy hoods covering the entire top of the gas kiln to capture all carbon monoxide released.

5. Adequate makeup air should be available for any exhaust systems in the kiln area.

6. The chimneys should have a high enough stack to prevent kiln gases from entering areas or buildings where people are located. If necessary, stack fans that thrust the kiln gases out at a high velocity can be installed.

Salt Glazing

Most glaze firings involve putting the glaze-coated pot in the kiln and then firing. Salt glazing, however, involves placing the bisque ware in the kiln and throwing wet salt (sodium chloride) into the heated kiln. The wet salt reacts to form soda, which vaporizes and reacts with the bisque ware to form a glaze. During this process, large amounts of hydrogen chloride gas and possibly chlorine are formed.

An alternative type of salt glazing uses sodium carbonate (washing soda) instead of sodium chloride. This process generates carbon dioxide instead of hydrogen chloride.

Hazards

1. Salt glazing produces large amounts of hydrogen chloride gas, which is highly toxic by inhalation. Its effects are similar to, but more irritating than, the effects of most other kiln gases. In many areas, local environmental protection laws will not allow salt kilns.

2. The hydrogen chloride and water vapor form hydrochloric acid, which can corrode metal fittings in the area.

Precautions

1. Replace sodium chloride salt glazing with the safer sodium carbonate.

2. Salt glazing using sodium chloride should be done only in outdoor kilns. The kiln should have a canopy hood and high enough chimney to disperse the hydrogen chloride safely.

3. Check regularly for corrosion of metal in the area, including gas piping.

Raku Firing

Raku is a low-fire process in which the ware is fired in a regular gas kiln and then removed while still hot and placed in sawdust, leaves, or similar materials for a reduction phase.

Hazards

1. See above for the hazards of gas kilns.
2. The reduction step involves the production of large amounts of smoke, including carbon monoxide.
3. If treated wood or other materials are used in raku, there could be exposure to highly toxic preservatives or pesticides, such as arsenic and chromium compounds.

Precautions

1. Raku should be done only outdoors because of the large amounts of smoke generated during the reduction phase. To prevent complaints, however, this should not be done near air intakes of buildings or open windows.
2. Do not use materials that have been treated with preservatives or pesticides for the reduction phase.

▨▨▨ HAZARDS OF THE FINAL PRODUCT

Lead

As discussed in the section on leaded versus unleaded glazes, there is concern about lead leaching into food and drink from pottery fired with lead glazes. Both the U.S. Food and Drug Administration (FDA) and the Canadian Consumer and Corporate Affairs have regulations concerning how much lead can leach into food and drink. This is a particular concern with acidic liquids. There have been many cases of lead poisoning, and even some fatalities, from lead leaching out of lead-glazed pottery.

The lead leaching test involves placing acid in the vessel for 24 hours and then testing the liquid to see how much lead has leached. The most recent FDA guidelines, published in 1991, give the maximum amount of lead that can leach from various types of ware:

flatware (e.g., plates, saucers)	3 ppm
small hollow ware (e.g., cereal bowls)	2 ppm
cups and mugs	0.5 ppm
large hollow ware (e.g., bowls over 1.1 liter)	1 ppm
pitchers	0.5 ppm

Commercial ceramics companies routinely test their ware for lead leaching. Craft potters do not have the same quality control as the ceramics industry, so lead leaching is much more of a problem.

In the United States, ware that does not pass the lead leaching tests must have a permanent fired decal stating: "NOT FOR FOOD USE—MAY POISON FOOD. FOR DECORATIVE PURPOSES ONLY." As mentioned earlier, you can also drill a hole in the pottery so that it cannot be used for liquids or food.

It is preferable not to use lead glazes, especially for food and drink vessels. In fact, as of the writing of this edition of *Artist Beware*, there are legislative initiatives that might ban lead glazes. If you do decide to use lead glazes for food and drink vessels, the finished ware should be tested regularly by certified laboratories. There are home kits that can be used for testing lead leaching, but you should not rely on them completely. They are available from:

- Test for Lead in Pottery ($25) and The FRANDON Lead Alert Kit ($29.95), Frandon Enterprises, Inc., P.O. Box 300321, Seattle, WA 98103; (800) 359-9000.

- LeadCheck Swabs ($30), HybriVet Systems, Inc., P.O. Box 1210, Framingham, MA 01701; (800) 262-LEAD.

- LEADCHECK II ($25), distributed by Michigan Ceramic Supplies, 4048 Seventh Street, P.O. Box 342, Wyandotte, MI 48192; (313) 281-2300.

Other Leachable Metals

Unfortunately, lead is not the only metal that can be leached into food and drink. The only metal besides lead that is presently regulated in Canada and the United States is cadmium. There is growing concern, however, about other possible toxic metals in glazes. Barium, for example, is one that some tests have shown can leach in hazardous amounts from certain glaze formulations. If a barium glaze changes color from contact with food, do not use the vessel for food. Potters who are making glazed pottery for food and drink vessels should be aware of this problem. One way to minimize the concern is to use only glazes with calcium, magnesium, potassium, and sodium fluxes, and to minimize the amounts of toxic metal colorants. You should also regularly test your finished ware for leaching of toxic metals. Unfortunately, little research has been done in this area.

REFERENCES

American Art Clay Co., Inc. (1987). *Ceramics Art Material Safety in the Classroom and Studio.* Indianapolis: AMACO.

Food and Drug Administration. (1991). Getting the lead out. *FDA Consumer* (July–Aug.), 26-31.

Lange, A. (1980). Occupational health hazards in the potting studio/classroom. In *Health Hazards in the Arts and Crafts. Proceedings of the SOEH Conference on Health Hazards in the Arts and Crafts.* Eds.: Michael McCann and Gail Barazani. Washington, DC: Society for Occupational and Environmental Health.

Lead Industries Association. (1972). *Facts About Lead Glazes for Artists, Potters and Hobbyists.* New York.

Rossol, M. (1981–82). *Ceramics and Health.* Compilation of articles from *Ceramic Scope.*

Stopford, W. (1988). Safety of lead-containing hobby glazes. *North Carolina Med. J.* 49(1), 31–34.

Vukovich, M. (1987–88). Technically Speaking column: Series of 8 articles on kiln safety. Westerville, OH: Edward Orton Jr. Ceramic Foundation.

Waller, J. (ed). (1987). *Health and the potter. Studio Potter* (entire June issue).

15

Photography

This chapter discusses the hazards of black-and-white photography, color photography, and nonsilver photo processes such as Cyanotype, Van Dyke process, and platinum printing. Holography is discussed in Chapter 23.

BLACK-AND-WHITE PHOTOGRAPHIC PROCESSING

Photographic film contains a light-sensitive emulsion of gelatin and silver halide crystals. When exposed to light, some of the silver halide is reduced to silver, creating a latent image. The developing process reduces more of the silver halide to metallic silver, creating a visible image. The stop bath stops further development, and the fixing bath reacts with unexposed silver halide to form a soluble silver complex, which is removed during the washing step.

A wide variety of chemicals is used in black-and-white photographic processing. Film developing is usually done in closed canisters. Print processing uses tray processing, with successive developing baths, stop baths, fixing baths,

and rinse steps. Other treatments include the use of hardeners, intensifiers, reducers, toners, and hypo eliminators.

Photochemicals can be purchased both as ready-to-use brand-name products or as individual chemicals that you can mix yourself. The *Photo Lab Index* lists the compositions of many brand-name products.

Mixing Photochemicals

Photochemicals can be bought in liquid form, which needs only diluting, or powder form, which needs dissolving and diluting.

Hazards

1. Developer solutions and powders are often highly alkaline; glacial acetic acid, used in making the stop bath, is also corrosive by skin contact, inhalation, and ingestion.

2. Developer powders are highly toxic by inhalation, and moderately toxic by skin contact, due to the alkali and developers themselves (see Developing Baths below). The developers may cause methemoglobinemia, an acute anemia resulting from converting the iron of hemoglobin into a form that cannot transport oxygen. Fatalities and severe poisonings have resulted from ingestion of concentrated developer solutions.

Precautions

1. Use liquid chemistry whenever possible, rather than mixing developing powders. Pregnant women, in particular, should not be exposed to powdered developer.

2. When mixing powdered developers, use a glove box (see Chapter 8), local exhaust ventilation, or wear a National Institute for Occupational Safety and Health (NIOSH)-approved toxic dust respirator. In any case, there should be dilution ventilation if no local exhaust ventilation is provided.

3. Wear gloves, goggles, and protective apron when mixing concentrated photochemicals. Always add glacial acetic acid to water, never the reverse.

4. An eyewash fountain and emergency shower facilities should be available where the photochemicals are mixed due to the corrosive alkali in developers and because of the glacial acetic acid. In case of skin contact, rinse with lots of water. In case of eye contact, rinse for at least 15 to 20 minutes and call a physician.

5. Store concentrated acids and other corrosive chemicals on low shelves to reduce the chance of face or eye damage in case of breakage and splashing.

6. Do not store photographic solutions in glass containers.

7. Label all solutions carefully so as not to ingest solutions accidently. Make sure that children do not have access to the developing baths and other photographic chemicals.

Developing Baths

The most commonly used developers are hydroquinone, monomethyl para-aminophenol sulfate, and phenidone. Several other developers are used for special purposes. Other common components of developing baths include an accelerator, often sodium carbonate or borax, sodium sulfite as a preservative, and potassium bromide as a restrainer or antifogging agent.

Hazards

1. In general, developers cause some of the most common health problems in photography (see Table 15-1). The developers are skin and eye irritants and, in many cases, strong sensitizers. Monomethyl-p-aminophenol sulfate creates many skin problems, and allergies to it are frequent (although this is thought to be due to the presence of para-phenylene diamine as a contaminant). Hydroquinone can cause depigmentation and eye injury after five or more years of repeated exposure, and it is a mutagen. Some developers also can be absorbed through the skin to cause severe poisoning (e.g., catechol, pyrogallic acid). Phenidone is only sightly toxic by skin contact.

2. Most developers are moderately to highly toxic by ingestion, with ingestion of less than one tablespoon of compounds such as hydroquinone, monomethyl-p-aminophenol sulfate, or pyrocatechol being possibly fatal for adults. Some fatalities and severe poisonings have occurred from accidentally drinking concentrated developer solution. This might be a particular hazard for home photographers with small children. Symptoms of poisoning from common developers include ringing in the ears (tinnitus), nausea, dizziness, muscular twitching, increased respiration, headache, cyanosis (turning blue from lack of oxygen) due to methemoglobinemia, delirium, and coma. With some developers, convulsions also occur. Inhalation of the powders can be similarly hazardous.

3. Para-phenylene diamine and some of its derivatives are highly toxic by skin contact, inhalation, and ingestion. They cause very severe skin allergies and can be absorbed through the skin.

4. Sodium hydroxide, sodium carbonate, and other alkalis used as accelerators are highly corrosive by skin contact or ingestion. This is a particular problem with pure alkali or with concentrated stock solutions.

5. Potassium bromide is moderately toxic by inhalation or ingestion and slightly toxic by skin contact. Symptoms of systemic poisoning include somnolence, depression, lack of coordination, mental confusion, hallucinations, and skin rashes. It can cause bromide poisoning in fetuses of pregnant women experiencing high exposure.

6. Sodium sulfite is moderately toxic by ingestion or inhalation, causing gastric upset, colic, diarrhea, circulatory problems, and central nervous system depression. It is not appreciably toxic by skin contact. If heated or allowed to stand for a long time in water or acid, it decomposes to produce sulfur dioxide, which is highly irritating by inhalation.

Precautions

1. See the section on mixing photochemicals above for mixing precautions.

2. Do not put your bare hands in developer baths. Use tongs instead. If developer solution splashes on your skin or eyes, immediately rinse with lots of water. For eye splashes, continue rinsing for 15 to 20 minutes and call a physician. Eyewash fountains are important for photography darkrooms. See Chapter 11 for a discussion of eyewash fountains.

3. Do not use para-phenylene diamine or its derivatives if at all possible.

Stop Baths and Fixer

Stop baths are usually weak solutions of acetic acid. Acetic acid is commonly available as pure glacial acetic acid or 28% acetic acid. Some stop baths contain potassium chrome alum as a hardener.

Fixing baths contain sodium thiosulfate (hypo) as the fixing agent, and sodium sulfite and sodium bisulfite as preservatives. Fixing baths also may also contain alum (potassium aluminum sulfate) as a hardener and boric acid as a buffer.

Hazards

1. Acetic acid, in concentrated solutions, is highly toxic by inhalation, skin contact, and ingestion. It can cause dermatitis and ulcers and can strongly irritate the mucous membranes. The final stop bath is only slightly hazardous by skin contact. Continual inhalation of acetic acid vapors, even from the stop bath, may cause chronic bronchitis.

2. Potassium chrome alum or chrome alum (potassium chromium sulfate) is highly toxic by skin contact, causing dermatitis and allergies. It is highly toxic by inhalation (see Table 15-1).

3. In powder form, sodium thiosulfate is not significantly toxic by skin contact. By ingestion it has a purging effect on the bowels. Upon heating or long standing in solution, it can decompose to form highly toxic sulfur dioxide, which can cause chronic lung problems. Many asthmatics are particularly sensitive to sulfur dioxide.

4. Sodium bisulfite decomposes to form sulfur dioxide if the fixing bath contains boric acid, or if acetic acid is transferred to the fixing bath on the surface of the print.

5. Alum (potassium aluminum sulfate) is only slightly toxic. It may cause skin allergies or irritation in a few people.

6. Boric acid is moderately toxic by ingestion or inhalation and slightly toxic by skin contact (unless the skin is abraded or burned, in which case it can be highly toxic).

Precautions

1. All darkrooms require good ventilation to control the level of acetic acid vapors and sulfur dioxide gas produced in photography. Kodak recommends at least 10 air changes per hour, or 170 cfm for darkrooms and automatic processors. I recommend using the larger of the two ventilation rates. The exhaust duct opening should preferably be located behind and just above the stop bath and fixer trays. The exhaust should not be recirculated.

 Make sure that an adequate source of replacement air is provided. This can be achieved without light leakage by the use of light traps. The ducting used with local exhaust systems should prevent light leakage from the exhaust outlet.

2. Wear gloves and goggles.

3. Cover all baths when not in use to prevent evaporation or release of toxic vapors and gases.

Intensifiers and Reducers

A common aftertreatment of negatives (and occasionally prints) is either intensification or reduction. Intensification involves bleaching of the negative and subsequent redeveloping of the image. In this process, other heavy metals are

usually added to the silver. Common intensifiers include hydrochloric acid and potassium dichromate or potassium chlorochromate. Mercuric chloride followed by ammonia or sodium sulfite; Monckhoven's intensifier consisting of a mercuric salt bleach followed by a silver nitrate/potassium cyanide solution; mercuric iodide/sodium sulfite; and uranium nitrate are older, now discarded, intensifiers.

Reduction of negatives is usually done with Farmer's reducer, consisting of potassium ferricyanide and hypo. Reduction has also be done historically with iodine/potassium cyanide, ammonium persulfate, and potassium permanganate/sulfuric acid.

Hazards

1. Potassium dichromate and potassium chlorochromate are probable human carcinogens and can cause skin allergies and ulceration. Potassium chlorochromate can release highly toxic chlorine gas if heated or if acid is added.

2. Concentrated hydrochloric acid is corrosive; the diluted acid is a skin and eye irritant.

3. Mercury compounds are moderately toxic by skin contact and may be absorbed through the skin. They are also highly toxic by inhalation and extremely toxic by ingestion. Uranium intensifiers are radioactive, and are especially hazardous to the kidneys.

4. Sodium or potassium cyanide is extremely toxic by inhalation and ingestion, and moderately toxic by skin contact. Adding acid to cyanide causes the formation of extremely toxic hydrogen cyanide gas, which can be rapidly fatal by inhalation.

5. Potassium ferricyanide, although only slightly toxic by itself, will release hydrogen cyanide gas if heated, if hot acid is added, or if exposed to strong ultraviolet light (e.g., carbon arcs). Cases of cyanide poisoning have occurred through treating Farmer's reducer with acid.

6. Potassium permanganate and ammonium persulfate are strong oxidizers and may cause fires or explosions in contact with solvents and other organic materials.

7. Hazards of other intensifiers and reducers are listed in Table 15-1.

Precautions

1. Chromium intensifiers are probably the least toxic intensifiers, even though they are probable human carcinogens. Gloves and goggles should

346

be worn when preparing and using these intensifiers. Mix the powders in a glove box or wear a NIOSH-approved toxic dust respirator. Do not expose potassium chlorochromate to acid or heat.

2. Do not use mercury, cyanide, or uranium intensifiers, or cyanide reducers because of their high or extreme toxicity.

3. The safest reducer to use is Farmer's reducer. Do not expose Farmer's reducer to hot acid, ultraviolet light, or heat.

Toners

Toning a print usually involves replacement of silver by another metal, for example, gold, selenium, uranium, platinum, or iron. In some cases, the toning involves replacement of silver metal by brown silver sulfide, for example, in the various types of sulfide toners. A variety of other chemicals is also used in the toning solutions (see Table 15-1).

Hazards

1. As shown in Table 15-1, many of the metals used in toning are highly toxic.

2. Sodium and potassium sulfide release highly toxic hydrogen sulfide gas during toning or when treated with acid.

3. Selenium is a skin and eye irritant and can cause kidney damage. Treatment of selenium salts with acid may release highly toxic hydrogen selenide gas. Selenium toners also give off large amounts of sulfur dioxide gas.

4. Gold and platinum salts are strong sensitizers and can produce allergic skin reactions and asthma, particularly in fair-haired people.

5. Thiourea is a probable human carcinogen, since it causes cancer in animals.

Precautions

1. Carry out normal precautions for handling toxic chemicals as described in previous sections. In particular, wear gloves and goggles. Mix powders in a glove box or wear a toxic dust respirator. See also the section on mixing photochemicals.

2. Toning solutions should be used with local exhaust ventilation (e.g., slot exhaust hood, or working on a table immediately in front of a window with an exhaust fan at work level).

3. Take precautions to make sure that sulfide or selenium toners are not contaminated with acids. For example, with two-bath sulfide toners, make sure you rinse the print well after bleaching in acid solution before dipping it in the sulfide developer.

4. Avoid thiourea whenever possible because of its probable cancer-causing status.

Other Black-and-White Chemicals

Many other chemicals are also used in black-and-white processing, including formaldehyde as a prehardener, a variety of oxidizing agents as hypo eliminators (e.g., hydrogen peroxide and ammonia, potassium permanganate, bleaches, and potassium persulfate), sodium sulfide to test for residual silver, silver nitrate to test for residual hypo, solvents such as methyl chloroform and freons for film and print cleaning, and concentrated acids to clean trays.

Electrical outlets and equipment can present electrical hazards in darkrooms due to the risk of splashing water.

Hazards

1. See the hazards of particular chemicals in Table 15-1.

2. Concentrated sulfuric acid, mixed with potassium permanganate or potassium dichromate, produces highly corrosive permanganic and chromic acids.

3. Hypochlorite bleaches can release highly toxic chlorine gas when acid is added, or if heated.

4. Potassium persulfate and other oxidizing agents used as hypo eliminators may cause fires when in contact with easily oxidizable materials, such as many solvents and other combustible materials. Most are also skin and eye irritants.

Precautions

1. See previous sections for precautions in handling photographic chemicals.

2. Cleaning acids should be handled with great care. Wear gloves, goggles, and an acid-proof protective apron. Make sure the acid is always added to the water when diluting.

3. Do not add acid to, or heat, hypochlorite bleaches.

4. Keep potassium persulfate and other strong oxidizing agents separate from flammable and easily oxidizable substances.

5. Install ground fault interrupters whenever electrical outlets or electrical equipment (e.g., enlargers) are within six feet of the risk of water splashes.

COLOR PROCESSING

Color processing is much more complicated than black-and-white processing, and there is a wide variation in processes used by different companies. Furthermore, details on many processes are protected as trade secrets. Basically, however, color negative processing involves development in a dye coupling developer that forms the color image and silver image, bleaching to remove the silver image, and fixing to remove the bleached silver image and unexposed silver halide. Color transparency processing involves processing with black-and-white developers, a reversal developer (or reexposure to light), color developing using a dye coupling developer, bleaching to remove both positive and negative silver images, and then fixing. Other important steps involve hardening and stabilization of the dye image.

Color processing can be done either in trays or in automatic processors.

Developing Baths

The first developer of color transparency processing usually contains monomethyl-p-aminophenol sulfate, hydroquinone, and other normal black-and-white developer components. Color developers contain a wide variety of chemicals, including color coupling agents, penetrating solvents (such as benzyl alcohol, ethylene glycol, and ethoxydiglycol), amines, and others.

Hazards

1. See Table 15-1 and the developing section on black-and-white processing for the hazards of standard black-and-white developers.

2. In general, color developers are more hazardous than black-and-white developers. Para-phenylene diamine, and its dimethyl and diethyl derivatives, are known to be highly toxic by skin contact and absorption, inhalation, and ingestion. They can cause very severe skin irritation, allergies, and poisoning. Color developers have also been linked to lichen planus, an inflammatory skin disease characterized by reddish pimples that can spread to form rough scaly patches. Recent color developing agents such as 4-amino-N-ethyl-N-[P-methane-sulfonamidoethyl]-m-toluidine sesquisul-

fate monohydrate and 4-amino-3-methyl-N-ethyl-N-[,3-hydroxyethyl]-aniline sulfate are supposedly less hazardous, but still can cause skin irritation and allergies.

3. Most amines, including ethylene diamine, tertiary-butylamine borane, and the various ethanolamines, are strong sensitizers, as well as skin and respiratory irritants.

4. Although many of the solvents are not very volatile at room temperature, the elevated temperatures used in color processing can increase the amount of solvent vapors in the air. The solvents are usually skin and eye irritants.

5. Table 15-1 lists the hazards of many of the known chemicals in color developing.

Precautions

1. Wear gloves and goggles when handling color developers. Wash gloves with an acid-type hand cleaner (e.g., pHisoderm) and then water before removing them. According to Kodak, barrier creams are not effective in preventing sensitization due to color developers.

2. Mix powders in a glove box, or wear a NIOSH-approved toxic dust respirator.

3. Color processing needs more ventilation than black-and-white processing due to the use of solvents and other toxic components at elevated temperatures. Preferably, for tray processing, use a three-foot slot hood exhausting 1050 cubic feet per minute (cfm). Some automatic processors can be purchased with an exhaust, which would need to be ducted to the outside.

Bleaching, Fixing, and Other Steps

Many of the chemicals used in other steps of color processing are essentially the same as those used for black-and-white processing. Examples include the stop bath and fixing bath. Bleaching uses a number of chemicals, including potassium ferricyanide, potassium bromide, ammonium thiocyanate, and acids. Chemicals found in prehardeners and stabilizers include succinaldehyde and formaldehyde; neutralizers can contain hydroxylamine sulfate, acetic acid, and other acids.

Hazards

1. See Table 15-1 for the hazards of chemicals used in color processing steps.

2. Formaldehyde is moderately toxic by skin contact and highly toxic by inhalation and ingestion. It is a skin, eye, and respiratory irritant, a strong

sensitizer, and is a probable human carcinogen. Formaldehyde solutions contain some methanol, which is highly toxic by ingestion.

3. Succinaldehyde is similar in toxicity to formaldehyde, but it is not a strong sensitizer or a carcinogen.

4. Hydroxylamine sulfate is a suspected teratogen (causes birth defects) in humans, since it is a teratogen in animals. It is also a skin and eye irritant.

5. Concentrated acids, such as glacial acetic acid, hydrobromic acid, sulfamic acid, and p-toluenesulfonic acids, are corrosive by skin contact, inhalation, and ingestion.

6. Acid solutions, if they also contain sulfites or bisulfites (for example, neutralizing solutions), can release sulfur dioxide upon standing. In addition, if acid is carried over on the negative or transparency from one step to another step containing sulfites or bisulfites, then sulfur dioxide can be formed.

7. Potassium ferricyanide will release hydrogen cyanide gas if heated, if hot acid is added, or if exposed to strong ultraviolet radiation.

Precautions

1. Local exhaust ventilation is required for the mixing of chemicals and color processing. See the previous section for discussion of ventilation.

2. Use premixed solutions whenever possible. For powders, use a glove box or wear a NIOSH-approved respirator with toxic dust filters.

3. Avoid color processes using formaldehyde, if possible.

4. Wear gloves, goggles, and protective apron when mixing and handling color processing chemicals. When diluting solutions containing concentrated acids, always add the acid to the water. An eyewash and emergency shower should be available.

5. A water rinse step is recommended between acid bleach steps and fixing steps to reduce the production of sulfur dioxide gas.

6. Do not add acid to solutions containing potassium ferricyanide or thiocyanate salts.

7. Control the temperature carefully according to manufacturer's recommendations to reduce emissions of toxic gases and vapors.

Color Retouching

Color retouching is done by swabbing, brushing, or airbrushing water-soluble dyes onto the negative or print. Dilute acetic acid can increase penetration. Ex-

cess can be removed with wetting agents containing polymeric ether alcohols or glycols. Powdered dyes can also be applied, using denatured alcohol to remove excess dye. Decolorizing can be done with a variety of solutions, including water/formaldehyde, ammonia, and potassium permanganate/sulfuric acid/sodium bisulfite. For light retouching, colored pencils and retouching fluids containing aromatic hydrocarbons can be used.

Hazards

1. Little is known about the hazards of the dyes used for retouching.

2. Airbrushing produces a fine spray that can penetrate deep into the lungs. The spray mist can remain suspended in the air for hours.

3. Formaldehyde is moderately toxic by skin contact and highly toxic by inhalation and ingestion. It is a skin, eye, and respiratory irritant and a strong sensitizer, and is a probable human carcinogen. Formaldehyde solutions contain some methanol, which is highly toxic by ingestion.

4. Potassium permanganate is a skin and respiratory irritant and a strong oxidizing agent.

5. Aromatic hydrocarbons such as toluene and xylene are highly toxic by skin absorption and inhalation, and moderately toxic by ingestion.

Precautions

1. Preferably swab or brush dyes on, rather than airbrush.

2. Airbrushing should be done in a spray booth, or while wearing a NIOSH-approved respirator with toxic dust and mist filters. An exhaust fan is needed to remove the spray mist.

3. Avoid using formaldehyde decolorizing methods.

4. Do not point brushes or wet pencils with the lips.

5. Use a window exhaust fan when using retouching fluid containing aromatic hydrocarbons.

OTHER PHOTO PROCESSES

In addition to the traditional photography based on silver as the image former, several other methods are used by artists to obtain photoimages. Photosilkscreen,

photoetching, and photolithography have already been discussed in Chapter 13. Photo processes discussed in this section include cyanotype, the Van Dyke process, and platinum and palladium printing. The book *Overexposure: Health Hazards in Photography* contains more detailed information on the hazards of photographic processes, including many not discussed here (see chapter references).

Cyanotype

Cyanotype—or blueprinting, as it is often called—produces a blue iron compound, Turbell's blue. This is produced by (1) sensitizing paper or fabric with a mixture of ferric ammonium citrate and potassium ferricyanide; (2) exposing the sensitized material to ultraviolet light; (3) developing it with water; and (4) fixing with diluted hydrogen peroxide solution or potassium dichromate. The light source can be sunlight, sunlamp, quartz lamps, or carbon arcs.

Hazards

1. Ferric ammonium citrate and potassium ferricyanide are slightly toxic by skin contact or inhalation, and moderately toxic by ingestion. Potassium ferricyanide will release hydrogen cyanide gas if heated, if hot acid is added, or if exposed to strong ultraviolet radiation.

2. Potassium dichromate is a probable human carcinogen and can cause skin and respiratory allergies and ulceration.

3. Diluted hydrogen peroxide is slightly toxic by skin contact or ingestion.

4. Carbon arc fumes are highly toxic by inhalation. They produce highly toxic carbon monoxide, ozone, nitrogen oxides, and rare earth metal fumes. In addition, they produce harmful amounts of ultraviolet radiation, which can cause severe sunburn and eye damage. The ultraviolet radiation from carbon arcs decomposes potassium ferricyanide to release highly toxic hydrogen cyanide gas.

Precautions

1. Do not use carbon arcs unless they are directly vented to the outside. Wear goggles with a shade number of 14. Preferably, use a sunlamp, sunlight, or other light source.

2. Use hydrogen peroxide rather than potassium dichromate to fix the image.

Van Dyke Process

With the Van Dyke process (brown printing), a brown color is produced by (1) applying ferric ammonium citrate and silver nitrate solution to fabric or paper; (2) exposing with a light source; (3) developing with water; and (4) fixing with a solution of hypo (sodium thiosulfate). Gold chloride toning is sometimes done.

Hazards

1. Silver nitrate is moderately corrosive by skin contact or inhalation, and highly toxic by ingestion. Eye damage can be very serious.
2. Sodium potassium tartrate and ferric ammonium citrate are slightly toxic by skin contact and inhalation, and moderately toxic by ingestion.
3. Gold chloride is moderately toxic by inhalation and skin contact, causing a high rate of allergic reactions.
4. Sodium thiosulfate is not significantly toxic by skin contact, and is moderately toxic by inhalation and ingestion. Old solutions of hypo produce highly toxic sulfur dioxide gas.
5. Gases and fumes from carbon arcs are highly toxic by inhalation, and the ultraviolet light produced is very hazardous to the eyes.

Precautions

1. Wear gloves and goggles when handling silver nitrate and its solutions. Do not spray silver nitrate solutions.
2. Hypo solutions should not be stored for long periods and should be covered when not in use. Use with general or local exhaust ventilation.
3. Do not use carbon arcs unless directly vented to the outside by local exhaust ventilation. Wear appropriate goggles (shade number 14).

Platinum and Palladium Printing

Platinum prints are produced by (1) sensitizing paper with a solution of ferric oxalate, potassium chloroplatinite or platinum chloride, oxalic acid, and potassium chlorate; (2) exposing to light to reduce the ferric ion to ferrous ion; (3) developing with a saturated potassium oxalate solution, which dissolves the ferrous salts and converts the platinum salt to metallic platinum; and (4) clearing the print with a series of hydrochloric acid baths to remove any ferric salts. Toning can be done by adding mercuric chloride, lead oxalate, or potassium phosphate

to the developing bath. Aftertreatments may include uranium or gold toning, or intensifying with a potassium ferricyanide bleach followed by toning in a platinum salt/phosphoric acid solution.

Palladium printing replaces platinum salts with palladium salts.

Hazards

1. Overall, platinum and palladium printing use a wide variety of toxic metals and corrosive acids and oxalate salts. See Table 15-1 for the hazards of particular chemicals.

2. Soluble platinum salts are highly irritating by inhalation, and moderately so by skin contact or ingestion. Inhalation of small amounts of platinum salts can cause a very severe asthma, called platinosis. Palladium salts are less toxic, but less is known about their effects. Gold salts may cause skin and respiratory allergies, but less so than platinum salts.

3. Mercury compounds, lead compounds, and uranium compounds are highly toxic by inhalation. Mercuric chloride is also corrosive by skin contact.

4. Oxalic acid and oxalate salts are corrosive by skin contact, inhalation, and ingestion.

5. Concentrated hydrochloric acid is corrosive by skin contact and inhalation. Dilute solutions are irritating.

6. Potassium chlorate is a strong oxidizing agent and can cause fires in contact with solvents, glycerin, or other combustible materials. Potassium chlorate produces chlorine gas in combination with hydrochloric acid.

Precautions

1. If possible, buy only liquid solutions. Avoid mixing from the powders.

2. Powders should be mixed only inside a laboratory hood or glove box or while wearing a NIOSH-approved toxic dust respirator.

3. Wear gloves, goggles, and plastic apron when handling oxalic acid or its salts or concentrated hydrochloric acid. An eyewash fountain and emergency shower should be available.

4. Avoid using uranium, mercury, or lead toners.

5. Provide local exhaust ventilation (e.g., window exhaust fan at work level) for the clearing baths to remove any chlorine gas produced from the interaction of hydrochloric acid in the clearing bath and residual potassium chlorate in the print.

6. Store potassium chlorate away from solvents or other combustible materials.

◼◼◼ DISPOSAL OF PHOTOCHEMICALS

There is considerable concern about the effect of dumping photographic chemicals and solutions down the drain. Besides direct concern about toxicity of the effluent, many photochemicals use up oxygen in the water when they undergo biological or chemical degradation. This lowered oxygen content can affect aquatic life.

Most municipal areas have waste treatment plants with secondary bacterial treatment systems. These plants can handle most photochemicals solutions if the volumes and concentrations of contaminants are not too high. For these reasons, local sewer authorities regulate the concentrations and, often, the volume of chemicals released per day (the load) into sewer systems. The total volume of effluent includes the amount of wash water.

Septic tank systems are more fragile, although they too can handle a certain amount of waste photographic effluents, if they are not too toxic to the bacteria and if not too much is released into the septic system at one time.

The following recommendations are for disposing of small volumes of photographic solutions daily:

1. Old or unused concentrated photographic chemical solutions, toning solutions, ferricyanide solutions, chromium solutions, color processing solutions containing high concentrations of solvents, and nonsilver solutions should be treated as hazardous waste. A licensed waste disposal service should be contacted for proper disposal. Unused materials may be recycled by donating to arts organizations or, in some cases, schools, as an alternative.

2. Contact your local sewer authority for information and recommendations for disposing of your photographic solutions.

3. Most small-scale photographic processing will not exceed effluent regulations. If your total load (volume per day) is within regulated amounts, but the concentrations of particular chemicals in a bath may be too high, then a holding tank large enough to hold the process wash water and processing solutions can be used. Then the effluent can be slowly released into the sewer system. The holding tank should be kept covered, with some dilution ventilation provided.

4. Alkaline developer solutions should be neutralized first before being poured down the drain. This can be done with the stop bath or citric acid, using pH paper to tell when the solution has been neutralized (pH 7). If the developer contains sodium sulfite or bisulfite, there is the haz-

ard of producing toxic sulfur dioxide gas if the solution becomes acidic. Therefore, neutralize slowly using the pH indicator paper to tell you when to stop. The pH should not drop below 7. A chemistry teacher could probably help with this process.

5. Stop bath left over from neutralization of the developer can be poured down the drain, once mixed with wash water.

6. Fixing baths should never be treated with acid (e.g., mixing with stop bath), since fixing baths usually contain sulfites and bisulfites, which will produce sulfur dioxide gas.

7. Fixing baths contain large concentrations of silver thiocyanate, well above the 5 ppm of silver ion allowed by the U.S. Clean Water Act. The regulations include silver thiocyanate, although silver thiocyanate is not as toxic to bacteria as free silver ion, and can be handled by bacterial waste treatment plants. If large amounts of fixer waste are produced (more than a few gallons per day), then silver recovery could be considered. For small amounts, mixing with wash water and pouring down the drain are possible. Local authorities should be contacted for advice.

8. There are several types of silver recovery systems. The simplest uses steel wool or other source of iron. The iron dissolves and silver is precipitated out. The precipitated silver must be sent to a company that can recover the silver.

9. Replenishment systems, in which fresh solutions are added regularly to replace solutions carried out by film or paper, reduce the daily volume of solution needing disposal. Ultimately, you will have to dispose of these replenished solutions, using the above guidelines.

10. For septic systems, Kodak used to recommend that photographic solutions (including wash water) constitute a maximum of one third the amount of household sanitary waste going into the septic system, and that not more than a few pints be released at any one time. Kodak no longer recommends this because of variations in local laws. In some areas you need a permit to dump photographic wastes into septic systems.

11. If you have large amounts of photographic solutions for disposal (but less than 200 gallons daily, including wash water), Kodak recommends building your own activated-sludge waste treatment center from 55-gallon drums (see chapter references).

TABLE 15-1. Hazards of Photographic Chemicals

The following table is a list of common black-and-white, color, and nonsilver photographic chemicals. This list is obviously not inclusive, and trade names are not included.

The American Conference of Governmental Industrial Hygienists (ACGIH) Threshold Limit Values (TLVs) are listed, except when the NIOSH Recommended Exposure Limits (RELs) or OSHA Permissible Exposure Limits (PELs) are lower. Unless otherwise indicated, TLVs are 8-hour time-weighted averages. The TLVs for metals are listed in mg/m^3, expressed in terms of the metal.

Acetic Acid, Glacial

Use

Stop bath

Relative Toxicity Rating TLV: 10 ppm

Skin contact: high
Inhalation: high
Ingestion: high

Specific Hazards

Concentrated (glacial) acetic acid is corrosive to skin, eyes, mucous membranes, and stomach, and can cause severe burns. Ingestion may be fatal. Diluted solutions (e.g., stop baths) are slightly irritating to the skin. Acetic acid vapors are eye and respiratory irritants, and chronic exposure even to dilute solutions could cause chronic bronchitis. Glacial acetic acid is combustible (flash point 103°F or 39°C).

Alum (potassium aluminum sulfate)

Use

Hardener

Relative Toxicity Rating

Skin contact: slight
Inhalation: slight
Ingestion: slight to moderate

Specific Hazards

Skin contact, inhalation, or ingestion may cause slight irritation and possible allergies.

Amidol (see Diaminophenol hydrochloride)

Aminophenol

Use

Developer

Relative Toxicity Rating

Skin contact: moderate
Inhalation: moderate
Ingestion: high

Specific Hazards

Prolonged and repeated skin contact may cause irritation and skin allergies. Acute inhalation or ingestion may cause kidney damage and methemoglobinemia with resulting cyanosis (difficulty in breathing, blue lips and nails). Chronic inhalation may cause bronchial asthma.

Ammonium Alum (ammonium aluminum sulfate) (see Alum)

Ammonium Bromide

Use

Bleach bath

Relative Toxicity Rating

Skin contact: slight
Inhalation: moderate
Ingestion: moderate

Specific Hazards

Inhalation or ingestion of large amounts causes depression, emaciation, somnolence, vertigo, mental confusion, and, in severe cases, psychoses and mental deterioration. Ingestion often provokes vomiting. Prolonged inhalation or ingestion may cause skin rashes.

Ammonium Dichromate (see Potassium dichromate)

Ammonium Hydroxide (ammonia water)

Use

Intensification, toning, hypo elimination

Relative Toxicity Rating TLV: 25 ppm

Skin contact: high
Inhalation: high
Ingestion: moderate to high

Specific Hazards

Household ammonia is 5–10% ammonia; 27–30% concentrations are also available. Skin contact can cause first- and second-degree burns. The eyes and respiratory system are very sensitive to ammonia. Inhalation of high concentrations can cause chemical pneumonia. Ingestion can cause intense pain and damage to mouth and esophagus and can be fatal. Mixing ammonia with alkalis causes release of ammonia gas; mixing with chlorine bleaches causes formation of a poison gas.

Ammonium Persulfate

Use

Reducing solutions

Relative Toxicity Rating

Skin contact: slight
Inhalation: slight
Ingestion: moderate

Specific Hazards

Persulfates are skin, eye, and respiratory irritants when in concentrated solution or as powders. They may also cause allergies. Strong oxidizing agent; flammable in contact with solvents or other combustible materials. When heated, they emit highly toxic sulfur dioxide gas.

Ammonium Thiocyanate (see Potassium thiocyanate)

Ammonium Thiosulfate (see Sodium thiosulfate)

p-Benzoquinone (para-benzoquinone, quinone)

Use

Holography bleach

Relative Toxicity Rating TLV: 0.1 ppm

Skin contact: high
Inhalation: high
Ingestion: high

Specific Hazards

Can cause severe skin or eye irritation, ulcers, and brown stain and/or deformed cornea from repeated contact. Vapors irritating to eyes, nose, throat, and lungs. High exposure may cause chemical pneumonia. Severe overexposure may cause kidney and brain damage, with convulsions and possible death. Combustible solid.

Bleach, household (5% sodium hypochlorite solution)

Use

Hypo eliminator

Relative Toxicity Rating

Skin contact: moderate
Inhalation: moderate
Ingestion: moderate

Specific Hazards

Repeated or prolonged skin contact may cause dermatitis. Inhalation of chlorine gas from bleach decomposition can cause severe lung irritation. Heating or addition of acid releases large amounts of highly toxic chlorine gas; addition of ammonia causes formation of a highly poisonous gas.

Borax (sodium tetraborate, sodium metaborate, sodium pyroborate)

Use

Developing bath

Relative Toxicity Rating TLV: 1–5 mg/m^3

Skin contact: slight
Inhalation: moderate
Ingestion: moderate

Specific Hazards

Alkaline powder. Absorption through burned skin, ingestion, or inhalation can cause nausea, abdominal pain, diarrhea, violent vomiting, and skin rash. Chronic poisoning may cause loss of appetite, gastroenteritis, liver and kidney damage, and skin rash.

Boric Acid

Use

Buffer

Relative Toxicity Rating

Skin contact: slight
Inhalation: moderate
Ingestion: moderate to high

Specific Hazards

Acidic powder. Absorption through burned skin, ingestion, or inhalation can cause nausea, abdominal pain, diarrhea, violent vomiting, and skin rash. Chronic poisoning may cause loss of appetite, gastroenteritis, liver and kidney damage, and skin rash.

Bromine

Use

Holography bleach

Relative Toxicity Rating TLV: 0.1 ppm

Skin contact: high
Inhalation: high
Ingestion: high

Specific Hazards

Corrosive to skin, eyes, respiratory system, and gastrointestinal system. Can cause severe skin and eye burns with permanent scarring, and acne-like rash. Absorbed through skin. Can cause chemical pneumonia by inhalation of gas. Strong oxidizing agent. Poisonous gases are produced in fires.

Catechin (catechol, pyrocatechol, o-dihydroxybenzene)

Use

Developer

Relative Toxicity Rating TLV: 5 ppm (skin)

Skin contact: high
Inhalation: high
Ingestion: high

Specific Hazards

May be absorbed through skin; skin contact can cause irritation and possible allergies. Inhalation of dust can cause severe acute poisoning, with symptoms of cyanosis (blue lips and nails), anemia, convulsions, vomiting, liver and kidney damage, and difficulty in breathing. Ingestion can be fatal. Do not use.

Chlorquinol (chlorhydroquinone)

Use

Developer

Relative Toxicity Rating

Skin contact: moderate
Inhalation: moderate
Ingestion: high

Specific Hazards

See Catechin.

Chrome Alum (see Potassium chrome alum)

Diaminophenol Hydrochloride (hydroxy-p-phenylenediamine hydrochloride)

Use

Developer

Relative Toxicity Rating

Skin contact: moderate
Inhalation: high
Ingestion: high

Specific Hazards

Skin contact may cause severe skin irritation and allergies; may also be absorbed through the skin. Inhalation may cause bronchial asthma, and inhalation or ingestion may cause gastritis, rise in blood pressure, vertigo, tremors, convulsions, and coma. Do not use.

Diethanolamine

Use

Color developing baths

Relative Toxicity Rating TLV: 3 ppm

Skin contact: moderate
Inhalation: moderate
Ingestion: moderate

Specific Hazards

Alkaline. Irritating to eyes and respiratory system. May cause mild liver damage.

Diethyl-p-Phenylene Diamine (see p-phenylene diamine)

Dimethyl-p-Phenylene Diamine (see p-phenylene diamine)

Disodium Phosphate

Use

Color bleach bath

Relative Toxicity Rating

Skin contact: slight
Inhalation: slight
Ingestion: moderate

Specific Hazards

May cause slight irritation to skin and eyes.

Ethoxydiglycol (diethylene glycol ethyl ether, 2-(2-ethoxyethyl)ethanol, carbitol)

Use

Color processing solvent

Relative Toxicity Rating

Skin contact: slight
Inhalation: slight
Ingestion: moderate

Specific Hazards

Probable human developmental toxicant. Causes eye irritation and mild skin irritation. Absorbed through skin. Similar to ethylene glycol. Causes low birth weight in animals. Not appreciably volatile unless heated.

Ethylene Diamine

Use

Color developing baths

Relative Toxicity Rating TLV: 10 ppm

Skin contact: high
Inhalation: high
Ingestion: moderate

Specific Hazards

Concentrated or pure solutions are corrosive to skin and especially to eyes; may be absorbed through skin. Skin and respiratory allergies may occur from repeated exposure (e.g., asthma). Inhalation or ingestion may cause irritation and liver and kidney damage.

Ethylenediaminetetraacetic Acid (EDTA) and Salts

Use

Color developing baths, holography

Relative Toxicity Rating

Skin contact: slight
Inhalation: slight
Ingestion: moderate

Specific Hazards

EDTA and its salts chelate metal ions, including calcium. The sodium salt in particular can cause muscular spasms due to calcium deficiency.

Ethylene Glycol (glycol, 1,2-ethanediol)

Use

Color developing baths

Relative Toxicity Rating TLV-C: 50 ppm (for mist)

Skin contact: moderate
Inhalation: slight
Ingestion: moderate

Specific Hazards

Ingestion is the most serious problem: 3 ounces (100 ml) can be fatal in adults, affecting kidneys and central nervous system. Chronic ingestion affects kidneys and possibly liver. Low volatility unless heated.

Farmer's Reducer (see Potassium ferricyanide)

Ferric alum (ferric ammonium sulfate) (see alum)

Use

Toning solution

Ferric Ammonium Citrate

Use

Cyanotype

Relative Toxicity Rating TLV: 1mg/m^3

Skin contact: slight
Inhalation: slight
Ingestion: moderate

Specific Hazards

Soluble iron salts are slightly irritating to skin, eyes, nose, and throat, and can cause poisoning if ingested in large amounts (especially by children).

Ferric Oxalate (see Potassium oxalate)

Formaldehyde (formalin)

Use

Hardener, stabilizer

Relative Toxicity Rating TLV-C: 0.3 ppm (proposed 1991–92)

Skin contact: moderate
Inhalation: high
Ingestion: moderate to high

Specific Hazards

Probable human carcinogen and mutagen. Strong irritant to skin, eyes, and respiratory system. May cause allergic reactions by repeated skin contact or inhalation, including asthma. Poisonous by ingestion.

Freon 11 and 12 (dichlorofluoromethane, trichlorofluoromethane)

Use

Film cleaner

Relative Toxicity Rating TLV: 1,000 ppm

Skin contact: slight
Inhalation: slight
Ingestion: slight

Specific Hazards

Inhalation of large amounts may cause mild respiratory irritation, narcosis, and, in some cases, irregular heart rhythms, which can be fatal. Heating may produce highly poisonous gases. Damages ozone layer.

Glycin (p-hydroxyphenyl aminoacetic acid)

Use

Developer

Relative Toxicity Rating

Skin contact: moderate
Inhalation: moderate
Ingestion: moderate

Specific Hazards

Skin contact may cause irritation and allergies. Inhalation or ingestion may cause anemia, cyanosis (blue lips and nails), difficulty in breathing, nausea, and dizziness.

Gold Chloride

Use

Toner

Relative Toxicity Rating

Skin contact: moderate
Inhalation: moderate
Ingestion: moderate

Specific Hazards

Gold chloride can cause severe skin and respiratory allergies. Chronic inhalation or ingestion can cause anemia and liver, kidney, and nervous system damage.

Hydrobromic Acid, Dilute

Use

Holography, color bleach

Relative Toxicity Rating TLV: 3 ppm

Skin contact: moderate
Inhalation: moderate
Ingestion: high

Specific Hazards

Although the concentrated acid is extremely corrosive by skin contact, eye contact, or ingestion, the diluted acid found in photography solutions is less hazardous, but still may cause skin and eye irritation. Inhalation of vapors may cause lung irritation and possible chronic bronchitis.

Hydrochloric Acid

Use

Acid

Relative Toxicity Rating TLV-C: 7.5 mg/m^3

Skin contact: high
Inhalation: moderate
Ingestion: high

Specific Hazards

Concentrated acid is highly corrosive by skin contact, eye contact, or ingestion (less than ⅛ cup may be fatal); dilute acid is less hazardous, but still may cause skin and eye irritation. Inhalation of hydrochloric acid vapors may cause lung irritation and possibly chronic bronchitis.

Hydrogen Peroxide (3 1/2%)

Use

Hypo eliminator

Relative Toxicity Rating

Skin contact: slight
Inhalation: not significant
Ingestion: slight

Specific Hazards

Ingestion or repeated skin contact may cause slight irritation.

Hydroquinone

Use

Developer

Relative Toxicity Rating TLV: 2 mg/m^3; NIOSH REL: C 2 mg/m^3

Skin contact: moderate
Inhalation: moderate
Ingestion: high

Specific Hazards

Probable human mutagen. Skin contact may cause irritation and allergies; years of eye contact with vapor may cause depigmentation and eye injury. Ingestion and inhalation may cause ringing in ears (tinnitus), nausea, dizziness, muscular twitching, increased respiration, headache, cyanosis, delirium, and coma.

Hydroxylamine Sulfate

Use

Color neutralizing bath

Relative Toxicity Rating

Skin contact: moderate
Inhalation: moderate
Ingestion: moderate

Specific Hazards

Probable human developmental toxicant. Skin contact may cause irritation and allergies. Inhalation or ingestion may cause anemia, cyanosis (blue lips and nails), convulsions, and coma. It causes birth defects in rats.

Hypo (see Sodium thiosulfate)

Iodine

Use

Reducing agent

Relative Toxicity Rating

TLV-C: 0.1 ppm

Skin contact: moderate
Inhalation: high
Ingestion: high

Specific Hazards

Skin contact may cause a hypersensitivity reaction and burns. Heating produces highly toxic fumes, causing severe respiratory irritation similar to that caused by chlorine gas, but this is unlikely at room temperature due to low volatility. Ingestion is very serious due to corrosive effects and may be fatal.

Lead oxalate

Use

Platinum printing

Relative Toxicity Rating

PEL: 0.05 mg/m^3

Skin contact: moderate
Inhalation: high
Ingestion: high

Specific Hazards

Both acute and chronic ingestion or inhalation can cause inorganic lead poisoning. Inhalation is more of a problem than ingestion. Lead affects the gastrointestinal system (lead colic), red blood cells (anemia), and neuromuscular system (weakening of wrists, fingers, ankles, toes). Other common effects include weakness, headaches, irritability, malaise, pain in joints and muscles, liver and kidney damage, and possible birth defects and miscarriages. Corrosive. See also potassium oxalate.

Liver of Sulfur (see potassium sulfide)

Mercuric Chloride

Use

Intensifier, platinum toner

Relative Toxicity Rating TLV: 0.05 mg/m^3 (skin)

Skin contact: moderate
Inhalation: high
Ingestion: extreme

Specific Hazards

Corrosive to skin. Ingestion of 0.5 grams can be fatal. Skin absorption, ingestion, or inhalation may cause acute or chronic mercury poisoning, primarily affecting the nervous system but also the gastrointestinal system and kidneys. Acute poisoning is accompanied by metallic taste, salivation, swelling of gums, vomiting, and bloody diarrhea. Chronic poisoning also severely affects the nervous system, causing muscular tremors, irritability, and psychic changes (e.g., depression, loss of memory, frequent anger). Do not use.

Mercuric Iodide (see Mercuric chloride)

Methyl Chloroform (see 1,1,1-trichloroethane)

Metol (see Monomethyl p-aminophenol sulfate)

Monoethanolamine (ethanolamine, 2-aminoethanol)

Use

Color developing bath

Relative Toxicity Rating TLV: 3 ppm

Skin contact: slight
Inhalation: moderate
Ingestion: moderate

Specific Hazards

Alkaline. Irritating to eyes and respiratory system. May cause lethargy and mild liver and kidney damage.

Monomethyl p-Aminophenol Sulfate

Use

Developer

Relative Toxicity Rating

Skin contact: moderate
Inhalation: moderate
Ingestion: moderate

Specific Hazards

Skin contact may cause severe skin irritation and allergies. Inhalation or ingestion may cause anemia, cyanosis, difficulty in breathing, dizziness, and nausea.

o-Phenylene Diamine (see p-phenylene diamine)

Oxalic Acid

Use

Toning solution, platinum printing

Relative Toxicity Rating TLV: 1 mg/m^3

Skin contact: high
Inhalation: high
Ingestion: high

Specific Hazards

Skin and eye contact may cause severe corrosion, ulcers, and gangrene (of extremities). Inhalation causes severe respiratory irritation and ulceration. Acute ingestion may cause severe corrosion of mouth, esophagus, and stomach; shock; collapse; possible convulsions; and death. There may also be severe kidney damage.

Phenidone (1-phenyl-3-pyrazolidone)

Use

Developer

Relative Toxicity Rating

Skin contact: slight
Inhalation: moderate
Ingestion: moderate

Specific Hazards

Least toxic developer by skin contact. Hazards by inhalation or ingestion are similar to those for other developers.

p-Phenylene Diamine (para-phenylenediamine)

Use

Developer

Relative Toxicity Rating TLV: 0.1 mg/m^3 (skin)

Skin contact: moderate
Inhalation: high
Ingestion: high

Specific Hazards

Skin contact may cause severe skin allergies; it may also be absorbed through the skin. Inhalation may cause severe asthma and irritation of upper respiratory passages. Ingestion may cause vertigo, nervous system damage, gastritis, liver and spleen damage, double vision, and weakness. Avoid if possible.

Phosphoric Acid

Use

Platinum printing

Relative Toxicity Rating TLV: 1 mg/m^3

Skin contact: high
Inhalation: high
Ingestion: high

Specific Hazards

Highly corrosive by skin and eye contact and by ingestion. Ingestion can cause severe stomach damage and may be fatal. Diluted acid is less hazardous; repeated or prolonged skin contact can cause irritant dermatitis.

Platinum Chloride

Use

Toner, platinum printing

Relative Toxicity Rating TLV: 0.002 mg/m^3

Skin contact: moderate
Inhalation: high
Ingestion: unknown

Specific Hazards

Skin contact can cause severe skin allergies. Inhalation can cause nasal allergies (similar to hay fever) and platinosis, a severe form of asthma. Some lung scarring and emphysema may also occur. People with red or light hair and fine-textured skin appear most susceptible.

Potassium Bromide (see Ammonium bromide)

Use

Developing and intensifying baths

Potassium Chlorate

Use

Platinum printing

Relative Toxicity Rating

Skin contact: moderate
Inhalation: moderate
Ingestion: high

Specific Hazards

Strong oxidizing agent; flammable in contact with solvents or other combustible materials. Irritant. Ingestion causes methemoglobinemia, gastritis, and delayed kidney damage.

Potassium Chlorochromate

Use

Intensifier

Relative Toxicity Rating

Skin contact: moderate
Inhalation: high
Ingestion: moderate

Specific Hazards

Probable human carcinogen. Skin contact may cause irritation, ulceration, allergies, and eye burns. Inhalation may cause respiratory irritation and allergies and possible perforation of nasal septum. Ingestion may cause acute poisoning with gastroenteritis, vertigo, muscle cramps, and kidney damage. Heating or adding acid causes release of highly toxic chlorine gas.

Potassium Chloroplatinite (see Platinum chloride)

Potassium Chrome Alum (chrome alum, chromium potassium sulfate)

TLV: 0.3 mg/m^3 (as chromium)

Use

Hardener

Relative Toxicity Rating

Skin contact: moderate
Inhalation: high
Ingestion: high

Specific Hazards

Possible carcinogen; skin, eye, and respiratory irritant.

Potassium Cyanide

Use

Reducer

Relative Toxicity Rating TLV: 5 mg/m^3 (skin)

Skin contact: high
Inhalation: high
Ingestion: extreme

Specific Hazards

Chronic skin contact may cause skin rashes; it may also be absorbed through the skin. Acute ingestion is frequently fatal, even in small amounts, causing chemical asphyxia. Acute inhalation may also cause chemical asphyxia. Chronic inhalation of small amounts may cause nasal and respiratory irritation, including nasal ulceration, and systemic effects with symptoms of loss of appetite, headaches, nausea, weakness, and dizziness. Adding acid to cyanide causes the formation of extremely toxic hydrogen cyanide gas, which can be rapidly fatal by inhalation. Do not use.

Potassium Dichromate (potassium bichromate)

Use

Intensifier

Relative Toxicity Rating TLV: 0.05 mg/m^3; NIOSH: 0.001 mg/m^3 (10-hour REL)

Skin contact: high
Inhalation: extreme
Ingestion: extreme

Specific Hazards

Probable human carcinogen. Hexavalent chromium compounds are corrosive by skin contact; may cause irritation, ulceration, and allergies. Chronic inhalation may cause lung cancer, respiratory irritation, allergies, and perforated nasal septum. Ingestion may cause violent gastroenteritis, circulatory collapse, and kidney damage. Strong oxidizer; can cause fire in contact with reducing agents, solvents, and other organic materials. Avoid if possible.

Potassium Ferricyanide (Farmer's reducer)

Use

Reducer, cyanotype

Relative Toxicity Rating

Skin contact: slight
Inhalation: slight
Ingestion: moderate

Specific Hazards

Heating, treating with acid, or exposing to ultraviolet light can cause release of highly toxic hydrogen cyanide gas.

Potassium Iodide

Use

Holography

Relative Toxicity Rating

Skin contact: not significant
Inhalation: unknown
Ingestion: moderate

Specific Hazards

Known human teratogen. Chronic ingestion may cause "iodism," with symptoms of salivation, sneezing, inflammation of nasal passages and eyes, headache, fever, bronchitis, and skin rashes.

Potassium Oxalate

Use

Platinum printing

Relative Toxicity Rating

Skin contact: moderate
Inhalation: high
Ingestion: high

Specific Hazards

Corrosive to skin, eyes, nose, and throat. Ingestion causes intense damage to mouth, esophagus, and stomach. Also causes kidney damage. May be fatal by ingestion.

Potassium Permanganate

Use

Reducer, hypo eliminator

Relative Toxicity Rating

Skin contact: high
Inhalation: high
Ingestion: high

Specific Hazards

Concentrated solutions and the solid are highly corrosive to skin, eyes, lungs, mouth, and stomach. Dilute solutions are mildly irritating.

Potassium Persulfate (see ammonium persulfate)

Potassium Sulfide (liver of sulfur)

Use

Toner

Relative Toxicity Rating

Skin contact: moderate
Inhalation: moderate
Ingestion: extreme

Specific Hazards

Skin contact may cause skin softening and irritation, similar to alkalis. Dust can cause eye, nose, and throat irritation. Ingestion may cause corrosive effects and hydrogen sulfide poisoning due to decomposition in the stomach to alkali and hydrogen sulfide. Mixture with acid causes formation of highly toxic hydrogen sulfide gas.

Potassium Thiocyanate

Use

Color developing bath

Relative Toxicity Rating

Skin contact: not significant
Inhalation: slight
Ingestion: high

Specific Hazards

Ingestion may cause vomiting, excitation, delirium, and convulsions. Subacute or chronic poisoning is similar to bromide poisoning in terms of psychological effects. Heating or treatment with hot acid can cause decomposition to extremely toxic hydrogen cyanide gas.

Pyrogallic Acid (pyrogallol, 1,2,3-trihydroxybenzene)

Use

Developer

Relative Toxicity Rating

Skin contact: high
Inhalation: high
Ingestion: high

Specific Hazards

Skin contact can cause severe allergies and irritation and substantial amounts may be absorbed through the skin. Inhalation can cause severe acute poisoning with symptoms of cyanosis (blue lips and nails), anemia, convulsions, vomiting, and liver and kidney damage. Ingestion can be fatal. Do not use.

Selenium Oxide (selenium dioxide)

Use

Toner

Relative Toxicity Rating TLV: 0.2 mg/m^3

Skin contact: moderate
Inhalation: high
Ingestion: high to extreme

Specific Hazards

Can cause severe eye irritation, skin burns, and allergies; may also be absorbed through the skin. Acute inhalation may cause respiratory irritation, chemical pneumonia, and bronchitis. Acute toxicity of soluble compounds is very high. Chronic inhalation or ingestion may cause garlic odor, nervousness, nausea, vomiting, nervous disorders, and liver and kidney damage. Similar to arsenic poisoning. Treatment of selenium compounds with acid can cause the formation of the extremely toxic gas hydrogen selenide.

Silver Nitrate

Use

Test for hypo, Van Dyke process

Relative Toxicity Rating TLV: 0.01 mg/m^3

Skin contact: moderate
Inhalation: high
Ingestion: high

Specific Hazards

Silver nitrate is corrosive to skin, eyes, and mucous membranes. May cause blindness. Ingestion may cause severe gastroenteritis, shock, vertigo, coma, and convulsions.

Sodium Bisulfite

Use

Fixing bath

Relative Toxicity Rating TLV: 5 mg/m^3

Skin contact: moderate
Inhalation: high
Ingestion: high to extreme

Specific Hazards

Aqueous solutions are acidic. Adding acid to bisulfite solutions causes formation of sulfur dioxide gas.

Sodium Carbonate (soda ash) (see sodium hydroxide)

Sodium Formaldehyde Bisulfite

Use

Developing solution

Relative Toxicity Rating

Skin contact: slight
Inhalation: slight
Ingestion: moderate

Specific Hazards

Not irritating like formaldehyde. Allergies are rare.

Sodium Hydroxide (caustic soda)

Use

Developing bath

Relative Toxicity Rating TLV-C: 2 mg/m^3

Skin contact: high
Inhalation: high
Ingestion: high

Specific Hazards

Highly corrosive to the skin and eyes. Ingestion of small amounts of concentrated solutions can cause severe pain and damage to the mouth and esophagus and can be fatal. Inhalation of dust can cause chemical pneumonia. Some inhalation may occur during accidental ingestion of solutions. Dilute alkaline solutions are more corrosive to the skin and eyes than dilute acid solutions.

Sodium Nitrate

Use

Color bleach bath

Relative Toxicity Rating

Skin contact: not significant
Inhalation: not significant
Ingestion: moderate

Specific Hazards

Sodium nitrate may be converted by intestinal bacteria into more toxic nitrites if ingested. This can result in anemia and cyanosis (blue lips and nails). Strong oxidizer; can cause fire in contact with reducing agents, solvents, and other combustible materials.

Sodium Sulfide (see Potassium sulfide)

Sodium Sulfite

Use

Preservative

Relative Toxicity Rating

Skin contact: not significant
Inhalation: moderate
Ingestion: moderate

Specific Hazards

Inhalation can cause respiratory irritation. Ingestion can cause gastric irritation in small doses and violent colic, diarrhea, circulatory disturbances, and central nervous system depression in large doses. Heating or treating with acid causes formation of highly toxic sulfur dioxide gas.

Sodium Thiocyanate (see Potassium thiocyanate)

Sodium Thiosulfate (hypo)

Use

Fixer

Relative Toxicity Rating

Skin contact: not significant
Inhalation: high
Ingestion: slight

Specific Hazards

Ingestion of large amounts causes purging. Old solutions, or solutions that are heated or treated with acid, release highly toxic sulfur dioxide gas.

Succinaldehyde

Use

Color prehardener

Relative Toxicity Rating

Skin contact: moderate
Inhalation: moderate
Ingestion: moderate

Specific Hazards

Skin and eye irritant. Not very volatile, so inhalation less of a risk.

Sulfamic Acid

Use

Color bleach

Relative Toxicity Rating

Skin contact: moderate
Inhalation: high
Ingestion: high

Specific Hazards

Corrosive to skin, eyes, respiratory system, and intestinal system. Heating or adding acid causes formation of highly toxic sulfur dioxide gas.

Sulfuric Acid (oleum)

Use

Cleaning

Relative Toxicity Rating TLV: 1 mg/m^3

Skin contact: high
Inhalation: high
Ingestion: high

Specific Hazards

Concentrated sulfuric acid is corrosive to skin, eyes, respiratory system, and stomach; ingestion of small amounts may be fatal. Dilute acid solutions are less hazardous. Heating sulfuric acid releases highly toxic sulfur oxide gases.

Tertiary-Butylamine Borate

Use

Color developing bath

Relative Toxicity Rating

Skin contact: high
Inhalation: high
Ingestion: high

Specific Hazards

May cause skin irritation and be absorbed through the skin. May cause nervous system damage.

Thiourea (thiocarbamide)

Use

Toning solution

Relative Toxicity Rating

Skin contact: slight
Inhalation: high
Ingestion: moderate to high

Specific Hazards

Probable human carcinogen and mutagen. Thiourea causes cancer in rats.

para-Toluenesulfonic Acid

Use

Color bleaching

Relative Toxicity Rating

Skin contact: moderate
Inhalation: moderate
Ingestion: moderate

Specific Hazards

Corrosive. Skin, eye, and respiratory irritant. Decomposes with heat or acid to form sulfur dioxide and hydrogen sulfide.

1,1,1-Trichloroethane (methyl chloroform)

Use

Film cleaner

Relative Toxicity Rating TLV: 350 ppm; (NIOSH 350 ppm C)

Skin contact: slight
Inhalation: moderate
Ingestion: moderate

Specific Hazards

Causes skin and eye irritation, mild narcosis. May cause heart arrhythmias and death at high concentrations (e.g., enclosed spaces, "sniffing"). Chronic exposure to large amounts may cause some liver damage.

Triethanolamine

Use

Color developing bath, holography

Relative Toxicity Rating TLV: 0.5 ppm

Skin contact: slight
Inhalation: high
Ingestion: slight

Specific Hazards

Probable human carcinogen. Alkaline. May cause allergic skin reactions. Absorbed through skin. Irritating to skin, eyes, and respiratory system. May cause mild liver damage.

Trisodium Phosphate (see Sodium hydroxide)

Use

Color developing bath

Uranium Nitrate

Use

Toner

Relative Toxicity Rating TLV: 0.05 mg/m^3

Skin contact: slight
Inhalation: high
Ingestion: moderate

Specific Hazards

Soluble uranium compounds are poorly absorbed but can cause severe kidney damage and kidney failure. Do not use.

RESOURCES

The following are some resources for information on photographic chemicals:

Kodak's 24-hour emergency hotline: (716) 722-5151

Kodak Material Safety Data Sheet information (8 AM-6:30 PM eastern time, Monday to Friday): (800) 445-6325, ext. 25

Ciba-Geigy (Ilford) 24-hour emergency hotline: (914) 478-3131

REFERENCES

Ayers, G., and Zaczkowski, J. (1991). *Photo Developments—A Guide to Handling Photographic Chemicals*. Bramalea, Ontario: Envisin Compliance Ltd.

Clement, J. D. (1976). *An Assessment of Chemical and Physical Hazards in Commercial Photographic Processing*. M.S. thesis, University of Cincinnati.

The Compact Photo Lab Index. (1990). 41st ed. Dobbs Ferry, NY: Morgan Press.

Eastman Kodak Co. (1979). *Safe Handling of Photographic Chemicals*. Publication No. J-4. Rochester, NY: Eastman Kodak.

Eastman Kodak Co. (1986). *CHOICES—Choosing the Right Silver-Recovery Method for Your Needs.* Publication No. J-21. Rochester, NY: Eastman Kodak.

Eastman Kodak Co. (1986). *Disposal of Small Volumes of Photographic Processing Solutions.* Publication No. J-52 (discontinued). Rochester, NY: Eastman Kodak.

Eastman Kodak Co. (1986). *Disposal and Treatment of Photographic Effluent.* Publication No. J-55. Rochester, NY: Eastman Kodak.

Eastman Kodak Co. (1987). *General Guidelines for Ventilating Photographic Processing Areas.* CIS-58. Rochester, NY: Eastman Kodak.

Freeman, V. A., and Humble, C. G. (1988). *Prevalence of Illness and Chemical Exposure in Professional Photographers.* Boston, MA: American Public Health Association, 16th annual meeting.

Handley, M. (1988). *Photography and Your Health.* Berkeley, CA: Hazard Evaluation System and Information Service, California Department of Health Services.

Hodgson, M., and Parkinson, D. (1986). Respiratory disease in a photographer. *Am. J. Ind. Med.* 9(4), 349-54.

Houk, C., and Hart, C. (1987). Hazards in a photography lab; a cyanide incident case study. *J. Chem. Educ.* 64(10), A234-36.

Kipen, H., and Lerman, Y. (1986). Respiratory abnormalities among photographic developers: A report of three cases. *Am. J. Ind. Med.* 9(4), 341-47.

Shaw, S. D., and Rossol, M. (1991). *Overexposure: Health Hazards in Photography.* 2d ed. New York, NY: Allworth Press.

Tell, J. (ed). (1988). *Making Darkrooms Saferooms.* Durham, NC: National Press Photographers Association.

16

Sculpture

his chapter discusses the hazards of plaster, stone, lapidary, clay, wax, and other modeling materials and plastic sculpture. Subsequent chapters discuss the hazards of woodworking, metalworking, and modern sculpture methods.

PLASTER

There are many varieties of plaster, including the common plaster of Paris, casting plaster, white art plaster, molding plaster, and Hydrocal. These are all varieties of calcined gypsum, which is composed of calcium sulfate. Plaster can be used for modeling, casting, and carving.

Plaster Mixing and Setting

Plaster is mixed by sifting the powder into water. Setting of plaster can be hastened by the addition of salt, potassium sulfate, or potassium alum, and setting can be retarded by the addition of borax, diluted acetic acid, or burnt lime.

Hazards

1. Plaster dust (calcium sulfate) is slightly irritating to the eyes and respiratory system. In cases of heavy inhalation of the dust, more severe respiratory problems can result.

2. Potassium sulfate and potassium alum are slightly toxic by ingestion; potassium alum is slightly toxic by skin contact and can cause mild irritation or allergies in some people.

3. Borax is moderately toxic by ingestion, by inhalation, and by absorption through burns or other skin injuries. It is also slightly toxic by skin contact, causing alkali burns.

4. Concentrated acetic acid is highly corrosive by ingestion, inhalation, and skin contact.

5. Burnt lime (calcium oxide) is moderately corrosive by skin contact (especially if the skin is wet) and highly toxic by inhalation or ingestion.

Precautions

1. If you mix large amounts of plaster at one time, wear a dust mask. Vacuum or mop up plaster dust carefully; do not sweep.

2. Wear gloves and goggles when mixing acetic acid and burnt lime. For large amounts of burnt lime, wear an approved toxic dust mask.

Plaster Modeling and Carving

Silica sand, vermiculite, sand, and coarse stone can be added to the plaster for textural effects. The plaster can be modeled when wet or carved when dry with a variety of tools, including special plaster carving chisels, knives, rasps, and scrapers.

Hazards

1. Many of the additives used may be hazardous. Silica sands and vermiculite dust are highly toxic by inhalation and may cause silicosis. Small amounts are not a major hazard.

2. Careless use of sharp tools can cause accidents.

3. Chipping set plaster can result in eye injuries if the chips fly into the eyes.

Precautions

1. If you add hazardous materials to the plaster, wear an approved dust mask and clean up dust carefully by wet mopping or vacuuming.

2. Always carve or cut in a direction away from you, and keep hands behind the tool. If the tool falls, do not try to catch it.

3. Wear approved safety goggles when chipping plaster.

Casting in Plaster

Plaster can be used for the model, molds, and final castings. Mold releases used with plaster include vaseline, tincture of green soap, auto paste wax/benzine, silicone/grease/benzine, and mineral oil/petroleum jelly. In waste molding, the plaster mold is chipped away.

Hazards

1. Benzine used with many mold releases is moderately toxic by skin contact and inhalation and is highly toxic by ingestion. It is also flammable.

2. Making plaster casts of hands, legs, and other body parts can be very hazardous due to the heat released during the setting process. Many children and adults have been severely burned doing this.

Precautions

1. Wear gloves and goggles when pouring benzine. Store in safety containers and do not use near open flames or cigarettes.

2. Do not use plaster for body-part casts. Instead, use a plaster-impregnated bandage (such as Johnson and Johnson's Pariscraft), along with vaseline or similar mold release as protection.

Finishing Plaster

Plaster can be painted directly with most types of paint or powdered pigments, and dyes can be added directly to the plaster. Patinas are made by sealing the plaster with shellac or acrylic sprays. They can also be made with a 50/50 mixture of water and white glue, with water-based glue mixed with a 50/50 mixture of lacquer and alcohol, or with bronzing liquids.

Hazards

1. Powdered pigments and dyes are often hazardous by inhalation or inges-
tion, and in some cases by skin contact. See Table 12-1 for the hazards of
particular pigments.

2. Spraying of acrylics is highly hazardous by inhalation.

3. Lacquers contain solvents that are highly toxic by inhalation and moder-
ately toxic by skin contact. Alcohol and shellac are slightly toxic unless
the shellac contains methyl alcohol, in which case it is moderately toxic.
These solvents are also flammable.

Precautions

1. Wear an approved dust mask when handling powdered pigments or dyes.
(See also the pigments section of Chapter 12 and dyes section of Chapter 21.)

2. Spray in a spray booth or use a spray respirator. A preferable method is to
brush the dye or paint onto the plaster or dip the plaster into the dye or
paint.

3. When using solvents, have good general ventilation and wear gloves and
goggles.

4. Store solvents safely and keep them away from open flames and lit ciga-
rettes; dispose of solvent-soaked rags in approved waste disposal cans that
are emptied each day.

▆▆▆ STONE

Stone carving involves chipping, scraping, fracturing, flaking, crushing, and pul-
verizing with a wide variety of tools. Soft stones can be worked with manual
tools, whereas hard stones such as granite require crushing and pulverizing with
electric and pneumatic tools. Crushed stone can also be used in casting proce-
dures.

Soft Stone Carving

Soft stones include soapstone (steatite), serpentine, sandstone, African wonder-
stone, greenstone, sandstone, limestone, alabaster, and several others. They can
be carved with many of the same tools used with plaster, although electric drills
and saws can also be used.

Hazards

1. Some stones are highly toxic by inhalation because they contain large amounts of free silica. Examples are sandstone, soapstone, and slate. Stones such as limestone, which usually contains only small amounts of free silica, are less hazardous.

2. Serpentine, soapstone, and greenstone may contain asbestos, which can cause asbestosis, lung cancer, mesothelioma, and stomach and intestinal cancers.

3. In chipping and some other carving techniques, flying chips and pieces of rock may cause eye injury.

4. Slipping or falling tools may also cause physical injury.

5. Lifting heavy pieces of stone may cause back injuries, and falling stones may injure your feet.

Precautions

1. Do not use stones that may contain asbestos unless you are certain that your particular pieces are asbestos free. New York soapstones, for example, commonly contain asbestos, whereas Vermont soapstones are usually asbestos free. Alabaster is a substitute.

2. Wear a NIOSH-approved toxic dust respirator when carving all stones. Particular care should be taken with stones that contain free silica.

3. Techniques to keep down dust levels in the air include daily vacuuming or wet mopping and use of a water spray over your sculpture when you are carving. Do not dry sweep.

4. Wear chipping goggles to protect against flying particles; wear protective shoes to protect against falling stones.

5. Change clothes and shower after work. Do not track the dust home. Wash your clothes regularly.

6. When using carving tools, keep your hands behind the tools, and carve or cut in a direction away from you. If the tool falls, do not try to catch it.

7. Learn to lift properly using your knees and straightening rather than bending. (See Chapter 10.)

Hard Stone Carving

Hard stones, which usually require the use of electric and pneumatic tools as well as hand tools, include granite and marble. Electric tools include saws, drills,

grinders, and sanders, and pneumatic tools include rotohammers, drills, and other tools powered by compressed air.

Hazards

1. Dusts from granite, slate, quartz, and onyx are highly toxic by inhalation because they contain large amounts of free silica (see Table 5-1). Stones that contain small amounts of free silica are less hazardous.

2. Power tools create larger amounts of fine dust than hand tools. Pneumatic tools, in particular, can create large amounts of fine silica dust.

3. Pneumatic and electric tools and compressors can create a noise hazard, with pneumatic chippers in particular creating unsafe noise levels. Excessive exposure to continuous or intermittent noise can cause a temporary decrease in hearing ability (a temporary threshold shift). If exposure to hazardous noise levels continues for some years, the temporary hearing loss can become permanent. Noise can also adversely affect the heart, circulation, blood pressure, intestines, and balance. See also the noise section of Chapter 10.

4. Pneumatic equipment can also create problems due to vibration. Raynaud's phenomenon, which is also called "white fingers" or "dead fingers," is a disease caused by vibration. It affects the circulation of the fingers, causing them to turn white from lack of blood and to lose sensation. This can occur particularly when you are also exposed to cold, for example, from the air blast from pneumatic tools. This condition, which is a lot more common than is normally realized, is initially temporary, but it can spread to the whole hand and cause permanent damage.

5. Electrical tools create the potential hazard of electrical shock from improperly grounded or faulty wiring. See the electrical safety section of Chapter 10.

6. See the section on soft stone carving for other common hazards.

Precautions

1. Pneumatic and electric carving tools should be equipped with portable exhaust systems if possible to reduce dust levels. Also see the section on soft stone carving.

2. Carry out precautions discussed in the section on soft stone carving to protect against flying particles and freak accidents.

3. Make sure all electrical tools are properly grounded and that the wiring is adequate and in good repair.

4. Place the compressor for pneumatic tools as far away from people as possible, shield it with sound-absorbing materials or mufflers, and wear protective ear muffs or ear plugs if needed.

5. Protect against vibration damage from pneumatic tools by having comfortable hand grips, directing the air blast away from your hands, keeping hands warm, taking frequent work breaks, and using preventive medical measures such as massage and exercises.

6. Tie long hair back or put up under a head covering. Do not wear ties, jewelry, or loose clothing that can get caught by machinery. See also the section on machine and tool safety in Chapter 10.

Stone Casting

Stone casts can be made using Portland cement, sand, and crushed stone. Marble dust in particular is often used with this technique. Cast concrete sculptures can also be made using sand and Portland cement. The most common mold is plaster with stearic acid/benzine as the mold release. Portland cement contains calcium, aluminum, iron and magnesium oxides, and about 5% free silica. Some modern cements used by sculptors have plastic resins in them to give stronger bonding. Sometimes, fiberglass is added as a reinforcement.

Hazards

1. Calcium oxide in Portland cement is highly corrosive to the eyes and respiratory tract and is moderately corrosive to the skin. Allergic dermatitis can also occur due to chromium contaminants in the cement. The silica in the cement is also highly toxic by inhalation. Lung problems from inhalation of Portland cement include emphysema, bronchitis, and fibrosis.

2. The hazards from the stone dust depend on the type of stone. See previous sections on stone carving and Table 5-1 for the hazards of various stone dusts.

3. See the plastics section later in this chapter for the hazards of plastics resins and fiberglass.

Precautions. Follow the same precautions discussed in previous sections on stone carving to protect against stone dusts.

Lapidary

Cutting and carving semiprecious stones has much the same risks as hard stone carving. Stones carved include garnet, jasper, jade, agate, travertine, opal, turquoise, and many others.

Hazards

1. The dust from quartz gemstones such as agate (chalcedony), amethyst, onyx, and jasper is highly toxic because the stones are made of silica. Other gemstones such as lapis lazuli and garnet may be contaminated with substantial amounts of free silica. See the silica section of Chapter 5.
2. Opal is made of amorphous silica, which is slightly toxic by inhalation.
3. Gem cutting machines used in lapidary can create very high noise levels, which can cause hearing loss. They are usually water cooled.

Precautions

1. Wear hearing protectors around noisy lapidary machines.
2. Install ground fault circuit interrupters when water can splash onto motors, or if water is within six feet of electrical outlets.
3. See the hard stone carving section for other precautions with dusts.

Stone Finishing

Stones can be finished by grinding, sanding, and polishing. This can be done by hand or with machines. Polishing can use a variety of materials, depending on the hardness of the stone being polished. Polishing materials include carborundum (silicon carbide), corundum (alumina), diamond dust, pumice, putty powder (tin oxide), rouge (iron oxide), tripoli (silica), and cerium oxide.

Hazards

1. Grinding and sanding, especially with machines, can create fine dust from the stone that is being worked. Depending on the stone, this can create an inhalation hazard. In addition, dust from the grinding wheel (especially sandstone wheels with the silica hazard) can create inhalation hazards.

392

2. Grinding and sanding can release small pieces of stone and dust, which are hazardous to the eyes.

3. Some polishing materials such as tripoli (silica) are highly toxic if inhaled in powder form (see Table 5-1).

Precautions

1. Equip all grinding wheels, sanding machines, and polishing wheels with local exhaust ventilation.

2. Use wet sanding and polishing techniques whenever possible to keep down dust levels.

3. Wear approved safety goggles when grinding, sanding, or polishing. For heavy grinding also wear a face shield. Do not have loose hair, ties, or unfastened shirt sleeves, which can get entangled in the machines.

4. If you do not have adequate local exhaust ventilation, wear an approved toxic dust respirator for sanding, grinding, or polishing operations that create dust.

MODELING MATERIALS

Modeling materials used in sculpture include traditional moist clays, nonhardening modeling clays, self-hardening clays, oven-hardening clays, wax, and papier-mâché type products.

Moist Clays

Moist clays are clays mixed with water. They can be bought premixed or in powder form. These clays are similar to those used in pottery, and pottery clay can be used here. The clay can be modeled, carved, or cast as clay slip, and then fired in a kiln. Again, as with plaster casting, mold releases are required. Talc may be used with casting slip.

Hazards

1. Mixing your own clay is highly hazardous by inhalation due to the presence of free silica in many clays (see Chapter 14).

2. Talcs may be contaminated with asbestos, the inhalation of which may cause asbestosis, lung cancer, and mesothelioma.

3. Firing clay in a kiln can release toxic gases, as is discussed in Chapter 14.

Precautions

1. See the precautions for ceramics in Chapter 14.

2. Do not use asbestos-contaminated talcs.

Nonhardening Modeling Clays

Modeling clays of the plasticine type usually contain China clay in an oil and petrolatum base. Many other additives are often present, including dyes, sulfur dioxide, vegetable oils, aluminum silicate, preservatives, and turpentine. These can be modeled and carved with simple tools.

Hazards. Some of the additives such as turpentine and preservatives might cause skin irritation or allergies, and sulfur dioxide might cause some respiratory problems in certain asthmatics. However, the amounts present are usually small.

Precautions. Use gloves or apply a barrier cream to hands if skin irritation results from using modeling clays.

Hardening Modeling Clays

Self-hardening and oven-hardening modeling clays are often based on polyvinyl chloride and are not really clays at all.

Hazards

1. Until 1990, many of these materials contained di-(ethylhexyl) phthalate (DEHP), a probable human carcinogen, as a plasticizer.

2. Baking any art material in an oven that is also used for food carries the risk of contaminating food.

Precautions

1. Do not bake oven-hardening clays in ovens that are used for food.

2. Do not use hardening modeling clays that contain DEHP. Sometimes this is listed as dioctyl phthalate (not to be confused with di-n-octyl phthalate, which is not a carcinogen).

Wax

Many different types of waxes are used for modeling, carving, and casting. These include beeswax, ceresin, carnauba, tallow, paraffin, and microcrystalline wax. In addition, there are synthetic chlorinated waxes. Solvents used to dissolve various waxes include alcohol, acetone, benzine, turpentine, ether, and carbon tetrachloride.

Waxes can be softened for modeling and carving by heating in a double boiler or with a light bulb, by sculpting with tools warmed over an alcohol lamp, or by the use of soldering irons, alcohol lamps, and blowpipes. Wax can be melted for casting in a double boiler.

Additives used with waxes include rosin, dyes, petroleum jelly, mineral oil, and many solvents.

Hazards

1. Overheating wax can result in the release of flammable wax vapors, as well as in the decomposition of the wax to release acrolein fumes and other decomposition products that are highly irritating by inhalation. Explosions have occurred from heating wax that contained water.

2. Alcohol and acetone are slightly toxic solvents by skin contact and inhalation; benzine and turpentine are moderately toxic by skin contact, inhalation, and ingestion. Carbon tetrachloride is extremely toxic, possibly causing liver cancer and severe liver damage, even from small exposures. Exposure to carbon tetrachloride can be fatal by skin absorption or inhalation.

3. Chlorinated synthetic waxes are highly toxic by skin contact and skin absorption, causing a severe form of acne (chloracne). Some may be contaminated with polychlorinated biphenyls (PCBs), which are highly toxic, causing chloracne, liver problems, and possibly cancer of the pancreas and melanoma (a serious form of skin cancer).

Precautions

1. Do not overheat waxes. Use a double boiler and a temperature-controlled hot plate, or a crock pot. Do not use an open flame to melt waxes.

2. Use the least hazardous solvent to dissolve your wax. Do not use carbon tetrachloride under any circumstances. Store solvents safely, do not smoke or have open flames near solvents, and dispose of solvent-soaked rags in an approved waste disposal container that is emptied each day.

3. Do not use chlorinated synthetic waxes.

PLASTICS

Plastic sculpture can be divided into two basic areas: working with plastic resins, or working with finished plastics. Working with plastic resins involves carrying out a chemical reaction to produce a finished plastic. The chemical reaction consists of either linking together many small molecules (monomers) to form the plastic (a polymer) or cross-linking many polymer chains with monomers to form a thermosetting plastic. Hardeners are used to initiate the reaction. Catalysts, accelerators, fillers, pigments and dyes, and many other additives are also used. Examples of plastic resins include amino and phenolic resins, acrylic resins, epoxy resins, polyester resins, polyurethane resins, and silicone resins. They can be molded, cast, laminated, and foamed.

Working with finished plastics involves changing the plastic physically, rather than chemically. These fabrication processes include heating, softening, bending, gluing, machining, sawing, finishing, and similar mechanical processes.

Acrylic Resins

Acrylic resins can be used for casting and as acrylic cements. They are of two types: monomer and monomer/polymer mixtures. Both types use benzoyl peroxide as the hardener. The monomer is methyl methacrylate. The polymerization is carried out at elevated temperatures that must be controlled carefully. The monomer/polymer process also requires increased pressures.

Hazards

1. Methyl methacrylate monomer is moderately toxic by skin contact, eye contact, and inhalation. It is an irritant and causes headaches, irritability, and narcosis when inhaled. It is also a sensitizer, and may cause asthma.

2. The benzoyl peroxide hardener is flammable and explosive and is a slight skin and eye irritant. See the section on organic peroxides later in the chapter for further details.

3. Finely divided acrylic polymer dust is also a sensitizer.

396

Precautions

1. Wear gloves and have good local exhaust ventilation when using acrylic resins. If local exhaust ventilation is not possible, use a window exhaust fan, and wear a National Institute for Occupational Safety and Health (NIOSH)-approved organic vapor respirator, if needed.
2. See the section on organic peroxides for precautions when handling benzoyl peroxide.
3. Wear a NIOSH-approved toxic dust mask when handling finely divided acrylic polymer dust.

Amino and Phenolic Resins

Urea-formaldehyde, melamine-formaldehyde, phenol-formaldehyde, and resorcinol-formaldehyde resins are used as thermosetting adhesives and, in the case of phenol-formaldehyde, as a binder in sand casting. These are usually available as two-component systems with formaldehyde or paraformaldehyde as the hardener. Urea-formaldehyde and resorcinol-formaldehyde resins can be cured at room temperature. Others require heat.

Hazards

1. Amino and phenolic resins contain formaldehyde, which is highly toxic by inhalation, highly toxic by eye contact and ingestion, and moderately toxic by skin contact. It is an irritant and strong sensitizer. Formaldehyde is a probable human carcinogen.
2. Phenol-formaldehyde resin contains phenol, which is highly toxic by skin absorption and inhalation. It also causes severe skin burns.
3. If these resins are improperly cured and contain residual formaldehyde, they may cause irritation and allergic reactions. Even trace amounts of free formaldehyde may cause allergic reactions in people who are already sensitized to it.
4. Machining, sanding, or excessive heating of the cured resins can cause decomposition, releasing formaldehyde, carbon monoxide, hydrogen cyanide (in the case of amino resins), and phenol (in the case of phenol-formaldehyde resins).

Precautions

1. Avoid resin systems using formaldehyde whenever possible.

397

2. Wear gloves when handling amino and phenolic resins. Follow mixing instructions carefully so that the resin is properly cured.

3. When fabricating the finished or cured resin in such a way that localized heating and decomposition can occur, make sure there is adequate local exhaust ventilation.

4. People who have become sensitized to formaldehyde will probably have to avoid these resins.

Epoxy Resins

Epoxy resins can be used for casting, laminating, and molding, and as adhesives. When mixed with stone dusts or metal dusts, they can produce sculpture with stone or metal-like appearances. Epoxy resins consist of two components: the epoxy resin itself and the hardeners, which are often amines. The reaction gives off heat, which can vaporize solvents and other components.

Hazards

1. Epoxy resins are moderately toxic skin and respiratory irritants and sensitizers. Resins containing diglycidyl ethers are probable human carcinogens, skin and eye irritants, and may damage the bone marrow.

2. Amine hardeners are moderately toxic by skin contact and highly toxic by inhalation. They are potent skin sensitizers and irritants, causing dermatitis in almost 50% of workers regularly exposed to them. They also can cause asthma, coughing, bronchospasm, and other respiratory difficulties. Other hardeners are also toxic.

3. Epoxy resins contain solvents of varying toxicity.

Precautions

1. Wear goggles and gloves when using epoxy resins.

2. Use with local exhaust ventilation, or work at a bench against a window with a window exhaust fan. If ventilation is not adequate, wear a NIOSH-approved organic vapor respirator for large amounts of epoxy resins.

3. If the epoxy system contains flammable solvents, follow the rules for preventing fires (see the flammable and combustible liquids section of Chapter 8).

Polyester Resins

Polyester resins are used for laminating, molding, and casting. For molding and laminating, fiberglass is the most commonly used reinforcement. In most polyester resins, styrene is used as the cross-linker; other cross-linkers include methyl methacrylate, vinyl toluene, and alpha-methyl styrene. Ketone solvents are sometimes included. Methyl ethyl ketone peroxide is the most common hardener, although benzoyl peroxide and cumene hydroperoxide are also sometimes used. Promoters or accelerators used with polyester resins include cobalt naphthenate and dimethylaniline.

Hazards

1. Styrene is moderately toxic by skin contact and highly toxic by inhalation. It is absorbed through the skin. Styrene is a probable human carcinogen, a potent narcotic, and a respiratory and eye irritant, causing coughing and burning of the eyes and nose. There is also some question whether it causes liver and nerve damage. It has good odor-warning properties initially, but olfactory fatigue may set in. Vinyl toluene and alpha-methyl styrene have toxicity similar to styrene. The toxicity of methyl methacrylate monomer was discussed under the acrylic resins section.

2. Cobalt naphthenate is moderately toxic by skin contact and inhalation, possibly causing allergies.

3. Dimethylaniline is highly toxic by skin absorption and inhalation, causing methemoglobinemia (in which the hemoglobin in the red blood cells is converted into a form that will not release oxygen), resulting in cyanosis. Primary symptoms are a bluish discoloration of the lips, ears, and nail beds, and, later, headaches, weakness, and oxygen starvation.

4. The hazards of peroxide catalysts are discussed later in the chapter.

5. Fiberglass is a skin and respiratory irritant. Inhalation of fiberglass dust created by cutting fiberglass or sanding the cured fiberglass-containing polyester can cause irritation and other respiratory problems.

6. Styrene, vinyl toluene, a-methyl styrene, and cleaning solvents such as methyl ethyl ketone are flammable. Acetone is extremely flammable.

Precautions

1. Wear gloves and protective goggles when pouring and handling polyester resins.

2. Use in a local exhaust hood or use a window exhaust fan with a NIOSH-approved organic vapor respirator. Large-scale polyester resin sculpture should be done in a large spray booth or while wearing a supplied-air respirator.

3. Clean up any spills immediately. Cover the work area with disposable paper towels or newspapers.

4. Do not use styrene for cleanup; instead, use acetone.

5. Wear clothing that covers the arms and legs and remove it immediately after work; then shower.

6. Wear a NIOSH-approved toxic dust respirator when cutting fiberglass or sanding the cured sculpture. If the sculpture has not completely cured, the respirator should also have organic vapor cartridges.

7. Cover exposed areas of the neck and face with a protective barrier cream.

8. Wear heavy neoprene rubber when handling dimethylaniline accelerator. Be very careful not to spill it on clothing, since it can go through the clothing.

9. Store flammable solvents safely. Do not use solvents or resin near an open flame or lit cigarette. Store solvent- or resin-soaked rags or paper in an approved self-closing waste disposal can that is emptied every day.

10. See the section on organic peroxides for precautions on handling peroxides.

Polyurethane Resins

Polyurethane resins can be used to make elastomers (e.g., coatings and molds), adhesives, and rigid or flexible foams. Normally these come in two-component systems, one consisting of the polyol and the other consisting of isocyanates, which are used to cross-link the polyol. The polyol also contains other components such as metal salts or amine catalysts. Foaming systems also contain blowing agents to make the polyurethane foam. These are commonly fluorocarbons (e.g., freons). Polyurethane elastomer resins can be one- or two-component systems. The one-component systems are air or moisture cured. Household urethane varnishes and paints do not contain isocyanates. They consist of the finished polyurethane dissolved in solvents, which dry by evaporation.

Hazards

1. Isocyanates are extremely toxic by inhalation, causing bronchitis, bronchospasm, chemical pneumonia, and severe acute and chronic asthma at

very low concentrations, even in people without a prior history of allergies. They also cause severe eye irritation. Methyl isocyanate was the chemical that killed over 2,500 people in Bhopal, India, when it escaped into the atmosphere several years ago.

The degree of hazard depends on the volatility of the diisocyanate and its physical form. TDI (toluene diisocyanate) is the most volatile and the most hazardous. MDI (diphenyl methane diisocyanate) is less volatile and, therefore, less hazardous than TDI. Polymeric isocyanates usually contain about 50% MDI. If heated or sprayed, any isocyanate is extremely hazardous. Note that isocyanates cannot be detected by odor until the concentration is many times higher than recommended levels. The TLVs for TDI and MDI are 0.005 ppm.

2. Amines used as catalysts are moderately toxic by skin or eye contact or inhalation, since they are sensitizers and irritants. They may cause asthma.

3. Organotin compounds used as catalysts are highly toxic by skin absorption, damaging the liver and nervous system. They may also cause skin allergies and irritation.

4. Fluorocarbon blowing agents used for foaming are slightly toxic by inhalation. They can cause narcosis at high concentrations, changes in the heart rhythm (arrhythmia), and even cardiac arrest at very high concentrations.

5. One-component polyurethane systems using precapped isocyanate polymers are less hazardous than the two-component systems due to low volatility, unless they are sprayed.

6. Dust from sanding and cutting finished polyurethane may cause skin and respiratory problems due to the presence of unreacted chemicals from the curing process.

7. Heating polyurethane is highly hazardous, since decomposition products include carbon monoxide, nitrogen oxides, acrolein, and hydrogen cyanide, all of which are highly or extremely toxic by inhalation.

Precautions

1. Do not work with polyurethane resins if you have any history of allergies such as asthma or other respiratory problems.

2. Do not spray polyurethane resins unless it is done inside a spray booth or you wear a supplied-air respirator (e.g., self-contained breathing apparatus).

3. Mix polyurethane resins in a local exhaust hood or wear a NIOSH-approved full-face gas mask with organic vapor canister or air-supplied respirator. Use an exhaust fan to remove the vapors from the room.

4. Wear gloves and goggles when handling polyurethane resins.

5. When sawing, sanding, or otherwise fabricating polyurethane, wear a NIOSH-approved respirator with organic vapor cartridges and toxic dust and mist prefilters.

Silicones and Natural Rubbers

Silicones and natural rubber can be used as sealants, adhesives, molds, and mold releases. There are two basic types of silicone resins: single-component systems that are cured by atmospheric moisture, and two-component systems that are cured by peroxides. These can contain solvents such as acetone or methylene chloride. Water-based natural rubber latex can also be used to make molds. Other rubber compounds are rubber cements or contact cements that contain rubber dissolved in solvents such as hexane, naphtha, and 1,1,1-trichloroethane. The rubber cements and latex rubbers dry by evaporation.

Hazards

1. Single-component silicones (including spray types) release acetic acid or methanol into the air. The acetic acid is irritating to the eyes and respiratory system. Methanol is a nervous system poison and is moderately toxic by inhalation.

2. The silicone resin in two-component systems is moderately toxic by skin contact, often containing irritating chemicals.

3. See the section on organic peroxides later in this chapter for the hazards of peroxides.

4. Natural rubber latexes contain chemicals that are skin irritants and can cause severe allergic reactions in some people.

5. n-Hexane, present in many rubber cements and contact adhesives, is extremely flammable and is highly toxic by chronic inhalation, causing damage to the nerves of the arms and legs.

6. Methylene chloride is highly toxic by inhalation. It may cause narcosis and changes in heart rhythm (arrhythmia). It is also converted into carbon monoxide in the body. Smokers and people with heart problems are especially at risk.

7. 1,1,1-trichloroethane is moderately toxic by inhalation. At very high concentrations (e.g., enclosed spaces), it can be fatal.

Precautions

1. Preferably use water-based or heptane-based rubber cements or contact adhesives.

2. Use rubber cements containing hexane with good ventilation to prevent buildup of vapors. Do not allow smoking or open flames when hexane or acetone is present. Store large amounts (greater than one pint) in approved safety containers.

3. People with heart problems should not use methylene chloride-containing products.

4. Wear gloves and goggles when handling silicone resins, rubber latex, or solvents.

5. See the section on organic peroxides below for precautions with these chemicals.

Organic Peroxides

Organic peroxides are commonly used as hardeners or catalysts (more accurately, initiators) for curing polyester, acrylic, and some types of silicone resins. Common peroxides used are benzoyl peroxide, methyl ethyl ketone peroxide (not to be confused with the solvent methyl ethyl ketone), and cumene hydroperoxide. Usually these peroxides come as liquids or pastes dissolved in materials such as dimethyl phthalate.

Hazards

1. All organic peroxides are highly flammable and often explosive. Benzoyl peroxide becomes a shock-sensitive explosive above 120°F (49°C) and explodes above 176°F (80°C). Methyl ethyl ketone peroxide (MEK peroxide) can be decomposed by sunlight and explodes above 230°F (110°C); it is extremely shock sensitive. These peroxides can also decompose explosively when mixed with materials such as mineral acids, plastic resin accelerators, and many combustible materials. MEK peroxide forms an explosive mixture with acetone.

2. MEK peroxide can cause blindness if splashed in the eyes. I know of several instances of this happening to artists. Cumene hydroperoxide is moderately toxic by skin and eye contact and may have cumulative effects. It may also cause allergies. Benzoyl peroxide is only slightly toxic by skin contact and somewhat more toxic by eye contact.

Precautions

1. Store peroxides separately from other combustible materials. Always keep in the original container. Never put in glass containers.

2. Do not store large amounts of organic peroxides or keep them for long periods of time.

3. Never dilute peroxides with other materials. Never add accelerators to peroxides or acetone to MEK peroxide.

4. Do not heat peroxides.

5. Use disposable paper cups and wooden sticks for mixing small amounts of resin and peroxide. Otherwise use polyethylene, glass, or stainless-steel containers.

6. Soak all tools and containers in water before disposing of them.

7. Clean up spills immediately by soaking up the peroxide with vermiculite if in liquid form, or with wet vermiculite if in powder or paste form. Do not sweep, since this has been known to start fires. Use nonsparking tools to clean up the peroxide/vermiculite mixture.

8. Do not discard unused peroxide or peroxide/vermiculite mixtures, since they might cause a fire or explosion. Peroxides can be disposed of by carefully reacting with 10% sodium hydroxide solution.

Finished Plastics

Plastic sheets, blocks, and film can be fabricated by cutting, drilling, carving, sawing, heating, vacuum forming, and a variety of other methods that use physical tools or processes. Examples of plastics that can be treated in this way include acrylic (Lucite, Plexiglas), polyvinyl chloride, polystyrene, polyethylene, and polypropylene. Foamed plastics (e.g., polystyrene and polyurethane) can also be sawed, sanded, and heated to form them into various shapes. Some plastics, such as polystyrene, polyvinyl acetate, and polyvinyl chloride, are available as molding pellets that can be heated in a mold. Plastics can also be glued with solvent cements or other adhesives.

Hazards

1. Some polymer dusts may cause irritation or allergies if inhaled due to the presence of an unreacted monomer of other additives. Examples are phenolic and amino plastics, acrylic powder, and polyurethane dusts.

2. Heat decomposition of finished plastics can result from processes such as hot wire cutting, electric sanding, drilling, and sawing. This can produce highly toxic gases such as carbon monoxide and monomers and, in some cases, nitrogen oxides and hydrogen cyanide.

3. Heating acrylic plastic results in decomposition to the monomer methyl methacrylate, a respiratory irritant, sensitizer, and narcotic (see the section on acrylic resins).

4. Heat decomposition of polyvinyl chloride (PVC) occurs above about 400°F (205°C), releasing highly toxic hydrogen chloride gas. This gas can cause a disease called "meatwrappers asthma," since it was first noticed among meatwrappers who cut PVC film with a hot wire.

5. Heat decomposition of foamed polystyrene (styrofoam) or polyurethane can release a large variety of highly toxic gases including nitrogen oxides, hydrogen cyanide, carbon monoxide, and monomers (e.g., styrene).

6. Heating polyfluorocarbons can cause polymer fume fever, a disease similar to metal fume fever, with symptoms of nausea, chills, fever, headaches, coughing, and shortness of breath. This is often caused by smoking a cigarette in the presence of fluorocarbon dust. The heat of the lit cigarette is high enough to decompose the fluorocarbon.

7. Many of the solvents used to cement plastics are highly toxic. Acrylic cements in particular commonly contain chlorinated hydrocarbons such as ethylene dichloride or methylene chloride. Both are probable human carcinogens and narcotics, especially ethylene dichloride, which can also cause liver and kidney damage. Methylene chloride is converted into carbon monoxide in the body and can cause heart arrhythmias. This is especially hazardous for smokers and people with heart problems.

Precautions

1. Have good general ventilation or local exhaust ventilation when fabricating plastics. Use water-cooled or air-cooled tools, if possible, to keep decomposition of the plastic to a minimum. In heat fabrication processes, use as low a temperature as possible to avoid decomposition of the plastic.

2. You may need an organic vapor respirator to work safely with acrylic plastics if you do not have adequate ventilation. Use a NIOSH-approved respirator with combination organic vapor/acid gas cartridges with PVC.

3. Sanders, saws, and other electric tools that generate a lot of dust should be equipped with dust-collecting attachments.

4. Clean up all dust carefully by vacuuming or wet mopping. Do not sweep.

405

5. Wear gloves and goggles when handling solvent cements. Use as low toxicity a solvent as possible, for example, acetone instead of chlorinated solvents.

Plastics Additives

Additives used with plastics and their resins include plasticizers, stabilizers (e.g., ultraviolet absorbers and antioxidants), colorants (dyes and pigments), fillers (e.g., talc, quartz, clay, fused silica), reinforcements (e.g., fiberglass), fire retardants, inhibitors, accelerators, and solvents. Some of these, especially plasticizers and inhibitors, are already in the resin when you buy it. You can add most of the others yourself.

Hazards

1. For mineral additives, see Table 5-1.

2. For pigments, see Table 12-1.

3. For dyes, see the dyes section of Chapter 21.

4. Organic phosphate esters are used as fire retardants and plasticizers. Many organic phosphate esters can be absorbed through the skin. Inhalation or ingestion may cause central nervous system damage, possibly leading to paralysis; nervous system stimulation leading to convulsions; or, sometimes, anesthetic effects. Some also act like mild nerve gases. They are skin, eye, and respiratory system irritants. Examples are tributyl phosphate, tri-orthocresyl phosphate (TOCP), and tri-para-cresyl phosphate. TOCP is one of the most toxic, possibly causing paralysis.

5. Phthalates are used as plasticizers and as a solvent for organic peroxides. One of the most common is dioctyl phthalate (DOP). This comes in two chemical forms: di-n-octyl phthalate and di (2-ethylhexyl) phthalate (DEHP). DEHP is a probable human carcinogen and should not be used. The di-n-octyl phthalate is less hazardous. Heated plasticizer vapors may cause slight eye and nose irritation. Ingestion of massive amounts may affect liver or kidneys.

Precautions

1. Avoid the most dangerous materials (e.g., asbestos, phosphate esters, DEHP).

2. Wear a NIOSH-approved toxic dust respirator when adding hazardous powdered materials to plastics resins.

406

REFERENCES

Hedeboe, J., Moller, L. F., Lucht, U., and Christensen, S. T. (1982). Heat generation in plaster-of-paris and resulting hand burns. *Burns* 9(1), 46-48.

Kronoveter, K. (1980). Rock dust exposure to a sculptor. In *Health Hazards in the Arts and Crafts. Proceedings of the SOEH Conference on Health Hazards in the Arts and Crafts.* Edited by M. McCann and G. Barazani. Washington, DC: Society for Occupational and Environmental Health.

Patty, F. (ed). (1982). *Industrial Hygiene and Toxicology.* Volume II. 3 parts. 3d ed. New York: Interscience Publishers.

Siedlicki, J. (1972). Potential hazards of plastics used in sculpture. *Art Education* (Feb.), 78.

Woodworking

T his chapter discusses the hazards not only of wood sculpture but also of furniture and cabinet making. Included are techniques such as carving, laminating, joining, sawing, sanding, paint removing, and painting and finishing.

WOOD HAZARDS

Wood sculpture and furniture making use a large number of different types of hard and soft woods, including many exotic tropical woods. Many of these woods are hazardous themselves. In addition, wood preservatives and pesticides used to treat wood are hazardous.

Hardwoods

Many hardwoods are commonly used in wood sculpture and furniture making. Many rare hardwoods are imported from tropical countries. In recent years, there

408

has been considerable controversy in the woodworking community about the ethics of using rare tropical hardwoods in sculpture because the market for them is contributing to deforestation in many parts of the world.

Hazards

1. The saps present in many green woods, and in lichens and liverworts present on the surface of freshly cut wood, can cause skin allergies and irritation from direct contact.

2. Many hardwood dusts, especially those from exotic woods, are common sensitizers and can cause allergic skin reactions. In addition, some hardwoods can cause allergic reactions in individuals working with or using finished hardwoods. Prolonged contact with rosewood, for example, which was used in making musical instruments, has caused allergic reactions in some musicians.

3. Contact with the dust of many hardwoods can cause conjunctivitis (eye inflammation), hay fever, asthma, coughing, and other respiratory diseases. Canadian and Western Red Cedar are examples.

4. Some hardwoods can cause hypersensitivity pneumonia (alveolitis), and frequent attacks can cause permanent lung scarring (fibrosis). Examples of these highly toxic woods include giant sequoia, cork oak, some maple woods, and redwood.

5. Some hardwoods contain chemicals that are toxic and can cause a variety of symptoms, including headaches, salivation, thirst, giddiness, nausea, and irregular heartbeat. A classic example is hemlock.

6. Inhalation of hardwood dust is associated with a particular type of nasal and nasal sinus cancer (adenocarcinoma). This type of cancer has a latent period of 40 to 45 years and occurs to the extent of about 7 in 10,000 among woodworkers who are heavily exposed. This rate is many times higher than the rate of nasal adenocarcinoma in the general population, which is normally very low. In fact, over half of all known cases of this type of cancer are found in woodworkers.

7. See Table 17-1 for the hazards of particular hardwoods. Hardwoods such as beech and oak have been assigned a Threshold Limit Value (TLV) of 1 mg/m^3.

Precautions

1. Whenever possible, use common hardwoods rather than rare tropical hardwoods.

2. If you have a history of allergies, you should avoid common sensitizing woods.

3. Do not use sensitizing woods for utilitarian objects where people would be in frequent contact with the wood.

4. Avoid inhalation of wood dusts by using local exhaust ventilation or wearing a National Institute for Occupational Safety and Health (NIOSH)-approved toxic dust respirator.

5. If you are handling woods that can cause skin irritation or allergies, wear gloves or apply a barrier cream. Wash hands carefully after work.

6. See also precautions for particular woodworking processes described below.

Softwoods

Softwoods, for example pine, are often used in furniture making. Domestic softwoods are the most common.

Hazards

1. Softwoods, in general, do not cause as high a frequency of skin and respiratory problems as do hardwoods. A few individuals, however, can develop allergic reactions to some softwoods.

2. It is not known whether softwood dust also causes nasal and nasal sinus cancer, since epidemiological studies involving softwoods have also involved exposure to hardwood dusts.

3. Softwoods have been assigned a TLV of 5 mg/m^3.

Precautions. See precautions listed for hardwoods.

Plywood and Composition Board

Plywood is made by gluing thin sheets of wood together with either urea-formaldehyde glues (for indoor use) or phenol-formaldehyde glues (for outdoor use). Composition board, for example, particleboard, is made by gluing wood dust and chips together with urea-formaldehyde resins. The materials can emit unreacted formaldehyde for some years after manufacture, with composition board emitting more formaldehyde. In addition, heating these materials or machining them can cause decomposition of the glue to release formaldehyde. In

the last few years, manufacturers of plywood and composition boards have tried to formulate them to reduce formaldehyde emissions. However, you often have to specify low-formaldehyde plywood to ensure that you get the proper product.

Hazards

1. Formaldehyde is highly toxic by inhalation, eye contact, and ingestion, and moderately toxic by skin contact. It is an irritant and strong sensitizer. Formaldehyde is a probable human carcinogen. Even trace amounts of free formaldehyde may cause allergic reactions in people who are already sensitized to it.

2. Machining, sanding, or excessive heating of plywood or composition board can cause decomposition, releasing formaldehyde, carbon monoxide, hydrogen cyanide (in the case of amino resins), and phenol (in the case of phenol-formaldehyde resins).

Precautions

1. Use low-formaldehyde products whenever possible.

2. Do not store large amounts of plywood or composition board in the shop, since it will emit formaldehyde. Instead store it in a ventilated area where people do not work.

3. Dust collectors connected to woodworking machines should be exhausted to the outside, since emitted formaldehyde will not be captured by dust collectors.

Wood Preservatives and Other Treatments

Pesticides and preservatives are often applied to wood when it is being timbered, processed, or shipped. Unfortunately, it is hard to find out what chemicals, if any, have been added. This is especially a problem with imported woods, since pesticides and wood preservatives banned in the United States and Canada are often used in other countries. Pentachlorophenol and its salts, creosote, and chromated copper arsenate (CCA), have been banned for sale in the United Sates as wood preservatives because of their extreme hazards. They can, however, still be found in older woods, and CCA is still allowed as a commercial treatment (e.g., "green" lumber, playground equipment, and other outdoor uses). It is supposed to be labeled. A variety of other chemicals can be used in treating wood, including fire retardants and bleaches.

411

Hazards

1. Pentachlorophenol is highly toxic by all routes of entry. It can be absorbed through the skin, cause chloracne (a severe form of acne) and liver damage, and is a probable human carcinogen and reproductive toxin. See Table 12-2.

2. Chromated copper arsenate is extremely toxic by inhalation and ingestion, and highly toxic by skin contact. It is a known human carcinogen and teratogen. Skin contact can cause skin irritation and allergies, skin thickening, loss of skin pigmentation, ulceration, and skin cancer. Inhalation can cause respiratory irritation and skin, lung, and liver cancer. Inhalation or ingestion may cause digestive disturbances, liver damage, peripheral nervous system damage, and kidney and blood damage. Acute ingestion may be fatal.

3. Creosote has a tarry look and is also used for outdoor wood. It is a strong skin and respiratory irritant and is a probable human carcinogen and teratogen.

4. Zinc and copper naphthenate are slight skin irritants; copper naphthenate is moderately toxic by ingestion. If suspended in solvents, the solvent would be the main hazard.

Precautions

1. Obtain Material Safety Data Sheets (MSDSs) on all chemicals being used in wood treatment. Treated wood itself does not have MSDSs, so you have to try to find out about any treatments from the supplier. In the United States, CCA-treated wood is required to have a label and information on safe handling.

2. Do not handle woods that have been treated with pentachlorophenol or creosote. Avoid scrap or old woods of unknown origin.

3. Do not saw, sand, or otherwise machine CCA-treated wood, if at all possible. If you do, use with local exhaust ventilation or wear a NIOSH-approved respirator with high-efficiency (HEPA) filters.

4. If you add wood preservatives yourself, use zinc or copper naphthenates, if possible.

5. Do not burn wood that has been treated with creosote, pentachlorophenol, or chromated copper arsenate.

412

Carving and Machining Wood

Woods can be hand carved with chisels, rasps, files, hand saws, sandpaper, and the like, or they can be machined with electric saws, sanders, drills, lathes, and other woodworking machines.

Hazards

1. As discussed in the section on wood hazards, many wood dusts are hazardous by skin contact or inhalation. See Table 17-1.

2. Woodworking machines are often very noisy, with noise levels ranging as high as 115 dB. This can cause permanent hearing loss with long-term exposure. The noise is often increased with old machinery with worn parts and poor maintenance. See the noise section of Chapter 10.

3. Woodworking machinery and tools also present physical hazards from accidents. Machinery accidents are often due to missing machine guards, faulty equipment, or using the wrong type of machine for a particular operation. Tool accidents are often caused by dull tools or improper use. See the machine and tool safety section of Chapter 10 for more information.

4. Vibrating tools, for example, chain saws, can cause "white fingers" (Raynaud's phenomenon) involving numbness of the fingers and hands. This can lead to permanent damage. See the ergonomics section of Chapter 10.

5. Electrical equipment can also present electrical shock and fire hazards from faulty or inadequate wiring. See the electrical safety section of Chapter 10.

6. Sawdust and wood are fire hazards. In addition, fine sawdust is an explosion hazard if enclosed.

Precautions

1. Equip woodworking machines that create substantial amounts of sawdust with dust collectors. Portable dust collectors are available that can connect to several machines. A possible alternative is to connect the machine being used to an industrial vacuum cleaner. Make sure there is as tight a connection as possible from the dust collector duct to the machine.

2. If you cut or machine particleboard or plywood, the dust collector should be located outside.

3. Wear a NIOSH-approved toxic dust respirator when it is not possible to use a local exhaust system.

4. Vacuum all sawdust after work; avoid dry sweeping. Clean wood dust from around and inside machines to avoid fire hazards.

5. Wear goggles when using machines that create dust. For lathes and similar machines that may produce wood chips, use a face shield and goggles, and make sure that the machines are properly shielded.

6. Shield noisy machines whenever possible. Mount the machinery with vibration isolators (like shock absorbers), and keep all machinery in good working condition. Replace old, noisy machinery whenever possible. Ear plugs or muffs may be necessary if these measures do not work.

7. Make sure that all woodworking machines are equipped with proper guards to prevent accidents. Use the proper machine for particular operations and repair defective machines immediately. Do not wear ties, long loose hair, loose sleeves, necklaces, or other items that could catch in the machinery.

8. Keep hand tools sharpened, and cut away from your body. Do not place your hands in front of the tool.

9. The woodshop should be equipped with panic buttons that can shut off all machines immediately in an emergency.

10. Keep all electrical equipment and wiring in good repair, and avoid extension cords that can be tripped over and are electrical hazards.

Gluing Wood

A variety of glues is used for laminating and joining wood. These include contact adhesives, casein glue, epoxy glues, formaldehyde-resin glues (e.g., formaldehyde-resorcinol), hide glues, white glue (polyvinyl acetate emulsion), and the cyanoacrylate "instant" glues.

Hazards

1. *Epoxy glues:* These are moderately toxic by skin and eye contact, and by inhalation. Amine hardeners (as well as other types of hardeners) can cause skin allergies and irritation in a high percentage of the people using them. Inhalation can cause asthma and other lung problems.

2. *Cyanoacrylate glues*: These are moderately toxic by skin or eye contact. They can glue the skin together or glue the skin and other materials together, sometimes requiring surgical separation. Eye contact can cause se-

vere eye irritation. Their long-term hazards are not well studied, especially with respect to inhalation.

3. *Formaldehyde-resin glues*: Resorcinol-formaldehyde and urea-formaldehyde glues are highly toxic by eye contact and by inhalation, and moderately toxic by skin contact. The formaldehyde can cause skin and respiratory irritation and allergies, and is a known human carcinogen. The resin components may also cause irritation. Even when cured, any unreacted formaldehyde may cause skin irritation, and sanding may cause decomposition of the glue to release formaldehyde. Formaldehyde can be a problem when working with fiberboard and plywood.

4. *Contact adhesives*: Extremely flammable contact adhesives contain hexane, which is highly toxic by chronic inhalation, causing peripheral nerve damage. Other solvents in contact adhesives are mineral spirits or naphtha, and 1,1,1-trichloroethane (methyl chloroform), which are moderately toxic by skin contact, inhalation, and ingestion.

5. *Water-based glues*: Water-based contact adhesives, casein glues, hide glues, white glue (polyvinyl acetate), and other water-based adhesives are slightly toxic by skin contact and not significantly or only slightly toxic by inhalation or ingestion.

6. *Dry casein glues*: These are highly toxic by inhalation or ingestion and moderately toxic by skin contact, since they often contain large amounts of sodium fluoride and strong alkalis.

Precautions

1. Avoid formaldehyde-resin glues because of the carcinogenicity of formaldehyde.

2. Use water-based glues rather then solvent-type glues whenever possible.

3. Wear gloves or barrier creams when using epoxy glues, solvent-based adhesives, or formaldehyde-resin glues.

4. Epoxy glues, cyanoacrylate glues, and solvent-based glues should be used with good dilution ventilation, for example, a window exhaust fan. Large amounts of these glues would need local exhaust ventilation.

5. When using solvent-based glues—particularly those with flammable solvents—do not smoke or allow open flames in the studio. Eliminate other sources of ignition in the room.

6. Wear gloves, goggles, and a NIOSH-approved toxic dust mask when mixing dry casein glues.

Paint Stripping

Stripping old paint and varnish from wood and furniture is done with paint and varnish removers containing a wide variety of solvents. One major class of paint and varnish removers formerly contained benzol (benzene). Now the benzene has been replaced with toluene. "Nonflammable" paint strippers contain methylene chloride. They may also contain many other solvents, including acetone, glycol ethers, methyl alcohol, and acetates. In recent years, a safer paint stripper based on dimethyl adipate has been developed by 3M Company. Caustic soda, acids, blowtorches, and heat guns are also used to remove old paint. Old stains on wood are often removed with bleaches, which can contain caustic soda, hydrogen peroxide, oxalic acid, or hypochlorite.

Hazards

1. Methylene chloride is highly toxic by inhalation and moderately so by skin contact. It is converted to carbon monoxide in the body and can cause changes in heart rhythm and possible fatal heart attacks. Smokers and people with heart problems are especially at risk. Methylene chloride is also a probable human carcinogen.

2. Many of the other solvents used in paint strippers are highly or moderately toxic by inhalation, ingestion, and skin contact and/or absorption. In addition to the hazards of specific solvents, most solvents can also cause narcosis if inhaled (dizziness, fatigue, loss of coordination, nausea). Many of these solvents are also flammable. See the solvents section of Chapter 4 and Table 4-4.

3. Caustic soda used in some bleaches and for paint stripping is highly corrosive by skin or eye contact, causing severe burns. Similarly, oxalic acid is corrosive. Concentrated hydrogen peroxide used in some bleaches is moderately toxic by skin or eye contact. Hypochlorite (chlorine-type) bleaches are moderately toxic by skin contact or inhalation. Mixtures of chlorine bleaches and ammonia are highly toxic by inhalation, possibly being fatal.

4. Heat guns and torches can vaporize the paint. There have been many cases of lead poisoning from using torches, and even heat guns, to remove lead-based paint.

Precautions

1. Dimethyl adipate paint strippers are safer than other solvent types because of their high boiling point, which means that little evaporates.

416

2. Volatile, solvent-based paint strippers should preferably be used outside, unless only small amounts of stripper are being used. If used indoors, be sure to have good dilution ventilation (e.g., window exhaust fan). In enclosed spaces, or if there is not adequate ventilation, use a NIOSH-approved respirator with organic vapor cartridges.

3. Do not smoke or have open flames or other sources of ignition (e.g., pilot light) in the room if you are using flammable solvents. Solvent-soaked rags should be placed in an approved, self-closing waste disposal can that is emptied each day.

4. Wear gloves and goggles when handling caustic soda (sodium hydroxide), oxalic acid bleaches, or chlorine-type bleaches. An eyewash fountain and emergency shower should be available.

5. Avoid using torches to remove paint. Do not use heat guns if the paint contains lead.

Painting and Finishing

Wood can be painted with most types of paint (see the painting section of Chapter 12); stained, lacquered, or varnished; or oiled with linseed oil, tung oil, or other types of oil. Other materials that are used in finishing wood include shellacs, polyurethane coatings, and waxes. Some woodworkers mix their own paints from dry pigments.

Hazards

1. Mixing paint from dry pigment can lead to possible inhalation of the pigment powder or accidental ingestion. In particular, lead chromate pigments are extremely toxic due to the risk of lung cancer. See the pigments section of Chapter 12.

2. Solvent-based paints, waxes, polyurethane varnishes, and wood stains commonly contain mineral spirits or turpentine, which are moderately toxic by skin contact, inhalation, and ingestion. Some wood stains might also contain wood preservatives.

3. Water-based paints usually contain 5 to 10% solvents to help dissolve the plastic resins. These solvents include ethylene glycol, propylene glycol, and the more toxic glycol ethers. Ethylene glycol is moderately toxic by ingestion, but the amount present is small enough to make the risk negligible.

4. Shellac usually contains ethyl alcohol, which is slightly toxic by skin contact and inhalation, and sometimes methyl alcohol, which is moderately

toxic by skin absorption and inhalation. Lacquers can contain more toxic solvents such as toluene, and hexane.

5. Most of the solvents used in varnishes, lacquers, and shellacs are flammable. Paints, waxes, and polyurethane coatings based on mineral spirits are combustible.

6. Tung oil, linseed oil, and most other oils have no significant hazards, although a few people might develop allergies to them.

Precautions

1. Use ready-made paints rather than mixing your own. Do not eat, drink, or smoke in the area where painting is done.

2. Use water-based paints rather than solvent-based ones if possible. Use latex paints containing ethylene glycol or propylene glycol rather than glycol ethers.

3. Use shellacs containing denatured (ethyl) alcohol rather than ones containing methyl alcohol.

4. Wear gloves and goggles when painting or finishing.

5. Have dilution ventilation (e.g., window exhaust fan) or do the finishing outside. If ventilation indoors is not adequate, wear a NIOSH-approved respirator with organic vapor cartridges.

6. Finishes should be sprayed inside an explosion-proof spray booth, or you should wear a NIOSH-approved respirator with organic vapor cartridges and dust and mist filters. Touchup with spray cans could be done outdoors. Brush on materials, whenever possible, to avoid the hazards of spraying.

7. Avoid open flames, lit cigarettes, and other sources of ignition in the room when applying flammable finishes, or when spraying.

8. Place oil-soaked rags in an approved oily waste can and empty daily.

TABLE 17-1. Toxic Woods

Wood	Reaction	Site	Potency	Source	Incidence
Bald cypress	S	R	+	D	R
Balsam Fir	S	E,S	+	LB	C
Beech	S,C	E,S,R	++	LB,D	C
Birch	S	R	++	W,D	C
Black locust	I,N	E,S	+++	LB	C
Blackwood	S	E,S	++	D,W	C

Wood	Reaction	Site	Potency	Source	Incidence
Boxwood	S	E,S	++	D,W	C
Cashew	S	E,S	+	D,W	R
Cocobolo	I,S	E,S,R	+++	D,W	C
Dahoma	I	E,S	++	D,W	C
Ebony	I,S	E,S	++	D,W	C
Elm	I	E,S	+	D	R
Goncalo aves	S	E,S	++	D,W	R
Greenheart (Surinam)	S	E,S	+++	D,W	C
Hemlock	C	R	?	D	U
Iroko	I,S,P	E,S,R	+++	D,W	C
Mahogany (Swietenia)	S,P	S,R	+	D	U
Mansonia	I,S	E,S	+++	D,W	C
	N		+	D	
Maple (C. Corticale mold)	S,P	R	+++	D	C
Mimosa	N		?	LB	U
Myrtle	S	R	++	LB,D	C
Oak	S	E,S	++	LB,D	R
	C		?	D	U
Obeche	I,S	E,S,R	+++	D,W	C
Oleander	DT	N,C	++++	D,W,LB	C
Olivewood	I,S	E,S,R	+++	D,W	C
Opepe	S	R	+	D	R
Padauk	S	E,S,N	+	D,W	R
Pau ferro	S	E,S	+	D,W	R
Peroba rosa	I	R,N	++	D,W	U
Purpleheart		N	++	D,W	C
Quebracho	I	R,N	++	D,LB	C
	C		?	D	U
Redwood	S,P	R,E,S	++	D	R
	C		?	D	U
Rosewoods	I,S	R,E,S	++++	D,W	C
Satinwood	I	R,E,S	+++	D,W	C
Sassafras	S	R	+	D	R
	DT	N	+	D,W,LB	R
	C		?	D	U
Sequoia	I	R	+	D	R
Snakewood	I	R	++	D,W	R
Spruce	S	R	+	D,W	R
Walnut, Black	S	E,S	++	D,S	C
Wenge	S	R,E,S	++	D,W	C
Western red cedar	S	R	+++	D,LB	C
Willow	S	R,N	+	D,W,LB	U
Teak	S,P	E,S,R	++	D	C
Yew	I	E,S	++	D	C
	DT	N,C	++++	D,W	C
Zebrawood	S	E,S	++	D,W	R

Reaction	Site	Potency	Source	Incidence
I irritant	S skin	+ Slight probability	D dust	R rare
S sensitizer	E eyes	++ Moderate probability	W wood	C common
C nasopharyngeal	R respiratory	+++ High probability	LB leaves,	U unknown
cancer	C cardiac	++++ Extreme probability	bark	
P pneumonitis,	N nausea,			
alveolitis	malaise			
(hypersensitivity				
pneumonia)				
DT direct toxin				

Source: This chart is reprinted with the permission of its author, Robert Woodcock, R.N., B.S.N., C.E.N.

▓▓▓ REFERENCES

Canadian Centre for Occupational Health and Safety. (1988). *Infograms on Hand Tools.* 16 pp. Hamilton, Ontario, Canada: CCOHS.

Canadian Centre for Occupational Health and Safety. (1988). *Infograms on Powered Hand Tools.* 11 pp. Hamilton, Ontario, Canada: CCOHS.

Canadian Centre for Occupational Health and Safety. (1988). *Infograms on Woodworking Machines.* 10 pp. Hamilton, Ontario, Canada: CCOHS.

Fink, T. J. (1990). Chemical hazards of woodworking. *Fine Woodworking* (Jan./Feb.), 58-63.

International Labor Office. (1983) E*ncyclopedia of Occupational Safety and Health.* 2 vols. 3d ed. Geneva, Switzerland: ILO.

Lampe, K., and McAnn, M. (1985). *AMA Handbook of Poisonous and Injurious Plants.* Chicago, IL: American Medical Association.

Poisondex. (1990). Denver, CO: Micromedix Inc.

Wills, J. H. (1982). Nasal cancer in woodworkers: A review. *J. Occup. Med.* 24(7), 526-30.

Woods, B., and Calnan, C. D. (1976). Toxic Woods. *Br. J. Dermat.* 9513, 1-97.

Metalworking

This chapter discusses the hazards of and precautions for the various types of metal sculpture and metalworking techniques. These include metal casting, welding, brazing, soldering, forging, metal fabrication, and surface treatment of metals.

WELDING, BRAZING, AND SOLDERING

Welding techniques discussed here include oxyacetylene welding, various arc welding techniques, brazing, silver or hard soldering, and soft soldering.

Because of the high hazards of many welding techniques, it is recommended that at least one teacher at schools and colleges teaching welding be certified in welding by the American Welding Society (AWS), which offers welding courses several times a year around the country.

421

Oxyacetylene Welding

An oxyacetylene torch can produce temperatures as high as 6,300°F (3,500°C) and can be used for welding or cutting metals such as mild steel, stainless steel, bronze, aluminum, copper, nickel silver, and many other metals and alloys. The oxygen and acetylene come in cylinders under high pressure.

The welding process itself produces carbon dioxide, carbon monoxide, unburned acetylene, and, in some cases, nitrogen oxides. The welding flame produces intense visible light and some ultraviolet radiation, and the molten and heated metals produce infrared radiation.

Many metals require fluxes for welding, many of which contain fluorides, and the welding process produces metal fumes from the metals that are being welded and from the welding rods.

Fire Hazards

1. Oxygen and acetylene cylinders are very hazardous because of the possibility of fire and explosion. Acetylene is a flammable gas, and oxygen supports combustion.

2. The welding process is a fire hazard because of the high temperatures and open flame, which can easily cause combustible materials to catch fire.

Fire Precautions

1. See the section on oxygen and flammable gases in Chapter 8 for detailed precautions for the storage and handling of compressed gases. See also the manufacturer's recommendations for the use of torches.

2. The welding surface should be fireproof, preferably made of steel or firebrick. Do not use asbestos sheeting.

3. Wooden floors and walls should be covered with fireproof materials. All combustible materials or flammable liquids should be removed or protected.

4. Do not weld on containers that have held combustible or flammable materials without first exercising the proper precautions recommended by the American Welding Society.

Cylinder Precautions

1. See section on oxygen and flammable gases in Chapter 8 for information on storage and handling of compressed gas cylinders.

422

2. Do not move cylinders unless the valve protection cap is in place. Do not drop or abuse cylinders in any way.

3. Make certain that cylinders are fastened in place so that they will not fall.

4. Make sure hoses are located where they will not get tangled or be tripped over. Protect the hose and cylinders from flying sparks, molten splashes, hot objects, and open flame.

5. Do not allow the hose or valves to come in contact with oil or grease. These can affect the rubber and can cause fires.

6. Be sure that all connections between the regulators, adapters, and cylinder valves are gas tight. Escaping acetylene can generally be detected by the odor. Test with nonfat soapy water or an approved leak-detection solution, never with an open flame.

7. Only use proper wrenches to open valves. Never force connections which do not fit. Never tamper with or try to repair cylinder safety devices.

8. Stand to one side away from the regulator face when opening cylinder valves. Open cylinder valves slowly, using approved keys or handwheels. Do not force. Oxygen cylinders should be opened fully, but acetylene cylinder valves should only be turned a maximum of 1 1/2 times. Leave key wrenches attached to the cylinder so they can be closed quickly. Never use acetylene at pressures in excess of 15 psi. The use of higher pressures is prohibited by all insurance authorities and by law in many localities.

9. Before lighting the torch, purge the lines to remove any mixed gases. To purge, open each torch valve in turn for one second for each 10 feet (3 meters) of hose. Purge lines before using and after shutdowns of more than half an hour.

10. To light a torch, open the torch fuel gas valve about one-quarter turn. Immediately light with friction spark lighters, stationary pilot flames, or some other suitable source of ignition; do not use matches, hot metal, or welding arc. Increase fuel gas flow until flame stops smoking; open torch oxygen valve and adjust flame to desired level.

11. Do not relight a torch that has "blown out" without first closing both torch valves and then relighting properly.

12. Do not hang a torch with its hose on cylinder regulators or valves.

13. When welding or cutting is to be halted for a few minutes, close the torch fuel gas valve, and then the torch oxygen valve (check manufacturer's recommendations).

423

14. To close down the torch for extended periods, close the torch valves as described above. Close the fuel gas cylinder valve, and then the oxygen cylinder valve. Drain the fuel gas line by opening the torch fuel gas valve, and closing it after both gauges have fallen to zero (0). Repeat with the oxygen line. Release the pressure-adjusting screws.

15. In case of flashback or backfire, shut the torch oxygen valve first to cut off the oxygen feeding the internal flame, and then shut the torch fuel gas valve. In case of flashback fires, close the cylinder valves and then extinguish the fire. Flashback arrestors are recommended as a preventive measure.

Safety Hazards

1. Hot metal, flying sparks, and infrared radiation can cause severe thermal burns on exposed skin.

Safety Precautions

1. Wear protective leather gloves, long-sleeved 100% wool or flame-retardant cotton shirts and pants, and a leather apron to protect against flying sparks, hot metal, and infrared and ultraviolet radiation. Synthetic fabrics should not be used because they are often flammable, and molten splashes could cause the fabric to melt. Clothing should not have any cuffs, pockets, or other folds in which sparks can be trapped.

2. Wear hightop leather boots that do not have rubber or crepe soles that could burn. If you are handling heavy pieces of metal, the shoes should have safety toes and be American National Standards Institute (ANSI)- or Canadian Standards Association (CSA)-approved.

Health Hazards

1. Ultraviolet radiation may cause skin cancer, eye damage, and sunburn. Oxyacetylene welding does not produce intense amounts of ultraviolet radiation, compared to arc welding. Ultraviolet light from welding will react with chlorinated hydrocarbons (e.g., perchloroethylene, 1,1,1-trichloroethane) to form the poisonous gas phosgene, which is extremely toxic by inhalation.

2. The intense visible light can cause eye strain, resulting in headaches, inflammation, and other temporary painful symptoms.

3. Infrared radiation can cause skin burns, chronic eye inflammation, and heat cataracts due to burning of the lens of the eye.

4. Carbon dioxide and unburned acetylene can act as asphyxiants by cutting off the normal supply of oxygen to the lungs if these gases have a chance to build up in concentration. This can occur in enclosed places. Acetylene also contains small amounts of toxic impurities.

5. Carbon monoxide is highly toxic by inhalation, since it binds to the hemoglobin in the blood and deprives the body of oxygen.

6. Fluoride flux fumes are highly toxic by inhalation, causing severe respiratory irritation and possible chemical pneumonia at high concentrations. Chronic exposure may cause nosebleeds and affect the bones and teeth (osteofluorosis).

7. Copper and zinc fumes, as well as those of iron, nickel, magnesium, and other metals, can cause metal fume fever when inhaled. This has also been called the zinc shakes. Symptoms of fever, chills, dizziness, nausea, and pain appear several hours after exposure and last for 24 to 36 hours. This is a moderate hazard. There do not appear to be any long-term effects.

8. Many metal fumes emitted by the metal being welded or the welding rods are highly toxic by inhalation. These include lead, cadmium (which can be fatal from a single exposure), manganese (which may cause a disease similar to Parkinson's disease), chromium, beryllium, and nickel (which can form the extremely toxic gas nickel carbonyl). Cadmium, chromium, nickel, and beryllium may cause cancer (see Table 5-2).

9. Welding of found metals may also be highly hazardous if they are coated with lead- or mercury-containing paints, if they are chromium or cadmium plated, or if they are of unknown composition.

10. Some metal dusts and fumes may cause skin irritation and allergies. These include brass dust, cadmium, nickel, titanium, and chromium.

Health Precautions

1. Wear welding goggles with a shade number of 4 to 8, depending on the intensity of the welding. Use the darkest shade number consistent with viewing ability.

2. Do not store chlorinated hydrocarbons where ultraviolet light from welding can reach them.

3. Know the composition of the metals and welding rods you use, so you can evaluate the hazards.

4. Natural ventilation should be used only if (a) you are not producing fumes of fluorides, zinc, lead, beryllium, cadmium, mercury, or other highly toxic metals; (b) you have at least 10,000 cubic feet (283 cubic meters) per welder; (c) the ceiling is greater than 16 feet (5 m); and (d) you are not welding in an enclosed space. (This precaution is from ANSI Z49.1-1983, "Safety in Welding and Cutting.")

5. Dilution ventilation should be at least 2,000 cubic feet (57 cubic meters) per minute per welder. Note that dilution ventilation is not adequate for fumes of highly toxic substances (e.g., lead, cadmium, nickel, zinc, fluorides). In these cases, use a local exhaust system or air-supplied respirator. For situations in which the metals used can vary (e.g., schools), use local exhaust ventilation.

6. Local exhaust systems for welding are commonly of two types: those with a movable hood with a flange, and those with slot hoods with side shields surrounding the welding operation. Both of these require a ventilation rate such that there is an airflow of 100 feet (30 m) per minute in the direction of the hood at the point of welding. Slot hoods are good for small-scale bench welding, and movable hoods for larger-scale welding.

7. If you cannot provide local exhaust ventilation and require it, you can use a National Institute for Occupational Safety and Health (NIOSH)-approved air-supplied respirator. For brief welding periods, you can use a NIOSH-approved respirator with dust, mist and fume filters.

Arc Welding

Metal electrode arc welding and inert gas-shielded arc welding produce temperatures much higher than oxyacetylene welding, on the order of 10,000°F (5,500° C). As a result, there is a much larger production of ultraviolet light, visible light, infrared radiation, heat, sparks, metal fumes, and nitrogen oxides (for metal electrode arc welding). Inert gas-shielded arc welding also produces large amounts of ozone. Arc welding electrodes are flux coated and often contain fluorides, manganese, chromium, and other toxic ingredients. Plasma arc welding can be much more dangerous than other types of electric welding because of the much higher temperatures achieved.

Safety Hazards

1. There is an increased risk of fire, thermal burns from sparks, and heat stress in arc welding.

2. Arc welding has a high risk of electric shock due to the large electric currents used.

Safety Precautions

1. Wear appropriate protective clothing, as discussed in the previous section. You should also wear leather leggings and sleeves.

2. See the fire safety section under oxyacetylene welding for precautions against fire.

3. For general information on electrical safety, see Chapter 10.

4. Electric arc welders should be installed and grounded according to the manufacturer's instructions.

5. Cables and connectors should be of proper size for the amperage, regularly inspected and properly secured so they won't come loose. The cables should be covered so sparks cannot contact them.

6. Electrode holders should be regularly inspected for damage to cables and insulation, and for loosened screws. Welding lead and return cables should be appropriately sized for the maximum welding amperage and adequately secured to the work.

7. To protect against electrical shock, never allow the metal electrode, any metal part of the electrode holder, or electrode insulation to contact your bare skin or a wet body covering.

Health Hazards

1. The greater amounts of ultraviolet, visible, and infrared radiation produced in arc welding greatly increase the hazards from radiation. In particular, eye damage from ultraviolet light is very common among arc welders, as shown by the common term "arc eye."

2. Ozone is highly toxic by inhalation, with even short exposures at low levels causing severe lung irritation, congestion, and possible chemical pneumonia. Exposure to larger amounts of ozone can be fatal. Long-term exposure can cause chronic bronchitis and premature aging of lung tissue.

3. Nitrogen dioxide is highly toxic by inhalation, causing chemical pneumonia from large acute exposures. Chronic exposure can cause emphysema. Nitrogen dioxide has poor odor-warning properties.

4. Arc welding produces larger amounts of metal fumes than oxyacetylene welding due to the higher temperatures. This increases the risk of poisoning by inhalation.

5. Manganese and fluoride fumes from coated electrodes are highly toxic by inhalation, as discussed in the previous section on oxyacetylene welding. Chromates may cause lung irritation, allergies, nasal septum ulceration, and lung cancer.

6. Plasma arc welders can produce much higher concentrations of ozone, nitrogen dioxide, and metal fumes than other types of electrical welding. They also produce high noise levels.

Health Precautions

1. Place fireproof ultraviolet radiation screens around arc welding units if other people are present in the same area. Walls can be coated with zinc oxide paint to cut down on reflection of ultraviolet radiation from the walls. Leave at least 20 inches (50 cm) clear at the bottom of the screen for ventilation.

2. Wear a welding helmet over impact-resistant flash goggles (to protect your eyes when you inspect your work against accidentally striking an arc or against other welding going on). The shade numbers of the goggles and helmet should add up to 10 to 14, depending on the electrode size and type of arc (see Table 9-2). In general, use the darkest shade number consistent with viewing ability.

3. Provide ventilation as discussed in the previous section. If general ventilation is being used, you will require rates of greater than 2,000 cubic feet (57 cubic meters) per minute if electrodes greater than $3/16$ inch (4.8 mm) in diameter or flux-coated electrodes greater than $1/8$ inch (3.2 mm) are used. (See ANSI Z49.1-1973, "Safety in Welding and Cutting.") Preferably, use local exhaust ventilation such as a movable exhaust, slot hood, or downdraft table.

4. Do not use plasma arc welders unless you have local exhaust ventilation or a supplied-air respirator.

FOUNDRY

The steps involved in making metal sculpture using foundry techniques include pattern making, mold making, burning out the pattern, metal casting, and breaking the mold to release the metal cast.

Pattern Making

The lost wax process uses a wax pattern, which is burned out once the mold is made. The foam vaporization process uses polystyrene or polyurethane patterns, which are vaporized when the molten metal is poured into the mold. Patterns can

also be made out of wood, plaster, and other materials. A negative mold is then made out of plaster or polyurethane casting resin, and the final positive wax or foam pattern is made by casting into the negative mold. The hazards of making these patterns, along with suitable precautions, are discussed in Chapter 16 on sculpture and Chapter 17 on woodworking. Polyurethane molds are discussed in the plastics section of Chapter 16.

Mold Making

To produce sand molds or cores that can withstand molten metal, sand is mixed with various binders, including water and glycerin or linseed or other oils, which are baked with the sand. Various cold-setting resins, such as phenol-formaldehyde, can also be used. Many of the sands used are high in silica. The sand and binders are usually mixed in a muller.

Investment molds use investment plaster that contains silica flour or cristobalite (a form of silica), plaster, grog, (fired clay), and clay. The containers for investment molding have sometimes been lined with asbestos sheeting. Shell molds use silica solutions, zircon, fused silica, and sometimes ethyl silicate as slurries. The resulting mold is heated in a kiln to form the ceramic shell. The wax pattern is then burned out in a furnace.

Mold releases include French chalk, finely powdered graphite, and silica flour. Asbestos has been used in the past.

Hazards

1. High-silica sands, silica flour, and investment plasters are highly toxic by inhalation, possibly causing silicosis. This is a hazard only in powder form.

2. The formaldehyde in phenol-formaldehyde and similar resins are moderately toxic by skin contact and extremely toxic by inhalation. Formaldehyde can cause skin and respiratory irritation and allergies and is a known human carcinogen. Hexamethylenetetramine used in some formulations may cause skin allergies and irritation by decomposing to formaldehyde. See amino and phenolic resins in Chapter 16.

3. Polyurethane casting resins release isocyanates, which are highly toxic by inhalation, causing severe respiratory irritation and asthma. See polyurethane resins in Chapter 16.

4. Asbestos inhalation may cause asbestosis, lung cancer, mesothelioma, and stomach and intestinal cancer. French chalk may contain substantial amounts of free silica and asbestos.

429

5. Ethyl silicate is highly toxic by inhalation or eye contact, possibly causing irritation and liver and kidney damage.

Precautions

1. Use foundry sand for sand molds instead of fine, high-silica sands, whenever possible.

2. When mixing powdered silica-containing materials, use local exhaust ventilation. This can consist of a movable exhaust hood or a semicircular slot hood that wraps around the top of the muller or mixer. If local exhaust ventilation is not available, wear a NIOSH-approved toxic dust respirator.

3. Avoid formaldehyde and polyurethane resins if possible. If you use these resins, wear gloves and goggles and have local exhaust ventilation. If the ventilation is not available, wear a NIOSH-approved respirator with organic vapor cartridges and toxic dust filters.

4. Use ethyl silicate with good dilution ventilation. If you can smell it, you need better ventilation.

5. Do not use asbestos, silica flour, or French chalk of unknown compositions. For mold releases, use graphite, an asbestos-free talc, or other safer mold releases.

Burnout of the Pattern

Wax patterns are burned out in a furnace or with a torch before the molten metal is poured into the mold. Foam patterns are vaporized when the molten metal is poured into the mold.

Hazards

1. Burnout of the wax produces large amounts of smoke consisting of highly toxic carbon monoxide and wax decomposition fumes, which are highly irritating to the eyes and respiratory system.

2. Foam vaporization can produce a wide variety of toxic gases, including styrene, carbon monoxide, and hydrogen cyanide.

Precautions

1. Wax burnout must be ventilated by a local exhaust system (e.g., a canopy hood over the burnout furnace).

2. See the section on pouring the metal below for precautions with foam vaporization.

Melting the Metal

Metals commonly used for casting include bronze, brass, aluminum, and iron. Pewter, Britannia or white metal, silver, gold, and lead are used for jewelry and small-scale casting (see Chapter 19). Lead is often found in bronze, and lead and zinc are often added to bronze. The metals are melted in a crucible furnace. These can be bought commercially or assembled from 55-gallon drums lined with refractory materials. As fuel, the furnace can use natural gas from gas mains, propane from portable tanks, coke, or coal. Electric furnaces can also be used.

Hazards

1. The crucible furnace produces large amounts of carbon dioxide and carbon monoxide from burning the fuel. Carbon monoxide is highly toxic by inhalation.

2. Natural gas and bottled propane gas are fire and explosion hazards.

3. Lead fumes from lead metal and bronze are highly toxic by inhalation due to the possibility of lead poisoning. Zinc fumes from bronze and brass are moderately toxic by inhalation, causing metal fume fever (also known as zinc shakes and foundry ague). Nickel fumes may be extremely toxic due to the production of nickel carbonyl, which can be fatal if inhaled, and due to the growing evidence that nickel fumes and dusts cause lung and nasal cancer (see Table 5-2).

4. Using alloys of unknown composition can result in exposure to other toxic metals, besides producing variable casting results.

5. The crucible furnace produces large amounts of heat that can cause heat stress. Molten metal also produces infrared radiation, which can cause skin burns and cataracts.

6. Oil, grease, and water are very hazardous around molten metal, since molten metal splashes in contact with these materials can cause a fire or explosion.

Precautions

1. Gas furnaces should be connected only by gas company personnel. For safe handling of propane tanks, see the oxygen and flammable gases section of Chapter 8.

2. Use alloys of known composition only. Avoid casting with alloys containing nickel, lead, and other toxic metals whenever possible.

3. The crucible furnace should be provided with local exhaust ventilation, such as a canopy hood. The canopy hood has to be located high enough to allow easy removal of the crucible. Enclosing the canopy hood and furnace with fire-resistant curtains or shields improves the efficiency of exhausting toxic gases and fumes.

4. Wear infrared goggles and face shield; long-sleeved, buttoned wool shirt; and insulated leggings, jacket, apron, gloves, and shoe coverings. You should ensure that molten metal cannot splash into eyelets of boots. Do not wear asbestos clothing; use leather or asbestos substitutes.

5. Make sure that all crucibles, stirrers, and other tools are free of moisture, grease, and oil.

Pouring the Metal

The crucible containing the molten metal is lifted from the furnace with tongs and then placed inside the opening of the shank and ring. The slag is skimmed off the surface of the crucible, and the molten metal is poured into the molds, which are located in a sand pit.

Hazards

1. Manual pours are limited by the weight of the crucible and molten metal and the strength of the individuals participating in the pouring operation.

2. Hazardous metal fumes are released during the pouring process, as discussed under melting the metal (above).

3. The pouring of molten metal into the molds causes thermal decomposition of binders and other organic materials in the mold. This can release toxic gases such as formaldehyde, carbon monoxide, acrolein, and cancer-causing substances. The burning out of polyurethane foam in the foam vaporization process can also release hydrogen cyanide gas, which is extremely toxic by inhalation.

4. Molten metal splashes can cause severe thermal burns from skin contact.

5. Molten metal splashes on cement result in the heat vaporizing the water trapped in the cement, causing the cement to violently break apart in a steam explosion.

Precautions

1. Make sure you have the physical strength to lift the loaded crucible before participating in a pour.

2. You should not attempt pours by yourself, except for small crucibles, due to the instability of a one-person shank and ring. Use a two-person shank and ring. For loaded crucibles weighing more than 100 pounds (45 kg), use mechanical lifting and handling equipment. Abort procedures should be discussed in advance before commencing the pour.

3. The molds should be embedded in a sand pit about 18 inches deep to catch any overflow of molten metal. The sand should be damp, not wet. Ideally, the sand pit should be sunken below floor level (or the floor level raised in the area) so that the crucible need only be raised a few inches to pour the molten metal. The sand pit should preferably be enclosed with metal, since wood can char or burn.

4. The foundry floor, in the area where molten metal could splash, should consist of a raised metal grate, or be covered with about four inches of sand, to prevent molten metal from contacting the cement.

5. The pouring area should be covered by a canopy hood (or movable exhaust for small pours) to remove toxic metal fumes and decomposition products from the sand binders.

6. All spectators should be kept well away from the pouring area.

Removing the Mold

After the cast has solidified, the sand mold has to be removed. The bulk of the sand and unwanted metal projections are often removed manually, and then burnt-on sand and rough edges are removed by abrasive blasting using sand or other abrasives.

Hazards

1. Breaking up sand molds is very hazardous due to possible inhalation of free silica. Silica exposures during this stage are particularly dangerous, since the intense temperatures of the molten metal convert the normal quartz sand into the more dangerous tridymite and cristobalite forms of silica.

2. Sand is a very hazardous material to use in abrasive blasting, since sandblasting can cause silicosis in just a few years of exposure.

3. Abrasive blasting also creates large amounts of noise, which can cause hearing loss.

Precautions

1. Wear NIOSH-approved toxic dust respirators when breaking up and disposing of silica-containing molds. Vacuum or wet mop; do not sweep.
2. Do not use sand for abrasive blasting. Instead use less hazardous abrasives such as alumina, silicon carbide, or crushed walnut shells. Avoid foundry slags that are contaminated with arsenic and other toxic metals.
3. If the abrasive blasting machine is an enclosed machine, inspect it regularly to make sure all seals are intact to prevent escape of abrasive powder. The machine should be under negative pressure. Hearing protectors might be necessary.
4. For nonenclosed abrasive blasting, wear an abrasive blasting hood with supplied air, and protective clothing to protect skin against the high-pressure abrasive particles.

FORGING AND METAL FABRICATION

Metal sculpture can be fabricated by a variety of processes, including cutting, sawing, filing, bending, and forging. The metal also requires annealing to keep it malleable.

Cutting, Piercing, and Filing Metals

These processes use a variety of saws, drills, metal snips, and files. Cutting with a welding torch is excluded from this section, since it was discussed earlier in the chapter under welding.

Hazards

1. Most of these processes can give off small metal filings that can damage the skin and eyes.
2. Electric drills can cause electric shocks if they are not properly grounded.
3. Saws, drills, and metal snips can cause cuts if they are not handled properly.

Precautions

1. Wear ANSI-approved goggles to protect your eyes against flying metal pieces or filings.

2. Make sure all electrical drills and other electrical equipment are properly grounded and that the wiring is in good condition. See the electrical safety section of Chapter 10.

3. Handle tools with sharp points or edges carefully. Fasten the metal piece you are working with securely in a vise so it will not slip. Put tools away so that they will not cause accidents. See the hand tools section of Chapter 10.

Forging

Forging, silversmithing, blacksmithing, and goldsmithing are all similar processes in which the metal is hammered while cold or hot to change its shape. A variety of hammers, mallets, metal blocks, and anvils are used to accomplish this. For hot forging, a furnace is required. Fuels for the furnace include coal, coke, oil, and natural gas.

Hazards

1. Noise is a hearing hazard in both cold and hot forging due to the continual use of hammers and other tools on the metal.

2. Furnaces for hot forging give off large amounts of carbon monoxide and other fumes and gases that are highly toxic by inhalation.

3. Furnaces also produce infrared radiation, which is an eye and skin hazard, and large amounts of heat that can give rise to heat stress.

4. Careless handling of hot objects can cause thermal burns.

Precautions

1. Forging should be done in a separate room to ensure that only people doing forging are exposed to noise.

2. Wear ear plugs or ear muffs while forging to reduce noise exposure. If the workshop also contains other people, erect soundproof barriers to protect the hearing of people not doing the forging.

3. Equip all furnaces with chimneys or canopy hoods. An exhaust fan is needed to exhaust the toxic gases produced.

4. If doing hot forging, wear approved protective goggles (shade numbers 1.7 to 3.0) to protect eyes against infrared radiation.

5. Wear protective clothing for hot forging: long-sleeved, closely-woven cotton shirts; leather gloves for handling hot metal; safety shoes; and, in case of flying sparks, face shields. Tie back long hair.

6. Make sure the workshop has good general ventilation with cooled air to keep the temperature at a comfortable level.

7. Other protective measures with hot forging should include ice for treatment of minor burns, salted water for heat stress, and a cool room for work breaks.

Annealing

Metal that has been forged, bent, or otherwise stressed must be annealed by heating with a torch or in a furnace to a low, red dun color and then, in most cases, quenched by dropping into cold water or into a pickling bath. After annealing, the metal must be cleaned to remove the firescale. This is done in a pickling bath, consisting of diluted sulfuric acid, or Sparex (sodium bisulfate).

Hazards

1. The use of torches involves flammable gases such as propane and acetylene, and oxygen or compressed air. These are fire and explosion hazards.

2. Use of furnaces for annealing involves the same hazards as discussed under forging in the last section.

3. Sulfuric acid and other acids are highly corrosive to the skin and eyes. Diluted acid solutions are less hazardous, although they can also cause skin and eye burns. Sparex is also corrosive to the skin and eyes.

Precautions

1. When using gas torches, obey the precautions discussed earlier in this chapter under welding, brazing, and soldering.

2. Obey precautions discussed in the previous section on forging for fuel-fired furnaces.

3. Wear protective goggles, gloves, and protective apron when handling and using concentrated acid solutions. Always add the acid to the water when mixing, never the reverse. Preferably, use Sparex and avoid handling concentrated acids.

4. In case of acid splashes on the skin, rinse with water. In case of splashes in the eyes, rinse for at least 15 to 20 minutes using an eyewash fountain. An emergency shower should also be available.

5. Neutralize acid solutions or spills with sodium bicarbonate. The neutralized acid may be poured down the sink, if local regulations permit.

SURFACE TREATMENT OF METALS

Surface treatment of metals involves processes such as repousse and chasing, punching, engraving, photo processes, electroplating, anodizing, and chemical coloring.

Mechanical Treatment

Repousse and chasing involve the indentation of the metal surface by hammering while the metal is supported by a bowl of pitch consisting of pitch, plaster of Paris, and tallow. The pitch can be removed from the metal with benzine or by burning off in a furnace or with a torch. Engraving uses sharp tools to incise a line in the metal surface.

Hazards

1. Heating pitch and use of benzine to remove pitch from the metal creates fire hazards.

2. Benzine (VM&P naphtha) is moderately toxic by skin contact and inhalation. It is flammable.

3. Hot pitch is a skin irritant, and frequent and prolonged contact may cause skin cancer.

4. Engraving tools may cause cuts if used improperly.

Precautions

1. Carry out normal precautions against fire when using pitch and benzine. Do not smoke or have open flames (except under controlled conditions when burning off pitch), store solvents in safety cans, and store benzine-soaked rags in self-closing safety disposal cans that are removed at the end of each day. If you burn off the pitch in a furnace, make sure there is an adequate exhaust system.

2. Use gloves when handling hot pitch or benzine.

3. Handle engraving tools carefully and always cut in a direction away from you. Place your free hand behind or to the side of the engraving tool.

Etching and Photoetching

Many metals can be etched with acids, although silver, copper, and zinc are the most common. Nitric acid (1:10) is the most common etch. Areas that you do not wish etched are coated with a resist, for example, asphaltum resist. Photoetching is commonly done by coating the metal with a photoresist containing ethylene glycol monomethyl ether acetate (methyl cellosolve acetate); exposing the metal through a negative or positive with a carbon arc, sunlamp, metal halide lamp, or mercury lamp; and then developing with a xylene-containing developer. The etching process and its hazards are discussed in more detail in Chapter 13.

Hazards

1. Nitric acid and other acids are highly corrosive to eyes and skin, especially when concentrated.

2. Nitrogen dioxide gas released during etching is highly toxic by inhalation, causing pulmonary edema and pneumonia in large amounts, and emphysema from long-term exposure.

3. Methyl cellosolve acetate in the photoresist is highly toxic by inhalation and skin absorption, causing adverse reproductive effects in both men and women, kidney damage, and anemia. Xylene, found in the photodeveloper, is also highly toxic by inhalation and is moderately toxic by skin contact. Both these solvents are flammable.

4. Carbon arcs give off nitrogen oxides, ozone, and other gases and metal fumes that are highly toxic by inhalation. They also emit large amounts of ultraviolet radiation, which can cause severe sunburn and eye damage.

5. Hot pitch, sometimes used as a resist, can cause severe thermal burns and is a fire hazard.

Precautions

1. Wear gloves, goggles, and protective apron when handling acids. Always add the acid to the water, never the reverse. Wear gloves when handling organic solvents.

2. In case of acid splashes on the skin, rinse with water. In case of splashes in the eyes, rinse for at least 15 to 20 minutes using an eyewash fountain. An emergency shower should also be available.

3. Vent nitric acid baths directly to the outside by an enclosed hood or similar local exhaust system.

4. Use commercial resists.

5. Use photoetching resists in an enclosed hood or similar local exhaust system. Otherwise wear a NIOSH-approved organic vapor respirator. Wear gloves.

6. Carry out normal fire prevention measures when using organic solvents. Do not smoke or allow open flames, store solvents in safety cans, dispose of solvents in approved safety containers, and store solvent-soaked rags in self-closing waste disposal cans that are emptied each day.

7. Do not use carbon arcs for exposing the plate. Instead use sunlamps, mercury lamps, or metal halide lamps.

8. Neutralize acid solutions or spills with sodium bicarbonate. The neutralized acid may be poured down the sink, if local regulations permit. The etching process can result in large concentrations of silver, zinc, or copper ions in the used etching bath.

Electroplating and Electroforming

Electroplating of metals onto other metals uses an electrolyte solution containing a metal salt of the metal to be applied, metal anodes, and the metal to be electroplated as the cathode. Copper plating can be done with copper sulfate and sulfuric acid as electrolytes; other plating metals often use cyanide salts. Gold and silver electroplating with cyanide salts are discussed in Chapter 19.

The metal to be electroplated must be cleaned carefully, often with caustic soda as well as with regular cleaning methods. In addition to the deposition of the plating metal on the metal cathode, some dissociation of water occurs, releasing hydrogen at the cathode and oxygen at the anode. When these gases bubble out of solution, they produce a fine mist of whatever chemicals are in the electroplating bath. This mist contains sulfuric acid for copper plating and cyanide salts for cyanide-based electroplating baths.

Sculptures made of any material can also be electroplated by an electroforming process. Nonconductive surfaces can be made conductive by first sealing with wax or plastic lacquer and then coating with powdered graphite or a conductive metal paint.

Hazards

1. Electroplating can involve large electrical currents, which create the hazard of electrical shock.

2. Caustic soda and concentrated sulfuric acid are highly corrosive to the skin and eyes.

3. The mist from the electroplating bath for copper plating contains sulfuric acid, which is a skin, eye, and respiratory irritant.

4. Lacquer vapors and mists are highly toxic by inhalation and are moderate skin irritants.

Precautions

1. Whenever possible, send pieces out to a commercial electroplater or electroformer to avoid the hazards of doing it yourself.

2. Wear rubber gloves, goggles, and protective apron when handling acids and caustic soda, and when electroplating. Always add the acid to the water, never the reverse. Wear gloves when handling organic solvents.

3. In case of acid splashes on the skin, rinse with water. In case of splashes in the eyes, rinse for at least 15 to 20 minutes using an eyewash fountain. An emergency shower should also be available.

4. Vent electroplating baths directly to the outside by an enclosed hood or similar local exhaust system. The hood and ducting should be corrosive resistant if the plating bath contains acid.

5. Avoid spraying lacquers if possible; otherwise use in a spray booth or wear a NIOSH-approved spray respirator with an organic vapor cartridge.

6. Install a ground fault circuit interrupter.

7. Install your electroplating unit on a wooden or nonconducting surface, not on metal. Place a heavy rubber mat on the floor where you would stand. Do not use a metal chair.

8. Wear rubber-soled shoes and insulating rubber gloves.

9. Do not touch electroplating bath, wires, or electrodes with bare hands while the current is on to avoid shock. Unplug the power supply before making or undoing connections or making adjustments to the bath. Wear insulating rubber gloves.

10. Special rectifiers and masking tape (for resists) are needed that are approved for the voltages and currents used.

11. See also the electrical safety section of Chapter 10.

Anodizing

Anodizing involves the oxidation of metals such as titanium, tantalum, and niobium at the anode of an electrolytic bath. Trisodium phosphate is recommended as an electrolyte. The process involves dissociation of water, producing hydrogen at the cathode and oxygen at the anode. The oxygen causes a controlled surface oxidation of the anode. Anodizing can be done in an anodic bath, similar to electroplating (except the metal being anodized is the anode, not the cathode), or with anodic painting, in which you paint on the anode metal using a paintbrush soldered to the cathode lead. The titanium must be cleaned before anodizing, often with hydrofluoric acid.

Hazards

1. Titanium and, to a lesser extent, tantalum, are combustible metals like magnesium. Their filings and dust will burn.
2. Trisodium phosphate is alkaline and can cause skin, eye, and respiratory irritation.
3. Hydrofluoric acid is highly corrosive to the skin, eyes, and lungs. Serious, deep burns can occur without pain warning several hours after exposure. Its vapors may cause severe lung irritation, including chemical pneumonia. Ingestion can be fatal. Hydrofluoric acid can also cause chronic bone and teeth damage (osteofluorosis) and possibly kidney damage. Handling concentrated hydrofluoric acid is very dangerous due to the risk of splashing.
4. Anodizing, like electroplating, can involve large electrical currents, which create the hazard of electrical shock.

Precautions

1. Wear insulating rubber gloves, goggles, and protective apron.
2. Avoid hydrofluoric acid if possible. Instead, use wet sand with a very fine grade of emery paper.
3. If hydrofluoric acid is used, do so only in a laboratory hood, or use an acid gas respirator with a full facepiece to protect both lungs and eyes. Wear natural or neoprene rubber gloves, protective apron, face shield, and chemical splash goggles when handling concentrated hydrofluoric acid. In case of contact, flush exposed skin and eyes with water for at least 15 minutes. Immerse affected area in 0.13% iced solution of Zephiran chloride for 30 to 60 minutes. Call a physician immediately. See the chapter references for more detailed information.

4. Leftover hydrofluoric acid should be treated as hazardous waste. See the section on waste management in Chapter 8.

5. Keep a class D fire extinguisher for potential titanium or tantalum fires.

6. See the electroplating section above for electrical precautions.

Patinas

A variety of chemicals can be used to color metals. The coloring solutions can be applied by immersion of the metal, brushing on the solution or paste, spraying, and exposure to vapors of the chemical colorant. In many instances, the patinas are applied to metal that has been heated with a torch. Prior to application of the patinas, the metal usually has to be cleaned and degreased, often with solvents. After coloring, the metal is often coated with auto wax, lacquer solution, or beeswax dissolved in benzine.

Hazards

1. Chlorinated solvents used for degreasing are usually highly toxic by inhalation and can be absorbed through the skin. Most are probable human carcinogens. If heated with a torch, they will decompose to poisonous phosgene gas. See Table 4-4 for the hazards of specific chlorinated hydrocarbons.

2. Many patinas are highly poisonous by ingestion and inhalation, and many are corrosive to the skin and eyes. The hazards of the various coloring agents are listed in Table 18-1.

3. Spraying is more hazardous than brushing or dipping, due to possible inhalation of spray mists.

4. Concentrated acids are highly corrosive to the skin, eyes, respiratory system, and gastrointestinal system. Diluted acid solutions are less hazardous, although they can also cause skin and eye irritation.

5. Oxidizing agents, such as ammonium nitrate, concentrated hydrogen peroxide, potassium dichromate, and concentrated nitric acid, can react with solvents and other combustible materials to cause fires or explosions.

6. Some patina solutions can emit toxic gases when heated. For example, potassium ferricyanide decomposes to release poisonous hydrogen cyanide gas when heated, and sodium thiosulfate releases sulfur dioxide, a lung irritant.

7. Benzine and lacquer solutions are flammable. Benzine is moderately toxic by inhalation, skin contact, and ingestion. Lacquers are highly toxic by inhalation and moderately toxic by skin contact.

Precautions

1. Use mineral spirits or detergent solutions for cleaning and degreasing metals, not chlorinated hydrocarbons.

2. Do not use antimony, arsenic, cyanide, or mercury compounds as patinas due to their very high toxicity and the possibility of release of extremely toxic gases.

3. Wear protective goggles, gloves, and protective apron when handling and using acid solutions. Always add the acid to the water when mixing, never the reverse. In case of acid splashes on the skin, rinse with water. In case of splashes in the eyes, rinse for at least 15 to 20 minutes using an eye-wash fountain. An emergency shower should also be available.

4. Do not add acids to sulfides when coloring, as described in some older literature. This would cause the release of large amounts of extremely toxic hydrogen sulfide gas.

5. Store oxidizing agents away from solvents and organic materials. Do not use them with techniques involving sawdust, wood shavings, or other organic materials, because of the risk of fire or explosion.

6. Wear gloves and goggles when preparing and using coloring solutions. Highly toxic powders should be mixed in a glove box (see Chapter 8), with local exhaust ventilation, or while wearing a NIOSH-approved toxic dust respirator. Do not eat, drink, or smoke in the studio. Wash hands carefully after work.

7. Dip or brush on patinas, rather than spraying them, whenever possible. Spraying should be done only in a spray booth.

8. Patinas should be applied with local exhaust ventilation, especially if applied to hot metal.

9. When using flammable solvents, do not smoke or have open flames in the working area. Wear gloves and goggles when handling solvents. Have good general room ventilation. Dispose of waste solvents and solvent-soaked rags in approved waste disposal vessels and empty daily.

Niello

To make niello, silver, copper, and lead are melted and poured into a crucible with sulfur. After cooling, the mixture is remelted, poured onto water or steel, and ground into small pieces. A paste is made with saturated ammonium chloride, which is applied to the metal and then heated.

Hazards

1. The melting of the lead can result in the emission of lead fumes, which are highly toxic by inhalation. In the second remelting, hazardous fumes may also be given off.

2. Grinding of the niello may give off lead sulfide dust, which is highly toxic by inhalation and ingestion.

Precautions

1. All melting and heating operations should be carried out in an enclosed hood or similar local exhaust system.

2. Wear a NIOSH-approved toxic dust respirator when grinding the niello, or do the grinding with local exhaust ventilation.

3. Carry out good personal hygiene measures. Do not eat, drink, or smoke in the studio; wash your hands carefully after work, including under the fingernails.

4. Wet mop all surfaces where lead dust could accumulate.

5. Heat the ammonium chloride paste inside a hood.

Gilding

Gold and silver amalgams for gilding are made by heating mercury and gold or silver together. The mercury is burned away after the surface of the metal is gilded, leaving the silver or gold. Other gilding mixtures can also be used instead of mercury.

Hazards. Mercury metal is highly toxic by skin absorption and inhalation, but is poorly absorbed by ingestion. Acute mercury poisoning is accompanied by a metallic taste, excessive salivation, swelling of the gums and mouth, vomiting, bloody diarrhea, possible kidney failure, and, in case of inhalation, possible bronchitis and pneumonia. Chronic mercury poisoning, in addition to the above symptoms, severely affects the central nervous system, causing muscular tremors, irritability, and psychological changes (depression, loss of memory, frequent anger, and indecision).

Precautions

1. Do not use mercury amalgams, if possible.

2. Store mercury under water in closed containers.

3. If you do use mercury, make the amalgam on a tray to contain spills. Do this inside an enclosed hood, or in front of a slot exhaust hood.

4. Clean up spills immediately with a mercury spill kit, which can be obtained from a safety equipment supplier. Do not vacuum, since this will cause mercury droplets to be dispersed into a fine mist, which is much more dangerous. Surfaces that have been contaminated with mercury should be washed with a ferric chloride solution.

5. Clean hands very carefully after work. Also use careful dental hygiene.

CLEANING, POLISHING, AND FINISHING

Pickling, filing, sandblasting, grinding, wire brushing, and buffing are examples of the various types of cleaning, polishing, and finishing treatments used with metals.

Pickling

Cleaning metals before working with them or afterwards to remove firescale is done by soaking in acid baths. Acids used are diluted nitric and sulfuric acids and Sparex (sodium bisulfate). Aluminum is cleaned with caustic soda or other alkalis. After welding and casting, mixtures of sulfuric and hydrofluoric acids are often used. For high-copper alloys, mixtures of sulfuric acid and potassium dichromate are sometimes used.

Hazards

1. Nitric and sulfuric acids are highly toxic by skin and eye contact, particularly when concentrated (see Table 4-2). The gases emitted from these acid baths are also highly toxic by inhalation. Boiling acid solutions can be very hazardous due to the danger of splashing.

2. Hydrofluoric acid is highly corrosive to the skin, eyes, and lungs. Serious deep burns can occur without pain warning several hours after exposure. Its vapors may cause severe lung irritation, including chemical pneumonia. Ingestion can be fatal. Hydrofluoric acid can also cause chronic bone and teeth damage (osteofluorosis) and possibly kidney damage. Handling concentrated hydrofluoric acid is very dangerous due to the risk of splashing.

Ammonium bifluoride, although not as corrosive as hydrofluoric acid, is still highly toxic by skin contact and ingestion, since it does produce hydrofluoric acid in solution.

3. Sodium bisulfate is moderately corrosive to skin and eyes.

4. Potassium dichromate is moderately toxic by skin contact and highly toxic by inhalation. It can cause irritation, allergies, and skin ulcers. Inhalation of the powder can have similar effects on the nose and respiratory system. Dichromates are also probable human carcinogens.

Precautions

1. Wear gloves, goggles, and protective apron when handling acids. Always add the acid to the water, never the reverse.

2. In case of acid splashes on the skin, rinse with water. In case of splashes in the eyes, rinse for at least 15 to 20 minutes, using an eyewash fountain. An emergency shower should also be available.

3. Cover acid baths at all times. Provide local exhaust ventilation.

4. Preferably use bifluoride pastes. If hydrofluoric acid is used, do so only in a laboratory hood, or use an acid gas respirator with a full facepiece to protect both lungs and eyes. Wear natural or neoprene rubber gloves, face shield, and chemical splash goggles when handling hydrofluoric acid. In case of contact, flush exposed skin and eyes with water for at least 15 minutes. Immerse affected area in 0.13% iced solution of Zephiran chloride for 30 to 60 minutes. Call a physician immediately. This first-aid information also applies to burns from ammonium bifluoride.

5. Neutralize acid solutions or spills with sodium bicarbonate. The neutralized acid may be poured down the sink, if local regulations permit. Hydrofluoric acid and bifluoride solutions should be treated as hazardous waste (see Chapter 8).

Grinding, Polishing, and Other Mechanical Techniques

Grinding, wire-brushing, buffing wheels, sanding, and other similar techniques using powered equipment can produce flying metal particles, dust, and, in some cases, particles from abrasives and the grinding wheel. Hand-operated sanding and polishing using abrasives such as rouge, tripoli (silica), and pumice can also produce dust. Filing can produce flying metal particles.

Hazards

1. Flying metal particles from grinding, sanding, and filing can cause eye damage.

2. Grinding and sanding of lead-containing alloys can produce lead-containing dusts, which are highly toxic by inhalation or ingestion.

3. Silica-containing grinding wheels, for example, sandstone grinding wheels, can produce free silica, which is highly toxic by inhalation, causing silicosis (also called grinders' asthma). In addition, grinding wheels using synthetic formaldehyde resins as binders can produce formaldehyde and other gases, which are highly irritating by inhalation. They may also cause respiratory allergies.

4. Silica-containing abrasives (e.g., tripoli, sometimes rouge) may cause silicosis from chronic inhalation.

5. Synthetic, semisynthetic, and soluble cutting oils (also known as lubricating oils, cutting fluids, and grinding oils) often contain nitrosamines, which cause cancer in animals. Cutting fluids may also cause dermatitis.

Precautions

1. Wear grinding goggles to protect your eyes. For heavy grinding, also wear a face shield. The grinding wheels should have eye shields attached.

2. Do not wear ties, loose long sleeves, necklaces or other dangling jewelry, or anything that could get caught in the grinders or buffers. Keep long hair tied back or wear a hair net.

3. Do not use sandstone grinding wheels. Instead use silicon carbide (carborundum) or alumina. Use grinding wheels with rubber or shellac binders. All grinding wheels should be equipped with a vacuum attachment or similar local exhaust system to trap dusts and particles. Otherwise wear a NIOSH-approved toxic dust respirator for more than brief exposures.

4. Use wet techniques whenever possible to keep down dust levels.

5. Have local exhaust ventilation when using abrasives, or wear a NIOSH-approved toxic dust respirator.

6. Use cutting oils that do not contain amines or nitrites. Check with the manufacturer. Use local exhaust ventilation. Other precautions should include wearing impervious clothing, washing exposed areas with soap and water, frequent showering, and use of nonamine barrier creams.

TABLE 18-1. Hazards of Patina Chemicals

Acetic Acid

Relative Toxicity Rating TLV: 10 ppm

Skin contact: high
Inhalation: high
Ingestion: high

Specific Hazards

Concentrated acetic acid or glacial acetic acid is very corrosive to skin, eyes, mucous membranes, and stomach. Ingestion may be fatal. Diluted acetic acid is less irritating, although repeated inhalation of vapors may cause chronic bronchitis. Vinegar is about 2–3% acetic acid.

Ammonia

Relative Toxicity Rating TLV: 25 ppm

Skin contact: high
Inhalation: high
Ingestion: moderate to high

Specific Hazards

Household ammonia is 5–10% ammonia; 27–30% concentrations are also available. Skin contact can cause first- and second-degree burns. The eyes and respiratory system are very sensitive to ammonia. High concentrations can cause chemical pneumonia. Mixing ammonia with alkalis causes release of ammonia gas; mixing with chlorine bleaches causes formation of a poison gas.

Ammonium Chloride

Relative Toxicity Rating TLV: 10 mg/m^3 (as fume)

Skin contact: not significant
Inhalation: slight
Ingestion: slight

Specific Hazards

If heated, ammonium chloride decomposes to hydrogen chloride and ammonia, which are strong respiratory irritants.

Ammonium Nitrate

Relative Toxicity Rating

Skin contact: not significant
Inhalation: slight
Ingestion: moderate

Specific Hazards

Ammonium nitrate is a powerful oxidizing agent, which can react explosively with solvents, other organic materials, and acids.

Ammonium Sulfate

Relative Toxicity Rating

Skin contact: slight
Inhalation: slight
Ingestion: slight

Specific Hazards

If heated, ammonium sulfate decomposes to irritating ammonia and sulfur oxides.

Ammonium Sulfide

Relative Toxicity Rating

Skin contact: moderate
Inhalation: high
Ingestion: extreme

Specific Hazards

Skin contact, eye contact, or inhalation can cause severe irritation. The reaction involves release of extremely toxic hydrogen sulfide gas. If heated or treated with acid, ammonium sulfide decomposes to produce large amounts of ammonia and hydrogen sulfide gas. Hydrogen sulfide can also form in the stomach due to reaction with stomach acid, if ingested.

Arsenic Oxide

Relative Toxicity Rating

Skin contact: high
Inhalation: extreme
Ingestion: extreme

PEL: 0.01 mg/m^3
NIOSH: C 0.002 mg/m^3

Specific Hazards

Known human carcinogen. Skin contact can cause skin irritation and allergies, skin thickening, loss of skin pigmentation, ulceration, and skin cancer. Inhalation can cause respiratory irritation and skin and liver cancer. Inhalation or ingestion may cause digestive disturbances, liver damage, peripheral nervous system damage, and kidney and blood damage. Acute ingestion may be fatal. Reaction with acid forms poisonous arsine gas. Do not use.

Barium Sulfide

Relative Toxicity Rating TLV (soluble compounds): 0.5 mg/m^3

Skin contact: moderate
Inhalation: high
Ingestion: extreme

Specific Hazards

May cause skin and eye irritation. Inhalation may cause nose and throat irritation. Chronic inhalation or ingestion may cause intestinal spasms, heart irregularities, and muscle pain due to the barium. The patina reaction releases extremely toxic hydrogen sulfide gas. Reaction with acid produces large amounts of hydrogen sulfide. The sulfide can also react with stomach acid to produce hydrogen sulfide gas, if ingested.

Chromium (VI) Compounds (chromium trioxide, potassium dichromate)

Relative Toxicity Rating TLV: 0.05 mg/m^3
 NIOSH: 0.001 mg/m^3 (10-hour REL)
Skin contact: high
Inhalation: high to extreme
Ingestion: high to extreme

Specific Hazards

Known or probable human carcinogens. Strong oxidizing agents. Hexavalent chromium compounds are corrosive by skin contact; may cause irritation, ulceration, and allergies. Chronic inhalation may cause lung cancer, respiratory irritation, allergies, and perforated nasal septum. Ingestion may cause violent gastroenteritis, circulatory collapse, and kidney damage. Do not use.

Copper Compounds (copper sulfate, copper carbonate, copper chloride, copper nitrate)

Relative Toxicity Rating TLV (dusts and mists): 1 mg/m^3
 PEL (fumes): 0.1 mg/m^3
Skin contact: slight
Inhalation: moderate
Ingestion: high

Specific Hazards

May cause skin allergies and eye, nose and throat irritation, including possible ulceration and congestion, and perforation of nasal septum. Inhalation of metal fumes from heating may cause metal fume fever. Acute ingestion may cause gastrointestinal irritation, vomiting, and other effects.

Ferric Chloride (iron perchloride)

Relative Toxicity Rating

Skin contact: moderate
Inhalation: slight
Ingestion: moderate

Specific Hazards

Powder. Forms small amount of hydrochloric acid in solution. Skin and eye irritant in solution. Ingestion of large amounts by children could cause iron poisoning. Heating releases highly toxic hydrogen chloride gas, which can cause severe lung irritation and pulmonary edema.

Hydrochloric Acid (muriatic acid)

Relative Toxicity Rating

Skin contact: high
Inhalation: high
Ingestion: high

Specific Hazards

Concentrated hydrochloric acid is highly corrosive by skin and eye contact and ingestion. Ingestion causes severe stomach damage. Diluted acid is less hazardous but can still cause skin and eye irritation. Hydrochloric acid vapors are highly toxic if inhaled, causing severe lung irritation and possible chronic bronchitis by repeated inhalation of small amounts.

Hydrogen Peroxide (concentrated)

Relative Toxicity Rating TLV: 1 ppm

Skin contact: moderate
Inhalation: slight
Ingestion: high

Specific Hazards

Concentrated hydrogen peroxide solutions are corrosive to skin, eyes, and gastrointestinal system. Also a strong oxidizing agent. May react with flammable liquids, combustible materials, and some metal salts under certain conditions. Dilute hydrogen peroxide solutions are not considered hazardous.

451

Iodine

Relative Toxicity Rating TLV-C: 0.1 ppm

Skin contact: moderate
Inhalation: high
Ingestion: extreme

Specific Hazards

Skin contact may cause hypersensitivity reaction and burns. Inhalation of vapors causes severe respiratory irritation similar to chlorine gas, but at room temperature this is not much of a problem because of its low volatility. Ingestion is very serious due to corrosive effects, and may be fatal. Oxidizing agent.

Lead Acetate

Relative Toxicity Rating PEL: 0.05 mg/m³

Skin contact: not significant
Inhalation: high
Ingestion: high

Specific Hazards

Probable human carcinogen, mutagen and developmental toxicant. Chronic inhalation or ingestion may cause lead poisoning, affecting gastrointestinal system (lead colic), red blood cells (anemia), and neuromuscular system (weakening of fingers, wrists, ankles, toes). Other common effects include weakness, headaches, irritability, malaise, pain in joints and muscles, kidney damage, and possible birth defects. Do not use.

Liver of Sulfur (see Potassium sulfide)

Nitric Acid

Relative Toxicity Rating TLV: 2 ppm

Skin contact: high
Inhalation: high
Ingestion: high

Specific Hazards

Concentrated nitric acid is highly corrosive by skin and eye contact and ingestion. Ingestion causes severe stomach damage. Diluted acid is less hazardous but can still cause skin and eye irritation. Reacts with copper and copper alloys to produce highly toxic nitrogen dioxide gas, which can cause emphysema by chronic inhalation. The concentrated acid is a strong oxidizing agent.

Oxalic Acid

Relative Toxicity Rating TLV: 1 mg/m^3

Skin contact: high
Inhalation: moderate
Ingestion: high

Specific Hazards

Powder and its solutions are corrosive to skin, eyes, respiratory system, and gastrointestinal system. Ingestion can also cause severe gastroenteritis and kidney damage. Sufficient skin contact can cause gangrene of extremities.

Platinum Chloride

Relative Toxicity Rating TLV (soluble salts): 0.002 mg/m^3

Skin contact: moderate
Inhalation: high
Ingestion: unknown

Specific Hazards

Skin contact can cause severe skin allergies. Inhalation can cause nasal allergies (similar to hay fever) and platinosis, a severe form of asthma. Some lung scarring and emphysema may also occur. People with red or light hair and fine-textured skin appear most susceptible.

Potassium Chlorate

Relative Toxicity Rating

Skin contact: moderate
Inhalation: moderate
Ingestion: high

Specific Hazards

Strong oxidizing agent used in pyrotechnics. A skin, eye, and respiratory irritant. Ingestion can cause gastritis, methemoglobinemia, and kidney damage. Do not use.

Potassium Ferricyanide

Relative Toxicity Rating

Skin contact: slight
Inhalation: slight
Ingestion: moderate

453

Specific Hazards

When heated strongly, treated with acid, or exposed to ultraviolet radiation, potassium ferricyanide decomposes to poisonous hydrogen cyanide gas.

Potassium Sulfide (potassium polysulfide, liver of sulfur)

Relative Toxicity Rating

Skin contact: moderate
Inhalation: high
Ingestion: extreme

Specific Hazards

Skin contact, eye contact, or inhalation can cause severe irritation. The reaction involves release of extremely toxic hydrogen sulfide gas. If heated or treated with acid, potassium sulfide decomposes to produce large amounts of hydrogen sulfide gas. This can also happen in the stomach due to reaction with stomach acid, if ingested.

Sodium Hydroxide (lye)

Relative Toxicity Rating TLV-C: 2 mg/m^3

Skin contact: high
Inhalation: high
Ingestion: high

Specific Hazards

Sodium hydroxide solutions are highly corrosive to the skin and eyes. Ingestion of small amounts of concentrated alkaline solutions can cause severe pain and damage to the mouth and esophagus, and can be fatal. Inhalation of its powder can cause chemical pneumonia. Dilute alkaline solutions are more corrosive to the skin and eyes than dilute acid solutions.

Sodium Thiosulfate

Relative Toxicity Rating

Skin contact: not significant
Inhalation: high
Ingestion: moderate

Specific Hazards

Ingestion of large amounts can cause purging. Reacting with acid or heating causes decomposition to sulfur dioxide, which is highly irritating by inhalation. Aqueous solutions also decompose to form sulfur dioxide. Chronic inhalation may cause chronic bronchitis. Asthmatics may be especially sensitive to sulfur dioxide.

Zinc Chloride

Relative Toxicity Rating TLV: 1 mg/m^3 (as fume)

Skin contact: moderate
Inhalation: high
Ingestion: high

Specific Hazards

Zinc chloride and its solutions are corrosive to skin, eyes, and stomach. Inhalation of zinc chloride fumes from heating is highly irritating to the respiratory system and may cause bronchitis or pulmonary edema from large acute exposures or chronic bronchitis from chronic exposure.

REFERENCES

American National Standards Institute. (1973). *Safety in Welding and Cutting* ANSI Z49.1-1983. New York: ANSI.

Burgess, W. (1981). *Recognition of Health Hazards in Industry.* New York: John Wiley and Sons.

Canadian Centre for Occupational Health and Safety. (1988). *Infograms on Welding.* 17 pp. Hamilton, Ontario, Canada: CCOHS.

Hughes, R., and Rowe, M. (1982). *The Coloring, Bronzing and Patination of Metals*. London: Craftscouncil.

Seeley, W. A. (1982). *Studio Preparation and Coloring of Titanium.* M.A. thesis, University of Kansas. Available from Society of North American Goldsmiths.

Weiss, L. (1987). *Health Hazards in the Field of Metalsmithing* Society of North American Goldsmiths Education and Research Department.

Jewelry
and
Enameling

T

JEWELRY

The main processes discussed here are silver soldering, lost wax casting, gold and silver electroplating, shaping techniques, and finishing. Many of the metal processes were discussed in Chapter 18 on metalworking. Lapidary and plastics are discussed in Chapter 16, and woods in Chapter 17.

Silver Soldering

Silver or hard soldering is carried out at about 600–1400°F (316–760°C) and is commonly used for soldering gold or silver. In addition to silver, a variety of other filler metals are used in silver solders, depending on the temperature desired. Many of the lowest melting silver solders contain large amounts of cadmium (technical designations BAg-1, BAg-la, BAg-2, BAg-2a, and BAg-3). Some substitutes use antimony instead. Silver soldering is carried out with torches that use propane or other liquefied natural gases. Fluxes usually contain borax or

fluorides (or both). After soldering, the flux and metal oxides are removed with a pickling bath containing nitric or sulfuric acids or Sparex (sodium hydrogen sulfate).

Hazards

1. Cadmium-containing silver solders are extremely toxic by inhalation. Acute exposure may cause chemical pneumonia and may be fatal. Chronic exposure may cause kidney damage, lung damage, prostate cancer, and lung cancer. Cadmium oxide fumes are a known human carcinogen.

2. Silver particles that become embedded in the skin can cause a permanent tattoo; in the eyes they cause a permanent blue-black stain. Chronic inhalation of silver dust or fumes can cause argyria, a permanent, bluish-black discoloration of eyes, nails, inner nose, mouth, throat, skin, and internal organs, which is very disfiguring but does not have any known ill effects. It may also cause clouding of the cornea, and decreased night vision might occur. High, repeated exposure may cause kidney damage.

3. Antimony is highly toxic by inhalation. Antimony poisoning is similar to arsenic poisoning. Acute inhalation of antimony fumes may cause metallic taste, vomiting, diarrhea, severe irritation of mouth and nose, slow shallow breathing, irregular heart beat, and pulmonary congestion. Chronic exposure may cause loss of appetite and weight, nausea, headache, sleeplessness, and later liver and kidney damage. It is also a probable cause of birth defects and miscarriages.

4. Flux fumes are moderately irritating by inhalation, unless the flux contains fluoride, in which case the fumes are highly toxic by inhalation. Fluoride fumes can cause chronic nosebleeds, respiratory irritation, and chronic bone and teeth defects.

5. Contact with hot metal or with the torch flame can cause thermal burns.

6. The glare from the torch and infrared radiation given off by heated metal can cause eye damage.

7. Propane tanks or other sources of liquefied gases for torches are highly flammable and explosive.

8. Concentrated acids are highly corrosive to the skin, eyes, respiratory system, and gastrointestinal system. Diluted acid solutions are less hazardous, although they can also cause skin and eye burns. Sparex is also corrosive to the skin and eyes, but is not as dangerous as handling concentrated acids.

9. Sulfuric acid and Sparex solutions give off highly irritating sulfur oxides, especially when heated.

10. Asbestos soldering boards (or a mixture of asbestos and plaster) have been used to embed rings and other small jewelry in while soldering. Asbestos boards have also been used to insulate work tables. This practice has caused asbestosis and mesothelioma, cancer of the lining of the chest cavity, in jewelers.

Precautions

1. Do not use cadmium-containing silver solders. All cadmium silver solders should have a label stating that they contain cadmium, although they commonly do not. Also avoid antimony if possible.

2. Use fluxes based on borax rather than fluorides.

3. Use local exhaust ventilation (e.g., slot exhaust hood) for silver soldering. Working at a table placed against a window, with a window exhaust fan at work level, will also work. If the ventilation is not adequate, wear a National Institute for Occupational Safety and Health (NIOSH)-approved respirator with dust, mist, and fume filters.

4. Wear protective goggles with a shade number of at least 4 to protect against infrared radiation.

5. Take precautions against fire and explosion when handling liquefied gas cylinders. Store them securely away from other flammable materials. Do not use near flammable materials. See the section on oxygen and flammable gases in Chapter 8 and the section on welding in Chapter 18.

6. Use leather protective gloves to handle hot metals.

7. Use Sparex in preference to diluting concentrated acids for pickling baths. The pickling bath should be provided with local exhaust ventilation.

8. Wear protective goggles, gloves, and protective apron when handling and using acid solutions, including Sparex. If you use concentrated acids, always add the acid to the water when mixing, never the reverse.

9. In case of acid splashes on the skin, rinse with water. In case of splashes in the eyes, rinse for at least 15 to 20 minutes using an eyewash fountain. An emergency shower should also be available.

10. Do not use asbestos in any form. Nonasbestos soldering boards are available.

Soldering

Soldering, or soft soldering as it is also called, is often used for joining metals other than gold or silver. Soft soldering temperatures are below 660°F (350°C). In the past, soft solders were 50/50 tin/lead or 60/40 tin/lead. Recently, antimony-free and lead-free solders have been developed that are mostly tin, with some copper and a small amount of silver. Common fluxes contain zinc chloride (acid type), rosin, and oleic acid (or similar organic acids). Soft soldering is usually done with an electric soldering iron, although gas torches can also be used.

Hazards

1. Soft soldering using high-lead solders can result in the vaporization of some lead, especially if gas torches are used, which can achieve higher temperatures. The lead fumes can be inhaled, and the lead fumes can settle out onto table surfaces. In addition, excess pieces of lead solder can collect in the work area. Lead is highly toxic by both inhalation and ingestion. Antimony is also highly toxic and an ingestion and inhalation hazard if present in soft solders.

2. Zinc chloride is moderately corrosive to the skin. The fumes produced during soldering are corrosive to the eyes and respiratory system.

3. Fumes from the decomposition of rosin and similar fluxes are moderately irritating by inhalation and eye contact. Constant inhalation may cause chronic lung problems. Rosin fumes may cause asthma.

4. Contact with hot metal or with a soldering iron can cause thermal burns.

Precautions

1. Use lead- and antimony-free soft solders.

2. Avoid zinc chloride and rosin fluxes whenever possible.

3. Have local exhaust ventilation when soldering. Soldering immediately in front of a window exhaust fan at work level will also work. If adequate ventilation is not available and you are doing extensive amounts of soldering, wear a NIOSH-approved respirator with dust, mist, and fume filters.

4. Avoid contact with the hot soldering iron. Place the soldering iron in a holder.

Lost Wax Casting

Metal casting for jewelry mostly uses the lost wax method, with gold or silver as the main casting metal.

Channel molds or cuttlebone molds are sometimes used for jewelry casting. Channel molds are made by carving a pattern into tufa, a soft, porous rock. Modern variations of this use a mixture of investment plaster and powdered pumice, which is allowed to set. Cuttlebone molds are made by sawing the cuttlebone in half, sanding the surface smooth, pressing the pattern into the soft bone, and then painting the mold first with borax flux and then with water glass (50% aqueous sodium silicate).

The metal is commonly melted with a torch. Usually, centrifugal casters are used to pour the molten metal into the mold, rather than gravity pouring. Vacuum casting systems are also used.

Hazards

1. Investment plaster usually contains free silica, which is highly toxic by inhalation. It may cause silicosis. Powdered pumice may also contain small amounts of silica.

2. Like most bone dusts, cuttlebone dust is slightly irritating by inhalation. It may cause respiratory irritation and allergies, especially if not cleaned properly.

3. Sodium silicate is moderately toxic by skin and eye contact, causing alkali burns.

4. Molten metal splashes are a hazard with centrifugal casters, especially if not properly balanced. In addition, most old centrifugal casters do not have adequate shields if the casting arm breaks during operation.

5. See also the foundry section of Chapter 18.

Precautions

1. Preferably use a nonsilica investment plaster, when possible. If a silica-type material is used, carry out the mixing in a glove box (see Chapter 8), or wear a NIOSH-approved toxic dust respirator. Wet mop dusts; do not sweep.

2. Clean cuttlebone carefully to avoid the possibility of infection or allergies.

3. Use wet sanding techniques to keep down dust levels.

4. Wear gloves and goggles when handling sodium silicate solutions.

5. Wear protective goggles when melting the metal and casting.

6. Make sure that your centrifugal casting equipment is properly balanced when you are casting. The machine should also have a protective shield against both molten metal splashes and breaking of the casting arm.

7. Wear a NIOSH-approved toxic dust respirator when removing the mold, or work inside a glove box if practical.

Electroplating

Electroplating in general was discussed in Chapter 18. Gold and silver electroplating solutions contain cyanide solutions. The labels of some gold and silver electroplating solutions have said that they do not contain free cyanide, but do contain metal cyanide complexes (e.g., cyanoaurate salts), which will release hydrogen cyanide when heated or treated with acid. There are noncyanide silver succinimide and gold sulfite electroplating solutions, but at present they have not been used much by artists.

Hazards

1. Cyanide salts are highly toxic by skin contact and inhalation, and extremely toxic by ingestion. Chronic skin contact may cause skin rashes, and skin absorption may occur. Acute ingestion is frequently fatal, even in small amounts, causing chemical asphyxia. Acute inhalation may also cause asphyxia. Chronic inhalation of small amounts may cause nasal and respiratory irritation, including nasal ulceration, and systemic effects with symptoms such as loss of appetite, headaches, weakness, and nausea. Adding acid to cyanide solutions causes the formation of extremely toxic hydrogen cyanide gas, which can be rapidly fatal by inhalation. There have been cyanide poisonings in jewelers from the use of cyanide electroplating solutions.

2. The electroplating process can produce a mist that contains cyanide salts.

3. Gold salts may cause allergic reactions by skin contact.

4. Electroplating can involve large electrical currents, which create the hazard of electrical shock.

Precautions

1. Avoid cyanide plating solutions if at all possible, including cyanide complexes. Send the piece out to be plated commercially.

2. If you do use cyanide solutions, do so only in a laboratory hood that has been installed and tested by an expert. An antidote kit should be available. In case of poisoning, give artificial respiration, administer amyl nitrite by inhalation, and immediately phone a doctor. You should take the antidote kit to the hospital with you in case the hospital does not have one.

3. Cyanide electroplating solutions should be stored in plastic containers in a locked cabinet away from other materials.

4. Do not touch electroplating bath, wires, or electrodes with bare hands while the current is on to avoid shock. See the electroplating section of Chapter 18 for more information.

5. Spent cyanide solutions must not be poured down the sink. They should be stored in a plastic container until disposed of as hazardous waste.

Annealing, Cleaning, Polishing, and Finishing

Annealing of heated precious metals usually does not involve quenching, but air cooling before pickling. Cleaning, polishing, and finishing gold and silver jewelry uses the same techniques discussed in Chapter 18. Sodium or potassium cyanide solutions are, unfortunately, also used to clean gold jewelry. This practice caused a fatality in 1990. The hazards and precautions of cyanide solutions are discussed above under electroplating.

ENAMELING

Traditionally, enameling is the art of fusing glass particles, or various colored oxides suspended and mixed with silica, onto a base metal to form the enamel surface. Enamel work can be both functional and nonfunctional and includes jewelry, hollow ware, wall pieces and/or installations, sculpture, and mixed-media pieces.

Application techniques include brushing, spraying, stenciling, and sifting or wet packing enamel onto the metal surface. The most common enamel techniques are cloisonné, champlevé, china painting, airbrush, basse taille, grisaille, limoges, plique-a-jour, repousssé, stenciling, and silk screen, and modifications of these styles.

The base metals most often used in the United States are silver, gold, or copper for jewelry; copper and more often steel for larger-scale pieces.

Most enamelists purchase preground enamels in powdered form that are almost ready for use. There are two basic types of enamels: borosilicate, and lead.

Some enamels contain fluorides and arsenic. Common colorants used include antimony, cadmium, cobalt, copper, chromium, magnesium, manganese, and nickel. In the past, radioactive uranium (e.g., Thompson's burnt orange and forsythia) and thorium were also used, but these are now banned in the United States.

Cleaning the Metal Surface

In order for the enamel to fuse evenly to the base metal, the surface must be clean and free of grease. One method of cleaning is to place the metal in a kiln heated to 1,500°F (816°C) to burn off oils and grease and then run cold water over the surface. A torch may be used instead of a kiln. The metal is then pickled with dilute nitric or sulfuric acids to remove the firescale. Sparex (sodium bisulfate), which is dissolved in water or in vinegar and salt, may be used for pickling instead of working with concentrated acids. In addition, for cleaning the metal surface, use powdered pumice plus water, or a coarse sponge and liquid dishwashing detergent.

Hazards

1. Kiln firing presents the hazard of kiln fumes and thermal burns. Using a torch also presents the additional hazard of fire, and possible fumes from the torch.

2. Concentrated sulfuric and nitric acids are highly corrosive to the skin and eyes. The diluted acids and Sparex are less hazardous, but are still irritating.

3. Pickling with nitric acid may release nitrogen dioxide gas, which is highly toxic by inhalation and may cause emphysema from chronic exposure.

Precautions

1. Take normal precautions against thermal burns, including wearing welder's gloves, using tongs, wearing long-sleeved cotton shirts, and keeping a supply of iced water for minor burns.

2. Kilns should be equipped with a canopy hood or placed near a window fan to exhaust kiln emissions.

3. When using a torch, take precautions against fire. These include not storing flammable liquids and combustible materials in the area, having a fire extinguisher present, fastening gas cylinders securely, and working on a noncombustible surface. See also Chapter 10.

463

4. Wear gloves, chemical splash goggles, and a protective apron when handling acids. Always add the acid to the water, never the reverse. Also wear gloves and goggles when using Sparex.

5. In case of acid splashes on the skin, rinse with water. In case of splashes in the eyes, rinse for at least 15 to 20 minutes using an eyewash fountain. If concentrated acids are used, an emergency shower should also be available. See a physician for all eye splashes.

6. The pickling bath should be used with local exhaust ventilation or in front of a window exhaust fan. Cover when not in use.

7. Neutralize acid solutions or spills with sodium bicarbonate (baking soda). The neutralized acid may be poured down the sink, if local regulations permit.

Preparing Enamels

Some enamelists sift the enamels to obtain a variety of particle sizes that will produce different hues when fired. Prepared enamels can be washed to remove contaminants.

Enamels can be prepared using quartz, red lead, borax (or boric acid), and other raw materials. This involves grinding the materials in a ball mill or mortar and pestle, firing in the kiln, and then pouring into cold water or onto cold steel. The resulting frit is then ground and mixed with metal oxides to give the desired color.

Hazards. The hazards of the ingredients used in preparing your own enamels are the same as those in preparing ceramic glazes (see Chapter 14). Working with lead compounds, in particular, is highly hazardous by inhalation and ingestion.

Precautions

1. Use lead-free, ready-made enamels, since they are already fritted and are not as hazardous as the raw ingredients. Know what is in your frit, since even lead frits are highly hazardous by inhalation and ingestion.

2. Sift enamels by nesting the sifters on top of each other and covering to minimize dust release. Sifting can also be done in a glove box to minimize dust exposure (see Chapter 8).

3. Take standard precautions to avoid inhaling and ingesting dusts. This includes wearing NIOSH-approved toxic dust respirators and gloves; careful housekeeping; not eating, smoking, or drinking in the studio; and careful washing of hands after working.

Applying Enamels

Enamels can be applied to the metal surface in a variety of ways, including dusting or sifting the enamel powder onto a gum tragacanth-coated plate by hand or through a screen, wet charging with damp enamel and a spatula or knife blade, spraying an alcohol/water solution of the enamel with an airbrush or spray gun, and painting the enamel or luster onto the surface by dipping or brushing. A painting medium for enamels consists of mixing the enamel with soft damar or copal resin in gum turpentine. A slurry for dipping or spraying can be prepared from a mixture of the enamel, bentonite, potash, clay, and water. Ceramic decals can also be used.

In cloisonné, the colors are separated by metal wires—usually silver, gold, or copper—which are called cloisons. These cloisons are either fused to the base coat of enamel in the kiln or soldered. The enamels are then inlaid into the cloisons and applied to the surface.

Champlevé is done on thick sheet metal and involves etching out the design with ferric chloride or nitric acid. Areas not to be etched are protected with a resist. After etching, the depressed (etched) areas are filled with enamel and then fired.

Hazards

1. If gum tragacanth is sprayed onto the metal surface before dusting, inhalation of the spray may cause respiratory allergies.

2. Inhalation of enamel dust or spray is highly hazardous, especially from lead-based enamels and from certain of the colorants. Some may also cause skin irritation. (See Table 5-2 for the hazards of particular metals.)

3. Turpentine is moderately toxic by skin contact, inhalation, and ingestion. It can cause irritation, allergies, and kidney damage.

4. Potash (potassium carbonate) is corrosive by skin contact, causing skin burns.

5. The hazards of silver soldering were discussed earlier in this chapter under silver soldering.

6. Hazards involved in champlevé include inhalation of vapors from the etching resist, skin and eye contact with ferric chloride or nitric acid, and inhalation of highly toxic nitrogen dioxide gas produced during nitric acid etching.

Precautions

1. Whenever possible, brush or dip enamels instead of dusting or spraying. If you must spray, do so in a spray booth or wear a NIOSH-approved respirator with toxic dust and mist filters. If the solution contains solvents,

you also need organic vapor cartridges. In the latter case, you also need an exhaust fan to clear the spray from your studio.

2. Wear gloves when handling turpentine or potash.

3. Wear a NIOSH-approved toxic dust respirator and gloves when handling enamel dusts outside a glove box or hood.

4. Take normal precautions to avoid accidental ingestion of hazardous materials. These include no eating, smoking, or drinking in the work area, careful housekeeping, and washing hands carefully after working.

5. Take normal fire prevention measures when using flammable solvents. These include storing in self-closing safety cans, closing all containers, no smoking or open flames in the work area, and storage of waste solvents or solvent-soaked rags in approved self-closing waste cans that are emptied each day.

6. See the silver soldering section of this chapter for hazards of soldering cloisons.

7. Ferric chloride is preferred over nitric acid because of the hazards of concentrated nitric acid and the nitrogen dioxide gas emitted during etching. Do not heat ferric chloride, because that will result in the production of highly toxic chlorine gas. See also the etching and photoetching section of Chapter 18 for precautions to be used with champlevé.

Firing Enamels

Enamels are fired in small kilns at temperatures between 1,800° and 2,300°F (980° and 1,260°C).

Hazards

1. Toxic metals, fluorides, and other fumes can be emitted during the firing process, similar to those emitted in ceramic firings. Firing decals and enamels containing gums and other organic materials will emit smoke.

2. The hot enamel can cause thermal burns.

3. The hot kiln emits infrared radiation, which can cause cataracts from long-term exposure by looking inside the heated kiln.

Precautions

1. All enameling kilns should be vented. This can be done by placing the kiln on a bench immediately in front of a window containing an exhaust fan, or by placing a canopy hood directly over the kiln.

2. Take normal precautions against thermal burns, including wearing welder's gloves, using tongs, wearing long-sleeved cotton shirts, and keeping a supply of iced water for minor burns.

3. Goggles with a shade number of 1.8 to 3, or infrared goggles intended just for protection against infrared radiation, should be worn when looking inside hot kilns.

Finishing Enamels

The fired enamel can be finished by filing the edges, grinding or sanding the enamel surface, and occasionally etching with hydrofluoric acid or fluoride pastes to give a matte finish.

Leftover enamels can be combined and used as counter enamels for the reverse side of the piece, thus eliminating the need to dispose of the residual enamel.

Hazards

1. Filing and grinding can produce enamel and metal particles, which can be an inhalation and eye hazard.

2. Hydrofluoric acid is highly corrosive to the skin, eyes, and lungs. Serious deep burns can occur without pain warning several hours after exposure. Its vapors may cause severe lung irritation, including chemical pneumonia. Ingestion can be fatal. Hydrofluoric acid can also cause chronic bone and teeth damage (osteofluorosis) and possibly kidney damage. Handling concentrated hydrofluoric acid, or even weaker hydrofluoric acid solutions, is very dangerous due to the risk of splashing.

3. Ammonium bifluoride paste, although not as corrosive as hydrofluoric acid, is still highly toxic by skin contact and ingestion, since it produces hydrofluoric acid in solution.

Precautions

1. Whenever possible, do wet grinding to minimize enamel dust getting into the air.

2. Wear protective goggles when grinding or sanding.

3. I recommend against the use of hydrofluoric acid solutions for glass etching due to its very high risks. Instead use ammonium bifluoride pastes.

Gloves and goggles are still essential even with the pastes, but the risks are much lower. See below for first-aid recommendations.

4. If hydrofluoric acid is used, do so only in a laboratory hood, or use an acid gas respirator with a full facepiece to protect both lungs and eyes. Wear natural or neoprene rubber gloves, face shield, and chemical splash goggles when handling hydrofluoric acid.

In case of contact, flush exposed skin and eyes with water for at least 15 minutes. Immerse affected area in 0.13% iced solution of Zephiran chloride for 30 to 60 minutes. Call a physician immediately. This first aid information also applies to burns from ammonium bifluoride. See the chapter references for more detailed information.

5. Leftover hydrofluoric acid should be treated as hazardous waste. See the section on waste management in Chapter 8.

Hazards of Finished Enamels

The metals in the fired enamel are usually even more soluble in stomach acid than fired pottery glazes. Thus enameled pieces should never be used for holding food or drink because of the risk of toxic metals leaching into the food or liquid. See also the discussion on leaching from ceramics in Chapter 14.

REFERENCES

Burgess, W. (1981). *Recognition of Health Hazards in Industry.* New York, NY: John Wiley and Sons.

Goh, C. (1988). Occupational dermatitis from gold plating. *Contact Dermatitis* 18(2), 122–23.

Kern, D. G., and Frumkin, H. (1988). Asbestos-related disease in the jewelry industry: Report of two cases. *Amer. J. Ind. Med.* 13, 407–10.

Letts, N. (1991). Artist dies in basement cyanide accident. *Art Hazards News* 14(1), 1.

Quinn, M., Smith, S., Stock, L., and Young, J. (eds). (1980). *What You Should Know About Health and Safety in the Jewelry Industry.* Providence, RI: Jewelry Workers Health and Safety Research Group.

Weiss, L. (1987). *Health Hazards in the Field of Metalsmithing.* Society of North American Goldsmiths.

Glass Arts

This chapter discusses the hazards and precautions for glassblowing and related glass arts. Stained glass is discussed in Chapter 22, and neon sculpture in Chapter 23.

▰▰▰ GLASSBLOWING

Glassblowing can involve a variety of steps, including mixing the batch, firing, melting, working, and annealing the glass, and a variety of decorating and finishing processes. There is also a brief discussion of slumping and fusing glass and lampworking.

Making Your Own Glass

You can make your own glass from the basic chemicals (fluxes, silica, and stabilizers)—a process called batching—or you can use scrap glass (cullet) or "second

melts," as it is also called. The chemicals used to make glass vary depending on the type of glass. There are four common varieties: (1) lead/potash glasses using potash (potassium carbonate) as flux and lead compounds as stabilizers; (2) borosilicates (Pyrex) using boric oxide as replacement for some of the silica in standard formulations; (3) soda/lime glasses using soda ash (sodium carbonate) as flux, and lime (in the form of hydrated lime or calcium carbonate) as stabilizer; and (4) opal or opaque glasses using either phosphate (bone ash) or fluoride compounds to yield the opacity.

All these glasses use silica in the form of sand, silica flour, or flint as the glass former. Other chemicals added include sodium and potassium nitrates, dolomite, small amounts of arsenic and antimony oxides, and other metallic oxides.

Colorants are usually added to the melt at the time of either mixing up the glass composition or when adding the colorants to the molten glass (for example, if you are using cullet). The common colorants used are oxides or carbonates of chromium, copper, cobalt, or manganese; other colorants include gold, nickel, iron, silver, various sulfides, titanium, and uranium. Reducing agents used include tin oxide, sodium potassium tartrate (Rochelle salt), potassium bitartrate (cream of tartar), and sodium cyanide.

Hazards

1. Chronic inhalation of free silica can cause silicosis (see Chapter 5 for more information). Many minerals used in making glass contain large amounts of silica. See Table 5-1 in Chapter 5 for information on these.

2. Lead compounds can cause anemia, peripheral nervous system damage, brain damage, kidney damage, intestinal problems, chromosomal damage, birth defects and miscarriages. See Chapter 5 for more information on the hazards of lead compounds.

3. Arsenic oxide is highly toxic by skin contact and extremely toxic by inhalation and ingestion. It is a known human carcinogen. Repeated skin contact may cause burning, itching, and ulceration (particularly of the lips and nostrils). Chronic inhalation may cause digestive disturbances, liver damage, peripheral nervous system damage, kidney damage, and blood damage. Acute ingestion may cause fatal arsenic poisoning.

4. Antimony oxide is highly toxic by inhalation and moderately toxic by skin contact and ingestion. It is a probable human carcinogen. Its toxic effects are similar to those of arsenic.

5. Potassium carbonate, sodium carbonate, and lime are corrosive to skin, eyes, and respiratory system. See the alkali section and Table 4-3 in Chapter 4.

6. Compounds of the following metals used as colorants are known or probable human carcinogens: cadmium, chromium (VI), nickel, and uranium. Compounds of cobalt and manganese are highly toxic by inhalation. Chromium (VI) compounds and nickel compounds are moderately toxic by skin contact. Table 5-2 lists the hazards of specific metal compounds.

7. Sodium cyanide is extremely toxic by ingestion, highly toxic by inhalation, and moderately toxic by skin contact. Chronic skin contact may cause skin rashes; it may also be absorbed through the skin. Acute ingestion is frequently fatal, even in small amounts, causing chemical asphyxia. Acute inhalation may also cause chemical asphyxia. Chronic inhala- tion of small amounts may cause nasal and respiratory irritation, including nasal ulceration, and systemic effects with symptoms of loss of appetite, headaches, nausea, weakness, and dizziness. Adding acid to cyanide causes the formation of extremely toxic hydrogen cyanide gas, which can be rapidly fatal by inhalation.

8. Potassium bitartrate (cream of tartar) and sodium potassium tartrate (Rochelle salt) are moderately toxic by ingestion and only slightly toxic otherwise.

Precautions

1. Use cullet whenever possible, since this eliminates exposure to hazardous dusts in preparing the glass composition and to toxic fumes during melting.

2. A new batch method consists of adding premixed, pelletized batches. This involves very little dust exposure and is much less hazardous than mixing the materials yourself.

3. If you do batch glass from scratch, avoid using lead, arsenic, and antimony compounds because of their high toxicity.

4. Do not use sodium cyanide, if at all possible. If you do, use only in a fume hood and keep an antidote kit available. In case of poisoning, give artificial respiration, administer amyl nitrite by inhalation, and immediately phone a doctor. You should take the antidote kit with you to the hospital. Time is critical.

5. Use a plain-opening local exhaust hood with flexible duct when weighing out glassblowing chemicals. An alternative is to wear a National Institute for Occupational Safety and Health (NIOSH)-approved toxic dust respirator.

6. Wet mop all powder spills. Keep containers covered.

7. Do not eat or drink in work areas. Wear special clothing and wash your hands frequently.

8. Wear gloves when handling powders to avoid skin contact.

471

Firing, Melting, and Annealing

Furnaces used to form the glass from the raw materials, and to melt and reheat the glass, can reach temperatures as high as 2,500–3,000°F (1,370–1,640°C). They are usually gas fired. Annealing ovens, used to reheat the glass to eliminate stresses that can cause fracturing, can be either gas fired or electric.

Hazards

1. Gas-fired furnaces give off large amounts of carbon monoxide, which is highly toxic by inhalation. In addition, when you make your own glass, the melting process gives off many toxic gases, such as nitrogen oxides, fluorine, sulfur oxides, chlorine, and metal fumes. These are all highly toxic by inhalation.

2. Glassblowing furnaces and ovens give off tremendous amounts of heat, which can produce heat stress diseases, particularly in people who are not acclimatized to the heat. People with heart, kidney, and other chronic diseases, older people, and overweight people are particularly susceptible to heat stress diseases. See the heat stress section in Chapter 10 for more information on heat stress.

3. The high temperatures achieved in the furnace, coupled with the fact that it is often necessary to reach into the furnace during various stages of melting, can result in thermal burns from contact with the hot glass or furnace. In addition there is a possible danger of your clothing or hair catching fire.

4. Infrared radiation produced by the molten glass is absorbed by the skin and converted into heat, which can cause tissue damage similar to sunburn. This heat can be detected, so you usually have warning of excess acute exposure to infrared radiation. Regular exposure to small doses of infrared radiation can cause chronic inflammation of the eyelids and can also damage the eye lens, causing it to become opaque. This is known as "heat cataracts" or "glassblower's cataracts" because of its prevalence among glassblowers. There are no warning signs to indicate chronic overexposure to infrared radiation.

5. The use of large electric currents and complex electronic control devices can result in fire hazards if the electric wiring is not adequate or is not in good condition. Similarly, with gas-fired furnaces, there is the danger of fires and explosions from gas leaks.

6. Boards and blankets made from refractory ceramic fibers are commonly used around glassblowing ovens and furnaces. The ceramic fibers from

these materials are classified as possible carcinogens. Refractory ceramic fibers are also partially converted to cristobalite, one of the more toxic forms of silica, above 1,800°F (982°C).

Precautions

1. All furnaces in which chemicals are added—whether electric or fuel fired—must be vented with a local exhaust ventilation system. An updraft or canopy hood is best because it takes advantage of the fact that hot gases rise and thus can provide some protection if the fan fails. Note that in the case of gas-fired furnaces, care should be taken that the inlet for the blower providing air to the burner is located outside the canopy hood area. The back, sides, and front of the canopy hood should be enclosed as much as possible to ensure effective capture of carbon monoxide and other contaminants. The hood, if designed properly, will also remove much of the excess heat.

2. Insulation should be made of firebrick or other refractory materials if possible. Do not use asbestos, and avoid refractory ceramic fibers if possible, since some of these materials are possible human carcinogens. Wall off existing fiber insulation to prevent fiber release. Firebricks contain some silica but are less hazardous.

3. Take frequent rest periods in a cool environment to give your body a chance to lose excess heat. If you are not acclimatized to the heat, be careful not to expose yourself to high heat for extended periods of time. Drink lots of cool beverages to replace water lost by sweating. Lost salt can be replaced by drinking water containing one teaspoon of salt per gallon, or preferably drinking a commercial salted beverage such as Gatorade.

4. Heat rash can be helped by the use of mild skin-drying lotions and cooled sleeping quarters; both allow the skin to dry between heat exposures.

5. People with heart or kidney disease, or who are very overweight, should not undertake glassblowing because of the excess strain of the heat on their body. Pregnant women should consult their physicians.

6. Protection against infrared radiation can consist of movable reflecting shields (e.g., silver-painted transite or aluminum foil) and infrared-absorbing barriers (e.g., water). Note that air conditioning will not protect against infrared radiation, since the radiation can travel through cool air as well as hot air.

7. Use infrared goggles or welding goggles with a shade number between 1.7 and 3 to protect against infrared radiation. Do not use didymium lenses, which just protect against visible light.

8. Wear long-sleeved closely woven cotton shirts to protect against heat. Do not use polyesters and other synthetic fibers, which might melt from contact with molten glass.

9. Other types of useful items include safety showers or fire blankets in case of clothing fires and a refrigerator or other source of cold water for treatment of minor burns.

Working Freeblown Glass

Glass is actually "blown" by gathering molten glass on the end of a four- to five-foot blowpipe and forcing air into the molten glass with your breath.

Hazards

1. During this process, many of the heat and infrared hazards discussed in the previous section are also present.

2. Studies have shown that, for unknown reasons, many glassblowers develop chronic lung problems, including a decrease in lung capacity.

3. Working freeblown glass requires a considerable expenditure of physical energy and strength. Heavy gathers of glass (often five to ten pounds) at the end of a four- to five-foot steel blowpipe must be lifted, swung, and otherwise manipulated with ease, dexterity, and speed. It must often be controlled with one hand while the other hand uses various tools. In addition, this strenuous work is performed in a very warm atmosphere, since the furnaces containing the molten glass must be open much of the time.

4. Working with glass carries the risk of injury from broken glass.

5. Some people add colorants and other chemicals at this stage. This can result in vaporization of metal fumes or release of other toxic gases into the air where they will not be trapped by the canopy hood.

Precautions

1. See precautions listed in the previous section for protection against heat, infrared radiation, and burns.

2. Wear heavy shoes that broken glass can't penetrate and metal mesh safety gloves when picking up broken glass.

3. Add chemicals to the hot glass only under the canopy hood to avoid inhalation of toxic fumes and gases.

474

4. Using glass color bars to add colorants to the molten gather can eliminate the hazards of vaporizing metal oxides.

5. People with lung problems or impaired reflexes, dexterity, or strength should not undertake glassblowing.

Decorating Glass

Techniques used to decorate freeblown glass include metallic decorating, staining, iridescent effects, and mirroring. Metallic decorating is achieved by brushing, spraying, marvering, or dipping metal salts dissolved in oil of lavender onto the surface of the glass and remelting. Metals used include the Bright Metals (gold, platinum, palladium, and silver), and the Luster Colors (copper, manganese, cobalt, and uranium).

Glass staining is accomplished by applying slurries of silver or copper chloride (or nitrate), clay, and water to the glass surface and firing. An alternative method for copper staining on soda/lime glass involves cuprous chloride fumes in contact with the hot glass for several hours.

Iridescent effects are achieved by spraying tin chloride, iron chloride, and hydrochloric acid onto the hot glass surface, or by introducing metallic salts into the annealing oven, where they fume and coat the glass surface. Other metals used to give iridescent effects include titanium chloride, vanadium tetrachloride, uranium compounds, and cadmium compounds. Mirroring solutions usually contain ammonia, silver compounds, and a reducing compound such as Rochelle salt. Other chemicals may include nitric acid and tin compounds.

Hazards

1. Many of the metal salts used for metallic decorating techniques are hazardous both by skin contact and inhalation. Spraying, in particular, is highly hazardous due to the possibility of inhaling large amounts of toxic materials. Gold and platinum salts can cause severe asthma by inhalation. Silver nitrate and the chlorides of iron, titanium, vanadium, and tin are skin, eye, and respiratory irritants. Silver nitrate is particularly hazardous by eye contact. (See Table 5-2 for more information on the hazards of metals.)

2. Fuming, marvering with metal salts, and firing can result in the production of hazardous metal fumes and gases. Inhalation of the metal fumes of zinc, and sometimes of iron and copper, may cause metal fume fever. This is an acute disease that appears some hours after exposure, disappears within 24 to 36 hours, and has no known long-term effects. Symptoms include dizziness, nausea, fever, chills, pains, headache, and other flu-like symptoms. Attacks can be mild or severe depending on the individual and the amount

475

of exposure. Other metal fumes (e.g., lead, cadmium, and selenium) can cause more serious acute or chronic poisoning (see Table 5-2).

3. Hazardous gases produced during these processes include fluorine, chlorine, sulfur dioxide, and nitrogen dioxide. These are all lung irritants and may cause pulmonary edema in huge exposures or chronic bronchitis from repeated exposure to small amounts.

4. Concentrated acids are corrosive to skin, eyes, respiratory system, and gastrointestinal system. Dilute acids are skin, eye, and respiratory irritants. See the section on acids in Chapter 4 and Table 4-2.

Precautions

1. Use painting and dipping techniques instead of spraying whenever possible. If you do spray metal salts and acid, do so under the canopy hood or wear an approved respirator with acid gas cartridges and toxic dust, mist, and fume prefilters.

2. Marvering with metal salts, fuming, or firing should be done only with local exhaust ventilation, for example, under a canopy hood.

3. Wear gloves, goggles, and protective apron to protect against materials that are skin and eye irritants.

4. When diluting concentrated acids, add the acid slowly to the water.

5. In case of skin contact with acids or ammonia, rinse with water; in case of eye contact, rinse eyes for 15 to 20 minutes. An eyewash fountain and emergency shower should be readily available.

Cutting and Finishing Glass

Cutting glass, finishing it, mechanical polishing, and grinding can be done with a variety of different machines, including glass lathes, diamond glass saws, grinders, polishers, and edge-bevelers. Most of these machines use abrasives and dripping water. The abrasives used include cerium oxide, pumice, silicon carbide, alumina, tin oxides, and rouge. Sandblasting uses compressed air to blow sand or other abrasives against the glass surface.

Chemical finishing—etching, polishing, and frosting—uses hydrofluoric acid, mixtures of hydrofluoric acid and sulfuric acid, or ammonium bifluoride or other fluorides.

Hazards

1. With many of the machine techniques, there is the danger of injury from small flying particles of glass, or from actual pieces of glass if the vessel

476

breaks (especially if improperly annealed). This is hazardous to the eyes and, in the case of fine glass particles, an inhalation hazard.

2. Water splashing near electrical equipment can result in electric shocks. The water in recirculating machines can become contaminated with microorganisms, which can cause infections.

3. Most abrasives are only slightly toxic unless they contain more than 1% crystalline silica. Ones of concern are rouge, sand pumice, and tripoli. Chronic inhalation of large amounts of putty (tin oxide) may cause a harmless pneumoconiosis. Cerium oxide may cause corneal damage if it gets in the eyes. The use of wet techniques minimizes the inhalation risk. Table 5-1 in Chapter 5 discusses the hazards of particular abrasives.

4. The use of sand in sandblasting is highly hazardous by inhalation. It is one of the best known causes of rapidly developing silicosis.

5. Hydrofluoric acid is highly corrosive to the skin, eyes, and lungs. Serious deep burns can occur without pain warning several hours after exposure. Its vapors may cause severe lung irritation, including chemical pneumonia. Ingestion can be fatal. Hydrofluoric acid can also cause chronic bone and teeth damage (osteofluorosis) and possibly kidney damage. Handling concentrated hydrofluoric acid is very dangerous due to the risk of splashing.

6. Ammonium bifluoride, although not as corrosive as hydrofluoric acid, is still highly toxic by skin contact and ingestion, since it produces hydrofluoric acid in solution.

Precautions

1. Wear protective goggles when using glass-cutting and -finishing machines.

2. Install a ground fault circuit interrupter on all outlets connected to machines using dripping water.

3. Water reservoirs should be cleaned regularly to prevent the growth of microorganisms. If necessary, clean with a biocide such as bleach.

4. Do not use sand as an abrasive in sandblasting. Instead use less hazardous abrasives such as alumina, silicon carbide, or crushed walnut shells. Avoid foundry slags that are contaminated with arsenic and other toxic metals.

5. If the abrasive blasting machine is an enclosed machine, inspect regularly to make sure all seals are intact to prevent escape of abrasive powder. The machine should be under negative pressure. Hearing protectors might be necessary.

6. For nonenclosed abrasive blasting, wear an abrasive blasting hood with supplied-air respirator and protective clothing to protect skin against the high-pressure abrasive particles.

7. I recommend against the use of hydrofluoric acid solutions for glass etching due to its very high risks. Instead use ammonium bifluoride pastes. Gloves and goggles are still essential even with the pastes, but the risks are much lower. See below for first-aid recommendations.

8. If hydrofluoric acid is used, do so only in a laboratory hood, or use an acid gas respirator with a full facepiece to protect both lungs and eyes. Wear natural or neoprene rubber gloves, face shield, and chemical splash goggles when handling hydrofluoric acid. In case of contact, flush exposed skin and eyes with water for at least 15 minutes. Immerse affected area in 0.13% iced solution of Zephiran chloride for 30 to 60 minutes. Call a physician immediately. This first-aid information also applies to burns from ammonium bifluoride. See the chapter references for more detailed information.

Slumping and Fusing Glass

Slumping involves heating glass in an electric kiln so it softens and changes its shape, for example, to fit a mold. Fusing involves the heating of two pieces of glass together until they join.

Hazards and Precautions. Slumping and fusing involve many of the same hazards present in glassblowing. See the relevant sections for hazards and precautions.

Lampworking

Lampworking involves the use of a torch (oxyacetylene for "hard" glasses or a propane torch for "soft" glasses) to soften or melt glass tubing that is then "blown" into the desired shape. Many of the decorating and finishing techniques described for free-form glassblowing can also be used here.

Hazards

1. Many of the hazards found in freeblown glass working—thermal burns, use of hazardous metals, production of fumes during decorating—are also present in lampworking.

2. The use of torches—either oxyacetylene or propane—involves fire hazards.

Precautions

1. See precautions for different procedures involved with free-form glassblowing.

2. Use normal fire prevention precautions in handling flammable gas cylinders. Fasten the cylinders securely, use them away from flammable materials, and have a fire extinguisher present. (See also the oxygen and flammable gases section of Chapter 8, and the welding section of Chapter 18.)

REFERENCES

Braun, S., and Tsiatis, A. (1979). Pulmonary abnormalities in art glassblowers. *J. Occup. Med.* 21(7), 487-89.

Lydahl, E., and Philipson, B. (1984). Infrared radiation and cataract. II. Epidemiological investigation of glass workers. *Acta Ophthalmol.* 62(6), 976-92.

Nixon, W. (1980). Safe handling of frosting and etching solutions. *Stained Glass* (Fall), 215.

Textile Arts

This chapter discusses fiber arts and dyeing.

FIBERS

The textile arts include spinning, weaving, felting, macrame, sewing, knitting, crocheting, needlepoint, and a variety of other related crafts. The fibers used can be vegetable, animal, or man-made. The dyeing of fibers and cloth is also discussed in this chapter.

Vegetable Fibers

There are three types of vegetable fibers: bast or stem fibers (e.g., flax, jute, hemp, and ramie); leaf fibers (e.g., sisal and manilla); and seed or fruit fibers (e.g., cotton and coir). Other fibers are also used. For spinning, the various fibers usually have to be cleaned by carding. For weaving and other techniques, the fibers can be bought in yarn or thread form.

480

Hazards

1. The main hazard from vegetable fibers is due to inhalation of the dusts from the fibers or from molds growing on the fibers. One such problem is an acute temporary illness that can last 24 to 48 hours: Symptoms consist of chills, headache, fever, gastric upset, sneezing, and sore throat. This illness appears at the onset of exposure to the dusts and then does not return except after long absences from dust exposure or with heavy dust exposures.

2. Heavy exposure to cotton, flax, and hemp dusts—especially in carding and spinning stages—can cause the serious lung disease called byssinosis, or brown lung. Initial symptoms appear only when a person returns to work after being away for a few days. These early symptoms include chest tightness, shortness of breath, and increased sputum flow. There is a decrease in lung capacity. However, after removal from exposure, these early symptoms are reversible.

 After 10 to 20 years of exposure, these symptoms can appear whenever there is exposure to the dust and, eventually, even when there is no exposure. These stages are not reversible, and advanced cases of brown lung are often fatal.

3. Long or heavy exposure to dusts of hemp, sisal, jute, and flax can cause respiratory problems such as acute and chronic bronchitis or emphysema.

4. Weaver's cough is a disease characterized by chest tightness, dry cough, shortness of breath, malaise, and headache; it can be very disabling and last for weeks after exposure is ended. It is thought to be caused by mildewed yarn or low-grade stained cotton, which favors the growth of fungi.

5. Weaving can involve specific hazards such as carpel tunnel syndrome, skeletal deformation from weaving in a squatting position on certain older types of looms, eyestrain from poor lighting, and hand and finger disorders (e.g., swollen joints, arthritis, neuralgia) from threading and tying knots.

Precautions

1. Examine yarn and fiber for mold contamination before buying.

2. Store yarns and fibers in a dry location so that molds will not grow. The relative humidity should be less than 60%.

3. When carding or carrying out other dust-producing processes, maintain good ventilation. For example, carding can be carried out over a grill with downdraft ventilation to carry the dust away from your face. An alternative is to wear a dust mask.

481

4. Keep your studio clean and free of dust by vacuuming or wet mopping daily.

5. Make sure that there is sufficient lighting and that you adopt a comfortable working position when weaving. Take work breaks to help avoid hand and finger disorders.

6. Inform your doctor that you are working with these dusts and have regular lung function tests.

Animal Fibers

Animal fibers used by craftspeople include sheep's wool, horse hair, camel hair, mohair, goat hair, and angora, among others. Some craftspeople even use hair from dogs, cats, and people. The other major type of animal fiber is silk. Wool and hair must be processed through several steps to prepare it for spinning. These include sorting, washing in mild soap or detergent, spraying of scoured wool with olive oil or mineral oil, teasing, and carding and combing.

Hazards

1. The major, but rare, hazard in the handling of animal hair is anthrax. This can result from skin contact or inhalation of anthrax spores from hair that has come from diseased animals, especially goat hair and sometimes camel hair. This can be particularly a problem with hair from Central Asian and Middle Eastern countries such as Pakistan, India, Iran, and Iraq, where anthrax is common. Wool is not a problem unless it is mixed with goat hair, according to the Centers for Disease Control.

 There are two main forms of anthrax: the cutaneous form and the inhalation form. The inhalation form is usually fatal. In 1976, a California weaver died of this form of anthrax after being exposed to Pakistani yarn that had been mixed with contaminated goat hair. The skin form is less frequently fatal. In theory, these hazards apply not only to the weaver but also to people handling the finished work, if it is contaminated.

2. Animal fibers can also be contaminated with molds, spore, feces, or other infectious agents (e.g., Q fever). Many people are allergic to molds or spores or to the animal dander itself.

Precautions

1. Do not use animal hair (especially goat hair) from Middle Eastern and Central Asian countries unless it is certified to have been cleaned and

sterilized. Crafts organizations should lobby to make this a requirement for importation and sale.

2. There are several types of possible disinfection procedures: (a) steam sterilization by autoclaving at 15 pounds per square inch at 120°F (48°C) for 15 minutes; (b) ethylene oxide sterilization (often used by hospitals) using 50% relative humidity and 700 mg of gas per liter of chamber volume for six hours; and (c) steam-formaldehyde sterilization in an autoclave.

 You should not carry out these procedures but have them done by someone experienced. The procedures are often available in hospitals. Some of the disinfectants used are highly toxic. For sterilization of finished work, ethylene oxide has been recommended as having the best effect on the work.

3. According to the Centers for Disease Control, microwaving yarn or hair to disinfect it does not work.

4. Immunization against anthrax is not a possibility. The vaccine is not available because of concern with side effects and liability.

5. Do not make wearable pieces from goat or camel hairs from the above-mentioned countries.

6. See the precautions listed above for vegetable dusts.

Man-Made Fibers

Man-made fibers are of two types: reprocessed cellulose materials (e.g., rayon, acetate, and triacetate) and synthetic fibers (e.g., nylon, polyesters, acrylics, and modacrylics).

Hazards

1. Little is known about the hazards of man-made fibers. Dusts from these fibers are slightly irritating by inhalation.

2. Synthetic fibers or textiles often have been treated with formaldehyde resins as permanent press treatments, sizing, or fire retardants. Formaldehyde is a skin, eye, and respiratory irritant and sensitizer. People working with bolts of cloth in particular that have been treated with formaldehyde resins can experience respiratory irritation and may become sensitized to the formaldehyde.

Precautions

1. See the precautions listed above for vegetable fibers.

2. Do not store large quantities of cloth that have been treated with formaldehyde resins in the studio. This cloth should be stored in a ventilated location to prevent buildup of formaldehyde.

▪ DYEING

Fabric can be dyed in several ways: whole cloth dyeing, tie dyeing, resist techniques (e.g., batik), painting dyes on fabric, marbleizing, and silk screening, to name a few. In addition, some of these techniques are used to dye yarn and fibers. The type of dye used depends primarily on the type of fiber. Dye classes used include natural dyes, mordant dyes, fiber-reactive dyes, direct dyes, acid dyes, basic dyes, vat dyes, and azoic dyes. With many of these dyes, dyeing assistants and other chemicals are necessary.

General Hazards. Most dyes have not been adequately studied with respect to their long-term hazards, especially cancer risk. The major risk is inhalation of dye powders.

General Precautions

1. Buy dyes in liquid or paste form whenever possible to eliminate inhalation risks.

2. Mix dye powders inside a glove box (see Chapter 8), inside an enclosed hood, or wear a National Institute for Occupational Safety and Health (NIOSH)-approved toxic dust respirator.

3. Wear gloves when handling dye solutions.

4. If the dye bath is heated near boiling, install a canopy hood over the dye bath.

Acid Dyes

Acid dyes are used for wool, silk, and sometimes nylon. Sulfuric acid, vinegar, or diluted glacial acetic acid, and sometimes common salt or Glauber's salt (sodium sulfate), are used as dyeing assistants. The temperature of the dye bath can be simmering (140°F or 60°C) or at a boil. Acid dyeing is also done at 90–100°F (32–38°C).

Hazards

1. In general, the long-term hazards of many of these dyes are unknown. Many acid dyes, which were formerly food dyes, have been shown to cause liver cancer in animal studies.

2. Glacial acetic acid and concentrated sulfuric acid are highly corrosive by skin contact, inhalation, or ingestion. Vinegar and dilute sulfuric acid are only slightly irritating by skin contact; repeated and long-term inhalation of the acetic acid and sulfuric acid vapors may cause chronic bronchitis. Splashing hot or boiling dye bath containing acid into the eyes could be highly hazardous.

3. Glauber's salt (sodium sulfate) is only slightly toxic by ingestion, causing diarrhea.

Precautions

1. See general precautions.

2. Use vinegar as a dyeing assistant rather than diluting glacial acetic acid or using sulfuric acid.

3. If you dilute concentrated acids, always add the acid to the water. Wear gloves, goggles, and protective apron. An eyewash fountain and emergency shower should be available.

4. Wear goggles when dyeing at high temperatures to avoid splashing hot liquid in your eyes.

5. Boiling dye baths should be exhausted with a canopy hood, since the steam can carry dye with it into the air.

Azoic Dyes

Azoic dyes, or naphthol dyes as they are also called, are used to dye cotton, linen, rayon, silk, and polyester. They consist of two components—"fast salts" and "fast bases"—which must react together on the fabric to form the dye. Dyeing assistants used with these dyes are lye and Monopol oil (sulfonated castor oil).

Hazards

1. Azoic dyes are very reactive and may cause severe skin irritation (dermatitis, hyperpigmentation). Long-term effects of these dyes have not been well studied.

2. Lye (sodium hydroxide) is highly corrosive by skin and eye contact and ingestion.

3. Sulfonated castor oil is moderately toxic by ingestion.

Precautions

1. If possible, avoid azoic dyes. Most other types of dyes are less hazardous.

2. See general precautions.

3. Wear gloves and goggles when handling lye.

Basic Dyes

Basic dyes, also called cationic dyes, are used to dye wool, silk, and cellulosics that have been mordanted with tannic acid. They are also sometimes found in all-purpose household dyes. Most fluorescent dyes are basic dyes.

Hazards. Some basic dyes are known to cause skin allergies. Whether they cause respiratory allergies if inhaled is not known.

Precautions. See general precautions.

Direct Dyes

Direct dyes are used for dyeing cotton, linen, or viscose rayon. They use ordinary table salt (sodium chloride) as a dyeing assistant and require heat during the dyeing process. Direct dyes are azo dyes. In the past, a large number of direct dyes, particularly in the dark shades, were made from benzidine. Dyes based on benzidine derivatives (3,3'-dimethoxybenzidine, and 3,3'-dimethylbenzidine) may still be available. Direct dyes are the most common dyes used by craftspeople and are present in all household dye products.

Hazards

1. Benzidine and benzidine-derivative direct dyes are extremely or highly toxic by inhalation and ingestion, and possibly through skin absorption. Bladder cancer may be caused by the breakdown of these dyes by intestinal bacteria and also by the liver to form free benzidine, one of the most powerful carcinogens known in humans. It has been shown that workers

using these dyes have free benzidine in their urine. Another source of concern with imported benzidine dyes is that they were often found to be contaminated by free benzidine.

2. The long-term hazards of other types of direct dyes are unknown.

Precautions

1. Do not use direct dyes based on benzidine or benzidine derivatives, if known.

2. See general precautions.

Disperse Dyes

Disperse dyes are used to dye polyester, nylon, and acetates. They are often applied at high temperatures.

Hazards. Many disperse dyes are known to cause skin allergies, even from skin contact with the dyed fabric.

Precautions. See general precautions.

Fiber-Reactive Dyes

Fiber-reactive dyes, or cold-water dyes, are dyes that work by reacting chemically with the fiber, usually cotton or linen. These dyes use sal soda or washing soda (sodium carbonate) for deactivating the bath after dyeing. Other chemicals often used are water softeners, urea, and sodium alginate (as thickeners).

Hazards

1. Fiber-reactive dyes can react with lung tissue and other mucous membranes to produce very severe respiratory allergies. Symptoms include tightness in the chest, asthma, swollen eyes, "hay fever," and possible skin reactions. These dyes are very light, fine powders and are easily inhaled. There have been many cases of craftspeople working with these dyes for several years without problems and then suddenly developing a severe allergy.

2. Sodium carbonate is moderately corrosive by skin contact and highly corrosive by inhalation or ingestion.

Precautions

1. See general precautions.

2. Purchase liquid, fiber-reactive dyes rather than powdered dyes.

3. If possible, mix up a full package of the dye at a time rather than storing partly filled packages. One possible way to avoid inhalation of the dye powder is to use a glove box. Another alternative is to open the dye package under water while wearing gloves rather than pouring the powder into the water.

4. Wear gloves and goggles when handling sodium carbonate solutions.

5. Be sure to clean up any dye powder that has spilled by wet mopping.

French Dyes

So-called French dyes are solvent-based, brilliant dyes often used for painting on silk. These are mostly based on ethyl alcohol, but Material Safety Data Sheets should be obtained to ensure this.

Hazards. The solvents used are flammable. Ethyl alcohol is a mild respiratory irritant and is only slightly toxic. Methyl alcohol is moderately toxic and is absorbed through the skin. It can affect the nervous system.

Precautions

1. Use only dyes containing ethyl alcohol. Dilute the dyes with water, isopropyl alcohol, or denatured alcohol, not methyl alcohol.

2. Use with good dilution ventilation (e.g., window exhaust fan at work level).

3. Do not allow open flames, lit cigarettes, or other sources of ignition around the solvents.

Household Dyes

All-purpose household dyes, also called Union dyes, are mixtures of several dye classes with salt, so that they will dye almost any type of fiber. The dye class that is not suited to a fiber will be left in the dye bath.

Hazards. The hazards of household dyes depend on the classes of dyes present. Usually these include an acid dye and basic dye. Fiber-reactive dyes are also sometimes present.

Precautions. See general precautions.

Mordant Dyes

Mordant dyes are synthetic dyes that, like some natural dyes, use mordants to fix the dye to the fabric. They are commonly used to dye wool and leather and sometimes cotton. You can use the same mordants used with natural dyes.

Hazards

 1. The hazards of synthetic mordant dyes have not been extensively studied.

 2. See natural dyes below.

 3. See Table 21-1 for the hazards of the mordants.

Precautions

 1. See general precautions.

 2. Wear rubber gloves when mordanting, preparing dye baths, and dyeing.

Natural Dyes

Natural dyes are mordant dyes prepared from plants, insects, algae, and any other likely material. Most of these natural dyes are prepared by soaking plant, bark, or other material in water or simmering for one to two hours. In some cases, for example, indigo, these dyes are also available synthetically.

Natural dyes are used to dye cotton and silk fibers and fabric and usually require the use of mordants to fix the dye to the fiber. Mordanting is usually done by simmering the fibers or other material in a mordant bath for 30 to 45 minutes. After mordanting, the material is dyed.

Common mordants used are alum (potassium aluminum sulfate), ammonia, blue vitriol (copper sulfate), copperas or green vitriol (ferrous sulfate), cream of tartar (potassium acid tartrate), chrome (potassium dichromate), oxalic acid, tannin (tannic acid), tin (stannous chloride), and urea.

Hazards

1. The hazards of natural dyes are mostly unknown, particularly with respect to their carcinogenic effects. Usually there is no hazard due to inhalation, and the only problem is possible skin contact and absorption. Some plant materials, however, can release irritating vapors (e.g., eucalyptus).

2. Table 21-1 lists the hazards of the mordants. Oxalic acid, potassium dichromate, and copper sulfate are the most hazardous.

3. The hazards of using indigo are discussed below under vat dyes.

Precautions

1. Wear rubber gloves when mordanting, preparing dye baths, and dyeing.

2. Whenever possible, prepare your own dye bath by soaking wood, plant, and other natural dye sources rather than buying prepared dye powders. If you do use dye powders, use a glove box or wear a NIOSH-approved toxic dust respirator.

3. A safer, cold mordanting procedure can be done as follows: (a) dissolve the mordant in a small amount of warm water; (b) pour the dissolved mordant and cold water into a container with a tight lid or seal; (c) submerge the scoured fiber or other material, and secure the lid; (d) let sit for at least 12 hours; (e) remove the fiber and rinse thoroughly; and (f) dye the mordanted material or let dry.

Vat Dyes

Vat dyes, including the natural vat dye indigo, are dyes that are insoluble in their colored form. They must be reduced to a colorless, soluble leuco form with lye or caustic soda (sodium hydroxide) or sodium hydrosulfite before they can be used for dyeing. Vat dyes are commonly purchased in their colorless reduced form. The color is produced after dyeing by air oxidation or by treatment with chromic acid (potassium dichromate and sulfuric acid). Vat dyes are used to dye silk, cotton, linen, and viscose rayon.

Hazards

1. Vat dyes in their prereduced form are moderately irritating by skin contact, inhalation, and ingestion. Vat dyes may cause allergies.

2. Sodium hydroxide is highly corrosive by skin contact and ingestion.

3. Sodium hydrosulfite is moderately irritating by inhalation and ingestion. Its powder is very easily inhaled. When heated or allowed to stand in basic solution, sodium hydrosulfite decomposes to form highly toxic sulfur dioxide gas.

4. Chromic acid is highly corrosive by skin contact or ingestion, as are its separate components sulfuric acid and potassium dichromate. It is a known human carcinogen and can cause skin ulceration and allergic reactions.

Precautions

1. Wear gloves and a NIOSH-approved toxic dust respirator when handling prereduced or presolubilized vat dye powders or sodium hydrosulfite. When possible, mix in a glove box.
2. Wear gloves and goggles when handling lye.
3. Do not store solutions containing sodium hydrosulfite.
4. Do not oxidize vat dyes to their colored form with chromic acid. Instead use heat and air.

SPECIAL DYEING TECHNIQUES

Some dyeing techniques have particular hazards due to the nature of the technique. These include tie-dyeing, batik, and discharge dyeing.

Tie-Dyeing

Tie-dyeing involves the pouring of concentrated dye solutions over the tied fabric.

Hazards. The pouring of concentrated dye solutions over fabric, as done in tie-dyeing, may involve a greater risk from skin or eye contact if the dye is splashed.

Precautions

1. See general precautions.
2. Wear gloves and goggles when tie-dyeing.

Batik

Batik involves applying molten wax to the fabric to form a resist pattern, dyeing the resisted fabric, and then removing the wax resist by ironing the fabric between layers of newspaper or by the use of solvents.

Hazards

1. Melting wax for batik can be a fire hazard if the wax is allowed to spill or if it is overheated so that wax fumes form. Overheating can also produce decomposition of the wax to acrolein and other strong lung irritants.

2. Ironing out the wax often releases highly irritating wax decomposition products.

3. Carbon tetrachloride and gasoline have been used to remove residual wax from the fabric. Carbon tetrachloride is extremely toxic. It can cause severe cumulative and even fatal liver damage in small amounts by skin absorption or inhalation and is also a probable human carcinogen. Gasoline is also hazardous due to the presence of benzene, a known human carcinogen.

Precautions

1. See general precautions and precautions for the particular type of dye used.

2. Do not melt wax with an open flame or use a hot plate with an exposed element. Instead use an electric frying pan that can be temperature controlled, or melt the wax in a double boiler to avoid overheating and possible fire. Heat to the lowest temperature that will make the wax liquid.

3. Use an exhaust fan to remove wax fumes produced by ironing out the wax. Using several layers of newspaper may reduce the amount of fumes produced. Set the iron at the lowest setting feasible.

4. Do not use carbon tetrachloride or gasoline to remove residual wax. Use mineral spirits, or send the piece to be dry-cleaned.

Discharge Dyeing

Discharge dyeing uses chlorine bleach or other chemicals to remove color from fabric.

Hazards. Household bleaches contain sodium hypochlorite, which is moderately toxic by skin contact, inhalation, and ingestion. The use of bleach to remove dye from the hands can cause dermatitis. Inhalation of chlorine gas from bleach decomposition can cause severe lung irritation. Heating or the addition of acid releases large amounts of highly toxic chlorine gas; addition of ammonia causes formation of a highly poisonous gas.

Precautions

1. Do not use bleach to remove dye from your hands. Instead wear gloves or a barrier cream to protect your skin.

2. Have dilution ventilation when using bleach.

3. Do not heat bleach solutions or add acid or ammonia to bleach.

TABLE 21-1 Hazards of Mordants

Alum (potassium aluminum sulfate)

Relative Toxicity Rating

Skin contact: slight
Inhalation: slight
Ingestion: slight to moderate

Specific Hazards

Skin contact, inhalation, or ingestion may cause slight irritation and possible allergies.

Ammonium Alum (ammonium aluminum sulfate) (see Alum)

Ammonium Hydroxide (ammonia water)

Use

Intensification, toning, hypo elimination

Relative Toxicity Rating TLV: 25 ppm

Skin contact: high
Inhalation: high
Ingestion: moderate to high

493

Specific Hazards

Household ammonia is 5–10% ammonia; 27–30% concentrations are also available. Skin contact can cause first- and second-degree burns. The eyes and respiratory system are very sensitive to ammonia. Inhalation of high concentrations can cause chemical pneumonia. Ingestion can cause intense pain and damage to mouth and esophagus and can be fatal. Mixing ammonia with alkalis causes release of ammonia gas; mixing with chlorine bleaches causes formation of a poison gas.

Blue Vitriol (see Copper sulfate)

Chrome (see Potassium dichromate)

Copper Sulfate (blue vitriol)

Relative Toxicity Rating TLV: 1 mg/m^3 (as copper)

Skin contact: slight
Inhalation: moderate
Ingestion: high

Specific Hazards

May cause skin allergies and irritation to skin, eyes, nose, and throat, including possible congestion and ulceration and perforation of nasal septum. Acute ingestion causes gastrointestinal irritation and vomiting. If vomiting does not occur, more serious poisoning can result.

Copperas (see Ferrous sulfate)

Cream of Tartar (potassium acid tartrate)

Relative Toxicity Rating

Skin contact: slight
Inhalation: slight
Ingestion: moderate

Specific Hazards

Mildly irritating. Fatalities have occurred from ingestion of large amounts.

Ferrous Sulfate (copperas)

Relative Toxicity Rating TLV: 1 mg/m^3 (as iron)

Skin contact: slight
Inhalation: slight
Ingestion: moderate

Specific Hazards

Soluble iron salts are slightly irritating to skin, eyes, nose, and throat and can cause poisoning if ingested in large amounts (especially by children).

Oxalic Acid

Relative Toxicity Rating TLV: 1 mg/m^3

Skin contact: high
Inhalation: high
Ingestion: high

Specific Hazards

Skin and eye contact may cause severe corrosion, ulcers, and gangrene (of extremities). Inhalation causes severe respiratory irritation and ulceration. Acute ingestion may cause severe corrosion of mouth, esophagus, and stomach; shock; collapse; possible convulsions; and death. There may also be severe kidney damage.

Potassium Dichromate (potassium bichromate, chrome)

Relative Toxicity Rating TLV: 0.05 mg/m^3 (as chromium)
 NIOSH: 0.001 mg/m^3 (10-hour REL)
Skin contact: high
Inhalation: extreme
Ingestion: extreme

Specific Hazards

Probable human carcinogen. Hexavalent chromium compounds are corrosive by skin contact; may cause irritation, ulceration, and allergies. Chronic inhalation may cause lung cancer, respiratory irritation, allergies, and perforated nasal septum. Ingestion may cause violent gastroenteritis, circulatory collapse, and kidney damage. Strong oxidizer; can cause fire in contact with reducing agents, solvents, and other organic materials. Avoid if possible.

Stannous Chloride (tin chloride)

Relative Toxicity Rating TLV: 2 mg/m^3 (as tin)

Skin contact: slight
Inhalation: moderate
Ingestion: moderate

Specific Hazards

Stannous chloride is irritating to the skin, eyes, mucous membranes, and gastrointestinal system.

Tannin (tannic acid)

Relative Toxicity Rating

Skin contact: slight
Inhalation: slight
Ingestion: moderate

Specific Hazards

Possible human carcinogen. Slight skin irritant. Ingestion of large doses may cause gastritis, vomiting, pain, diarrhea, or constipation. Causes cancer in animals.

Tin Chloride (see Stannous chloride)

Urea

No significant hazards.

REFERENCES

Docker, A., Wattie, J. M., and Topping, M. D. (1987). Clinical and immunological investigations of respiratory disease in workers using reactive dyes. *Br. J. Ind. Med.* 44(8), 534–41.

Jenkins, C. L. (1978). Textile dyes are potential hazards. *J. Environ. Health* 40(5), 279–84.

National Institute for Occupational Safety and Health. (1983). *Preventing Health Hazards from Exposure to Benzidine-Congener Dyes.* DHHS (NIOSH) Publication No. 83-105. Cincinnati: NIOSH.

Other Arts and Crafts

This chapter discusses stained glass, papermaking, leathercraft, working with bone and animal materials, and shellcraft.

STAINED GLASS

Stained glass techniques used today include enameling, painting, etching, and staining glass as decorative treatments. There are two basic glazing techniques: using lead came and using copper foil. Modern variations on stained glass use epoxy resins to glue the glass pieces together into a pattern. (See the section on plastics in Chapter 16 for the hazards of working with epoxy resins.)

Glass Cutting

Glass is usually cut by scoring the glass with a steel wheel cutter and then breaking it along the scored line. Sharp edges or unevenness are eliminated with a small grinding wheel.

Hazards

1. Sharp edges on the glass can cause cuts.

2. Grinding and breaking of glass can result in flying chips or flying glass particles, which can cause cuts or damage the eyes.

Precautions

1. Wear goggles when cutting glass and grinding it.

2. Handle pieces of glass with sharp edges carefully and grind them smooth with a grinding wheel or sandpaper. Wet grinding can help reduce glass dust levels.

Glass Decoration

Techniques used to decorate glass include painting, enameling, staining, and etching. Painting can use mixtures of glass dust, iron oxide, colored metallic oxides, and flux (usually borax) that are mixed with gum arabic and water (and sometimes acetic acid). This mixture can be brushed on the glass and then fired.

Many glass paints today are actually enamels, consisting of lead frits combined with metal oxide colorants. These are often airbrushed onto the glass and then fired in a kiln. These glass paints can also be suspended in gum arabic and water and brushed on.

Glass staining is accomplished by brushing a mixture of finely ground silver nitrate, gamboge, water, and gum arabic onto the glass and then firing.

Diluted hydrofluoric acid or ammonium bifluoride pastes are used to etch glass. Stop-outs used include melted wax, bitumen paint, and latex glues.

Hazards

1. Lead-based glass paints are highly toxic by inhalation. Airbrushing these paints is particularly hazardous. Lead compounds can cause anemia, peripheral nervous system damage, brain damage, kidney damage, intestinal problems, chromosomal damage, birth defects, and miscarriages. See Chapter 5 for more information on the hazards of lead compounds.

2. The hazards of enamels used in coloring glass are discussed in Chapter 19. Compounds of the following metals used as colorants are known or probable human carcinogens: cadmium, chromium (VI), nickel, and uranium. Compounds of cobalt and manganese are highly toxic by inhala-

tion. Chromium (VI) compounds and nickel compounds are moderately toxic by skin contact. Table 5-2 lists the hazards of specific metal compounds.

3. Silver nitrate is moderately corrosive by skin contact, inhalation, and ingestion. Gamboge (a gum resin) is highly toxic by ingestion.

4. Hydrofluoric acid is highly corrosive to the skin, eyes, and lungs. Serious deep burns can occur without pain warning several hours after exposure. Its vapors may cause severe lung irritation, including chemical pneumonia. Ingestion can be fatal. Hydrofluoric acid can also cause chronic bone and teeth damage (osteofluorosis) and possibly kidney damage. Handling concentrated hydrofluoric acid is very dangerous due to the risk of splashing.

5. Ammonium bifluoride, although not as corrosive as hydrofluoric acid, is still highly toxic by skin contact and ingestion, since it produces hydrofluoric acid in solution.

6. Heated and molten wax are fire hazards if spilled or if overheated. Wax vapors and highly irritating wax decomposition products can also be produced by overheating.

7. See also Chapter 20 for hazards of other decorating techniques sometimes used with stained glass.

Precautions

1. If possible, avoid the use of lead-based glass paints and colorants that are known or probable human carcinogens.

2. Glass paints should be airbrushed only in a spray booth, or while wearing a National Institute for Occupational Safety and Health (NIOSH)-approved toxic dust and mist respirator.

3. Wear a toxic dust respirator when handling toxic metal oxides or glass enamels.

4. Wet mop the floor and all surfaces to eliminate toxic dusts.

5. Wear gloves and goggles when handling silver nitrate.

6. I recommend against the use of hydrofluoric acid solutions for glass etching due to its very high risks. Instead use ammonium bifluoride pastes. Gloves and goggles are still essential even with the pastes, but the risks are much lower. See below for first-aid recommendations.

7. If hydrofluoric acid is used, do so only in a laboratory hood, or use a NIOSH-approved acid gas respirator with a full facepiece to protect both lungs and eyes. Wear natural or neoprene rubber gloves, face shield, and

chemical splash goggles when handling hydrofluoric acid. In case of contact, flush exposed skin and eyes with water for at least 15 minutes. Immerse affected area in 0.13% iced solution of Zephiran chloride for 30 to 60 minutes. Call a physician immediately. This first-aid information also applies to burns from ammonium bifluoride. See the chapter references for more detailed information.

Kiln Firing

Kilns used for firing glass that has been decorated usually are electric or gas fired. Temperatures in firing can go as high as 840°F (450°C) when glass is fused as a decorating technique. Gas-fired kilns emit carbon monoxide. The organic materials used in decorating decompose to form carbon monoxide or carbon dioxide. In addition, there is the possibility of vaporizing some lead and other low-boiling metals.

Hazards

1. Hot kilns or hot glass can cause thermal burns.
2. Carbon monoxide from gas-fired kilns is highly toxic by inhalation; gases and fumes from the firing process itself may also be toxic.

Precautions

1. Wear leather or other heat-resistant gloves when handling hot objects or tools.
2. Ventilate kilns with a local exhaust system, for example, a canopy hood. For occasional use, an exhaust fan might be sufficient with small kilns.

Glazing

Glazing involves soldering the glass pieces together with either lead came or copper foil that is then tinned with tin/lead solder. This process may use large amounts of solder. Possible changes in environmental laws in the United States and Canada will likely eliminate the use of lead came and the traditional high lead (50/50 or 60/40) solders in the near future. Recently, antimony-free and lead-free solders have been developed that are mostly tin, with some copper and a small amount of silver.

For cementing, a mixture of whiting, linseed oil, and mineral spirits can be used. Powdered red lead has been used as a drying agent.

Hazards

1. Cutting or sanding lead came produces fine lead dust, which is highly toxic by inhalation or ingestion. Similarly, red lead used as a drying agent is highly toxic. There have been several cases of lead poisoning among stained glass craftspersons (and their children) in recent years.

2. Soldering can produce lead fumes, which are highly toxic by inhalation. This is particularly hazardous in tinning copper foil when high temperatures and large amounts of solder are used. The technique of working very close to the glass pieces being soldered can increase the hazard. The settled lead fumes can coat work surfaces and create an ingestion hazard.

3. Zinc chloride flux is moderately corrosive by skin contact, and the fumes produced during soldering are also highly toxic by inhalation, causing severe lung irritation and possible bronchitis. Oleic acid flux fumes are moderately toxic by inhalation. Rosin fluxes may cause asthma.

4. Whiting (calcium carbonate) has no significant hazards.

Precautions

1. Whenever possible, replace lead came with copper foil, zinc came, or other metals.

2. Use lead- and antimony-free solders instead of the 50/50 or 60/40 lead solders.

3. You should have a local exhaust system when doing large amounts of soldering. Working on a table immediately in front of a window exhaust fan at work level or using a slot hood are two options. If ventilation is not adequate and you are doing extensive amounts of soldering, wear a NIOSH-approved respirator with dust, mist and fume filters.

4. Use oleic acid as a flux in preference to the more toxic zinc chloride.

5. Scrape up spilled pieces of solder.

6. Wet mop the floor and all surfaces where came dust or soldering fumes can accumulate. Do not eat, drink, or smoke in the studio. Wash your hands carefully after working, including under the fingernails.

7. Do not use red lead as a drying agent.

Antiquing

Lead can be antiqued with antimony sulfide (butter of antimony). Other antiquing agents include copper sulfate and acid and selenium dioxide.

Hazards

1. Antimony sulfide is highly toxic by inhalation and ingestion and moderately toxic by skin contact. It causes severe dermatitis. Antimony poisoning is similar to arsenic poisoning. See antimony sulfide in Table 5-2.
2. Copper sulfate is slightly toxic by skin contact, moderately toxic by inhalation, and highly toxic by ingestion. See copper compounds in Table 5-2.
3. Selenium dioxide is moderately toxic by skin contact and highly toxic by inhalation and ingestion. In the stomach it may be converted into the highly toxic gas hydrogen selenide. This can also happen if selenium dioxide is heated in acid. See selenium compounds in Table 5-2.

Precautions

1. Wear gloves when handling antimony sulfide and selenium dioxide. If you are handling the powder you should wear a NIOSH-approved toxic dust mask.
2. Take careful precautions to avoid accidental ingestion of these chemicals; do not eat, drink, or smoke in the studio, and wash your hands carefully after work.

PAPERMAKING

Papermaking involves first preparing the pulp and then making the paper. A wide variety of woods, plants, vegetables, used paper, rags, and so on can be used in papermaking. Preparing the pulp involves separating out the cellulose fibers from the plant material. Many plant materials are very tough and require boiling in sodium carbonate (soda ash) or sodium hydroxide (lye) at a pH of 12-14 to accomplish this. Rotten or mulched plants require less preparation time. The fibers are then washed and placed in a beater to complete preparation of the pulp. After the pulp is ready, the paper is made by trapping the pulp on a wire or fabric screen frame. Either the pulp is allowed to air dry on the screen, and then removed as a sheet of paper, or, after draining, the screen frame is inverted onto

damp felt and water is expelled by applying pressure between layers of felt. This latter process is called couching.

A variety of other chemicals can be used in papermaking, including bleach for decolorizing the pulp; sizings such as methyl cellulose, kaolin, starch, and gelatin; cationic retention agents; calcium carbonate to adjust the pH; and dyes and pigments.

Hazards

1. Some wood and plant materials can cause allergic reactions and skin irritation.

2. The alkaline soda ash and lye are highly corrosive by skin and eye contact, inhalation, and ingestion. Boiling solutions of these alkaline materials can be very dangerous because of the risk of boiling over and the fact that the steam will contain trapped alkali.

3. Chlorine bleach is a skin, eye, and respiratory irritant.

4. Beaters can be severe safety hazards due to the chance of trapping hands in the blades when cleaning pulp out of the blades. In addition, beaters can present noise hazards.

5. The presence of large amounts of water presents electrical hazards if it splashes onto electrical outlets or other electrical equipment. In addition, there is the possibility of major water leaks.

6. Some pigments can be hazardous. Titanium dioxide, which is commonly used, has no significant hazards. See Table 12-1 for hazards of other pigments.

Precautions

1. Learn to identify possible toxic or allergic woods and plants in your area.

2. If possible, do not boil fibers in alkali. In particular, this should not be allowed in secondary schools. Making paper from used paper or cardboard, or from rotten or mulched plant materials, eliminates the need for boiling in alkali.

3. For softer fibers, soda ash can be used instead of lye. Soda ash is somewhat safer than lye, but still requires careful precautions.

4. When using lye or soda ash, wear rubber gloves, protective apron, and chemical splash goggles. When boiling alkali, I also recommend wearing a face shield over the goggles. An eyewash fountain and emergency shower should be readily accessible.

503

5. Add alkali slowly to water while stirring. Adding it too fast can result in boiling and splashing.

6. If possible, do not boil the lye or soda ash solution. It would be safer to heat it to a lower temperature for a longer period of time. Never leave the heated alkaline solution unattended, to prevent boiling over.

7. The boiling or heated alkali solution should be equipped with a canopy hood exhausted to the outside.

8. Wear gloves, goggles, and protective apron when using bleach. There should be ventilation to remove the irritating gases from the bleach.

9. When rinsing the pulp with fresh water to remove the alkali or bleach, remember that the wash water can be alkaline. Adjust the pH of the wash water to between 7 and 8 with citric acid or white vinegar before pouring down the drain.

10. To minimize the chance of electrical shocks, ground fault circuit interrupters (GFCIs) should be installed on all electrical outlets within six feet of possible water-splashes areas. It is also possible to install a GFCI at the circuit breaker for the entire area.

11. Waterproof the floor and area to avoid leaks.

12. The beater must be equipped with machine guards that will prevent anyone from putting his or her hands near the blades as long as the blades are still rotating. In some old beaters, the blades take a long time to stop, even after the power is cut off.

13. If the beater is excessively noisy, it should be located in a room where only the operator is exposed to the noise. The operator should wear ear plugs or ear muffs. Good maintenance can often decrease noise levels.

14. An alternative to using a beater for small-scale papermaking (e.g., in schools) would be to use a large blender.

15. Whenever possible, use premixed pigments or dyes to color the paper. To mix the powder, make a concentrated solution or paste inside a glove box (see Chapter 8).

Marbleizing

Marbleizing is a technique in which patterns of color on paper (or textiles) are achieved by creating a pattern on the surface of a tray of water with pigments or paints and then depositing this pattern onto paper lifted out of the tray from underneath. A solution of carageenan (seaweed extract) and water softeners is mixed up, and thinned liquid paints or inks are poured onto the surface of the

water/seaweed solution. Paper treated with alum as a sizer is then carefully lowered into the tray vertically and lifted out horizontally to trap the paint pattern.

Hazards

1. Alum is a slight irritant and may cause allergic reactions in a few people.
2. If powdered pigments are used, there is the hazard of inhalation of the pigments. See the pigments section of chapter 12.

Precautions

1. Use premixed paints or inks when possible.
2. If powdered pigments are used, mix them inside a glove box.

LEATHERCRAFT

Working with leather involves two basic steps: (1) cutting, carving, sewing, and other physical processes; and (2) cementing, dyeing, and finishing the leather.

Leather and Tools

Tools used to work leather include knives, awls, chisels, punches, needles, and bevelers. These can be used to cut, carve, model, lace, sew, and otherwise manipulate the leather into the shape and design desired.

Hazards. Inhalation of leather dust results in increased rates of nasal cavity, sinus, and bladder cancer in leather and shoe workers. This appears after 40 to 50 years and is probably not a serious hazard for leather craftspeople, since these cancers are still very rare.

Precautions

1. Cut in a direction away from yourself, and keep your free hand behind or to the side of knives and other tools that can slip. Do not try to catch sharp tools that fall.
2. Do not allow leather dust to accumulate. Wet mop or vacuum it regularly.

Cementing, Dyeing, and Finishing

Leather cementing is done with either rubber cement or Barge cement. Before dyeing and finishing, the leather may be cleaned with an oxalic acid solution. Solvent-type leather dyes usually contain denatured alcohol or carbitol. Other solvents may also be used. Oil dyes contain turpentine or mineral spirits. Lacquer and resin finishes may contain a variety of solvents including toluene (toluol). Waxes and preservative mixtures such as neatsfoot oil may also be used as protective finishes.

Hazards

1. Rubber cements and their thinners that are labeled extremely flammable usually contain hexane, which is highly toxic by inhalation, causing damage to the nerves of the hands, arms, legs, and feet, and possibly paralysis in severe cases. These symptoms usually disappear in two to three years after exposure is ended.

2. Toluene, found in Barge cement and many lacquers, is moderately toxic by skin contact and highly toxic by inhalation. It can be absorbed through the skin.

3. Denatured alcohol is slightly toxic by skin contact and inhalation and moderately toxic by ingestion because of added toxic chemicals.

4. Mineral spirits and turpentine are moderately toxic by skin contact, inhalation, and ingestion.

5. Carbitol is slightly toxic by skin contact and inhalation and moderately toxic by ingestion.

6. Denatured alcohol, hexane, and toluene are flammable; mineral spirits and turpentine are combustible.

Precautions

1. Use leather dyes that contain ethyl alcohol rather than more toxic solvents.

2. Wear gloves when using solvents and dyes.

3. Use solvents with good general ventilation (e.g., window exhaust fan at work level).

4. Obey standard precautions against fire. Do not smoke or have open flames in areas in which solvents are used. Store waste rags in a self-closing safety container that is emptied each day.

BONE, SHELL, AND SIMILAR CRAFT MATERIALS

The use of bone, ivory, horn, antler, feathers, and mother of pearl, coral, and other shells is widespread in the crafts.

Shells

Coral, mother of pearl, abalone, and other shells are processed by cutting, sawing, or shaving the shell with electric circular saws; grinding with electric grinders; polishing; and finishing.

Hazards

1. Cutting and grinding can result in eye and hand injuries from flying particles of shell and from sharp edges. Skin problems include calluses, thickening of the skin, overgrowth of the horny layers of the skin, and lacerations.
2. Inhalation of the fine shell dust from grinding and sawing can cause irritation of the upper respiratory tract and respiratory allergies, especially if the shell was not washed properly and still contained organic material.
3. Inhalation of mother of pearl dust can cause fevers and a pneumonia-like disease. It can also cause ossification and inflammation of the tissue covering the bones. This is particularly true in young people.

Precautions

1. Use wet grinding and polishing techniques whenever possible.
2. With dry grinding, wear a NIOSH-approved toxic dust respirator.

Feathers

Feathers can be dyed and used for weaving and crocheting and are often used as a filler for pillows and other stuffed creations. Para-dichlorobenzene or naphthalene is used for mothproofing.

Hazards

1. Dust from duck, goose, and other feathers may cause "feather-picker's disease." Symptoms of this disease include coughing, chills, fever, nausea,

and headaches when you are first exposed to the feathers. Some tolerance develops within a week, but complete immunity may take years.

2. To most people, naphthalene is moderately toxic by skin contact (and skin absorption), inhalation, and ingestion. It becomes volatile easily. It causes irritation of skin and eyes, anemia, and liver and kidney damage. To certain people of African, Mediterranean, and Semitic origin with hereditary glucose-6-phosphate dehydrogenase deficiency, naphthalene is highly toxic, causing very severe hemolytic anemia.

3. Para-dichlorobenzene is moderately toxic by skin contact and ingestion and highly toxic by inhalation. It is a strong eye and respiratory irritant and may cause liver damage. It is a probable human carcinogen, based on animal studies.

4. See Chapter 21 for the hazards of dyes.

Precautions

1. Vacuum the feathers before working with them. This can be done by placing them on a wire screen and vacuuming from below.

2. Wear a NIOSH-approved toxic dust mask when handling the feathers.

3. Air out stored feathers that have been mothproofed before working with them.

4. Use oil of cedarwood as a mothproofing agent, if possible.

Animal Materials

Bone, antler, horn, and ivory may be carved or sawed to make sculpture, jewelry, and other craft items. Raw bone and other materials have to be cleaned before carving. Degreasing solvents such as naphtha and mineral spirits can be used.

Hazards

1. Improperly cleaned or raw bones and antlers may cause infections if the material is diseased. This can be a problem if you have cuts or abrasions. If the materials come from the Middle or Far East, there is a risk of anthrax, which can be fatal, especially by inhalation (see the section on animal fibers in Chapter 21).

2. Dust from these materials can cause respiratory irritation and allergies. Inhalation of ivory dust causes an increased susceptibility to pneumonia

and other respiratory diseases.

3. Degreasing solvents may be hazardous by skin contact or inhalation. Carbon tetrachloride and other chlorinated solvents are particularly hazardous. (See Table 4-4.)

Precautions

1. Degrease raw bones and other materials immediately to remove all organic material.

2. Do not use highly toxic chlorinated solvents such as carbon tetrachloride. Instead use mineral spirits.

3. When using degreasing solvents, wear gloves and have good dilution ventilation, or work outdoors. Keep degreasing baths covered.

4. Use wet techniques for carving, sanding, and grinding.

5. For dry carving, wear a NIOSH-approved toxic dust mask.

REFERENCES

Feldman, R., and Sedman, T. (1975). Hobbyists working with lead. *New Engl. J. Med.* 292, 929.

International Labor Organization. (1983). *Encyclopedia of Occupational Safety and Health.* 2 vols. 3d ed. Geneva, Switzerland: ILO.

Richardson, M. (1990). *Plant Papers.* Romilly Brilley Herefordshire, England: Plant Papers Mill.

Rossol, M. (1991). *Professional Stained Glass Safety Training Manual: Our Right-to-Know Program.* Brewster, NY: Edge Publishing Group, Inc.

Modern Technology in Art

This chapter discusses the hazards of the applications of modern technology to art, including laser sculpture, holography, neon sculpture, computer art, and photocopiers.

LASERS

Lasers are sometimes used as a form of light sculpture and in making holograms. In contrast to normal visible light, which consists of many different wavelengths, a laser emits light of usually just one wavelength. A laser beam is usually very narrow and is emitted in one direction.

Laser Safety

Laser light or radiation can be very intense. Laser beams can cause eye and skin damage and present other hazards, depending on the class of laser. The laser

510

beam is the major concern with respect to eye damage. The laser device itself is not an eye hazard unless it is malfunctioning and safety devices are bypassed. In this book, I discuss only visible lasers, not infrared or ultraviolet lasers.

Hazards

1. Class 1 lasers are the lowest power lasers and do not emit hazardous levels of energy under normal operating conditions.

2. Class IIa lasers are low-power lasers that represent eye hazards only if viewed for more than 1,000 seconds. Class II lasers are considered chronic hazards with any prolonged viewing.

3. Class IIIa lasers, usually less than 5 milliwatts of power, are chronic eye hazards and may be acute eye hazards when viewed through optical instruments or when you look directly into the beam.

4. Class IIIb lasers can extend in power up to 0.5 watts and are acute and chronic eye hazards from viewing the beam directly or viewing specular reflections. Higher-power Class IIIb lasers are also skin hazards; 150-milliwatt lasers, for example, can cause third-degree burns, whereas a 20-milliwatt laser cannot be felt on the skin.

5. Class IV lasers are lasers of power greater than 0.5 watts. They are acute skin and eye hazards by both direct and scattered radiation. They are also fire hazards.

6. In addition to the hazards from the laser beam, there are severe electrical hazards from the high voltages involved.

Precautions

1. Use the lowest power laser that is feasible.

2. All lasers must be labeled with their classification and appropriate warnings. Warnings should also be posted on the entrance to areas where lasers are used.

3. All lasers must have a protective housing that prevents exposure to more than Class I radiation levels, except when operating the beam. Leakage from the housing should not exceed Class I levels.

4. Lasers should never be left unattended when in operation.

5. All lasers have at least one safety interlock to prevent exposure to more than Class I levels during operation or maintenance. For Class IIIb and IV lasers, the safety interlocks must be redundant or fail-safe; in addi-

tion, there must be a remote interlock connector to allow connecting of remote emergency stop switches.

6. All lasers, except Class I lasers, must have emission indicators to tell when the laser is energized. For Class IIIb and IV lasers, the indicator must give warning in advance of energizing the laser.

7. All lasers, except Class I lasers, must have a beam attenuator (e.g., shutter) to block laser beam emission. This allows the laser beam to be stopped without turning off the laser.

8. Class IIIb and IV lasers must have key controls to prevent unauthorized operation.

9. Class IV lasers must have manual reset buttons to prevent automatic restarting of the laser after interruptions.

10. There should be written procedures for the setup, alignment, and testing of lasers prior to use. Always follow the laser manufacturer's recommended procedures.

11. Only Class I lasers may be viewed directly (that is, the laser beam coming from the front). However, as a matter of good practice, no laser beam should be stared at.

12. The room in which the laser is located should be brightly lit to prevent dilation of pupils. Dilated pupils could allow more laser radiation to enter in case of accidental viewing.

13. The laser room should have only nonreflecting surfaces (except where deliberately designed).

14. Appropriate laser goggles should be worn with Class IV lasers where there is a hazard from diffuse reflections.

15. Laser operators should have regular eye examinations.

16. See the electrical safety section of Chapter 10 for electrical precautions when working with lasers.

17. More information on laser safety can be found in ANSI Z136.1, "1986 Safe Use of Lasers."

Public Performances and Lasers

In the United States, the use of lasers is regulated by the Food and Drug Administration's (FDA) Center for Devices and Radiological Health (formerly the Bureau of Radiological Health) under Public Law 90-602, the Radiation Control for Health and Safety Act of 1968. Lasers for use in entertainment, such as light shows where the public is present, are regulated as demonstration lasers. Under

these regulations, reports on the laser and the light show have to be filed. These regulations allow the use of only Class I, IIa, II, and IIIa lasers. To use Class IIIb or Class IV lasers in a light show, a variance must be obtained. This variance spells out in detail exactly how the laser can be used. In addition to federal regulations, there may be state and local regulations.

Regulations

1. Audiences may be exposed to only Class I radiation levels. According to the FDA regulations, employees (e.g., laser operators) can be exposed to Class II and IIa laser radiation levels as long as any direct viewing is only by accident for very brief periods.

2. Class IIIa, IIIb, and IV laser beams should not contact any part of the human body. For unattended lasers, the radiation levels should not exceed Class II levels inside a region 6 meters above the floor, 2.5 meters below the floor, and 2.5 meters laterally from where a person could stand. If a laser operator is present, the vertical separation could be 3 meters.

3. The laser beam can be less than 2.5 meters in lateral distance or below the floor if physical barriers prevent access to higher than Class II levels. The laser operator should have a clear view of all laser beams and people in the area and have no other responsibilities.

4. Audience scanning involves the passing of direct or reflected laser beams of radiation exceeding Class I levels across the audience. This could be achieved directly or through the use of rotating mirrored balls, for example. The amount of audience exposure must be reduced to below Class I levels by scanning devices. The scanning device must have a scanning safeguard to rapidly shut off the laser if a malfunction of the scanner increases exposure to laser radiation above these levels. In some instances, the rotating mirrored balls might also need scanning safeguards, since if the mirror rotation slowed or stopped, there could be an increased exposure to laser radiation in certain locations.

5. Laser radiation levels scattered by fogs, smoke, mist, or similar diffusing media should be at Class I levels where the audience could be exposed.

▓▓▓ HOLOGRAPHY

Holography is the process of producing a three-dimensional photograph of an object using lasers. Basically, the coherent laser beam is reflected off the object, and the interference patterns between this object laser beam and a reference

ARTIST BEWARE

laser beam are photographed. After developing, the hologram is reconstructed by viewing through a laser beam or reasonably monochromatic light source such as a yellow sodium lamp or slide projector with color filter.

Holographic Lasers

The most common laser used in holography by art holographers is a 50-milliwatt helium neon laser, a Class IIIB laser. Low-power, 5-15-milliwatt helium neon lasers are often used in schools for demonstrations. Higher power 1-5-watt argon and krypton lasers and pulsed ruby lasers are used by some holographers, but they are very expensive and very dangerous. This discussion is predominantly aimed at the helium neon lasers in common use.

Hazards

1. The 50-milliwatt helium neon lasers commonly used are Class IIIb lasers. They can cause acute and chronic eye hazards from viewing the beam directly or viewing specular reflections from flat, reflecting surfaces. Higher-power Class IIIb and IV lasers can also cause skin damage.
2. Class IIIb and Class IV lasers are strictly regulated and, in many states, require licensing to operate.
3. The high voltages used for lasers involve electrical hazards, including electrical shock and fire.
4. Xylene, perchloroethylene, and other solvents have been used between the photographic plate and glass holder to match the refractive index of glass. Perchloroethylene is a probable human carcinogen and can cause dizziness, headaches, nausea, and liver and kidney damage. Xylene can cause dizziness, headaches, and nausea.

Precautions

1. See the section on laser safety for standard laser precautions.
2. The height of the vibration-free holographic table is often at waist level to minimize the chance of accidentally viewing the laser beam directly.
3. Targeting cards should be used in aligning the laser beam, not the eyes.
4. Make sure all electrical equipment and wiring are approved for the voltages used and are in good repair. See the electrical safety section of Chapter 10.

5. Use xylene in preference to perchloroethylene. Provide dilution ventilation (e.g., window exhaust fan). Keep the flammable solvents away from sources of ignition, including the undiffused laser beam.

6. Visitors to holographic studios should wear laser safety goggles when lasers are operating.

7. Never use lasers to illuminate holograms being viewed by the public. If this was done, it would come under the FDA regulations discussed for laser shows.

Developing Holograms

Holograms are developed using standard photographic chemicals. Often, bleaching and other postdevelopment processes are done, using a variety of chemicals. Processing recipes published before the late 1980s often suggest very hazardous chemicals, and special care should be taken when using them.

Hazards

1. See Table 15-1 for the hazards of photographic chemicals used in holography.

2. Holographic developers are also usually strongly alkaline, causing severe skin, eye, respiratory, and gastrointestinal irritation.

3. Pyrogallic acid (pyrogallol) is the most toxic developer. It is highly toxic by all routes of absorption, including skin absorption.

4. Bleaches are often strongly acidic, often containing sulfuric acid and hydrobromic acid. Dichromates are probable human carcinogens, irritants, and sensitizers.

5. Bromine, used in water as a bleach, is a strong oxidizing agent and is very corrosive. The aqueous solutions are also very irritating to the skin, eyes, and respiratory system.

6. Parabenzoquinone is highly toxic by all skin contact, ingestion, and inhalation. Its vapors may cause chemical pneumonia. It can cause skin and eye damage.

7. Triethanolamine (TEA), used for color control in preprocessing of holographic plates, is a skin sensitizer and irritant and probable human carcinogen.

515

Precautions

1. Wear rubber gloves, goggles, and protective apron when mixing and handling developers, bleaches, and other holographic chemicals.

2. An eyewash fountain and emergency shower should be readily available if concentrated acids or bromine is used.

3. Avoid using highly toxic developers such as pyrogallol, if possible.

4. Avoid highly toxic bleaches such as parabenzoquinone, bromine, and dichromates. A safer alternative is EDTA.

5. Avoid handling concentrated acids if possible. A possible substitute for concentrated sulfuric acid is sodium bisulfate (Sparex), used in jewelry as a pickle.

6. Dilution ventilation is adequate for developing holograms if concentrated acids, bromine, and parabenzoquinone are not used. Otherwise, local exhaust ventilation (e.g., a slot exhaust hood) is essential.

7. Liquid bromine should be mixed only with local exhaust ventilation, gloves, face shield plus goggles, and protective apron. An eyewash fountain and emergency shower are needed.

8. See Chapter 15 for recommendations on the disposal of photochemicals.

9. See the section on black-and-white photography in Chapter 15 for more information on precautions.

NEON SCULPTURE

Neon sculpture is an offshoot of commercial neon signs for advertising. It involves evacuating a lead glass tube of desired shape, adding small amounts of neon gas, or mercury, and applying a high voltage across the tube to ionize the neon gas or mercury vapor and achieve the desired luminous effect. To obtain a variety of colors, phosphor-coated neon tubes are used, which convert the ultraviolet radiation from the mercury or neon ions into various visible colors.

Hazards

1. The neon tube pattern is drawn on paper and an aluminum screen placed over it, so the hot glass tube can be shaped to the pattern without burning the paper. In the past, asbestos paper was commonly used. Asbestos paper gives off asbestos fibers when abraded. Inhalation of asbestos fibers can cause mesothelioma, lung cancer, and other types of cancer.

PART 2

2. Shaping the glass tube into the desired shape is done using gas burners and torches. As discussed in Chapter 20, this involves risks of thermal burns, low-level infrared radiation exposure, and fire from the use of fuel gases. If compressed gases are used, there are also the hazards associated with them.

3. If fluorescent phosphor-coated tubes are heated, there is a risk of inhalation of phosphor powders. Beryllium phosphors have not been used for decades because of their extremely high toxicity. However, modern phosphors can include rare earth, cadmium, and other potentially toxic metals.

4. Vacuum pumps are used to evacuate the neon tube. Mechanical vacuum pumps are usually used, although mercury diffusion pumps were common in the past. The mechanical pumps give off an oil mist, and mercury pumps produce mercury vapor. There is also the risk of breakage of the mercury reservoir and subsequent spillage of mercury with mercury pumps.

5. Small amounts of liquid mercury are often added to the evacuated neon tube to achieve a blue color. Mercury can be absorbed through the skin, but inhalation of mercury vapors is the major risk. It is not appreciably absorbed by ingestion. Large, acute exposures can cause chemical pneumonia, but it is rare. Acute poisoning is accompanied by metallic taste, salivation, swelling of gums, vomiting, and bloody diarrhea. Chronic poisoning severely affects the nervous system, causing muscular tremors, irritability, and psychic changes (e.g., depression, loss of memory, frequent anger). Mercury also affects the gastrointestinal system and kidneys.

6. Neon sculpture involves the use of high voltages, which can involve risks of fires from faulty electrical equipment and wiring, and electrical shock. This is particularly a hazard with the bombarding transformer, which involves very high voltages.

7. Faults in neon glass tubing could cause implosions, during the bombarding stage to remove impurities and during final evacuation of the neon tube.

8. Neon tubes, especially those containing mercury, give off ultraviolet (UV) radiation. The glass tube blocks the most dangerous far UV, but some near UV can pass through the glass. Depending on its intensity, the lower end of the near UV radiation could cause some corneal damage, cataracts, skin cancer, and sunburn. Phosphor-coated tubes would absorb most of this UV and convert it into light. The main hazard would be to the neon artist, especially during bombardment, which uses higher voltages.

Precautions

1. See Chapter 20 for precautions when shaping the neon tubing. It is essential to ensure that the glass tubing is annealed properly to eliminate dangerous faults in the glass.

2. If compressed gases are used, see the precautions listed under oxygen and flammable gases in Chapter 8 and under welding in Chapter 18.

3. When heating phosphor-coated tubes, provide local exhaust ventilation (e.g., movable exhaust hood) to prevent inhalation of the phosphor fumes.

4. Do not use asbestos paper for drawing the shape of the glass tubing. Use aluminum screen or paper made from asbestos substitutes.

5. Do not use mercury pumps.

6. Vent the exhaust from mechanical pumps to the outside to eliminate inhalation of oil mist.

7. Make sure all electrical equipment and wiring is in good repair. See also the electrical safety section of Chapter 10.

8. All electrical cables, transformers, and connectors should be approved by Underwriters' Laboratories for the voltage being used.

9. All high-voltage equipment should be labeled and properly shielded.

10. Insulate all high-voltage electrical wiring when possible. Exposed, high-voltage leads should be out of reach of normal contact (e.g., along the ceiling) and marked with a warning sign. The operator and electrical controls should be located behind a transparent, protective shield to prevent access to voltage wires and in case of explosive breakage of the neon tubes. A heavy rubber mat should be placed in front of the testing workbench.

11. High-voltage electrical wiring inside the transformer mounting box should be straight and short, kept at least 2.5 inches from any metal parts, and well insulated. The mounting box should be grounded. No live electrical components should be accessible to spectators.

12. Add mercury to the neon tube carefully (e.g., with a syringe). A major concern is with possible mercury spills, since mercury can vaporize easily and is highly toxic. Even small spills can release a lot of mercury vapor. Store mercury in a secure place in a plastic, not glass, bottle. The area where the mercury is used should be sealed, to trap any spilled mercury easily. Working on a tray to contain mercury spills is one way.

13. A mercury spill control kit should be on hand. These are available from laboratory supply or safety supply companies. Do not vacuum up mercury spills, since a very fine mist of mercury vapor will pass through the vacuum cleaner.

14. When disposing of old neon tubes, carefully remove the residual liquid mercury that is in the tube. The mercury must be disposed of as hazardous waste.

518

15. Wear ultraviolet goggles when working close to the neon tubes in operation, especially during bombardment. Use the darkest practical shade number.

COMPUTER ART

Computer art is a relatively recent field. Computer video display terminals (VDTs) can be used as a canvas, and the resulting image can be printed out, photographed, or left as an image file that can be transmitted to other computers via modem. The hazards to computer artists are similar to those of other users of VDTs.

Hazards

1. Constant computer users report eye and vision problems after VDT use, including blurred vision, temporary nearsightedness (myopia), burning or itching eyes, tinted vision, eyestrain, eye fatigue, and headaches. Individuals with previous vision problems often experience more discomfort, and VDT use can trigger undetected vision problems. A causal link between VDT usage and cataracts has not been established, although it has been suspected.

 Factors influencing user comfort include character readability (pixel size), character oscillation, flicker (variation in luminance), blitz (visual vertical sweep velocity), and afterglow. Epileptics may be particularly sensitive to the flicker rate.

2. Ergonomic complaints such as back, neck, shoulder, and upper arm complaints are common in constant VDT users. Repetitive wrist motions can cause strain injuries such as carpal tunnel syndrome. Many VDT workers report leg pain. Circulation to the feet can be cut off when the work chairs are too high off the ground.

3. VDT operators sometimes report rashes and dermatitis. This is related to the buildup of static electrical fields on the VDT screen, which can attract dust. This commonly occurs in hot, dry environments.

4. Studies have shown that female VDT operators experience more adverse pregnancy outcomes than non-VDT workers. However, there has not been enough research to determine the specific cause, or whether it is by random occurrence. X-rays are not suspected as a cause, since VDTs in good condition do not emit enough x-ray radiation to be a hazard. One suspected cause is extremely low frequency (ELF) radiation emitted by the VDT

(see Chapter 10). Some preliminary animal research has suggested that exposure to ELF radiation can cause animal fetal abnormalities. More research is needed before any definitive conclusions can be drawn.

Most of VDT emissions are basically shielded, but radiation safety is imperfectly understood. Exposure is greatest at the back or sides of the terminals, provided the glass front is correctly sealed.

Precautions

1. There are several ways to reduce eye discomfort from glare:

- Reduce glare from the screen by blocking reflected light.
- Dim the room lights. Lighting levels for computer use should be about one half that used for regular work. Use desk lamps if needed.
- Use glare-reducing screens.
- Shade sunlight.
- Place terminals at right angles to the windows.

2. You should be able to change the contrast and brightness of the screen to comfortable settings.

3. You should have periodic eye examinations and take regular rest breaks during the working day (e.g., about 15 minutes for every hour of intense work).

4. Foot rests, proper computer chairs with adjustable heights and backs, and a proper computer table (height about 26 inches) are recommended. When seated, your feet should be flat on the floor, with your legs and hips at right angles. The height of the keyboard or mouse should be at the same level as your forearms, when your upper arms are at your sides and the forearms at right angles to the body. Small cushions for your wrists also help.

5. To minimize skin problems, precautions include the installation of a humidifier, placing a plastic mat under the user's chair, and using grounded glare screens and keyboard touchpads to increase humidity and decrease the buildup of static charge.

6. To decrease potential hazards during pregnancy, you can limit the time spent near VDTs and not sit near the backs or sides of terminals. Recommendations are to be at least 20 inches from the front of the screen and 36 inches from the sides and back.

PHOTOCOPIER ART

Color photocopiers are becoming increasingly popular to make multiple copies of collages or other artwork.

Hazards

1. Photocopiers use high voltages, which is an electrical shock hazard.

2. Photocopiers can emit ozone, a strong eye and respiratory irritant, which can cause chronic bronchitis. This is especially true if the photocopier is not maintained and cleaned regularly.

3. Toners contain polymers such as polymethylmethacrylate, which, when heated to the high temperatures involved in the photocopier process, can decompose to produce respiratory irritants.

4. Wet toners contain solvents, which are skin and respiratory irritants.

Precautions

1. See Chapter 10 for basic electrical safety rules.

2. Always pull the plug before opening the photocopier to make repairs or adjustments.

3. Place photocopiers in an open area, near an exhaust. Do not work in an unventilated closet.

4. Use dry toners in preference to wet toners. If using wet toners, wear gloves and allow the copies to dry in a ventilated location.

5. Use toner cartridges in preference to adding toner powders, whenever possible.

REFERENCES

American National Standards Institute. (1986). *Safe Use of Lasers*. ANSI Z136.1-1986. New York: ANSI.

Crenshaw, M. (1985). Hazards of processing chemistry. In *International Symposium on Holography Conference Notes*. Lake Forest College, Lake Forest, IL.

Miller, S. C. (1977). *Neon Techniques and Handling*. 3d ed. Cincinnati: ST Publications.

Office of Compliance, Center for Devices and Radiological Health. (1986). *Laser Light Show Safety. Who's Responsible*. HHS Publication FDA 86-8262. Rockville, MD: Food and Drug Administration.

Office of Compliance, Center for Devices and Radiological Health. (1988). *Regulations for the Administration and Enforcement of the Radiation Control Health and Safety Act of 1968.* CFR 1000, CFR 1002, CFR 1040. Silver Spring, MD: Food and Drug Administration.

Office of Compliance, Center for Devices and Radiological Health. (1988). *Reporting Guide for Laser Light Shows and Displays.* HHS Publication FDA 81-8140. Silver Spring, MD: Food and Drug Administration.

Pinsky, M. (1987). *The VDT Book—A Computer User's Guide to Health and Safety.* New York: New York Committee for Occupational Safety and Health.

Wenyon, M. (1985). *Understanding Holography.* 2d ed. New York: Arco Publishing, Inc.

24

Commercial Art

C ommercial art, also called graphic arts, covers a wide variety of areas, including pasteup of mechanicals, package design, textile design, computer graphics, illustration, and photo processes. Many of these processes have been discussed in previous chapters. Here I discuss only variations on these processes and new techniques not previously discussed.

Airbrushing

Airbrushing of paints and dyes is a common commercial art technique. Mostly water-based paints and dyes are airbrushed.

Hazards

1. Airbrushing can result in inhalation of the material being sprayed, including pigments, dyes, and the vehicle.

2. A variety of hazardous pigments is found in paints that are airbrushed. (See Table 12-1 for a list of toxic pigments.)

523

3. If solvent-based materials are airbrushed, there is also the hazard of inhalation of the solvent. (See Table 4-4 for hazards of solvents).

Precautions

1. If possible, spray or airbrush in a spray booth exhausted to the outside. (One company that makes spray booths for graphic arts is Paasche.) Otherwise, wear a National Institute for Occupational Safety and Health (NIOSH)-approved respirator with toxic dust and mist filters for water-based sprays. There should also be an exhaust fan in the studio to remove the excess spray so you can take off your respirator safely.

2. If possible, do not spray solvent-based materials, except in an explosion-proof spray booth. Otherwise, wear a NIOSH-approved paint spray respirator with organic vapor cartridges and dust and mist (or spray) prefilters.

3. Do not spray paints containing highly toxic pigments such as lead, cadmium, mercury, and manganese.

Blueprint Machines

Diazo blueprint machines are used by architects and others to make quick copies of large architectural drawings and by printers to make proofs of negatives prior to making the printing plates. Blueprint machines use ammonia or amines to develop the blueprint.

Hazards

1. Concentrated ammonia solutions are highly toxic by skin contact, inhalation, and ingestion. Acute overexposure can cause chemical pneumonia, although usually the strong irritation prevents people from staying in the area long enough to have sufficient exposure.

2. Amines are moderately irritating by skin contact and inhalation.

Precautions

1. Blueprint machines should be provided with local exhaust ventilation (e.g., canopy hood over the machine).

2. The fresh blueprint should be handled with gloves and allowed to dry in a ventilated area.

Color Correction

Dot etching is a chemical reduction process used for color correction of graphic arts negatives and positives. The same chemicals are used in photo retouching (see Chapter 15).

Computer Graphics

Computers are used more and more in commercial art. They can be used to create type, images, and logos and to manipulate them. This computer artwork can be printed, photographed, or stored in the computer memory. The hazards of using computers are described in Chapter 23.

Illustration

Most of the painting and drawing techniques discussed in Chapter 12 are used in commercial art. Gouache, in particular, is commonly used because of its opaque qualities and speed of drying. Airbrushing is one of the most common techniques used (see above). Drawings are commonly fixed with spray fixatives (see below).

Imaging and Proofing Systems

A variety of commercial processes is used to make off-press proofs and color copies of black-and-white logos and type. These can involve single colors, such as the 3M Image-N-Transfer (INT) process, or multicolor processes, such as the 3M Color Key process. Basically, the INT process involves contact printing of a negative or color transparency over a specially treated colored INT sheet in a vacuum frame, exposing with a carbon arc or similar lamp, and developing to remove unexposed dye.

Hazards

1. The developer for the INT process is strongly alkaline and can cause skin and eye irritation from brief exposures.
2. The developer for the Color Key process contains n-propyl alcohol, which is a mild skin, eye, and respiratory irritant. It is also flammable.
3. Carbon arcs produce intense ultraviolet radiation, as well as toxic metal fumes, ozone, nitrogen dioxide, and carbon monoxide.

Precautions

1. Wear gloves and goggles when handling developer solutions. An eyewash fountain should be available.

2. Local exhaust ventilation is needed for developers that include solvents (e.g., slot hood or window exhaust fan at work level).

3. Hair dryers are sometimes used to speed drying of the solvents. Since the solvents are flammable, I do not recommend the use of hair dryers near the solvents unless the hair dryers are known to be sparkproof.

4. The solvent-containing products should not be sprayed except in an explosion-proof spray booth, or while wearing a NIOSH-approved respirator with organic vapor cartridges and dusts and mists filters.

5. Do not allow smoking, open flames, or other sources of ignition in the same room where flammable solvents are being used.

6. Avoid carbon arcs if possible. If they are used, they must be equipped with local exhaust ventilation.

Marker Renderings

Permanent felt-tip markers are used for everything from sketches to finished renderings for graphic design, advertising, and package design. Permanent markers usually contain either xylene or alcohols.

Hazards

1. The practice of using several markers at one time, and of working close to the drawing, can result in fairly high levels of exposure to solvent vapors.

2. Xylene is highly toxic by inhalation, causing dizziness, headaches, nausea, and other symptoms of acute intoxication. Chronic exposure may cause liver damage and possible adverse reproductive effects.

3. Propyl alcohol is moderately toxic by inhalation, causing eye and respiratory irritation.

Precautions

1. Use alcohol-based permanent markers rather than xylene-based ones.

2. Use permanent markers with dilution ventilation (e.g., window exhaust fan).

Model Making

Product models, architectural models, and the like use a wide variety of sculpture materials including clay, wood, Plexiglas, and plastic resins. The hazards of these materials are covered in Chapters 16 and 17.

Mounting Work

Photographs, type, illustrations, and other work are often mounted onto cardboard or other backings for display. Mounting materials used include rubber cement, spray adhesives, and dry mount. Rubber cement thinner is used to unglue the mounting and remount the work if it was not mounted properly.

Hazards

1. Large amounts of rubber cement and thinner can be used in mounting large photographs and illustrations. Most rubber cements and their thinners contain n-hexane, which can cause peripheral neuropathy (nerve damage to the hands, arms, legs, and feet) through chronic inhalation. In severe cases, paralysis of the arms and legs can occur. These symptoms will disappear after two to three years as the peripheral nerves regenerate. In some cases, permanent central nervous system damage occurs.

2. Spray adhesives can contain a variety of toxic solvents, including n-hexane and 1,1,1-trichloroethane. Rubber cement thinner is commonly used to remove excess spray.

3. Rubber cement, its thinner, and spray adhesives are extremely flammable.

Precautions

1. Use nonsolvent mounting methods whenever possible. Alternatives include dry mounting and use of double-sided Scotch tape.

2. Use rubber cements and thinners based on heptane rather than hexane (e.g., Borden's). Heptane does not cause neuropathy, although it is extremely flammable and can cause respiratory irritation and narcosis.

3. Frequent use of large amounts of rubber cement requires local exhaust ventilation (e.g., slot hood, working on a table against a window with a window exhaust fan at work level). For small-scale use, dilution ventilation is adequate. For example, a 500 cfm exhaust fan would allow for the evaporation of 1.5 ounces per hour of rubber cement and rubber cement thinner combined.

527

4. Spray adhesives should be applied in an explosion-proof spray booth exhausted to the outside. For occasional use, spray outdoors or wear a NIOSH-approved respirator with organic vapor cartridges and dust and mist filters.

5. Do not allow smoking, open flames, or other sources of ignition in the same room in which rubber cement, rubber cement thinner, or other flammable solvents are used.

Pasteup of Mechanicals

Pasteup of mechanicals is still commonly done using rubber cement as the adhesive. Rubber cement thinner is used to take up pieces that have been pasted down onto the mechanical. Pasteup is also done using hot wax to adhere the type. Errors can be corrected and touch-ups done using water-based opaque white paint or correction fluids. These correction fluids can be either water based or solvent based.

Hazards

1. As discussed under mounting work, most rubber cements and their thinners contain n-hexane, which can cause peripheral neuropathy (nerve damage to the hands, arms, legs, and feet) through chronic inhalation. A number of commercial artists have developed this disease from exposure to rubber cement and rubber cement thinner, particularly from use of large amounts of rubber cement thinner to flood the mechanical.

2. The hexane in rubber cement and rubber cement thinner is extremely flammable.

3. Molten wax is a fire hazard and an inhalation hazard, if overheated.

4. Perchloroethylene and 1,1,1-trichloroethane, found in some correction fluids, have caused fatalities from "sniffing" the product.

Precautions

1. Use wax for pasteup, rather than rubber cement, whenever possible. Keep the wax at the lowest feasible temperature to minimize vaporization and decomposition of the wax. Remove excess wax by mechanical means (e.g., razor blade, rubber erasers), not solvents.

2. Use heptane-based rubber cement and rubber cement thinner, when available (e.g., Borden's). Heptane does not cause peripheral neuropathy, although it is extremely flammable.

3. For frequent pasteup using rubber cement, local exhaust ventilation should be available (e.g., slot hood, working on a table against a window with a window exhaust fan at work level). For occasional use, dilution ventilation is adequate.

4. Do not allow smoking, open flames, or other sources of ignition in the same room in which rubber cement or rubber cement thinner is used.

5. Use water-based paint or correction fluids in preference to solvent-based fluids, especially if you are using more than a few drops.

Photostats

Photostats are black-and-white copies produced by a photographic process using high-contrast paper. They are suitable for printing.

Hazards. Developers and activators for photostat processing are usually alkaline and can contain other toxic chemicals such as methylaminoethanol, which is a skin, eye, and respiratory irritant. See also Chapter 15 and Table 15-1.

Precautions

1. I recommend providing 170 cfm of exhaust for stat camera processors or 10 air changes per hour of dilution ventilation, whichever is greater. Each processor should have an exhaust duct opening located just above it.

2. Gloves and goggles should be worn.

3. An eyewash fountain should be available in the area where processing chemicals are mixed and poured.

Sign Painting

Sign painting is commonly done with solvent-based paints. They can contain high percentages of mineral spirits (e.g., Japan colors), xylene, and other solvents. Many outdoor sign paints contain lead chromate.

Hazards

1. Mineral spirits are moderately toxic by inhalation, skin contact, and ingestion. They are irritating to the skin, eyes, nose, throat, and lungs. Acute exposure can cause narcosis, and chronic exposure possible brain damage.

2. Xylene is highly toxic by inhalation and ingestion and moderately toxic by skin contact. It is more acutely toxic than mineral spirits, but may also cause brain damage.

3. Lead chromate is a known human carcinogen. It can cause lead poisoning, skin ulcers, allergic reactions, and lung cancer.

Precautions

1. Brush on paints rather than spraying, if possible.

2. Spray sign paints only in a spray booth. For outdoors, wear a NIOSH-approved toxic dust respirator with organic vapor cartridges and toxic dusts and mists filters.

3. Avoid spraying lead chromate paints if possible. If spraying outdoors, wear a NIOSH-approved respirator with organic vapor cartridges and high-efficiency (HEPA) filters.

4. Brush on sign paints using dilution ventilation. For steady use, have local exhaust ventilation (e.g., slot hood or window exhaust fan at work level). Provide a ventilated drying area.

5. If paint solvents are flammable, do not allow lit cigarettes, open flames, or other sources of ignition in the room.

Spray Fixatives

Spray fixatives are used to fix drawings so they will not smudge. Spray fixatives can contain a wide variety of solvents, including acetone, ethyl alcohol, heptane, n-hexane, and toluene.

Hazards

1. See Table 4-4 for the hazards of individual solvents. N-hexane and toluene, in particular, are highly toxic by inhalation.

2. Spray fixatives are classified as extremely flammable because of the flammable propellants and solvents.

Precautions. Spray fixatives should be applied in an explosion-proof spray booth exhausted to the outside. Do not use spray booths that do not exhaust to the outside. For occasional use, spray outdoors or wear a NIOSH-approved respirator with organic vapor cartridge and dusts and mists filters.

Textile Design

Painting and printmaking on textiles is commonly done using French dyes and both water-based and solvent-based screen printing inks. For the hazards of painting on textiles with dyes, see Chapter 21. For the hazards of screen printing, see Chapter 13.

Typography

Phototypositors use a photographic processor to produce type generated by a computer system (cold type). Phototypositor chemicals are similar to ordinary black-and-white film processing chemicals. See Table 15-1 for more information.

Hazards

1. The developers are alkaline and usually contain hydroquinone, which is primarily a skin and eye irritant and may cause allergic reactions. Hydroquinone is also a mutagen.
2. The stop bath contains acetic acid and can cause burns.
3. The fixer often gives off ammonia gas.

Precautions

1. Wear gloves, goggles, and plastic apron when mixing solutions. An eyewash fountain should be available.
2. I recommend providing 170 cfm of exhaust for each processor, or 10 air changes per hour of dilution ventilation, whichever is greater. Each processor should have an exhaust duct opening located just above it.

Reference

Bruno, M. H. (ed.). (1989). *Pocket Pal: A Graphic Arts Production Handbook*. 14th ed. Memphis: International Paper Company.

Children
and Art
Materials

T his chapter discusses the hazards of art and craft materials as they relate to children and the special precautions that must be taken when using art and craft materials with children.

SPECIAL PROBLEMS OF CHILDREN

Before exposing children to art and craft materials, you should be aware of the special problems involved due to their age and state of body development. Consideration of these factors should determine what art materials that children of various ages can safely use.

Why Children Are a High-Risk Group

Up until their late teens, children are still growing. Their body tissues are metabolizing faster than those of adults and, as a result, are more likely to absorb toxic materials that can result in body damage.

Young children, however, are at even greater risk than teenagers, for a variety of reasons. First, the brain and nervous system of young children are still developing, making these organs a prime target for many toxic materials. This is why children are especially susceptible to lead poisoning.

Second, infants' lungs are immature at birth and develop slowly. They have smaller air passages, poorly developed body defenses, and inhale more air than adults in relation to their body weight. All these factors make young children more susceptible to inhalation hazards.

Third, children absorb more materials through their intestines than do adults. Therefore, they are more susceptible to poisoning by ingestion. What increases the risk even more is that children weigh much less than adults. The smaller the body weight, the greater the effect of a given amount of toxic material, since there is a higher concentration of the material in the body. Thus, the smaller and the younger the child, the greater the risk.

Age and Psychological Factors

As discussed above, children and even teenagers are at higher risk than adults from exposure to toxic materials for physiological reasons. The younger the child, the higher the risk. Psychological factors also affect which art materials can be recommended for children of different age groups.

Children under five—preschool children—are very likely to put things in their mouth and swallow them. This is the well-known pica syndrome. As a result, it is crucial that preschool children not be allowed to play with materials that are harmful if ingested—whether in a single dose or as a series of doses. This applies to children both at home and in day-care centers. In addition, preschool children should not be exposed to materials that are hazardous by skin contact or inhalation.

As children get older and into elementary school, the chances of deliberate ingestion decrease, although there is still the possibility of accidental ingestion. This can occur if hazardous materials are placed in unmarked containers a child might drink or eat from, or even from inadvertent hand-to-mouth contact.

Since it is difficult to make elementary school children understand the need for precautions and for cleanliness in handling hazardous materials—and even more difficult to make them consistently carry out such precautions—I recommend that elementary school children (under the age of 12) not be allowed to use materials that are hazardous by skin contact, inhalation, or ingestion.

Junior high school and high school students (over age 12) are at an age where they can reasonably be expected to understand and carry out precautions when working with hazardous materials. Of course with retarded or emotionally disturbed students, this might not be true.

Therefore, I believe that most secondary school students can work with art materials used by adults. The major exceptions would be highly toxic materials such as lead, cadmium, mercury, and uranium; these should not be used in any student situation, since the potential for damage is so high.

Home Exposure

The hazards discussed so far apply whether in the home or at school. However, home studios or workshops can expose children to art materials or other hazardous materials that are being used by adults. It is crucial to take very careful precautions against contamination of the home by hazardous materials if children are around. In addition, you should make sure that the children cannot get into the art materials. In fact, children should not be permitted in your studio while you are working unless you can keep a careful watch on what they are doing—which is difficult to do if you are busy working, or unless there are no toxic materials accessible in the studio.

LABELING

One problem has been with the labeling of art materials designed for use by children. Most of these materials are labeled "nontoxic." According to the U.S. Federal Hazardous Substances Act, the term "toxic" applies to "any substance (other than a radioactive substance) which has the capacity to produce personal injury or illness to man through ingestion, inhalation, or absorption through any body surface." However, until 1988, the Federal Hazardous Substances Act specified hazard warnings only for acute or immediate toxicity such as eye irritation, ingestion, and skin irritation. It did not specify warnings for long-term effects such as chronic poisoning or cancer.

One art manufacturer's association—the Art and Craft Materials Institute (ACMI)—has a toxicologist approve products. Children's art materials that carry the CP (Certified Product) or AP (Approved Product) seal of the ACMI are "certified by an authority of toxicology, associated with a leading university to contain no materials in sufficient quantities to be toxic or injurious to the body even if ingested." With respect to acute poisoning, this program has been praised by medical authorities. However, since the approval of art materials does not require actual long-term animal testing, there have been questions about the chronic effects of some of these materials. In addition, the ACMI has approved art materials such as certain oil paints, that are nontoxic but require toxic solvents for cleanup.

On October 18, 1988, the U.S. Congress passed the Labeling of Hazardous Art Materials Act which amended the the Federal Hazardous Substances Act to require warning labels on art materials with chronic hazards. The labeling requirements of the bill became effective two years from the date of its enactment (October 18, 1990). It requires all chronically hazardous art materials to carry a statement that such materials are inappropriate for children, and allows the Consumer Product Safety Commission to obtain a court injunction against any school purchasing chronically hazardous art materials for use by children in grade six and below. As of the writing of this book (1991), many art materials were still not properly labeled. Art materials labeled in accordance with the Labeling of Hazardous Art Materials Act are supposed to carry the statement "Conforms to ASTM D4236" or similar wording.

SELECTION OF CHILDREN'S ART MATERIALS

Preschool or elementary school children should not use any art material that presents a toxic hazard by skin contact, ingestion, or inhalation. This includes materials that could become hazardous by misuse as well as by proper use.

This does not mean that children are limited to only a few art materials. In the late 1980s, the California Department of Health Services published a list of over 2,000 approved children's art materials.

Do Not Use

The following is a list of general types of art materials that should not be used by children under the age of 12:

1. Adult art materials, which might contain toxic ingredients.

2. Powdered materials that could be inhaled or get in the eyes of children, even if nontoxic. If powdered paints are purchased, a teacher or parent should mix them up.

3. Solvents or solvent-containing materials (e.g., turpentine, paint thinner, shellac, toluene, rubber cement, solvent-based inks and glues, permanent felt-tip markers).

4. Art materials requiring solvents for cleanup (e.g., oil paints, oil-based printmaking inks).

5. Art materials that are sprayed (e.g., spray paints, spray fixatives, spray adhesives, airbrush paints).

6. Acids, alkalis, bleaches, or other irritating or corrosive chemicals.

7. Art materials containing toxic metals (e.g., pottery glazes, copper enamels, adult paints, stained glass, pastels).

8. Donated or found materials, unless the ingredients are known to be safe.

Many of these materials are discussed in later sections of this chapter. Note that the relative toxicity ratings used in the book are meant for adults, not children. With children, as discussed earlier, the risk is even greater.

Rules for Safe Use of Children's Art Materials

1. Control the art materials used by your child or in your classroom. Purchase only art materials approved for children. Do not allow friends to bring art materials unless they have been approved by you. Investigate donated art supplies before allowing them to be used in the classroom.

2. If your child or a student has allergies, asthma, or other physical or psychological limitations, or is taking medications, you should discuss with a physician the possible limitations on the type of art materials the child can use. Parents should make sure that schools are aware of any such limitations. This is even more important in secondary school, since teenagers can be exposed to more toxic art materials.

3. Preschool children should have access to only small amounts of art materials at any time, to limit the amount they can ingest.

4. Supervise children's art activities. Do not allow food or drink in the area. Open cuts and sores should be covered.

5. Be alert to any unusual reaction by children to art materials. Note that different children may react differently to the same materials.

6. In case of accidental ingestion, contact your regional poison control center for advice. Keep the product handy for label information.

7. After use of art materials, children should wash their hands.

TYPES OF CHILDREN'S ART MATERIALS

This section discusses the various types of children's art materials, their potential hazards, and precautions that should be taken with their use. In general, this applies only to children of elementary school or preschool age.

Paints

Children's paints come in a variety of types, including finger paints, watercolors, tempera paints, phosphorescent and fluorescent paints, acrylic paints, and poster paints. These are all water soluble and do not require the use of organic solvents for thinning or cleanup. Most of these paints contain small amounts of preservatives. Some of them—for example, poster and tempera paint—come in both liquid and powder form.

Adult paints contain a much wider range of pigments than children's paints and may require the use of solvents for thinning and cleanup.

Hazards

1. Adult paints may contain toxic pigments, which could be hazardous by accidental ingestion.

2. Ingestion of large amounts of approved children's paints may cause stomach upset, but this should not be serious.

3. Acrylic paints contain small amounts of ammonia and formaldehyde. Children who are sensitized to formaldehyde could develop an allergic reaction from acrylic paints. Some children might develop eye, nose, and throat irritation from the small amount of ammonia present.

4. Turpentine and mineral spirits used as thinners and for cleaning up oil paints and alkyd paints are highly hazardous to children by ingestion and inhalation. Ingestion of $1/15$ cup ($1/2$ ounce) of turpentine can be fatal. Turpentine is a moderate skin irritant and can cause allergies. Mineral spirits is also a skin irritant.

Precautions

1. Children under the age of 12 should not be allowed to use oil paints, alkyd paints, phosphorescent paints, or any other adult paints.

2. Children should not mix their own powdered paints. This should be done by the teacher or another adult.

3. Children who are allergic to formaldehyde or react to the small amount of ammonia should not use acrylic paints.

4. Children should never use solvents.

Drawing Materials

Common drawing materials used by children include chalk, charcoal, pastels, crayons, drawing inks, felt-tip markers (including scented types), and pencils. Many of these are available in children's varieties, especially pencils, chalk, and crayons. The inks and felt-tip markers may contain a variety of organic solvents.

Hazards

1. Inhalation of chalk and other dusts may cause slight respiratory irritation. Pastels may contain toxic pigments.

2. Permanent felt-tip markers contain xylene or alcohols. These can be hazardous by inhalation, ingestion, and skin contact. Water-soluble inks and markers are much less hazardous. In most cases, the hazards of the dyes used with these materials are unknown.

3. "Scented" markers are very popular with young children. For example, the red smells like cherry and the green like lime. Although they might be nontoxic, they are a problem because they teach children to sniff and taste art materials.

4. Carbon black, used as a black pigment in drawing or India inks, may cause skin cancer on prolonged contact. For this reason, the Food and Drug Administration has banned the use of carbon black in mascara.

5. Most "lead" pencils and charcoal have no significant hazards, although in the past, the yellow paint on the outside of pencils contained large amounts of lead. The "lead" in lead pencils is actually graphite. Some "greasy" charcoal pencils contain carbon black. Colored pencils may contain toxic pigments that could be an ingestion hazard.

6. Solvent-based drawing gums used as resists (e.g., rubber cement) are toxic due to the solvents.

Precautions

1. Children should not use excessively dusty materials such as charcoal, pastels, and many chalks. Choose children's nondusty chalks, pencil, crayons, and oil pastels instead.

2. Preschool children should not be allowed to use water-soluble drawing inks and felt-tip markers because of the likelihood that they will ingest them or draw on their (or other's) bodies, and risk possible hazards from the dyes.

3. "Scented" markers should not be used, because of the bad habits they teach children.

4. Elementary school age children should not be allowed to use permanent felt-tip markers or solvent-based drawing inks. Use water-based markers only.

5. Use approved water-based drawing gums only.

Dyes

Children's art courses have used a variety of dyes, including food dyes, household dyes, natural plant and vegetable dyes, direct dyes, and cold-water fiber-reactive dyes. Other dyes may also be used (see Chapter 21). These are used for many purposes including tie-dye, batik, and fabric dyeing. Batik also involves the use of heated wax.

Hazards

1. Dyes have a wide range of possible hazards, ranging from dermatitis and asthma to bladder cancer. Unfortunately, the long-term hazards of most dyes have not been adequately studied.

2. The hazards of most natural plant dyes have not been investigated. Vegetable dyes such as spinach and onion skins probably have no significant hazards.

3. Many of the mordants used with natural dyes are highly hazardous to children if ingested. This includes copper sulfate, ferrous sulfate, dichromates, and oxalic acid. Potassium dichromate and oxalic acid are also highly toxic by skin contact.

4. Heating wax for batik can create a fire hazard and, if overheated, can produce fumes that are highly irritating to the lungs.

5. See Chapter 21 for more information on the hazards of dyes.

Precautions

1. Do not allow preschool or elementary school children to use household dyes, direct dyes, cold-water fiber-reactive dyes, or other craft dyes.

2. Do not allow children to use mordants with natural dyes. Premordant the fabric yourself so that the children are not in contact with the mordants. A rusty nail is one iron mordant that could be used.

3. For dyeing, children can use food dyes or vegetable dyes that are known to have no significant hazards. Examples include coffee, tea, onion skins, spinach, and beets.

4. Children should not heat wax for batik or use hot wax.

Sculpture and Modeling Materials

Materials used by children for sculpture and modeling include moist clay, modeling clays and compounds, plaster of Paris, casting stones, acrylic gesso, papier-mâché, and flour and water. Carving materials include Styrofoam, alabaster, soapstone, soap, and wood. Pottery is considered separately below.

Hazards

1. Dry clay is highly toxic by inhalation, and long-term exposure can cause silicosis; moist clay has no significant hazards.

2. Modeling clays may contain a variety of hazardous materials, such as toxic preservatives. Some oven-curing modeling compounds have contained toxic plasticizers.

3. Dusts from plaster of Paris, casting stones, alabaster, and other stones and woods are irritating to the respiratory system.

4. Carving wood, stones, and Styrofoam may involve physical hazards as a result of accidents due to the use of sharp tools. Use of hot wires or electric saws to cut Styrofoam may release decomposition gases, which are highly hazardous by inhalation.

5. Casting of body parts with plaster of Paris (e.g., casts of arms) has caused severe skin burns in several instances, in both children and adults.

6. Instant papier-mâchés may contain toxic pigments or other ingredients, if made from magazines. Instant papier-mâchés made before the mid-1970s often contained large amounts of asbestos powder.

7. Acrylic gesso contains small amounts of ammonia, formaldehyde, and preservatives, which are slightly irritating to the eyes and respiratory system in the amounts used.

Precautions

1. Do not expose children to dusts of any modeling materials.

2. Do not allow preschool or elementary school children to work with dry clay; use only moist clay. Take careful housekeeping precautions such as cleaning up all spilled clay immediately, mopping instead of sweeping, and not allowing dry clay to accumulate. Do not allow children to sand clay sculptures after firing because of the danger of inhaling clay dust.

3. Use only children's modeling clay, not adult modeling clays.

4. Use homemade materials such as flour and water and newspaper and paste whenever possible instead of brand-name materials of unknown composition.

5. Children under junior high school age should not be allowed to use sharp tools, except under very close supervision (and never for preschool children).

6. Never allow children to do body casts with plaster of Paris.

7. Do not heat anything in an oven that is used for cooking food.

Pottery

Many children learn pottery at a young age, including use of a potter's wheel and application of ceramic glazes (see Chapter 14 for more complete details).

Hazards

1. Mixing of dry clay or exposure to clay dust is highly hazardous by inhalation, possibly causing silicosis.

2. Potters' wheels, particularly if they are too large for the child, can be a physical hazard, since the moving parts can easily cause cuts and bruises.

3. Handling of cold, wet clay—particularly when using a potter's wheel—can cause abrasion and drying of the hands and fingers.

4. Many pottery glazes are very hazardous by inhalation of many glaze ingredients, including free silica, which can cause silicosis, and highly toxic metals, especially lead. Accidental ingestion of liquid glazes is also hazardous. In addition, some glaze components can be hazardous by skin contact, causing dermatitis and allergies.

5. Kiln firing releases gases and metal fumes, which are highly hazardous by inhalation. In addition, handling of hot pottery or touching a hot kiln can cause thermal burns.

Precautions

1. Do not allow preschool or elementary school children to handle clay in dry form. Use wet clay instead. Also take very careful housekeeping precautions such as cleaning all spills and wet mopping instead of sweeping.

2. Do not allow preschool children to use glazes. Elementary school children should not use glazes unless they are clearly approved for children. Glazes marked "lead and cadmium free" are not necessarily safe, since they can contain other toxic materials. "Lead-safe" glazes are not safe for children to use, since they often contain lead. The term "lead-safe" means that lead will not leach out of the finished ware if properly fired. In any case, children should not be exposed to glaze dusts or spray mists.

3. An alternative to glazing is to allow the child to paint the fired object with acrylic or tempera paint. The child should never be allowed to make objects that could be used for food or drink.

4. Young children should not be allowed to use potter's wheels, particularly kickwheel types. Older children should use a wheel that can be adjusted to their smaller arms and legs.

5. All kilns should be ventilated directly to the outside by a canopy hood or similar local exhaust system. In addition, to prevent burns, the kiln should be located in a separate room. Children under junior high school age should not be allowed near hot kilns.

Screen Printing

Screen printing uses a variety of techniques to make the screen stencil, including shellac, water-soluble glues, lacquers, liquid wax resists, rubber latex resists, paper cutouts, film stencils, and photostencils. Inks used for printing include water-based inks as well as inks based on mineral spirits and lacquer thinners. A variety of solvents can be used for cleaning screens (see Chapter 13).

Hazards

1. Turpentine, mineral spirits, kerosene, lacquer thinners, and other organic solvents used for cleanup, for thinners, and for stencil making are highly hazardous to children by inhalation and ingestion. In addition, most solvents can cause skin irritation from prolonged and frequent contact.

2. Many silk screen inks contain pigments that are highly hazardous by ingestion. This includes lead, cadmium, chromium, and some synthetic pigments.

Precautions

1. Do not allow preschool children to do screen printing. Elementary school children should be allowed to use screen printing inks that contain only water and nontoxic pigments.
2. Stencil-making materials that could be used with elementary school children include water-soluble glues, liquid wax resists, rubber latex resists, and paper cutouts.

Other Printmaking Techniques

Lithography, etching, engraving, drypoint, woodcuts, wood engraving, linocuts, and collagraphs are other printmaking techniques that children sometimes use. These techniques use a wide variety of tools and chemicals.

Hazards

1. Most of these printmaking techniques use inks that may contain pigments that are highly hazardous by ingestion, including lead, chromium and cadmium.
2. Printmaking techniques using oil-based inks commonly use organic solvents such as turpentine, mineral spirits, and kerosene, which are hazardous by ingestion, inhalation, and skin contact.
3. Lithography and etching use a variety of acids—for example, nitric acid, sulfuric acid, and phosphoric acid—all of which are highly corrosive by skin and eye contact and by ingestion, and many of which produce gases that are highly hazardous by inhalation (see Chapter 13).
4. Sharp tools are used in engraving, woodcuts, drypoint, and linocuts to cut the pattern in the wood, metal, or linoleum. Improper use of these tools can result in accidents.
5. A variety of glues, and at times aerosol sprays, are used in making collagraphs. These hazards are discussed later in the chapter.

Precautions

1. Do not allow preschool or elementary school children to do lithography, etching, woodcuts, wood or metal engraving, or drypoint. Preschool children should not be allowed to do linocuts.

2. Elementary school children—particularly older ones—can do linocuts, since the tools used are less likely to slip and cause cuts. Heating the linoleum first makes it easier to cut. Use only special water-based inks approved for children to print the linocuts.

3. Collagraphs are another printmaking technique suitable for use with elementary school children. Simple water-soluble glues that are relatively safe can be used to make the plate.

Photography

Many children like using cameras and even want to develop their own film. As discussed in Chapter 15, film processing involves a wide range of chemicals.

Hazards. Photographic chemicals, especially developers, can be very dangerous by ingestion. In addition, many photographic chemicals are hazardous by skin contact and inhalation.

Precautions

1. Do not allow children into darkrooms or to have access to photochemicals.

2. Polaroid cameras are one way for children to avoid using photochemicals. Note that supervision is required, especially with young children, since chemicals inside the Polaroid print are corrosive if opened up (or chewed).

3. Using blueprint paper and sunlight is an alternative photographic type process (sungrams).

Glues and Adhesives

A wide variety of glues and adhesives is used in various art processes. These can be divided into three major groups. The first group includes water-based glues and adhesives, such as library paste, mucilages, polyvinyl acetate emulsions, casein glues, dextrin and other animal glues, and water-based contact cements.

The second group includes glues and adhesives that depend on the evaporation of organic solvents, such as most rubber cements and model cement glues. The final category of adhesives depend on chemical reactions to provide the adhesion. These often are composed of two components that are mixed and include epoxy glues, polyurethane adhesives, and cyanoacrylate instant glues.

Hazards

1. Glues and adhesives that depend on solvent evaporation, such as rubber cement, are highly hazardous by inhalation and ingestion. In many cases they are strong skin irritants. They are usually flammable.

2. Epoxy adhesives can cause severe skin and respiratory allergies. They also contain solvents that are moderately to highly hazardous by inhalation, ingestion, and skin contact.

3. Polyurethane adhesives contain isocyanates, which are extremely hazardous by inhalation, and solvents, which can be highly hazardous by ingestion, inhalation, and skin contact.

4. Cyanoacrylate instant glues are highly hazardous by skin or eye contact. They can glue the skin together so that surgery is required and can cause severe eye damage.

5. Dry casein powder may contain sodium fluoride, which is extremely hazardous by inhalation and ingestion, and calcium hydroxide, which is highly corrosive by skin contact, inhalation, or ingestion.

6. Many water-based glues contain small amounts of phenol, formaldehyde, or other preservatives that, if ingested in large amounts, could cause illness in small children.

7. Many wheat pastes, sold as wallpaper pastes, can contain hazardous amounts of toxic preservatives such as arsenic compounds and pentachlorophenol.

Precautions

1. Do not allow preschool or elementary school children to use solvent-based glues and adhesives, glues that involve chemical reactions, or dry casein glues.

2. Preschool and elementary school children should use water-based glues and adhesives such as library paste, mucilages, and polyvinyl acetates. Homemade glues such as flour and water that do not contain preservatives are also suitable.

3. Purchase only wheat pastes that have been approved for children. Do not use wallpaper paste.

4. Preschool children should not have access to large containers of glues or pastes so as to avoid ingestion of large amounts of these materials.

Aerosol Sprays

A wide variety of aerosol sprays is often used, including spray paints, spray adhesives, and spray fixatives. All these contain organic solvents to dissolve the various substances in the spray, and volatile propellants.

Hazards

1. The Consumer Products Safety Commission reports that over 5,000 injuries requiring emergencyroom treatment occur every year from aerosol sprays.
2. The solvents in the spray can be highly hazardous if inhaled.
3. If heated or punctured, aerosol spray cans can explode.
4. Spraying too close to the skin can cause freezing, blisters, and inflammation. Spraying too close to the eyes can cause eye damage.
5. Most aerosol sprays are highly flammable.
6. Many of the pigments, adhesives, and other materials found in aerosol sprays are highly hazardous if inhaled.

Precautions

1. Do not allow preschool and elementary school children to use aerosol sprays. Older students and teachers should not use aerosol sprays in the classroom, but should spray outdoors or in a fume hood.
2. Instead of using spray fixatives to fix drawings, use clear acrylic polymer emulsion.

REFERENCES

Babin, A., Peltz, P., and Rossol, M. (1989). *Children's Art Supplies Can Be Toxic* (rev). New York: Center for Safety in the Arts.

California Public Interest Research Group. (1984). *Not a Pretty Picture: Art Hazards in the California Public Schools*. Sacramento: CALPIRG.

California State Department of Health Services. (1988). *Art and Craft Materials Acceptable for Kindergarten and Grades 1–6.* 2d ed. Sacramento.

Jacobsen, L. (1984). *Children's Art Hazards.* New York: Natural Resources Defense Council.

Kawai, M., Torimumi, H., Katagiri, Y., and Maruyama, Y. (1983). Home lead-work as a potential source of lead exposure for children. *Arch. Occ. Environ. Health* 53(1), 37–46.

Massachusetts Public Interest Research Group. (1983). *Poison Palettes: A Study of Toxic Art Supplies in Massachusetts Schools.* Boston: MASSPIRG.

McCann, M. (1986). *Health and Safety for Secondary School Arts and Industrial Arts.* New York: Center for Safety in the Arts.

McCann, M. (1988). *Teaching Art Safely to the Disabled.* New York: Center for Safety in the Arts.

New York Public Interest Research Group. (1982). *Children Beware—Art Supplies in the Classroom.* New York: NYPIRG.

Oregon State Public Interest Research Group. (1985). *Toxics in Art Supplies Hazardous Hobbies.* Portland: Oregon PIRG.

Peltz, P. (1984). Day care centers using toxic art materials. *Art Hazards News* (March), 1.

Qualley, C. (1986). *Safety in the Art Room.* Worcester, MA: Davis Publications.

U.S. Public Interest Research Group. (1986). *Not a Pretty Picture: Toxics in Art Supplies in Washington, DC Area Public Schools.* Washington, DC: USPIRG.

U.S. Public Interest Research Group. (1987). *The Picture Looks Brighter: Improvements in Artroom Safety in Washington, DC Area Public Schools.* Washington, DC: USPIRG.

Bibliography

A rticles and books marked with an asterisk (*) are available from the Center for Safety in the Arts (CSA), 5 Beekman Street, New York, NY 10038. In addition, CSA has over 50 other data sheets on various topics in the visual arts. Most of the articles listed here are in CSA's library, which is available for research.

Agoston, G. (1969). Health and safety hazards of art materials. *Leonardo* 2, 373.

Alexander, W. (1973–74). Ceramic toxicology. *Studio Potter* (Winter), 35.

American Art Clay Co., Inc. (1987). *Ceramics Art Material Safety in the Classroom and Studio*. Indianapolis: AMACO.

Arts, Crafts and Theater Safety. *Acts Facts* (newsletter).

ASTM Subcommittee D01.57 on Artist Paints and Related Meetings. (1984). *ASTM D4236 Standard Practice for Labeling Art Materials for Chronic Health Problems* Philadelphia: American Society for Testing and Materials.

Ayers, G., and Zaczkowski, J. (1991). *Photo Developments—A Guide to Handling Photographic Chemicals*. Bramalea, Ontario: Envisin Compliance Ltd.

Bailey, J. R. (1977). What evil lurks? *Photomethods Magazine* 20(2), 51.

Ballesteros, M., Zuniga, C. M. A., Cardenas, O. A. (1983). Lead concentrations in the blood of children from pottery-making families exposed to lead salts in a Mexican village. *Bull. Pan. Am. Health Org.* 17(1), 35–41.

Barazani, G. (1974 to date). Protecting your health (column). *Working Craftsmen* (now in *The Crafts Report*).

Barazani, G. (ed). (1977). *Health Hazards in Art Newsletter I & II*. Chicago: Hazards in Art.

Barazani, G. (1978). *Safe Practices in the Arts and Crafts: A Studio Guide*. New York: College Art Association.

Barazani, G. (1979). *Ceramic Health Hazards*. Chicago: Hazards in the Arts.

Barazani, G. (1980). Glassblowing hazards. *Glass Studio* 11, 34.

Barazani, G. (1980). Hazards of stained glass. *Glass Studio* 10, 33.

Baxter, P. J., Samuel, A. M., and Holkham, M. P. E. (1985). Lead hazards in British stained glass workers. *Br. J. Ind. Med.* 291, 6492.

Berendosohn, R. (1987). Clearing the air. *Fine Woodworking* (Nov./Dec.), 70–75.

Bond, J. (1976). Occupational hazards of stained glass workers. *Glass Art* 4(1), 45.

Braun, S., and Tsiatis, A. (1979). Pulmonary abnormalities in art glassblowers. *J. Occup. Med.* 21(7), 487–89.

Buie, S. E., Pratt, D. S., and May, J. J. (1986). Diffuse pulmonary injury following paint remover exposure. *Am. J. M. Ed.* 81(4), 702–4.

*Canadian Centre for Occupational Health and Safety. (1988). *Infograms on Hand Tools*. 16 pp. Hamilton, Ontario, Canada: CCOHS.

*Canadian Centre for Occupational Health and Safety. (1988). *Infograms on Powered Hand Tools*. 11 pp. Hamilton, Ontario, Canada: CCOHS.

*Canadian Centre for Occupational Health and Safety. (1988). *Infograms on Welding*. 17 pp. Hamilton, Ontario, Canada: CCOHS.

*Canadian Centre for Occupational Health and Safety. (1988). *Infograms on Woodworking Machines*. 10 pp. Hamilton, Ontario, Canada: CCOHS.

Carnow, B. (1975). *Health Hazards in the Arts and Crafts*. Chicago: Hazards in the Arts.

*Carnow, B. (1976). Health hazards in the arts. *American Lung Association Bulletin* (Jan./Feb.), 2–7.

*Center for Safety in the Arts. (1978 to date). *Art Hazards News*.

Challis, T., and Roberts, G. (1984). *Caution: A Guide to Safe Practice in the Arts and Crafts.* Sunderland Polytechnic Faculty of Art and Design, England.

*Clark, N., Cutter, T., and McGrane, J. (1984). *Ventilation*. New York: Lyons & Burford, Publishers.

Clement, J. D. (1976). *An Assessment of Chemical and Physical Hazards in Commercial Photographic Processing*. M.S. thesis, University of Cincinnati.

Curry, S., Gerkin, P., Vance, M., and Kimkel, D. (1987). *Ingestion of Lead-Based Ceramic Glazes in Nursing Home Residents.* Presented at annual meeting American Association of Poison Control Centers, Vancouver.

Department of National Health and Welfare, Canada. (1988). *The Safer Arts: The Health Hazards of Arts and Crafts Materials.* Ottawa: Department of Supply and Services Catalogue Number H42-2/10-1988E.

Dreggson, A. (1977). Lead poisoning. *Glass* 5(2), 13.

Driscoll, R. J., Mulligan, W. J., Schultz, D., and Candelaria, A. (1988). Malignant mesothelioma: A cluster in a native American population. *New Engl. J. Med.* 318, 1437–38.

Eastman Kodak Co. (1977). *Safe Handling of Photographic Chemicals.* Rochester, NY: Eastman Kodak.

Eastman Kodak Co. (1987). *General Guidelines for Ventilating Photographic Processing Areas.* CIS-58. Rochester, NY: Eastman Kodak.

Feldman, R., and Sedman, T. (1975). Hobbyists working with lead. *New Engl. J. Med.* 292, 929.

Fink, T. J. (1990). Chemical hazards of woodworking. *Fine Woodworking* (Jan./Feb.), 58–63.

Firenze, R. B., and Walters, J. B. (1981). *Safety and Health for Industrial/Vocational Education for Supervisors and Instructors.* Washington, DC: National Institute for Occupational Safety and Health/Occupational Safety and Health Administration.

Food and Drug Administration. (1991). Getting the lead out. *FDA Consumer* (July–Aug.), 26–31.

Foote, R. (1977). Health hazards to commercial artists. *Job Safety and Health* (Nov.), 7.

Freeman, V., and Humble, C. G. (1989). *Prevalence of Illness and Chemical Exposures in Professional Photographers.* Presented at 1989 annual meeting of American Public Health Association, Boston.

Goh, C. (1988). Occupational dermatitis from gold plating. *Contact Dermatitis* 18(2), 122–23.

Graham, J., Maxton, D., and Twort, C. (1981). Painter's palsy: A difficult case of lead poisoning. *Lancet* (Nov. 21), 1159.

Hall, A. H., and Rumack, B. H. (1990). Methylene chloride exposure in furniture stripping shops: Ventilation and respirator use practices. *J. Occup. Med.* 32(1), 33–37.

Halpern, F., and McCann, M. (1976). Health hazards report: Caution with dyes. *Craft Horizons* (Aug.), 46–49.

Handley, M. (1988). *Photography and Your Health.* Berkeley: Hazard Evaluation System and Information Service, California Department of Health Services.

Hedeboe, J., Moller, L. F., Lucht, U., and Christensen, S. T. (1982). Heat generation in plaster-of-Paris and resulting hand burns. *Burns* 9(1), 46–48.

Helper, E., Napier, N., Hillman, M., and Gatz, R. (1979). *Final Report on Product/Industry Profile on Art Materials and Selected Craft Materials.* 3 parts. Columbus: Battelle.

Hodgson, M., and Parkinson, D. (1986). Respiratory disease in a photographer. *Am. J. Ind. Med.* 9(4), 349–54.

Houk, C., and Hart, C. (1987). Hazards in a photography lab; a cyanide incident case study. *J. Chem. Educ.* 64(10), A234–36.

Hughes, R., and Rowe, M. (1982). *The Coloring, Bronzing, and Patination of Metals.* London: Craftscouncil.

Jacobsen, L. (1984). *Children's Art Hazards.* New York: Natural Resources Defense Council.

*Jenkins, C. L. (1978). Textile dyes are potential hazards. *J. Environ. Health* 40(5), 279–84.

*Johnson, L. M., and Stinnett, H. (1991). *Water-Based Inks: A Screenprinting Manual for Studio and Classroom.* 2d ed. Philadelphia: Philadelphia Colleges of the Arts Printing Workshop.

Kawai, M., Toriumi, H., Katagiri, Y., and Maryuama, Y. (1983). Home lead-work as a potential source of lead exposure for children. *Arch. Occup. Environ. Health* 53(1), 37–46.

Kern, D. G., and Frumkin, H. (1988). Asbestos-related disease in the jewelry industry: Report of two cases. *Amer. J. Ind. Med.* 13, 407–10.

Kipen, H., and Lerman, Y. (1986). Respiratory abnormalities among photographic developers: A report of three cases. *Am. J. Ind. Med.* 9(4), 341–47.

Lampe, K., and McAnn, M. (1985) *AMA Handbook of Poisonous and Injurious Plants.* Chicago: AMA.

Lead Industries Association. (1972). *Facts About Lead Glazes for Artists, Potters and Hobbyists.* New York: Lead Industries Association.

Letts, N. (1991). Artist dies in basement cyanide accident. *Art Hazards News* 14(1), 1.

Liden, C. (1984). Occupational dermatoses in a film laboratory. *Contact Dermatitis* 10(2), 77–87.

Lydahl, E., and Pjhilipson, B. (1984). Infrared radiation and cataract. II. Epidemiological investigation of glass workers. *Acta Ophthalmol.* 62(6), 976–92.

Mallary, R. (1983). The air of art is poisoned. *Art News* (Oct.), 34.

McCann, M. (1974–78). Art hazards news column. *Art Workers News.*

McCann, M. (1975). Health hazards in printmaking. *Print Review* 34, 20.

McCann, M. (1976). Health hazards in painting. *American Artist* (Feb.), 73.

*McCann, M. (1978). The impact of hazards in art on female workers. *Preventive Medicine* 7, 338–48.

*McCann, M. (1985). *Health Hazards Manual for Artists.* 3d ed. New York: Lyons & Burford, Publishers.

*McCann, M., and Barazani, G. (eds). (1980). *Health Hazards in the Arts and Crafts Proceedings of the SOEH Conference on Health Hazards in the Arts and Crafts.* Washington, DC: Society for Occupational and Environmental Health.

*McGrane, J. (1986). *Reproductive Hazards in the Arts and Crafts.* New York: Center for Safety in the Arts.

Miller, A. B., and Blair, A. (1983). Mortality patterns among press photographers (letter). *J. Occup. Med.* 25, 439–40.

Miller, A. B., Blair, A., and McCann, M. (1985). Mortality patterns among professional artists: A preliminary report. *J. Environ. Path. Toxicol. Oncol.* 6, 303–13.

Miller, A. B., Silverman, D. T., Hoover, R. N., and Blair, A. (1986). Cancer risk among artistic painters. *Am. J. Ind. Med.* 9, 281–87.

MMWR. (1982). Chromium sensitization in an artist's workshop. *Mortality and Morbidity Weekly Reports* 31, 111.

Moses, C., Purdham, J., Bohay, D., and Hoslin, R. (1978). *Health and Safety in Printmaking.* Edmonton, Alberta, Canada: Occupational Hygiene Branch, Alberta Labor.

National Institute for Occupational Safety and Health. (1983). *Preventing Health Hazards from Exposure to Benzidine-Congener Dyes.* DDHS (NIOSH) Publication No. 83-105. Cincinnati: NIOSH.

Ng, T. P., Allen, W. G. L., Tsin, T. W., and O'Kelly, F. J. (1985). Silicosis in jade workers. *Amer. Rev. Resp. Dis.* 42(11), 761–64.

Nixon, W. (1980). Safe handling of frosting and etching solutions. *Stained Glass* (Fall), 215.

*Ontario Crafts Council. (1980). *Crafts and Hazards to Health* (bibliography). Toronto, Canada: Ontario Crafts Council.

Ontario Lung Association. (1982). *Health Hazards in Arts and Crafts.* New York: American Lung Association.

Polato, R., Morossi, G., Furlan, I., and Moro, G. (1989). Risk of abnormal lead absorption in glass decoration workers. *Med. Lav.* 80(2), 136–39.

Prockup, L. (1978). Neuropathy in an artist. *Hospital Practice* (Nov.), 89.

*Qualley, C. (1986). *Safety In the Art Room.*Worcester, MA: Davis Publications.

Quinn, M., Smith, S., Stock, L., and Young, J. (eds). (1980). *What You Should Know About Health and Safety in the Jewelry Industry.* Providence, RI: Jewelry Workers Health and Safety Research Group.

Ramazzini, B. (1940). *De Morbis Artificum (Diseases of Workers).* 2d ed. (1713). Translated by W. C. Wright. Chicago: University of Chicago Press.

*Rickard, T., and Angus, R. (1983). *A Personal Risk Assessment for Craftsmen and Artists.* Ontario Crafts Council/College, University and School Safety Council of Ontario, Toronto, Canada.

*Rossol, M. (1980–82). *Ceramics and Health.* Compilation of articles from *Ceramic Scope.*

Rossol, M. (1982). Teaching art to high risk groups. Washington, DC: Educational Resources Information Center, U.S. Department of Education.

Rossol, M. (1990). *The Artist's Complete Health and Safety Guide.* New York: Allworth Press.

Rossol, M. (1991). *Professional Stained Glass Safety Training Manual: Our Right-to-Know Program.* Brewster, NY: Edge Publishing Group.

Schultz, L. (ed). (1982). *Art Safety Guidelines K–12*. Reston, VA: National Art Education Association.

Seeger, N. (1984). *Alternatives for the Artist*. Rev. eds. Chicago: School of the Art Institute of Chicago.

An Introductory Guide to the Safe Use of Materials.

A Printmaker's Guide to the Safe Use of Materials.

A Photographer's Guide to the Safe Use of Materials.

A Painter's Guide to the Safe Use of Materials.

A Ceramist's Guide to the Safe Use of Materials.

Shaw, S., and Rossol, M. (1989). Warning: Photography may be hazardous to your health. *ASMP Bulletin* 8(6) (entire issue).

*Shaw, S. D., and Rossol, M. (1991). *Overexposure: Health Hazards in Photography*. 2d ed. New York: Allworth Press.

Siedlicki, J. (1968). Occupational health hazards of painters and sculptors. *J. Am. Med. Assoc.* 204, 1176.

Siedlicki, J. (1972). Potential hazards of plastics used in sculpture. *Art Education* (Feb.), 78.

Siedlicki, J. (1975). *The Silent Enemy*. 2d ed. Washington, DC: Artists' Equity Association.

*Spandorfer, M., Curtiss, D., and Snyder, J. (1992). *Making Art Safely*. New York: Van Nostrand Reinhold.

Stewart, R., and Hake, C. (1976). Paint-remover hazard. *J. Am. Med. Assoc.* 235, 398.

Stopford, W. (1988). Safety of lead-containing hobby glazes. *North Carolina Med. J.* 49(1), 31–34.

Swaen, G. M. H., Passier, P. E. C. A., and Van Attekum, A. M. N. G. (1988). Prevalence of silicosis in the Dutch fine-ceramic industry. *Int. Arch. Occup. Environ. Health* 60(1), 71–74.

Tell, J. (ed). (1988). *Making Darkrooms Saferooms*. Durham, NC: National Press Photographers Association.

*Vukovich, M. (1987–88). Technically speaking column. Series of 8 articles on kiln safety. Westerville, OH: Edward Orton Jr. Ceramic Foundation.

Waller, J. (1980). Another aspect of health issues in ceramics. *Studio Potter* 8(2), 60.

Waller, J. (ed). (1987). Health and the potter. *Studio Potter* (entire June issue).

Waller, J. A., Payne, S. R., and Skelly, J. M. (1989). Injuries to carpenters. *J. Occup. Med.* 31(8), 687–92.

Waller, J., and Whitehead, L. (1977–79). Health issues (regular column). *Craft Horizons*.

Waller, J., and Whitehead, L. (eds). (1977). *Health Hazards in the Arts—Proceedings of the 1977 Vermont Workshops*. Burlington: University of Vermont Department of Epidemiology and Environmental Health.

Weiss, L. (1987). *Health Hazards in the Field of Metalsmithing* Society of North American Goldsmiths Education and Research Department.

Wellborn, S. (1977). Health hazards in woodworking. *Fine Woodworking* (Winter), 54–57.

White, N. W., Chetty, R., Bateman, E. (1991). Silicosis among gemstone workers in South Africa. *Am. J. Ind. Med.* 19, 205–213.

Wills, J. H. (1982). Nasal cancer in woodworkers: A review. *J. Occup. Med.* 24(7), 526–30.

Woods, B., and Calnan, C. D. (1976). Toxic woods. *Br. J. Derm.* 9513, 1–97.

Index

556

Face and eye protection, 202
Face shields, 205
Fans, 170
Farmer's reducer, 346, **365**
Feathers, 47, 507
Federal Hazardous Substances Act, 16, 18, 175, 534
Feldspars, **112**, 329
Ferric alum, **365**
Ferric ammonium citrate, 128, 353, 354, **365**
Ferric ammonium sulfate, **365**
Ferric chloride, 73, **128**, 310, **451**, 465
Ferric ferrocyanide, **272**
Ferric oxalate, **365**
Ferrous sulfate, **128**, 489, **494**
Fiberglass, 44, 101, 399
Fiber-reactive dyes, 42, 47, 487
Fibers, 480
animal, 482; man-made, 483; vegetable, 480
Finger paints, 537
Fire clays, **112**
Fire extinguishers, 150
Fire hazard, 149, 157, 172, 174
asphaltum dust, 309; electric kilns, 335; flammable and combustible liquids, 175; flammable and combustible solids, 180; organic peroxides, 403; oxidizing agents, 181; rosin dust, 309; spontaneous combustion, 181; wax, 395; welding, 422; woodworking, 413
First-aid, 234
bleeding, 242; chemical burns, 237; chemical ingestion, 239; chemical inhalation, 239; CPR, 242; electric shock, 246; emergency medical services system, 236; heat stress, 247; rescue breathing, 240; thermal burns, 245
First-aid kit, 150, 234
Flake white, 252, 284
Flammable and combustible liquids, 175
Flammable and combustible solids, 180
Flammable gases, 182
Flammable liquids, definitions, 175
Flammability, solvents, 70
Flax, 48, 106, 480
Flint, 98, **112**
Flourescent blue, **270**
Flourescent red, **281**
Fluoride flux, 425
Fluorides, 145, 422, 457, 463, 466
Fluorine, 64
Fluorspar, **112**, 123
Fluxes, 456
Foam vaporization, 428
Food and Drug Administration, 338, 512
Foot protection, 210
Forging, 435

Formaldehyde, 42, 43, 44, 46, 47, 64, 253, 254, 290, 348, 350, 352, 366, 397, 410, 483
Formaldehyde-resin glue, 415
Formalin, 290, 366
Foundation for Community of Artists (FCA), 8
Foundries, 228, 428
abrasive blasting, 433; melting the metal, 431; mold making, 429; pattern making, 428; pouring, 432; removing mold, 433
Fountain solutions, 303
French chalk, 100, 115, 300
French dyes, 488
Freons, 49, 71, 92, 366, 400
Fresco paints, 256
Frisket, 316
Fumes, 104
Fungi, 106
Furniture making, 408
Fusel oil, **80**

Galena, **112**, 130, 329
Gamboge, 499
Garnet, **112**, 392
Gases, 64
Gasoline, **82**, 492
Giant sequoia, 409
Gilding, 444
Glacial acetic acid, 342
Glass
cutting, 476, 497; decorating, 475, 498; finishing, 475; mirroring solutions, 475; stumping and fusing, 478; staining, 475, 498
Glassblowers, lung problems, 474
Glassblowing, 228, 469
annealing, 472; batching, 469; melting, 472; working freeblown glass, 474
Glass wool, 101
Glaze firing, 333
Glazes, 329
and colorants, 330; applying, 332; fluxes, 329; frits, 329; leaded versus leadless, 329; lead-safe, 330; luster, 332; preparing, 331; spraying, 332
Gloss white, **283**
Glove box, diagram, 187
Gloves, 206
Glues, children, 544
Glues and cement, waste disposal, 193
Glycin, 366
Glycol ethers, 37, 50, 54, 87, 311
Glycols, 87, 88, 365
Gold bronze powders, **288**
Gold chloride, 354, **367**
Gold and compounds, **127**, 355, 460 461, 475
Goldsmithing, 435
Gouache, 255, 525
Governmental agencies, 21
Goya, 7

Granite, **112**, 389
Graphic arts, 523
Graphite, **265**, 269
Green earth, **274**
Greenstone, 100, **112**, 388
Grinding, 165, 446
Grisaille, 462
Grog, **112**, 325
Ground fault circuit interrupters, 504
Gum acacia, 262
Gum arabic, 255, 302
Gum spirits, **93**
Gum tragacanth, 262, 465
Gypsum, **112**

Hair, 482
Hand protection, 206
Hand tools, 224
Hansa orange, **277**
Hansa red, **279**, **281**
Hansa yellow, **287**
Hardwoods, 408, 409
Hazardous waste, 190, 192
Hazardous waste disposal companies, 192
Head protection, 207
Health and Welfare Canada, 29
Hearing protectors, 210
Heart, 49
Heat, 49
Heat stress, 228, 246, 472
Hematite, **112**
Hemlock, 409
Hemoglobin, 49
Hemp, 48, 106, 480
Hepatitis, 51
Heptane, **80**
2-hexanone, **92**
Hexone, **91**
Hide glue, 415
Highly toxic, 62
High risk groups, 34, 35, 37
High voltage equipment, 227
Holography, 513–14
Home studios, 148
Hooker's green, **275**
Horn, 508
Household dyes, 488
Housekeeping, 187
Hydrobromic acid, **367**, 515
Hydrocarbons
aliphatic, **80**; aromatic, **82**; chlorinated, **84**
Hydrochloric acid, 75, **367**, **451**
Hydrofluoric acid, 303, 441, 445, 499
Hydrogen chloride, 46
Hydrogen cyanide, 52, 65, 215, 430, 442
Hydrogen fluoride, 64
Hydrogen peroxide, 182, **368**, **442**
Hydrogen selenide, 64
Hydrogen sulfide, 52, 64, 65, 347
Hydrofluoric acid, **76**, 467, 477
Hydroquinone, 43, 343, **368**, 531

toxicants, 53; during pregnancy, 55; functional deficiency, 54; miscarriage, 54; prior to pregnancy, 54; protection, 55; reproductive toxicants, 53; teratogens, 54
Reproductive system, 53
Resist, 438
Resorcinol-formaldehyde resins, 397
Respirators
 air-purifying 196; advantages, 196; disadvantages, 197; selection of cartridges and filters, 198; fit testing, 199, air-supplying, 196; and eye irritants, 199; beards, 201; choosing, 197; cleaning, 202; full-face, 197; medical factors, 201; types, 196; use and maintenance, 201
Respiratory allergies, 487
Respiratory system, 46–48
Rhodamine, **281, 282**
Risk factors
 degree of exposure, 31; dose, 32; high rish groups, 34; multiple exposures, 33; multiple sources, 32; total body burden, 33; toxicity, 33
Rock wool, 101
Rose madder, 252, **278**
Rosewood, 409
Rosin, 180, 262, 302, 308, 309, 459
Rouge, **115, 392,** 446, 477
Routes of entry, 37
Rubber cement, 402, 527, 528
Rubber latexes, 402
Rutile, **115**

Salt glazing, 337
Sand, foundry, 430
Sand molds, 429
Sandstone, **115,** 388
Scarlet red, **277**
Scented markers, 538
Scheele's green, **275**
Screen printing, 315
 blockouts, 316; childre, 542; cleanup, 321; drying, 320; inks, 319; photo stencil, 318; printing, 320; lacquer film stencils, 317; resists, 316; solvent-based inks, 319; solvents, 316, 317, 319, 321; stencils, 315; water-based inks, 319; water-emulsion films, 317
Sculpture, 385
 hard stone carving, 389; lapidary, 392; modeling material, 393; plaster, 385; plastics, 396; soft stone carving, 388; stone casting, 391; stone finishing, 392; wax, 395
Sculpture material, children, 540
Selenium and compounds, 44, 51, 136, 347
Selenium dioxide, **377,** 502
Selenium oxide, 43, 377
Sensitizers, 42
Sepia, **273**

Septic tank, 191, 356
Serpentine, 100, **115,** 388
Sewage system, 191
Shellac, 261, 417
Shell molds, 429
Shells, 507
Shock, first-aid, 244
Sign painting, 529
Silica, 48, 98, **115,** 284, 386, 460, 470
 exposure limit, 99
Silica flour, 98, 429
Silicates, 100, **145**
Silicon carbide, 109, **115, 392**
Silicones, 402
Silicosis, 98
Silk screen printing, see screen printing, 315
Silver and compounds, **137,** 457, 460
Silver nitrate, 44, 46, 346, 348, 354, **377,** 499
Silversmithing, 435
Silver soldering, 456, 465
 cadmium, 456
Skin, 37, 43–49
Skin absorption, solvents, 37
Skin cancer, 43
Slag wool, 101
Slaked lime, **78**
Slate, **115**
Slightly toxic, 63
Smalt, **272**
Smoke detectors, 150
Smoking, 34, 48, 54
Soapstone, 48, 100, 115, 388
Soda ash, **77,** 502
Sodium benzoate, **293**
Sodium bisulfate, **74, 445**
Sodium bisulfite, 345, **378**
Sodium carbonate, **77,** 343, **378,** 487, 502
Sodium compounds, **138**
Sodium cyanide, 471
Sodium dichromate, **124**
Sodium fluoride, **293,** 415
Sodium formaldehyde bisulfite, **378**
Sodium hydroxide, **77, 378, 454,** 490, 502
Sodium hydrosulfite, 490
Sodium hypochlorite, **289,** 493
Sodium hypochlorite solution, **361**
Sodium metasilicate, **77**
Sodium Nitrate, **379**
Sodium Ortho-Phenyl phenate, 256, **293**
Sodium Oxide, **77**
Sodium Potassium Tartrate, **354,** 471
Sodium Selenate, **137**
Sodium Silicate, **78,** 460
Sodium Sulfide, **379**
Sodium sulfite, 343, **379**
Sodium Thiocyanate, **379**
Sodium Thiosulfate, 345, 354, **380,** 442, **454**
Sodium 2,4,5 Trichlorophenate, **293**

Soft soldering, 459
Softwoods, 410
Soldering, 459
Solvents, 35, 44, 52, 54, 69, 194, 405
Sparex, **74,** 436, 445, 457, 463
Spills, 187
Spinning, 480
Spontaneous abortions, 54
Spontaneous combustion, 181, 297
Spray adhesives, 527, 546
Spray finishing, 165
Spray fixatives, 265, 525, 530, 546
Spray guns, 72, 263
Spray painting, 165, 263, 546
Sprinkler systems, 150
Stained glass, 497
 antiquing, 502; glass cutting, 497; glass decoration, 498; glazing, 500; kiln firing, 500
Stains, waste disposal, 193
Stannous chloride, **139, 489, 495**
Stannous oxide, **139**
Steatite, **115,** 388
Stoddard solvent, **81**
Stone, crushed, 391
Stone carving, 389
 asbestos, 389; electric tools, 389; noise, 390; pneumatic tools, 390; silica, 389, 390; vibration, 390
Stone casting, 391
Stone finishing, 392
Stoneware-firing, 333
Stop-outs, 307
Storage
 clay, 326; toxic materials, 184
Stove black, **269**
Strontium chromate, 124, **287**
Strontium compounds, **138**
Strontium yellow, 252, **287,** 296
Studio location, 149
Studios, home, 148
Styrene, 43, 51, 54, **83,** 399
Styrofoam, 540
Substitution, 159
Succinaldehyde, 350, **380**
Sulfamic acid, **380**
Sulfates, **146**
Sulfides, 44, **146**
Sulfide toners, 347
Sulfites, 146
Sulfur dioxide, 40, 46, 64
Sulfuric acid, **75, 381,** 436, 439
Symptoms and art materials, 231
Systemic effects, 41

Talc, 48, 100, **115,** 284, 300, 302, 326
Tannic acid, **73,** 489, **496**
Tannin, **73, 496**
Tantalum, 441
TCL(0), 58
TDI, 401
TDL(0), 58
Telephone, emergencies, 150
Tempera paints, 255, 537